ARS ELECTRONICA

Hannes Leopoldseder — Christine Schöpf — Gerfried Stocker

1979 – 2004

Ars Electronica

The Network for Art, Technology and Society: The First 25 Years
25 Jahre Netzwerk für Kunst, Technologie und Gesellschaft

CONTENTS

ARS ELECTRONICA

HANNES LEOPOLDSEDER CHRISTINE SCHÖPF GERFRIED STOCKER

25 Jahre lang begleitet Ars Electronica bereits die digitale Revolution, und ihre Vitalität ist ungebrochen.

Ihre Einzigartigkeit und ihre herausragende Position im Kontext internationaler Medienkultur gewann und gewinnt Ars Electronica vor allem aus der Konstellation ihrer Elemente und Aufgabenfelder. Ars Electronica entwickelte sich in ihrer Geschichte stetig weiter und repräsentiert heute mehr als jede andere vergleichbare Institution einen umfassenden Ansatz in der Auseinandersetzung mit techno-kulturellen Phänomenen. Ihr Radius reicht dabei von philosophisch-theoretischen Auseinandersetzungen hochkarätiger Experten über aktive Förderung von Medienkunstprojekten bis hin zu Kooperationen mit Unternehmen aus der Privatwirtschaft. Darüber hinaus erreicht sie über das Museum der Zukunft interessierte Menschen aller Alters- und Gesellschaftsgruppen.

Ars Electronica wurde aber auch zu einer gestaltenden Einflussgröße in dem Wandel, den die Stadt Linz kulturell wie ökonomisch vollzogen hat. Zu einem Symbol und Leitbild für eine Stadt, in der Zukunftsorientierung keine Frage der Wirtschaft und Industrie alleine ist, sondern vorrangig als kulturelle Aufgabe verstanden wird. Entstanden ist dadurch ein Beweis für die

Ars Electronica has been accompanying the Digital Revolution for 25 years now, and its vitality remains undiminished.

Ars Electronica's uniqueness and the outstanding position it has assumed within the context of international media culture have resulted above all from the constellation of its elements and the areas in which it has focused its energies. Ars Electronica has undergone continual development throughout its history, so that today, more than any other comparable institution, it represents a comprehensive approach to the encounter with techno-cultural phenomena. In pursuing this mission, its radius of activities ranges from providing a setting for philosophical-theoretical discussions involving top international experts to actively fostering media art projects and collaborating on joint ventures with private sector associates. And, through the Museum of the Future, Ars Electronica reaches interested audiences in all age groups and social strata.

Ars Electronica has also become a significant source of inspiration in the process of cultural and economic change that has been underway in this city. As a result, Linz has come to epitomize the model municipality whose orientation on the future is not just a question of commerce and industry, but rather one that is envisioned primarily as a cultural

gesellschaftliche Relevanz künstlerischer Arbeit und ein prototypisches Modell für stadt- und kulturpolitische Entwicklungsoptionen jenseits von Traditionalismus und Tourismus.

Ihre Geschichte verdeutlicht eindrucksvoll, dass Ars Electronica nie auf einen Elfenbeinturm beschränkt war. Ihre Interdisziplinarität, ihre Offenheit gegenüber neuen Trends, ihre Auseinandersetzung mit Visionen zukünftiger Entwicklungen hatten letztlich immer einen wesentlichen Fokus: deren Auswirkungen auf unsere Gesellschaft. Damit steht trotz aller technoider Bilder und Maschinen der Mensch im Mittelpunkt der Auseinandersetzung: Der Mensch als Künstler, Arbeiter, Manager, Konsument, der Mensch als Nutznießer, als Benutzer, als Opfer und vor allem als Gestalter und Präger neuer Technologien.

Es liegt in der Natur von Ars Electronica, stets das Neue zu suchen. In ihrer Auseinandersetzung mit Kunst, Technologie und Gesellschaft erwies sich die Themenführerschaft der Ars Electronica als beständiges und konstitutives Element ihrer Aktivitäten. Unermüdlich eroberte sie seit 1979 neues, unbekanntes Terrain experimenteller technischer oder gesellschaftlicher Neuerungen. Auf diese Art erweiterte Ars Electronica laufend ihren Aktionsradius und erfüllte eine gesellschaftliche Vorreiterrolle. Als Netzwerk zu Künstlern in der ganzen Welt erfüllt der 1987 gegründete Prix Ars Electronica die Funktion als Scout für neueste Trends in Kunst und Technologie und somit als zentrales Werkzeug in der langjährigen Kontinuität der Themenführerschaft der Ars Electronica. Seit 1996 nehmen Ars Electronia Futurelab als Verbindungstor zu Wirtschaft und Wissenschaft sowie das Museum der Zukunft in seiner Vermittlungsfunktion gegenüber einer breiten Öffentlichkeit weitere wesentliche Aufgabenfelder wahr.

Ars Electronica steht heute auf einem Fundament aus vier starken Säulen, die sich inhaltlich und operativ optimal ergänzen. Ihr umfassender Ansatz und ihr einzigartiger Status, die Nutzung aus Synergien ihrer Teilbereiche und ihre internationale Vernetzung, sichern ihr auch für die nächsten 25 Jahre eine herausragende Stellung in der immer größer werdenden Welt der Medienkultur.

undertaking. This demonstrates the social relevance of artistic work and also serves as a prototype for urban renewal and cultural policy development options that go beyond traditionalism and tourism. Its history is impressive proof that Ars Electronica has never sealed itself off in an ivory tower. Its interdisciplinarity, its openness to new trends and its confrontation with visions of future developments have in the final analysis always had one essential focus: their impact on our society. Thus, in spite of all the techno-imagery and machinery, the human being ultimately occupies the center of attention in this encounter—the human being as artist, worker, manager and consumer, the human being as beneficiary, user, victim and, above all, creator and applier of new technologies.

It is the nature of Ars Electronica to pursue an ongoing quest for innovation. In its confrontation with art, technology and society, Ars Electronica's thematic leadership has proven to be a steadfast and constitutive element of its activities. Since 1979, it has tirelessly opened up new and uncharted territory of experimental, technical and social innovation. In this way, Ars Electronica has continually expanded its action radius and successfully assumed the role of social bell-wether. The Prix Ars Electronica founded in 1987 has become a network linking artists throughout the entire world and fulfills the function of scout discovering the latest trends in art and technology. It is thus a key instrument in the long continuity of Ars Electronica's thematic leadership. Since 1996, the Ars Electronica Futurelab as gateway to the worlds of business and science as well as the Museum of the Future functioning as mediator in the general public's encounter with the state of the art have been successfully carrying out additional, highly essential tasks.

Today, Ars Electronica stands upon a foundation supported by four solid pillars that optimally complement each other both functionally and with respect to content. Its comprehensive approach and singular status, the benefits yielded by the synergies of its interactive components and its manifold linkages to international networks assure Ars Electronica a prominent position in the ever-growing domain of media culture over the next 25 years as well.

DR. FRANZ DOBUSCH
Bürgermeister der Landeshauptstadt Linz

Mayor of the City of Linz

Labor der Zukunft

Linz bewirbt sich als „Europäische Kulturhauptstadt" für 2009. Im September werden die Bewerbungsunterlagen in Wien im Staatssekretariat für Kunst und Medien eingereicht. Inhaltlich positioniert sich die Stadt darin als „Labor der Zukunft", mit den Schwerpunkten Medienkunst und Kunst im offenen Raum. Das Ars Electronica Festival bildet dabei eine wesentliche Grundlage. 1979 hat alles begonnen. Linz stellte sich erstmals den Themen der Zukunft – im Spannungsfeld zwischen Kunst, Technologie und Gesellschaft. Brucknerhaus und ORF waren die Motoren des Festivals, ganz Linz wurde zu einer Bühne mit Open-Airs, Installationen, Interaktionen und Performances. Ab 1987 erhielt das Festival ein jährliches Generalthema. Ein weiterer Schritt in Richtung Zukunft wurde mit dem Prix Ars Electronica, dem höchst dotierten Wettbewerb für Computerkunst, gesetzt. Im Ars Electronica Center hat Ars Electronica schließlich seit 1996 ein Zuhause gefunden. Das Festival wird nun schon seit acht Jahren vom Museum der Zukunft aus gesteuert. Linz hat die Zeichen der Zeit erkannt und sich bis heute als Metropole der Computerkunst weit über die Grenzen hinaus einen Namen gemacht.

Laboratory of the Future

Linz is applying to be named European Cultural Capital in 2009. In September, the documentation supporting this application will be submitted to the office of the State Secretary for the Arts and Media in Vienna. With respect to the application's substance, the city is positioning itself as a "laboratory of the future" with an emphasis on media art and art in public spaces. The Ars Electronica Festival is an essential part of this. It all began in 1979 when, for the first time, Linz confronted the future taking shape in the field of tension and interplay where art, technology and society meet. The Brucknerhaus and the ORF were the driving forces behind the festival that turned the whole city into a stage for open-air events, installations, interactions and performances. A yearly festival theme was added in 1987. Another step toward the future was taken with the founding of the Prix Ars Electronica, the world's most highly endowed competition for computer art. The construction of the Ars Electronica Center finally provided Ars Electronica with a new home in 1996. During the eight ensuing years, the festival has been headquartered at the Museum of the Future. Linz recognized the signs of the times and has gone on to make a name for itself far beyond its borders as the metropolis of computer art.

DR. JOSEF PÜHRINGER
Landeshauptmann des Landes Oberösterreich

Governor of the Province of Upper Austria

Schrittmacher der Moderne

25 Jahre Ars Electronica in Linz: Dieses Jubiläum bedeutet um vieles mehr als nur eine weitere Eckzahl in der oberösterreichischen Kulturlandschaft. Es handelt sich um ein Vierteljahrhundert geschriebener und gelebter Medien- und Technologiegeschichte unserer Landeshauptstadt. Sie konnte sich mit diesem Festival für Kunst, Technologie und Gesellschaft als Ort des Wettbewerbs, der Präsentation, der Forschung und der Dokumentation weltweit positionieren und sich damit in die Spitzenliga der internationalen High-Tech-Gesellschaft spielen. Die Impulse, die mit dieser innovativen Einrichtung langfristig soziokulturell und ökonomisch gesetzt wurden, können gar nicht hoch genug geschätzt werden. Ars Electronica war für uns ein Schrittmacher der Moderne, und sie ist und bleibt ein Markenzeichen für visionäres Engagement und den kühnen Blick in die digitale Zukunft.

25 years of Ars Electronica in Linz—this anniversary means much more than just a numerically noteworthy occasion for the Upper Austrian cultural landscape. It represents a quarter century of medial and technological history written and lived out right in the capital of our province. With this festival for art, technology and new media, Linz has succeeded in positioning itself globally as a setting for competition, presentation, research and documentation, and has thus assumed a place in the top echelon of international high-tech society. It is hard to exaggerate the long-term sociocultural and economic effect that this innovative facility has had. Ars Electronica has been a pacemaker of modernism for us, and it continues to embody farsighted commitment and bold vision focused on the digital future.

FRANZ MORAK
Staatssekretär für Kunst und Medien
State Secretary for the Arts and Media

DR. ERICH WATZL
Vizebürgermeister der Landeshauptstadt Linz
Aufsichtsratvorsitzender Ars Electronica Center

Vice-Mayor of the City of Linz
Chairman of the Ars Electronica Board of Directors

Nach Bild, Text, Architektur, Musik und Film hat sich der digitale Raum als eine weitere Dimension der Kunst etabliert: Elektronische Kunst, Cyberart, bekam 1979 weltweit ihren ersten festen Standort: Ars Electronica, das Festival für Kunst, Technologie und Gesellschaft, wurde in Linz etabliert. Zuletzt hat – wie ich vor Ort selbst miterleben durfte – die erfolgreiche Präsentation der neuen Kategorie „Digital Communities" des internationalen Wettbewerbes Prix Ars Electronica in New York eindrucksvoll bewiesen, dass Ars Electronica mit ihren vier Bereichen – Festival, Prix, Museum der Zukunft und Futurelab – ein international führender Seismograf und Schrittmacher für neue Entwicklungen ist und einen ganz wesentlichen Beitrag zur Entwicklung der Informationsgesellschaft leistet. Ars Electronica ist zu einem unverzichtbaren Bestandteil der österreichischen Kulturlandschaft geworden und hat sich auch zu einem internationalen Kulturereignis mit unverwechselbarem Profil entwickelt. Zu ihrem Jubiläum wünsche ich Ars Electronica weiterhin viel Erfolg, internationales Ansehen und viele Besucherinnen und Besucher. Ich danke den Erfindern, Trägern und Kooperationspartnern der Ars Electronica für ihre Innovationskraft und ihr Engagement.

Following image, text, architecture, music and film, the digital realm has now established itself as the latest dimension of art. In 1979, electronic art and cyberart got their first fixed venue anywhere in the world when Ars Electronica, the festival for art, technology and society, was founded in Linz. As I recently saw for myself in person, the successful New York presentation of "Digital Communities," the new category of the international Prix Ars Electronica competition, impressively confirms that Ars Electronica with its four domains—Festival, Prix, Museum of the Future and Futurelab—has achieved international recognition as the leading seismograph and pacemaker for new developments, and is making a very essential contribution to advancing Information Society. Ars Electronica has become an indispensable part of the Austrian cultural landscape and has also developed into an international cultural event with an unmistakably distinctive image. On the occasion of this anniversary, I wish Ars Electronica continued success, growing international prestige and many, many more visitors. I also wish to thank the founders, directors and associates of Ars Electronica for the dynamic innovativeness and commitment they have displayed.

Ars Electronica nimmt im Kulturleben der Stadt Linz eine zentrale Rolle ein. Bereits vor 25 Jahren, als der Einfluss digitaler Medien noch wie Zukunftsmusik erschien, etablierte sich das Festival als Zentrum der Auseinandersetzung zwischen Kunst, Technologie und Gesellschaft. Es trug so den Namen der Stadt Linz als Zentrum des Fortschritts und der Innovation weit über die Landesgrenzen hinaus. Linz ist heute ein dynamischer, offener Raum – ein Bild, das nicht zuletzt stark durch Ars Electronica geprägt wurde.
Ars Electronica ist eine Erfolgsgeschichte. Gemeinsam bilden Festival und Prix Ars Electronica, Museum der Zukunft und Futurelab ein in Ausrichtung, Konfiguration und Größe einzigartiges Zentrum der Medienkultur. Sowohl im regionalen Rahmen als auch in seiner Bedeutung für das Bild der Stadt Linz auf internationaler Ebene wird Ars Electronica auch während der kommenden 25 Jahre weiterhin eine entscheidende Rolle einnehmen.

Ars Electronica has assumed a central role in the cultural life of the City of Linz. Twenty-five years ago, when the digital media still seemed like a utopian dream of the distant future, the festival was already establishing itself as the center of the encounter with art, technology and society. In doing so, it bore the name of the City of Linz as a hub of progress and innovation far beyond the borders of our land. Today, Linz is a dynamic, open space—an image that has been shaped to no small extent by Ars Electronica. Ars Electronica is a success story. The Festival and the Prix Ars Electronica, the Museum of the Future and the Futurelab combine to form a center for media culture whose orientation, configuration and size make it unique. Both in a regional context as well as with regard to its significance for the image of the City of Linz on an international level, Ars Electronica will continue to play a decisive role during the coming 25 years as well.

Wolfgang Winkler
Künstlerischer Leiter
Artistic Director/LIVA

Für das Festival Ars Electronica, das nachhaltig geholfen hat, das Bild der Stadt zu verändern, sind übliche Geburtstags-Lobhudeleien nicht angebracht. Es geht nicht darum, eine Jahreszahl mehr oder weniger willkürlich herauszuheben, es geht darum, die Wirkung dieses Festivals in seinem Verlaufe zu erkennen und hervorzuheben. Der Kulturbetrieb gerät allgemein vielfach zu einer Starmania höherer Ordnung. Festivalprogramme, speziell im Sommer, werden zu Auszügen aus den Marketingstrategien von Hotelmanagern. Dem Konsumieren steht das Denken gegenüber. Die Spannung zwischen Innovation, Vision und Neugierde auf etwas Weiterführendes und dem Mainstream des Repertoires machte Ars Electronica wertvoll – und wird sie auch in Zukunft wertvoll machen –, nicht nur für Linz, sondern grundsätzlich. 1979 war es sehr mutig, dieses Festival zu initiieren, aber auch leichter, da kaum jemandem bewusst war, dass seine Zukunft gerade begonnen hatte. Die nächsten 25 Jahre werden noch anspruchsvoller und spannender. Die Instrumente sollten dabei stete Innovation, Vernetzung und weltweite Partnerschaften sein.

For the Ars Electronica Festival—an institution that has made a lasting impact on how our city is perceived— the usual elated exclamations of happy birthday are hardly appropriate. The point here is not to pick out a number more or less arbitrarily; what is incumbent upon us is to recognize and honor what this festival has accomplished since its inception. The business of producing cultural events is becoming more and more like a high-class version of Starmania. Festival programs, especially those in summer, increasingly resemble something out of a hotel manager's marketing strategy. Consuming is juxtaposed to thinking. The tension among, on one hand, innovation, vision and curiosity about something of great future promise and, on the other hand, the mainstream of its repertoire has made Ars Electronica a valuable institution and will continue to do so in the future—and not only for Linz. It was a bold move in 1979 to initiate this festival, but an easy one too since hardly anyone realized that its future had just begun. The next 25 years will be increas-ingly demanding and ever more fascinating, though the instruments to achieve this will remain the same: innovation, networking and worldwide partnerships.

Dr. Helmut Obermayr
Landesdirektor ORF OÖ
Director, Austrian Broadcasting Company's Upper Austrian Regional Studio

ORF Oberösterreich und Ars Electronica sind ein Begriffspaar, das seit 25 Jahren aufs Engste miteinander verbunden ist. Ohne den damaligen, bis 1998 in dieser Funktion tätigen Landesintendanten Dr. Hannes Leopoldseder und die Leiterin unserer Kulturredaktion Dr. Christine Schöpf gäbe es Ars Electronica nicht. Sie wäre nicht entstanden, und sie hätte sich wahrscheinlich auch nicht gehalten. Im Lauf der Jahre hat sich die organisatorische Verflechtung mehrmals geändert. Jahrelang war der Prix Ars Electronica ein eigener Teil des Festivals, der vom ORF als Veranstalter getragen wurde. Gerade der Prix hat den internationalen Ruf des gesamten Festivals bewirkt. Nunmehr ist der Prix auch organisatorisch in die Ars Electronica eingebunden. Der ORF Oberösterreich ist wieder zum Mitveranstalter des Gesamtfestivals geworden. Für uns ist Ars Eletronica ein unverzichtbarer Teil unserer gesamten kulturellen und kulturpolitischen Aufgabe, die wir als öffentlich-rechtlicher Rundfunk in Oberösterreich wahrnehmen.

ORF Upper Austria and Ars Electronica comprise a conceptual pair that has been closely interconnected for 25 years. Without Dr. Hannes Leopoldseder, then director of the ORF's Upper Austria Regional Studio who served in that capacity until 1998, and Dr. Christine Schöpf, the head of our cultural department, there would not even be an Ars Electronica—it would not have come about, and it would probably not have lasted. Over the years, the organizational structure changed a number of times. For years, the Prix Ars Electronica was organized by the ORF as a separate part of the festival, and it was the Prix that endowed the festival as a whole with an international reputation. Now the Prix as well has been organizationally integrated into Ars Electronica, and ORF Upper Austria is once again a co-organizer of the entire festival. For us, Ars Electronica is an indispensable

part of our overall cultural mission and the cultural policies we pursue as a public broadcasting institution in Upper Austria.

Mag. Martin Sturm
Direktor O.K Centrum für
Gegenwartskunst
Director O.K Center for
Contemporary Art

Ars Electronica ist ein Parade-beispiel dafür, wie Kunst und Kultur als wichtige, zukunftsweisende gesellschaftliche Codes und Sub-Systeme sichtbar gemacht und nachhaltig positioniert bzw. verankert werden können. Die enorme Veränderung unserer Seh-, Denk- und Handlungsweisen durch die digitale Revolution und die damit einhergehende Produktion immer neuer medialer Wirklichkeiten war von Anfang an ein zentrales Thema des Festivals. Der kulturelle und künstlerische Anspruch des Festivals bot dabei den notwendigen Freiraum für eine ebenso spielerische wie kreative, aber auch kritische Auseinandersetzung mit medienpolitischen Entwicklungen, die sonst ausschließlich ökonomisch verhandelt werden. Gleichzeitig wurde durch die Einführung des Prix Ars Electronica als Preis- und Ausstellungsformat deutlich gemacht, welche Auswirkungen die Entwicklung digitaler Werkzeuge und Netzwerkstrukturen auf die künstlerische Praxis hat. Ars Electronica ist es jedenfalls durch die jahrelange, konsequente Arbeit nachhaltig gelungen, ein kulturelles, zukunftsorientiertes Image für die Stadt Linz und darüber hinaus für die ganze Region Oberösterreich aufzubauen. Allein dafür haben sich die Betreiber zehn Salutschüsse verdient.

Ars Electronica is an outstanding example of how art and culture as essential social codes and sub-systems that point the way to the future can be made visible and positioned/ anchored over the long term. The enormous changes that the Digital Revolution has brought about in how we see, think and behave, and the accompanying production of continually updated medial realities have been a central theme of the festival since its very inception. In pursuing an encounter with this theme, the festival's cultural and artistic mission offered the necessary latitude for playful, creative as well as critical confrontations with media policy develop-

ments that are otherwise treated exclusively from an economic perspective.

At the same time, the introduction of the Prix Ars Electronica as a prize and exhibition format has made clear what a powerful impact the development of digital tools and network structures is having on artistic practice now. Through persistent pursuit of its mission over the years, Ars Electronica has achieved long-term success in constructing a cultural, future-oriented image for the City of Linz and, indeed, for the entire region of Upper Austria. Its founders and directors deserve a ten-gun salute for this alone.

Stella Rollig
Direktorin Lentos
Kunstmuseum Linz
Director Lentos Museum
of Art, Linz

Linz hat sein Image – besonders in kulturellen Angelegenheiten – erfolgreich mit Aktualität, Trendsetting und lebendiger Zeitgenossenschaft verknüpft. Der leistungsstärkste Motor dieses Prozesses war und ist Ars Electronica. Erstklassige (Kunst-) Universitäten, faszinierende Museen und vitale freie Szenen gibt es (zum Glück) auch anderswo. Ars Electronica ist einzigartig, auch nach 25 Jahren und obwohl sie heute nicht mehr das einzige Festival ist, das eine Plattform für Kunst sowie für Gesellschafts- und Technologiekritik bereitstellt. Doch Ars Electronica ist es gelungen, sich jedes Jahr neu zu positionieren und anhaltend ein inter/nationales Publikum nach Linz zu bringen. Das Lentos, als junges Museum, das sich selbst als Medium künstlerischer und kommunikativer Diskurse versteht, freut sich über die erste Zusammenarbeit im Jubiläumsjahr – und auf viele weitere inspirierende gemeinsame Projekte.

Linz has successfully linked its image—especially in cultural affairs—to the state-of-the-art and the dynamic trendsetters of contemporary culture. The high-performance engine driving this process has been Ars Electronica. First-class universities (of art), fascinating museums and lively free art scenes can (fortunately) be found elsewhere as well. Ars Electronica is one-of-a-kind—even after 25 years, and even though it is no longer the only festival that provides a platform for art

and social/technological critique. But Ars Electronica has succeeded in positioning itself anew each year and in consistently attracting both regional and international audiences to Linz. Lentos, as a young museum that defines itself as a medium of artistic and communicative discourse, is looking forward to its first opportunity to work together with Ars Electronica as part of this anniversary celebration and to further collaboration on inspiring projects in years to come.

Univ. Prof.
Dr. Reinhard Kannonier
Rektor der Universität für
künstlerische und industrielle
Gestaltung
*Dean of the University of Art
and Industrial Design*

Das Ars Electronica Center wurde in den letzten Jahren zu einem der wichtigsten Kooperationspartner der Universität für künstlerische und industrielle Gestaltung. Denn ein Kernstück deren neu entwickelter Profilbildung liegt im Ausbau von spezifischen Medienkompetenzen, die – gebündelt durch gemeinsame strategische Konzeptionen – dem Medienstandort Linz weitere wichtige Impulse geben werden. Die bisher schon erfolgreiche und äußerst fruchtbare Zusammenarbeit der beiden Institutionen soll auf mehreren Ebenen strukturell ausgebaut werden, insbesondere in den Bereichen Interface Cultures, Medientheorie und -geschichte, Knowledge Design und Vermittlung. Zudem ist dem Team der Ars Electronica für die großzügige Kooperation im Rahmen des Ars Electronica Festivals zu danken – verbunden mit dem Wunsch, dass dies auch weiterhin so bleiben möge!
The Ars Electronica Center has become one of the University of Art and Industrial Design's most import associates in recent years, since an essential part of our efforts to develop a higher-profile public image is focusing on expanding competency in specific media fields, which—combined with a joint strategic concept—is designed to further enhance Linz's status as a place to locate media enterprises. This already successful and extremely fruitful collaboration of the two institutions is being structurally extended to encompass additional

levels, the most important areas of which are interface cultures, media theory and history, and knowledge design and mediation. We are also thankful for the Ars Electronica staff's generous cooperation in conjunction with the Ars Electronica Festival and are looking forward to carrying on this good working relationship in the future!

Univ. Prof.
Dr. Rudolf G. Ardelt
Rektor Johannes Kepler
Universität Linz
*Dean of the Johannes Kepler
University, Linz*

Was vor 25 Jahren als aufregende Erfahrung für junge Kunst-, Kultur- und Medienbegeisterte begann, hat sich zu einem wichtigen Kooperationspartner der Johannes Kepler Universität entwickelt. Mit ihren lebendigen Auseinandersetzungen – in den letzten Jahren auch zu wichtigen gesellschaftspolitischen Fragen und Entwicklungen – steht Ars Electronica nicht nur für ein wichtiges Impulszentrum für intellektuelle Diskurse. Mit dem Ars Electronica Center und dem Ars Electronica Futurelab wurden auch Netzwerke zur Johannes Kepler Universität geknüpft, die von der Beteiligung von Angehörigen der JKU an Projekten des Museums der Zukunft bis hin zur Zusammenarbeit im Bereich anwendungsorientierter Forschung reichen und so eine neue – auch ökonomische – Bedeutung erlangt haben.
What began 25 years ago as an exciting experience for young art, culture and media enthusiasts has since developed into a key partner and associate of the Johannes Kepler University. With its lively debates that have included confrontations with significant sociopolitical issues and developments in recent years, Ars Electronica has come to represent an important source of stimulus for intellectual discourse. Furthermore, the founding of the Ars Electronica Center and the Ars Electronica Futurelab has also established networks involving the Johannes Kepler University. These range from participation by JKU staff members in joint projects with the Museum of the Future to collaboration on application-oriented research, and are thus of scientific as well as economic significance.

PART I
ENTWICKLUNGSLINIEN
LINES OF EVOLUTION

Christine Schöpf

The Making of ...

Jede Idee, jedes Projekt braucht seine Mitstreiter, braucht Menschen, die für Visionen stehen, und jene, die sich für diese Visionen zu begeistern wissen; es braucht über manche Strecken Kämpfernaturen mit einem Schuss Guerilla-Mentalität und braucht letztendlich ein Maß an Zähigkeit und Überzeugungskraft. Ars Electronica hatte in den 25 Jahren ihres Bestehens von allem!

September 1977: Die Elektronikmusikpopgruppe Eela Craig tritt im Linzer Brucknerhaus auf. Nach Auftritten im Frankfurter Alten Theater und der Votivkirche in Wien eine weitere Station auf der Eroberung alternativer Räume zu den damals landläufigen Fußball-Stadien und Messehallen für elektronische Musik. Federführend hinter Eela Craig sind Chef Hubert Bognermayr und der deutsche Produzent Ulli A. Rützel.

Ende des Jahres 1978 werden die beiden in der Vorstandsetage des Linzer Brucknerhauses bei den damaligen Direktoren Horst Stadlmayr und Ernst Kubin vorstellig. Die Idee: das traditionelle Wissenschaftssymposion innerhalb des internationalen Brucknerfestes, das sich bislang mit Themen um Anton Bruckner oder Adalbert Stifter, also den Genii loci, befasst hatte, dem Thema elektronischer Musik zu widmen. Die beiden Vorstandsdirektoren signalisieren Interesse. Man sucht einen elektronischen Medienpartner und findet ihn im ORF in der Person des 38-jährigen Landesintendanten Hannes Leopoldseder.

Hannes Leopoldseder, immer am Thema Zukunft

Every idea and every project needs allies, people who believe in visions, and others who allow themselves to be inspired by these visions. At certain times, natural born fighters with a dash of guerilla mentality are needed, and a certain degree of tenacity and the power of conviction. Ars Electronica has been blessed with all of these in the 25 years of its existence!

September 1977: the electronic pop group Eela Craig performed in Linz's Brucknerhaus. Following performances in Frankfurt's Alten Theater (Old Theatre) and Vienna's Votivkirche (Votive Church), this was still another step towards performing electronic music at venues other than the usual soccer stadiums and fair pavilions of the times. The group behind this was Eela Craig—i.e. its leader Hubert Bognermayer and its German producer Ulli A. Rützel.

In late 1978 these two met Horst Stadlmayer and Ernst Kubin, the directors of the Brucknerhaus at that time. Their idea was to dedicate the traditional academic symposium held during the international Bruckner Festival, which had previously dealt with themes revolving around Anton Bruckner or Adalbert Stifter, famous sons of the city, to the theme of electronic music. The two directors of the board showed interest. An electronic media partner was sought, and then

Ars Electronica 79 – Großer Preis der Ars Electronica

Ars Electronica 79 – Musik von Bruckner aus dem Brucknerhaus zur Klangwolke

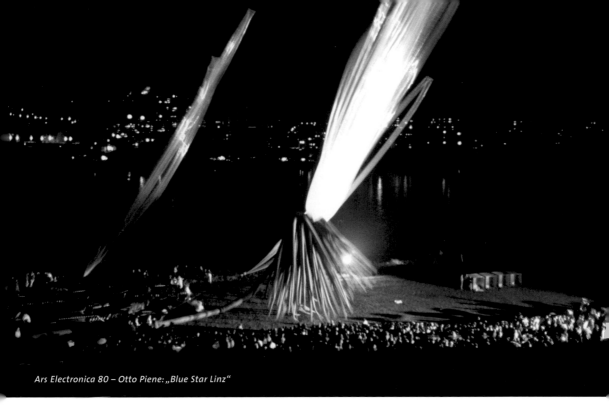

Ars Electronica 80 – Otto Piene: „Blue Star Linz"

interessiert, ist nicht nur der Nächste im Bunde. Seine Vision geht weit über ein Symposion hinaus: Ein kontinuierliches Festival, das sich den Themen Kunst, Technologie und Gesellschaft widmet, sollte es werden. In Fachsymposien, Performances und mit Einbeziehung der Wissenschaft sollten Insider ebenso angesprochen werden wie die Stadtöffentlichkeit mit Open-Air-Events.

Einer der wenigen Autoren, die sich zu dieser Zeit mit dem Thema Kunst und Technologie befassen und entsprechend publizieren, ist der bei München lebende Physiker und Kybernetiker Prof. Herbert W. Franke. Er verbündet sich sofort mit den aus Linz an ihn herangetragenen Ideen. Im Verlauf des Jahres 1979 erlangt die erste Ars Electronica in stundenlangen Tag- und Nachtsitzungen ihre programmatischen Konturen. Noch fehlt allerdings *das* Event.

Auf der Suche nach einem spektakulären Open-Air stößt Leopoldseder auf einen Komponisten, der in Bayern mit der Inszenierung von *Musik für eine Landschaft* auf sich aufmerksam gemacht hat – Walter Haupt: Er wird nächster Mitstreiter im Bund, und in wiederum langen Nachtsitzungen der Ars-Electronica-Truppe, der mittlerweile auch der damalige Brucknerhaus-Grafiker und Katalog-Macher

found in 38-year-old regional managing director Hannes Leopoldseder at the Austrian Broadcasting Corporation (ORF). Hannes Leopoldseder, a man who had always been interested in the topic of the future, was not simply another ally. His vision extended far beyond that of a symposium, to a permanent festival dedicated to the themes of art, technology and society, with specialist symposia, performances and scientific themes to appeal to both insiders and the town public via open-air events. At the time, one of the few writers exploring and publishing on the theme of art and technology was the physicist and cybernetician Professor Herbert W. Franke, who lived outside Munich. He immediately subscribed to the ideas presented to him from Linz. Throughout the course of 1979, in many long all-day and night meetings, the contours of the first Ars Electronica program took shape. However, *the* event was still missing.

During the search for a spectacular open-air event, Leopoldseder came across a composer who had made a name for himself with the production of *Music for a Landscape* in Bavaria—Walter Haupt. He became the next to join the league and in more all-night meetings the Ars Electronica troop, which by now also included the

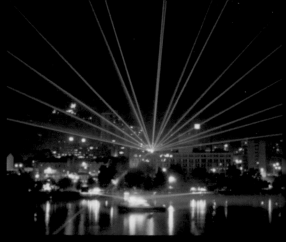

Ars Electronica 82 – Isao Tomita: „Bermuda-Dreieck"

Ars Electronica 84 – Isao Tomita: „Mind of Universe"

Gottfried Hattinger und Christine Schöpf vom ORF angehören, wird die Linzer Klangwolke geboren. Am 18. 9. 1979 eröffnen das Brucknerhaus Linz und das ORF-Landesstudio Oberösterreich mit der Linzer Klangwolke die erste Ars Electronica, das Festival für Kunst, Technologie und Gesellschaft. 100.000 Menschen kamen zur ersten Linzer Klangwolke, bei der Bruckners Achte quadrofonisch ausgestrahlt wurde.

Dem können sich auch die damaligen Stadtväter schwer verschließen. Die erste Ars Electronica sollte eine Fortsetzung finden.

Klangwolke 1980: Walter Haupt schlägt als Visualisierung eine übergroße Heliumplastik des in den USA beheimateten Künstlers, Lehrers, Wissenschafters und Leiters des Center for Advanced Visual Studies am MIT Otto Piene vor. Otto Piene realisiert für die Linzer Klangwolke den *Blue Star Linz* – und wird zum Mitstreiter für das noch junge Festival. Zwei Jahre später bringt er die *Sky Art Conference* erstmals nach Europa zur Ars Electronica – ein Stelldichein der Granden der Medienkunst und Wissenschaft.

Die Universität wird mit den Professoren Schulz und Mühlbacher sowie Wissenschaftssymposion-Organisator Berghold Bayer zum Partner.

Und eine Premiere gibt es: 1980 kommt es erstmals zu einer Zusammenarbeit zwischen dem japanischen Elektronikmusik-Guru Isao Tomita und dem Magier der elektronischen Bilderwelt aus Amerika, Ron Hays – beim *Bermuda-Dreieck* im Linzer Brucknerhaus.

Beim Besuch der Klangwolke 1980 weiß Tomita: Diesen Raum will und wird er bespielen. 1984 verwirklicht er sich seinen Traum mit *Mind of Universe*, den er im Donaupark unter Einsatz aller

Brucknerhaus graphic designer and catalogue maker Gottfried Hattinger, and Christine Schöpf from ORF, the idea for the Linz *Klangwolke* was born. On September 18th, 1979, the Brucknerhaus and the ORF Upper Austrian Regional Studio opened the first Ars Electronica, the festival for art, technology and society, with the Linz *Klangwolke*. One hundred thousand people attended this first event, during which Bruckner's 8th symphony was broadcast in quadraphonic sound. The city fathers could hardly ignore such a success: Ars Electronica had to be continued.

The *Klangwolke* in 1980: Walter Haupt put forward the idea of using a huge helium-filled sculpture by Otto Piene, an artist, teacher, scientist and the head of the Center for Advanced Visual Studies at MIT. Otto Piene realized his *Blue Star Linz* for the Linz *Klangwolke*—and so also became an advocate of the young festival. Two years later he brought the Sky Art Conference to Europe for the first time, to Ars Electronica—a gathering of the great minds of media art and science.

With professors Schulz and Mühlbacher and science-symposium organizer Berghold Bayer, the university in Linz became a partner of the festival.

There was also a premiere: in 1980 Japanese electronic music guru Isao Tomita and American magician of the electronic world of images Ron Hays worked together for the first time in the *Bermuda Triangle* at the Brucknerhaus.

Tomita had known when he visited the 1980 *Klangwolke* that he wanted to play there and would. In 1984 he fulfilled his dream with *Mind of Universe* in the Danube Park, performed using

damaligen Open-Air-Technologien erzählt. Mit Otto Pienes *Sky Art Conference* und zwei Jahre später mit Tomitas *Mind of Universe* öffnet sich Ars Electronica nach Ost und West.

Das Jahr 1984 wird zur Nagelprobe – die größte Ars Electronica seit Beginn. In der Chefetage des Brucknerhauses kommt es zum Wechsel. Karl Gerbel übernimmt die Geschäftsführung des Hauses an der Donau.

Peter Weibel präsentiert bei Ars Electronica 1984 als Uraufführung seine Multimedia-Oper *Der künstliche Wille*. In der Folge bleibt Peter Weibel als Leiter des künstlerischen Beirats beim Ars-Electronica-Kernteam und bestimmt über zehn Jahre hinweg entscheidend die künstlerische Linie des Festivals.

Ars Electronica hatte 1979 und 1980 jährlich stattgefunden, dann aus Finanzgründen als Biennale, 1986 setzt Karl Gerbel wieder die jährliche Ars Electronica durch. Das Festival bekommt einen neuen Termin im Juni, abgetrennt von Klangwolke und Brucknerfest, das jeweilige Symposions-Thema wird gleichzeitig zum Festivalthema.

Für das Brucknerhaus übernehmen 1986 Regina Patsch und Peter Weibel die Agenden der Ars Electronica, für den Partner ORF Hannes Leopoldseder und Christine Schöpf.

„Freie Klänge – offene Räume" ist das erste Festivalthema der Ars Electronica 87 von Peter Weibel

all the open-air technologies available at the time.

With Otto Piene's Sky Art Conference and Tomita's *Mind of Universe* two years later, Ars Electronica had opened up to both the east and the west. 1984 was something of a litmus test—it was the biggest Ars Electronica so far. There was a change in management at the Brucknerhaus, and Karl Gerbel took charge of this house on the Danube. During the 1984 Ars Electronica, Peter Weibel presented the premiere of his multimedia opera *The Synthetic Will*. He subsequently stayed on, as head of the core team's artistic committee, and played a decisive role in the artistic direction of the festival over the following ten years.

Ars Electronica had been held both in 1979 and 1980, but then for financial reasons it took place only biennially. In 1986 Karl Gerbel managed to reinstate Ars Electronica annually. The festival was rescheduled to June, separate from the *Klangwolke* and the Bruckner Festival. The theme of the symposium each year also became the festival's theme.

In 1986 Regina Patsch and Peter Weibel took over the Ars Electronica program for the Brucknerhaus; Hannes Leopoldseder and Christine Schöpf, for its partner ORF.

In 1987 "Free Sound" was the first theme of the Ars Electronica festival under the direction of Peter Weibel and Gottfried Hattinger. Hannes

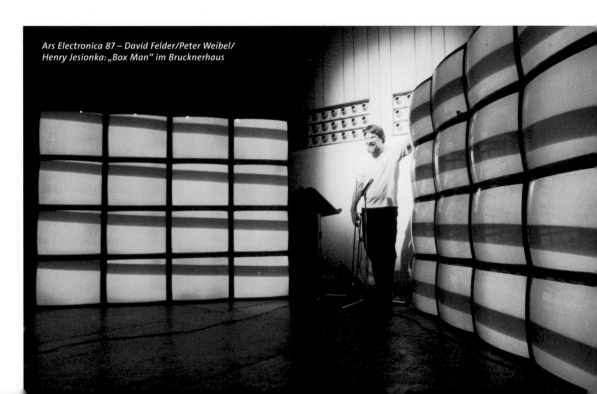

Ars Electronica 87 – David Felder/Peter Weibel/ Henry Jesionka: „Box Man" im Brucknerhaus

und Gottfried Hattinger. Hannes Leopoldseder und Christine Schöpf bringen erstmals den Prix Ars Electronica und die Computerkulturtage ins Festival ein.

Bis 1992 steht Ars Electronica unter dieser Personalkonstellation. 1992 scheidet Gottfried Hattinger aus der Kerngruppe aus, und Katharina Gsöllpointner nimmt bis 1995 seinen Platz ein.

Parallel zu den Entwicklungen der Jahre 1991 bis 1995 bekommt Ars Electronica nach dem Festival und dem Wettbewerb auf Initiative von Bürgermeister Franz Dobusch das dritte Standbein. Nach einer Idee von Hannes Leopoldseder wird in Zusammenarbeit mit der Stadt Linz, ad personam Kulturdirektor Siegbert Janko, und dem ORF das Ars Electronica Center – Museum der Zukunft geplant und verwirklicht. Die entscheidenden Machbarkeitsstudien kommen aus Berlin von Art+Com unter der Federführung von Prof. Edouard Bannwart.

1995 wird die stadteigene Ars Electronica Center

Leopoldseder and Christine Schöpf introduced the Prix Ars Electronica and the Computer Culture Days to the festival for the first time.

Ars Electronica retained the team in this constellation until 1992. Gottfried Hattinger then left in 1992 and was replaced by Katharina Gsöllpointner, who remained until 1995.

Parallel to the developments from 1991 to 1995, a third pillar was added to Ars Electronica's other two pillars—the festival and the competition—on the initiative of Mayor Franz Dobusch. Based on an idea by Hannes Leopoldseder, the Ars Electronica Center—Museum of the Future was planned and realized together with the City of Linz, ad personam cultural director Siegbert Janko, and ORF. The decisive feasibility studies were carried out by Art+Com in Berlin under the overall supervision of Professor Edouard Bannwart.

The city-owned Ars Electronica Center Linz Ltd. was founded in 1995. New life was brought to the festival by a core team consisting of 31-year-old

Ars Electronica Center – Medienfassade

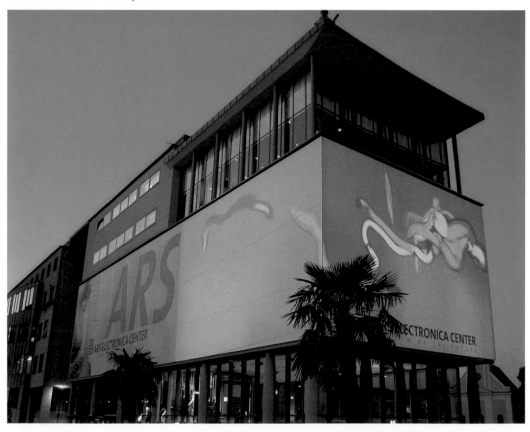

Linz GmbH gegründet. Für frischen Wind sorgt das Kernteam bestehend aus dem 31-jährigen österreichischen Medienkünstler, Vorkämpfer und Ideenträger Gerfried Stocker als Geschäftsführer und künstlerischer Leiter des Ars Electronica Center, Technologie-Guru Horst Hörtner als Leiter des Ars Electronica Futurelab und Jutta Schmiederer als engagierte Producerin der ersten Stunde des sich radikal verjüngenden Festivals.

Ab 1996 hat die Ars Electronica ihr eigenes Haus. Auch die Trägerschaft des Festivals wird neu geregelt: Anstelle des Brucknerhauses übernimmt das AEC die Veranstalterposition für die Stadt Linz; für Festivalthemen und Programm zeichnen Gerfried Stocker (AEC) und Christine Schöpf (ORF) als Direktorium verantwortlich.

Mit dem Ars Electronica Center und dem angeschlossenen Futurelab erhält die bisherige Trademark Ars Electronica ein neues Gewicht. Das Ars Electronica Center wird zum lebendigen öffentlichen Ort und Showcase für digitale Medien – als

Austrian media artist, pioneer and originator Gerfried Stocker as managing and artistic director of the Ars Electronica Center, technology guru Horst Hörtner as head of the Ars Electronica FutureLab, and Jutta Schmiederer as engaged producer of the first hour of this radically rejuvenated festival. Since 1996 Ars Electronica has had its own premises.

Responsibility for organizing the festival was also re-delegated: instead of the Brucknerhaus, the Ars Electronica Center took on the job of organizing the event for the City of Linz; as its artistic directors, Gerfried Stocker (AEC) and Christine Schöpf (ORF) became responsible for the festival themes and program. With the Ars Electronica Center and its affiliated Futurelab, the Ars Electronica trademark took on a new significance. The Ars Electronica Center was now a lively public showcase for digital media—as Museum of the Future, a meeting place for artists, scientists and media experts. Exploration of digital media

Ars Electronica Center – Fassade „Face The Future II"

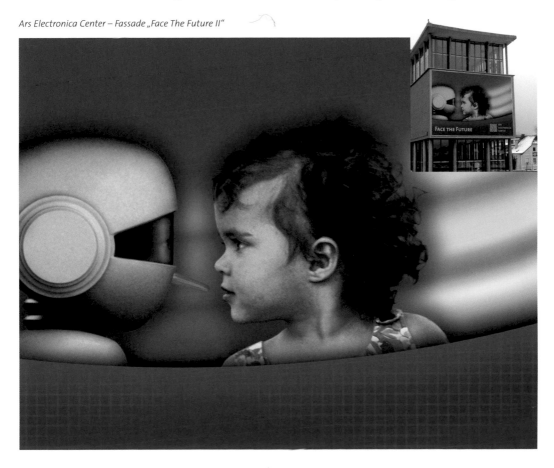

Museum der Zukunft ein Treffpunkt für Künstler, Wissenschafter und Medienexperten. Die Befassung mit digitalen Medien weitet sich über den limitierten Zeitraum des Festivals kontinuierlich aus.

Das Futurelab wird zur international be(ob)achteten Forschungseinrichtung für Kunst, Forschung und Wirtschaft. Projekte ambitionierter Medienkünstler werden im Rahmen von Artist-in-Residence-Programmen ebenso realisiert wie eigenständige Technologieentwicklungen im Zusammenhang mit CAVE-Technologie (ARS BOX) und Augmented Reality, daneben aber auch Forschungs- und Entwicklungsaufträge der Wirtschaft. Maßgebliche internationale Kontakte mit den USA, dem asiatischen Raum und Europa entstehen, werden über die Jahre vertieft und etablieren so ein einzigartiges Netzwerk an der Schnittstelle Kunst-Wissenschaft-Wirtschaft und digitale Medien.

1998 gesellte sich zu den Institutionen der Ars Electronica mit Martin Sturm das O.K Centrum für Gegenwartskunst als Ausstellungsort für die preisgekrönten Arbeiten des Prix Ars Electronica. 1999, 20 Jahre nach Festivalbeginn, wird Ars Electronica wieder mit der Linzer Klangwolke eröffnet. Der langjährige E-Musik-Leiter des Landesstudios, Wolfgang Winkler, zwei Jahrzehnte Betreuer der Klangwolke seitens des ORF, ist in der Zwischenzeit als Vorstandsdirektor der LIVA für die künstlerischen Agenden des Brucknerhauses verantwortlich.

2001 wird die Universität für künstlerische und industrielle Gestaltung unter Rektor Reinhard Kannonier zum Veranstaltungsort des Ars Electronica Campus, einer internationalen Diskurs-und Ausstellungsplattform für medienkünstlerische Ausbildungsfelder. 2004 wird unter der Direktorin des Kunstmuseums Lentos, Stella Rollig, das vielleicht schönste Kunsthaus Europas ein weiterer wichtiger Kooperationspartner.

Wenn Ars Electronica heute – in der Stadt, in der Region, in Österreich und international – als Synonym oder (um in der heute so gern angewandten Marketingsprache zu reden) Branding für künstlerisch-kulturelle Weichenstellungen im digitalen Mediendiskurs steht, ist es ein Verdienst aller Künstler und Wissenschafter, die über 25 Jahre der Idee Ars Electronica ihre Kontur gaben, die sich auf das Abenteuer Ars Electronica eingelassen haben und dem Publikum vor Ort und in der Welt mit ihrer Arbeit eine andere Sicht der Medienwelt vor Augen führten.

increasingly came to extend beyond the short period of the festival.

Futurelab was becoming an internationally regarded study facility for art, research and the industry. Projects by ambitious media artists were realized during artist-in residence programs, as were independent technological developments in conjunction with CAVE technology (ARS BOX) and augmented reality, as well as research and development assignments for the industry.

Influential international contacts in the USA, Asia and Europe were established; over the years they deepened, forming a unique network at the interface of art, science and industry, as well as digital media.

In 1998, the O.K Center for Contemporary Art, with Martin Sturm, joined Ars Electronica's institutions as a venue for exhibiting the prize-winning works of the Prix Ars Electronica.

In 1999, 20 years after the first festival, Ars Electronica was once again opened with the Linz *Klangwolke*. The long-standing electronic music director of the regional broadcasting studio, Wolfgang Winkler, the man who had supervised the *Klangwolke* on behalf of ORF for 20 years, had in the meantime become director of LIVA, which was responsible for the artistic program at the Brucknerhaus.

In 2001 the University of Art and Industrial Design in Linz, under dean Reinhard Kannonier, became the venue of the Ars Electronica Campus, an international discussion and exhibition platform for fields of education related to media art. And in 2004, under the director of the Lentos Art Museum in Linz, Stella Rollig, Europe's perhaps most beautiful art institution became an important partner of the festival.

Today Ars Electronica is —citywide, nationwide and worldwide—a synonym or (to use the currently so popular marketing term) a branding for setting the artistic and cultural course of the digital media debate. Credit for this must certainly go to all the artists and scientists who helped shape the idea of Ars Electronica over the past 25 years. For they were the ones to let themselves in for the adventure of Ars Electronica, and with their works they gave on-site visitors and audiences across the globe a different perspective on the media world.

Ars Electronica 97 – Toshio Iwai, Ryuichi Sakamoto: „Music plays Images x Images play Music " (Posthof Linz)

Hannes Leopoldseder

25 Jahre Ars Electronica

Sprungbrett in die Zukunft

Der 10-jährige Nicholas in New York, die 10-jährige Maya in Oslo, der 10-jährige Toshiya in Tokio und die 10-jährige Julia in Linz. Sie alle haben im September 2004 Geburtstag, wenn Ars Electronica 25 Jahre alt wird. Eines ist diesen Kindern gemeinsam: Für sie ist eine Welt ohne CD, ohne Handy (in Österreich) oder Mobile (in den USA) oder ohne Internet und dem Eintauchen in die globale Spielwelt nicht mehr vorstellbar. Kein anderes Vierteljahrhundert zuvor in unserer Geschichte hat unser Leben in diesem Maße verändert.
Als Festival für Kunst, Technologie und Gesellschaft hat Ars Electronica mit ihrem Fokus auf das Ineinandergreifen von Wissenschaft und Kunst den Innovationsschub der Informationstechnologie in den Jahren des Booms und des Absturzes mitvollzogen. Die Ars-Electronica-Publikationen, in Print sowie im Netz, sind die historischen Zeitzeugen dieser entscheidenden Medienentwicklung. Den Einleitungstext zu „Cyberarts 1999" begann ich mit der Geschichte des 29-jährigen Fernando Espuelas, der mit dem Börsegang von „StarMedia Network" – mit einer spanisch-portugisischen Search-Engine – innerhalb von Tagen mehr als 350 Millionen Dollar für sich kapitalisieren konnte. 2004 ist alles verschwunden, die Millionen in den Wind geschrieben. „Ich spielte die Hauptrolle in einem Shakespeare'schen Stück", zitiert 2004 das _Hispanic Magazin.com_ Espuelas, „ich war danach vollkommen erschöpft". Nach dem Dot-Com-Crash hat allerdings das Internet mehr Kraft denn je – als treibende Kraft der „Old Economy" in der Globalisierung. Digitale Kunst ist von Jahr zu Jahr mehr auf dem Wege, in den Mainstream vorzudringen, insbesondere im Bereich der Interaktivität und des Spiels. Vor uns stehen bereits längst die neuen Ankömmlinge, von Bio-, Gen-und Nanotechnologien. Für Ars Electronica bedeutet dies, nicht auf der Tradition zu ruhen, sondern täglich neu in die Zukunft aufzubrechen, wie der britische Außenminister Harold MacMillan meinte: „Die Vergangenheit", sagte er, „sollte ein Sprungbrett sein, nicht ein Sofa".

25 Years of Ars Electronica

A Springboard to the Future

Ten-year-old Nicholas in New York, ten-year-old Maya in Oslo, ten-year-old Toshiya in Tokyo and ten-year-old Julia in Linz – they will all celebrate their birthdays in September 2004 when Ars Electronica turns 25. And these children have one thing in common: for them a world without CDs, without Handys (as they are called in Austria) or cell phones (in the USA), without the Internet and immersion in global games is no longer imaginable. No other quarter of a century in our history has altered our lives on such a huge scale.
As a festival for art, technology and society, Ars Electronica with its focus on the intermeshing of science and art, also experienced the spurt of innovation in information technology in the years of the boom and its collapse. Ars Electronica's publications, both in print and online, are historical testimony of these crucial media developments. I began my introduction to Cyberarts 1999 with the story of 29-year-old Fernando Espuelas who after going on the stock market with StarMedia Network – a Spanish-Portuguese search engine – succeeded in making more than 350 million dollars for himself. Now in 2004, it's all gone; his millions, irretrievably lost. "I was the main character of a Shakespearean play", Hispanic Magazin.com quoted Espuelas as saying in 2004. "It left me exhausted."
Yet since the crash of dot-coms, the Internet has grown stronger than ever – as the driving force of the "Old Economy" toward globalization. From year to year, digital art has increasingly penetrated the mainstream, especially in the fields of interactivity and games. For some time now we have been confronted with newcomers, from gene, bio- and nanotechnologies. For Ars Electronica this means not to rest on its laurels, but to set forth into the future each day anew – as British Foreign Minister Harold Macmillan once remarked: "The past must be a springboard, not a sofa."

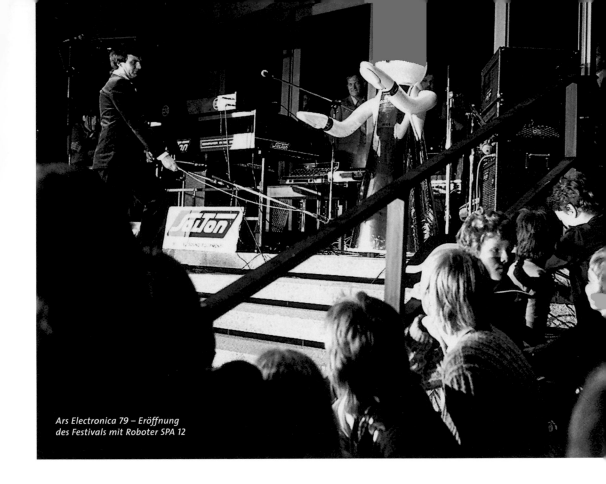

Ars Electronica 79 – Eröffnung
des Festivals mit Roboter SPA 12

ARS ELECTRONICA 1979

Idee und Konzept

Wenn am 18. September 1979 in Linz zum ersten
Mal innerhalb des Internationalen Brucknerfestes
Ars Electronica eröffnet wird, so kommt diesem
Ereignis in mehrfacher Hinsicht eine weichenstel-
lende Bedeutung zu. Mit dieser Veranstaltung über
elektronische Kunst erfolgt eine weitere konse-
quente und in diesem Fall spezifisch ausgerichtete
inhaltliche Ausweitung des Linzer Brucknerfestes.
Die Linzer Veranstaltungsgesellschaft mbH und
das Landesstudio Oberösterreich des ORF wollen
damit nicht nur einen Beitrag zum Ausbau des
Internationalen Brucknerfestes leisten, sondern
gleichzeitig einen Impuls für die Richtung dieser
Entwicklung setzen: in Linz, im Rahmen des
Internationalen Brucknerfestes, ein Zentrum für
elektronische Kunst, einen spezifischen, aber
sehr entscheidenden Bereich der Avantgarde,
ins Leben zu rufen.
Der Konzeption von Ars Electronica in Linz liegen

Idea and Concept

On September 18, 1979, when Ars Electronica is
opened in Linz for the first time in conjunction
with the International Bruckner Festival, this event
will be setting the course for the future in several
different ways. This electronic arts event signals a
further, logical expansion of the Bruckner Festival,
addressing in this case a specific subject matter.

Ars Electronica 79 – Ekseption und Ludwig Rehberg

als Ausgangsüberlegung das Spannungsverhältnis und die Wechselbeziehungen zwischen Mensch und Technik, zwischen Kunst und Technologie, zwischen der Kulturstadt Linz und der Industriestadt Linz zu Grunde.

Die inhaltliche Grundkonzeption von Ars Electronica stammt von dem Kybernetiker und Physiker Dr. Herbert W. Franke aus München, dem Elektronikmusiker und Komponisten Hubert Bognermayr, dem Musikproduzenten Ulli A. Rützel und dem Intendanten des ORF-Landesstudios Oberösterreich Dr. Hannes Leopoldseder.

Ars Electronica ist keine Veranstaltung mit einer Bilanz über die Vergangenheit, sondern auf Entwicklungen von morgen gerichtet. Aus diesem Grund kommt dieser Veranstaltung über elektronische Kunst und über neue Erfahrungen der Charakter des Unkalkulierbaren, des Risikos und des Wagnisses zu.

Gleichzeitig aber ist Ars Electronica eine Herausforderung an Künstler, Techniker, Kulturkritiker und nicht zuletzt an das Publikum, das neuen Ausdrucksformen der Kunst begegnen wird.

In this way, the LIVA and the ORF Upper Austrian Regional Studio intend not only to contribute to the further development of the International Bruckner Festival, but also to provide a decisive impulse for the future direction of the development: to initiate in Linz a center for electronic arts, a specific but crucial field of the avant-garde. The present fundamental concept for the contents of Ars Electronica originated with the cyberneticist and physician Dr. Herbert W. Franke from Munich, the electronic musician and composer Hubert Bognermayr, Ulli A. Rützel and the head of the ORF Upper Austrian Regional Studio, Dr. Hannes Leopoldseder. The purpose of Ars Electronica is not to take stock of the past; it is oriented instead to the developments of tomorrow. Thus this event for electronic arts and new experience assumes a character of incalculability, of risk, and of daring to try something new. At the same time, however, Ars Electronica poses a challenge to artists, technicians, cultural critics, and ultimately to the public encountering new forms of expression in art.

ARS ELECTRONICA 1980

Elektronik – Kunst – Gesellschaft

Ars Electronica 80 präsentiert sich mit der vorliegenden Programmkonzeption als interdisziplinäres Forum für Elektronik, Kunst und Gesellschaft und umschließt im Wesentlichen fünf Bereiche:
1. Sozio-kulturelle Animationsprojekte (Linzer Stahlsinfonie von Klaus Schulze, Stahlarbeitern und Maschinen der VOEST-ALPINE Linz, Linzer Klangwolke von Walter Haupt als sinfonisches Open-Air mit Bruckner 4, Mach-Mit-Konzert Musica Creativa auf dem Linzer Hauptplatz)
2. Elektronische Musik-Perfomances („Großer Preis der Ars Electronica")
3. Workshop-Symposien über Elektronik in der Musik, in der Literatur, in der visuellen Gestaltung, in Wissenschaft und Gesellschaft (u. a. mit Bob Moog, Wendy Carlos).
4. Ausstellung und Publikumsaktivitäten
5. Schachcomputer-Weltmeisterschaft Linz
Ars Electronica will Signale für die Zukunft setzen. Nicht nur als Versuch, Tradition und Avantgarde in Verbindung zu bringen, sondern als kulturelles Experiment, das über neue Wege auf das kulturelle Bewusstsein der Menschen einzuwirken versucht.

Electronics—Art—Society

With the present program concept, Ars Electronica 80 is presented as an interdisciplinary forum for electronics, art, and society and involves five main objectives:
1. Socio-cultural animation projects (Linzer *Steel Symphony* by Klaus Schulze, steel workers and machines of the VOEST-ALPINE Linz, Linz *Klangwolke* by Walter Haupt symphonic open-air concert with Bruckner's

Ars Electronica 80 – Mach-Mit-Konzert / Linzer Hauptplatz

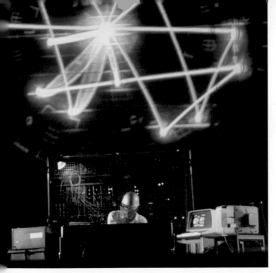

Ars Electronica 80 – Klaus Schulze: „Linzer Stahlsinfonie"

4th Symphony, Join-In-Concert MUSICA
CREATIVA in the main square of Linz),
2. Performances of electronic music,
3. Workshop symposia on electronics in
 music, in literature, in visual design, and
 in science and society (with participation
 of e.g. Bob Moog, Wendy Carlos),
4. Exhibition and audience activities,
5. Chess computer world championship.
Ars Electronica is intended to set signals for
the future. Not only as an attempt to link
tradition and avant-garde, but also as a
cultural experiment seeking to influence
the cultural awareness of the public in
new ways.

ARS ELECTRONICA 1982

Kultur der Informationsgesellschaft

Ars Electronica 82 beginnt am 24. September
1982 – 6308 Tage vor dem Jahr 2000. Um das
Jahr 2000 setzen Wirtschaftstheoretiker die
fünfte Kondratieff-Welle mit der Trägerstruktur
Mikroprozessoren an. Wie die Maschine im
Mittelpunkt der Industriegesellschaft steht,
werden Informationen und Kommunikation
wesentlich das Zeitalter der Mikroprozessoren,
die dritte industrielle Revolution, bestimmen. Die
Informationsgesellschaft mit den Entwicklungen
der Breitbandkabelsysteme, der Heimelektronik
und des Rundfunk-Direktsatelliten wird neue
kulturelle Verhaltensweisen, aber auch durch die
veränderten Technologien und Medien neue
Formen und Inhalte künstlerischer Kreativität
hervorbringen.
Für die Programmentwicklung von Ars Electronica
82 sind vor allem fünf Faktoren entscheidend:
1. Ars Electronica 82 setzt sich mit unserer
 Zukunft auseinander.
2. Ars Electronica 82 zielt auf eine definierbare
 Stadtöffentlichkeit und eine Gesellschafts-
 struktur, für die es einen erweiterten Kultur-
 begriff zu entwickeln gilt. Dieser Prozess soll
 sich bewusst aus den Gegebenheiten heraus
 entwickeln und den Ansatz für eine kulturelle
 Stadtkommunikation schaffen.
3. Ars Electronica 82 sucht die Anwendung neu-
 er Technologien im künstlerischen Bereich, in
 der interdisziplinären Konzentration sowie in
 neuen Wegen der Vermittlung.

Culture of the Information Society

Ars Electronica 82 will begin on September 24,
1982—that is, 6,308 days before the year 2000.
For the year 2000, economists expect the fifth
Kondratieff wave, with microprocessors being
the carrier structure. As industrial society has
revolved around the machine, the age of the
microprocessor-the third industrial revolution-
will be determined by information and commu-
nication. Information society, with the develop-
ments of broadband cable systems, home elec-
tronics, and direct radio satellites, will produce
new modes of cultural behavior and-due to the
change of technologies and media-also new
forms and contents of artistic creativity.
Five features have been main considerations in
developing the program for Ars Electronica 82:
1. Ars Electronica 82 is concerned with our
 future.
2. Ars Electronica 82 is directed at a definable
 municipal community and a social structure
 for which an expanded cultural concept is to
 be developed. This process is to evolve from
 existing conditions and is to initiate cultural
 intra-city communication.
3. Ars Electronica 82 wants to use new technolo-
 gies in art, in interdisiplinary concentration, as
 well as in new ways of communication.
4. Ars Electronica 82 strives to integrate
 electronic possibilities and media and the
 contents offered—the electronic facilities
 of radio and television are not only repro-

Ars Electronica 82 – Charlotte Moorman & Nam June Paik: „Sky Kiss"

4. Ars Electronica 82 integriert bewusst die elektronischen Möglichkeiten und Medien in das inhaltliche Angebot; die elektronischen Facilitäten von Hörfunk und Fernsehen sind nicht Medien der Reproduktion, sondern Impulsgeber für Animation, Kreativität und schöpferische Kulturarbeit.

5. Ars Electronica 82 präsentiert ausschließlich Auftragswerke bzw. speziell für Ars Electronica entwickelte Projekte. Damit soll dem Anspruch nach Innovation unter Berücksichtigung der spezifischen Identität von Linz als Kultur- und Industriestadt Rechnung getragen werden.

ductive media but initiators of animation, creativity, and creative cultural achievement.

5. Ars Electronica 82 presents commissions exclusively; that is projects developed specifically for Ars Electronica. Thus the claim of innovation and the specific identity of Linz as a cultural and industrial city are being taken into account.

Ars Electronica begins 6,308 days before the year 2000, it ends 6,300 days before the year 2000, as we may see from the "Calendar 2000" initiated by the "Committee 2000." The days in between belong to the future, to the stimulation of forms of art for the information society.

ARS ELECTRONICA 1984

Die neue Computerkultur

„Es ist unfassbar, aber wahr: Eine einzige neue Technologie wird unser aller Leben grundlegend verändern." Diese These stellt Dieter Balkhausen an die Spitze seiner in der Zwischenzeit zu Standardwerken gewordenen Bücher über „Die dritte industrielle Revolution". Was Balkhausen in den Siebzigerjahren für die Mikroelektronik formulierte, zeichnet sich heute noch wesentlich eindringlicher für eine zweite Schlüsseltechnologie, die

The New Computer Culture

"It is incredible but true: one single new technology will radically change all of our lives." This thesis is the epigraph that Dieter Balkhausen puts at the front of his books about the "Third Industrial Revolution," renowned standards by now. What Balkhausen formulated about microelectronics in the seventies seems to apply even more impressively to another key technology: to biotechnology. Both are basic

Biotechnologie, ab. Beide sind Basisinnovationen, die unsere Wirtschaft, unsere Gesellschaft und unser Leben als Ganzes verändern: Sie sind für eine neue Kulturstufe unserer Zivilisation verantwortlich.

Die heute erkennbaren Trends sind voraussichtlich nicht mehr als Anfangstendenzen. Die neue Ära kommt erst nach der Umbruchszeit zum Tragen. Den Innovationen und Veränderungen ist eines gemeinsam: Sie haben einen neuen Rohstoff – nicht Gold, nicht Stahl, nicht Öl, sondern Information und Wissen. Information ist die Währung des Neuen Zeitalters. Während die Industriegesellschaft, angefangen mit Fords T-Modell, das Auto als Massenprodukt hervorgebracht hat, wird in unserem Jahrzehnt immer mehr die Produktion von Information zur entscheidenden Triebkraft der Wirtschaft.

Die Kinder, die im Orwell-Jahr geboren werden, sind im Jahr 2019 35 Jahre alt. Sie bilden die Generation, die dann weitgehend die Verantwortung für die Gesellschaft tragen wird. Markiert 1984 den Umbruch unserer Gesellschaft, wird dieser Wandel 2019 voraussichtlich abgeschlossen sein; die neuen Basisinnovationen werden bereits zu den alten Technologien zählen, ihre Infrastruktur wird unsere Wirtschaft, unsere Gesellschaft, Kunst und Kultur bestimmen. Das elektronische Zeitalter wird in der Blüte stehen. Die Spuren dahin zu legen, ist allerdings die Herausforderung von heute.

innovations, changing our economy, our society, and the whole of our life: they are responsible for a new cultural stage of our civilization. The trends visible today are presumably no more than primary tendencies. The new era will not establish itself until after a period of transition. Innovations and changes have one thing in common, a new raw material: not gold, not steel, not petrol, but information and knowledge.

Information is the currency of the new age. As the industrial society, starting from Ford's Model T, made the automobile a mass product, so our decennium uses the production of information as the propelling force of its economy.

The children born in the Orwell year of 1984 will be 35 years old in 2019. They are the generation that will be responsible for our society then.

Does 1984 mark the beginning of a revolution of our society—and will it be completed by 2019? Today's new basic innovations will rank among the old technologies by then; their infrastructure will determine our economy, our society, art, and culture. The electronics society will be in full bloom. Working out the tracks-this is today's challenge.

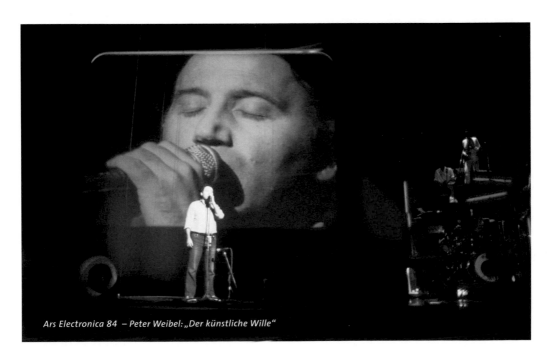

Ars Electronica 84 – Peter Weibel: „Der künstliche Wille"

ARS ELECTRONICA 1986

Zehn Indizien für das Werden der Computerkultur

1. Die Computerkultur ist eine Kultur im Werden.
2. Die Computerkultur erfordert ein neues Alphabet, eine neue Sprache, ein neues Denken.
3. Die Computerkultur erfordert die computeralphabete Lerngesellschaft.
4. Die Computerkultur erfordert die Neustrukturierung von Arbeit, Freizeit, Gesellschaft.
5. Die Computerkultur erfordert den Bildschirm als zentrales Gerät in Heim und Büro.
6. Die Computerkultur ermöglicht einen neuen Typ des Künstlers.
7. Die Computerkultur ermöglicht eine neue Bild- und Klangwelt.
8. Die Computerkultur ermöglicht neue Netzwerke.
9. Die Computerkultur ermöglicht neue Medien.
10. Die Computerkultur ermöglicht neue Kunst- und Kulturerlebnisse.

Ten Indications of an Emerging Computer Culture

1. Computer culture is an emerging culture.
2. Computer culture calls for a new alphabet, a new language, a new way of thinking.
3. Computer culture demands a society capable of becoming computer-literate.
4. Computer culture requires restructuring of work, leisure time, and society.
5. Computer culture requires the screen as major tool in home and office.
6. Computer culture permits a new type of artist.
7. Computer culture permits a new world of images and sound.
8. Computer culture permits new networks.
9. Computer culture permits new media.
10. Computer culture allows new experiences in art and culture.

Ars Electronica 86 – Bernd Kracke / Rommy Haag: „Still Life – Queen Zero"

ARS ELECTRONICA 1987

Die fünfte Kulturtechnik

The Fifth Cultural Technique

Prix Ars Electronica 87 – John Lasseter: „Luxo Jr."
(Goldene Nica für Computeranimation)

Die Computerkultur charakterisiert eine neue Kulturstufe. Hermann Hesses „Glasperlenspiel" enthüllt sich als Vision der Gesellschaft der Computerkultur. Wie die Glasperlenspieler eine „universale Sprache und Methode erfunden haben, um alle geistigen und künstlerischen Werte und Begriffe auszudrücken und auf ein gemeinsames Maß zu bringen", schafft der Computer mit dem binären Alphabet ein neues Sprach- und Denksystem. Hesses Utopie sucht eine Antwort auf die Frage, wie sich ein Teil einer Gesellschaft in Relation zur Nicht-Computer-kultur zur Computerkultur entwickelt.

Die Anforderung der Computerkultur geht weit über das hinaus, was vielfach unter der vierten Kulturtechnik verstanden wird: nämlich Computerkompetenz als Handhabung eines Computers, als Vertrautsein mit dem neuen Alphabet.

Die Computerkultur bewirkt radikale Veränderungen in der Kulturgeschichte: Alle bisherigen Kulturtechniken – Rechnen, Lesen und Schreiben – können als einzelne Tätigkeiten nun auch vom Computer übernommen werden. Die Computerkultur verlangt daher nach einer Neubewertung menschlicher Fähigkeiten, fordert zu einem Umdenken auf, ermöglicht einen Neubeginn.

Wie Schreiben und Lesen zusammengehören, erfordert die Computerkultur mit ihrer binären Charakteristik zusätzlich zur vierten Kulturtechnik unmittelbar die fünfte Kulturtechnik.

Was bedeutet die fünfte Kulturtechnik? Es ist eine Entwicklung des „Humanum", des Bewusstseins, der

Computer culture characterizes a new step in culture. Hermann Hesse's Glasperlenspiel reveals itself as a vision of the computer culture's society. As the players of the glass bead game had invented "a universal language and method of expressing all spiritual and artistic values and terms to give them a common dimension," the computer with the binary alphabet creates a new system of language and thought. Hesse's utopia is the quest for an answer to how a part of a society is developing towards computer culture in relation to a non-computer culture. The requirements of a computer culture go far beyond what is usually understood as the "fourth cultural technique," computer competence (i.e., competence in using the computer; being acquainted with the new alphabet). Computer culture induces radical changes in the history of culture. All the cultural techniques hitherto used-reading, writing, calculating-may be taken over as such by the computer. Computer culture asks for a new evaluation of human capacities, asks for a change in thinking, enables a new start. Just as reading and writing go together, computer culture with its binary characteristics requires the fifth cultural technique in addition to the fourth.

Now, what does the fifth cultural technique mean? It is the development of the humanum, of conscience, of ethics, of interpretation, of creativity. Man must concentrate on those abilities beyond the computer's reach. What is within human power might be beyond the computer's in some cases, or else what is possible for the computer could be unachievable for man. The goal, therefore, must be a coexistence of man and machine rather than the replacement of man by the machine. But this implies a new distribution of tasks between man and machine, between man and computer.

In conjunction with Ars Electronica, the ORF introduces the Prix Ars Electronica: an international competition for artists working with the medium of the computer in a creative field; in graphics, in animation, in music. The results of the Prix Ars Electronica 87 contest should help us to read the trends in these sectors of the arts. Thus the Prix Ars Electronica 87 understands

Ethik, der Sinngebung, der Kreativität. Der Mensch muss sich auf jene Fähigkeiten konzentrieren, die für die Maschine unerreichbar bleiben. Das Menschenmögliche ist in bestimmten Bereichen maschinenunmöglich, das Maschinenmögliche ist ebenso in bestimmten Bereichen menschenunmöglich. Das Ziel kann daher nur die Koexistenz von Mensch und Maschine sein, nicht der Ersatz des Menschen durch die Maschine. Voraussetzung dafür ist eine neue Funktionsverteilung zwischen Mensch und Maschine, zwischen Mensch und Computer.
Der ORF ruft innerhalb von Ars Electronica den Prix Ars Electronica ins Leben: den Internationalen Wettbewerb für Künstler, die mit dem Medium Computer im gestalterischen Bereich arbeiten, in der Grafik, in der Animation, in der Musik. Ergebnisse des Prix Ars Electronica 87 sollen einen Beitrag leisten, um Trends in diesem Kunstbereich ablesen zu können. Der Prix Ars Electronica 87 begreift sich daher auch als Impuls, Computerkunst, Computer Aided Art und den Einsatz des Computers in der Kunst nicht isoliert, sondern im Gesamtzusammenhang der Computerkultur zu verstehen.

Ars Electronica 87 – Jeannete Yankikian: „Aorta"

itself also as an impulse to understand computer art/computer-aided art, the use of the computer in the arts not as an isolated phenomenon but within the overall context of computer culture.

ARS ELECTRONICA 1988

Der goldene Balken

Ars Electronica 88 – Ed Emshwiller / Morton Subotnick: „Hungers"

Die Frage, ob es eine Beziehung zwischen Gehirn und Computer gebe, beantwortete der Biophysiker und Kybernetiker Heinz von Foerster, einer der Väter des Konstruktivismus, in einem Gespräch

The Golden Crossbar

In a personal interview, the biophysicist and cybernetics researcher Heinz von Foerster—one of the fathers of constructivism—answered the question of whether there is a relation between the human brain and the computer with a "yes and no." Then he added: "No computer is a brain, but all brains are computers." So it is not by chance that human cerebral research and computer technology have been following a fascinating common development over the past decades. Medical cerebral research has stressed its interest in the different functions of left and right hemispheres of the human cerebrum.
Scientists and artists have developed two distinct specific understandings of their role: the scientist as the exponent of the left cerebral hemisphere, the artist of the right.
The two hemispheres of our brain are connected by the *corpus callosum* as an interface. As we know, the left half of our body is controlled by the right hemisphere of the cerebral cortex and vice versa. Communication between these two

mit „Ja und Nein" und fügte hinzu: „Kein Computer ist ein Gehirn, aber alle Gehirne sind Computer." Es ist daher kein Zufall, dass Gehirnforschung und Computertechnik seit Jahrzehnten gemeinsam in einer aufregenden Entwicklung stehen.

Besondere Aufmerksamkeit gilt in der Gehirnforschung den unterschiedlichen Funktionsweisen der linken und der rechten Hemisphäre des menschlichen Gehirns.

Wissenschafter und Künstler haben sich auch zu zwei spezifischen Rollenbildern entwickelt: der Wissenschafter als Exponent der linken Gehirnhälfte, der Künstler als Exponent der rechten Gehirnhälfte.

Die beiden Hemisphären der Großhirnrinde werden durch das „Corpus callosum", den Balken, miteinander verbunden. Bekanntlich wird die linke Hälfte des Körpers hauptsächlich von der rechten Hälfte der Großhirnrinde gesteuert und umgekehrt. Für die Kommunikation zwischen beiden Hemisphären ist der Balken verantwortlich. Jede der beiden Hälften erfüllt bestimmte Funktionen. Bei einer Trennung des Balkens funktionieren die Hirnhälften unabhängig voneinander, allerdings eingeschränkt. Die Vollkommenheit des menschlichen Geistes kann nur in der Integration beider Hälften durch das Corpus callosum erreicht werden.

Die großen schöpferischen Leistungen einer Kultur, von der Wissenschaft über die Technologie bis zur Kunst, entstammen dem Zusammenwirken von linker und rechter Hemisphäre. Wenn menschliche Kultur auf der Funktion des Corpus callosum beruht, symbolisiert dieses Nervenbündel für die Computerkunst das, was ich den „Goldenen Balken" nenne, der das Tor zum Zusammenwirken beider Hemisphären, zum Wirksamwerden des ganzen Menschen in besonderer Weise erschließt.

Ars Electronica 88 – Ed Emshwiller / Morton Subotnick: „Hungers"

disjunct parts is supported by the *corpus callosum,* which in fact acts as a connecting cross member. Now, each of the two halves executes different functions. If the connection by the corpus callosum is interrupted, both hemispheres, although somewhat limited, independently retain their functions. But the perfection of the human mind cannot be kept up except by the integration of the two hemispheres by the *corpus callosum.*

The great creative achievements of a culture, from science via technology to art, derive from this cooperation of the left and the right hemisphere. If human culture is based upon the function of the *corpus callosum,* this string of nerves symbolizes in computer arts what I should like to call the "golden crossbar" which opens the door to a fruitful interaction of both hemispheres, which discloses the effectiveness of the whole human capacity in a special way.

ARS ELECTRONICA 1989

Zehn Jahre Ars Electronica
Kunst im Zeitsprung – Zeitsprung in die Zukunft

Ars Electronica präsentierte sich 1979 als Zeitsprung in die Zukunft: Ein Dezennium „elektronische Kunst" wird zur Kunst im Zeitsprung. Von Beginn an war Ars Electronica offen für Signale aus der Zukunft, offen für Deutungen, Experimente, und

Ten years of Ars Electronica
Art in a Time Warp—A Time Warp into the Future

In 1979 Ars Electronica appeared as a time warp into the future: a decade of "electronic art" becomes art in a time warp. From the beginning, Ars Electronica has been open to signals from the future, open to experiments. This openness

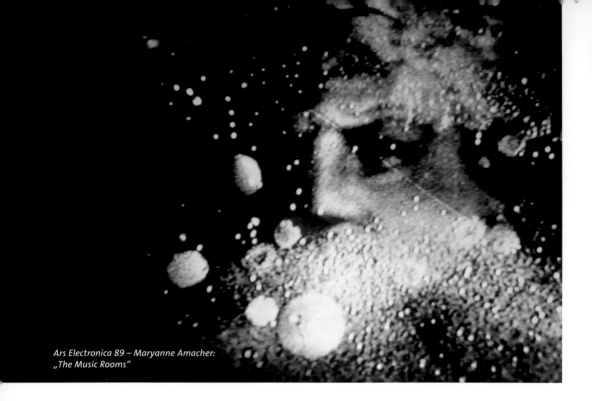

Ars Electronica 89 – Maryanne Amacher:
„The Music Rooms"

zwar vor dem Hintergrund der Überlegung, dass die Basistechnologie Mikroelektronik mit dem Computer – wie kaum eine andere Technologie zuvor – unsere Arbeit, unsere Wirtschaft, unser Denken und schließlich unsere Kultur verändert. Was 1979 zunächst nur global zu prognostizieren war, wird 1989 in deutlicheren Spuren sichtbar: Aber auch jetzt ist die Computerkultur noch im Kleinkindalter, Erwachsenwerden und Erwachsensein dieser Ära bleiben dem 21. Jahrhundert vorbehalten.

Was ist der charakteristische Wesenszug, der Ars Electronica von Anfang an inne war und dem Festival die Schubkraft sicherte, um von Linz aus international zu einem Markenzeichen für ein spezifisches Festival zu werden? Auf einen Nenner gebracht: die Offenheit. Es ist das ständige Bekenntnis zur Offenheit, das Bestreben, die Grenzen zwischen einzelnen Kunstgattungen abzubauen und Barrieren zu überwinden, das so genannte U und E nicht zu trennen, sondern zusammenzuführen. Die Offenheit ist zu einem Grundzug des Festivals geworden: offen für neue Trends, offen für die Wechselwirkungen zwischen Kunst und Technologie, offen für das Unfertige, offen für das Widersprüchliche, offen für das Neuland, vor allem aber offen für die Begegnung von Künstlern, Wissenschaftern und Persönlichkeiten, die sich mit unserer Zukunft auseinandersetzen.

is based on the idea that in conjunction with the computer, the basic technology of microelectronics is changing our work, our economy, our thinking, and ultimately our culture, more than almost any other technology before. What was only globally prophesied in 1979 has become more clearly evident in 1989: yet even now the computer culture is still in its infancy; the adolescence and adulthood of this era are reserved for the 21st century.

What is the characteristic feature that has been inherent to Ars Electronica from the beginning, that imbued the festival with the dynamic to take off from Linz to become the international trademark of a specific festival? In a word: openness. It is the continuous dedication to openness, striving to break down the boundaries and overcome the barriers between individual genres of art, not separating so-called popular and serious art but rather merging them. Openness has become a fundamental characteristic of the festival: open to new trends, open to the interactions between art and technology, open to that which is yet unfinished, open to contradictions, open to new territories, but especially open to the encounters between artists, scientists, and those who are involved in discussing our future.

ARS ELECTRONICA 1990

Multi-Trends zu Millennium III

Millennium III minus 10. Das ist in diesem Jahr die zeitliche Einordnung des Prix Ars Electronica 90, der mittlerweile auf vier Jahre Entwicklung zurückblickt und Strömungen der letzten Jahrzehnte dieses Jahrhunderts Rechnung zu tragen versucht. Die Computerzeit wird die Erfindung eines neues Zeitbegriffes erforderlich machen. Geschwindigkeit und Tempo sind zu Phänomenen des Wandels geworden, der alle Bereiche unseres Lebens erfasst. Die neuen Strukturen der Computerkultur werden mehr und mehr ablesbar. Der Wandel lässt Offenheit, Dynamik, Prozesse, Bewegung und Chaos in den Vordergrund, Statik und alte Ordnungssysteme in den Hintergrund treten. Der Prix Ars Electronica als internationaler Wettbewerb für Computerkünste ist vom Umfeld dieser Entwicklung direkt betroffen, denn der Computer ist ein Agens dieser Veränderung, die Künstler wiederum haben eine erhöhte Sensibilität für die unterschiedlichen Strömungen der Zeit.

Aus den Prognosen für das Jahr 2000 zeichnen sich einige Multi-Trends zum Millennium III ab, die das Umfeld des Prix Ars Electronica , das Umfeld der Computerkünste, mitbestimmen: Multidimensionalität, Multimind, Multimedia, Multiart sind die Stichworte. Die Multi-Trends werden zu den Pfaden in die „Mentopolis" des nächsten Jahrhunderts. Eine künstliche Welt ohne Grenzen steht vor uns – neue Formen der Unterhaltung, neue Formen der Kunst, neue Erlebnisse für den Einzelnen. Die heute

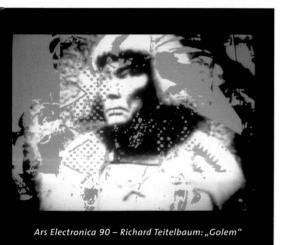

Ars Electronica 90 – Richard Teitelbaum: „Golem"

Multi-Trends for Millennium III

Ars Electronica 90 – Serge Dutrieux: „Das System der Welt"

Millennium III minus 10. This is where Prix Ars Electronica 90 is situated, an award looking back on four years of development and trying to give an account of the tendencies of the last decades of this century.

The age of the computer will necessitate a new notion of time. Speed has become a phenomenon of the changes affecting all areas of our life.

The new structures of computer art become more and more readable. The change is putting openness, dynamics, processes, movement, and chaos into the foreground, and old systems of ordnance shift into the background. As an international computer arts competition, Prix Ars Electronica is directly affected by the environment of this development, for the computer is an agent of this change, and artists do have an extended sensitivity to the various streams in our time.

From the prognoses for the year 2000 we can deduce some multi-trends towards the Millennium III that affect the environment of Prix Ars Electronica, the environment of computer arts: multi-dimensionality, multi-mind, multi-media, multi-art are the terms to be remembered. These multi-trends are becoming the pathways into the "Mentopolis" of the millennium to come.

An artificial world without bounds or limits is set before us-new kinds of entertainment, new shapes

prognostizierten Möglichkeiten der Virtual Reality könnten unser Verhalten und unsere Welt verändern. Das „künstliche Leben" gewinnt seine Konturen. Manche Prognosen deuten darauf hin, dass die Entwicklung der Virtual Reality am Beginn der 90er Jahre vergleichbar ist mit der Erfindung des Personalcomputers in den 70er Jahren. Die Möglichkeiten der Virtual Reality können für den Einzelnen zur virtuellen Droge der Zukunft werden. Der Einzelne wird aus der Passivität gerissen, der Computer ermöglicht das interaktive Eingreifen und damit eine neue Erlebnismöglichkeit für jeden Einzelnen, abgestimmt auf jedes Individuum. Dem passiven Kommunikationsmedium Fernsehen folgt das aktive Medium Computer als zweites Jahrhundertmedium.

of art, new experiences for the individual. Possibilities in virtual reality prognosticated today may be able to change our behavior and our world. "Artificial life" is gaining shape.
Some predictions point out that the development of virtual reality in the early 1990s may be compared to the invention of the personal computer in the seventies. Virtual reality may become the virtual drug of the individual in the future. The individual is taken out from his passivity, the computer allows for an interactive interference and thus for new sets of experiences for the individual in accordance with his personal self. The passive communication medium of television is replaced by the active medium of the computer, the second great medium of the century.

ARS ELECTRONICA 1991

Der Mythos des Künstlichen

Im Jahr 1991 hat der Computer seine Unschuld verloren: am 17. Jänner 1991, um 1.00 Uhr mitteleuropäischer Zeit, als die erste lasergesteuerte Bombe ihr Target trifft. Der Golfkrieg hat begonnen – der erste „totale elektronische Krieg" (Paul Virilio). In keinem Krieg zuvor wurde das elektronische Führungs- und Entscheidungssystem in einer derartigen Komplexität eingesetzt.
Für Ars Electronica, ein Festival, das sich von Beginn an in einem Bezugsnetz zwischen Kunst, neuen Technologien und Gesellschaft gesehen hat, beginnt eine andere Zeitrechnung. 1991 wird Ars Electronica erstmals zum Festival danach, zum Festival nach dem ersten totalen elektronischen Krieg.
Die virtuelle Wirklichkeit, bei Ars Electronica 90 noch theoretisches Symposiumsthema, wird jeder Spielerei beraubt: Der Krieg wird zu einer inszenierten Wirklichkeit, jenseits der Realität. Jean Baudrillard nennt den Golfkrieg ein „Paradebeispiel für Simulation". Zum ersten Mal finden zwei Kriege statt: ein Krieg auf dem Schlachtfeld und ein Krieg in den Köpfen der Menschen, verursacht durch das weltumspannende Netz der Medien. Der Krieg der Bilder in Echtzeit und als Live-Kriegsfilm wird zum ersten wirklichen „Weltkrieg", in den die Menschen aller Kontinente via Bildschirm involviert werden. Ein Krieg der Bilder, der sich als Videoclip präsentiert, Tod und Leid ausspart, gleichzeitig aber die Krieger in Filmstars verwandelt.
Der Krieg am Golf hat den Megatrend zur Künst-

The Myth of the Artificial

In the year 1991, the computer lost its innocence. On January 17, 1991, at 1:00 a.m. Central European time, to be exact, when the first laser-controlled bomb met its target, the Gulf War had started: the first "totally electronic war" (Paul Virilio). In no war before had the electronic command and decision system been used to such a degree of complexity.
For Ars Electronica, a festival that has from the beginning always understood itself in a relational network of art, new technologies, and society, a new era has begun.
In 1991, Ars Electronica becomes for the first time the "Festival after," a festival after the first totally electronic war.
Virtual reality-topic of a theoretical symposium at Ars Electronica 90-is bereft of its playfulness: war becomes a staged reality beyond real life. Jean Baudrillard called the Gulf War an "exemplary specimen of simulation." For the first time, two wars take place: one war on the battlefield, the other war in people's minds, created by the worldwide network of media. The war of images, in real time and as a live battlefield movie, becomes the first actual "world war" involving people on every continent via their TV screens. A war of images presenting itself like a video clip, exempting death and suffering and simultaneously transforming the warriors into movie stars.

lichkeit nicht entstehen lassen, sondern lediglich vom akademischen Symposiumsthema in die Realität gestellt und den Beginn eines neuen Mythos noch klarer als bisher erkennen lassen: Den Mythos des Künstlichen, der zweiten Natur.

The Gulf War, though, did not actually create the megatrend towards artificiality, but shifted it from a symposium topic into reality, even more clearly pointing out the beginning of a new myth: the myth of the artificial, of a second Nature.

ARS ELECTRONICA 1992

Ars Electronica Center
Museum des 21. Jahrhunderts

Der 19. März hat in diesem Jahr für Ars Electronica in Linz und für die Gemeinschaft der Computerkünstler eine besondere Bedeutung: Es war der erste Tag, an dem die Jury des Prix Ars Electronica zu ihren diesjährigen Beratungen in Linz zusammengekommen ist, um unter 1500 Einreichungen die Gewinner des Wettbewerbes zu ermitteln.

Gleichzeitig war es der Tag, an dem sich die Stadt Linz entschieden hat, den Computer- und Medienkünstlern ein weiteres Forum zu bieten: Zur jährlichen Ars Electronica, seit 1979 das traditionsreichste Festival für Kunst, Technologie und Gesellschaft, entsteht nun das Ars Electronica Center als „Museum des 21. Jahrhunderts". Ein Museum, das nicht in die Vergangenheit weist, sondern als Ort der Begegnung Entwicklungen präsentiert, die in der Zukunft wichtig sind. Drei Faktoren werden für das Ars Electronica Center in Linz besonders charakteristisch sein: Interaktivität, Szenarien im virtuellen Raum und Netzwerke. Das Ars Electronica Center ist in diesem Sinne auch kein „Center", sondern ein Punkt in einem dynamischen „Net".

Mit dem Ars Electronica Center will Linz auch der weltweiten Künstlergemeinschaft rund um den Prix Ars Electronica eine zusätzliche Heimat anbieten.

Detail der Projektstudie zum Ars Electronica Center, ART + COM, Berlin

Ars Electronica Center
Museum of the 21st Century

Detail der Projektstudie zum Ars Electronica Center, ART + COM, Berlin

March 19 of this year was a date of special importance for Ars Electronica in Linz and for the community of computer artists: it was the first day of this year's jury meeting in Linz, where the winners were to be selected from 1,500 entries. But it was also the day when the City Council of Linz decided to offer an additional forum to computer and media artists. In addition to Ars Electronica-since 1979 the traditional festival of art, technology, and society-the Ars Electronica Center was to be installed as a "museum of the 21st century": a museum that does not point into the past, but is a place of encounter pinpointing important developments in the future. Three factors will be characteristic of the AEC in Linz: interactivity, scenarios in a virtual space, and networking. In this sense, the AEC is no "center," but rather a node in a dynamic "net." With the AEC, Linz also wants to offer an additional home to the worldwide community of artists around the Prix Ars Electronica.

ARS ELECTRONICA 1993

Ars Electronica, Prix Ars Electronica, Ars Electronica Center

Ars Electronica 93 – Christa Sommerer / Laurent Mignonneau: „Interactive Plant Growing"

War das Erdöl die Energie des ausklingenden 20. Jahrhunderts, wird Information die „intelligente Energie" des 21. Jahrhunderts sein. Für die Auseinandersetzung mit dieser Thematik hat sich in Linz seit über einem Jahrzehnt eine Tradition entwickelt. Mit Ars Electronica setzte Linz 1979 zum ersten Mal ein Signal für die Notwendigkeit eines Festivals für Kunst, Technologie und Gesellschaft, in der Zwischenzeit hat sich Ars Electronica als erstes kontinuierliches Festival dieser Art weltweit etabliert. Um „die Nase vorn zu haben", ist es auch für eine Festivalstadt notwendig, die Innovationsspirale nicht nur in der Technologieentwicklung zu beobachten, sondern die Innovationsspirale auch in den eigenen Aktivitäten wirken zu lassen. Aus diesem Grund weist Ars Electronica in Zukunft drei Wirkungsfelder auf: ein Festival, einen internationalen Wettbewerb, den Prix Ars Electronica , sowie das Ars Electronica Center, ein Museum der Zukunft.

Ars Electronica, Prix Ars Electronica, Ars Electronica Center

In the same way that oil was the energy of the 20th century, information will be the "intelligent energy" of the 21st. For over a decade now, a tradition of artistic and scientific examination of this issue has been taking root in Linz. With the founding of Ars Electronica in 1979, the city took a stand for the need for a festival of art, technology, and society. Ars Electronica has since become the first continuous festival of this kind in the world. For a festival city, staying one step ahead means not just watching the innovation cycle at work in the development of technology, but putting it to work in the festival itself. Hence Ars Electronica's three future areas of operation: the festival, the international competition, and the Ars Electronica Center, museum of the future.

Ars Electronica 93 – Ulrike Gabriel: „Terrain 01"

ARS ELECTRONICA 1994

Ein Festival als Frühindikator des Medienbruchs

Die Rundfunk- und Fernsehunternehmen, auch der ORF, stehen heute angesichts der digitalen Medienrevolution voraussichtlich vor der größten Herausforderung in ihrer Geschichte. Was heute für die elektronischen Medien einen radikalen Wandlungsprozess in der Position, in den Aufgabenfeldern

A Festival for Advance Indications of Media Disintegration

In the digital media revolution, today's radio and television broadcasters, including the ORF, are facing what will probably be the biggest challenge in their history. The developments that are now confronting the electronic media with a radical transformation in their position,

Ars Electronica 94 – Christian Möller / Joachim Sauter: „Netzhaut"

sowie in der Marktsituation mit sich bringt, hat der ORF Ende der Siebzigerjahre gemeinsam mit dem Brucknerhaus Linz mit der Initiative zu einem elektronischen Festival wie in einem Labor zu beobachten und zu entwickeln versucht.

Während heute Megaindustrien in dem Zusammenwachsen von Computer, Fernsehen und Telekommunikation eines der großen Wachstumspotenziale um die Jahrtausendwende sehen, denken andere Forscher, wie George Gilder vom Discovery Institute in Seattle, den Medienbruch um einen Quantensprung weiter: Gilder hält Fernsehen und Telefon bereits für überkommene Medien, die die digitale Revolution nicht überleben, wie er in seinem Buch *Life after Television* darzulegen versucht. Wie die Achtzigerjahre den Zusammenbruch der zentralen Systeme der Mainframes und der Terminals gebracht haben, erwartet Gilder in den Neunzigerjahren den Zusammenbruch von Telefon und Fernsehen.

Seine Zukunftsvision liegt in der selbstständigen Nutzung der Computernetze durch den Einzelnen, ermöglicht durch das enorme Anwachsen der Computerkapazität und der globalen Kommunikationsnetze. Wir stehen vor der Geburt eines neuen Kommunikationsmedium – eine gewaltige Herausforderung für die jetzigen elektronischen Medien. Die nächsten 15 Jahre – bis zum Jahre 2009 – zählen gewiss zu den abenteuerlichsten Jahren des Wandels.

areas of activity, and market conditions are the same developments that the ORF tried to address in the late 70s by attempting to observe and foster them as if in a laboratory environment-this is what the ORF's joint initiative with the Brucknerhaus Linz for an electronic festival was intended to bring about.

While today's multinationals view the convergence of computer, television, and telecommunications around the turn of the century as one of the areas with the most growth potential, other researchers like George Gilder from the Discovery Institute in Seattle see media disintegration as being a quantum leap further ahead. As he tries to demonstrate in his book Life after Television, television and telephone should be considered obsolescent media that will not survive the digital revolution. Just as the central systems of mainframes and terminals lost the upper hand in the eighties, Gilder expects telephone and television to fade away in the nineties.

His vision of the future lies in the independent use of computer networks by the individual, made possible by the enormous increase in computing power and by the growth of global communications networks. We are about to witness the birth of a new communications medium, a major challenge to present-day electronic media.

Ars Electronica 95 – Sludtwerkstatt: „Checkpoint 95"

ARS ELECTRONICA 1995

Welcome to the Wired World

Wir stehen nicht nur am Ende eines Jahrhunderts, wir nehmen Abschied vom analogen Zeitalter. Vor uns liegt die digitale Weit. *Being Digital,* wie Nicholas Negroponte seine Bibel für diese neue Welt nennt.

Wenn wir uns in die von Negroponte optimistisch gezeichnete digitale Welt bewegen, ist die Geschwindigkeit eines der entscheidendsten Phänomene in der Veränderung, in einer Veränderung, die kaum Zeit zum Innehalten, auch kaum Zeit zum Lernen lässt. Die radikale Transformation verändert unsere Arbeitswelt genauso wie das kulturelle und gesellschaftliche Leben.

Ars Electronica 95 will mit „Welcome to the Wired World" dem heraufdämmernden dritten Millennium ein Willkommen sagen – gleichzeitig den „Mythos Information" bilanzieren, der diesen Wandel zum digitalen Zeitalter verursacht.

Ars Electronica 95 will ein Forum für diese Entwicklung sein, der ORF will mit dem Prix Ars Electronica , insbesondere mit der neuen Kategorie des World Wide Web, die kulturelle Dimension dieses neuen Mediums unterstreichen. Zum ersten Mal wurden von einer Jury Kriterien für einen mit Geld dotierten Wettbewerb von World-Wide-Web-Sites erarbeitet, die auf die spezifische mediale Eigenheit der Netze hinzielen, wie zum Beispiel „Webness", die Netzgemäßheit, oder „Community forming", das Bilden einer Gemeinschaft, einer globalen Gemeinschaft, das Ermöglichen eines globalen Bewusstseins.

Dabei wird eines immer deutlicher: Wenn das Atom das Markenzeichen der Wissenschaft des 20. Jahrhunderts war, wird das dynamische

Welcome to the Wired World

Not only are we at the end of a century, we are also about to leave the analog age. There is a digital world before us. *Being Digital*, as Nicholas Negroponte calls his bible for this new world.

If we move into the digital world so optimistically pictured by Negroponte, then speed is one of the most critical phenomena of the change, a change that hardly leaves time to pause and reflect, hardly leaves time to learn.

The radical transformation is changing our working world just as it changes our cultural and social life. With "Welcome to the Wired World," Ars Electronica 95 wants to welcome the dawning third millennium-and take stock at the same time of the "information myth," which has caused this transformation to a digital age.

Ars Electronica 95 intends to be a forum for this development; with the Prix Ars Electronica, particularly with the new World Wide Web category, ORF wants to emphasize the cultural dimension of this new medium. This is the first time that a jury for World Wide Web sites in a money prize competition has developed criteria to address the specific media character of the Net, for instance "Webness" as a way of being appropriate to the possibilities available on the Net, or "Community," which applies to the formation of community, a global community enabling global consciousness.

Along the way, there is one thing becoming clearer and clearer. If the atom was the trademark of the science of the twentieth century,

Netz Symbol für das 21. Jahrhundert sein. Das dynamische Netz als Ikone eines globalen Geistes, eines globalen Bewusstseins im Sinne des Mystikers des Informationszeitalters, Teilhard de Chardin. Das Netz ist als neue Form der menschlichen Kommunikation zu verstehen, als neues globales Medium, das gegenwärtig schneller wächst, als Fernsehen, Radio oder Printmedien es jemals taten.

the dynamic Net will become the symbol for the twenty-first century. The dynamic Net is an icon of a global mind, a global consciousness in the sense intended by Teilhard de Chardin, the mystic of the era of information. The Net is to be understood as a new form of human communication, as a new global medium currently growing faster than television, radio, or the printed media ever did.

ARS ELECTRONICA 1996

Eröffnung des Ars Electronica Center Von der Idee zur Wirklichkeit

Opening of the Ars Electronica Center From the Idea to Reality

Ars Electronica 96 – Sky Events und Open-Airs

Das Jahr 1996, Österreichs Millenniumsjahr, ist für Ars Electronica ein weiterer Meilenstein. Mit der Eröffnung des Ars Electronica Center als Museum der Zukunft erfährt die Entwicklung dieses Festivals einen vorläufigen Höhepunkt, gleichzeitig wird damit der Weg in die nächste Zukunft der Jahrtausendwende anvisiert. Das Center, das sich bewusst als „House in Progress" versteht, will ein lebendiger Organismus sein, will vor allem eines sein: ein Haus der Bewusstseinsbildung für den digitalen Wandel, für die Radikalität des digitalen Medienbruchs und damit für die neue digitale Kulturstufe, die sich vor uns auszubreiten beginnt. Wie jedes neue Medium bestimmte Orte hervorgebracht hat – der Buchdruck die Bibliotheken, das Telefon die Telefonzelle, der Film das Kino oder wie das Fernsehen jedes Wohnzimmer verändert hat –, wird die digitale Medienkultur ebenfalls neue Plätze, neue Orte, neue Einrichtungen schaffen: Das Ars Electronica Center will ein Prototyp eines solchen Ortes der neuen digitalen Kulturstufe sein. Linz will damit die Vorreiterrolle

Austria's 1,000-year anniversary in 1996 marks a further milestone for Ars Electronica. With the opening of the Ars Electronica Center as a museum of the future, the development of this festival has reached another high point, and one that simultaneously points the way for its subsequent evolution in the years immediately ahead. The Ars Electronica Center sees its mission as that of a "house in progress," a living organism. Above all, the Ars Electronica Center will strive to be a place dedicated to the formation of consciousness-of the digital revolution and thus of the new stage of digital culture which has already begun to unfold before us. Just as certain sites have emerged as a consequence of every new medium—as the invention of printing led to libraries, the telephone to the telephone booth, film to the cinema, or as television has changed living rooms—digital media culture will also lead to new sites, new places, new institutions: the Ars Electronica Center is intended to be a prototype of this kind of site

Ars Electronica Center

der Ars Electronica weiter ausbauen und sich durch das Ars Electronica Center als Prototyp eines neuen Kraftortes digitaler Kultur festigen.

Das Ars Electronica Center basiert auf einer von mir 1992 vorgelegten Projektidee, für deren Realisierung sich die Stadt Linz nach einem Hearing und einer Präsentation von insgesamt fünf Projektideen im Zuge der Nutzungsdiskussion des bereits planmäßig bestehenden Gebäudes Donautor der Architekten W. H. Michl und K. Leitner im März 1992 entschieden hat.

Das Triangel Ars Electronica Festival, Prix Ars Electronica und Ars Electronica Center zielt schließlich darauf ab, den digitalen Wandel unserer Kultur hin zu einer kognitiven Gesellschaft, deren entscheidende Ressource das Wissen ist, im Einklang mit den wirtschaftlichen und sozialen Gegebenheiten zu bewältigen.

for the new digital phase of culture. With it, Linz intends to further expand the pioneering role of the Ars Electronica and establish itself through the Ars Electronica Center as a prototype of a new site of the power of digital culture.

We stand at the dawn of this new era. There is much that cannot yet be seen or identified, much is still hidden; no one really knows yet where the digital revolution will lead in a new century.

The Ars Electronica Center is based upon a project proposal which I submitted in 1991. Following a hearing and a presentation of a total of five project ideas in the course of the proposed use discussions, in March 1992, regarding the Donautor Building already completed as planned by the architects W. H. Michl and K. Leitner, the City of Linz decided in favor of the realization of this idea.

With the triangle of Ars Electronica Festival, Prix Ars Electronica, and Ars Electronica Center, Linz has established itself in a leading position in cyberspace, both regionally and worldwide. The ultimate aim of this Ars Electronica triangle in Linz is to enable us to work together, bringing economic and social efforts into harmony in dealing effectively with the digital transformation of our culture as we move further along the way to a cognitive society in which knowledge is the most decisive resource.

ARS ELECTRONICA 1997

Cyberart: Art of the Future – The Future of Art

„Ich will, dass man als Zentrum der modernen Kunst die Krise erkennt", formuliert Catherine David als Ausstellungsmacherin der documenta X in Kassel ihre Absicht für diese Weltausstellung zeitgenössischer Kunst. Davids Zielsetzung: „Ich versuche, den Ort der Kunst neu zu bestimmen." Wo ist der neue Ort der Kunst? „Ist die bildende Kunst am Ende", wie Paul Virilio meint, „bleibt nichts von ihr übrig?"

Die Antworten auf diese Fragestellung mit der Suche nach einer Neubestimmung von Kunst an der Schwelle der Jahrtausendwende sind vielfältig. Eine der Ursachen liegt im Aufbruch einer neuen Kommunikationsgesellschaft. Die Kommunikation erhält eine neue Qualität. Neue Technologien,

Cyberart: Art of the Future— The Future of Art

"I want people to recognize the crisis as the center of modern art," stated Catherine David, director of Documenta X in Kassel, formulating her intention for this world exhibition of contemporary art. "I am seeking to redefine the place of art."

Where is the new place of art? "Have the fine arts come to an end," as Paul Virilio asked; "is there nothing left?"

The answers to this question, seeking a redefinition of art at the threshold of the millennium, are many. One of the reasons for this is the way a new communication society has set off in new directions.

Information technology and telecommunica-

Breitbandigkeit, Konvergenz, neue Dienste, Mobilität, Vernetzung – all das sind Bausteine der Kommunikationsgesellschaft.
Informationstechnologie und Telekommunikation sind dabei, sich als größte Industrie der Welt zu etablieren. Globalisierung und Konvergenz der Medien zählten zu den bekannten Kennzeichen dieses Umbruchs. Die Sprache des anbrechenden 21. Jahrhunderts ist digital, die neue universelle Sprache der Kommunikationsgesellschaft .
Der Prix Ars Electronica 97 zeigt, dass digital und online mehr und mehr zu den charakteristischen Kennzeichen dieser Entwicklung werden. Traditionelle Medien- und Computerkunst ist auf dem Weg zur Cyberkunst.
Aus diesem Grund stellt der Prix Ars Electronica 1997 bewusst im ersten Jahr der zweiten Dekade dieses Wettbewerbes den Begriff Cyberkunst auf den Prüfstand des Diskurses. Kaum ein anderes Wort hat in den Neunzigerjahren eine vergleichbare Karriere hinter sich wie das Wort „Cyber", das aber nicht nur eine Überstrapazierung hinter sich hat, sondern alle Chancen hat, von einem Präfix zu einem der Schlüssel-begriffe des 21. Jahrhunderts zu werden. „Wo ist der neue Ort der Kunst?" Wenn wir auf Catherine Davids Frage zumindest eine einzige Antwort versuchen: Ein neuer Ort der Kunst wird der Cyberspace sein. Für das Vordringen in diesen neuen Ort der Kunst will der Prix Ars Electronica ein Forum anbieten.

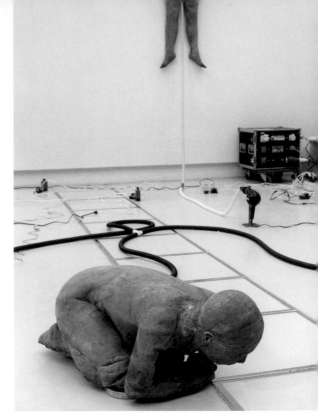

Ars Electronica 97 – César Martìnez Silva· „Las Transpiraciones del Desgaste o la Devaluaciòn Aspirada"

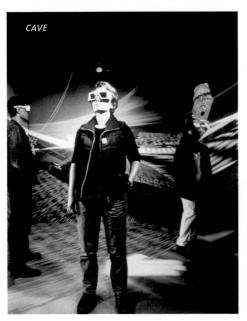

tions are about to establish themselves as the largest industry in the world. Globalization and media convergence are among the characteristics of the upheaval. The language of the dawning 21st century is digital, the new universal language of the communication society.
The example of the Prix Ars Electronica 97 shows that digital and online are increasingly becoming the characteristic features of this development. Traditional media and computer art is on the way to becoming cyberart.
For this reason, the Prix Ars Electronica 97, now in the first year of its second decade, has put the term cyberart to the test of the discourse. There is hardly another word in the nineties that has had a career comparable to that of the word "cyber." Even though it has also been seriously overused, it nevertheless stands a good chance of being transformed from a prefix to one of the key terms of the 21st century.
"Where is the new place of art?" If we attempt to respond to Catherine David's question with at least a single answer, one new place of art will be cyberspace. The Prix Ars Electronica intends to provide a forum for forging this new place of art.

ARS ELECTRONICA 1998

Aufbruch der Cybergeneration

„Die Kinder, die im Orwell-Jahr 1984 geboren wer-
den, sind im Jahr 2019 35 Jahre alt", schrieb ich im
Katalog zur Ars Electronica 84.

„Sie bilden die Generation", setzte ich fort, „die dann
weitgehend die Verantwortung für die Gesellschaft
tragen wird." In der Geschichte von Ars Electronica
wird der Prix Ars Electronica 98 eine Besonderheit
darstellen, denn zusätzlich zu Künstlern, Wissen-
schaftern und Cyberartisten, die weltweit zu diesem
Wettbewerb eingeladen wurden, forderte der Prix
Ars Electronica 98 zum ersten Mal in einem Pilot-
projekt jene Generation zur Teilnahme auf, die mit
dem Computer aufwächst.

Der Prix Ars Electronica 98 hat aus diesem Grund die
Cybergeneration – u19, also die unter 19 Jahren – zu
einer Initiative eingeladen, zu einem Wettstreit der
Ideen, zu einem kreativen Brainstorming: Als Motto
haben wir einen für diese Generation bezeichnen-
den Titel gewählt, der mehr als ein Wettbewerbstitel
ist; der ein Lebensgefühl dieser Generation aus-
drückt: Freestyle – mache, was du willst; entscheide
selbst, was du tust; zeige, was du selbst mit dem
Computer kannst.

Im kommenden Jahr, 1999, wer-
den es 20 Jahre sein, dass Ars
Electronica in Linz entstanden
ist. Dieser Anlass wird Gelegen-
heit sein, in einer Reflexion den
Entwicklungsspuren der elektro-
nischen und digitalen Entwick-
lung der letzten Jahrzehnte
nachzugehen, gleichzeitig aber
auch in die Welt der neuen

The Cybergeneration Takes Off

"The children who are born in the Orwell year
of 1984 will be 35 years old in the year 2019,"
I wrote in the 1984 Ars Electronica catalogue,
continuing, "They are the generation that will
be largely responsible for our society then."
In the history of Ars Electronica, the Prix Ars
Electronica 98 will assume a special position,
because in addition to the artists, scientists,
and cyberartists from around the world who
are invited to take part in this competition, as
part of a pilot project and for the first time,
the Prix Ars Electronica 98 has called upon the
generation now growing up with the computer
to take part.

For this reason, the Prix Ars Electronica 98
has invited the cybergeneration-u19—under
19 in other words-to take part in a new initia-
tive, in a competition of ideas, in a creative
brainstorming. The title we have chosen is
more than just a name for a competition; it is a
motto that is characteristic of this generation:
Freestyle-do what you want; decide for your-
self; show what you can do with a computer.

Next year, in 1999, it will
be 20 years since Ars Elec-
tronica was initiated in
Linz. This anniversary will
provide an occasion to
reflect on the traces of the
electronic and digital de-
velopments of recent
decades, but also to look
ahead to the world

Prix Ars Electronica 98: Die Anonymen Titaniker

Cybergeneration des 21. Jahrhunderts zu blicken. Die Cybergeneration steht aber auch vor der Schwelle, ob die digitale Revolution mit dem Umbruch in der Gen- und Biotechnologie die Wirtschaft und damit den Einzelnen in die Krise führt oder ob wir vor einer noch nie da gewesenen Ära des Wohlstands, der wirtschaftlichen und gesellschaftlichen Aufwärtsentwicklung stehen, wie dies die Pulitzer-Preis-Gewinner und *Wall Street Journal*-Reporter Bob Davies und David Wessel in ihrem jüngsten Buch *Prosperity – The Coming Twenty-Year-Boom and What It Means To You* prognostizieren.

Eines steht auf alle Fälle fest: Für Ars Electronica und für den Prix Ars Electronica werden die nächsten Jahrzehnte keinen Mangel an Themen und künstlerischen Herausforderungen bringen, sondern das Gegenteil wird der Fall sein. Die radikale Änderung in unserer Welt wird mehr denn je der kritischen Reflexion sowie der künstlerischen Gestaltung bedürfen.

of the new cybergeneration of the 21st century. The cybergeneration is standing on the verge. Will the digital revolution, with its upheavals in genetic engineering and biotechnology, lead the economy, and with it the individual, into a crisis; or are we approaching an entirely new era of prosperity, of economic and social upward development, as prognosticated by the Pulitzer Prize winner and *Wall Street Journal* reporter Bob Davies and David Wessel in their recent book *Prosperity: The Coming Twenty-Year Boom and What It Means to You.*

One thing is certain in any case: the coming decades will bring no lack of topics and artistic challenges for Ars Electronica and the Prix Ars Electronica; indeed the opposite is true. The radical changes in our world will be more in need of critical reflection and artistic treatment than ever before.

ARS ELECTRONICA 1999

Digitale Morgendämmerung

Digital Dawn

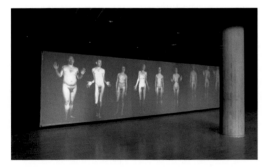

Ars Electronica 99 – Gina Czarnecki: „Stage Elements Humans"

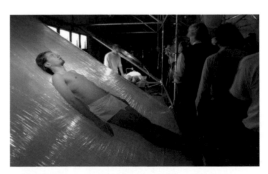

Ars Electronica 99 – Fakeshop: „[Multiple_Dwelling]"

Vor drei Jahren, im Sommer 1996, machte der 29-jährige Fernando Espuelas mit seiner Frau in den Bergen von Nepal Urlaub. Am Fuße eines Berges, erzählt er später, habe es ihm gedämmert, daß das Internet auch Lateinamerika verändern werde. Da kam ihm die Idee, dass er das Internet nach Lateinamerika bringen könnte.

Drei Jahre später, am 26. Mai 1999, geht Fernando Espuelas mit seiner Firma „StarMedia Network" in der Wallstreet an die Börse. Es wurde ein Kurs von $ 10 bis $ 12 pro Stück erwartet, am ersten Tag

Three years ago, in the summer of 1996, 29-year-old Fernando Espuelas was on holiday with his wife in the mountains of Nepal. At the foot of a mountain, as he recounted later, it dawned on him that the Internet would change Latin America, too. An idea came to him of how he could bring the Internet to Latin America.

Three years later, on May 26, 1999, Fernando Espuelas' company "StarMedia Network" went on the stock market in Wall Street. A rate of $ 10 to $ 12 per share was expected, but on the first

stieg der Kurs auf $26 und schloss am Wochenende mit $58. „StarMedia Network" hat nun eine Marktkapitalisation von mehr als drei Milliarden Dollar, Fernando Espuelas verfügt mit einem persönlichen Firmenanteil von 11,4 % plötzlich, drei Jahre nach seiner Idee, über ein Vermögen von mehr als $350 Millionen, das sind ungefähr 4,5 Milliarden Schilling. StarMedia ist eine spanisch- und portugiesischsprachige Search-Engine wie z. B. Yahoo! und Excite.

Die letzten Dezennien des ausgehenden Jahrhunderts haben nicht nur Bill Gates mit Microsoft zu einem der großen Unternehmer des 20. Jahrhunderts gemacht, sondern tagtäglich demonstrieren im digitalen Aufbruch einzelne Menschen wie Fernando Espuelas das pionierhafte Vordringen in die digitale Welt. Mit den Chancen, mit den Risiken. In keinem anderen Jahrzehnt unserer industriellen Geschichte haben sich größere Chancen eröffnet als an der Pforte von der analogen zur digitalen Welt.

In der Geschichtsschreibung des 21. Jahrhunderts werden diese Jahrzehnte als neue Goldgräberzeit bezeichnet werden. Die wirtschaftliche, technologische und kulturelle Entwicklung der letzten zwei Dezennien wird gleichzeitig in einem Festival widergespiegelt, in Ars Electronica, dem Festival für Kunst, Technologie und Gesellschaft in Linz. Dieses Festival konnte durch Kontinuität, Kompetenz und Zukunftsorientierung die ständigen Phasen des Wandels wie ein Seismograph begleiten. Ars Electronica umspannt als Festival exakt

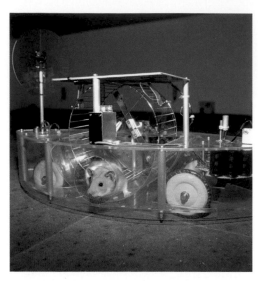

Ars Electronica 99 – Christoph Ebener, Frank Fietzek, Uli Winters: „Hamster – symbiotic exchange of hoarded energy"

day the rate rose to $26 and closed on the weekend at $58. "StarMedia Network" now has a market capitalization of over three billion dollars; with a personal share of 11.4 % in the company Fernando Espuelas suddenly, three years after his initial idea, has a fortune of $350 million, approximately 4.5 billion Austrian shillings. StarMedia is a Spanish and Portuguese language search engine, similar to Yahoo! or Excite, for instance.

The last decennia of the closing century have made not only Bill Gates with Microsoft one of the greatest entrepreneurs of the twentieth century, but every day in the era of digital transformation, individuals like Fernando Espuelas may be seen setting off like pioneers into the digital world. With all the opportunities, with all the risks. In no other decade of our industrial history have greater opportunities arisen than at the threshold from the analog to the digital world.

When history is written in the 21st century, these decades will be referred to as the new gold rush era. At the same time, the economic, technological and cultural development of the last two decennia are reflected in a festival, in the Ars Electronica, the festival for art, technology and society in Linz. On the basis of continuity, skill and an orientation to the future, this festival has been able to accompany the continuously occur-

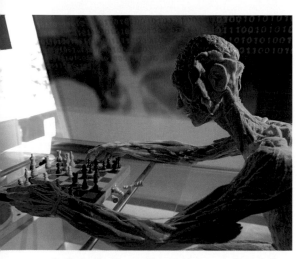

Ars Electronica 99 – Gunther von Hagens: „Anatomy Art"

jene zwei Dezennien, die nicht nur eine tief greifende Veränderung unserer Zivilisation in Gang bringen, sondern auch für Nationen, Länder, Städte und letztlich für jeden einzelnen Menschen Chancen eröffnen, die es in diesem Ausmaß zuvor nie gegeben hat.

Die Schlüsselkulturtechnik an der Schwelle zum dritten Jahrtausend ist die Interaktivität, und letztendlich ist das Internet jener digitale Strom, in dem alles zusammenfließt. „Das Internet verändert alles", sagt Larry Ellison, einer der Goldgräber unserer Zeit. Das Jahr 1999 bedeutet für Ars Electronica und für den Prix Ars Electronica vor allem auch eines: Im Festival der Zukunft geht es nicht darum, in die Geschichte zurückzublicken, sondern ausschließlich darum, vorauszuschauen. Daher bedarf es der Innovationskraft und des Durchsetzungsvermögens, um die Morgendämmerung der digitalen Entwicklung des 20. Jahrhunderts zu durchschreiten und die Chancen des 21. Jahrhunderts wahrnehmen zu können.

ring phases of transformation like a seismograph. As a festival Ars Electronica spans exactly the two decades that have seen not only a profound transformation of our civilization, but which have also opened up opportunities for nations, states, cities and ultimately for each individual person, which have never existed before to this extent. The key cultural technique at the threshold of the third millennium is interactivity, and finally the Internet has become the digital stream in which everything flows together. "The Internet is changing everything," says Larry Ellison, one of the gold-diggers of our era.

For the Ars Electronica and the Prix Ars Electronica, the year 1999 means one thing especially: the festival of the future is not about looking back at history, but about looking ahead.

For this reason, innovative drive and assertive power will be needed to pass through the dawn of the digital development of the 20th century and perceive the opportunities of the 21st century.

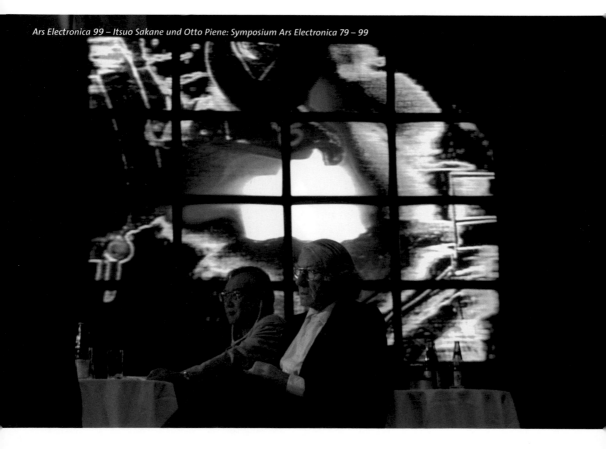

Ars Electronica 99 – Itsuo Sakane und Otto Piene: Symposium Ars Electronica 79 – 99

ARS ELECTRONICA 2000

Ars Electronica 2000 – Golan Levin, performer: Gregory Shakar, Scott Gibbons: „Active Score Music, Scribble"

Individuality— Mobility—Globality

"The whole internet could be re-architected by Napster-like technology", says Intel Chairman Andy Grove in *FORTUNE* about the hot idea of the year 2000.The reference is to Napster, a tiny start-up company in San Mateo, California, which was founded by 19-year-old Shawn Fanning and 20-year-old Sean Parker in late 1999. It is a new idea for the exchange of information, continued by the Gnutella technology developed by 23-year-old Gene Kann and 26-year-old Spencer Kimball, which links the PC of an individual with as many users as possible in a network of so-called "peer-to-peer" connections. Regardless of how Napster and Gnutella continue to develop, one thing is certain: the Internet is by no means at the end of its development or in a phase of maturity, but rather at the beginning. The core idea of the net, all with all com-

Individualität – Mobilität – Globalität

„Die ganze Architektur des Internet könnte durch eine Napster-ähnliche Technologie neu strukturiert werden", sagt Intel-Chairman Andy Grove in FORTUNE über die „heiße Idee des Jahres 2000". Gemeint ist Napster, eine winzige Startup-Firma in San Mateo, Kalifornien, die vom 19-jährigen Shawn Fanning und vom 20-jährigen Sean Parker Ende 1999 gegründet wurde. Es ist eine neue Idee des Informationsaustausches, die von der Gnutella-Technologie, entwickelt vom 23-jährigen Gene Kan und vom 26-jährigen Spencer Kimball, weitergeführt wird und den PC des Einzelnen mit so vielen Usern wie möglich in einem Netz von so genannten Peer-to-Peer-Verbindungen zusammenschließt. Wie immer sich Napster und Gnutella entwickeln, eines ist sicher: Das Internet steht am Beginn der Entwicklung, keineswegs am Ende oder in der Reifezeit. Die Kernidee des Netzes, die Alle-mit-Allen-Kommunikation, steht noch am Beginn der Ausschöpfung des Potenzials, wie es Jeff Bezos, der Gründer von Amazon.com, drastisch ausdrückt, der die Zeitdimension des Internet, verglichen mit geologischen Zeitabläufen, derzeit noch in der kambrischen Ära, also vor etwa 550 Millionen Jahren, angesiedelt sieht. Die direkte Kommunikation untereinander ist es letztlich auch, die für die Künstler, insbesondere für die Medienkünstler, völlig neue Perspektiven eröffnet. Der Prozess, der derzeit mit Napster-ähnlichen Technologien in der Musikdistribution beginnt, geht selbstverständlich weit über diesen Bereich hinaus. Tatsächlich hätten diese Technologien das Potenzial, die PC-Industrie auf den Kopf zu stellen.

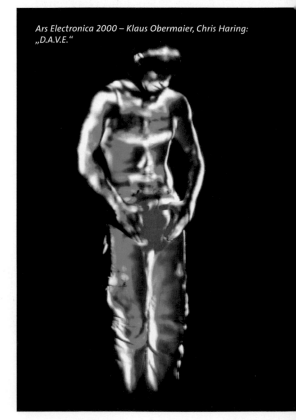

Ars Electronica 2000 – Klaus Obermaier, Chris Haring: „D.A.V.E."

Ars Electronica 2000 – „20' to 2000"

In Europa sind weniger Napster und Gnutella das Thema des Jahres 2000, sondern ein anderer Begriff scheint das Karrierewort des Jahres 2000 zu werden: Mobile-Computing. Nach E-Business, E-Commerce und E-Life heißt der neue Zauberbuchstabe „M" wie „mobil". Mit Mobile-Computing folgt dem E-Commerce der „M-Commerce". Bedeutet diese Verschiebung eine einzelne Verästelung oder bedeutet diese Verschiebung eine neue Richtung? Für beide Ansichten lassen sich Indizien finden. Eines allerdings steht fest: Über das Handy erreicht das Internet mit unwahrscheinlicher Geschwindigkeit eine rapid wachsende Anzahl von Kunden. Daher wird das Jahr 2000 die Wende zur Mobilität markieren, gleichzeitig aber auch den Schritt zur individuellen Unabhängigkeit von Raum und Zeit. Der individuelle mobile WAP-Zugang, in der Folge der UMTS-Standard, ist nicht nur ein Hoffnungsträger der IT-Branche, sondern legt in der digitalen Entwicklung den Fokus auf das Ich, die individuelle Unabhängigkeit, die Ortsungebundenheit, auf die Freiheit des Einzelnen. Wo immer ich bin – ich kann in nahezu allen Bereichen des Lebens, der Wirtschaft, der Unterhaltung, der Freizeit, der Kultur, in die vernetzte Welt einsteigen. Die jüngste Innovation des Prix Ars Electronica, die Cybergeneration, ist charakteristisch für die gesamte Entwicklung, die von einer extrem jungen Generation getrieben wird. Diese Generation wird die Trägerin der globalen Kultur sein, der globalen Kultur, die von der Individualität des Einzelnen, der Zeit- und Ortsungebundenheit geprägt sein wird. Für diese Generation gilt, was Anders Eriksson von der schwedisch-amerikanischen E-Commerce-Firma Razorfish, einer Consulting-Firma, meint: „Wir denken und atmen digital, unsere Seele ist digital." Mit dieser Voraussetzung wird es möglich sein, den digitalen Wandel zu bewältigen.

munication, is only beginning to exploit its potential. As Jeff Bezos, founder of Amazon.com, drastically states it, in comparison with geological timelines, the time dimension of the Internet is currently still located in the Cambrian period, in other words about 550 years ago. Direct communication ultimately also opens up completely new perspectives for artists, especially for media artists. The process that is beginning in music distribution with Napster-like technologies, for instance, naturally goes far beyond this field alone. In fact, these technologies have the potential to turn the PC industry upside down. Napster and Gnutella are not quite the hottest topic of the year 2000 in Europe, but rather there is another term that seems to be the buzz word of the year 2000: mobile computing. Following e-business, e-commerce, e-life, the new magic letter is "m"— mobile. With mobile computing, e-commerce is succeeded by "m-commerce." Does this shift indicate a single fork, or does it indicate a new direction? Evidence may be found to support both views. In any case, one thing is certain: the Internet is reaching a rapidly growing number of customers with astonishing speed via cell phones. For this reason, the year 2000 marks a turn to mobility, but also a step toward the individual's independence from time and space. Individual mobile WAP access, consequent to the UMTS standard, is not only the great hope of the IT branch, but also focuses digital development on the individual, on individual independence of location, the freedom of every single person. No matter where I am, I can participate in nearly every area of life, business, entertainment, leisure time, culture, in the networked world. The most recent innovation of the Prix Ars Electronica, the Prix Ars Electronica Cyber Generation, is characteristic for the overall development that is being driven by an extremely young generation. This generation will become the bearers of global culture, a global culture characterized by the individuality of each person and independence of time and place. The words of Anders Eriksson from the Swedish-American e-commerce company Razorfish, a consulting firm, apply to this generation: "We think and breathe digital, our soul is digital." With this qualification, it will be possible to cope with the digital transformation.

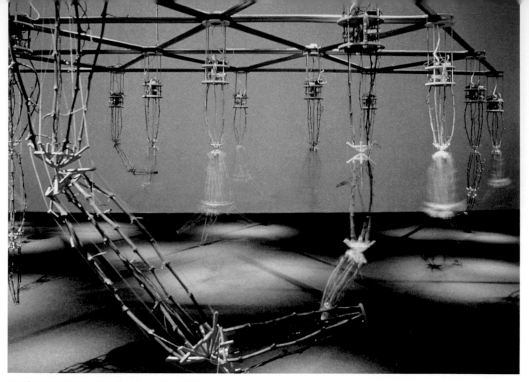

Ars Electronica 2001 – Ken Rinaldo: „Autopoiesis"

ARS ELECTRONICA 2001

Douglas Adams Traum

Computertechnologie, Gentechnologie und Nanotechnologie entwickeln sich mehr denn je zu den tragenden Säulen unseres jungen Jahrhunderts. Frank Schirrmacher, Herausgeber der FAZ, fasst diese drei in einer Wissenschaftsdebatte sowie in einer Publikation unter dem Begriff „Darwin-AG" zusammen. Es wird im kommenden Diskurs weniger um die Frage des Verzichtes auf neue Technologien gehen, wie es Bill Joy vorschlägt, sondern vielmehr darum, in der Zukunft auch die entsprechenden ethischen Richtlinien in diesem Dreigestirn zu finden. Eines wird immer deutlicher: Aus der Entwicklung des Dreigestirns Nanotechnologie, Biotechnologie und Computertechnologie wird in unserem Jahrhundert die Evolution zum ersten Mal auch in die Hände des Menschen gelegt. Vor dieser Morgendämmerung stehen wir, dahinter verbirgt sich letztlich noch unbekanntes Neuland. Mit der Computerkultur wird sich, so schrieb ich 1987 in der Publikation zum Prix Ars Electronica, eine neue Kulturstufe entwickeln. Als Vergleich wählte ich damals Hermann Hesses Glasperlenspiel, als Vision einer Gesellschaft, in der Glasperlenspieler eine universale Sprache und

Douglas Adams' Dream

Computer technology, gene technology, nanotechnology are developing more than ever before into the central pillars of our young century. Frank Schirrmacher, publisher of the *Frankfurter Allgemeine Zeitung*, summarizes these three in a scientific debate and in a publication with the term "Darwin Ltd." In future discourse, it will be less a question of renouncing the new technologies, as Bill Joy suggests, but rather of finding the appropriate ethical guidelines in this triad in the future. One thing is becoming increasingly clear: in consequence of the development of this triad nanotechnology, biotechnology and computer technology, now in our century, evolution is placed in the hands of human beings for the first time. This is the dawn we face; what is concealed behind it is ultimately unknown virgin territory. With computer culture, as I wrote in the publication on the Prix Ars Electronica in 1987, a new stage of culture will be developed. At that time, as a comparison I chose Hermann Hesse's *Glass Bead Game* as the vision of a society, in which the glass bead game players have invented a universal language and method to

Methode erfunden haben, um alle geistigen und künstlerischen Werte und Begriffe auszudrücken und auf ein gemeinsames Maß zu bringen, in der Art und Weise, wie der Computer mit dem binären Alphabet ein neues Sprach- und Denksystem schafft.

Heute, 15 Jahre später, greift Douglas Adams, der geniale Denker, der im Mai dieses Jahres in Santa Barbara im Alter von knapp 50 Jahren verstorben ist, das Glasperlenspiel von Hermann Hesse auf. In einer Aufzeichnung von Claudia Riedel in der Wochenzeitung *Die Zeit* sagt Douglas Adams: „Ich träume schon lange davon, so etwas wie das Glasperlenspiel mit der Technologie des Internet zu realisieren. Ein Spiel, in dem nicht Spieler die Hauptrolle spielen, wie beim Schach und anderen Kriegsspielen; bei dem es nicht um Punkte geht, sondern um Ideen, Musik, Informationen, Erfahrungen, Gedichte, Literatur." Douglas Adams hat auch bereits seine Spieler parat – unter anderen wären es gewesen Johann Sebastian Bach, Danny Hillis, Richard Dawkins und seine Frau Lalla, Schauspieler Steven Fry, die Astrophysikerin und Science-Fiction-Autorin Fiorella Terenzi, um nur einige von ihnen anzuführen.

Der Magister Ludi, sagt Douglas Adams, das wäre er schließlich selbst. Der Traum eines Gesellschaftsspiels mit winzigen Supercomputern ist ein Traum geblieben. Douglas Adams starb am 11. Mai dieses Jahres, nicht aber seine Ideen. Die werden weiterreichen, wie seine Trilogie *Per Anhalter durch die Galaxis*. Ars Electronica 2001 stellt zu Beginn des neuen Jahrhunderts die Frage „Takeover – Wer macht die Kunst von morgen?" Ars Electronica will zu Beginn des neuen Jahrhunderts Bilanz legen, weniger über die Vergangenheit, eher über die neuen Entwicklungslinien, die neuen Referenzsysteme, über das Potenzial der Netzkunst, der Cyberkultur.

Ars Electronica 2001 – Carsten Nicolai, Ryoji Ikeda in concert

express all intellectual and artistic values and find a common measure for them, in the way that the computer created a new system of language and thinking with the binary alphabet. Today, fifteen years later, Douglas Adams, the brilliant thinker, who died this year in May in Santa Barbara at the age of barely 50, picks up Hermann Hesse's glass bead game again. In an article by Claudia Riedel in the weekly newspaper *Die Zeit*, Douglas Adams said that he had long been dreaming of doing something like the glass bead game with the technology of the Internet. A game, where it is not the players who play the main role, as in chess or other war games; where it is not a matter of points, but rather of ideas, music, information, experience, poetry, literature. And Douglas Adams already had players in mind— these would include Johann Sebastian Bach, Danny Hillis, Richard Dawkins and his wife Lalla, the actor Stephen Fry, the astrophysicist and science fiction author Fiorella Terenzi, to name only a few.

The Master Ludi, said Douglas Adams, would be himself. The dream of a social game with tiny supercomputers remained a dream. Douglas Adams died this year on May 11, but his ideas did not. They will continue on, like his trilogy *The Hitchhiker's Guide to the Galaxy*. At the beginning of this century, Ars Electronica 2001 poses the question "Takeover—Who is doing the art of tomorrow?" At the beginning of this new century, Ars Electronica is taking stock, not so much of the past, but rather of the new lines of development, new systems of reference, the potential of net art, of cyberculture.

Ars Electronica 2001 – Barbara Lippe: „electrolobby gamejam"

ARS ELECTRONICA 2002

Fantasie der Realität

Mondlandung, Kennedy-Mord, Attentat auf das World Trade Center – drei unterschiedliche Ereignisse, aber ein gemeinsames Merkmal: die stigmahafte Einprägung in die Köpfe der Menschen. Jeder, der von Medien umgeben war, erinnert sich an die individuelle Örtlichkeit, an der er sich zum Zeitpunkt der jeweiligen Ereignisse aufgehalten hat. Auch Jahrzehnte später ist dieses Bild in der Imagination nicht verblasst, sondern hautnah und lebendig.

11. September 2001, 8.46 Uhr in New York, 14.46 MEZ. Der Nordturm des World Trade Center wird von der American-Airlines-Maschine Flug 11 gerammt, der Südturm um 9.02 vom United Airlines Flug 175. Beide Flugzeuge sind vom Typ Boeing 767-200.

Es wurde daraus ein Ereignis, von dem Monate später der französische Philosoph Jean Baudrillard in seiner heftig umstrittenen Wortmeldung sagte: „Das ist der vierte Weltkrieg" (*Der Spiegel*, 3/2002), mit der Zielrichtung auf die Globalisierung, die, so Baudrillard, mehr Opfer als Nutznießer schaffe und insbesondere jede Singularität, jede andere Kultur, aufhebe. Ein Jahr danach. Der Jahrestag fällt in die Festivalwoche der Ars Electronica 2002, in die Woche jenes Festivals, das sich seit mehr als 20 Jahren erfolgreich zum Ziel gesetzt hat, den Wechselwirkungen zwischen Kunst, Technologie und Gesellschaft nachzuspüren und das sich innerhalb von zwei Jahrzehnten einen Ruf als zuverlässiger Indikator von Entwicklungen im digitalen Medienbereich erworben hat.

„Unplugged – Kunst als Schauplatz globaler Konflikte" – unter diesem Titel will Ars Electronica 2002 Spuren verfolgen, die die Globalisierung hinterlässt – in den Köpfen und Herzen der KünstlerInnen. In gewissem Sinn berührt Ars Electronica 2002 nicht nur einen Pfeiler im konstanten programmatischen Festivalsdreiklang von Kunst, Technologie und Gesellschaft, sondern alle drei in einem. Der 11. September hat in allen Bereichen einen Riss hinterlassen.

Sowohl die New Economy als auch das Vordringen der digitalen Medien in die kreative Gestaltung sind ein Jahr nach dem 11. September entfernt von jeder Euphorie, denn der 11. September hat unsere Welt und unser Denken mehr verändert, als uns

Fantasy of Reality

The moon landing, Kennedy's assassination, the attacks on the World Trade Center – three different events but all with a feature in common: the indelible impression they have left on people's minds. Everyone who had media around them remembers their particular location at the exact moment of each of these events. Even decades later, their imagery has not faded from our minds but is still immediate and vivid. September 11, 2001 at 8:46 a.m. in New York, 2:46 p.m. CET. The North Tower of the World Trade Center is rammed by an American Airlines plane, Flight 11; the South Tower at 9:02 a.m. by United Airlines Flight 175. Both planes are Boeing 767-200s.

It turned into an event which the French philosopher Jean Baudrillard commented on a few months later in a fiercely controversial statement: "It is indeed a World War, not the third one, but the fourth." (*Le Monde* 2/11/2001), and it aims at a globalization, according to Baudrillard, that creates more victims than beneficiaries and, moreover, levels all singularity and other culture.

Now, a year later, the first anniversary of this event falls during Ars Electronica 2002, that festival which for more than 20 years has successfully striven to trace interactions between art, technology and society. And over these two decades, the festival has established a reputation as a reliable barometer of developments in the field of digital media.

"Unplugged—Art as the Scene of Global Conflicts"—under this title, Ars Electronica 2002 is attempting to uncover traces of globalization— in the heads and hearts of artists. In a certain sense, Ars Electronica 2002 touches not only on a pillar of what has been a constant triad in the festival program, the triad of art, technology and society, but on all three in one. For September 11 has deeply jarred all these realms.

One year after September 11, the new economy and the digital media's progress in the field of creative design are far from a state of euphoria. September 11 changed our world and our thinking more than we may at present realize.

im Augenblick bewusst sein mag. Während ich diese Zeilen schreibe, lese ich im News-Ticker, dass der amerikanische Verteidigungsminister mitteilte, eine von Attentätern präparierte so genannte schmutzige Atombombe sei rechtzeitig entdeckt worden. Ars Electronica 2002 will als Festival mit seinem Thema vonseiten der Kunst Schauplätze globaler Konflikte aufzeigen, beispielhaft in einer Zeit, in der das Unerwartete, aber auch das bisher Undenkbare in den Raum der Wirklichkeit gerückt ist. Dies kann nicht umfassend geschehen, aber an Nahtstellen und Bruchlinien, an denen die Zeichen einer beunruhigenden Zeitepoche klarer in Umrissen erkennbar werden.

Jules Verne sagte einmal: „Alles, was ein Mensch sich vorstellen kann, werden andere Menschen verwirklichen." An diesen Satz habe ich mich am 11. September erinnert: Der bekannte Thriller-Autor Tom Clancy publizierte bereits 1996 einen Roman mit dem Titel *Executive Order*, in dem er nicht nur eine Boeing 707 in das Capitol rasen und fast alle Spitzenpolitiker umkommen lässt, sondern auch Anschläge mit Anthrax und Ebola-Virus als Folge beschreibt. Wenn sich die Geschwindigkeit der technischen und der gesellschaftlichen Transformation weiter radikalisiert, werden wir auch mehr und mehr mit der Vorstellung leben, dass Undenkbares sich in Denkbares wandelt, dass Fantasie Schritt um Schritt Realität wird.

While writing these lines, I saw on the news ticker that the US Secretary of Defense had announced that terrorists' plans to make a so-called radioactive dirty bomb had been discovered in time. As a festival and with this year's central theme, Ars Electronica 2002 wants to present the scenes of global conflict from the standpoint of art—exemplary in a time when the unexpected and hitherto unthinkable have shifted to the realm of reality. Such a presentation cannot cover everything, but concentrates on the seams and sites of fracture where signs of a disquieting epoch are becoming more clearly discernible.

Jules Verne once said: "Whatever one man is capable of conceiving, other men will be able to achieve." This sentence came to my mind on September 11. And the famous thriller author Tom Clancy published a novel entitled *Executive Order* in 1996, in which he not only had a Boeing 707 crash straight into the Capitol and kill top politicians, but also described the attacks with Anthrax and the Ebola virus that followed. If the speed of technological and societal transformation continues to accelerate so radically, we will increasingly have to live with the idea of the unthinkable becoming the thinkable and of fantasy turning bit by bit into reality.

Ars Electronica 2002 – 66b/cell: „Test Patches"

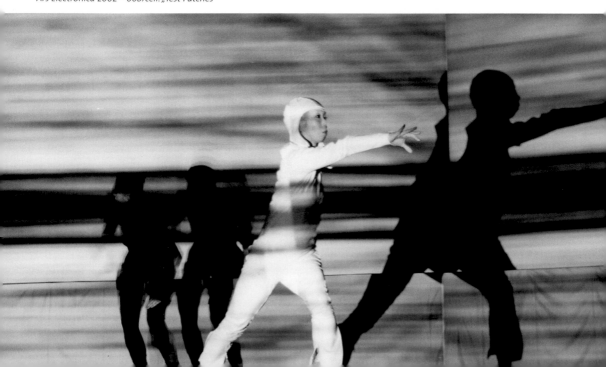

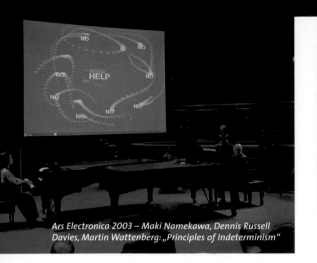

Ars Electronica 2003 – Maki Namekawa, Dennis Russell
Davies, Martin Wattenberg: „Principles of Indeterminism"

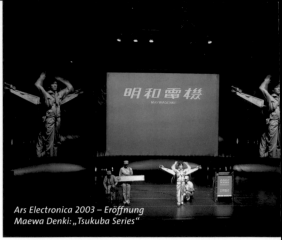

Ars Electronica 2003 – Eröffnung
Maewa Denki: „Tsukuba Series"

ARS ELECTRONICA 2003

Orwells Kinder werden erwachsen

Ein Festival, das sich seit mehr als zwei Jahrzehn-
ten mit Zukunftsthemen befasst, kann 2003 an
einem Namen nicht vorbeigehen: an George
Orwell, der vor 100 Jahren in Motihari in Indien
geboren wurde. George Orwell hat bekanntlich
knapp vor seinem Tod im Jahr 1950 den wohl
meist zitierten Zukunftsroman, *1984* geschrieben,
in dem er das Negativbild eines totalitären Über-
wachungsstaates zeichnet.

Als das reale Jahr *1984* kam, war es für Ars Electro-
nica naheliegend, an dieses Zukunftsszenario
anzuknüpfen. Angesichts der Vielzahl von Veran-
staltungen und Projekten, die sich in diesem Or-
well-Jahr mit den Schreckensszenarien befassten,
wählte Ars Electronica ebenfalls einen Sprung in
die Zukunft, und zwar in das Jahr 2019. Die Wahl
dieses Jahres hatte zwei Gründe: Erstens, so war
unsere Überlegung, werden die Kinder, die im
Orwell-Jahr 1984 zur Welt kommen, im Jahr 2019
35 Jahre alt sein, also in verantwortlichen Positio-
nen in Politik und Wirtschaft stehen; zweitens
waren seit dem Tod von George Orwell im Jahr
1950 34 Jahre vergangen, also kamen wir eben-
falls der Zahl 35 nahe.

Soweit zur Geschichte. Ars Electronica, mit ihrer
Gründung im Jahr 1979 wohl das traditionsreich-
ste Medienfestival der Welt, kann im Jahr 2003
bereits wiederum an das historische Jahr 1984
anknüpfen: denn die Kinder, die im Orwell-Jahr
1984 geboren wurden, werden 2003, also in die-
sem Jahr, 19 Jahre alt. Orwells Kinder werden er-
wachsen. Wie sieht also jene Generation aus, die
1984 geboren worden ist?

Eine Studie über das Leben im Informationszeit-
alter (Forschungsinstitut der British American

Orwell's Children Are Growing Up

A festival which has devoted itself to topics re-
lated to the future for more than two decades
cannot get around one name in 2003: George
Orwell, who was born 100 years ago in Motihari,
India. Shortly before his death in 1950, George
Orwell wrote, as we all know, *1984*, the most
frequently cited novel on the future. In it he
paints a negative picture of a totalitarian state
under constant surveillance.

So when the year 1984 actually came round, the
most obvious thing for Ars Electronica to do was
to take up this scenario of the future. In view of
the many projects and events dealing with hor-
rifying scenarios in that Orwellian year, Ars Elec-
tronica chose to take a leap into the future, to
the year 2019. And there were two reasons why
we picked exactly that year: first of all, we re-
flected, children born in the Orwellian year of
1984 would be 35 years old in 2019, putting
them in political and financial positions of re-
sponsibility; and, secondly, 34 years had gone by
since George Orwell's death in 1950, again giving
us a number approaching 35.

So much for the past. In 2003, Ars Electronica,
which was founded in 1979 and is without a
doubt the media festival with the richest tradi-
tion in the world, has again succeeded in taking
up the historic year of 1984: for the children
born in the Orwellian year of 1984 are turning
nineteen this year. Orwell's children are growing
up. So what is this generation, born in 1984, like?
A study on life in the information age (by the
research institute of British-American Tobacco)
talks about the "generation @". The 13th Shell
Youth Study sees the world of today's children

Tabacco) spricht von „Generation @". Die 13. Shell-Jugendstudie sieht die Welt der heutigen Kinder und Jugendlichen gekennzeichnet durch einen zunehmend rascher werdenden Wandel der Familienformen, durch kleinere Familien, geringe Verbindung zwischen der Welt der Kinder und der Arbeitswelt der Eltern, vor allem aber durch eine Allgegenwart den Medien. Die Kinder sind von einer umfassenden Medienwelt umgeben. Die Imagination der Medienwelt tritt in Konkurrenz zur Realwelt.

Orwells Kinder leben heute weniger in der Familien-Szene, sondern in selbst geschaffenen Szenen, wie in der Musikszene, in der Sportszene, in der Subkultur, in der Neuen-Medien-Szene und sich ständig neu generierenden Szenen. Nach einer Untersuchung des Wiener Institutes für Jugendkulturforschung und Kulturvermittlung zählen quer durch die Szenen Spaß, Vertrauen, Verlässlichkeit. Darüber hinaus sind Freundschaft, Partnerschaft, Familienleben und Eigenverantwortung vorrangig. Im Technologiebereich steht nach wie vor Fernsehen an erster Stelle, allerdings eingebettet in Hi-Fi, PC, Handy, Internet, Sampling, Networking. Die Orwell-Kinder sind zu einer Netz-Generation geworden.

Das Kennzeichen Globalität ermöglicht durch den Tod der Entfernung die zunehmend punktgenaue Erreichbarkeit jedes Punktes auf dem Globus der industrialisierten Welt. Im Gegenzug wird immer stärker das Auseinanderklaffen greifbar, das durch die Zugangsmöglichkeit bzw. durch den Nicht-Zugang zu den weltweiten Netzen entsteht. Es geht heute nicht mehr um das Netz als Verbin-

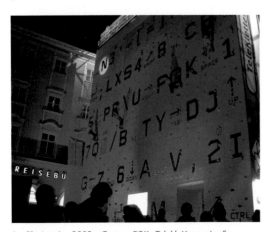

Ars Electronica 2003 – Gruppe FOK: „Teleklettergarten"

and young people as being marked by ever more rapidly changing family constellations, by smaller families, and frailer ties between the worlds of children and the working lives of parents, but above all by the ubiquity of the media. Children are surrounded by an all-encompassing media world. And the imagination of this media world has entered into competition with the real world.

Today it is no longer common for Orwell's children to live within a family scene, but within scenes created by them, such as a music scene, sports scene, subculture, new media scene, or new scenes that are constantly being generated. According to a study by the Vienna Institute for Youth Culture Research and Cultural Mediation, throughout these scenes it is fun, trust and reliability that count. Other priorities are friendship, partnership, family life and taking responsibility for oneself and one's actions. With regards to technology, television still comes first, though in combination with a hi-fi, PC, mobile phone, the Internet, sampling and networking. Orwell's children have become a net generation. By eliminating distances, globality makes it possible to reach every point on the globe of the industrial world with ever more precision. Conversely, the gap between those able to access worldwide networks and those not able to access them is becoming ever more glaring. It is no longer a matter of the net as a link from one computer to another, but of communication from each of us to the other, whether person or object, as well as communication from any one location to another, wireless there and wireless back. It is not technology that has top priority but the relationship between one person to another person that is all-important.

"Life goes mobile", Nokia's president Ala-Pietila's guiding principle, is no longer just an indication of the direction things are taking but has become their natural course. For the artist, especially for those whose works are directed towards interactivity, new design options are emerging.

Beyond the natural sciences, whether in engineering, medicine or in other disciplines, a reorientation of values is imminent, the challenge to build a "better world". Measured in terms of this task, justifiably set by every generation over and

dung von Computer zu Computer, sondern um die Kommunikation von jedem zu jedem, ob Mensch oder Gegenstand, sowie um die Kommunikation von überall zu überall, wireless und nochmals wireless. Nicht die Technologie steht im Vordergrund, sondern die Beziehung zwischen Person und Person ist entscheidend. „Life goes mobile", das Evangelium von Nokias Chef Ala-Pietila, ist nicht nur richtungsweisend, sondern in der Zwischenzeit eine Selbstverständlichkeit. Für die Künstler, insbesondere jene, deren Arbeiten interaktiv ausgerichtet sind, entstehen neue Gestaltungsmöglichkeiten. Über die Naturwissenschaft hinaus, ob in der Technik, in der Medizin oder in anderen Disziplinen, steht eine Neuorientierung der Werte bevor, die Herausforderung, eine „bessere Welt" zu bauen. Gemessen an dieser Forderung, die immer wieder und von jeder Generation mit Recht neu gestellt wird, sind die Fortschritte, selbst die der letzten Jahrzehnte, noch in keiner Weise zufriedenstellend, sondern angesichts der unendlichen Not in weiten Regionen der Erde erschreckend. Der Prix Ars Electronica spiegelt auch dieses Bild, von einzelnen Künstler in ihren Werken gezeichnet, wider. „Orwells Kinder" stellen heute bereits eine beträchtliche Anzahl von Teilnehmern beim Prix Ars Electronica, und alle Teilnehmer der Kategorie „cybergeneration – u19 freestyle computing" gehören dieser Generation an.

over again, progress, even of the last decades, is by no means satisfactory but, in face of the immense need to be found across vast areas of the earth, horrifying. The Prix Ars Electronica also reflects this situation, as illustrated by individual artists in their works.
Today "Orwell's children" make up a considerable number of the Prix Ars Electronica's entrants. The participants of the category "cybergeneration – u19 freestyle computing", on the other hand, all belong to this generation.

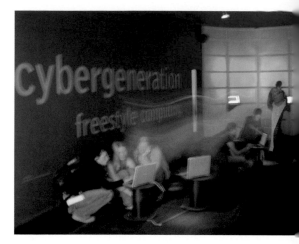

Ars Electronica 2003 – u19 freestyle computing

ARS ELECTRONICA 2004

25 Jahre Ars Electronica Linz
Medienkultur als Markenzeichen

Dem Leitthema „Kunst – Technologie – Gesellschaft", das Ars Electronica über all die Jahre beibehalten hat, wird in den kommenden Jahrzehnten noch verstärkte Bedeutung zukommen: Ars Electronica wird sich über IT hinaus den Innovationen von Biotechnologie bis Nanotechnologie zu stellen haben, aber auch Problemen rund um Themen wie Energie, Wasser oder Klimawandel, denn diese Bereiche werden unsere Gesellschaft im neuen Jahrtausend mit Radikalität und Vehemenz herausfordern. „Future historians will doubtless view this unfolding century as pivotal", schreibt Christopher Flavin, der Präsident des

Media Culture as a Trademark
25 Years of Ars Electronica in Linz

The festival's central theme of "Art – Technology – Society", which it has retained throughout the years, is certain to take on even greater importance in the next decades: in addition to innovations from IT, Ars Electronica will be confronted with those from fields like biotechnology and nanotechnology. Moreover it will have to cope with problems related to such issues as energy, water or the change of climate, for these areas are going to make radical and vigorous demands on our society in the next millennium. "Future historians will doubtless view this unfolding century as pivotal", Christopher Flavin, president

Worldwatch Institute in „The Future of Earth",
dem jüngsten *U.S. News & World Report*. „Perhaps
no generation has shaped the choices available to
its children and grandchildren as much as we will
during the decades ahead."

Der bisherigen IT-Entwicklung wird nach dem
Zusammenbruch der Dot-Coms eine „Next Econo-
my" folgen. Alan Greenspan, der Chef der US-
Notenbank, sieht neuerdings in der Ausbreitung
der modernen Telekommunikations-und Satelli-
tentechnik die treibende Kraft für die Verände-
rung der Wirtschaft.

Was heute entsteht, ist „eine vernetzte Wirt-
schaft mit einem elektronischen Nervensystem"
(Manuel Castells). Das Internet ist zum Rückgrat
dieser vernetzten Welt geworden. Wenn sich Ars
Electronica in den 1980er Jahren mit „Ubiquitous
Computing" befasst hat, ist jetzt die Umsetzung
in die Realität des Alltags im Gange, auch wenn
sich die Bezeichnungen verändert haben und
heute von „Seamless Computing" oder „Adaptive
Computing" die Rede ist. Die Computer verändern
unsere Kleider, unser Wohnen, unsere Autos, un-
ser Lernen – einfach alles. In der Industrie wird das
Schwergewicht der Veränderungen in den Pro-
duktionsketten und in den Geschäftsprozessen
über Unternehmens- und Ländergrenzen hinweg
zu suchen sein.

Die Globalisierung hat insbesondere durch die
Steuerungsmöglichkeiten des Internet einen nie
da gewesenen Schub erhalten. Wenn Historiker
die ersten Globalisierungsbestrebungen im China
des 7. Jahrhunderts v. Chr. ansetzen, so hat die
Globalisierung bis Ende der 70er Jahre des 20.
Jahrhunderts über Jahrhunderte nur langsam

Ars Electronica 2004 – Amanda Parkes, Hayes Raffles: „Topobo"

of Worldwatch Institute, wrote in "The Future
of Earth", the most recent *U.S. News & World
Report*. "Perhaps no generation has shaped the
choices available to its children and grandchildren
as much as we will during the decades ahead."
After the crash of dot-coms, IT development as we
know it will be followed by the "Next Economy".
Alan Greenspan, Chairman of the US Federal
Reserve Board, now sees the spread of modern
telecommunications and satellite technology as
the driving force for a change in the economy.
What is now emerging is "a networked economy
with an electronic nervous system" (Manuel
Castells). The Internet has become the backbone
of this networked world. While Ars Electronica
explored "ubiquitous computing" in the 1980s, its
implementation is today taking place in our daily
lives, and this is so even if the labels have changed
and we now talk of "seamless computing" or
"adaptive computing". Computers are changing
our clothes, our homes, our cars and our schools –
simply everything.
In industry, the main focus of such changes will
have to be sought in production chains and busi-
ness processes which transcend the boundaries
of companies and national borders. Due to the
possibilities of control offered by the Internet,
globalization has received an unprecedented
thrust forward. If, as historians assume, the first
efforts toward globalization occurred in China in
the 7th century B.C., then globalization increased
over the centuries only very gradually until the
late 1970s. From 1600 to 1979 there were approxi-
mately 8000 multinational corporations operat-
ing worldwide, from 1980 to 2000 – in other
words, during the two and a half decades of Ars
Electronica – the number has risen to 63,000
(Global Inc., New York). "In the future there will
be two kinds of corporations", says C. Michael
Armstrong, CEO of AT&T, "those that go global,
and those that go bankrupt."
Cultural globalization goes hand in hand with
economic globalization, especially via global
media like AOL Time Warner, Disney, Bertelsmann,
CNN and others. For art and culture this deve-
lopment opens up opportunities, yet these oppor-
tunities are counteracted, if not wrecked, by
immense dangers. For Ars Electronica a multitude
of controversial themes are going to present
themselves.

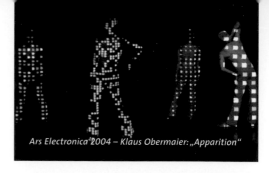

Ars Electronica 2004 – Klaus Obermaier: „Apparition"

zugenommen. Von 1600 bis 1979 gab es weltweit an die 8000 multinational operierende Unternehmen, von 1980 bis zum Jahr 2000 – also während der zweieinhalb Jahrzehnte von Ars Electronica – ist die Zahl auf 63.000 angestiegen (Global Inc. New York). „In the future there will be two kinds of corporations", sagt C. Michael Armstrong, CEO von AT&T, „those that go global, and those that go bankrupt."Mit der wirtschaftlichen Globalisierung geht die kulturelle Globalisierung Hand in Hand, insbesondere durch die globalen Medien wie AOL Time Warner, Disney, Bertelsmann, CNN und andere. Für Kunst und Kultur bedeutet diese Entwicklung zwar Chancen, allerdings werden diese Chancen von gewaltigen Gefahren konterkariert, wenn nicht zerstört. Für Ars Electronica wird sich ein weites Feld kontroversieller Themen eröffnen. Die Bilanz der Ars Electronica 2004 beweist deutlich, dass das Ziel der 1970er Jahre, mit einer über die Grenzen des Landes hinaus reichenden Kulturveranstaltung zu einem neuen Profil der Stadt Linz beizutragen, erreicht werden konnte. Linz konnte sich in dieser Zeit einen spezifischen Platz auf der globalen Kulturkarte sichern, der der zukunftsorientierten Stadt ein Alleinstellungsmerkmal und damit einen Standortvorteil verschafft. Die Herausforderung wird darin liegen, mit der neuen Geschwindigkeit im Wettbewerb Schritt zu halten, und zwar sowohl mit starken Ideen als auch mit entsprechenden Budgetmitteln.

In 2004 Ars Electronica's balance clearly demonstrates that the goal set in the 1970s – to contribute to a new image for Linz by organizing a cultural event that would have an impact outside the region – has been achieved. Over the years, Linz has been able to secure itself a certain position on the global map of culture, and this has given this future-oriented city a quality of its own and hence a bonus as a location. Within 25 years, the City of Linz has made the leap into the 21st century, not only in years, but also in how it has changed its conception of itself. This iron-and-steel town, once marked by environmental problems, has become a modern industrial city and a technology-oriented town of culture. Ars Electronica and the Linz *Klangwolke* have not only accompanied this process for more than two decades, but have been catalysts and provided impetus for the transformation of the city's image and the development of a new identity. The challenge will now be to keep pace with the new speed of competition by contributing powerful ideas and the necessary funds.

Ars Electronica 2004 – James Auger, Jimmy Loizeau, Stefan Agamanolis: „Iso-phone"

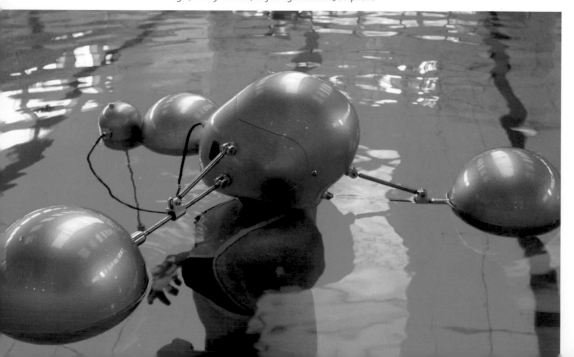

Die Texte sind folgenden Publikationen entnommen:
The texts come from the following publications:

Linzer Veranstaltungsgesellschaft (Hrsg.): Ars Electronica 1979 im Rahmen des Internationalen Brucknerfestes 79, Linz 1979, S. 5

Linzer Veranstaltungsgesellschaft (Hrsg.): Ars Electronica 1980 im Rahmen des Internationalen Brucknerfestes 80, Linz 1980, S. 6ff

Linzer Veranstaltungsgesellschaft (Hrsg.): Ars Electronica im Rahmen des Internationalen Brucknerfestes Linz, Festival für Kunst, Technologie und Gesellschaft 1982, Linz 1982, S. 6ff

Linzer Veranstaltungsgesellschaft (Hrsg.): Ars Electronica im Rahmen des Internationalen Brucknerfestes Linz, Festival für Kunst, Technologie und Gesellschaft 1984, Linz 1984, S. 9ff

Österreichischer Rundfunk ORF, Landesstudio Oberösterreich (Hrsg.): Computerkulturtage Linz – ORF-Videonale 86, Linz 1986, S. 5ff

Leopoldseder, Hannes (Hrsg.): Prix Ars Electronica, Meisterwerke der Computerkunst, Edition 87, Verlag H.S.Sauer, Worpswede, S. 1ff

Leopoldseder, Hannes (Hrsg.): Prix Ars Electronica, Meisterwerke der Computerkunst, Edition 88, TMS-Verlag, Bremen, S. 9ff

Gerbel, Karl/Leopoldseder, Hannes (Hrsg.): Die Ars Electronica. Kunst im Zeitsprung, Landesverlag Linz 1989, S. 11ff

Leopoldseder, Hannes (Hrsg.): Der Prix Ars Electronica. Internationales Kompendium der Computerkünste, Veritas Verlag, Linz 1990, S. 8ff

Leopoldseder, Hannes (Hrsg.): Der Prix Ars Electronica. Internationales Kompendium der Computerkünste, Veritas Verlag Linz, 1991, S. 6ff

Leopoldseder, Hannes (Hrsg.): Der Prix Ars Electronica. Internationales Kompendium der Computerkünste, Veritas Verlag, Linz 1992, S. 6ff

Leopoldseder, Hannes (Hrsg.): Der Prix Ars Electronica. Internationales Kompendium der Computerkünste, Veritas Verlag, Linz 1993, S. 6ff

Leopoldseder, Hannes (Hrsg.): Der Prix Ars Electronica. Internationales Kompendium der Computerkünste, Veritas Verlag, Linz 1994, S. 6ff

Leopoldseder, Hannes/Schöpf, Christine (Hrsg.): Der Prix Ars Electronica. Internationales Kompendium der Computerkünste, Österreichischer Rundfunk (ORF), Landesstudio Oberösterreich, Linz 1995, S. 7ff

Janko, Siegbert/Leopoldseder, Hannes/Stocker, Gerfried (Hrsg.): Ars Electronica Center. Museum der Zukunft, Linz 1996, S. 34ff

Leopoldseder, Hannes /Schöpf, Christine (Hrsg.): Der Prix Ars Electronica. Internationales Kompendium der Computerkünste, Springer Wien – New York 1996, S. 11ff

Leopoldseder, Hannes / Schöpf, Christine (Hrsg.): CyberArts. International Compendium. Prix Ars Electronica. Springer Wien – New York 1997, S. 6ff

Leopoldseder, Hannes / Schöpf, Christine (Hrsg.): CyberArts 98. International Compendium. Prix Ars Electronica. Springer Wien – New York, 1998, S. 8ff

Leopoldseder, Hannes/Schöpf, Christine (Hrsg.): CyberArts 99. International Compendium. Prix Ars Electronica. Springer Wien – New York, 1999, S. 8ff

Leopoldseder, Hannes/Schöpf, Christine (Hrsg.): CyberArts 2000. International Compendium. Prix Ars Electronica. Springer Wien – New York, 2000, S. 8ff

Leopoldseder, Hannes/Schöpf, Christine (Hrsg.): CyberArts 2001. International Compendium. Prix Ars Electronica. Springer Wien – New York, 2001, S. 9ff

Leopoldseder, Hannes/Schöpf, Christine (Hrsg.): CyberArts 2002. International Compendium. Prix Ars Electronica 2002. Hatje Cantz – Ostfildern-Ruit, 2002, S. 11ff

Leopoldseder, Hannes/Schöpf, Christine (Hrsg.): CyberArts 2003. International Compendium. Prix Ars Electronica 2003. Hatje Cantz – Ostfildern-Ruit, 2003, S. 11ff

Leopoldseder, Hannes/Schöpf, Christine/Stocker, Gerfried (Hrsg.): CyberArts 2004. International Compendium. Prix Ars Electronica 2004. Hatje Cantz – Ostfildern-Ruit, 2004, S. 11ff

Wolfgang Winkler/Wolfgang Lehner

Linzer Klangwolke

Anfangs der 70er spielte sich Kultur in Österreich in Wien und im Sommer in Salzburg, den Fremdenverkehr fördernd, ab. In Graz rumorte der Steirische Herbst in seinen Anfängen, und in Linz gab es den Willen, zu einem eigenen kulturellen Image zu kommen: Forum Metall, geplante Gründung der Universität, Kunsthochschule u. a. m. Das Brucknerhaus war 1974 ein weiterer wichtiger Schritt in diese Richtung, das Brucknerfest ein erster Schritt der Eigendefinition der Stadt in Sachen Kultur zwischen Wien und Salzburg. Das Werk Bruckners ist allerdings nicht annähernd in ähnlicher Weise „ausbeutbar" wie das Mozarts, sodass Ars Electronica, das Festival zwischen „Kunst und Technologie", wie die Erstdefinition lautete, Entscheidendes ändern sollte. 1979 war der PC ein für breite Kreise der Bevölkerung unbekanntes Gerät und die Kultur, die sich aus diesem Gerät entwickeln würde, die Sache von wenigen Utopisten. Abgesehen von grundsätzlicher, erster Neugierde konnte ein Festival, das sich mit diesen Utopien befasste, mit umfassendem Unverständnis seitens der Bevölkerung rechnen. Es galt also ein Ereignis zu planen, das breite Kreise ansprach und so zur Einstiegsdroge in die Computerwelt werden sollte, gleichzeitig aber die Verbindung zu traditionellem Kulturverständnis, wie es im Brucknerfest dieser Zeit symbolisiert war, herzustellen.

Das Modell Klangwolke (Walter Haupt, Hannes Leopoldseder) entsprach für das Brucknerhaus , das Festival Ars Electronica und letztlich für Stadt und Land in mehrfacher Hinsicht den strategischen Anforderungen.

Die Verwendung von Bruckners Musik brachte eine heftige, aber wichtige und zukunftsweisende Diskussion über Fragen der Demokratisierbarkeit von klassischer Musik in Gang. Die Empörung des Kulturbürgertums über die Entweihung von Bruckner durch das Abspielen seiner Musik im freien Raum vor „Jedermann" musste der Erkenntnis weichen, dass Musik nicht Ornament einer bestimmten Bevölkerungsschicht sein kann.

In the early '70s, cultural life in Austria was played out in Vienna, and during the summer in Salzburg as a means of fostering tourism. In Graz, rumors of a nascent *Steirische Herbst* were making the rounds. And in Linz, the city aspired to create a distinct image of its own: *Forum Metall*, plans were afoot to found the university, the art institute and much more. The Brucknerhaus, established in 1974, was a further step in this direction; the Bruckner Festival a first step in the city's process of self-definition in matters of culture between Vienna and Salzburg. Indeed, the "exploitability" of Bruckner's oeuvre does not even come close to that of Mozart's, so that Ars Electronica - the festival at the nexus of "art and technology" as the original definition put it —would ultimately have a decisive impact.

The PC was an unfamiliar contraption for most segments of the population in 1979, and the culture that would develop out of this device was then the concern of a handful of utopians. Aside from basic, initial curiosity expressed by the general populace, a festival dealing with these utopias could certainly expect to encounter thoroughgoing incomprehension on the part of the public. Thus, the challenge was to plan an event that would appeal to a broad spectrum of society and entice many of them to get more intensively involved in the world of computers, but at the same time to establish a linkage to a traditional understanding of culture, as embodied at this time by the Bruck-ner Festival.

The model of the *Klangwolke* developed by Walter Haupt and Hannes Leopoldseder was, for the Brucknerhaus, the Ars Electronica Festival

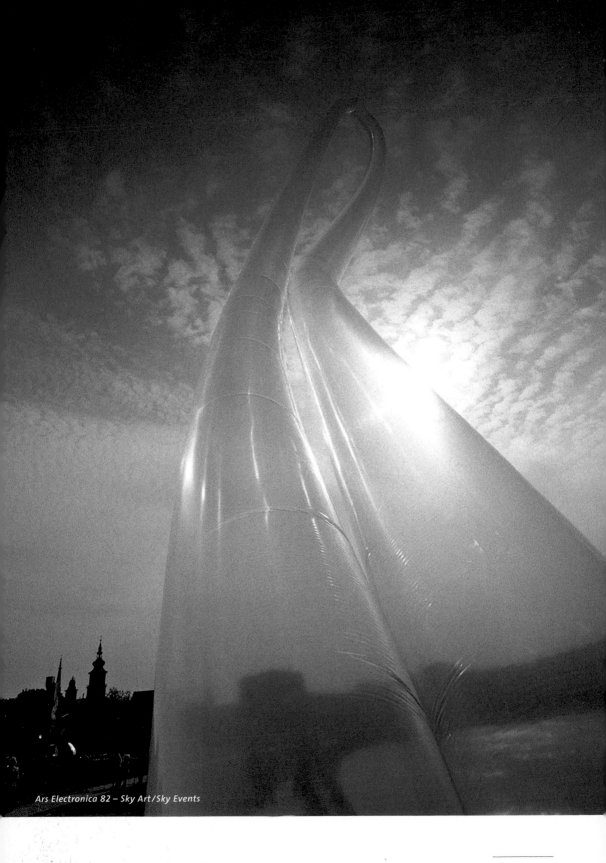

Ars Electronica 82 – Sky Art/Sky Events

Ein Minimum von rund 15 000 Zuhörern, die still der Musik bei der klassischen und in keiner Form visualisierten Klangwolke lauschten, ist deutlicher Beweis. Eine wichtige Erkenntnis für die programmatische Arbeit des Brucknerhauses für die Zukunft. Der Paradigmenwechsel im Kulturverhalten der Gesellschaft, wie er in diesen Tagen überall stattfindet, deutete sich hier bereits an.

Aus dem optischen Zeichen des Jahres 79, dem Ballon, entwickelte sich die visualisierte Klangwolke. Sie war und ist Experimentierfeld für die gestalterische Bewältigung des faszinierenden, großen Donauraumes. Haupt, Hoffer, Curran, Zykan, Baumgartner, Isao Tomita, Peter Wolf, Gulda, Spour und Obermaier sind Namen, die für diesen Weg stehen. Auslotung des Raumes, technische Klangentwicklung im freien Raum durch den Partner ORF in beispielgebender Weise, Entwicklung neuerer Präsentationsformen von Musik kennzeichnen diesen Weg. 1998 kam die Kinderklangwolke, ein Mitmach-Modell, hinzu.

Der Rhythmus des Festivals Ars Electronica änderte sich im Laufe seiner Geschichte: Es wurde zweijährig vor dem Sommer veranstaltet und kam schließlich wieder in den Herbst, vor das Brucknerfest, zurück. Die Klangwolke blieb immer am Be-

and, ultimately the City of Linz and the Province of Upper Austria, a satisfactory response to these challenges in several respects.

The use of Bruckner's music triggered a discussion about the "democratizability" of classical music which was extremely heated, but also tremendously significant, and one which pointed the way to the future.

The indignant reaction of the culturally elitist haute bourgeoisie to the profanation of Bruckner through the act of playing his music at open-air concerts for Everyman was forced to yield to the understanding that music cannot be the ornament of a certain class of society. Attesting to this was the presence of at least 15,000 concert-goers who attentively listened to the music of this classical *Klangwolke* unaccompanied by any visualized form whatsoever. This was an important insight for the programmatic work of the Brucknerhaus for the future. The paradigm shift in society's cultural behavior, which was ubiquitous in those days, had already begun to make itself evident here.

From out of the optical symbol of the year 1979, the balloon, there developed the visual *Klangwolke*. It was an experimental domain to bring

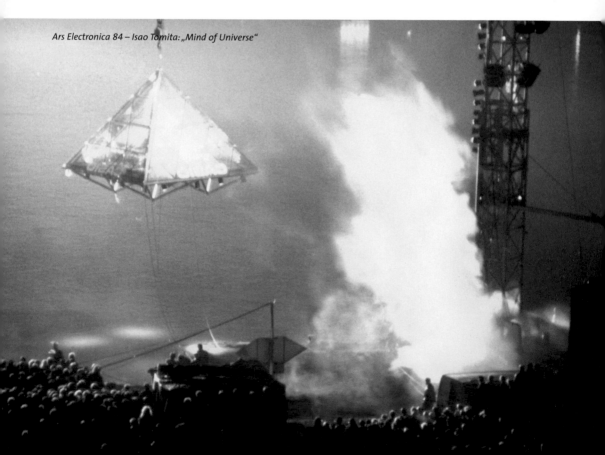

Ars Electronica 84 – Isao Tomita: „Mind of Universe"

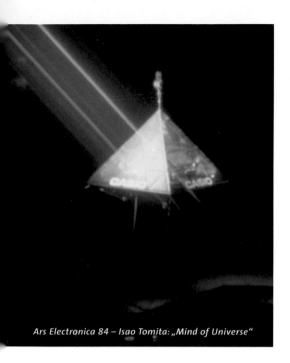

Ars Electronica 84 – Isao Tomita: „Mind of Universe"

creativity to bear on the process of coming to terms with the fascinating Danube region, and remains so to this day. Haupt, Hoffer, Curran, Zykan, Baumgartner, Isao Tomita, Peter Wolf, Gulda, Spour and Obermair are names that stand for this course. Plumbing the depths of space, the exemplary technical tonal generation in an open-air venue courtesy of our associates from the Austrian Broadcasting Corporation, and the development of new forms of presenting music are characteristic features of this course.

In 1998, we added a *Klangwolke* for kids, to enable young people to take part and play along. The rhythm of the Ars Electronica Festival has changed over the course of its history. For two years, it was staged during the summer before finally returning to fall, prior to the Bruckner Festival. The *Klangwolke* has always come at the beginning of the Bruckner Festival—at times, separating itself from Ars Electronica, but always remaining a part of the Festival. The question of who stages the *Klangwolke*, to whom the *Klangwolke* is to be attributed, is almost always answered with Ars Electronica. The *Klangwolke* has become a symbol of the cultural life of Upper Austria and one of the definitive cultural landmarks of the City of Linz.

The Brucknerhaus and Ars Electronica have been managed separately since 1996. The *Klangwolke* remains an important link connecting the two institutions which shared a common history up to that point. In 1998, this collaboration was reinitiated. The visual *Klangwolke* kicks off the festival month of September that includes Ars Electronica, the Brucknerfest, the *Klangwolke*, galleries, the Posthof and the Kinderkulturzentrum—thus, focusing the creativity of our region and launching a new festival format for Linz and Upper Austria.

If Linz is to be able to rightly make the claim of having a distinct cultural profile among European cities, then this image is well to be based on the astute networking of it's facilities and institutions: Brucknerhaus, Ars Electronica, *Klangwolke*, Lentos Kunstmuseum Linz, O.K Center for Contemporary Art and other important institutions. The Danube region surrounding Linz as a cultural space with the *Klangwolke* as its common symbol.

ginn des Brucknerfestes, löste sich zeitweise von der Ars und blieb doch immer ein Teil des Festivals Ars Electronica. Die Frage, wer die Klangwolke veranstaltet, wem man die Klangwolke zurechnen kann, wird nahezu immer mit Ars Electronica beantwortet.

Die Klangwolke wurde zum Symbol der Kultur in Oberösterreich und zum Wahrzeichen der Stadt Linz. Brucknerhaus und Ars Electronica trennten sich 1996. Die Klangwolke blieb ein wichtiges Verbindungsglied der beiden Institutionen, die eine bis dahin gemeinsame Geschichte hatten. 1998 wurde diese Gemeinsamkeit neu begründet. Die visualisierte Klangwolke eröffnet den Festmonat September, der Ars Electronica, Brucknerfest, Klangwolke, Galerien, Posthof, Kinderkulturzentrum umfasst, also einen Fokus der Kreativität des Landes darstellt und ein für Linz und Oberösterreich neues Festspielformat begründet.

Wenn Linz in Anspruch nehmen kann, dass es ein eigenes kulturelles Profil im Konzert der europäischen Städte hat, so beruht dieses Image auf der sinnhaften Vernetzung seiner Möglichkeiten: Brucknerhaus, Ars Electronica, Klangwolke, Lentos Kunstmuseum Linz, O.K Centrum für Gegenwartskunst und anderen wichtigen Institutionen. Der Donauraum in Linz als Kulturraum mit der Klangwolke als gemeinsamem Symbol.

Siegbert Janko

The Spirit of Linz

Von der Stahlstadt zur Kulturstadt

Die Stadt war immer der Ort vielfältigster Kommunikation in allen Lebensbereichen, von der Wirtschaft bis zur Kultur. Im Prozess des Überganges von der Industriegesellschaft zur Informationsgesellschaft, Dienstleistungsgesellschaft oder Wissenschaftsgesellschaft kommt ihr eine Schlüsselrolle zu. In den Städten prallen die Widersprüche am deutlichsten aufeinander. Die Informationsgesellschaft mit ihren Möglichkeiten der Dezentralisierung wird Einfluss auf die neuen Strukturen und auch auf die Größe der Stadt haben. Aber in der Stadt, an dieser mehrtausendjährigen Ausprägung von Zivilisation, wird sich entscheiden, ob technologische Innovationen dauerhaft in Einklang gebracht werden können mit sozialem und kulturellem Verhalten, ohne dass es zu dauerhaften, nicht lösbaren Konflikten kommt. Mehr denn je ist die Kunst Begleiterin dieser Prozesse. Keine andere österreichische Stadt hat einen so dramatischen ökonomischen, sozialen und demografischen Wandel im 20. Jahrhundert vollzogen wie Linz. Jahrzehntelang wurde das Image der Stadt fast ausschließlich von der Großindustrie bestimmt. Linz war 40 Jahre lang das Herz der österreichischen Stahlindustrie – die Stahlstadt. Prägend für Linz war schon am Beginn des 20. Jahrhunderts zum einen die soziale und räumliche Öffnung im Rahmen kultureller Veranstaltungen, zum anderen die Aufgeschlossenheit gegenüber modernen Technologien. Von beiden Bereichen aus führen direkte Traditionslinien bis in die Gegenwart.

Gegen Ende der Zwanziger- und zu Beginn der Dreißigerjahre des 20. Jahrhunderts wurden kulturelle Großveranstaltungen in Linz durchgeführt, die wohl als Vorläufer für die Prinzipien „Kultur im offenen Raum" und „Interdisziplinarität" gelten können. Als ein Beispiel ist das monumentale Weihefestspiel „Die Flammen der Nacht" zu nennen, das 1928 mit über tausend Mitwirkenden an Fabriks- und Schiffssirenen aufgeführt wurde. Dieses Projekt kann als erste Linzer Klangwolke bezeichnet werden.

Der zweite Hinweis betrifft den Bereich Kultur

From Steeltown to City of Culture

In all areas of life, from the economy to the arts, the city has always been the place with the most varied forms of communication, and has played a key role in the process of transition from the industrial society to the information society, service society or scientific society. It is in the cities that the clashing of contradictions is most apparent. Information Society with its possibilities of decentralization will influence the new structures and the size of the city. Yet it is in the city, in this form of civilization that has taken over several centuries to shape, that we will see whether technological innovations can be permanently brought into harmony with social and cultural behavior, without giving rise to lasting, insoluble conflicts. More than ever, art accompanies such processes.

No other Austrian city has undergone such a dramatic economic, social and demographic change in the 20th century as Linz. For many decades the city's image was almost exclusively dependent on heavy industry, and Linz was the heart of the Austrian steel industry for 40 years —the Steeltown.

Characteristic of early 20th-century Linz was, on one hand, the city's social and spatial opening within the framework of cultural events and, on the other hand, its openness to modern technologies. Direct lines of tradition reach from both fields up to the present day.

The big cultural events that were held in Linz in the late 1920s and early 1930s can be regarded as the precursors of the principles of "culture in public places" and "interdisciplinarity." The monumental inauguration festival, *Die Flammen der Nacht* (The Flames of the Night), which took place in 1928 with more than a thousand participants sounding factory and ships' sirens in Linz, serves as an example. This project can be described as the first Linz *Klangwolke*. It can be seen as the precursor of big modern interdisci-

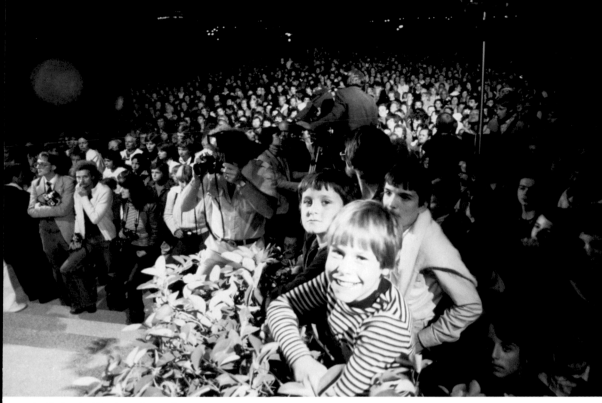

Ars Electronica 79 – Linzer Klangwolke

und moderne Technologie bzw. Kommunikation. Linzer Radiovereine waren in der Ersten Republik bei der Einführung und Verbreitung des Rundfunks sehr engagiert und innovativ beteiligt. 1928 ging ein eigener Linzer Sender am Freinberg in Betrieb und im Jahr darauf eine Radio-Schule. Beide eben genannten Ansätze wurden von den Nationalsozialisten nach der Machtübernahme 1938 aufgenommen und für ihre eigenen Zwecke instrumentalisiert.

1945 ergab sich somit für die weitere Kulturentwicklung eine ambivalente Situation. Zum einen drohte nach den „enormen Ansprüchen" während der NS-Zeit erneut der Rückfall von der privilegierten „Führerstadt" in die Provinzialität. Andererseits ging es um die klare Abgrenzung gegenüber der nationalsozialistischen Ideologie und Kulturpraxis.

In der Kulturpolitik nach 1945 war es der erklärte Wille der politisch Verantwortlichen, deutliche Signale zu setzen. Die Gründung der Volkshochschule, der Neuen Galerie, der städtischen Kunstschule und der städtischen Büchereien zeigt die – auch überregional stark beachtete – kulturpolitische Linie, die hinter den damaligen Entscheidungen stand. Es war der Versuch, verbunden mit der

plinary projects and stands for the democratization of the cultural enterprise.

The second reference applies to the fields of culture and modern technology and communications. Linz radio clubs were very actively and innovatively involved in the introduction and spread of radio in the First Republic. Linz's own radio station at Freinberg was started up in 1928 and followed by a radio school a year later. Both of the aforementioned initiatives were taken over by the National Socialists after they assumed power and used for their own purposes.

In 1945 the future development of culture was faced with an ambivalent situation. On one hand, there was the danger of relapsing into provincialism after the privileged "Führer City" era and the "high expectations" during the Nazi period; on the other hand, it was a case of clear dissociation from National Socialist ideology and culture.

It was the declared will of those entrusted with political responsibility to blaze a new trail in cultural policymaking after 1945. The founding of adult education centers, the Neue Galerie, the city's school of arts and libraries shows the cultural policy direction—which also aroused

kulturpolitischen Zielsetzung, dem Kulturkonservativismus und der Herrschaftsideologie des Nationalsozialismus mit einer Phase künstlerischer Öffnung und kultureller Modernisierung zu antworten.

Symbiose von Industrie und Kultur

In den vergangenen Jahrzehnten hat der Kulturbegriff eine tief greifende Änderung erfahren. Mit seiner Dynamisierung änderte sich auch das Verhältnis von Arbeitswelt und Kultur. Kunst und Kultur haben den elfenbeinernen Turm verlassen; sie sind zu einer sozialen Notwendigkeit für unser Zusammenleben und zu einem integralen Bestandteil aller Lebensbereiche geworden. In diese Phase fällt auch der grundlegende gesellschaftliche und technische Wandel, der sich mit dem Fortschreiten von der Industriegesellschaft zur postindustriellen und zur Informationsgesellschaft vollzogen hat. Attraktivität und Lebensqualität einer Stadt werden in der Zukunft weit stärker daran gemessen, ob sie ausreichend Raum bieten für kulturelle und soziale Experimente, für Kreativität, Innovation und Begegnung. Die kommunale Kulturpolitik darf sich dabei nicht „nur" auf den Bau und Betrieb von Kultureinrichtungen und die unmittelbaren Kulturpflege beschränken, sondern muss umfassend an der Gestaltung einer menschen- und umweltfreundlichen, einer kulturellen Stadt, mitwirken und Raum für Experiment und Neues schaffen.

In Linz wurden dieser Wandel und die Suche nach neuen Perspektiven immer wieder von signifikanten kulturellen und künstlerischen Projekten begleitet. Die permanente Einbindung der Künstler und Kulturschaffenden in den Entwicklungsprozess hat sehr wesentlich das Denken und das

considerable interest beyond regional borders — behind the decisions made at this time. This was an effort made in connection with cultural policy aimed at countering cultural conservatism and the Nazis' ideology of domination with a phase of artistic openness and cultural modernization.

The Symbiosis of Industry and Culture

The concept of culture has undergone a radical change in the past few decades. As it became more dynamic, the relationship between the working world and culture also changed. Art and culture have left the ivory tower and become a social necessity of our co-existence and an integral part of all spheres of life. The radical social and technical change that took place during the shift away from Industrial Society towards the Post-Industrial and Information Society also fell in this phase.

In the future, a city's attractiveness and the quality of life there will depend more and more on whether it offers sufficient space for cultural and social experiments, for creativity, innovation and encounters. But in pursuing this goal, municipal cultural policymaking cannot restrict itself to "only" building and operating cultural facilities and directly nurturing and subsidizing cultural events; it must also cooperate in a comprehensive effort to create an environmentally friendly city that caters to human needs, a cultural city, and a space for experiment and innovation.

In Linz, this process of transformation and the search for new perspectives have repeatedly been accompanied by significant cultural and artistic projects. The constant involvement of

Ars Electronica 80 – Giorgio Battistelli: „Linzer Stahloper" (Oskar Czerwenka als Tubalkain)

Ars Electronica 80 – Mach-mit-Konzert am Linzer Hauptplatz – Musica Creativa (Walter Haupt)
von l.n.r.: Horst Schender, Karl Grünner, Franz Hillinger, Hugo Schanovsky, Fred Sinowatz

geistig offene Klima in der Stadt motiviert. Heute setzt Linz auf die enge Verzahnung von moderner Technologie und offener Kultur. In beiden Bereichen hat sich die Stadt führend positioniert. Kultur und Industrie stehen durchaus gleichwertig nebeneinander. Es gibt enge Vernetzungen und Symbiosen zwischen Industrie und Kultur und gerade diese Symbiosen prägen das Image der Stadt und führten mit dem Ars Electronica Center zur international anerkannten Poleposition in Bezug auf Neue Technologien.

Pionierleistung für Computerkunst

Durch die Errichtung des Ars Electronica Center konzentrierte die Stadt ihre Ressourcen im Bereich von Kunst, Technologie, Wissenschaft und Wirtschaft und setzte ein Signal in Richtung Kommunikation und Kooperation zwischen diesen zukunftsträchtigen Faktoren.

Das Festival Ars Electronica war bei seiner Gründung 1979 weltweit das erste Festival auf dem Gebiet Kunst, Technologie und Gesellschaft. Linz hat in diesem Spektrum einer neuen Technik- und Kunstgesellschaft Pionierarbeit geleistet.

Das Festival Ars Electronica initiiert und gestaltet seit 25 Jahren eine spannende Auseinandersetzung mit Zukunftstechnologien. WissenschaftlerInnen, TechnikerInnen und KünstlerInnen aus

artists and culturally creative individuals in the development process of the city has greatly motivated the ideas and the intellectually open climate to be found here.

Today, Linz sets great store in tightly interweaving modern technology and open culture. The city holds a leading position in both fields. Culture and industry stand side by side as definite equals. There exist tightly woven networks and a functional symbiosis linking industry and culture, and it is precisely this symbiosis that characterizes the image of the city and, with the Ars Electronica Center, has placed it in an internationally recognized pole position in matters of new technology.

A Pioneering Feat for Computer Art

With the opening of the Ars Electronica Center, the city concentrated its resources in the fields of art, technology, science and business, and blazed a trail in the direction of communication and co-operation between these fields of such great promise for the future.

Back in 1979, the Ars Electronica Festival represented the world's first festival of art, technology and society. Linz has achieved a great feat of pioneering work in this spectrum of a new technological and artistic society.

Ars Electronica 98 – Fadi Dorninger: „Ridin' A Train"

aller Welt haben von Linz aus immer wieder versucht, künstlerische und technologische Abenteuer und Visionen der Zukunft zu erkunden sowie Trends aufzuspüren oder sie zu bestimmen.
Der Prix Ars Electronica, der vom ORF-Landesstudio Oberösterreich seit 1987 durchgeführt wird, ist weltweit einer der wichtigsten Preise für Computerkunst; gleichsam der „Oscar für Computerkunst". Ars Electronica und der Prix Ars Electronica haben gemeinsam mit einer sehr dynamischen und experimentierfreudigen kulturellen und künstlerischen Szene in Linz ein Klima der Innovation auch für Wirtschaft und Industrie geschaffen. Ein weiterer entscheidender Schritt wurde 1996 mit der Errichtung des Ars Electronica Center – Museum der Zukunft getan. Ein permanentes Vermittlungszentrum und Forschungslabor für die unterschiedlichsten Bereiche neuer Medien und Informationstechnologien wurde geschaffen. Ars Electronica und Ars Electronica Center bündeln und vernetzen regionale Kompetenzen und Ressourcen in den Bereichen Kunst, Technologie, Wissenschaft und Wirtschaft. Sie sind ein Wahrzeichen für die Zukunftsorientierung und Innovationskraft von Linz, Oberösterreich und Österreich; ein Signal für den Aufbruch ins 21. Jahrhundert.

Grundsätze städtischer Kulturpolitik

Städtische Kulturpolitik schafft auch die Rahmenbedingungen für die Existenz und die Entfaltung des kulturellen und künstlerischen Lebens in einer Stadt.
Die Qualität des kulturellen Angebots wird in Zukunft mehr als bisher zu einem entscheidenden Faktor für Lebensqualität und Zufriedenheit der BürgerInnen und Kriterium der Positionie-

For 25 years the Ars Electronica Festival has been initiating and hosting a fascinating encounter with technologies that have great future promise. Scientists, technicians and artists come to Linz from all over the world to undertake artistic and technological adventures, to investigate visions of the future and to analyze trends. The Prix Ars Electronica, conducted by the Austrian Broadcasting Corporation's Upper Austria regional studio since 1987, is one of the most important prizes for computer art in the world —what amounts to the "Oscar for computer art." Ars Electronica and the Prix Ars Electronica, together with an extremely dynamic and experimental cultural and artistic scene in Linz, have created a climate of innovation for business and industry as well.
A further decisive step was taken in 1996 with the opening of the Ars Electronica Center— Museum of the Future. The result was the creation of a laboratory for research into the entire spectrum of new media and information technologies as well as a permanent center for mediating the encounter with them. Ars Electronica and the Ars Electronica Center assemble and disseminate regional expertise and resources in technological, scientific and commercial sectors. They are hallmarks of the innovative strength of Linz, the region of Upper Austria and Austria as a whole. They signal a new spirit for the 21st century.

Principles of Urban Cultural Policy

Urban cultural policy also creates the basic conditions for the existence and the unfolding of the cultural and artistic life in a city. The con-

rung und der Standortqualität im europäischen Städtevergleich sein.

Mit dem Bau des Brucknerhauses wurde im Jahr 1974 der Grundstein zur Linzer Kulturmeile an der Donau geschaffen, die 30 Jahre später mit dem Bau des Kunstmuseums Lentos zu einer Kulturachse von internationalem Format geworden ist: Die hohe künstlerische Qualität der Sammlung der Neuen Galerie und das offene Klima für zeitgenössische Kunst hat die Linzer Kulturpolitik motiviert ein neues, angemessenes Gebäude zu schaffen.

Mit der Errichtung und Inbetriebnahme des Kunstmuseums Lentos verbessert und erweitert Linz am Beginn des 21. Jahrhunderts sein kulturelles Angebot in außergewöhnlicher Art und Weise. Dank seiner Architektur, seines Inhalts und seiner Aktivitäten hat das Lentos die Chance, sich bei aller programmatischen Flexibilität, die in Zukunft voraussichtlich noch mehr gefordert sein wird als heute, als spezifische Konstante mit Qualitätsanspruch zu etablieren. Mit dem Lentos wurde ein neuer Maßstab für Architektur, Inhalt und Programm eines zeitgemäßen Kunstmuseums geschaffen.

Vom Ars Electronica Center mit der angrenzenden Stadtwerkstatt sowie dem nördlichen Donauufer als Kulturgelände, über die Nibelungenbrücke zur Kunstuniversität (vielleicht bald in beiden Brückenkopfgebäuden), zum neuen Lentos Kunstmuseum Linz, dem Forum Metall bis zum Brucknerhaus, dem Musikpavillon und dem Bereich der Architekturjuwele Parkbad, Austria Tabak Werke und Schlachthof – mitten in Linz besteht damit einer der attraktivsten und modernsten urbanen Kulturbereiche. Die Gestaltung und „Bespielung" eines derartigen Areals bedeutet zweifellos eine

struction of the Brucknerhaus in 1974 laid the cornerstone for Linz's cultural mile on the banks of the Danube, which, with the addition of the new Lentos Museum of Art 30 years later, has become a world-class cultural axis.

The high artistic quality of the collection of the Neue Galerie Linz and the open climate for contemporary art motivated Linz cultural policy-makers to create a new and more appropriate building to house the collection. The construction and opening of the Lentos Museum of Art at the outset of the 21st century has enhanced and expanded cultural life in Linz in an extraordinary and munificent way. Thanks to its architecture, its content and its activities, Lentos has the chance—in light of all the programmatic flexibility that may well be anticipated to be even more in demand in the future than it is today—to establish itself as a specific constant in the pursuit of excellence. The construction of the Lentos has set a new standard for a state-of-the-art art museum's architecture, content and program.

It extends from the Ars Electronica Center and the adjacent Stadtwerkstatt as well as the north bank as a cultural quarter, across the Nibelungen Bridge to the University of Art (which will perhaps soon occupy both buildings on the south side of the bridge), to Linz's new Lentos Museum of Art, the Forum Metall, the Brucknerhaus, the Musikpavillon and the adjoining neighborhood containing three architectural jewels: the Parkbad, the Austria Tabak Works and the Schlachthof. Thus, an extremely attractive and modern urban cultural zone has emerged right in the middle of

Ars Electronica Center

Ars Electronica 97 – Stadtwerkstatt: „Autodrom"

Ars Electronica 96 – Stadtwerkstatt: „Glasfieber"

städteplanerische, raumordnungsmäßige, soziale und kulturpolitische Innovation ersten Ranges. Neben den Kultureinrichtungen der öffentlichen Träger Stadt und Land gibt es in Linz eine Vielzahl und Vielfalt von kulturellen Gruppen und Initiativen. Die so genannte freie Kulturszene reicht von „alternativen" Kultureinrichtungen bis hin zu kleinen, selbstständig arbeitenden künstlerischen Teams. Die städtische Förderung folgt dem Grundsatz einer „Anstiftung zur Initiative". Ziel ist es, die Voraussetzungen für eine auf Eigeninitiative, Kreativität und Qualität basierende Kulturarbeit und Kunstproduktion zu schaffen. Die Devise lautet: Freiräume öffnen und verfügbar machen. Künstlerisches Experiment und künstlerischer Freiraum sollen Motor der Gesellschaft sein. Vieles davon ist Vision und Ziel, es sind jedenfalls dezidierte im Kulturentwicklungsplan (KEP) festgeschriebene Grundsätze städtischer Kulturpolitik. Es muss daher das Ziel sein, die Strukturen und Rahmenbedingungen in den öffentlichen Kultureinrichtungen so weiterzuentwickeln, dass die künftigen Anforderungen erfüllt und die Leistungsfähigkeit entsprechend gesteigert werden kann. Die Kultureinrichtungen der Stadt Linz haben in den bestehenden und gewachsenen Strukturen die hervorragende Entwicklung der Kulturstadt

Linz. The design and "staging" of such an area is without a doubt an achievement of the first magnitude in urban planning, zoning, and social as well as cultural policymaking.
In addition to the cultural institutions of the city and the region, there are a great number and a wide variety of cultural groups and initiatives. The so-called free cultural scene in Linz ranges from "alternative cultural facilities" to small groups of artists working independently. The municipal support provided to artistic initiatives and experiments follows the principle of "promotion to develop initiative." The objective is to put in place the preconditions for cultural work and art production based on individual initiative, creativity and quality. Our maxim is opening up free spaces and making them available. Artistic experimentation and artistic latitude ought to provide stimuli to society. Many of these are long-term visions and plans for the future, but they are nevertheless basic principles of urban cultural policymaking as set down in Linz's Cultural Development Plan (KEP). Therefore, the aim has to be to further develop the structures and framework conditions in public cultural facilities in a way that anticipates future demands and increases efficiency accord-

Linz mitgeprägt und mitgestaltet. Aber alle Struk-
turen sind aufgrund von politischen, gesellschaft-
lichen und wohl auch ästhetischen Veränderungen
anzupassen.

Kulturentwicklungsplan Linz

Mit dem Kulturentwicklungsplan hat die Linzer
Stadtpolitik einerseits ein Zeichen für Zukunfts-
orientierung und Dynamik gesetzt, andererseits
sich selber eine besondere politische Herausforde-
rung gestellt. Mag es auch in anderen Städten
kulturpolitische Leitlinien geben, so ist der KEP-Linz
jedenfalls das erste kulturpolitische Konzept einer
österreichischen Stadt, das Leitlinien und Konzepte
für eine systematische kulturelle Neupositionie-
rung vorgibt, also für eine langfristige und zielge-
richtete Neugestaltung von Linz.
Wesentlich für die Qualität des KEP-Linz und auch
für die Akzeptanz und Identifikation ist die außer-
ordentlich breite Partizipation am Entstehungs-
prozess. Der KEP ist das Ergebnis von intensiven
öffentlichen Diskussionen und Debatten mit
kulturinteressierten BürgerInnen, PolitikerInnen,
KünstlerInnen, ExpertInnen und Kulturschaffen-
den. Dieser breite, partizipatorische Prozess macht
einerseits die Bedeutung des kreativen und künst-
lerischen Potenzials für eine Stadt bewusst.
Andererseits zeigen sich darin auch wesentliche
Unterscheidungsmerkmale zu anderen österreichi-
schen und europäischen Städten.

Linz – europäische Kulturstadt

Zentrale Rolle in diesem Entwicklungsprozess
spielen das Festival Ars Electronica (seit 25 Jahren),
der Prix Ars Electronica und das Ars Electronica
Center. Aber auch alle anderen Kultureinrichtungen,
Kulturinitiativen, KünstlerInnen und Kulturschaffen-
den haben wesentliche Beiträge dazu geleistet,
dass Linz internationale Anerkennung als Europä-
ische Kulturstadt gefunden hat.
Linz wurde im Jahr 1998 mit der Ausrichtung des
„Europäischen Kulturmonats" beauftragt. Diese
Wahl von Linz bringt eine Erkenntnis in Erinne-
rung, die für alle Städte und Regionen Geltung
besitzt und auch den Eckpfeiler der europäischen
Kulturpolitik bildet: die Erkenntnis nämlich, dass
Wirtschaft, Wissenschaft, Handel und Technologie-
politik das Korrektiv und die Ergänzung einer
offenen und zukunftsorientierten Kulturpolitik
brauchen.

ingly. The cultural institutions of the City of Linz
with their existing and newly emerging struc-
tures have had an enormous impact on Linz's
superb development as an urban cultural center.
Nevertheless, all structures have to adapt to
political, social and aesthetic change.

Linz's Cultural Development Plan

With the enactment of the city's Cultural Develop-
ment Plan (KEP), Linz policymakers on one hand
demonstrated their orientation on the future and
their commitment to dynamic development; on
the other hand, they confronted themselves with a
very special political challenge. Cultural policy
guidelines are in place in other cities too, but Linz's
KEP is nevertheless the first such concept for an
Austrian city that provides for guidelines and con-
cepts for a systematic cultural repositioning, and
thus for a long-term, goal-oriented cultural
makeover of Linz.
The essential ingredient that went into both the
quality of the KEP as well as the acceptance of and
identification with it was the extraordinarily broad-
based process of developing it. The KEP is the result
of intensive public discussions and debates with
citizens actively involved in cultural affairs, politi-
cians, artists, experts and producers of cultural
events. On one hand, this broad, participatory
process makes all involved conscious of the city's
creative and artistic potential; on the other hand, it
reflects the essential differences between Linz and
other Austrian and European cities.

Linz—European City of Culture

The central role in this developmental process
has been played by the Ars Electronica Festival
(for the last 25 years), the Prix Ars Electronica and
the Ars Electronica Center as well as all other
cultural institutions and initiatives, artists and
organizers of cultural events. They have made
essential contributions to the international recog-
nition Linz has garnered as an international city
of culture. In 1998, Linz was commissioned to
organize the European Cultural Month. This
choice of Linz brings to mind an insight that
applies to all cities and regions, and one that is
also a cornerstone of European cultural policy-
making: namely, the realization that the economy
and the worlds of science, commerce and technol-
ogy need a corrective and supplement in the form
of an open and future-oriented cultural policy.

Linz auf dem Weg zur Kulturhauptstadt Europas 2009

Im Jahr 2004 hat sich die Stadt Linz mit Unterstützung des Landes Oberösterreich als „Europäische Kulturhauptstadt 2009" beworben. Es besteht berechtigte Hoffnung, dass Linz diese Auszeichnung zugesprochen wird.

Das unverwechselbare Profil der Kulturstadt Linz beruht auch auf einer kulturellen Infrastruktur, die auf einem hohen qualitativen Niveau ausgebaut ist. Mit dem Bau des Wissensturms, der Entscheidung für den Neubau des Landestheaters, dem Ausbau und der Erweiterung der Linzer Universitäten sowie der Errichtung und Erneuerung „kleinerer" Kulturbauten kann bis 2009 nahezu eine „Vollversorgung" an Kultur-, Bildungs- und Wissenschaftsinstitutionen erreicht werden. Darüber hinaus konnte sich unter den fruchtbaren Rahmenbedingungen und einem äußerst innovativen Klima ein Potenzial der Kunst- und Kulturszene von außerordentlich hohem internationalem Niveau entwickeln.

Und nicht zuletzt wurden mit dem Kulturentwicklungsplan und den dort formulierten Schwerpunkten in den Bereichen Technologie und Neue Medien, Offene Räume, Freie Szene und Kultur für alle inhaltliche Grundlagen und kulturpolitische Leitlinien erarbeitet, die eine ausgezeichnete Basis für ein zukunftsorientiertes Konzept einer Europäischen Kulturhauptstadt Linz bilden.

Es stellt sich nun die große Herausforderung, die Bewerbung und hoffentlich auch die Realisierung des Projektes „Linz – Europäische Kulturhauptstadt 2009" in einem breiten Prozess der Partizipation und Diskussion mit kulturinteressierten BürgerInnen, KünstlerInnen, ExpertInnen und Kulturschaffenden zu entwickeln. Die Projekte „Europäischer Kulturmonat 1998" und „Kulturentwicklungsplan Linz" waren sehr positive Modelle und Lernfelder für eine umfassende Beteiligung und Einbindung aller gesellschaftlichen Kräfte.

The Spirit of Linz

Entwicklung braucht gelebte Kultur, um menschlich und angemessen zu sein. Gerade die Geschichte der Stadt Linz ist ohne das Korrektiv und der Ergänzung durch Kunst und Kultur nicht denkbar. Die so erfolgreiche Entwicklung von Linz, der klassischen Industriestadt in der zweiten Hälfte des zwanzigsten Jahrhunderts, zur dienstleistungs-

Linz on its Way to European Capital of Culture 2009

In 2004 the City of Linz, with the support of the Province of Upper Austria, has applied to be named European Capital of Culture 2009, and there is justified hope that Linz will be granted this honor.

Linz's unmistakable profile as a cultural center is also based on cultural infrastructure constructed to achieve a high level of quality. The construction of the Wissensturm, the decision to build a new Landestheater, the expansion of Linz's universities as well as the construction and renovation of "smaller" cultural facilities will make it possible to achieve what amounts to a "full supply" of cultural, educational and scientific institutions by 2009.

Moreover, the fertile framework conditions and an extremely innovative climate could nurture the development of an art and culture scene on an extraordinarily high international level.

And by no means least of all, the KEP and the areas of emphasis formulated within it with respect to the fields of technology and new media, open spaces, free art scenes and "culture for all" worked out substantive fundamentals and cultural policy guidelines that constitute an outstanding basis for a future-oriented concept for Linz as European Capital of Culture 2009.

Now, the big challenge is to move forward with the application process and, hopefully, with the realization of the Linz—European Capital of Culture 2009 project in a broad-based process of participation and discussion with citizens actively involved in cultural affairs, artists, experts and producers of cultural events. The European Cultural Month project in 1998 and the KEP were extremely positive models and learning experiences for all-encompassing participation and the involvement of all sectors and strata of society.

The Spirit of Linz

Development requires the experience of culture if it is to be human and appropriate. And particularly the history of the City of Linz is inconceivable without the supplementary corrective influence of art and culture. The successful development of Linz—this classic industrial city in the second half of the 20th century—to a service and technology-

und technologieorientierten Kulturstadt wäre ohne die Kunst- und Kulturszene dieser Stadt nicht gangbar gewesen. Der von der Stadt Linz beschrittene Weg hat sich in den vergangenen 25 Jahren zunehmend an Ars Electronica orientiert. Durch das 1996 eröffnete Ars Electronica Center wurde ihre Präsenz nicht nur im kulturellen Jahreslauf verstärkt, sondern auch eine maßgebliche Markierung für den zukünftigen Weg gesetzt.

Die Tradition und Unverwechselbarkeit von Ars Electronica sichert Linz gegenüber allen Medienzentren und Technologieregionen einen Vorsprung und besondere Stärke. Für Linz bietet sich diese Spezialisierung auf Grund der bisherigen Entwicklung von Kunst, Technologie, Wirtschaft, Wissenschaft und Forschung an.

Diese Stärke wird Linz für die Entwicklung von spezifischen Kulturräumen und zukunftsbezogenen Kulturkonzepten nutzen. Aufbauend auf diese Stärken wird Linz als Labor der Zukunft versuchen, eine Vision für Linz 2009 – Kulturhauptstadt Europas zu formulieren. Es gilt eine Klammer zu finden, die vorhandene Traditionen, industrielle Produktion und digitale Information zu einem Kunstwerk Stadt verbindet: The Spirit of Linz.

oriented cultural center would not have been possible without the art scene and the cultural scene of this city. The road followed by the City of Linz has increasingly focused on Ars Electronica in the past 25 years. The opening of the Ars Electronica Center—Museum of the Future in 1996 not only strengthened its position in the cultural course of the years, it also gave a clear indication of the path to be followed in the future.

The tradition and the distinctiveness of Ars Electronica give Linz a special strength and the edge over all other media centers and technology regions. This specialization presented itself as a natural option to Linz because of the previous developments in art, technology, business, science and research.

Linz will use this strength for the development of cultural spaces and future-oriented cultural concepts. Building upon this strength, Linz, as a laboratory of the future, will attempt to formulate a vision for Linz 2009 – European Capital of Culture. The job is to find something that will bring existing tradition, industrial production and digital information together to form a work of art 'the City': The Spirit of Linz.

Ars Electronica 96 – Contained: „Rückspiegel zur Realität" (Werksgelände der Voest)

Gerfried Stocker

Next Generation

*Viele kamen allmählich zu der Überzeugung,
einen großen Fehler gemacht zu haben, als
sie von den Bäumen heruntergekommen waren.
Und einige sagten, schon die Bäume seien ein
Holzweg gewesen, die Ozeane hätte man
niemals verlassen dürfen.*

*Douglas Adams –
Per Anhalter durch die Galaxis*

Die digitale Revolution und die ihr zugrunde lie-
genden Informationstheorien und -technologien
haben eine unmittelbare Entsprechung im Ent-
stehen einer neuen Kunst gefunden.
Elektronische Kunst, Medienkunst, Cyberart, Net-
Art – mittlerweile selbstverständliche, aber den-
noch unscharfe Begriffe für den künstlerischen
Umgang mit den konstituierenden Elementen
der Informationsgesellschaft, ihren technologi-
schen wie sozialen Dimensionen – haben sich
längst von der Erprobung des technisch Mög-
lichen weiterentwickelt und sind zu einem brei-
ten Spektrum unterschiedlicher künstlerischer
Formen gewachsen.
Wenngleich die heterogenen, hybriden Ausfor-
mungen der aktuellen Arbeiten oftmals nur mehr
den Einsatz des Computers, also einen technolo-

*Many gradually became convinced that they had
made a big mistake by coming down
from the trees. And a few even said that living in
the trees had been a case of barking up
the wrong tree, and we should have never
left the oceans.*

*Douglas Adams—
The Hitchhiker's Guide to the Galaxy*

The Digital Revolution and the theories and
technologies of information upon which it is
based have found a direct correspondence in the
emergence of a new type of art.
Electronic art, media art, cyberart, net-art—
terms which have come to be taken completely
for granted but nevertheless remain ambiguous
labels for the ways artists deal with the con-
stituent elements of the Information Society
and its technological as well as social dimen-
sions—have long since gone beyond testing out
that which is technically feasible and have de-
veloped into a broad spectrum of highly diverse
artistic forms.

Prix Ars Electronica 98 – Paul Garrin / Andreas Troeger: „name.space" (Anerkennung .net)

Ars Electronica 96 – Beusch / Cassani: „SOS Radio TNC"

gischen bzw. werkstofflichen Aspekt, gemeinsam haben, ist ein prägendes Charakteristikum dieser neuen Kunst unübersehbar: Trotz aller Virtuosität und Routine, die sich entwickelt hat, ist Medienkunst vor allem ein Experiment.

Ein Experiment, das die ProtagonistInnen dieser „neuen Kunst" sehr oft in den Zusammenhang mit IngenieurInnen und ForscherInnen bringt.

Das Besondere der Medienkunst als „neue Kunst" ist das Überschreiten jener Bereiche, in denen der Computer und seine informationstechnischen Derivate nur als weitere Werkzeuge oder letztlich doch austauschbare Darstellungsmittel verwendet werden. In Entsprechung der dieser Technologie innewohnenden Konvergenz von Produktion, Übertragung (= Vermittlung) und Rezeption bedienen sich KünstlerInnen der digitalen Informationstechnologien gleichermaßen als Werkzeug, Material und Thema.

Sie haben dabei angestammte Domänen verlassen und begonnen, sich jenseits formaler und ästhetischer Grundlagenforschung in die technologischen und soziokulturellen Kontexte der Neuordnung unserer Gesellschaft zu einer globalen Informationsökonomie einzubringen, indem sie statt Interpretation und Beschreibung die analytische Untersuchung in den Vordergrund stellen, um so den Blick auf die Mechanismen und Funktionsprinzipien ihrer systemischen Grundlagen freizugeben.

In einer Situation, in der die Konfiguration von Soft- und Hardware stärker, als dies Gesetze zu tun vermögen, die Bewegungsfreiheit innerhalb der neuen Öffentlichkeit (public domain) globaler Netzwerke bestimmt, kommt dieser

Even though the only aspect that the heterogeneous, hybrid configurations of current works often have in common is their use of the computer—that is, their technological or material medium—an essential, defining feature of this new art is impossible to overlook: despite the experience that has been gained and the virtuosity that has developed, media art is, above all, an experiment—one that often brings the creators and proponents of this "new art" into an association with engineers and researchers.

The unique characteristic of media art as "new art" is the process of getting beyond that realm in which the computer and its data processing derivatives are used merely as one more implement or, ultimately, as a medium of representation that would be interchangeable with any number of other ones.

As a counterpart to the convergence of production, transmission (i.e. mediation) and reception that is inherent in this technology, artists employ digital information technologies not only as a tool and a material, but as a subject as well.

In doing so, they have taken leave of familiar domains, and have begun to go beyond basic formal and aesthetic research and to delve into the technological and sociocultural contexts of the process of reordering our society into a global information economy, in that their highest priority is accorded not to interpretation and description but rather to analytical investigation in order to thus shed light upon the mechanisms and functional principles of that society's systemic foundations.

Ars Electronica 96 – Michel Redolfi: „Liquid Cities"

In a situation in which the configurations of software and hardware act much more powerfully than laws as determinants of the freedom of movement within the new public domain of global networks, this artistic strategy is also endowed with an immediate political relevance.

Faster than media art theory (in any case largely nonexistent) is capable of offering a description of this phenomenon, a conception of media oriented upon transmission and dissemination (that is, centralized, unidirectional distribution) has become passé in actual artistic practice. This conceptual schema—one rooted in the industrial epoch and in which the overcoming of geographical distance, the transfer of messages, and thus speed are inherent central parameters—is now countered by the concept of omnidirectional and participatory spheres of communication of which the Internet is the prototypical example.

These are networks in which presence and community do not have to coincide physically and geographically or even temporally in order

künstlerischen Strategie auch eine unmittelbare politische Relevanz zu.

Schneller als die – ohnedies weitgehend fehlende – Medienkunsttheorie dies zu beschreiben vermag, hat in der künstlerischen Praxis das auf Übertragung und Ausstrahlung (also auf zentrale, uni-direktionale Verteilung) ausgerichtete Medienverständnis ausgedient. Diesem in der industriellen Epoche wurzelnden Denkschema, dem das Überwinden von geografischer Entfernung, das Translozieren von Botschaft und somit Geschwindigkeit als zentrale Parameter eingeschrieben sind, wird nun die Vorstellung von omni-direktionalen und partizipatorischen Kommunikationsfeldern, wie sie das Internet prototypisch skizziert, entgegengestellt.

Es entstehen Netzwerke, in denen Anwesenheit und Gemeinschaft nicht nur von physikalischen, geografischen, sondern auch von synchronen Koinzidenzen getrennt stattfinden können.

Räume, deren Beschaffenheit primär von sozialen anstelle geometrischen Dimensionen entschieden wird und in denen die Anzahl der User und deren Aktivität zur bestimmenden Maßeinheit werden.

Ars Electronica 98 – openX

Prix Ars Electronica 96 – etoy
(Goldene Nica / World Wide Web Sites)

In solchen Szenarien, in denen Teilnahme nicht Resultat, sondern Voraussetzung ist, entsteht eine konzentrierte Form von Interaktivität, die den Anspruch von Kunst als Interface zwischen Gesellschaft/Kultur und Wissenschaft/Technik einzulösen vermag.

Das Bild der Ingenieur- und ForscherkünstlerInnen (das lange Zeit die Medienkunstpraxis adäquat beschreiben konnte) muss erweitert werden um einen noch zu findenden Begriff, der das Zurücktreten der Bezogenheit der/des KünstlerIn und ihres/seines Werkes als Genie und Original zugunsten einer prozessorientierten Position als kontextuelle Netzwerkknoten beschreibt.

Medienkunst gewinnt dabei ihre Meisterschaft nicht aus den Bildern und Klängen, die sie zum Einsatz bringt, sondern aus der Qualität, mit der die expliziten Charakteristiken der verwendeten Medien bewältigt werden. Es ist keine Errungenschaft, traditionelle künstlerische Muster und Verhaltensschemata in die Medienkunst zu übertragen, die Herausforderung ist, neue zu erfinden.

Die Produkte dieser Kunst verlagern sich vom Objekt zum Prozess, von Information und Präsentation zu Interaktion und Kommunikation, oder wie es der japanische Forscher-Künstler Masaki Fujihata fromuliert hat, „from document to event". Dies sollte aber nicht notwendigerweise mit einem Verschwinden in die Virtualität gleichgesetzt werden. Ästhetik als qualitative Kategorie sinnlicher Wahrnehmung bleibt auch in der Cyberart relevant.

Um diesen Anforderungen zu begegnen, muss der Kunstbetrieb neue Vermittlungsstrategien entwickeln. Ein Festival darf sich nicht als Leistungsschau saisonaler Meisterwerke begnügen, sondern muss Fenster öffnen in die künstlerisch/technologischen Arbeitsprozesse. Es muss versuchen, dem Prinzip der wechselseitigen Gleichstellung von Sender und Empfänger

for them to be able to take place; these are spaces whose make-up is primarily specified by social rather than geometric dimensions, and in which the number of users and their activities become the determinative units of measure.

In such scenarios in which participation is not a result but a precondition, there arises a concentrated form of interactivity which can fulfill art's claim to serve as an interface between society/culture and science/technology.

The image of the engineer/artist and researcher/artist which has long sufficed to describe the practice of media art must be expanded by one yet-to-be-invented term to refer to the diminishment of the linkage of artist and artwork characterized as that of genius and original in favor of a process-oriented position as contextual network node.

Media art thus does not reign supreme as a result of the images and sounds that it is able to marshal and dispatch, but rather due to the quality with which the explicit characteristics of the employed media are orchestrated. It is no great achievement to transfer traditional artistic patterns and behavioral schema into media art; the challenge is to invent new ones.

The products of this art shift from object to process, from information and presentation to interaction and communication—or as the Japanese researcher-artist Masaki Fujihata put it: "from document to event." This, however, should not necessarily be equated with a process of vanishing into virtuality. Aesthetics as a qualitative category of sensory perception remain relevant in cyberart as well.

In order to meet these demands, the business of art must develop new strategies of mediation and dissemination. A festival cannot content itself to function as an exposition of this season's masterpieces; rather, it must open windows to artistic/technological working processes.

It must strive to live up to the principle whereby transmitter and receiver are mutually equated. The chance to accomplish this lies in the conglomeration of many different network-linked processes. By enabling artists and their audiences to come together and

Ars Electronica 97 – Maurice Benayoun / J. B. Barrière: „World Skin"
(Goldene Nica / Interaktive Kunst, Prix Ars Electronica 98)

nachzukommen. Die Chance liegt in der Konglomeration vieler vernetzt stattfindender Prozesse. Im Zusammenkommen und Aufeinandertreffen von KünstlerInnen und deren Publikum kann ein Festival als Projektwerkstatt zum Katalysator solcher Arbeitsprozesse werden.

Ein Festival solcher Prägung bleibt trotzdem auch Ort der Produkte dieser Kunst, allerdings nicht mehr der Ort, an dem sie aus- und abgestellt werden, sondern als Ort ihrer Entstehung und Wirkung, wobei die Entstehung aber nicht mehr als der künstlerischen Vermittlung und Erfahrung vorgelagert und von ihr getrennt zu denken ist. Ars Electronica versucht ihre Aktionsräume zwischen diesen unterschiedlichen Aufgabenfeldern zu bewegen, um Tendenzen erkennen und Entwicklungen wiedergeben zu können und um im Aufeinanderprallen der Positionen Energie frei zu setzen.

meet one another, a festival as a project workshop can become a catalyst of such working processes.

Nevertheless, a festival of this kind also remains a venue of the products of this art—though, indeed, no longer the place where they are exhibited and warehoused, but rather one where they originate and have an effect, whereby the origination, however, can no longer be accorded precedence over the processes of mediating and experiencing art and cannot be thought of separately from them.

Ars Electronica seeks to maneuver its scope of action within these myriad fields that delineate its mission, in order to be able to recognize tendencies and reflect developments, and to release energy generated by the collisions of positions with one another.

Itsuo Sakane

Gedanken zur Geschichte der Ars Electronica

Reminiscences on the History of Ars Electronica

Persönliche Erinnerungen aus meinem Netzwerk menschlicher Kontakte

Das erste Mal war ich im Jahr 1982, d. h. im dritten Jahr nach der Gründung der Ars Electronica, in Linz dabei. Seit damals sind nun 17 Jahre vergangen, in denen ich die Ars Electronica nur zwei Mal versäumt habe. Bei so vielen nostalgischen Erinnerungen kann ich gar nicht anders, als tief bewegt zu sein, wenn ich an die Gesichter der vielen Freunde und Bekannten denke, die ich in all den Jahren in Linz kennen gelernt habe. Es ist, als blicke man in ein Kaleidoskop voller Rückblenden. Ich war damals ein Journalist, der über Kunst, Wissenschaft und Technologie schrieb, und kam nach Linz, um die hier stattfindenden histori-

Personal Recollections from My Network of Human Contact

I first participated in the Ars Electronica event in Linz, Austria, in 1982, in its third year and since then 17 years have already gone by. Since that time, I have attended every event except two. With so many nostalgic memories, I cannot help but feel a deep emotion when I recollect the faces of so many friends and acquaintances whom I met in Linz during these past years. It's as if I am looking at a kaleidoscope of flashback images. I was a journalist around that time, covering the

Masaki Fujihata:
„Nuzzle Afar"

Ars Electronica 96 – Motoshi Chikamori: „Kage"

schen Ereignisse zu verfolgen und darüber zu berichten. Ich empfand eine Art Verantwortung als Augenzeuge. Außerdem sollte ich an einem Treffen teilnehmen, dem ich in der frohen Erwartung entgegensah, alte und neue Freunde und Bekannte zu sehen, deren Zahl beständig wuchs. Dieses Netz menschlicher Kontakte und nicht so sehr das elektronische Netz war es, das mich dazu veranlasste, Jahr für Jahr nach Linz zu reisen. Wenn ich auf die Zeiten zurückblicke, in denen ich – seit den frühen Sechzigerjahren – über die aneinander grenzenden Welten von Kunst und Wissenschaft berichtete, so kann ich sagen, dass meine Erfahrung durch die Freude bereichert wurde, die mir die persönlichen Kontakte und die faszinierenden Persönlichkeiten der Künstler, Wissenschaftler und der vielen anderen Menschen, die ich kennen lernen durfte, bereitete. Von Ars Electronica erfuhr ich in deren frühester Zeit

fields of art, science and technology. I came to Linz to observe and cover the historical events happening there, and felt a sense of responsibility as an eyewitness. Another purpose was to attend a reunion gathering, which I did with a strong anticipation of meeting both old and new friends and acquaintances whose numbers continued to increase. It was through this human network rather than the electronic network, which motivated me to continue taking the trip to Linz year after year. Actually, when I look back at my past history of covering the bordering worlds of Art and Science, since the beginning of the 60's, I can say that my experience was enhanced because of the joy I had from the personal encounters and the charming personalities of the artists, scientists and others I met. I learned about Ars Electronica at its earliest stage from Otto Piene and his colleagues, who organized the Sky Art Conference at

durch Otto Piene und seine Kollegen, die im Jahr zuvor die *Sky Art Conference* im CAVS organisiert hatten. Sie erklärten mir, die nächste Konferenz würde 1982 im Rahmen der Ars Electronica in Linz stattfinden. Damals hörte ich erstmals davon, und im Herbst 82 reiste ich mit hohen Erwartungen und großer Neugierde nach Linz. Die ehrgeizige Idee, das traditionelle Bruckner-Musik-Festival und die neue elektronische Medienkunst in dieser kleinen Stadt in Österreich miteinander zu verbinden, beeindruckte mich. Ich bewunderte dieses kühne Projekt und die große Energie, mit der es organisiert und präsentiert wurde.

Ich erinnere mich noch lebhaft an die ersten Performances bei Ars Electronica 82, zu denen auch die lange und leidenschaftliche Performance von Nam June Paik und Charlotte Moorman gehörte. Sie fand im ORF-Studio statt. In einer anderen Vorführung mit dem Titel *Sky Kiss* spielte Charlotte auf ihrem Cello, während sie von einem Otto-Piene-Ballon hängend in der Luft schwebte. Eine weitere Sensation war die fantastische, von Walter Haupt dirigierte Klangwolke. Dieses Ereignis fand an der wunderschönen Donau neben dem Brucknerhaus statt. Seit damals haben ich und die meisten anderen Teilnehmer den Anbruch des Zeitalters der neuen Medien erlebt, und wir haben diesen Geist der Veränderung mit ausgewählten Künstlern, Mitarbeitern und sogar den einmaligen Kameraleuten der Stadt geteilt, die jedes Jahr wieder auftauchten.

Ich erinnere mich besonders gut an Charlotte, die nicht mehr unter uns ist. Sie war mehrere Male bei Ars Electronica, und wann immer sie Freunde oder Bekannte traf, umarmte sie diese, schenkte ihnen ein liebevolles Lächeln und küsste sie. Sie litt schon damals seit langem an Krebs, und es schien mir, als wolle sie ihren Freunden in Vorahnung ihres baldigen Todes noch einen letzten Abschiedsgruß mitgeben.

Traurige Erinnerungen habe ich auch an andere, die ich kennen lernte und die seither verstorben sind. Einer von ihnen war Kenneth Boulding, den ich bei Ars Electronica interviewte und über den ich damals für unsere Zeitung einen Artikel schrieb. Ron Hays, der ein wunderschönes Konzert mit Isao Tomita gab, war ein weiterer guter Bekannter (ich habe ihn vor einigen Jahren im CAVS kennen gelernt), der ebenfalls nicht mehr unter uns ist. Obwohl die Welt durch die digitalen Netze kleiner geworden ist, scheint das von Marshal McLuhan

CAVS the year before. They informed me that the next Conference would be held within the framework of Ars Electronica in Linz in 1982. It was the first time I had heard about it, and visited Linz in the fall of '82 with much anticipation and curiosity. I was struck by the challenging idea of integrating both the traditional Bruckner Music Festival and the new electronic media art in this small town in Austria. I was impressed by this audacious project and the great energy it took to organize and present it.

I vividly remember the first performances at Ars Electronica in 1982, one of which was the long, yet passionate performance by Nam Jun Paik and Charlotte Moorman. It was held in the ORF studio. In another piece titled *Sky Kiss,* Charlotte played her cello while suspended in the air from an Otto Piene balloon. Another piece was the magnificent concert /performance of *Klangwolke,* directed by Walter Haupt. It took place along the beautiful River Danube, next to the Brucknerhaus. Since that time, I and most of the participants have witnessed the coming of the new media age, and we have shared that spirit of change with chosen artists, staff and even the unique cameramen from the town who have appeared every year.

I especially remember Charlotte, who is no longer with us. She attended Ars Electronica several times, and whenever and wherever she met her friends and acquaintances, she hugged them and gave them a caressing smile and kissed them. At that time, she had been suffering from cancer for a long time, and for me it seemed as if she was giving her friends a farewell salutation as a premonition of her coming death.

I also have several sad memories of the other people whom I met but who have since passed away. Kenneth Boulding was one such person whom I interviewed at Ars Electronica, and wrote an article about for our newspaper at that time. Ron Hays, who gave a beautiful concert with Isao Tomita was another good acquaintance I made at CAVS a few years ago, and he has also passed away.

Even though the world has become smaller with the aid of digital networks, the Global Village which Marshal McLuhan prophesied seems already to be realized. I myself have been feeling that this kind of human network based on face to face encounters among people is still the most important bond of union among human

prophezeite globale Dorf bereits Wirklichkeit zu sein. Ich selbst habe das Gefühl, dass diese Art des menschlichen Netzwerks auf der Basis persönlicher Begegnungen noch immer die wichtigsten Bande zwischen den Menschen darstellt. Ich sage das aus den persönlichen Erfahrungen, die ich bei weltweiten Ereignissen mit langer Tradition, so wie bei Ars Electronica, häufig gemacht habe. Ich bin zutiefst dankbar dafür, dass ich die Gelegenheit hatte, in dieser Welt, die Kunst, Wissenschaft und Gesellschaft verbindet, so viele schöpferische Menschen kennen zu lernen. Aus diesen Begegnungen erwächst eine viel stärkere persönliche Kommunikation. Ich konnte das Gefühl der Bewegung und Entwicklung in der Medienkultur nicht nur auf gedanklicher Ebene, sondern auch durch unmittelbare sinnliche Erfahrung verstehen und beobachten. Für einen japanischen Besucher wie mich, der aus dem Fernen Osten anreist, ist Europa natürlich enorm weit entfernt. Deshalb weitete ich meine Reisepläne mitunter aus, um auf dem Rückweg nach Japan noch bei anderen Kunstveranstaltungen und interessanten Künstlern vorbeizuschauen: bei der Documenta in Kassel, beim zwanzigjährigen Jubiläum der FLUXUS-Ausstellung in Wiesbaden, bei der Biennale in Venedig. Auch habe ich Walter Haupt in München und viele andere Künstler aufgesucht, die bei Ars Electronica mit fantastischen Performances und Ausstellungen beeindruckten. Seit Anfang der Neunzigerjahre ist das dynamische Netz, das die Medienzentren in der ganzen Welt untereinander verbindet, wesentlich gewachsen. Neben dem im Jahr 1996 eröffneten Ars Electronica Center werden vielleicht das ZKM in Karlsruhe, Le Fresnoy in Frankreich und das ICC in Tokio durch die Verwendung digitaler Verbindungen wichtige Knotenpunkte dieses Netzes werden. Ich habe das Gefühl, dass diese Knoten in der Zukunft in unserer digital vernetzten Gesellschaft stark an Bedeutung gewinnen werden. Gleichzeitig bin ich davon überzeugt, dass diese Knotenpunkte im Netz der Medienkultur sich nicht auf das digitale Netz allein beschränken, sondern auch der Vernetzung zwischen den Menschen dienen sollten.

Beitrag des Prix Ars Electronica im Zeitalter der Medienkultur

Einer der wichtigsten Beiträge der Ars Electronica zur Welt der Medienkultur war und ist ihr großer Wettbewerb, der so genannte *Prix Ars Electronica*, der die Welt mit der Medienkunst bekannt ge-

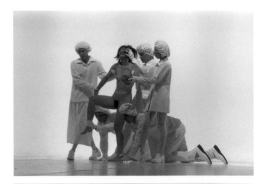

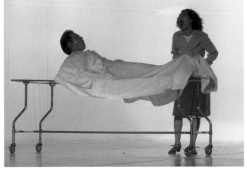

Ars Electronica 97 – Dumb Type: „OR"

beings. I have learned this from personal experiences, often at worldwide events with long histories such as Ars Electronica. I am deeply grateful that I have had the opportunity to encounter so many creative people in the world connecting art, science and society. From these encounters comes much more personal communication. I have been able to understand and observe the sense of movement and development in this media culture, not only from ideas but also from tangible experiences of the senses.

For a Japanese visitor like myself, coming from the Far East, Europe was far from my mother country. For that reason, I sometimes extended my trip to visit other art events and interesting artists on the way back to Japan. I visited Documenta in Kassel, the twentieth anniversary of FLUXUS exhibition at Wiesbaden, and the Venice Biennial. I also visited Walter Haupt in Munich, as well as many other artists who gave beautiful performances and exhibitions at the Ars Electronica.

Since the beginning of the 1990's, there has been significant growth in the dynamic network connecting media centers the world over. In addition to the Ars Electronica Center, opened in 1996, ZKM in Karlsruhe, Le Fresnoy in France, and

macht hat. Dieser vom ORF veranstaltete Wettbewerb hatte starken Einfluss auf die Entwicklung der neuen Medienkunst. Künstler, die bei diesem Wettbewerb mit der Goldenen Nica oder anderen Preisen ausgezeichnet wurden, haben das Feld für weitere Aktivitäten im Bereich der neuen Medienkunst bereitet. Der Prix Ars Electronica gab und gibt den Künstlern eine hervorragende Möglichkeit, ihre Arbeit zu präsentieren, und ist für viele junge, talentierte Künstler/Techniker ein hohes Ziel, auf das sie hinarbeiten. Die meisten der Artists-in-Residence, die wir an unsere Akademie eingeladen haben, sind Preisträger, die in verschiedenen Kategorien des Prix Ars Electronica mit der Goldenen Nica ausgezeichnet wurden. Aus diesem Grund bewerben sich viele Lehrende und Studierende unserer Hochschule für diesen Wettbewerb, und einige wurden auch eingeladen, ihre Kunstwerke im Rahmen anderer Ausstellungen zu präsentieren. Auch viele der Künstler, die wir zu unserer Biennale mit dem Titel „Interaction" eingeladen haben, wurden davor oder danach mit Preisen der Ars Electronica ausgezeichnet. Im Vergleich zu ähnlichen Medienkunst-Wettbewerben auf der ganzen Welt kann ich die Ars Electronica für ihren wichtigen Beitrag zur Welt der Medienkultur nur lobend hervorheben.

Kulturelle Signifikanz als Barometer für den Geist eines Zeitalters

Die Ars Electronica hat seit ihren Anfängen immer das Motto „Kunst, Technologie und Gesellschaft" vertreten. Das Festival entstand als Zusammenarbeit mit dem traditionellen Bruckner-Fest. Man konnte fühlen, dass die Gründer getreu ihrem Motto die wachsenden Möglichkeiten der Elektronik voraussahen und dass eines ihrer Ziele in der Förderung der kreativen Kräfte derer bestand, die in der globalen Technokultur der Medien tätig waren. Wenn man auf die Geschichte der Verflechtung dieser Tendenzen und sozialen Faktoren seit den Fünfzigerjahren zurückblickt, so lässt sich allgemein eine solche Integration beobachten. Beispiele dafür finden sich in C. P. Snows *Two Cultures* aus den späten Fünfzigerjahren, in der gegenwärtigen Kunst- und Technologiebewegung, die ihren Anfang in den späten Sechzigern nahm, und in der Medienkunstbewegung, die in den Achtzigerjahren aufkam.
Wenn wir die Tendenzen der historischen neuen Bewegungen im Bereich der Medienkultur beob-

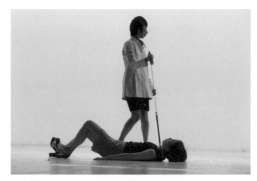

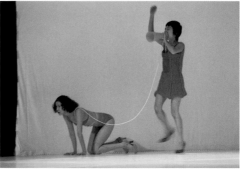

Ars Electronica 97 – Dumb Type: „OR"

ICC in Tokyo will perhaps become important node points of the network by using digital line connections. I feel that in the future, these nodes will become very important in our digitally networked society. At the same time, I feel strongly that these nodes of the network of media culture should not be confined to the digital network alone, but should be open to human contact networking.

Contribution of the Prix Ars Electronica in the Age of Media Culture

One of the most important contributions of Ars Electronica to the world of media culture has been its major contest called the Prix Ars Electronica, which introduced media art to the world. This contest, organized by ORF, has been strongly influential in creating new media art. Artists who have received the Golden Nica or other awards at this contest have set the stage for further creation in the field of new media art. It has given artists an excellent opportunity to showcase their work, and it has become a lofty goal for young talented artists/engineers to aim for. Most of the artists-in-residence whom we have invited to our Academy have

achten, so scheinen sie Trends für die kommenden Zeiten vorherzusagen und auch als Barometer für künftige soziale, kulturelle und technologische Welten zu fungieren. Seit Ende der Achtzigerjahre hat diese Einstellung an Bedeutung gewonnen, und man hat versucht, den Horizont der Welten von Wissenschaft, Kunst und Gesellschaft zu erweitern. Die Themen der Veranstaltungen, die Struktur der Symposien und die Ausstellungen selbst erfüllen weiterhin ihre Rolle, der Welt Fragen über die Bedeutung und den Zweck künftiger menschlicher Unternehmungen zu stellen. Die hinter den Kulissen entstandenen Konzepte und Drehbücher kamen von einem von Peter Weibel geleiteten Team. Ihr Bewusstsein ihrer Zeit spiegelte sich im Symposium und sogar im Genre der künstlerischen Wettbewerbe wider.

Eine feine Veränderung in der Philosophie der Ars Electronica machte sich besonders zu Beginn der neunziger Jahre bemerkbar. Ich erinnere mich klar und deutlich an eine Veranstaltung mit dem Titel „Out of Control", die die gespannte Atmosphäre des Golfkriegs einfing.

been prizewinners, and have received the Golden Nica in several categories of Prix Ars Electronica. For that reason, many instructors and students at our school apply for the contest, and some have been invited to present their artworks in other exhibitions. Also, many of the artists whom we invited to our Biennale called "Interaction" have either received awards at Ars Electronica before our show or have won awards there after our show. Compared with similar worldwide media arts contests, I highly praise Ars Electronica for its great contribution to the world of media culture.

Cultural Significance as the Barometer of the Spirit of the Age

From its beginning, Ars Electronica has advocated the motto "Art, Technology and Society." It began as collaboration with the traditional Bruckner Festival. True to its motto, one could sense that the founders foresaw the expanding possibilities of electronic technology, and that there was a goal of stimulating the creative power of those who were active in the global media techno-culture. If we

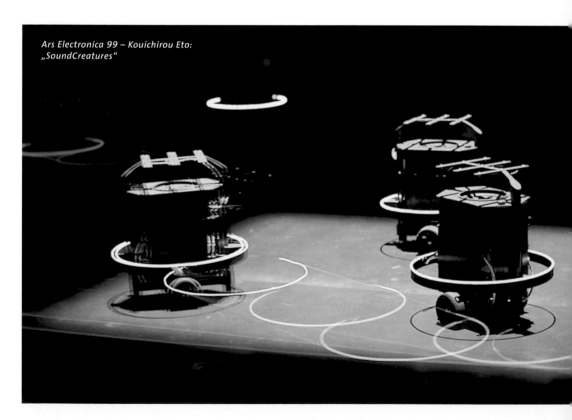

Ars Electronica 99 – Kouichirou Eto:
„SoundCreatures"

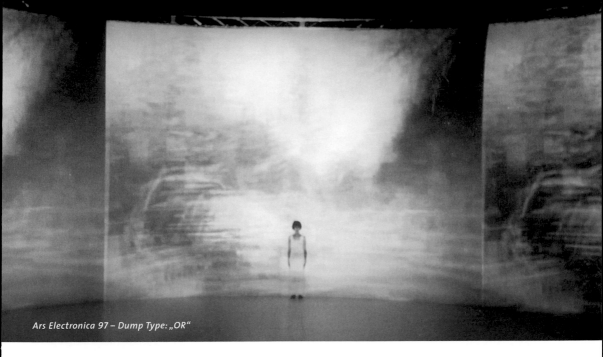

Ars Electronica 97 – Dump Type: „OR"

Ein weiteres Beispiel für ein neues, auf der Beziehung zwischen den nicht nur in der Elektronik, sondern auch in den Biowissenschaften und in der sich entwickelnden Kosmologie vorhandenen Mikro- und Makrophänomenen beruhendes Konzept war auch „Endo and Nano". Ich kann das starke, beinahe gewalttätige Umweltkunstwerk nicht vergessen, das – auch wenn es mitunter bedrohlich war – fast alle im Publikum anzusprechen schien. Es schien eine Gegenmaßnahme gegen das Zeitalter der Hi-Tech-Kriegsführung zu sein, die uns die tagtraumartigen Szenen aus dem Golfkrieg vor Augen führten. Man hatte beinahe den Eindruck, als wolle es an einen menschlichen Sinn für Enthaltung appellieren.

Diese Performances übten einen starken Einfluss auf die Besucher aus, indem sie betonten, wie wichtig es ist, Körperlichkeit und die Beziehung zwischen Körper und Sinnen anzuerkennen, die im Zeitalter der digitalen Technologie und der Simulationstechnologie der virtuellen Realität im Begriff waren, verloren zu gehen.

In den Jahren rund um die Eröffnung des Ars Electronica Center schien sich das Konzept des Festivals hin zu einem stärkeren öffentlichen Bewusstsein und einem leichter verständlichen Ansatz zu verändern und wegzugehen von der Betonung konzeptueller Manifestationen. Das grundlegende Konzept der Ars Electronica jedoch zielte

look back at the history of interweaving these trends and social factors since the 1950's, we can observe this integration. Some examples are seen in C. P. Snow's "Two Cultures" from the end of the 50's, in the current art and technology movement which began at the end of the 1960's, and in the media art movement which began in the 1980's. When we observe the trends in historic new movements in the field of media culture, they seem to forecast trends for the coming ages, and also act as a barometer of future social, cultural and technological worlds. Since the end of the 1980's, this attitude has seemed more prominent, and there has been an attempt to expand the scope of perspective in the worlds of science, art and society. The theme of the event, the structure of the symposia and the exhibitions themselves continue with their role of posing questions to the world about the significance and purpose of future human endeavors. The concepts and screenplays behind the scenes were from a team directed by Peter Weibel. Their conscious awareness of the age has been reflected in the symposium and even in the genre of the art contests. A subtle change in the philosophy of Ars Electronica was especially strong at the beginning of the 1990's. I clearly remember an event titled "Out of Control," which captured the tense atmosphere of the Gulf War. "Endo and Nano" was

Prix Ars Electronica 98 – Hachiya Kazuhiko: „Post Pet" (Auszeichnung .net)

immer noch auf eine Integration von Technologie, Kunst und Gesellschaft und nicht bloß auf „l'art pour l'art". Aus diesem Grund, weil sie den Tendenzen von Kunst und Gesellschaft nachging, hat sie ihre Rolle als „Wetterfahne" beibehalten. Sie fungierte als eine Art Spiegel, der die Veränderungen der Welt reflektierte, und schien zugleich dem Lauf des kommenden Zeitalters zu folgen. Der Charakter der Ars Electronica unterscheidet sich stark von den im Zusammenhang mit der SIGGRAPH in den USA festgestellten Tendenzen. Die SIGGRAPH hat eine längere Geschichte in Bezug auf avancierte Technologien wie die Computergrafik, wurde jedoch von Digitaltechnikfirmen unterstützt und entsprechend durch die Profite aus der Informationsindustrie beeinflusst. Allerdings hat auch sie sich zunehmend mit den sozialen Anwendungen von Technologie befasst. Ars Electronica hat versucht, weiter reichende Anwendungen der Medientechnologie zu identifizieren, doch scheint sie gleichzeitig auch an ihrem Ziel festzuhalten, die Bedeutung und den Einfluss der Medien-Technowissenschaft in einem eher sozialen und kulturellen Kontext zu suchen. Sie hinterfragt weiterhin, welche Rolle

another example of a new concept based on the relationship between the micro and macro phenomena found not only in electronics, but also in the life sciences and in expanding cosmology. I cannot forget the strong, almost violent environmental artwork, which seemed to appeal to everyone in the audience, even if it was sometimes threatening. It seemed a counteraction to the age of hi-tech war strategy seen in the Gulf War's daydream-like scenes. It almost seemed to appeal to a sense of deprivation in humans. These performances strongly influenced people by stressing the importance of acknowledging physicality and the relationship between the body and the senses, which was being lost in the age of digital technology and the simulation technology of virtual reality. During these years, around the time of the opening of the Ars Electronica Center, its concept seemed to change into one of more public awareness and a more easily understandable approach rather than stressing conceptual manifestations. However, the basic concept which Ars Electronica had been following still targeted the integration between technology, art and society, not just

menschliche Bestrebungen für die nächste Generation spielen.

Unglücklicherweise hatte das Publikum auch bei den sorgfältig konzipierten Symposien seit Anfang der Neunzigerjahre mitunter das Gefühl, dass es nicht einfach ist, ein Bewusstsein von der jeweiligen Fragestellung zu entwickeln. Manchmal lag dies daran, dass die Diskutanten am Podium, die aus speziellen Bereichen etwa der Wissenschaft kamen, ihre Gedanken wegen feiner terminologischer Differenzen nicht austauschen konnten. Deshalb waren diese Symposien nicht immer erfolgreich. Dennoch dürfen wir die Verdienste der Ars Electronica und auch den wichtigen Beitrag, den sie zur Vermittlung der Bedeutung einer Integration von Kunst, Technologie und Gesellschaft geleistet hat, nicht gering schätzen. Sie bestand darin, der Versuchung des engeren Ansatzes der so genannten zeitgenössischen Kunst zu widerstehen, der manchmal rein persönlich oder subjektiv ist, das kollektive Bewusstsein der breiteren menschlichen Gesellschaft aber vernachlässigt.

Auch von meinem persönlichen Standpunkt aus meine ich, der Argumentation in den Symposien nicht gut genug folgen zu können, um den ganzen Kontext zu erfassen. Dies liegt an sprachlichen Problemen, aber auch an feinen Unterschieden, die auf verschiedenen kulturellen Standpunkten und Wertesystemen beruhen. Diese Unterschiede hängen vielleicht mit Auffassungsunterschieden zwischen Ost und West in Bezug auf Raum und Zeit, aber auch in Bezug auf die Beziehung eines Menschen zu seinen Mitmenschen zusammen. Die grundlegende Vorstellung von Medienkultur, die hier präsentiert wird, wird mehr oder weniger im Rahmen des so genannten europäischen Individualismus und nicht so sehr im östlichen Sinne eines Feldes und der Wechselbeziehung eines Menschen zu allen anderen dargestellt.

Vom digitalen Denken zur Feldtheorie

In der globalen Gemeinschaft wurden die Verdienste der digitalen Technologie und ihres Einflusses überschätzt. Dies gilt insbesondere für den Glauben an die Macht der Computer. Im Rahmen dieser Tendenzen wurde der körperliche/sinnliche Aspekt des Menschen vernachlässigt oder nur oberflächlich berücksichtigt. Es mangelte entschieden an Projekten zur Entwicklung

"art for art's sake". As a result, it has kept its role of 'weather vane' by following the trends of society and artwork. It acted as a sort of mirror, reflecting the changes of the world, yet appeared to follow the tides of the coming age.

Ars Electronica's character is quite different from the trend seen at SIGGRAPH in the U.S. SIGGRAPH has a longer history in advanced technologies such as computer graphics, but it has been supported by digital technology industries, and as such has been influenced by the profits from information industries. However, it has also been expanding into social applications of technology. Ars Electronica has been trying to find wider applications of media technology, but at the same time, it still seems to be adhering to the goal of seeking the meaning and influence of media techno-science in a more social and cultural context. It continues to question the role of human endeavors for the next generation.

Unfortunately, even in such carefully conceived symposia since the beginning of the 1990's, many audiences have felt that it was not easy to be aware of the issues. Sometimes this is because the panelists, who have come from specific fields such as science, could not exchange concepts because of the subtle differences in terminology. Therefore, these symposia were not always successful. Nonetheless, we cannot neglect the achievements of Ars Electronica, nor the great contributions it has made in conveying to human beings the meaning and importance of integrating art, technology and society. This has meant resisting the narrower approach of so-called contemporary art, which is sometimes purely personal or subjective, yet neglects the collective consciousness of greater human society.

From my personal point of view, I also feel that I cannot follow the points of arguments in symposia thoroughly enough to grasp the complete context. This is because of language problems, but also because of the subtle differences in cultural standpoints and differing value systems. These differences may be related to differences in the concepts of time and space between East and West and also the relationships between one person and others. The main idea of media culture which is being presented here is being presented more or less within the framework of so-called European individualism, and not so much in the Oriental sense of the

eines theoretischen Denkens, das auch eine Betrachtung der Beziehungen zwischen dem Selbst und dem Ganzen umfasst. Mitte der Siebzigerjahre gab es in der Beziehung zwischen West und Ost und zwischen Wissenschaft und Kunst im Daoismus und in der Theorie David Bohms eine Bewegung in diese Richtung. In letzter Zeit geriet diese Denkweise jedoch beinahe völlig in Vergessenheit.

Vor einiger Zeit traf ich mit dem Wissenschaftler und Philosophen Professor Hiroshi Shimizu zusammen. Er hat an der so genannten „BA-Theorie" gearbeitet, einer Feldtheorie über die Existenz von Individuen und die sie beeinflussenden Umgebungsfaktoren. Seine Theorie, dass zwischenmenschliche Beziehungen die Identität jedes Menschen beeinflussen, scheint mit dem grundlegenden Konzept übereinzustimmen, das David Bohm vertritt. Wenn man von den zwischenmenschlichen Beziehungen des Einzelnen ausgeht – Beziehungen, die nicht deterministisch bestimmt sind, sondern auf einer Gesamtbeziehung beruhen –, so wird der einzelne Mensch und sein gesamter Zustand überaus wichtig. Diese Denkweise bedeutet, dass bessere Kommunikation aus der Aufrechterhaltung besserer Binnenbeziehungen zwischen einem Element und seinem Ganzen erwächst. Professor Shimizu meint, dass gemeinsames Schaffen und Zusammenarbeit wichtiger sind als aggressiver Wettbewerb.

Ich habe nicht genug Platz zur Verfügung, um an dieser Stelle auf die Einzelheiten einer solchen Theorie einzugehen. In Bezug auf die Entwicklung der auf dem Netz und insbesondere der digitalen Technologie basierenden Kommunikation könnte diese Theorie jedoch für die künftige menschliche Kommunikation sehr wichtig sein. Dies ist scheinbar ohne ein explizites Bewusstsein von den zwischenmenschlichen Beziehungen im Osten geschehen. Deshalb habe ich von dieser Perspektive aus das klare Gefühl, dass die Ars Electronica bereits den ersten wirklich bedeutsamen Schritt zur Verbindung der Menschen untereinander gesetzt hat.

Zusammenfassend möchte ich nochmals betonen, dass die Entwicklung der Ars Electronica, wie eingangs erwähnt, nicht einfach auf die Entwicklung der Medientechnologie oder auf das digitale Netz zurückzuführen ist. Vielmehr ist sie einer anderen Art von Netz zu verdanken, das auf menschlichen Kontakten und Beziehungen

field and the inter relationship between one person and all peoples.

From Digital Thinking to Field Theory

Overestimating the merits of digital technology and its influential power has prevailed in the global community, especially in the belief in the power of computers. Within these trends, the body/senses aspect of human beings has been neglected or only superficially dealt with. There has been a decided lack of projects on developing theoretical thinking, which should include a consideration of the relationships between the self and the whole. In the mid 1970's, there was the beginning of such movements in the relationships between East and West, Science and Art, Taoism and in the theory of David Bohm. But recently, this way of thinking has almost been forgotten.

I have recently met with Professor Hiroshi Shimizu, who is a scientist and a philosopher. He has been working on the theory of BA, a field theory about the existence of individual people and the surrounding factors which affect them. His theory that interrelationships affect each person's identity seems to share the basic concept held by David Bohm. Maintaining the interpersonal relationships of each person, not influenced by determinism but based on a total relationship, means that each person and his/her whole condition become very important. This way of thinking maintains that better communication comes from keeping better inner-relationships between an element and its whole. He thinks that co-creation and collaboration are more important than aggressive competition.

I do not have enough space here to discuss the details of such a theory. But for the future development of communication based on the network, and especially that based on digital technology, this theory could be very helpful for future human communication. This has seemingly been done without the overtly conscious awareness of Oriental interpersonal relationships. Therefore, from this point of view, I feel strongly that Ars Electronica has already set the first real influential stage for connecting people with each other. In summary, as I mentioned at the beginning, the growth of Ars Electronica has not simply come from the development of media technology or from the digital network. It was brought

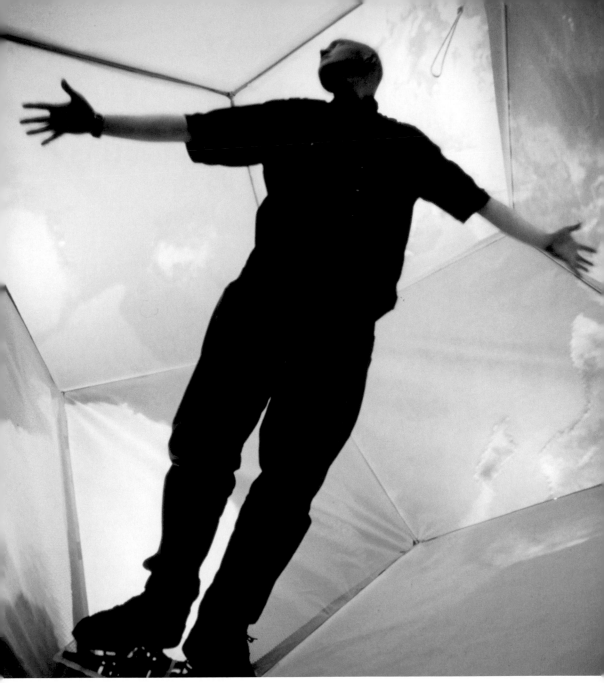

Ars Electronica 97 – Hiroo Iwata: „Garnet Vision"

zwischen dem Individuum und der Gesamtheit beruht. Ich hoffe, dass sich ein Interfeedback-System persönlicher Sympathie zwischen verschiedenen Menschen entwickelt und dass dieses System als künftiger Knotenpunkt fungieren wird, der eine Brücke zwischen Künsten und Wissenschaften schlagen und der Welt eine diversifizierte Kultur bringen wird.

about by another type of network based on human contact and interrelationships between one and the whole. I hope that an inter-feed-back system of personal sympathy between human beings will develop. It is also my hope that this system will function as a future node, bridging the arts and sciences as well as bringing diversified culture to the world.

Hans-Peter Schwarz

Entwicklungen der Medienkunst

Developments in Media Art

„Are our eyes targets?" Wenn in Lynn Hershmans Miniatur-Environment *Room of One's Own* diese Frage aufscheint, wird damit nicht nur ein neuer Akt im Drama jenes multimedialen Voyeurismus angekündigt, mit dem sich die Arbeit der kalifornischen Künstlerin so oft beschäftigt; die Frage, ob unsere Augen gewissermaßen militärische, jedenfalls strategische Ziele sein könnten, könnte man ohne weiteres als das Problem schlechthin beschreiben, um das es der Medienkunst in allen ihren Facettierungen wesentlich zu tun ist – ganz gleich, ob man ihren Gründungsvorgang kunstmarktpolitisch korrekt in jenem Wuppertaler Ereignis vom 11. März 1963 sieht, als der damals 31-jährige Nam June Paik in den Räumen der Galerie Parnaß sein *Electronic Television* (de-)konstruierte oder in dem interessanterweise etwa gleichzeitig entwickelten Scatch-Pad-Programm Ivan Sutherlands, durch das der Computer in die Welt der Ab-Bilder eindrang.

Und mit diesem Grundinteresse enden die Gemeinsamkeiten der beiden wichtigsten Medienkonzeptionen Video und Computer, vorerst, wenn sie auch seit den Achtzigerjahren längst im digitalen Schein miteinander verschmolzen sind. Denn als Nam June Paik 1963 in der Wuppertaler Galerie Parnaß seine ersten manipulierten TV-Geräte aufstellte, unter denen *Zen für TV*, das mit seinem auf einen vertikalen Streifen von weniger als einem Zentimeter komprimierten Fernsehbild die vielleicht wichtigste programmatischste Arbeit war, und als Wolf Vostell im gleichen Jahr in New York einen Fernseher bei laufendem Programm in die Erde versenkte, wurde ein gesellschaftliches Phänomen, das zuvor nur als Folie für die Polemik zwischen Elitekunst und Massenunterhaltung gedient hatte, endlich zum Aktionsfeld der bildenden Künstler: das Fernsehen. Auch wenn es sicherlich zu kurzsichtig ist, in diesen beiden Ereignissen so etwas wie die Geburtsstunde der Medienkunst zu sehen, wie es diejenigen Kunstkritiker gerne tun, die Medienkunst auf den Bereich der Videokunst reduzieren wollen,

"Are our eyes targets?" When this question appears in Lynn Hershman's Miniature Environment, *Room of One's Own,* it doesn't simply serve to introduce a new act in the play of that multimedia voyeurism that is so often a theme in the work of the Californian artist. The question whether our eyes could become military targets to a certain extent, but at any rate strategic targets, could be described, without any hesitation, as the problem with which media art in all its different facets is concerned, regardless of whether you perceive its beginnings art-market-politically correct in the Wuppertal Event on 11th March 1963, when the then 31 year-old Nam June Paik (de-) constructed his *Electronic Television* in the Galerie Parnaß, or in Ivan Sutherland's Scatch-Pad-Programme, that was interestingly enough developed at approximately the same time, and with which the computer penetrated the world of images.

And apart from this basic interest, the two most important media conceptions, video and computer, have nothing in common. For the time being at least, even if they have seemed to merge in digital appearance since the eighties. For when Nam June Paik set up his first manipulated television sets in the Galerie Parnaß in Wuppertal in 1963, including the *Zen for TV* with a television picture condensed into a vertical strip of less than one centimeter—perhaps the most important programmatic work, and when Wolf Vostell lowered a switched-on television into the ground in New York in the same year, a social phenomenon that had previously only served as a foil for the polemic between elite art and mass entertainment finally became the field of action of artists: the television.

Even if it is certainly too short-sighted to regard these two events as the birth of media art—as

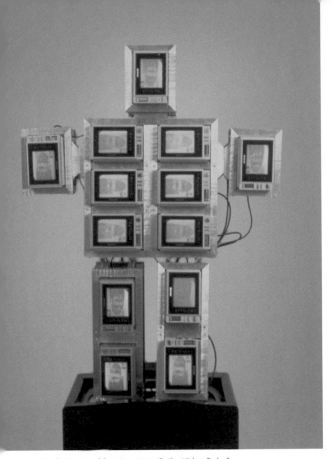

Ars Electronica 88 – Nam June Paik: „Video Baby"

zeigen die Ansätze von Paik und Vostell Gemeinsamkeiten, die ihre Ansätze erst einmal von denen der Künstler unterscheiden, die sich gleichzeitig mit dem Computer beschäftigen. Da ist vor allen Dingen die Aggression gegen die objektive Emanation des Fernsehens, den Monitor. Die Gestik der Zerstörung oder der Zweckentfremdung wird an Wolf Vostells frühen Dé-coll/agen, in denen er beispielsweise vorschlägt, Fernsehprogramme durch gegen den Monitor geworfene Sahnetorten zu sehen, ebenso deutlich wie an Wolf Kahlens verspiegelten Bildröhren, die den Raum des Betrachters zum Inhalt des Fernsehens machen, an Günther Ueckers vernagelten TV-Monitoren oder an Joseph Beuys' vielleicht bekanntester Auseinandersetzung mit dem Fernsehen, dem Filz-TV-Apparat von 1968, wo er einen Fernsehapparat mit seinem mit einer Filzfläche verkleideten Bildschirm gegen eine Wand richtet, auf der ebenfalls eine Filzfläche befestigt wurde. Diese überwiegend auf das Objekt TV-Gerät gerichtete Auseinandersetzung mit dem Medium Fernsehen hängt natürlich auch mit der Tatsache

those art critics who would like to reduce media art to the field of video art do, Paik's and Vostell's approaches have something in common that, for one thing, distinguishes their approaches from those of the artists that are simultaneously concerned with the computer. First and foremost is the aggression towards the objective emanation of the television, the monitor. The gestures of destruction or of misuse are just as evident in Wolf Vostell's early de-collages, where he suggested, for example, watching television shows through cream cakes that had been thrown at the monitor, as they are in Wolf Kahlen's mirrored picture tubes that make the room of the observer the contents of the television, in Günther Uecker's nailed up TV monitors, or in Joseph Beuys' perhaps most well-known examination of the television, the Felt TV Set from 1968, where he directed a television with a monitor covered with a felt surface at a wall that was likewise covered with a felt surface.

This examination of the medium of television, which focused mainly on the object TV set, is naturally connected with the fact that it was not possible for the artists to use the technical resources of the professional television companies. Things only changed when the Sony Company brought portable video equipment, the so-called Porter Pack, onto the market at a reasonable price in 1965. And it was no coincidence that Nam June Paik was one of the first people to buy one. In the same year he presented his do-it-yourself television in the New York Café à Go-Go. Completely new possibilities to elicit new language forms from the video medium now open up, and video art that at times completely dominates the public view of media art can develop. However, very different types of artist are interested in the development potential of the new medium video. There are musicians such as Nam June Paik or Steina Vasulka, who were influenced by the intermedia scene of the sixties, those influenced by pop art, or those influential artists such as Robert Rauschenberg or Oijvind Fahlström, who come across media tech-

zusammen, dass es für die Künstler nicht möglich war, die technischen Ressourcen der professionellen Fernsehanstalten zu nutzen. Dies ändert sich erst, als 1965 die Firma Sony eine tragbare Videoausrüstung, den so genannten Porter-Pack, zu einem erschwinglichen Preis auf den Markt brachte. Und nicht von ungefähr war Nam June Paik einer der ersten Käufer und präsentierte im gleichen Jahr sein Do-it-yourself-Fernsehen im New Yorker Café A Gogo. Jetzt eröffnen sich ganz neue Möglichkeiten, dem Medium Video auch neue Sprachformen zu entlocken und es kann eine Videokunst entstehen, die zeitweise das öffentliche Bild der Medienkunst insgesamt dominiert. Allerdings sind es sehr verschiedene Künstler, die an den Entwicklungsmöglichkeiten des neuen Mediums Video interessiert sind: Da gibt es Musiker wie Nam June Paik oder Steina Vasulka, die durch die Intermedia-Szene der Sechzigerjahre geprägt wurden, an Pop-Art geschulte oder diese bestimmende bildende Künstler wie Robert Rauschenberg oder Oijvind Fahlström, die durch ihr eher allgemeines Interesse an einer Erweiterung der künstlerischen Ausdrucksformen durch die banalen Gegenstände des Alltags auf die Medientechnologie stoßen, aber auch solche, denen die Medien ihre in der Happening- und Fluxus-Szene formulierten Konzepte realisieren oder dokumentieren helfen, die Arbeiten von Valie Export, dem schon erwähnten Wolf Vostell oder auch Otto Piene, der als Leiter des Center for Advanced Visual Studies in Boston allerdings bald gewissermaßen die Seiten wechseln wird.
Es gibt Site-specific Worker und Filmer wie Lynn Hershman oder Woody Vasulka oder die politisch motivierten Künstler wie Hans Hake oder Paul Garrin, für welche die neuen Medien, vor allem das Video, Mittel zum direkten Eingriff in gesellschaftliche Prozesse werden.
Vor allem die letztere Gruppe signalisiert einen Bruch, der sich durch die ganze Geschichte der Medienkunst hindurchzieht und auch heute noch, wenn auch abgeschwächt durch eine allgemeine politische Desillusionierung, spürbar ist: der Dissens zwischen Medienkünstlern und Medienarbeitern.
Auf die Politisierung der Medienarbeiter sind auch die vielen wichtigen, allerdings meist gescheiterten Versuche zurückzuführen, neue Organisations- und Verbreitungsmöglichkeiten zu finden, die geeignet sein sollten, die damals

nology via their more general interest in extending the range of artistic forms of expression using banal objects of everyday life. But there are also those who use the media to help them realize and document their concepts formulated in the happening and fluxus scene—the works of Valie Export, of Wolf Vostell, who has already been mentioned, or also of Otto Piene, who will, however, soon change sides to a certain extent as the Director of the Center for Advanced Visual Studies in Boston.
There are site-specific workers and film directors such as Lynn Hershman or Woody Vasulka, or politically motivated artists such as Hans Hake or Paul Garrin, for whom the new media, especially the video, are a means to directly intervene in social processes.

Ars Electronica 82 – Otto Piene: „Sky Art / Olympic Rainbow"

Ars Electronica 82 – Otto Piene: „Light Line Experiment"

relativ neue Technologie als Sprengsatz in die monolithe Massenmedienkultur hineinzutragen. Dazu gehören die Bestrebungen, günstige Sendezeiten in den Fernsehprogrammen zu bekommen ebenso wie die Entwicklung neuer Distributionsformen, unter denen das von 1982 bis 1991 erscheinende Videomagazin *Infermental* herausragt.

Es entstehen auch neue, selbstständige Institutionen wie die New Yorker Kitchen, wie Gerry Schumskohts liebige Fernsehgalerie oder die Versuche des WGBH-TV-Kanals in Boston, die Produktion und Präsentation der Videokunst auf eine neue, gesellschaftlich relevante Stufe heben sollten.

Allerdings erweist sich das Massenmedium Fernsehen, wie vorauszusehen, als äußerst resistent gegenüber diesen Versuchen, wenn auch eine ganze Reihe von ästhetischen Strukturen, unter denen die Entstehung des Musikvideos sicherlich die nicht unproblematischste ist, davon zeugen, dass die Videokunst durchaus wenigstens im ästhetischen Bereich ihren Einfluss auf das Massenmedium ausübte.

Im Wesentlichen aber entfaltete die frühe Videokunst ihre Wirkung auf speziellen Festivals und konnte sich im Betriebssystem Kunst erst behaupten, indem sie ihre „Museumsreife" mit einem Hang zum abgeschlossenen Werk erkaufte, gewissermaßen zur Videoskulptur oder zum Videoenvironment erstarrte.

Aufgefangen und weiter gespielt wurde der Ball der kritischen Medienauseinandersetzung, den die Videokunst auf ihre Flucht zurück ins Betriebssystem Kunst fallen gelassen hatte,

The last group in particular signalizes a break that can be traced through the history of media art and that, even today, albeit in a weaker form due to a general political disillusionment, can still be felt—the dissension between media artists and media workers.

The many important, but mostly failed attempts to find new organization and distribution forms that were suited to bring the then relatively new technology as an explosive device into the monolithic mass media culture were due to the politicization of the media workers. Among them, the efforts to get good transmission times in the television channels and the development of new distribution forms, including the video magazine *Infermental* that stands out and appeared between 1982 and 1991.

New, independent institutions are created, such as the New York Kitchen, Gerry Schumskoht's delightful television gallery or the attempts of the WGBH TV channel in Boston to raise the production and presentation of video art to a new, socially relevant level.

However, as to be expected, the mass medium television has proved to be extremely resistant to such attempts, even though a whole series of aesthetic structures, including the creation of the music video—which is certainly not the least problematic—show that video art definitely had an influence on the mass medium, at least in the aesthetic field.

Essentially, however, early video art developed its effect at special festivals, and was only able

gewissermaßen durch einige Künstler, Designer, Architekten, Ingenieure und Computerfachleute, die sich um Ausbildungszentren wie dem MIT-nahen Center for Advanced Visual Studies zentrierten oder um Ausstellungs- und Festivalereignisse wie Siggraph, Imagina und vor allem dem Prix Ars Electronica.

Interaktivität war das Schlagwort der Stunde. Und hier kam es gewissermaßen zu einem Paradigmenwechsel, der das gesamte Verhältnis von Kunst und Technologie in der Moderne veränderte.

Myron Krueger, selbst Pionier der interaktiven Medienkunst, hat in seiner Dissertation von 1983 schon darauf hingewiesen, dass eine ganze Reihe technologischer Entwicklungen, die das Konzept Multimedia seit den späten achtziger Jahren für die gesamte gesellschaftliche Kommunikationssphäre so bedeutend machten, in künstlerischen Problemlösungen ihre Ursache hatten, vom Datenhandschuh über das Head-mounted-Display bis zum projizierten Cyberspace.

Es ist also nicht länger das für die gesamte Moderne normative, pure Antiverhältnis zur Technologie, das dazu führte, dass sich die Künstler, mit wenigen, aber bedeutenden Ausnahmen, zu denen vor allem die von dem Ingenieur Billy Klüver und dem Künstler Robert Rauschenberg inspirierte E.A.T.-Gruppe (Experiments in Art Technology)

to assert itself in the operating system of art by paying for its "museum piece status" with a tendency towards the closed work, to become ossified, so to speak, as a video sculpture or a video environment.

The ball of critical media examination, which video art had dropped as it fled back to the operating system of art, was caught and passed on, as it were, by certain artists, designers, architects, engineers and computer specialists who gathered around training centers such as the Center for Advanced Visual Studies close to MIT, or around exhibition and festival events such as Siggraph, Imagina and, above all, the Prix Ars Electronica. Interactivity was the motto of the hour.

And it was here, so to speak, that a paradigm shift took place, which altered the entire relationship between art and technology in the modern age.

Myron Krueger, himself a pioneer of interactive media art, had already mentioned in his thesis from 1983 that the origin of a whole series of technological developments that had made the concept multimedia so important for the entire social communication sphere since the late eighties, lay in artistic solutions to problems—from the data glove through the head-mounted display to projected cyberspace.

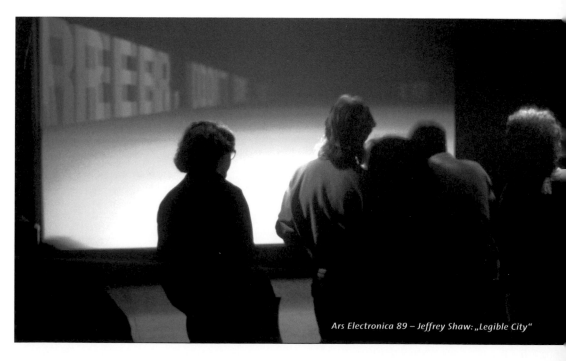

Ars Electronica 89 – Jeffrey Shaw: „Legible City"

Ars Electronica 98 – Granular Synthesis: „POL"

gehört, der Technik, wenn überhaupt, nur von außen näherten, und dann oft auch nur denjenigen Technologiekonzepten, die in der Industrieproduktion längst obsolet geworden waren. Interaktive Medienkünstler gehörten plötzlich zu den Erfindern und Entwicklern der Technologien selbst, versuchten wenigstens, ihre „Sprache" zu verstehen, um die künstlerische Technologiekritik quasi von innen neu und fundierter zu formulieren. Die Phase des „schamanistischen Handauflegens" der am wilden Denken eines Levi-Strauss geschulten Künstlergeneration war vorbei, wie es Beat Wyss neulich festgestellt hat; die Medienmacht erforderte eine ganz neue Professionalisierung auch der Künstler, wenn sie sich mit einiger Aussicht auf Erfolg mit ihr auseinandersetzen wollten.

Die Kunst, die so entstand und deren Bezeichnung als „interaktive Medienkunst" sicher nur ein Arbeitsbegriff sein kann, brach aber auch in anderer Hinsicht mit einem Paradigma der Moderne, mit ihrem „Reinheitsgebot".

Die neue Kunst ist eine „hybride Kunst, die mehr als nur die Fähigkeiten des Künstlers erfordert. Sie umfasst Fachgebiete, die in sich selbst hybrid sind: die Erkenntniswissenschaften und ihre neuronalen Netze, Biotechnik und ihre genetischen

So it is no longer the pure anti-relationship to technology, normative for the entire modern age, that caused the artists to approach technology, if at all, from the outside, and then often only those concepts of technology that had long been obsolete in industry production. There are just a few, but significant exceptions, which include the E.A.T. group (Experiments in Art Technology) that was inspired by the engineer Billy Klüver and the artist Robert Rauschenberg. Interactive media artists suddenly belonged to the inventors and developers of the technologies themselves, tried at least to understand their 'language' in order to formulate artistic technology criticism virtually from within, in a new and more sound manner. The phase of the "shamanistic laying on of hands" of a generation of artists influenced by the wild thoughts of a Levi-Strauss was over, as Beat Wyss recently put it. The media power demanded a totally new professionalization, of the artists as well, if they wanted to tackle it with some hope of success. Yet the art which in this way developed and whose description as media art can certainly only be a working concept, also broke with a paradigm of the modern age in another respect, with its "purity regulations".

Manipulationen, die Physik des Bewusstseins", bringt Roy Ascott diesen neuen, ganz und gar unmodernen Ansatz auf den Punkt.

Wenn man die durch Computertechnologie ermöglichte Interaktion als kleinsten gemeinsamen Nenner dieser Phase der Medienkunst nehmen will, so lassen sich anhand der hier wirksamen Technologiekonzepte vier unterscheidbare ästhetische Strategien herausarbeiten, die sich zwar überschneiden, in ihren Interaktionsangeboten aber deutlich voneinander geschieden sind: Das interaktive Video, die Echtzeit-Interaktion, die telematische Interaktion und die Augmented-Reality-Interaktion.

Zur auch zeitlich gesehen ersten Gruppe gehören die von den „Erfindern" der Videodisc entwickelten *Movie Maps*, 1978/79 von der Architectural Machine Group um Nicholas Negroponte am MediaLab des MIT projektiert.

Kunsthistorisch bedeutsam sind diese von Jeffrey Shaw treffend als „Virtual Voyaging" beschriebenen Eingriffsmöglichkeiten in die Zweidimensionalität der Produktion vor allen Dingen deshalb

The new art is a "hybrid art that demands more than just the skills of the artist. It covers specialist areas that are themselves hybrid—the cognitive sciences and their neuronal nets, biotechnology and its genetic manipulations, the physics of awareness", as Roy Ascott put his finger on the point of this completely non-modern approach.

If one was to take the interaction made possible by computer technology as the lowest common denominator, four distinct aesthetic strategies can be distinguished from the technological concepts at work here, which, despite some overlapping, are clearly separate from each other in their interaction offerings—the interactive video, real-time interaction, telematic interaction and augmented reality interaction.

The *Movie Maps*, developed by the "inventors" of the video disc and projected 1978/79 by the Architectural Machine Group around Nicholas Negroponte in the MediaLab of the MIT, belong to the first group, which was also chronologically the first group.

Prix Ars Electronica 99 – Lynn Hershman: „Difference Engine#3" (Goldene Nica Interaktive Kunst)

Prix Ars Electronica 90 – Myron Krueger: „Videoplace" (Body-Surfacing, Goldene Nica, Interaktive Kunst)

geworden, weil sie eine radikale Veränderung in der Zeitstruktur des Bildes ermöglichen. Die Entwicklung vom Raumbild zum Zeitbild, die Gilles Deleuze überzeugend als die zentrale Entwicklung in der Bildvorstellung der Moderne insgesamt beschrieben hat, wird gewissermaßen umgedreht, zumindest angehalten.

Neben der von Otto Piene 82/83 am CAVS herausgegebenen *Center Disc* und *Sky Disc* und der von der Film- und Videogruppe am MediaLab des MIT herausgebrachten *Elastic Movie Disc,* an der auch Künstler wie Bill Seaman und Luc Courchesne beteiligt waren, war die erste künstlerische Umsetzung der Möglichkeiten des interaktiven Video Lynn Hershmans *Lorna-Installation.*

Lorna ist, und diese „kunstferne" Wurzel hat der interaktiven Medienkunst kapitale Missverständnisse eingetragen, ein künstlerisches Video-Spiel, das allerdings keinen agonalen oder teleologischen Charakter hat, wie er kommerziellen Videospielen eigen ist. Der Benutzer der Installation kann in die Erzählung eingreifen, kann die Geschichte einer jungen, klaustrophobischen Frau auf unterschiedliche Weise zusammensetzen, ist aber, wie Söke Dinkla sehr schön herausgearbeitet hat, in einem Circulus vitiosus gefangen, da ihm dieselben medialen Zwänge auferkroyiert werden wie der Protagonistin des interaktiven Kunststücks.

The possibilities of intervention in the two-dimensionality of production, described so aptly as Virtual Voyaging by Jeffrey Shaw, have become significant for art history primarily because they allow a radical change in the time structure of the image. The development from 3-D picture to time picture, which Gilles Deleuze has convincingly described as the main development in the conception of the picture in the modern age as a whole, is turned around so to speak, or at least put on hold.

The first artistic implementation of the possibilities of the interactive video, alongside Otto Piene's *Center Disc* and *Sky Disc,* produced at CAVS 82/83, and the *Elastic Movie Disc,* produced by the film and video group at the MediaLab of MIT—in which artists such as Bill Seaman and Luc Courchesne were also involved, was Lynn Hershman's *Lorna Installation.*

Lorna is—and these "artistically-distant" roots have led to major misunderstandings of interactive media art, an artistic video game that lacks, however, the agonal or teleological character of commercial video games. The user of the installation can intervene in the story and put together the history of a young, claustrophobic woman in different ways, but is, however, caught in a vicious circle, because the same media

Von *Lorna* aus vollzieht sich die Entwicklung zu etwas, was man als „Interactive Cinema" bezeichnen könnte und für das Künstler wie Graham Weinbren mit *Earl King* und *Sonata* oder Jill Scott mit ihrer großen Trilogie *Machine Dreams / Frontiers of Utopia* und *Body Automata* stehen. Die Weiterentwicklung der interaktiven Videoerzählung durch das Medium der CD-ROM scheint mir im Wesentlichen in den Ansätzen stecken geblieben zu sein. In die Gruppe der Echtzeit-Interaktion fallen vor allem die technisch aufwändigen, mit Reality Engines betriebenen Großinstallationen. Als Pioniertat gehören Myron Kruegers *Videoplace* dazu, Jeffrey Shaws *Legible City* oder David Rokebys *Very Nervous System,* später dann auch die Experimente von Char Davies. Allen gemeinsam ist – und deswegen vielleicht sind die Echtzeit-Interaktionen auf besondere Weise „museumsreif" geworden – dass sie den ganzen Körper des Benutzers als Handlungsinstrument nutzen, um in den von ihnen geschaffenen Cyberspace zu gelangen.

In diesem Sinne sind vielleicht die wenigen künstlerisch akzeptablen CAVE-Installationen die konsequente Weiterentwicklung dieses Ansatzes. Während die Echtzeit-Interaktionen ihre kunsthistorischen Wurzeln in Performance, Aktionismus oder gar Fluxus hatte, kann die telematische Interaktion ihre Herkunft aus der Communication Art nicht leugnen.

Das Werk Paul Sermons, der nicht umsonst bei Roy Ascott studiert hat, gibt einen Weg vor, der mehr oder weniger direkt in die aktuelle Web-Art führt oder zumindest in einen bestimmten Bereich der auf Vernetzung angewiesenen Kunstformen. Für die Augmented-Reality-Interaktion, der es darum geht, die Transition zwischen realen und virtuellen Wirklichkeiten zu erproben, kann wieder eine Installation Lynn Hershmans als Paradigma dienen: ihre *Difference Engine #3,* die 1999 mit der Golden Nica für interaktive Kunst ausgezeichnet wurde.

In dem noch relativ wenig erprobten Bereich der Augmented-Reality-Interaktion entstehen für mich gegenwärtig die vielleicht spannendsten und künstlerisch überzeugendsten Experimente der Medienkunst insgesamt. Masaki Fujihatas *Nuzzle Afar* gehört beispielsweise dazu, eine Installation, die gegenwärtig als Prototyp des ENCART-Projektes fungiert, in dessen Rahmen die wichtigsten europäischen Medienzentren zu einem virtuellen Multimedialabor vernetzt wer-

constraints imposed upon the protagonist of the interactive work of art are also imposed upon the user—as Söke Dinkla has so nicely shown. The development continues from *Lorna* to something that could be described as "Interactive Cinema", represented by artists such as Graham Weinbren with *Earl King* and *Sonata* or Jill Scott with her great trilogy *Machine Dreams/Frontiers of Utopia* and *Body Automata*. The further development of the interactive video story through the medium of CD-ROM seems to me to have essentially remained in the initial stages.

The technically extravagant big installations powered by Reality Engines primarily fall in the group of real-time interaction. Myron Krueger's *Videoplace* belong here as a pioneering feat, as do Jeffrey Shaw's *Legible City* or David Rokeby's *Very Nervous System,* and then later the experiments by Char Davies. What they all have in common—and perhaps this is why the real-time interactions have become "museum pieces" in a special way—is that they use the entire body of the user as an instrument of action to reach the cyberspace that they have created.

In this sense the few artistically acceptable CAVE installations may represent the logical development of this approach.

Whereas real-time interactions had their art history roots in performance, actionism, or even fluxus, telematic interaction cannot deny its Communication Art origins.

The work of Paul Sermon, who didn't study with Roy Ascott for nothing, professes a way that leads more or less directly to the latest Web Art, or at least to a particular field of the network-dependent art forms.

For 'augmented reality interaction', which is concerned with testing the transition between real and virtual realities, another of Lynn Hershman's installations can serve as an example:— her *Difference Engine #3,* which has only this year been awarded the Golden Nica for Interactive Art.

It is in the still barely tested field of augmented reality interaction that, in my eyes, the perhaps most exciting and artistically convincing experiments of media art as a whole are taking place. One example here is Masaki Fujihata's *Nuzzle Afar,* an installation that is currently serving as a prototype of the ENCART project, in the scope of which the most important European media cen-

Ars Electronica 1993 – Karl Sims: „Genetic Images"

den sollen, oder Perry Hobermans *System Mainte-nance,* um nur einige Beispiele zu nennen.

Aber die Zukunft gehört sicherlich dem, was gegenwärtig noch etwas unscharf als Web-Art bezeichnet wird. Die auf Reality Engines angewie-senen Großinstallationen mit ihren nur für eine relativ begrenzte Zahl von Künstlern zugänglichen High-Tech-Komponenten wirken schon fast wie Saurier – eine junge Generation von Medienkünst-lern ist weniger daran interessiert, die technologi-schen als vielmehr die kommunikativen Möglich-keiten des Cyberspace auszuloten.

Interessanterweise begegnen sich so die neueste Experimentierphase der Medienkunst und die frühe Videokunst. Damit ist die Medienkunst aber noch keineswegs am Ende, wenn auch ihre heroische Phase mit ihrer Lust am Hich-Tech-Experiment zu einem gewissen Abschluss ge-kommen zu sein scheint.

Vielleicht wird die Medienkunst zum Beginn des nächsten Jahrhunderts in eine Phase eintreten, in der sie, befreit vom Zwang sich dem rasanten Ent-wicklungstempo der Medientechnologieindustrie unterwerfen zu müssen, sich wieder mehr auf das ästhetische Experiment konzentrieren kann.

tres will be networked to a virtual multimedia laboratory. Another example is Perry Hober-man's *System Maintenance.*

But the future will surely belong to what is presently still described somewhat fuzzily as Web Art. The big installations dependent upon Reality Engines, with their high-tech compo-nents that are only accessible to a relatively limited number of artists, already appear almost like dinosaurs. The new generation of media artists is more interested in plumbing the depths of the communicative possibilities of cyberspace than the technological possibilities. Interestingly enough the most recent experi-mental phase of media art and early video art meet each other here. But this is by no means the end of media art, even if its heroic phase with its love for high-tech experiments seems to have come to a certain end.

Maybe media art will enter a new phase at the beginning of the next century in which, freed from the obligation to subject itself to the rapid pace of development of the media technology industry, it can once more concentrate on the aesthetic experiment.

PART II

SEIT 1979 IST ARS ELECTRONICA EINE IN IHRER SPEZIFISCHEN AUSRICHTUNG UND LANGJÄHRIGEN KONTINUITÄT WELTWEIT EINMALIGE PLATTFORM FÜR DIGITALE KUNST UND MEDIENKULTUR, DIE VON VIER SÄULEN GETRAGEN WIRD.

FESTIVAL ARS ELECTRONICA

Interdisziplinarität und die offene Begegnung internationaler Experten aus Kunst und Wissenschaft mit einem breiten interessierten Publikum charakterisieren das international renommierte Festival Ars Electronica. Seit 1979 widmet es sich jährlich in Symposien, Ausstellungen, Performances und Events den künstlerischen und wissenschaftlichen Auseinandersetzungen um die gesellschaftlichen und kulturellen Phänomene, die aus dem technologischen Wandel hervorgehen.

The essence of the internationally renowned Ars Electronica Festival is interdisciplinarity and an open encounter of international experts from the arts and sciences with a broad audience of highly diverse backgrounds and interests. Annually since 1979, the Festival has featured a lineup of symposia, exhibitions, performances and events designed to further an artistic and scientific confrontation with the social and cultural phenomena that are the consequences of technological change.

PRIX ARS ELECTRONICA

Als weltweit wichtigster Wettbewerb für Cyber-Arts bietet der Prix Ars Electronica seit 1987 ein Forum für künstlerische Leistungen und Innovationen. Er ist Trendbarometer einer expandierenden und sich zunehmend diversifizierenden Medienkunstwelt. Dank der jährlichen Frequenz, der internationalen Reichweite und der Fülle der eingereichten Projekte ermöglicht das gewaltige Archiv des Prix Ars Electronica detaillierte Einblicke in die Entwicklung der Medienkunst, in ihre Offenheit und Vielfalt.

As the world's premier cyberarts competition, the Prix Ars Electronica has been a forum for artistic creativity and innovation since 1987. It is the trend barometer in an ever-expanding and increasingly diversified world of media art. Thanks to its annually recurring nature, its international scope and the incredible variety of the works submitted for prize consideration, the enormous Prix Ars Electronica Archive provides a detailed look at the development of media art and a feel for its openness and diversity.

WITH ITS SPECIFIC ORIENTATION AND THE
LONG-STANDING CONTINUITY IT HAS
DISPLAYED SINCE 1979, ARS ELECTRONICA
IS AN INTERNATIONALLY UNIQUE PLATFORM
FOR DIGITAL ART AND MEDIA CULTURE
CONSISTING OF FOUR DIVISIONS.

ARS ELECTRONICA CENTER

Das 1996 eröffnete Ars Electronica Center stellt den Prototyp eines „Museums der Zukunft" dar. Mit seinen interaktiven Vermittlungsformen, mit Virtual Reality, digitalen Netzwerken und modernen Medien wendet es sich an ein breites Publikum. Themenstellungen zwischen Medienkunst, neuen Technologien und gesellschaftlichen Entwicklungen prägen den innovativen Charakter der Ausstellungen. Das Ars Electronica Center ist darüber hinaus permanente Basis und somit organisatorisches Fundament der internationalen und regionalen Aktivitäten von Ars Electronica.

The Ars Electronica Center opened in 1996 as a prototype of a "Museum of the Future." Its mission is to utilize interactive forms of mediation to facilitate the general public's encounter with virtual reality, digital networks and modern media. A focus on issues at the interface of media art, new technologies and social developments characterize the Center's innovative exhibitions. Beyond this, the Ars Electronica Center is the permanent base and thus the organizational foundation of Ars Electronica's regional and international activities.

ARS ELECTRONICA FUTURELAB

Das Futurelab ist das Modell eines Medienkunstlabors neuer Prägung, bei dem sich künstlerische und technologische Innovation wechselseitig inspirieren. Die Teams des Labors vereinigen unterschiedlichste Fachrichtungen und sind in ihrer Arbeitsweise durch Transdisziplinarität und internationale Vernetzung geprägt. Konzeption und Realisierung von Ausstellungsprojekten, künstlerische Installationen sowie Kooperationen mit Universitäten und der Privatwirtschaft bilden das breite Spektrum der Aktivitäten.

The Futurelab is a model of a new kind of media art laboratory in which artistic and technological innovations engender reciprocal inspiration. The lab's teams bring together a wide variety of specialized skills; their approach is characterized by interdisciplinarity and international networking. The Futurelab's wide-ranging activities include designing and engineering exhibitions, creating artistic installations, as well as pursuing collaborative research with universities and joint ventures with private sector associates.

THE GOLDEN NICA
GODDESS ON A NEW COURSE?

DIE GOLDENE NICA
GÖTTIN AUF NEUEN WEGEN?

CHRISTINE SCHÖPF

Die Nike von Samothrake, geschaffen um 190 v. Chr. von Bildhauern aus Rhodos, ist ein Meisterwerk griechischer Kunst. Seit 120 Jahren steht sie im Aufgangsbereich des Pariser Louvre und gehört neben der Venus von Milo zu den Hauptattraktionen des Museums. Ihr ursprünglicher Standort am obersten Punkt des samothrakischen Heiligtums gleicht einem Fanal: die Göttin mit wehendem Mantel am Bug eines Schiffes, das sie im Sturm zum Sieg führt – die Nike von Samothrake ist das Siegessymbol kämpferischer Schlachten schlechthin.
Gut 2000 Jahre später, 1986/87, denken wir – Hannes Leopoldseder, Grafiker Hansi Schorn und ich – über eine Trophäe nach: Die Idee des Prix Ars Electronica war gerade geboren, jetzt geht es darum, wie der Preis aussehen könnte. Kinetisch? Technologisch? Modern(istisch)? Irgendwie interaktiv? Nein – es sollte in den stürmischen Zeiten der digitalen Revolution ein

Nike of Samothrace, created at about 190 B.C. by sculptors on the island of Rhodes, is a masterpiece of Greek art. For 120 years, it has stood in the entrance hall of the Louvre in Paris where, along with the Venus de Milo, it is one of the museum's main attractions. Its original location at the zenith of the Samothracian shrine suggests the role of a figurehead—the goddess with her windblown outer-garment posed on the bow of a ship that she leads on through the storm to victory. Nike of Samothrace is the victory symbol par excellence of fierce battles.
A good 2,000 years later, in 1986—87, Hannes Leopoldseder, graphic artist Hansi Schorn and I were thinking about a trophy. The idea of the Prix Ars Electronica had just been born, and now it was time to give some thought to what the prize would look like. Kinetic? Technological? Modern(istic)? Somehow interactive? No—in the stormy days of the digital revolution, it had to be a symbol of

Siegessymbol von ähnlich barocker Schönheit und mit Bestand sein. Die letzte Silbe von „ Ars Electronica" – NICA – und der Name der Siegesgöttin – NIKE – passen akustisch wie visuell fast zu gut zueinander – die Goldene Nica ist geboren. Ein neuer Wettbewerb, ausgeschrieben vom ORF Oberösterreich, der seit 1979 Motor für die Gründung und Weiterentwicklung von Ars Electronica ist, hat seine Trophäe. Diese Trophäe des Prix Ars Electronica, der ab 2004 vom Ars Electronica Center organisiert wird, wandelt sich im Lauf der Jahre zum Oscar der vorerst elektronischen und mittlerweile digitalen Künste.

Will man die Idee des Prix Ars Electronica bei seiner Geburtsstunde 1987 verstehen, so muss man die Uhr der digitalen Entwicklung zurückdrehen: Rund zehn Jahre davor hatte der erste PC von Silicon Valley aus seinen Siegeszug um die Welt angetreten; 20 Jahre davor hatte die E.A.T.-Gruppe rund um Robert Rauschenberg das Thema Kunst und Technologie erstmals artikuliert; 30 Jahre vorher begann die Künstliche-Intelligenz-Forschung, und 35 Jahre davor hatte der damalige Großrechner UNIVAC entgegen aller Expertenmeinungen das richtige Ergebnis bei den amerikanischen Präsidentenwahlen (Eisenhower) prognostiziert. Der Computer hatte also begonnen, unser Leben kräftig zu verändern. 1987 ging man von 100 Millionen arithmetischen Schritten in der Sekunde und einer Schätzung von weltweit 1 Milliarde Computer aus. Die schnellsten heutigen Parallelrechner arbeiten im Teraflop-Bereich (10^{12} Fließkommaoperationen in der Sekunde), während Wissenschaftler sich bereits Rechner im Petaflop-Bereich vorstellen. Der Computer ist längst nicht mehr neues Medium (im Sinne von Marshall McLuhan), sondern Alltagstechnologie.

Wenn aber Computer in den vergangenen Dekaden unsere Sicht der Welt und unser Verständnis von Kommunikation und Umgang mit Wissen entscheidend verändert haben, dann auch deshalb, weil Künstler, Wissenschaftler und Forscher weltweit dazu ihre Beiträge geleistet und damit die Entwicklungsschraube weiter gedreht haben. Als Treffpunkt war der Prix Ars Electronica ein Fokus dafür.

Auf dem Weg zu einer neuen Kulturtechnik haben Persönlichkeiten und Institutionen Geschichte geschrieben – hier ist eine Auswahl:

triumph of almost baroque beauty and timelessness. The final syllable of Ars Electronica—NICA—and the name of the goddess of victory—NIKE—went together visually and acoustically—were almost too good a match—and the Golden Nica was born. This was to be the trophy for a new competition launched by the ORF-Upper Austria, since 1979 the driving force behind the founding and ongoing development of Ars Electronica. This trophy for the Prix Ars Electronica—which, for the first time in 2004, is being organized by the Ars Electronica Center—has, over the years, become the Oscar of, initially, electronic, and, subsequently, digital art.

If we wish to understand what the idea of the Prix Ars Electronica meant at the hour of its birth in 1987, then we have to turn back the clock of digital development. Approximately 10 years before, the PC left Silicon Valley and began its triumphal progress around the world; 20 years before, the E.A.T. group centered around Robert Rauschenberg articulated the theme of art and technology for the first time; 30 years before, research into artificial intelligence began; and 35 years before, UNIVAC, the biggest mainframe of its day, defied all expert opinions and correctly predicted the result of an American presidential election (Eisenhower). Thus, the computer had begun to significantly change our lives. In 1987, we proceeded on the basis of 100 million arithmetical operations per second, and an estimated 1 billion computers worldwide. Today's fastest parallel computing operations are capable of teraflop (10^{12} floating-point operations per second) speeds, and scientists have already begun to envision computers operating at petaflop speeds. The computer has long since ceased to be a new medium (in Marshall McLuhan's sense) and has instead become the technology of everyday life.

But if, over recent decades, computers have decisively changed our view of the world and our understanding of communication and how to deal with knowledge, then one of the reasons for this is that artists, scientists and researchers around the world have contributed to this undertaking and kept the wheels of progress turning ever further. As a meeting place for all those involved, the Prix Ars Electronica has been a focus of this.

Prix Ars Electronica 2003, Romain Segeaud, Christel Pougeoise: „Tim Tom", Goldene Nica Computer Animation/Visual Effects

Prix Ars Electronica 2003, Tippett Studio: „3D Character Animation for Blockbuster Entertainment", Anerkennung Computer Animation/Visual Effects

Eine bestaunte Animation der jungen kalifornischen Spin-off-Firma von Lucas-Film, PIXAR, war 1986 *Luxo Jr.* von John Lasseter – heute im Vorspann sämtlicher Blockbuster des mittlerweile zu Hollywoodformat angewachsenen Unternehmens. Geduldig bot der damals nur in Insiderkreisen bekannte John Lasseter 1987 den Hollywood- und Kapitalismus-Attacken von Peter Weibel und Konsorten in den Künstlergesprächen Paroli.

Along the path to a new cultural technique, history has been written by personalities and institutions. Here, a selection. A much-admired work of animation by what was then a young California company named PIXAR, a spin-off of Lucas Films, is *Luxo Jr.* This 1986 computer animation by John Lasseter can be spotted today in the opening credits of every blockbuster released by that studio, which has since grown to Hollywood proportions. In the 1987 Prix Ars Electronica

1996

1997

1999

Prix Ars Electronica Künstlerforum 1993: Michael Tolson, Char Davies, Karl Sims, Peter Weibel, Pascal Roulin, Daniel Barthelemy (Bériou), Darrin Butts, Mark Malmberg.

Prix Ars Electronica Verleihung der Goldenen Nicas:
1988: *Dennis Smalley, Konrad Zuse, John Lasseter und Sohn, Walter Wolfsberger, David Sherwin*
1990: *Myron Krueger, LH Josef Ratzenböck*
1993: *Christian Hübler/Knowbotic Research, Michael Tolson, Pascal Roulin, Bernard Parmigiani*
1996: *Masaki Fujihata, Robert Normandeau, Pete Docter/Pixar, etoy.agent*
1997: *Ryuichi Sakamoto, Toshio Iwai*
1999: *Aphex Twin (Richard D. James) und Chris Cunningham, LH Josef Pühringer*

Peter Gabriel, Experimentator, Demokratieverfechter und dementsprechend späterer MP3-Hero, erhielt eine Goldene Nica. Jury-Vorsitzender und Mitentwickler des Prix Ars Electronica, Jean-Baptiste Barrière, erkannte bereits, dass die zweite Hälfte der 80er Jahre vom unaufhaltsamen Aufstieg der PCs gekennzeichnet sein werde. Seine Vision wird Jahre später durch die Umbenennung der Kategorie Computermusik in Digital Musics Realität und in Zusammenarbeit

Forum, John Lasseter—then a name familiar only to industry insiders—patiently parries the attacks on Hollywood and capitalism launched by Peter Weibel and consorts.

Peter Gabriel, the experimenter and advocate of democracy who would, appropriately, go on to be the hero of MP3, receives a Golden Nica. Jean-Baptiste Barrière, jury foreman and co-developer of the Prix Ars Electronica, already recognizes that the second half of the '80s would be characterized by the inexorable ascent of the PC. His visions would become reality years later with the reformulation of the Computer Music category into Digital Musics which was done with the help of the American composer, musician and producer Naut Humon.

Over the years, young artists with a lust for experimentation, software developers and provocateurs have showcased their concepts at the Prix Ars Electronica right alongside the grandees of media art. Here, new careers have been launched and the paths of established artists have meshed with digital thinking and creating to engender new concepts.

In 1990, the competition's original lineup—Computer Animation, Computer Graphics and Computer Music—is complemented by a new Interactive Art category, the Prix Ars Electronica's official acknowledgment of this emerging artform. The role of the artist as the sole creator of an artwork is called into question in radical fashion. Hypertext, CD-ROM and Laserdisc come forth as the formats with the most promising future prospects. The viewer/participant becomes an artistic parameter. *Videoplace* by Myron Krueger, pioneer and guiding intellectual force in the field of Artificial Reality, is the first prizewinner in this new category and, together with Jeffrey Shaw's *Legible City*, provides an introduction to the new cultural technique of interactivity.

In 1995, the networks begin to function—thanks to Tim Berners-Lee and the World Wide Web. We cross the threshold into globality and are at large in network-linked worlds. Nicholas Negroponte's book "Being Digital" opens our eyes to the vision of the new digital world—the cufflink as personal computer. The Prix Ars Electronica recognizes the signs of the times and wants to be the focal point. Experts and jury members in the newly established Net category debate how to sum up

mit dem amerikanischen Komponisten, Musiker und Produzenten Naut Humon umgesetzt.
Junge experimentierfreudige KünstlerInnen, EntwicklerInnen und ProvokateurInnen legen im Lauf der Jahre beim Prix Ars Electronica ihre Konzepte ebenso vor wie die Granden der Medienkunst. Neue Karrieren nehmen hier ihren Anfang, die Wege etablierter Künstler vernetzen sich mit digitalem Denken und Gestalten zu neuen Konzepten.
1990 kommt zu den ersten Kategorien des Wettbewerbs – Computeranimation, Computergrafik und Computermusik – die neue Kategorie Interaktive Kunst. Der Prix Ars Electronica trägt damit einer neu aufkommenden Kunstform Rechnung. Die Rolle des Künstlers als alleiniger Schöpfer des Kunstwerks wird radikal in Frage gestellt. Hypertext, CD-ROM und Laserdisc sind die scheinbar zukunftsträchtigen neuen Formate. Der Zuschauer/Teilnehmer wird zum künstlerischen Parameter. Myron Krueger, ein Pionier und Vordenker der Artificial Reality, ist mit *Videoplace* erster Preisträger der neuen Kategorie und unterweist uns gemeinsam mit Jeffrey Shaw *(Legible City)* in der neuen Kulturtechnik Interaktivität.
1995 beginnen die Netzwerke zu funktionieren – Tim Berners-Lee und dem World Wide Web sei Dank. Wir bewegen uns in global vernetzten Welten; Nicholas Negroponte führt uns die Vision der neuen digitalen Welt mit seinem Buch *Being Digital* vor Augen – der Manschettenknopf wird zum PC. Der Prix Ars Electronica erkennt die Zeichen der Zeit und will Fokus sein. Experten und Jury der neu gegründeten Netzkategorie diskutieren, wie die Netzwelt auf einen Punkt zu bringen sei: Community Forming, Virtual Identity, Social Impact, Artistic Merit sind einige der Kriterien, die zur Diskussion stehen.

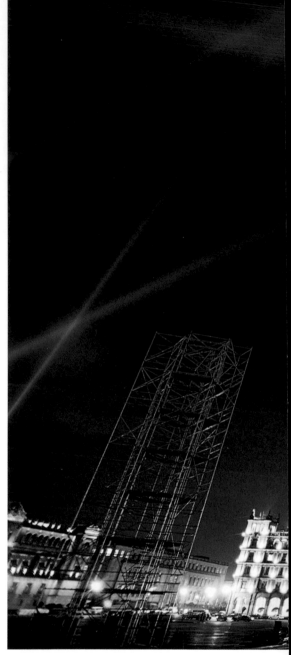

this networked world in a nutshell: community forming, virtual identity, social impact and artistic merit are a few of the criteria that come up for discussion.
Meanwhile, the under-19 cohort was increasingly emerging as a source of creative potential for innovators in the private sector. They are the advance elements of a generation that has grown up with the computer. The motto is "freestyle":

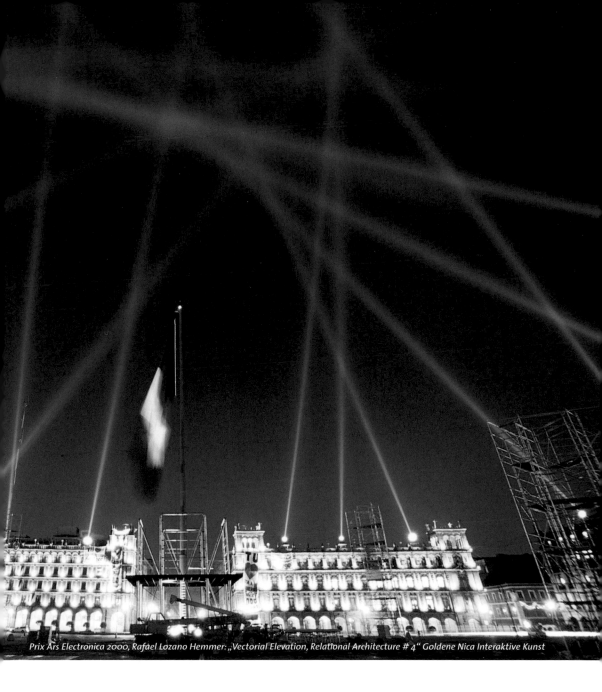

Prix Ars Electronica 2000, Rafael Lozano Hemmer: „Vectorial Elevation, Relational Architecture # 4" Goldene Nica Interaktive Kunst

Gleichzeitig werden die Unter-19-Jährigen zunehmend zum Kreativpotenzial für innovative Wirtschaftsbetriebe. Sie sind die ersten Vorboten einer Generation, die mit dem Computer aufgewachsen ist. Das Motto ist Freestyle: Mache, was du willst, entscheide selbst, was du tust; zeige, was du mit dem Computer kannst. Der Prix Ars Electronica lädt die Jung-Pioniere der Cybergeneration ein, mit ihren Ideen am Wettbewerb teil-

do what you want, decide for yourself what to do, but show what you can do with the computer. The Prix Ars Electronica now extends an invitation to the young pioneers of the cybergeneration to submit their ideas for prize consideration —and the "cybergeneration – u19 freestyle computing" category is born. Up-and-coming creatives have been showing us what it's all about ever since!

zunehmen – die Kategorie „cybergeneration – u19 freestyle computing" ist geboren. Junge Kreative zeigen seither, wo es lang geht!
Digital Communities – die Plattform für engagierte soziale, politische und kulturelle technologiegestützte Projekte – kommt 2004 als neuer internationaler Showcase zum Prix Ars Electronica. Und wiederum gibt der Erfolg vom Start weg den Veranstaltern recht. [the next idea] als Ideenwettbewerb für junge Menschen zwischen 19 und 27 Jahren, also für die Altersgruppe zwischen u19 und dem „großen" Prix Ars Electronica, ist eine zusätzliche Investition ins Potenzial jugendlicher Kreativer – und zwar weltweit.
Und das ist die Situation in den ersten Jahren des Millennium III: Die Werkzeuge der Informationsnomaden des 21. Jahrhunderts sind wireless, mobil und allgegenwärtig. Über immer komplexere Datennetze werden mittels immer kleinerer und benutzerfreundlicherer Hard- wie auch Software massive Datenpakete transportiert. Die im Hype der 1990er Jahre von Vordenkern prognostizierte Entwicklung geht scheinbar ungebremst weiter. Dem gegenüber standen ab den späten 1990er Jahren weltweit ruinöse Talfahrten noch kurz davor boomender Paradeunternehmen, zurückhaltende Investoren und sich im Sand verlaufende Erfolgsstories. Wird aus dem opimistischen „Going Digital" eine resignative „Going Nowhere"-Haltung? Sind wir jetzt also in einer Sackgasse gelandet?
Bei Ars Electronica 1980, also zu einer Zeit, in der in der Welt der digitalen Medien alles möglich schien, meinte der Visionär und zugleich auch Skeptiker Joseph Weizenbaum sinngemäß, dass wir erst unsere Wünsche kennen müssten, um jene Tools zu entwickeln, mit Hilfe derer wir diese verwirklichen können. Weltweit entwickeln, forschen und gestalten Künstler, Wissenschafter und Experten abseits vom industriellen Mainstream; sie nehmen alternative Positionen ein, hinterfragen das Medium an sich und leiten den aktuellen Diskurs von der Ist- auf eine Kann- und Soll-Ebene. Und genau für Letztere ist der Prix Ars Electronica seit 1987 die jährliche Einladung, sich mit ihren Arbeiten einer über Ateliers und Labors hinausgehenden Öffentlichkeit zu präsentieren. Genau 28.213 Einreichungen aus 85 Ländern sind seit Bestehen dieses Wettbewerbs für Cyberarts eingelangt. Professionisten aus Kunst, Wissen-

Digital Communities, the platform for projects that are utilizing technology as a means of channeling social, political and cultural commitment, was the international showcase added to the Prix Ars Electronica in 2004. Once again, success right out of the blocks confirms the astuteness of the organizers' judgment.
[the next idea] competition for concepts submitted by artists age 19 to 27—i.e. the interim years between the u19 age group and the Prix Ars Electronica for the "big boys and girls"—is another investment in the potential of young creatives—throughout the world.
Which brings us to the situation at the outset of Millennium III. The tools of the information nomads of the 21st century are wireless, mobile and omnipresent. Massive packets of information are transported across ever-more-complex data networks by means of increasingly compact and user-friendly hardware and software. The developments prognosticated by pioneering thinkers in the hype of the '90s seem to be proceeding unabated.
They provide a stark contrast to other global trends since the late '90s: the disastrous nosedives of what shortly before had been booming industry leaders, the hesitancy shown by investors, and the success stories that have come to unhappy endings. Is the optimism of "Going Digital" turning into a resigned "Going Nowhere" attitude? Have we now arrived at a dead end?
At the 1980 Ars Electronica—at a time when everything seemed possible in the world of digital media—Joseph Weizenbaum, a visionary and skeptic all in one, captured the spirit of the day by stating that we first had to know our wishes in order to develop the tools we needed to be able to make them come true.
All over the world, artists, scientists and experts in a wide variety of fields are doing R&D and experimental design work beyond the realm of the industrial mainstream. They are adopting alternative positions, calling the medium itself into question, and redirecting the current discourse from its focus on the status quo to a consideration of how things could and should be. And it is precisely for this latter undertaking that the Prix Ars Electronica has been, since 1987, an annual invitation to present one's work to a public beyond the confines of the atelier and the lab.

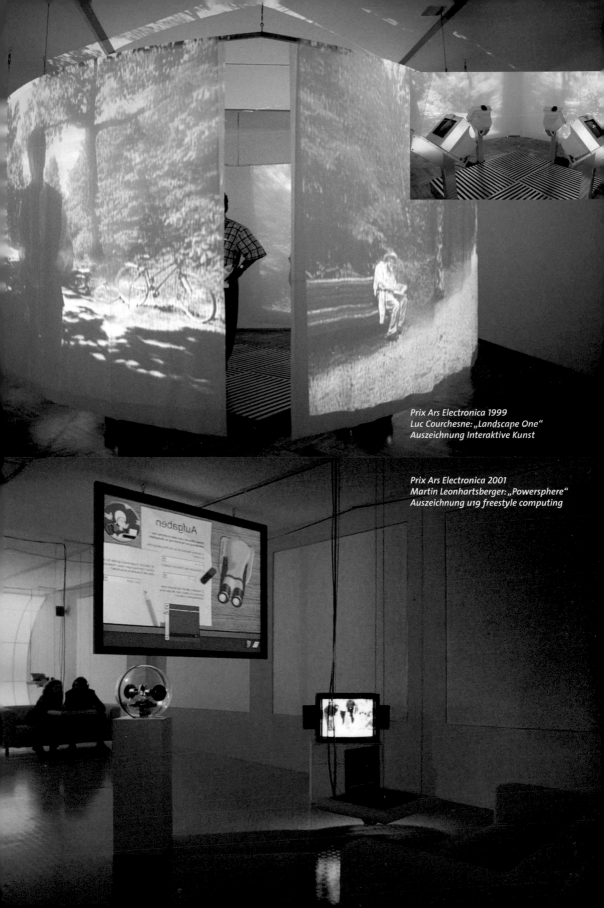

Prix Ars Electronica 1999
Luc Courchesne: „Landscape One"
Auszeichnung Interaktive Kunst

Prix Ars Electronica 2001
Martin Leonhartsberger: „Powersphere"
Auszeichnung u19 freestyle computing

schaft und Forschung ebenso wie Kinder und Jugendliche unter 19, also jener Generation, die als erste flächendeckend mit den digitalen Medien aufgewachsen ist, sind der Einladung des Prix Ars Electronica gefolgt. 1,4 Millionen Euro sind an Preisgeldern für Medienkunst ausgegeben worden.

Internationale Juries haben Jahr für Jahr aus allen Einreichungen jene ausgewählt, die sich durch besondere Sachkenntnis und Visionskraft auszeichneten und als solche beim Festival Ars Electronica sowie in Katalog, DVD und CD präsentiert und dokumentiert wurden.

Insgesamt ist der Prix Ars Electronica in seiner Kontinuität seit 1987 und durch seine Einbettung in das Festival Ars Electronica zu einem dauerhaften Seismografen künstlerischer wie wissenschaftlicher Formulierungen innerhalb der stür-

No fewer than 28,213 entries from 85 countries have been submitted to this cyberarts competition since its inception. Professionals from the arts, the sciences and engineering as well as youngsters under 19—thus, the generation that was the first to grow up totally within the era of digital media—have accepted Prix Ars Electronica's invitation, and 1.4 million euros in prizemoney have been awarded to them.

Year after year, juries of international experts have evaluated the submissions and selected those whose uniqueness, excellence and visionary power make them outstanding. These have been presented at the Ars Electronica Festival and also preserved for the future in various documentation media (catalog, DVD, CD). The Prix Ars Electronica —in the continuity it has displayed since 1987 and the way it has been embedded within the Ars

Prix Ars Electronica 2000 – Senking/Jens Massel performing at 20' to 2000, raster noton/Carsten Nicolai, Goldene Nica Digital Musics

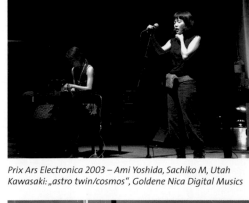

Prix Ars Electronica 2003 – Ami Yoshida, Sachiko M, Utah Kawasaki: „astro twin/cosmos", Goldene Nica Digital Musics

Prix Ars Electronica 2001 – bLectum from bLechdom: „The Messy Jesse Fiesta", Anerkennung Digital Musics

Prix Ars Electronica 1997 – Matt Heckert: „Machine Sound", Goldene Nica Computermusik

mischen Entwicklung der digitalen Medien geworden und hat damit auch seinen kulturpolitischen Stellenwert etabliert. Begleitet haben den Prix Ars Electronica auf diesem Weg Künstler, Wissenschaftler, Theoretiker, Philosophen, Techniker, Wizzards, Experten etc. Sie haben als Juroren beim Prix Ars Electronica nicht nur viele Tage in dunklen Räumen geteilt, sondern sie haben in einer jährlichen Laborsituation den Diskurs um Medienkunst und Medienentwicklung in den Juryberatungen weitergeführt, belebt und vorangetrieben. Und sie haben darüber hinaus den Prix Ars Electronica in die Community und die Welt getragen.

Electronica Festival—has become a permanent seismograph of artistic and scientific formulations within the tempestuous development of the digital media and has thereby established a place for itself in cultural-political life.

The Prix Ars Electronica has been accompanied along this way by artists, scientists, theoreticians, philosophers, technicians, wizards, experts, et al. Not only have they spent many days sequestered in darkened rooms as Prix Ars Electronica jurors; they have also joined in on an annual laboratory situation to carry on, enliven, reformulate and advance the discourse surrounding media art and media development in the jury deliberations. And, what's more, they have borne the Prix Ars Electronica out into the community and the world.

Prix Ars Electronica 2000 – 01001011101011101.ORG, Anerkennung .net, Sharon Denning: „The Exquisite Corpse",
Auszeichnung .net, agent.NASDAQ aka Reinhold Grether: „Toywar", Anerkennung .net

Prix Ars Electronica 2002: Jurymeeting

EINE IDEE ENTWICKELT
SICH WEITER ...
AN IDEA MOVES ON ...

GERFRIED STOCKER

Ein avantgardistisches Medienkunst Festival, ein internationaler Wettbewerb für Cyberarts, ein didaktisches Museum der Zukunft und ein interdisziplinäres Forschungs- und Entwicklungslabor sind die tragenden Säulen von Ars Electronica. Sie repräsentieren in der heutigen Konstellation erfolgreich die Idee der gemeinsamen Betrachtung und Bearbeitung der Bereiche Kunst, Technologie und Gesellschaft. Eine Idee, die bereits auf die Gründung im Jahre 1979 zurückgeht und bis heute Identität stiftend für das Projekt Ars Electronica ist. Eine reale, über eine konzeptionelle Setzung hinausgehende Ausprägung erfuhr diese Philosophie jedoch erst 1996 mit der Eröffnung des Ars Electronica Center und dem Aufbau des Ars Electronica Futurelab.
Die gebräuchliche Interpretation dieser Entwicklungsschritte als „Blöcke" bzw. „Säulen" ist in der heutigen Form von Ars Electronica begründet, in der durch diese Ausdifferenzierung sehr unterschiedliche Aufgabenfelder für verschiedene gesellschaftliche Zielgruppen wahrgenommen werden können. Nicht ein einzelnes Format, das in der Grätsche zwischen Kunst, Wirtschaft, Didaktik und Entertainment zerrissen würde, sondern mehrere, der gleichen Idee und dem gleichen Grundprinzip verpflichtete und synergetisch zusammenwirkende Arbeitsbereiche tragen den Erfolg des Projektes Ars Electronica. Das Festival und der Prix widmen sich voll und ganz der Kunst und Wissenschaft, wobei der Best-of-Charakter des Wettbewerbs das Festival frei spielt für riskante Experimente und Work-in-Progress.

An avant-garde media art festival, an international competition in the cyberarts, a didactic "museum of the future" and an interdisciplinary R&D lab are the four divisions that comprise Ars Electronica. Their current constellation represents the successful implementation of a comprehensive view of and joint approach to what is happening at the interface of art, technology and society. This idea goes all the way back to the founding of Ars Electronica in 1979 and has remained the project's mission statement to this day. But it was not until 1996, when the Ars Electronica Center opened and the Ars Electronica Futurelab was set up, that this philosophy was taken beyond the conceptual realm and put into actual everyday practice.
The conventional interpretation of these phases of development as "blocks" or "pillars" has its basis in the current form of Ars Electronica, where this differentiation allows extremely varied objectives to be realized for individual target groups of society.
It has not been a single format straining to straddle art, business, education and entertainment, but rather several of them—though all committed to the same concept and basic principles—and synergistically interactive fields of activity that have contributed to the success of the Ars Electronica undertaking.
The Festival and the Prix are wholly dedicated to art and science, whereby the competition's character as a "Best of" showcase opens up opportunities for the Festival as a setting for risky experiments and works-in-progress. The

Das Ars Electronica Center als Museum der Zukunft konzentriert sich auf einen Bildungsauftrag, der an sehr unterschiedlichen Zielgruppen orientiert ist.

Das Futurelab ist der Transmissionsriemen, über den die künstlerischen Kompetenzen auch für Forschung und Industrie zugänglich gemacht werden.

Erst durch dieses Zusammenspiel entstanden ein im Kulturbereich äußerst seltener Aktionsradius und ein Leistungsspektrum, in dem die Erwartungen an eine reale Vernetzung und Wechselwirkung mit den drei programmatischen Feldern (Kunst, Technologie und Gesellschaft) einlösbar wurden. Es hieße wohl, den Rückblick romantisch zu verschleiern, wenn dem Zustandekommen dieser einmaligen Konstellation ein großer Masterplan unterstellt würde, es ist aber ein Qualitätsmerkmal der Gründungsvision von Hannes Leopoldseder und eine bemerkenswert weit blickende Leistung der Stadt Linz, diese Entwicklung ermöglicht und unterstützt zu haben. Die Voraussetzung dafür bot das emanzipatorische Bemühen um eine neue Identität der Stadt über Industrie und historisches Erbe hinaus. Ars Electronica hatte in der Phase des städtischen Umbruchs und der Suche für Schlüsselbegriffe gesorgt, für deren Verankerung die Allianz von Stadt Linz und ORF Oberösterreich von ebenso entscheidender Bedeutung war wie die Rolle des ORF als Mediator und Multiplikator für die begeisternde Idee, dass ein Kunstevent für mehr als nur die Kunst von Bedeutung sein könnte.

Es ist Zeichen für das untrügliche Gespür für diese „Öffentlichkeitsarbeit" (Kunst als Arbeit an und mit der Öffentlichkeit) des Ars-Electronica-Vordenkers Hannes Leopoldseder, dass gemeinsam mit dem „elitären" Festival auch die Linzer Klangwolke als „populäres" Äquivalent der Ars-Electronica-Vision ins Leben gerufen wurde. Mitte der 1990er Jahre trat Ars Electronica gewissermaßen in den Schatten ein, den die Entwicklungen und Ereignisse der folgenden Jahre bereits vorauswarfen. Der Aufbau des

Ars Electronica Center—as the Museum of the Future—concentrates on a pedagogical mission oriented on the needs of a broad spectrum of users. The Futurelab is the transmission vehicle that makes Ars Electronica's artistic competence available in scholarly and commercial fields too. And it is precisely this interplay that has given rise to an action radius and a spectrum of offerings that are extraordinarily rare among institutions engaged in cultural pursuits, and ultimately makes it possible to fulfill what is expected of a process of real networking and to bring out the reciprocities among the three programmatic fields of art, technology and society.

It would certainly be a case of romantic revisionism to maintain now that this highly individualized configuration took shape in accordance with a grand master plan; nevertheless it Is an indication of the quality of Hannes Leopoldseder's founding vision, and it has been a remarkably far-sighted long-term effort by the City of Linz to have enabled and nurtured this process of development. Its preconditions were emancipatory strivings to endow the city with a new identity that would go beyond heavy industry and historical heritage. In this phase of urban upheaval and repositioning, Ars Electronica supplied the central concept; decisive for its acceptance and establishment were the alliance formed by the City of Linz and the ORF—Austrian Broadcasting Company's Upper Austria Regional Studio no less than the ORF's role as booster of the energizing idea that an artistic event could be of significance to more than art alone.

It is emblematic of Ars Electronica prophet Hannes Leopoldseder's unerring feel for involving the community (art accessible to, and working with, the public) that the beginnings of the "elitist" Festival were accompanied by the founding of the Linz *Klangwolke* as the "popular" counterpart of the Ars Electronica vision.

In the mid-90s, Ars Electronica entered the penumbra that was already being cast by developments and events looming on the horizon. In this

Ars Electronica Center markiert dabei für Ars Electronica eine weitreichende Zäsur, geschah er doch zeitgleich mit dem Einbruch der so genannten digitalen Revolution in eine breite öffentliche Wahrnehmung. Die immer wieder beschworene Wechselwirkung von Kunst, Technologie und Gesellschaft war nicht länger ein ambitioniertes Schlagwort, und es zeichnete sich eine Phase der technologischen Virulenz ab, die in vergleichbarer Form so bald nicht wieder zu erleben sein dürfte. Im Vorfeld dessen, was schließlich schneller als erwartet in den Alltag explodieren sollte – enormer Leistungszuwachs und Preisverfall der Rechner, Siegeszug von Mobile Phones, Computergames und WWW, die Entschlüsselung und Patentierung ganzer Genome etc. –, war abzusehen, dass die differenzierte Auseinandersetzung mit den kommenden Dingen nicht im Faszinosum spekulativer Zukunftsentwürfe stecken bleiben dürfte.

Es war an der Zeit, die Festivalschwerpunkte auf die mittlerweile eingetroffene Zukunft auszurichten und den sich bereits abzeichnenden und nachvollziehbaren Auswirkungen der digitalen Revolution auf unsere Gesellschaft und Kultur nachzugehen – weniger eine kuratorische Entscheidung als vielmehr das Gebot der Stunde, in der sich die „adoleszente Sturm-und-Drang-Periode" unvermittelt von der Wirklichkeit eingeholt sah, was, wenn man so will, ein „Erwachsen-Werden" eingefordert hat.
Die thematische, an Erscheinungen der soziokulturellen Evolution orientierte Ausrichtung des Festivals (INFOWAR, UNPLUGGED), die Erweiterung der Themen über digitale Technologien hinaus zu Gentechnik und Molekularbiologie

connection, the construction of the Ars Electronica Center represents a momentous turning point since it occurred simultaneously with the dawning of the so-called Digital Revolution in the public perception. The Ars Electronica's repeated evocations of reciprocities at work among art, technology and society were no longer just ambitious catchphrases. What began to emerge was a phase of technological virulence the likes of which we will certainly not experience again so very soon.
Even in the early stages of the process that eventually exploded into the midst of everyday life much more rapidly than anticipated—enormous increases in computer processing performance, the triumphal takeover of cell phones, computer games and the Web, the decoding and patenting of entire genomes, etc.—it was already becoming apparent that a multifaceted encounter with the reality that was emerging could not be permitted to remain arrested in the stage of enchanted fascination with futuristic speculations.
The time had come to orient the Festival's focal-point themes on a future that, meanwhile, had already arrived, and to confront and deal with the Digital Revolution's nascent and already perceptible consequences for our society and culture.
This was less a curatorial decision than the order of the day, since the "adolescent Sturm-und-Drang period" had suddenly seen itself overtaken by reality, which called for, as it were, a process of "growing up."
The thematic orientation of the Festival on manifestations of sociocultural evolution (INFOWAR, UNPLUGGED), the expansion of its thematic field beyond digital technologies to genetic engineering and molecular biology (LifeScience, NEXT SEX), explorations undertaken in peripheral realms of art and business (TAKEOVER) and the accompanying recourse to a discussion that is currently being hyped by the medial presence of technological and scientific themes have been, needless to say, a balancing act as well. It has called for heightened vigilance to make sure that the programmatic continuity was recognizable not on the basis of the hype itself but rather from their sociopolitical orientation.
But this path of development also meant that Ars Electronica would necessarily have to undergo a fundamental shift. Initial moves in this direction

(LifeScience, NEXT SEX) die Explorationen in Grenz-bereiche von Kunst und Wirtschaft (TAKEOVER) und der damit einhergehende verstärkte Rekurs auf eine aktuelle, durch die mediale Präsenz von Technologie- und Wissenschaftsthemen gehypte Diskussion war natürlich auch ein Balanceakt: Es galt verstärkt darauf zu achten, die programmati-sche Kontinuität nicht am Hype selbst, sondern in der gesellschaftspolitischen Ausrichtung zu verankern. Im Zuge dieser Entwicklung hieß das für Ars Electronica aber auch, über den eigenen Schatten zu springen. Gab es 1993 und 1997 bereits erste Annäherungen, so war erst mit Life-Science (1999) und NEXT SEX (2000) eine wirklich konsequente Bearbeitung dieses Themenfeldes möglich – begleitet von sorgenvollen Blicken und Kritik über die Zuwendung zu einem neuen Themenfeld. Eine besondere Herausforderung dabei war es, den für Ars Electronica so typischen Laborcharakter der Arbeiten und Präsentationen auch im Gen- und Biotechnologiebereich zu erhal-ten. Der Aufbau von funktionierenden Labors für Tissue-Culture (SymbioticA Research Group) oder die termingerechte Zucht von manipulierten Schmetterlingen (Nature!, Marta de Menezes) und die dafür notwendigen neuen Kooperationen mit Biotech-Labors und -firmen waren große Herausforderungen für die Festivalorganisation, aber auch Anlass für hitzige Diskussionen über ethische und moralische Grenzen künstlerischer Arbeit.

were already apparent in 1993 and 1997, but a really consistent process of dealing with this the-matic domain was not possible until LifeScience in 1999 and NEXT SEX in 2000—and this accompa-nied by concerned glances and critique of this turning of attention to a new thematic field. One particular challenge in going about this was to maintain, in the area of genetics and biotechnology as well, the laboratory character of works and presentations that is so typical of Ars Electronica. Setting up functioning labs for tissue culture (SymbioticA Research Group) or the timely breeding of genetically modified butterflies (Nature!, Marta de Menezes) and the collaboration with biotech labs and firms that was necessary to accomplish this were extreme challenges for the Festival's organizers as well as occasions for heated discussions about the ethical and moral boundaries of artistic work.

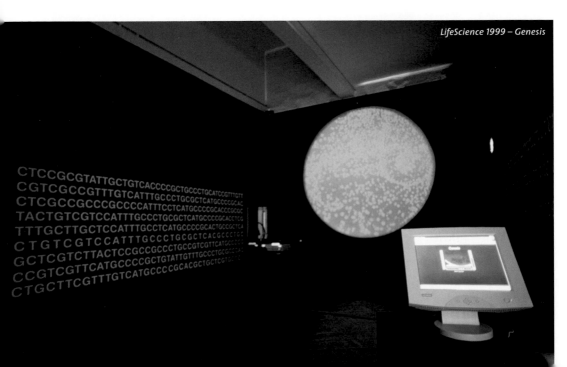

LifeScience 1999 – Genesis

INFOWAR 1998 – Projekt Minenfeld

LifeScience 1999 – National Heritage

NextSex 2000 – Spermrace, Laborcontainer

NextSex 2000 – Tissue Culture

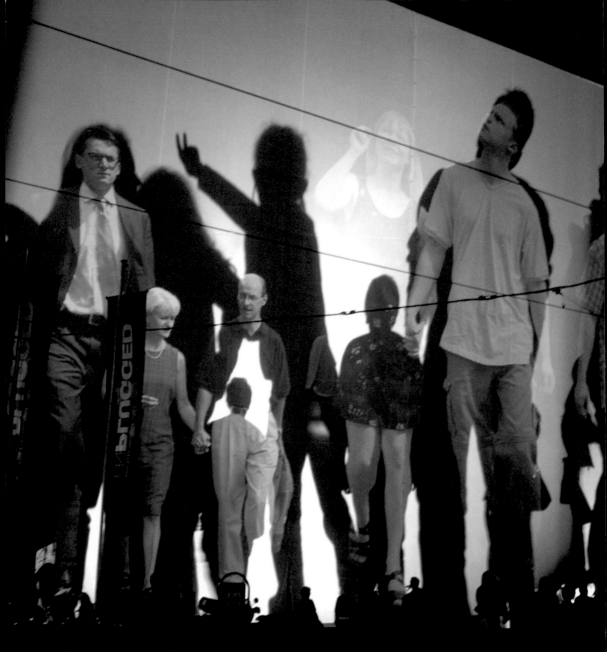

Industrie- und Hafengelände, Donaupark und Linzer Hauptplatz zählen zu den
regelmäßigen Outdoor-Locations des Festivalprogramms, z. B. mit *Body Movies* von
Rafael Lozano Hemmer (2002) oder mit Fadi Dorningers *Ridin' a Train* – nächtliche
Fahrten durch das Industriegelände der Voest, mit einem offenen Zug als Konzert-
halle, 2000 live bespielt von Marina Rosenfeld.

Industrial and harbor facilities, Linz's Danube Park and Main Square have
regularly served as outdoor venues for Festival events—for example, *Body Movies*
by Rafael Lozano Hemmer (2002) or Fadi Dorninger's *Ridin' a Train,* nighttime rail
excursions on the grounds of the Voest Steel Mill in a rolling concert hall. Marina
Rosenfeld provided live music in 2000.

INFOWAR 1998 – Solar
LifeScience 1999 – Klangpark

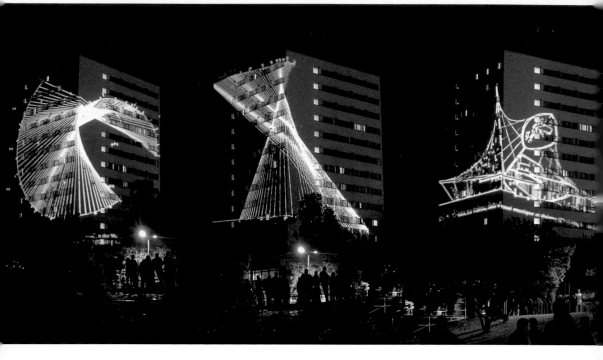

NextSex 2000 – D.A.V.E.

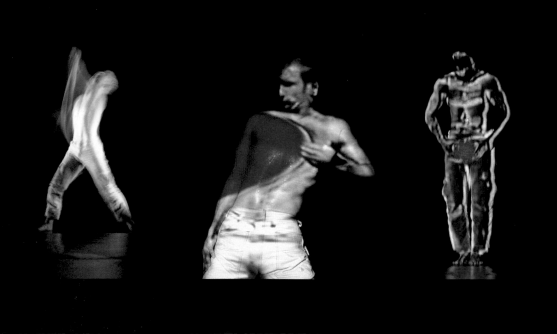

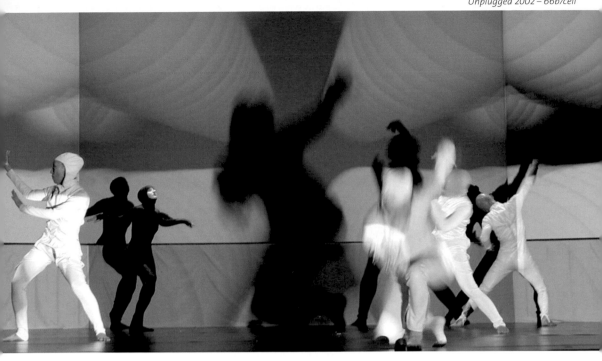

NextSex 2000 – 20' to 2000

CODE 2003 – Messa di Voce

CODE 2003 – Pol / LifeScience 1999 – Recombinant

Unplugged 2002 – Radiotopia Soirée / CODE 2003 – Principles of Indeterminism / TAKEOVER 2001 – Dialtones

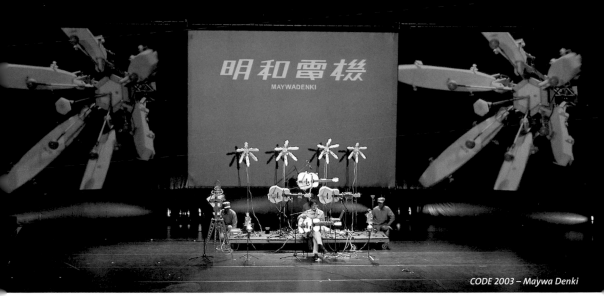

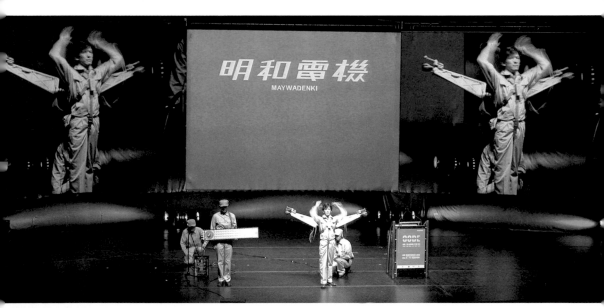

CODE 2003 – Maywa Denki

Festival als Labor – openX und electrolobby

Das Bemühen um adäquate Präsentations- und Kommunikationsformate für eine Kunst im und unter den Bedingungen des Netzes, wie sie sich in dieser Zeit erst auszuprägen begonnen hatte, kennzeichnet das Festival seit 1996. Telekommunikations- oder Netzwerkprojekte bezeichnen in der Geschichte der Ars Electronica natürlich kein Neuland, vom „Leben im Netz" bot das Thema jedoch selbst unter dem gleich lautenden Motto 1995 bestenfalls eine Skizze. Es gab zwar schon eine eigene Prix-Kategorie für WWW-Projekte, aber noch kein repräsentationstechnisches Pendant, das der zunehmenden Zahl an KünstlerInnen gerecht wurde, die bereits begonnen hatten ihre „Ateliers" hinter die Bildschirme zu verlegen. 1996 wurde diesem Trend erstmals ein flächen- wie budgetmäßig überragender Stellenwert zuerkannt: Auf ca. 600 m² wurden Web-Projekte, Netzinstallationen und Telekommunikationsprojekte präsentiert.

Unter dem Label *openX* wurden 1997 bis 1999 weitere Versuchsanordnungen inszeniert und getestet, wobei der Schwerpunkt vor allem auf prozessorientierten Net-Art und Netzaktivismus-Projekten lag. Aus diesen Erfahrungen wurde 2001 von TNC-Network die *electrolobby* entwickelt, gewissermaßen als Festival im Festival, und damit eine Entwicklung in Gang gesetzt, die innerhalb weniger Jahre im Festivalthema TAKEOVER (2001) kumulieren sollte.

Festival as Laboratory—openX and electrolobby

Since 1996, an essential element of the Festival has been the effort to come up with new formats to exhibit and mediate the encounter with an artform that had only begun to emerge at this time: art in and under the conditions of the Internet. Needless to say, telecommunications or network projects were by no means uncharted territory in the history of Ars Electronica, although "Life in the Wired World," the 1995 theme, did not constitute much more than a sketchy treatment of this field.

A separate Prix category for www projects has already been created, but for the critical mass of artists who had begun to relocate their "ateliers" to domains behind their monitor screens, there were basically no corresponding spaces for the public presentation of what they were doing. This trend was first officially acknowledged with its own space and budget in 1996, when aprox. 600 m² were dedicated to presenting web projects, network installations and telecommunications projects.

Further experimental arrangements were staged under the label *openX* in 1997 to 1999, the focus being largely on process-oriented net art and active network projects. The *electrolobby* was developed by TNC Network in 2001 as a result of these experiences, a festival within a festival so to speak, which in turn launched a process of development that would culminate a few years later in TAKEOVER, the 2001 festival theme.

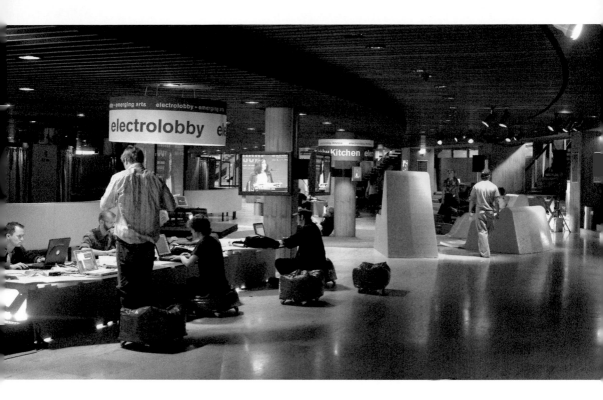

Museum als Plattform und Interface

In dem Spannungsfeld zwischen zunehmender Spezialisierung und breitem Interesse erhielt das Center die Funktion eines Katalysators und eines lokalen Interface für das Anliegen des Projektes Ars Electronica. Nicht als Museum für Medienkunst, sondern als Vermittler und Anlaufstelle für die Auseinandersetzung mit den gesellschaftlichen und kulturellen Implikationen (Medienkultur und -kompetenz) erfüllt es seit 1996 auch eine wichtige lokale Funktion als Mediator und Multiplikator – eine Aufgabe, bei der der Einrichtung eines Medienkunst-Labors eine zentrale Rolle zukam. Künstler durch Zugang zu Hightech-Equipment und durch kompetente Techniker zu unterstützen war wichtiger, als bloß für Ausstellungs- und Präsentationsmöglichkeiten zu sorgen. Ein „Museum der Zukunft" sollte sich im Besonderen auch als Ort der Produktion ausweisen. Mit seinen ausschließlich interaktiven Vermittlungsformen, mit starkem Einsatz von Virtual Reality und prototypischen Interface-Technologien wendet sich das AEC an ein breites Publikum.

Museum as Platform and Interface

To harness the energy between increasing specialization and widening interests, the Center was assigned the function of catalyst and local interface for the advancement of the Ars Electronica project. Not as a museum of media art but rather as a mediator of media competence and a physical setting for the encounter with the social and cultural implications of media culture, the Center has also been performing an important local role as facilitator and disseminator since 1996.
In light of this mission, the setup of a media lab assumed central significance. Nurturing artists by giving them access to high-tech equipment and competent technical support was more important than just providing exhibition space and presentation possibilities. One thing that a "Museum of the Future" ought to be in particular is a production site. With its exclusively interactive form of mediating the public's encounter with the state-of-the-art, with the intensive utilization of Virtual Reality and prototype interface technologies, the AEC targets the general public.

Technik nicht zu verstecken, nicht zu mystifizieren, sondern ihre Anwendungen sehr real zugänglich und verständlich zu machen, ist das Ziel des AEC. Interaktivität und intensive persönliche Betreuung der Besucher sollen die Auseinandersetzung mit den Inhalten möglichst intensiv gestalten und den Besucher dazu verführen, sich als User zu engagieren. Dass die Nutzung von künstlerischen Arbeiten für Vermittlungsaufgaben immer auch eine Gratwanderung ist, steht außer Frage, dass sie auch sehr gut funktionieren kann, zeigte sich z. B. in der Ausstellung *Print On Screen,* die mit Kunstprojekten von John Maeda, Camille Utterback, Christa Sommerer, Golan Levin, Casey Reas u.v.a. sehr erfolgreich Interaktivität als künstlerische Ausdrucksform erfahrbar machte und gleichzeitig viele Besucher zur kritischen Reflexion über den mangelhaften Status der User-Interfaces unserer heutigen Computertechnologie veranlasste. Wie sehr künstlerische Zugänge die technische Forschung inspirieren können, zeigt sich vorbildlich in den Arbeiten der Tangible Media Group von Hiroshi Ishii am MIT Medialab oder sehr exemplarisch in Futurelab-Forschungsprojekten wie z. B. INSTAR.

Neither to hide technology nor to mystify it but rather to make its applications accessible and understandable in a very concrete way is AEC's aim. Interactivity and the availability of trained guides to handle guests' queries are designed to make the public's encounter with exhibit content as intensive as possible and to encourage the visitor to get engaged as a user. There's no question that utilizing works of art to mediate the public's encounter with content is always a balancing act; that this approach can also function very well as illustrated by *Print On Screen* for instance. This exhibition featuring art projects by John Maeda, Camille Utterback, Christa Sommerer, Golan Levin, Casey Reas and others did a great job enabling visitors to experience interactivity as a form of artistic expression while simultaneously motivating many of them to undertake a process of critical reflection about the inadequate state of user interfaces in our current computer technology.
The great extent to which artistic approaches can inspire technical research is shown in exemplary fashion by the works of Hiroshi Ishii's Tangible Media Group at the MIT Media Lab as well as FutureLab R&D projects like INSTAR.

Ars Electronica Mediathek

CAVE / Crayoland (1996

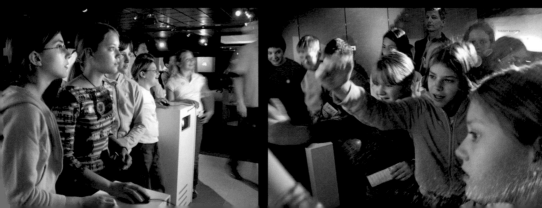

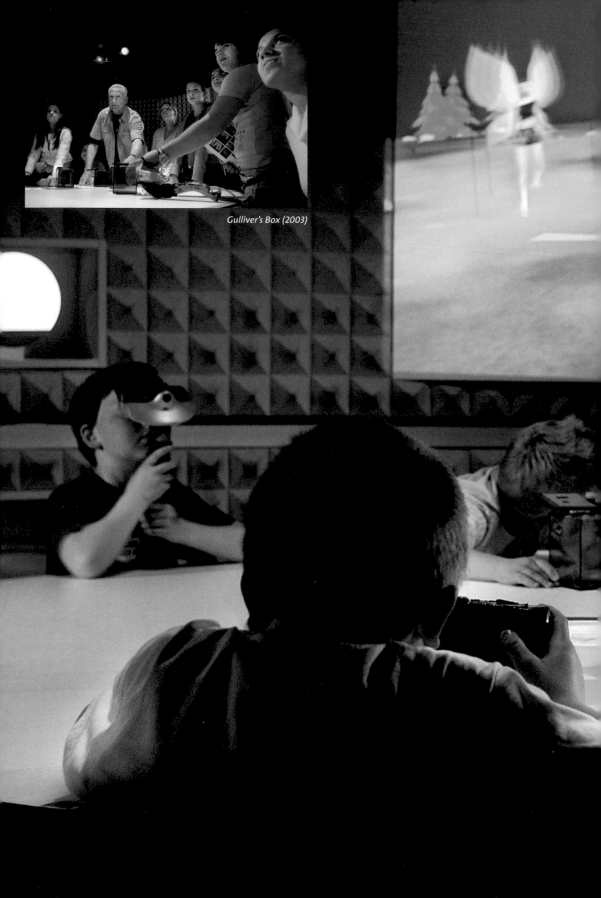

Gulliver's Box (2003)

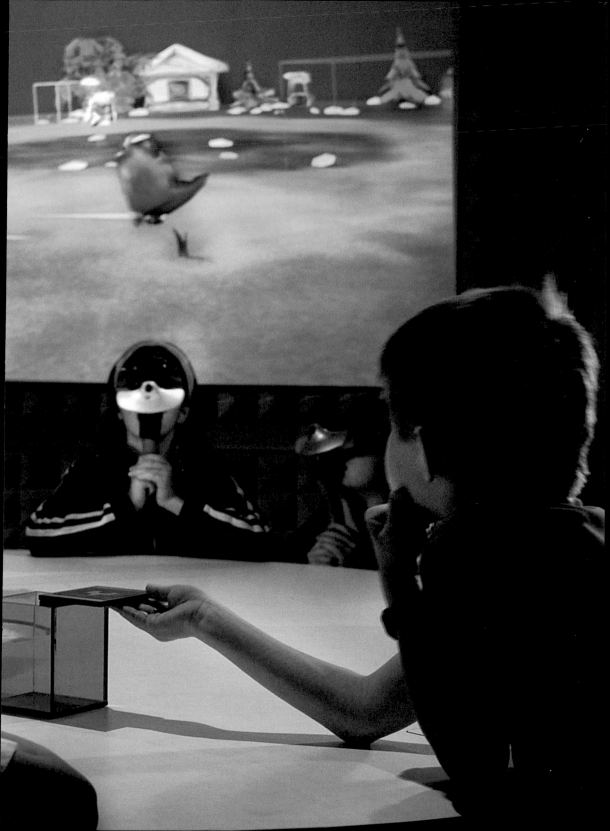

Re:Mark (2002)

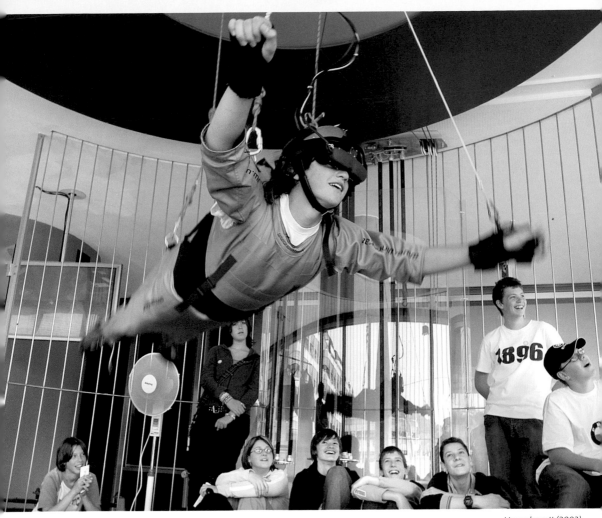

Humphrey II (2003)

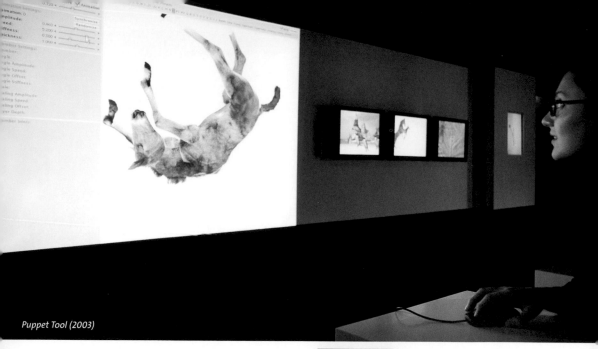

Puppet Tool (2003)

Vermittlung durch Interaktivität

Das Exploratorium in San Francisco hat ohne Zweifel vorgezeigt, wie man durch die Erkundung wissenschaftlicher Prinzipien und Phänomene informelles Lernen fördern kann. Seine Stärke bestand in der Definition der „Macht des Realen" – Echtzeit, reale Menschen, Räume und Objekte und die sich daraus ergebenden Möglichkeiten einer sinnvollen Einbeziehung der Besucher durch elektromechanische Interaktivität. Wie oft bei neu auftauchenden Genres, entstanden aber zahlreiche schlampige Nachahmungen und ein in der Kultur und in der Unterhaltungsindustrie allgegenwärtiges banalisiertes Mantra der Interaktivität. Das Ars Electronica Center hingegen zählt zu den löblichen Ausnahmen. Hier wurden Installationen entwickelt, die Praktizierende wie auch Endanwender mühelos dazu ermutigten, „die Grenzen zu überschreiten". Wissenschaftler, Medienkünstler, Kommunikatoren arbeiten zusammen, um Vorurteile und althergebrachte didaktische Prozesse zu hinterfragen. Als ein vollständig interaktives informelles Lern-Environment fördert es „Memory-Learning" durch intellektuelle und emotionale Einbeziehung der Besucher und vermittelt dabei spielerisch die komplexen Implikationen der digitalen Revolution.
Die Arbeit des Ars Electronica Center hat bei dem, was die Kulturindustrie nun mit „minds on"

Peter Higgins
Land Design Studio, London

Mediation via Interactivity

The San Francisco Exploratorium undoubtedly defined a way of encouraging informal learning through its investigation into scientific principles and phenomena. Its strength was to define the "power of the real"—real time, real people, real spaces and objects, and the consequential possibility of meaningful engagement of visitors through electro-mechanical interactivity. However, as with any emerging genre, it has inevitably generated half-baked derivatives and, even worse, a simplistic mantra of "interactivity" emanating from both cultural and entertainment industries. The Ars Electronica Center represents an exceptional departure. In developing installations, it has effortlessly encouraged both practitioners and end-users to "cross the line." Scientists, media artists and communicators collaborate to challenge preconceptions and traditional didactic processes. As a truly interactive, informal learning environment, it supports memory learning through intellectual and emotional engagement of the visitor, and thereby playfully imparts the complex implications of the Digital Revolution.

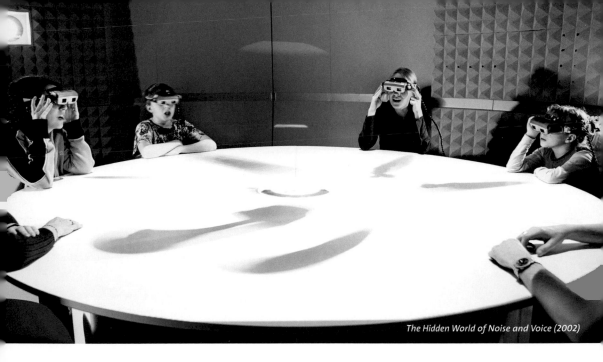

The Hidden World of Noise and Voice (2002)

statt „hands on" bezeichnet, neue Maßstäbe gesetzt. Es wird international als ein „Center of Excellence" gehandelt, das mittels intuitiver Interfaces, Datenzugänge und sensorischer Environments weitreichende neue Ausdrucks- und Erlebnisformen erforscht. Hier findet eine Annäherung zwischen der „Macht des Realen und des Virtuellen" statt.

Wie kann eine Institution, die sich selbst „Museum der Zukunft" nennt, überleben? Im Wesentlichen hat man den Fehler vieler anderer zeitgenössischer Zentren vermieden, lediglich sündteure deterministische Content-Strategien zu präsentieren. Hier in Linz hat man der Notwendigkeit, den technologischen und kulturellen Veränderungen Rechnung zu tragen, durch zusätzliche programmatische Aktivitäten wie dem Futurelab, dem Prix oder dem Festival entsprochen, die sich alle direkt auf die dynamischen kuratorischen Strategien des Centers ausgewirkt haben.

Der dauerhafte Erfolg einer öffentlichen Einrichtung wie dem Ars Electronica Center liegt auch in dem klaren Verständnis für die Bedürfnisse und Anforderungen der unterschiedlichen Zielgruppen, die von Schülern und Lehrern, Direktoren ähnlicher internationaler Initiativen, potenten Sponsoren aus der Wirtschaft bis hin zur illustren Community der Medienkünstler reichen.

Die vom Ars Electronica Center so erfolgreich vertretenen Bildungsstrategien sind heute wichtiger denn je zuvor.

The work of the Ars Electronica Center has set new standards in what the cultural industries now call "minds-on" in contrast to "hands-on." It is now internationally acclaimed as a center of excellence that investigates wide-ranging new forms of expression and experience by means of intuitive interfaces, data access, and sensory environments. It is a setting of the convergence of the "power of the real and the virtual."

How does an institution that dares call itself "a museum of the future" survive? Essentially it has avoided the trap of many contemporary centers that have been financially front-end-loaded with deterministic content strategies. Here in Linz, the need to actively respond to technological and cultural change has been satisfied through the diversity of complementary programs including the Futurelab, the Prix, and the Festival, all of which directly impact the dynamic curatorial strategies of the Center.

The sustainability of public institutions like the Ars Electronica Center is based on a clear practical understanding of the needs and demands of various target groups ranging from local educational programs, directors of similar international initiatives, the all-important corporate sponsors and, of course, the highly discerning community of media artists. The strategies of educational empowerment that have been so successfully championed by the Ars Electronica Center are today more important than ever.

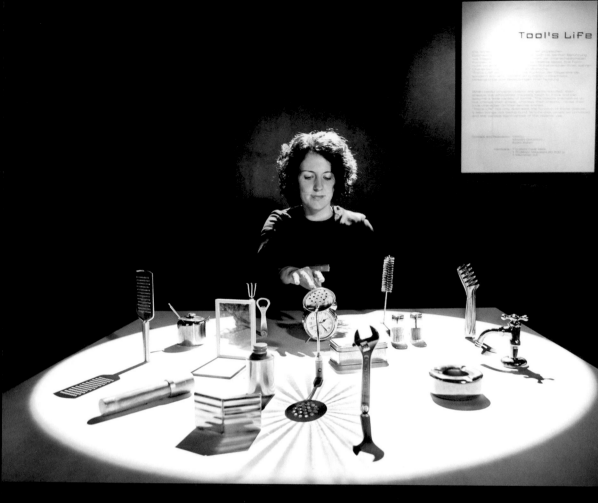

Tool's Life (2002)

Future Office Project (2002)

Informationsarchitektur:
Architektur als Information

Die Herausforderung bei der Gestaltung von Ausstellungen interaktiver Medienkunst liegt darin, eine Atmosphäre zu schaffen, in der viele Einzelteile (Einzelprojekte ebenso wie Projektteile) zu einem räumlichen Ganzen verschmelzen. Ein bestimmendes Charakteristikum von Medienkunst ist im Hinblick auf die Gestaltung das Vorhandensein der physischen Infrastruktur (Hardware). Jede einzelne Arbeit umfasst Hardwarekomponenten, die zwar für die Arbeit selbst wesentlich, zugleich aber für den Betrachter nicht von Interesse sind. Während das Kunstwerk häufig am Computer geschaffen wird, muss die fertige Arbeit in der Ausstellung innerhalb eines thematischen Rahmens zusammen mit anderen Projekten präsentiert werden. Die Grenzen zwischen Hardware und Objekt sowie zwischen Objekt und Ausstellungsraum sollten dabei ineinanderfließen, der Raum selbst zum Erlebnis werden und die Technologie, wie wir sie kennen, in den Hintergrund treten.

Hauptziel der Ausstellungsgestaltung im Ars Electronica Center war es in den vergangenen Jahren, Projektoberflächen und Betrachterschnittstellen nahtlos in die Präsentationsobjekte und in die Raumgestaltung selbst zu integrieren. Interaktive Medienkunst wirkt stärker, wenn sie „magisch" scheint – und der Benutzer sich nicht mit Objekten aus der Alltagswelt (Bildschirm, Tastatur, Maus) konfrontiert sieht. Neue Technologien – berührungssensitive Schnittstellen, Tracking-Technologien, Kameraerkennung – ermöglichen es den Benutzern, mit den Objekten auf eine Art und Weise zu interagieren, die sie aus dem täglichen Leben nicht kennen. Das Hauptaugenmerk liegt dabei auf der Entwicklung neuer, intuitiver, oft spielerischer Formen der Interaktion mit den Kunstwerken. Jeder Ausstellungsraum ist, soweit möglich, thematisch aufgebaut und so gestaltet, dass er eine eigene Identität erhält und den Besuchern das Gefühl gibt, sich in einem „Projektraum" zu befinden und nicht bloß in einem Raum voller Projekte. Das Ziel ist die Wechselwirkung und gegenseitige Ergänzung von gestaltetem Raum und den darin präsentierten Projekten.

Scott Ritter
Architect, Vienna

Information architecture:
architecture as information

The challenge of designing exhibitions for interactive media art is to create an atmosphere where many individual pieces (from both single projects as well as project components) can merge together into a unified environment. In a design sense, a defining characteristic of media art is the existence of the physical infrastructure (hardware). Each individual work has hardware components which are necessary for the piece but at the same time not interesting for the viewer. At the same time, the artwork was often created on a computer in a studio, and the piece itself must then be presented in exhibition form within a thematic framework together with other projects. The borders between hardware and object, as well as between object and room, should begin to blur whereby the objects and indeed the room itself becomes an interactive spatial experience—with technology, as we normally know it fading into the background. Over the past few years the main goal of exhibition design in the Ars Electronica Center has been this seamless integration of project surface and user interface into the presentation objects as well as into the room design itself. Interactive Media art has a stronger effect if it works "magically"—when the user is not confronted with objects from the everyday world (screens, keyboards, mouse). New technology—from touch interfaces, to tracking technology and camera recognition makes it possible for users to interact with pieces in ways not known from daily life. The emphasis is on developing new, intuitive, often playful forms of interaction with the artwork. Each exhibition floor is, as far as possible, arranged thematically and designed to have its own identity, giving the visitor the feeling that they are in a "project space" and not just a place with projects. The goal being a mutual reliance on each other—the designed space, and the projects presented.

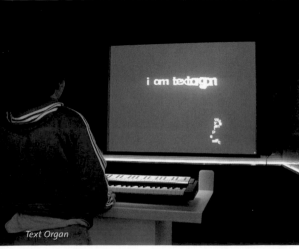

Text Organ

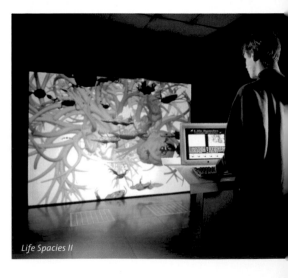

Life Spacies II

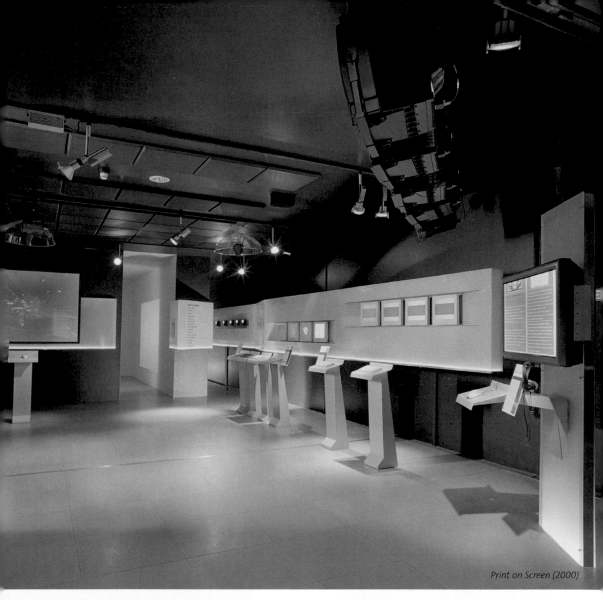

Print on Screen (2000)

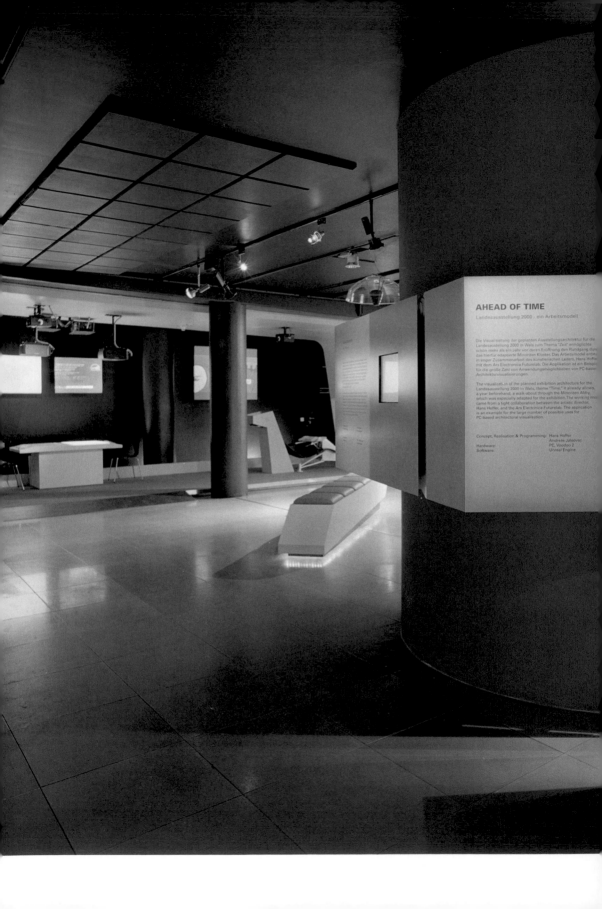

AHEAD OF TIME
Landesausstellung 2000 - ein Arbeitsmodell

Die Visualisierung der geplanten Ausstellungsarchitektur für die
Landesausstellung 2000 in Wels zum Thema "Zeit" ermöglichte
schon mehr als ein Jahr vor deren Eröffnung den Rundgang durch
das hierfür adaptierte Minoriten Kloster. Das Arbeitsmodell entstand
in enger Zusammenarbeit des künstlerischen Leiters, Hans Hoffer,
mit dem Ars Electronica Futurelab. Die Applikation ist ein Beispiel
für die große Zahl von Anwendungsmöglichkeiten von PC-basierten
Architekturvisualisierungen.

The visualization of the planned exhibition architecture for the
Landesausstellung 2000 in Wels, theme "Time," it already allows,
a year beforehand, a walk-about through the Minoriten Abbey,
which was especially adapted for the exhibition. The working model
came from a tight collaboration between the artistic director,
Hans Hoffer, and the Ars Electronica Futurelab. The application
is an example for the large number of possible uses for
PC-based architectural visualisation.

Concept, Realisation & Programming: Hans Hoffer
 Andreas Jalsovec
Hardware: PC, Voodoo 2
Software: Unreal Engine

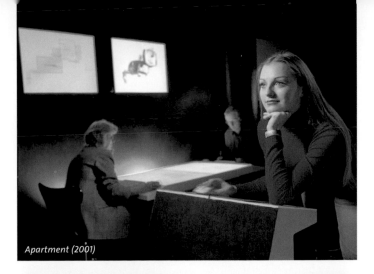

Apartment (2001)

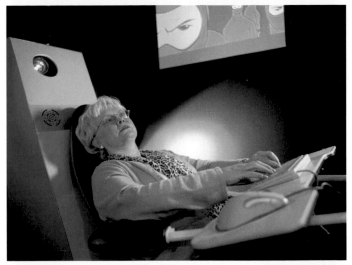

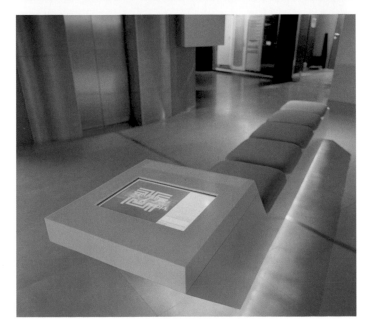

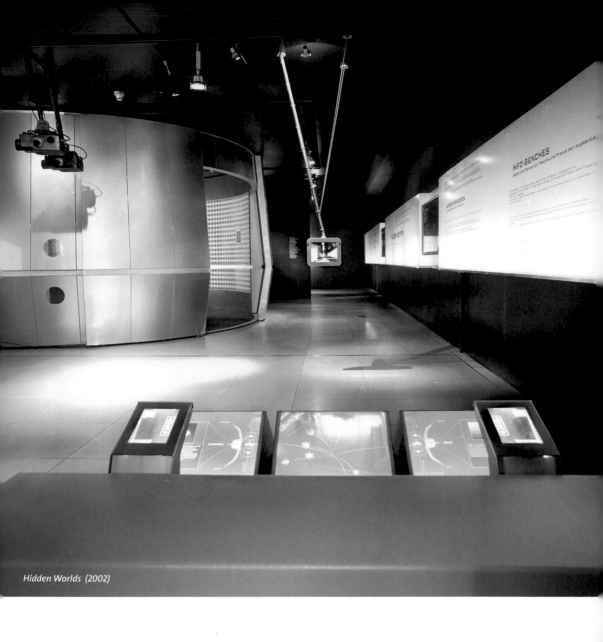

Hidden Worlds (2002)

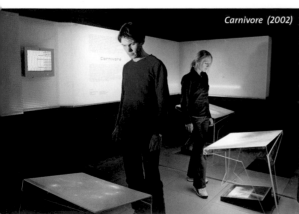

Carnivore (2002)

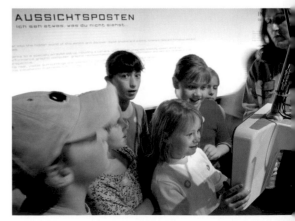

AUSSICHTSPOSTEN
ich seh etwas, was du nicht siehst.

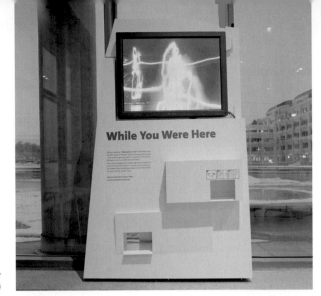

While You Were Here
Check out Terminal (2001)

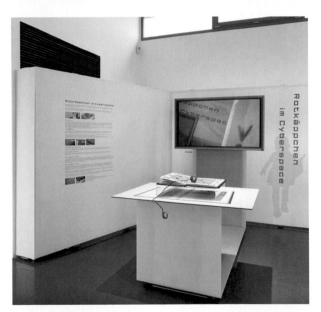

Little Red MR (2003)

n-lab, u19 Webterminal (2001)

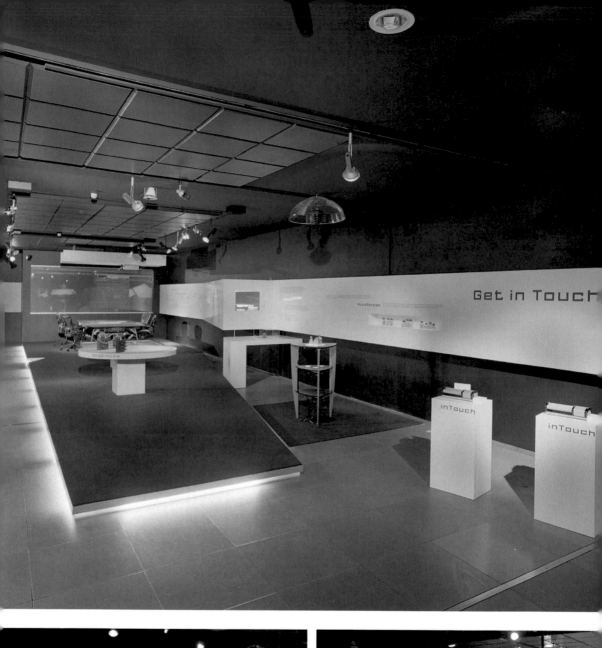

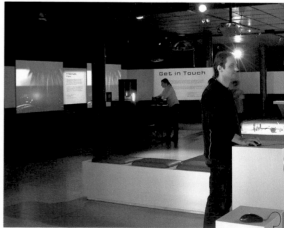

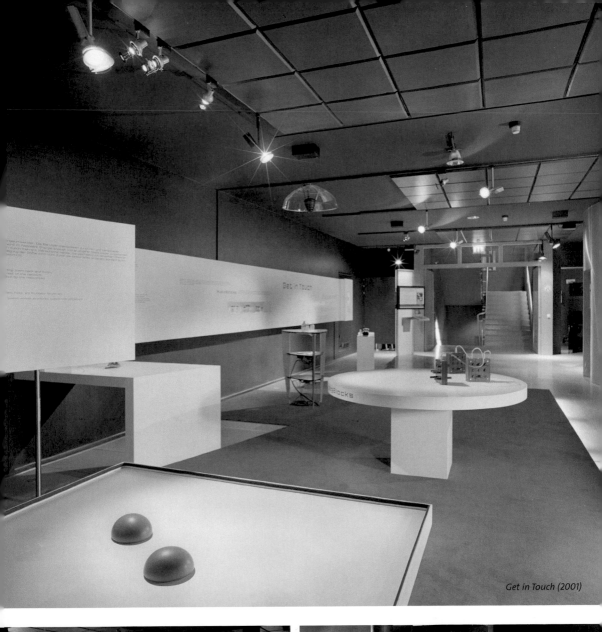

Get in Touch (2001)

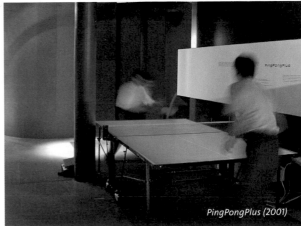

PingPongPlus (2001)

Hiroshi Ishii
MIT Media Lab, Boston

curlybot (2001)

Ars Electronica: Intellectual Inter-tidal Zone to Shape the Future

Poised on the bleeding edge where the arts and technology collide, the Ars Electronica Center has been for many years one of the most avant-garde places for me to test new ideas and develop them further.

"Where the sea meets the land, life has blossomed into a myriad of unique forms in the turbulence of water, sand, and wind. At another seashore between the land of atoms and the sea of bits, we are now facing the challenge of reconciling our dual citizenship in the physical and digital worlds."
This is the metaphor I used in the introduction to the "Get in Touch" exhibition that opened at the Ars Electronica Center in September 2001. The "Get in Touch" exhibition introduced novel interactive experiences designed in pursuit of our vision of "Tangible Bits"—an attempt to give physical form to digital information, making bits directly manipulable and perceptible. The goal is to blur the boundary between our bodies, cyberspace, and our physical environment.
We presented the Tangible Bits concept in the form of interactive art exhibits in the Museum of the Future. The museum visitors with a wide range of perspectives helped us shape our ideas in a larger cultural, social and historical context than the relative narrow context of traditional engineering. Especially the vision of Gerfried Stocker, the director of the AEC, inspired us greatly. We truly appreciate his strong leadership and his support of the cross-fertilization among the arts and technologies. The invaluable intellectual experience we gained within the Ars Electronica community inspired me to describe its value and to express this in the use of the "inter-tidal zone" metaphor.
"Where the sea meets the land, the coastline appears. It is unique in the landscape as a home to the living organisms of an inter-tidal zone. Here they engage in a fierce battle for survival between the tides, struggling in turn with heat and dryness followed by rough pounding waves. At the same time it is a fertile space where these organisms mix with light, water and air. Here at the border of

Ars Electronica: Interface zwischen Heute und Morgen

Seit vielen Jahren nimmt das Ars Electronica Center eine der avantgardistischsten Stellungen an jener Grenze, an der Kunst und Technologie aufeinanderprallen, ein. Hier konnte ich meine neuen Ideen testen und weiterentwickeln.
„Wo das Meer aufs Land trifft, hat das Leben in diesem Strudel aus Wasser, Sand und Wind Myriaden verschiedenster Blüten getrieben. An der Küste zwischen dem Land der Atome und dem Meer der Bits stehen wir heute vor der Herausforderung, unsere duale Zugehörigkeit zur physischen und digitalen Welt miteinander zu versöhnen."
Mit dieser Metapher leitete ich im September 2001 die Ausstellung „Get in Touch" im Ars Electronica Center ein, in der wir, mit Blick auf unsere „Tangible Bits"-Vision, neue interaktive Erfahrungen vorstellten – unseren Versuch, digitaler Information physische Gestalt zu verleihen und Bits direkt manipulier- und wahrnehmbar zu machen. Die Grenzen zwischen unseren Körpern, dem Cyberspace und der physischen Umgebung sollen verschwimmen.
Wir präsentierten das „Tangible Bits"-Konzept als interaktive Kunstobjekte im Museum der Zukunft. Die Museumsbesucher und ihre vielfältigen Betrachtungsweisen halfen uns, unsere Ideen in einem größeren kulturellen, sozialen und historischen Kontext zu formen anstatt im relativ schmalen Kontext traditioneller Technik. Allen voran inspirierten uns die Visionen von Gerfried Stocker, dem Direktor des AEC. Wir schätzen seine

Unterstützung bei der gegenseitigen Befruchtung von Kunst und Technologie. Ich schätze auch den unbezahlbaren intellektuellen Erfahrungsaustausch innerhalb der Ars-Electronica-Community, der mich letztlich dazu ermutigte, dies in der Metapher der intertidalen Zone auch zum Ausdruck zu bringen.

„Wo das Meer aufs Land trifft, erstreckt sich die Küste. Sie ist einmalig in der Landschaft, bietet sie doch den lebenden Organismen der intertidalen Zone Heimat. Zwischen den Gezeiten führen sie eine erbitterte Schlacht ums Überleben, kämpfen abwechselnd gegen sengende Hitze und rau pochende Wellen. Gleichzeitig ist es aber auch fruchtbarer Boden, wo sich diese Organismen mit Licht, Wasser und Luft mischen. Hier an der Grenze zwischen Meer und Land haben sie Myriaden verschiedenster Blüten getrieben. Vor Jahrmillionen haben unsere Vorfahren diese Grenze auch überschritten und das Meer verlassen."

Für die Tangible Media Group ist die Ars Electronica ein besonderer Ort, seit wir 1997 eingeladen wurden, unsere frühen Projekt inTouch und Triangles als Kunstinstallationen zu präsentieren. Damals stellte ich „Tangible Bits" in einer Sitzung mit Mark Weiser, der das Ubiquitous Computing (allgegenwärtige Infomationsverarbeitung) maßgeblich beeinflusste, vor. Seit 2001 haben wir im AEC musicBottles, inTouch, PingPongPlus, pinwheels, Triangles, curlybot, pegblocks, Urp, ClearBoard, SandScape und AudioPad ausgestellt. Unter all den möglichen Ausstellungsorten für diese Projekte habe ich das Ars Electronica Center wegen der von dieser „intertidalen Zone" ausgehenden Energie gewählt, da sie die Landschaft des nächsten Jahrhunderts prägen wird.

ClearBoard (2001)

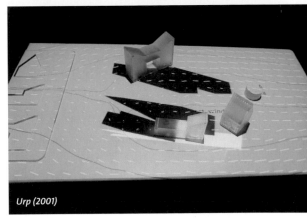

Urp (2001)

sea and land they have blossomed into a myriad of unique forms. Many millions of years ago our ancestors also emerged from the ocean across this border."

The Ars Electronica has been a very special place for the Tangible Media Group since 1997 when our early projects inTouch and Triangles were invited as art installations. That was also the time when I gave a talk on "Tangible Bits" in the same session with Mark Weiser who shaped the landscape of ubiquitous computing. Since 2001, we have exhibited musicBottles, inTouch, PingPongPlus, pinwheels, Triangles, curlybot, pegblocks, Urp, ClearBoard, SandScape and AudioPad at 2.OG of AEC. We are delighted to bring our new projects Topobo and I/O Brush to the AEC in the fall of 2004. Among the many possible venues to exhibit those projects, I chose the Ars Electronica Center simply because of its tremendous energy so similar to the intellectual "inter-tidal zone," which drives the evolution of the landscape of the next century.

SandScape (2002)

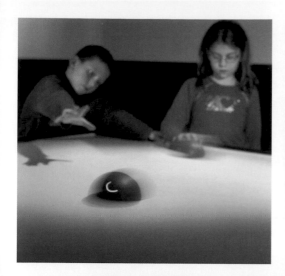

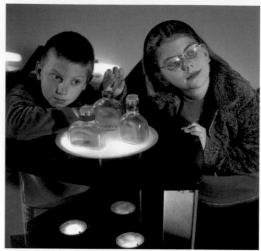

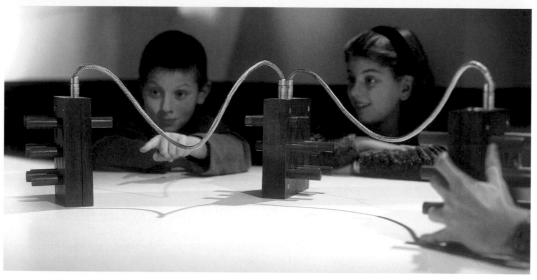

Tangible Media Group
Hiroshi Ishii
MIT Media Lab Boston

curlybot (2001)
musicBottles (2001)
pegblocks (2001)
◀ SandScape (2002)

AudioPad (2003) ▶

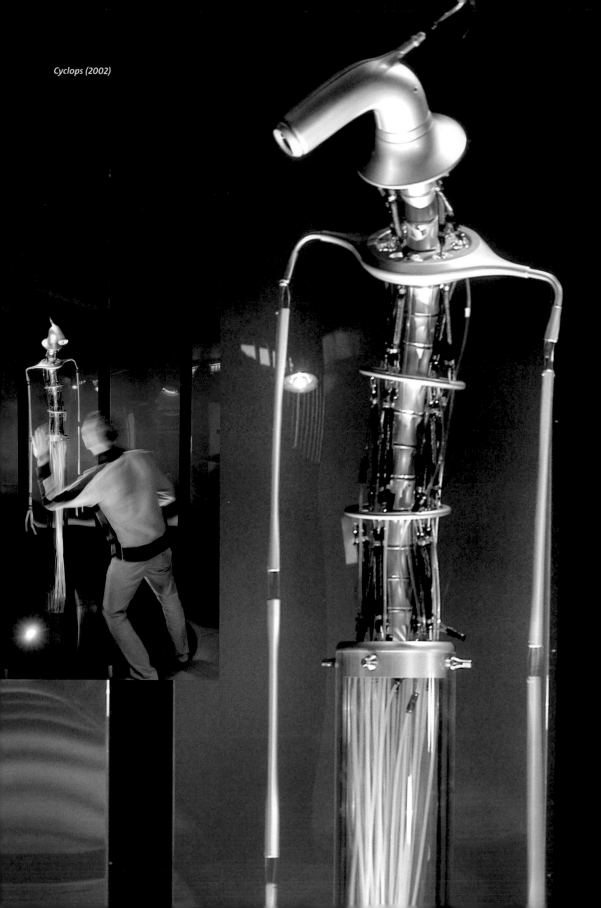

Cyclops (2002)

Responsive Window (2002)

Protrude, Flow (2003)

Small Fish (2000)

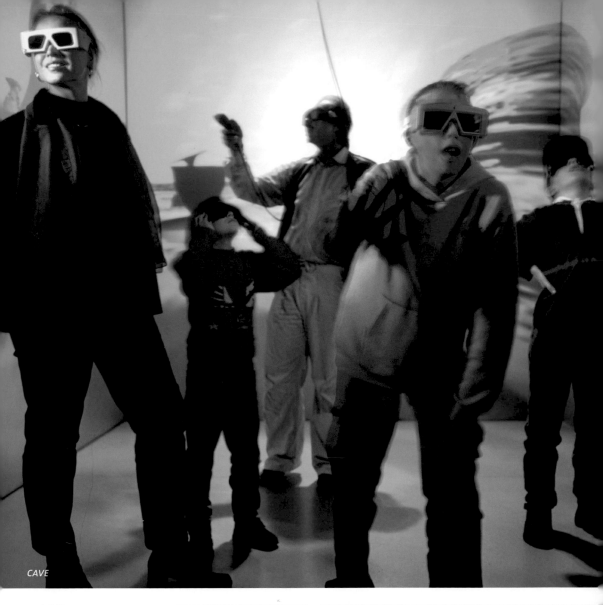

CAVE

Jam-O-Drum (2002)

Hidden Worlds (2002)

Von der Anziehungs- zur Zentrifugalkraft

Ne[...]er Erweiterung von exemplarischer Festivalarbeit zu permanenter Vermittlungsarbeit mit dem Museum der Zukunft ist vor allem das Futurelab das sichtbarste Zeichen für die Veränderung, die Ars Electronica seit 1996 erfahren hat.
Dabei wurde der ambitionierte Versuch gestartet, die Beschwörungsformel von der interdisziplinären Zusammenarbeit in ein funktionierendes Arbeitsprinzip zu entwickeln und Projekte und Problemstellungen von Grund auf gemeinsam zu bearbeiteten.
Das aus einer Wartungs- und Entwicklungsabteilung für die Stationen im Ars Electronica Center heraus gewachsene Futurelab hat in der Folge als technischer Kompetenzträger und Generator von Inhalten einen zentralen strategischen Stellenwert erlangt. Durch seine Projekte, die mittlerweile in der ganzen Welt gezeigt werden, hat das Futurelab dafür gesorgt, dass Ars Electronica von einem geografischen Anziehungspunkt für eine Welt-Elite aus Kunst und Wissenschaft auch zu einem Exporteur des Kreativen und Innovativen avancierte. Ars Electronica entwickelte zur Anziehungskraft nun auch eine Zentrifugalkraft. Die außergewöhnlich hohe Zahl an realisierten Projekten spricht dabei für die Qualität dieser interdisziplinären Konstellation; dass das Futurelab damit ein aktiver Posten im Gesamtbudget von Ars Electronica ist, spricht für die Effizienz.

From Force of Attraction to Centrifugal Force

In addition to the process of expansion from the Festival's annual showcase to permanent mediation set in the Museum of the Future, the Futurelab is the most obvious manifestation of the changes Ars Electronica has been going through since 1996.
The establishment of the Futurelab launched the ambitious effort to transform a formulaic commitment to interdisciplinary collaboration into a functioning approach to work on projects and problems that were to be worked on and solved through a joint approach right from the start. From its beginnings as a maintenance shop and development department for the Ars Electronica Center's exhibits, the Futurelab has subsequently grown up into the role of recognized source of technical expertise and generator of content. It has assumed a central strategic role and its projects—which, in the meantime, are on display all over the world—has led Ars Electronica's advancement from a geographic point of attraction for the international elite in the arts and sciences to an exporter of creativity and innovation. Thus, Ars Electronica is now complementing its force of attraction with a centrifugal force. In this connection, the extraordinarily high number of completed projects attests to the quality of this interdisciplinary constellation, and the fact that the FutureLab has turned into a profit center on Ars Electronica's income statement attests to its efficiency.

unitM (2001)

THE ARS ELECTRONICA FUTURELAB
A KNOW-HOW CLUSTER

ARS ELECTRONICA
EIN KNOWHOW-CLUSTER

HORST HÖRTNER

1995, lange bevor das Ars Electronica Future-lab im heutigen Sinn Konturen annahm, war von ihm vor allem als der technische und inhaltliche Support für die neuen Installationen des Museums die Rede. Die in dieser Zeit initiierten Kooperationen mit internationalen Experten und Künstlern blieben bis heute lebendig. Die ursprüngliche Idee für ein eigenes Entwicklungs- und Forschungslabor entstand aus der Überzeugung, dass das Ars Electronica Center als ein „Museum der Zukunft" auch ein Ort der Produktion sein müsse. Naturgemäß, möchte man im nachhinein behaupten, denn die Kurzlebigkeit der im Center angewandten Technologien und der rasante Ausstellungswechsel machen diese hauseigenen Entwicklungskompetenzen und -kapazitäten unabdingbar.

In 1995, long before the Ars Electronica Future-lab in its current form began to take shape, it was being discussed as a facility to provide technical support and content for the Center's new installations. The collaborative relationships formed at that time with international experts and artists have remained intact to this day. The original idea for an ongoing R&D lab arose from the conviction that the Ars Electronica Center as a "Museum of the Future" would also have to be a production site—naturally, one might maintain in retrospect, since the very short useful lives of the technologies utilized at the Center and the rapid turnover of its exhibitions make this in-house developmental competence and capacity indispensable.

Many top-name teams from Linz, Europe and

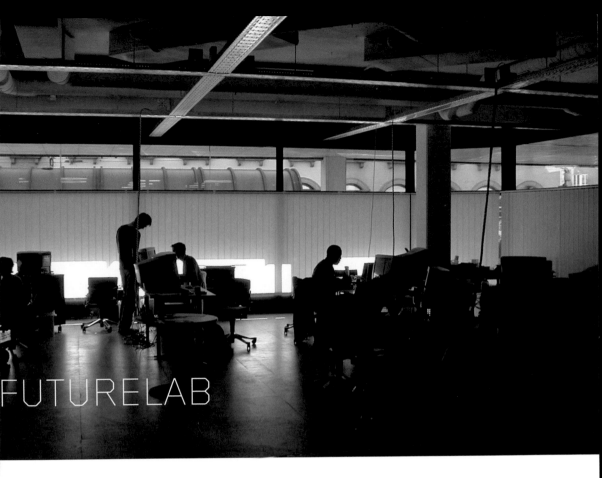

FUTURELAB

Viele namhafte Teams aus Linz, Europa und den USA arbeiteten gemeinsam mit den Exponenten des Lab an den diversen Einrichtungen des Museums. So auch die Künstler/Wissenschaftler des Electronic Visualisation Laboratory (EVL) der University of Illinois at Chicago, um den ersten CAVE außerhalb der USA zu installieren. Gemeinsam mit dem EVL wurde nicht nur eine wesentliche Infrastruktur des Center geschaffen, sondern vor allem der Grundstein für eine langjährige Kooperation gelegt – vielen Entwicklungen von CAVE-Applikationen sollten später mehrmonatige wechselseitige Aufenthalte vorausgehen. Genau zehn Jahre nach der Weltpremiere, die der CAVE des Teams um Dan Sandin bei der weltweit größten Fachtagung für Computergrafik, SIGGRAPH 1992, in Chicago,

the US worked jointly on the lab's output and the many installations in the museum. They include artists and scientists from the University of Illinois at Chicago's Electronic Visualization Laboratory (EVL), who worked on the installation of the first CAVE outside the US. Collaboration with the EVL not only led to the creation of the Center's essential infrastructure; it also laid the groundwork for a long cooperative relationship. The development of numerous CAVE applications would later result from extended stays by EVL staffers in Linz and vice versa. Exactly 10 years after the CAVE designed by Dan Sandin's team premiered at the world's largest computer graphics expo, SIGGRAPH 1992, in Chicago, Illinois, "the guys from Linz" debuted their ARSBOX, a PC variant of the CAVE, at

Illinois, hatte, präsentierten „the guys from Linz" erstmals die PC-Variante des CAVE bei der SIGGRAPH 2002 in San Antonio, Texas, die ARSBOX.

1996 bestand das Futurelab aus Dietmar Offenhuber, Manuel Schilcher, und Horst Hörtner. Manuel Schilcher ging einige Jahre danach nach New York, Dietmar Offenhuber, damals Student der Architektur an der TU-Wien, heute ein international viel gefragter Künstler und Experte für Medientechnologie, leitet unterdessen die Abteilung Interactive Spaces. Die Projekte *Architectours, Nomads* sowie *Apollo 13* oder *LivingRoom* sind einige Beispiele, die auf Dietmar Offenhubers Team zurückgehen.

Auftragsbedingt wuchs das Futurelab-Team noch im ersten Jahr auf über 40 Mitarbeiter an. In dieser Zeit arbeitete Andreas Jalsovec gemeinsam mit anderen Künstlern an einem auf einer Game-Engine basierenden Architek-turmodell des neueröffneten O.K Centrum für Gegenwartskunst in Linz. Seine Arbeit war es, die den Anstoß für die Umsetzung des Forschungs- und Entwicklungsschwer-punktes Low Cost Virtual Reality gab. Typi-sche Projekte aus diesem Bereich sind die Welten des Flugsimulator im Ars Electronica Center *Humphrey I & II*, Visualisierungen der Landesaustellungen Wels und Friesach oder auch *Mindsweeper, capture the Bandwith*. Selbstredend gehen alle Modelle zu den bis-herigen CAVE-oder ARSBOX-Produktionen auf sein Team zurück. Andreas Jalsovec ist heute die tragende Säule der Computergra-fik-Modellierung und unterrichtet unter an-derem an der Fachhochschule Hagenberg. Das erste CAVE-Projekt des Futurelab – Strö-mungssimulationen innerhalb einer von der VOEST-Alpine Tochter MCE zu entwickelnden

SIGGRAPH 2002 in San Antonio, Texas.

In 1996, the Futurelab consisted of Dietmar Offenhuber, Manuel Schilcher, and Horst Hörtner. A few years later, Manuel Schilcher moved to New York. Dietmar Offenhuber, then a student of architecture at the TU-Vienna and today an internationally respected artist and expert in media technology, headed the Interactive Spaces Department (among other assignments). *Architectours, Nomads, Apollo 13 and LivingRoom* were a few of the projects turned out by Dietmar Offenhuber's team.

Due to the many commissions received, the Futurelab staff grew to over 40 in its very first year. It was during this time that Andreas Jalsovec worked together with other artists on a game-engine-based architectural model of the newly-opened O.K Center for Contemporary Art in Linz, and it was this work that provided the impetus to continue to focus R&D activities on low-cost Virtual Reality. Representative projects in this area include the visualized worlds used in the Ars Electronica Center's *Humphrey I & II* flight simulators, visualizations for province expos in the Austrian cities of Wels and Friesach, and *Mindsweeper: Capture the Bandwidth*. Needless to say, all productions to date for the CAVE and ARSBOX owe a substantial debt to the work of this team. Today, Andreas Jalsovec is the head of computer graphics modeling, a subject he also teaches at the Hagenberg Technical College.

The Futurelab's first CAVE project—the simu-lation of flows within a turbine being devel-oped for MCE, a subsidiary of VOEST-Alpine—was carried out in 1997. That same year, Prof. Gustav Pomberger of Linz's Johannes Kepler University (JKU) proposed a collaborative

VR Googles – Stereo See-Thru Head-Mounted Display
Xedit – Mobile Audio Recorder
VRizer – Software Framework für VR
Innovision Board SAP
Palmist – Handheld VR-Navigation Interface
Installationsaufbau Stift Melk
unitM – Biosensor
Future Office Project – Montage

Turbine – entstand 1997. Noch im selben Jahr ergab sich auf Initiative des damaligen Leiters des Christian Doppler Institutes für Software Engineering, Prof. Gustav Pomberger von der Johannes Kepler Universität Linz (JKU), die Kooperation mit diesem Institut bei der Visualisierung von Ergebnissen einer Forschungsarbeit mit dem Welser Schweißtechnik-Spezialisten Fronius. Damit wurde das Fundament einer bis heute erfolgreich verlaufenden Forschungszusammenarbeit gelegt, der Kooperation mit dem Institut für Wirtschaftsinformatik, Lehrstuhl Software Engineering der JKU Linz. Zahlreiche gemeinsame Projekte und Publikationen entspringen dieser Kooperation mit immer wieder unterschiedlichen Partnern aus der Wirtschaft, darunter Unternehmen wie die VA-Tech und Siemens CT.

Forschungskooperationen sind ein wesentliches Standbein des Futurelab geworden, sowohl im lokalen Umfeld, mit dem von Prof. Alois Ferscha geleiteten Institut für Pervasive Computing der JKU oder mit der Kunstuniversität Linz und dem von Prof. Michael Shamiyeh geleiteten Design-Organisation-Medien Forschungslabor DOM, als auch im nationalen Umfeld (Technische Universität Wien, Universität Salzburg) und international mit Partnern wie dem MIT MediaLab in Boston, USA, der University of Osaka, Japan, und der National University of Singapore, um nur einige zu nennen.

Web-Produktionen waren in der Zeit von 1996 bis 2000 ein wesentlicher Teil der Aufgaben des Labors. In dieser Zeit stießen auch Helmut Höllerl und Christopher Lindinger dazu. Helmut Höllerl leitet heute die Abteilung Digital Surface und konzentriert sich dabei auf die Weiterentwicklung der Screen-

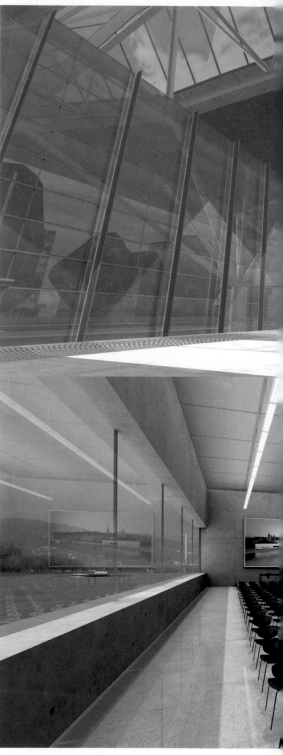

Architektur im CAVE:
Drehscheibe Linz, Lentos Kunstmuseum Linz

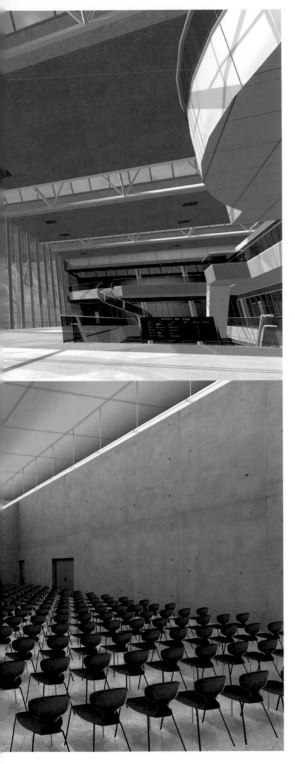

*Time Explorer.
Interaktive Multimedia-
Installation für die
OÖ Landesausstellung 2000
zum Thema „Zeit".*

basierten Interaktion. Die Projekte *Aussichts-posten, Wirtschaftsgeschichte Stift Melk, Info-benches* und wesentliche Teile von *Imagining*, entstammen diesem Entwicklungsschwer-punkt. Helmut Höllerl vermittelt sein Wissen u.a. an den Fachhochschulen Hagenberg und Joanneum in Graz und bildet gemeinsam mit Dietmar Offenhuber ein kongeniales Duo, auf das viele der inhaltlichen Ideen des Labors zurückgehen.

Die Web-basierten Entwicklungen, anfäng-lich ein Aufgabenschwerpunkt des Future-lab, wurden aus der Organisationsstruktur des Lab ausgegliedert und von einer eigenen professionalisierten Produktionseinheit innerhalb des Ars Electronica Center über-nommen.

Christopher Lindinger, Software Architekt, Absolvent der Johannes Kepler Universität, begann seine Tätigkeit 1997 als Besucherbe-treuer im Ars Electronica Center und über-zeugte – damals noch als Student – mit ei-nem Projekt für die Artists in Residence „Jodi", eine Net-Künstlergruppe aus Spanien. Er entwickelte innerhalb von nur wenigen Tagen im Alleingang eine Java-basierte 3D-Game-Engine für die Künstler. Lindinger übernahm bald die Position eines Software-architekten und leitet heute sehr erfolgreich das Team „Virtual Environments". Die Grup-pe hat durch ihre Software-Lösungen Pro-jekte wie *ARSBOX, Palmist, VRizer, Innovision Board* oder *Gulliver's Box* erst möglich ge-macht. Auf Lindingers unnachgiebige Suche nach Neuem gehen viele der herausragend-sten Entwicklungen des Labors zurück.

In den Jahren 2000 und 2001 wurden das Aktionsfeld sowie das Profil des Labors inhaltlich und strukturell geschärft. Unter Einbeziehung von Experten aus Wirtschaft,

undertaking with the Christian Doppler Institute for Software Engineering (which he headed at the time)—the visualization of the results of a joint research project with Fronius, a Wels company specializing in welding tech-nology. This assignment laid the foundation for cooperation with the Software Engineer-ing program of the JKU's Department of Busi-ness Informatics, an ongoing R&D relation-ship that is still functioning smoothly today. Numerous collaborative projects and publica-tions have resulted from this cooperative relationship that has also included a series of private-sector associates such as VA-Tech and Siemens CT.

Cooperative research projects have become an essential part of the Futurelab's activities —on a local level, with the JKU's Department of Pervasive Computing headed by Prof. Alois Ferscha, with Linz's University of Art, and with DOM – The Design-Organization-Media Research Lab headed by Prof. Michael Shamiyeh; on a national level with the Technical Univer-sity of Vienna and the University of Salzburg; and with international associates such as the MIT Media Lab in Boston, the University of Osaka, and the National University of Singa-pore, to name just a few.

Web productions made up a significant pro-portion of the lab's assignments between 1996 and 2000, when Helmut Höllerl and Christopher Lindinger joined the staff. Today, Helmut Höllerl is in charge of the Digital Surface Department and concentrates on the development of screen-based interaction. Projects such as Aussichtsposten, Economic History of the Melk Monastery and Info-benches as well as essential elements of Imagining arose from R&D focused on this area. Helmut Höllerl also teaches at the

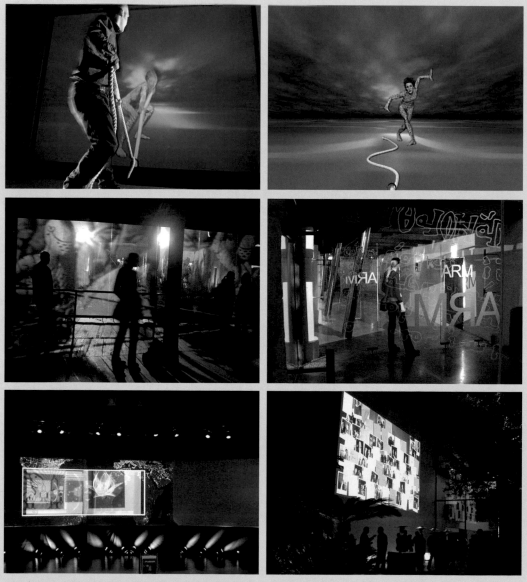

Interaktives Ausstellungsdesign: Tug of War – Millennium Dome London, Landesausstellung Friesach, ARSBOX – Eröffnung Ars Electronica 2003, Innovision Board SAP – Virtuelles Gästebuch

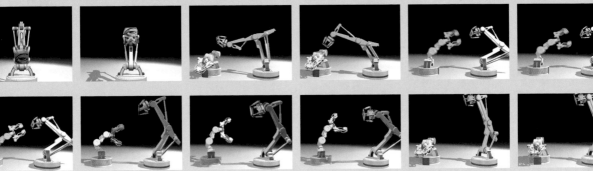

Interactive Bar, Roboter Bewegungsstudie

Wissenschaft und Kunst entstand das gültige Inhalts- und Betriebskonzept für das Futurelab, das den heutigen Standort (650 m² Produktionsflächen und Studios) sowie erweiterte Eigenständigkeiten vorsah. Mit erfolgreicher Umsetzung dieses Konzeptes fokussierte sich das Labor inhaltlich auf die bereits genannten Abteilungen, die sich im Wesentlichen mit der Mensch-Maschine-Interaktion im Realraum (Interactive Space), der Interaktion im schirmbasierten Medium (Digital Surfaces) und im 3D-Raum (Virtual Environment) – also mit dem Thema Human Computer Interface (HCI) vor, am und hinter dem „Screen" – beschäftigen.

Hagenberg Technical College and the Joanneum in Graz (among other institutions) and, together with Dietmar Offenhuber, is half of a congenial duo that has come up with many of the lab's substantive ideas.

Web-based developments—initially one of the Futurelab's chief areas of emphasis— were subsequently spun off from its organizational structure and taken over by a separate, specialized production unit within the Ars Electronica Center.

Christopher Lindinger, software architect and JKU grad, began his association with Ars Electronica in 1997 as a guide in the Museum. Even then—still an undergraduate—he

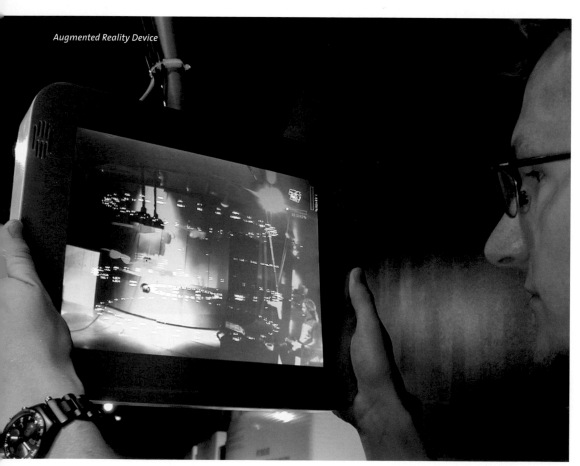

Augmented Reality Device

displayed his brilliance working together with "Jodi," a group of Spanish net-artists taking part in the Futurelab's Artist-in-Residence Program. In only a few days working on his own, he developed a Java-based 3-D game engine for the artists. Lindinger was quickly promoted to software architect and today heads the very successful Virtual Environments Team. This group's software solutions are what made possible projects like *ARSBOX*, *Palmist*, *VRizer*, *Innovision Board* and *Gulliver's Box*. Many of the lab's most outstanding technical developments are attributable to Lindinger's uncompromising quest for innovation.

In 2000—01, the lab's field of activities and profile were substantively and structurally focused. Consultations with experts from the worlds of business, science and art gave rise to the Futurelab's current mission statement and business plan, key elements of which are its current location (650-m² production facility and studios) as well as a greater degree of independence. With the successful implementation of this concept, the lab's substantive focus is on the previously mentioned departments that deal essentially with human-machine interaction in real space (interactive space) as well as interaction in screen-based media (digital surfaces) and in 3-D space (virtual environments)—in other words, with the human-computer interface (HCI) in front of, on and behind the "screen." The departments' most notable successes are those projects in which all staffers are involved in interdisciplinary fashion—in addition to those previously mentioned, the list includes *Hidden Worlds*, *Humphrey*, the *Interactive Bar*, *Walk.in.formation*, *TimeExplorer* and *SpaceTimeMirror*, *Imagining* (Urbis),

Logistiksimulation der „Via Donau" und Architekturvisualisierung „Solar City Linz" für den CAVE

Die wesentlichsten Erfolge der Abteilungen sind jene Projekte, bei denen alle Mitarbeiter abteilungsübergreifend beteiligt waren – neben den bisher erwähnten, insbesondere auch *Hidden Worlds*, *Humphrey*, die *Interactive Bar*, *Walk.in.formation*, *Time Explorer*, *Raum-ZeitSpiegel*, *Imagining* (Manchester/Urbis), *Future Office Project*, *VR Flipchart* sowie *Gulliver's Box* oder *LivingRoom*. Die Vielfalt der Projekte erklärt sich vor allem durch die für das Futurelab programmatische Transdisziplinarität eines vom Konzept bis zur Umsetzung engagierten Teams, dessen Wahrnehmung im öffentlichen Leben der Stadt Linz zuletzt durch die Verleihung des Design-Preises 2002 an das Futurelab unterstrichen wurde.

the *Future Office Project*, the *VR Flipchart* as well as *Gulliver's Box* and *LivingRoom*. The diversity of the projects is primarily attributable to the Futurelab's programmatic commitment to working with a transdisciplinary team involved from conception to completion. The positive perception of the Futurelab's place in public life in the City of Linz was most recently underscored when it was awarded the 2002 Design Prize.

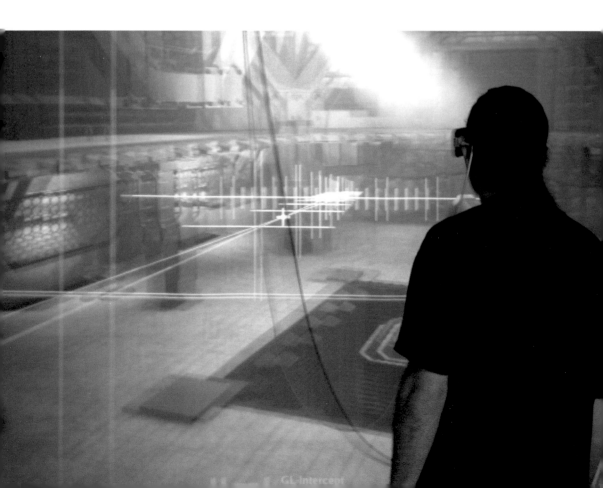

ARS ELECTRONICA FUTURELAB

EINE KEIMZELLE FÜR TRANSDISZIPLINÄRE FORSCHUNG
A CENTER FOR TRANSDISCIPLINARY RESEARCH

GUSTAV POMBERGER
Johannes Kepler Universität Linz

In einigen Jahren wird jedes moderne End-
gerät ein Computer sein, gleich ob wir es
zum Arbeiten, zum Fernsehen, zum Spielen
oder zum Wäschewaschen benutzen. Die
Computer kommunizieren drahtlos mitein-
ander, alle Endgeräte sind mit dem Internet
verbunden und beziehen darüber automa-
tisch die neueste Software ...

Der Wandel der Industrie- zur Informations-
und Wissensgesellschaft, die Konvergenz der
Medien und die hochgradige Vernetzung von
Personen, Unternehmen, Organisationen und
Volkswirtschaften gehören zu den wesentli-
chen aktuellen und künftigen Entwicklungen.
Sie ermöglichen neue Kommunikations-,
Kooperations- und Koordinationsformen,
verändern massiv existierende Geschäfts-

In the near future, every modern appliance
will be a computer, regardless of whether it is
designed for performing work, for watching
TV, playing games or doing the laundry. Com-
puters will communicate wirelessly with one
another, and all appliances will be linked to
the Internet from which they will automati-
cally download the latest software ...

The transformation of Industrial Society into
one based on information and knowledge,
the convergence of media, and the high de-
gree of network linkage connecting persons,
companies, organizations and economies are
among the most essential developments of
the present and the future. They are making
possible new forms of communication, coop-
eration and coordination, bringing about

und Produktionsprozesse und führen zur Bildung neuer Arten von Unternehmen und Dienstleistungen. Die Möglichkeiten der modernen Informationstechnologien haben auch zu einem neuen Paradigma für die Rolle der Kunst als wesentlicher Faktor gesellschaftlicher Innovation geführt.

Die Stadt Linz hat auf diese Entwicklungen u. a. 1996 mit der Errichtung des Ars Electronica Center – Museum of the Future reagiert, das es der Bevölkerung erleichtern soll, sich mit digitalen Medien als einer der maßgeblichsten Schlüsseltechnologien des 3. Jahrtausend auseinanderzusetzen. Durch das Ars Electronica Futurlab wiederum wurden der Kunst, der Wirtschaft und der Wissenschaft eine Experimentierplattform für die Auseinandersetzung mit Zukunftstechnologien zur Verfügung gestellt.

Die Universität Linz reagierte auf diese neuen Herausforderungen u.a. mit der Errichtung neuer Institute, um Forschungs- und Studienschwerpunkte wie Pervasive Computing, Augmented Reality und Local and Context based Services, einzurichten und verstärkt transdisziplinäre Forschungsprojekte zu initiieren.

Will man den Herausforderungen der Zukunft gewachsen sein, geht es nicht nur um Lösungen für ungelöste Probleme, sondern vielmehr darum, gute Ideen für Innovationen auf allen gesellschaftlich relevanten Gebieten hervorzubringen. Das erfordert einen neuen Ansatz, durch den die Zusammenarbeit vieler Experten und deren Bereitschaft, unkonventionelle Wege zu beschreiten, unkonventionelle Ziele zu verfolgen und das scheinbar Unmögliche anzudenken, gefördert und gefordert wird. Um einen solchen Prozess in Gang zu setzen, haben sich etablierte

massive changes in existing business and production processes, and leading to the formation of new kinds of enterprises providing new kinds of services. The possibilities of modern information technologies have also given rise to a new paradigm for the role of art as an essential factor in social innovation. One of the ways in which the City of Linz has reacted to these developments was the erection in 1996 of the Ars Electronica Center – Museum of the Future, an institution designed to facilitate the public's encounter with the digital media that are among the core technologies of the 3rd Millennium. The Ars Electronica Futurelab, in turn, was set up to provide the world of art, business and science with a platform for experimentation with the technologies of the future.

The University of Linz has also reacted in a number of ways to meet these challenges— setting up new departments, research facilities and study programs in specialized fields such as pervasive computing, augmented reality, and local and context-based services to name just a few, and initiating more strongly transdisciplinary research projects. Facing up to the challenges of the future is not only a matter of coming up with solutions for unsolved problems; what is also called for is engendering good ideas for innovation in all socially relevant spheres. This necessitates a new approach that demands and nurtures collaboration among a host of experts and their readiness to take unconventional paths, to pursue unconventional aims, and to display the spirit and creativity to consider the seemingly impossible. In order to launch this process, established research institutions like the Institut für Wirtschaftsinformatik—Software Engineering

Mobile Workshop (1996): Eines der weltweit ersten vernetzten CAVE-Environments anlässlich der Feiern zu 150 Jahre Siemens in Berlin. Mit dieser Applikation konnten User in Berlin und Linz gemeinsam ein Handy entwerfen und damit eine Ton- und Bildverbindung zwischen den beiden Orten aufbauen.
Mobile Workshop (1996): One of the world's first network-linked CAVE environments was created on the occasion of Siemens' 150th anniversary celebration in Berlin. With this application, users in Berlin and Linz could jointly assemble a cell phone and then use it to set up an audio/video linkup between the two locations.

Forschungsinstitute, wie das Institut für Wirtschaftsinformatik – Software Engineering, das Christian Doppler Labor für Software Engineering und neue Forschungsinstitute, etwa das Institut für Pervasive Computing und deren industrielle Kooperationspartner wie Siemens und VAI, mit außeruniversitären Gruppen von Künstlern und Entwicklern und dem Ars Electronica Futurelab zu einer Forschungsgemeinschaft zusammengeschlossen, um innovativ und visionär angelegte Projekte in Angriff zu nehmen.

Die bisher erzielten Erfolge bestätigen die Sinnhaftigkeit des eingeschlagenen Weges. So entstanden unter Ausnutzung der CAVE-Technologie die erste virtuelle Schweißwerkstadt der Welt und in der Folge zwei virtuelle Walzwerke, die die Fachwelt auf großen internationalen Konferenzen, zum Beispiel in Peking und in Düsseldorf, in Staunen versetzt und die Aufmerksamkeit auf die Technologieregion Oberösterreich gelenkt haben (was wiederum zu neuen Projekten führte).

Die von der Forschungsgruppe eingesetzte und vom Electronic Visualisation Laboratory

and the Christian Doppler Laboratory for Software Engineering, new research facilities like the Department of Pervasive Computing, and their private sector associates including Siemens and VAI have joined together with extramural groups of artists and developers and the Ars Electronica Futurelab in a research consortium whose aim is to carry out innovative and visionary R&D projects.

The successes that have already been achieved confirm the sagacity of the approach we have chosen. For example, taking advantage of CAVE technology led to the creation of the world's first virtual welding workshop. This was followed up by two virtual rolling mills that absolutely astounded audiences of experts at international conferences in Peking and Düsseldorf, and focused the spotlight of attention on the technological region of Upper Austria (and led, in turn, to new projects).

The CAVE technology utilized by the research group was developed at the Electronic Visualization Laboratory of the University of Illinois at Chicago and was the best VR technology available in the world. Nevertheless, it has

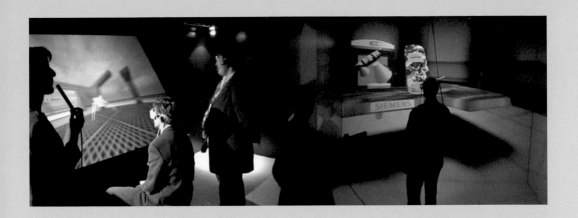

VAI Trainingssimulator (2000): Virtual-Reality-Simulator für eine Stranggussanlage zur Stahlverarbeitung.
Diese Applikation dient der Mitarbeiterschulung und ersetzt aufwändige Qualitätskontrollen im Labor.
VAI Training Simulator (2000): Virtual Reality simulator for a continuous casting plant for steel processing. This
application is designed for staff training purposes and replaces highly involved quality control procedures in the lab.

der University of Illinois at Chicago entwickelte CAVE-Technologie war zwar die weltweit beste VR-Technologie, benötigte allerdings enorm teure Supercomputer. Im Sinne der umfassenden Innovationsmotivation des Teams wurde daher auch ein Forschungsprojekt zur Verbesserung der CAVE-Infrastruktur in Angriff genommen: Das Ergebnis wurde ARSBOX genannt.

Die ARSBOX ist eine Kombination aus Hardware und Software mit multifunktionalen Eigenschaften: Realisierung und Präsentation immersiver interaktiver 3D-Welten (Computer Aided Engineering, Design-on-

taken an enormously expensive supercomputer to run it. Therefore, in the spirit of the team's comprehensive commitment to innovation, a research project to improve the CAVE infrastructure was launched. The result was dubbed the ARSBOX, a combination of hardware and software with multifunctional characteristics: realization and presentation of immersive, interactive 3-D worlds (computer-aided engineering, design-on-the-fly, virtual prototyping) and an easy-to-use multimedia mix (combined display of video, live video, PowerPoint™ presentations, 3-D worlds, etc.). Only standard, off-the-shelf PCs are used in

Siemens – Hybrex (2000): 3D-Erweiterung eines HYBREX-Simulators (Fließschema-Simulator) für Feinwalzwerke. Die Applikation simuliert die einzelnen Arbeitsschritte und Funktionsweisen der originalen Anlage. Das Projekt wurde zur Markteinführung des Simulators im Rahmen der Messe „Metals and Metallurgy 2000" in Peking, China, vorgestellt. Die vom Ars Electronica Futurelab für die Präsentation installierte I-Wall war die erste, die in der Volksrepublik China in Betrieb genommen wurde.

Siemens – Hybrex (2000): 3-D enhancement of a HYBREX simulator (flowsheet simulator) for a precision rolling mill. The application simulates the individual job steps and functional modes of an actual plant. The project was presented in conjunction with the launch of the simulator at the "Metals and Metallurgy 2000" expo in Beijing. The Ars Electronica Futurelab's installation of an I-Wall for use in the presentation was the debut of this piece of equipment in the People's Republic of China.

the ARSBOX infrastructure, which means a drastic cost reduction. It provides scientists, product developers, media artists, marketing experts and event managers with a completely novel tool opening up previously undreamt of possibilities.

One of the most innovative R&D projects that has led to a whole series of patent applications (several of which have already been granted) is INSTAR (Information and Navigation Through Augmented Reality). This project is taking a unique new approach to navigation systems (in autos, for example) that goes beyond conventional two-dimensional visualizations to

Siemens – Hybrex

the-fly, Virtual Prototyping) und Easy-to-use Multimedia Mix (kombinierte Präsentation von Video, Life-Video, PowerPoint™, 3D-Welten etc.). In der ARSBOX-Infrastruktur kommen nur Standard-Industrie-PCs zum Einsatz, was zu einer drastischen Kostenreduktion führt. Wissenschaftler, Produktentwickler, Medienkünstler, Marketing-Experten und Event-Manager erhielten damit ein völlig neuartiges Werkzeug mit bisher ungeahnten Möglichkeiten.

Eines der innovativsten Forschungs- und Entwicklungsprojekte, das zu einer Reihe von

the use of augmented reality. To accomplish this, a monitor mounted in the driver's instrumentation panel displays a real-time video image from the driver's point of view and features route suggestions as a graphic overlay to provide the driver with navigational support in a totally intuitive way. The decisive advantage is that the driver can keep his/her eyes on the road while viewing the navigation screen that displays a real live video image upon which the route to the chosen destination is marked in color. Special technology makes it possible not only to show routing

INSTAR: Information and Navigation Systems Through Augmented Reality – Ein Forschungsprojekt zur Entwicklung mobiler Augmented-Reality-Anwendungen.

INSTAR: Information and Navigation Systems through Augmented Reality—an R&D project working on mobile Augmented Reality applications.

Patentanmeldungen führte (von denen einige bereits positiv beschieden wurden), war und ist INSTAR (Information and Navigation Through Augmented Reality). Dieses Projekt beschreibt einen neuen und einzigartigen Ansatz für Navigationssysteme (z. B. in Autos), bei dem über die gewohnten zweidimensionalen Visualisierungen hinaus auf Augmented Reality gesetzt wird. Hierzu wird auf einem Monitor im Fahrercockpit ein Videobild der Fahrersicht in Echtzeit mit grafischen Routenempfehlungen überlagert, die den Lenker auf intuitive Weise bei der Navigation unterstützen. Der entscheidende Vorteil liegt darin, dass der Fahrer beim Blick auf den Navigationsschirm nicht vom Verkehrsgeschehen abgelenkt wird und in einem Abbild der Realität (Live Video) den Weg zu seinem Ziel farblich markiert sieht. Durch die spezielle Technologie lassen sich nicht nur Routenempfehlungen darstellen, sondern eine Vielzahl weiterer Informationen in das Videobild integrieren.

Gerade aus diesem Projekt lässt sich klar der Wert eines transdisziplinären Ansatzes ablesen: Wurden weltweit nicht unbeträchtliche Ressourcen in die Entwicklung von Autonavigationssystemen gesteckt, so gelang es hier erstmals, ein – eigentlich sehr naheliegendes – Potenzial der Augmented Reality zu heben. Diese Sensorik für Synergien von technisch Machbarem und intuitiv Fassbarem – einem Knowhow gerade der Künstler – wird im verstärkten Maß unverzichtbar für (technologische) Innovationen der Zukunft.

Nicht nur für die Forschungsinstitute der Johannes Kepler Universität ist das Futurelab zu einem unverzichtbaren und geschätzten Kooperationspartner geworden.

suggestions but also to integrate a wide variety of additional information into the video display.

This project is an outstanding example of the value of a transdisciplinary approach. All around the world, considerable resources are being invested into the development of auto navigation systems, but this was the first to take advantage of the—actually quite obvious—potential of augmented reality. This sensitivity to synergies of the technically feasible and the intuitively conceivable—know-how that is the artist's forte—will be increasingly important for (technological) innovation in the future.

For the research facilities of the Johannes Kepler University and many other collaborators as well, the Futurelab has become a valued and indispensable associate.

IDEAS NEED SPACE
A PC-based, stereographic, multimedia presentation unit

ARSBOX

ARSBOX—CREATING IN VIRTUAL ENVIRONMENTS

The ARSBOX has been designed as a form of cross-media infrastructure making it possible to present, develop and manipulate a broad spectrum of media content. Immersive interactive 3-D worlds can be combined with videos and PowerPoint™ presentations, or, for example, linked with scientific workspaces like Mathematica™ in order to revise parameters of the displayed mathematical models in real time. Not only is the ARSBOX an innovative achievement in its own right; it enables innovation as well. The infrastructure's features open up new dimensions to enhance CAE (Computer Aided Engineering), design-on-the-fly, virtual prototyping and digital mockups.

In fall 2002, a jury of international experts selected the ARSBOX to be showcased in the Emerging Technologies exhibit at Siggraph, the world's largest computer graphics trade show held in San Antonio/Texas, USA.

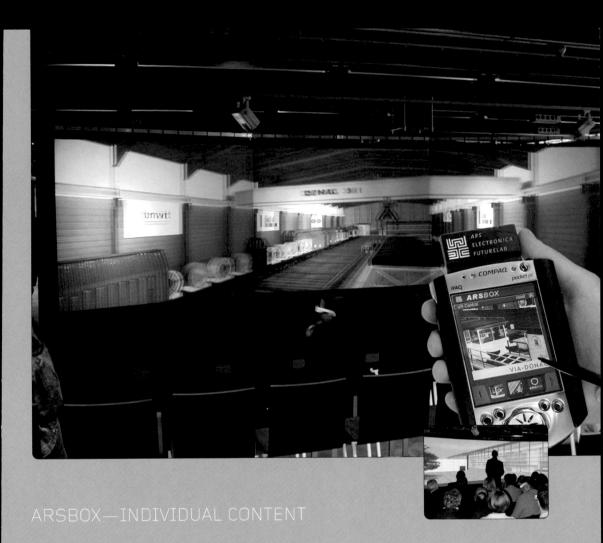

VRizer

VRizer – GAME ENGINES ON THE ARSBOX

The use of game engines is currently the most widespread way to generate PC-based, interactive, real-time applications. Numerous games come with high-performance editors as standard equipment and thus give a broad spectrum of users the opportunity to realize their own conceptions in three-dimensional environments. The Ars Electronica Futurelab has gone one step further with the development of a special software framework and, in doing so, has closed the gap between applications based on game engines and the PC Cluster System ARSBOX *(futurelab.aec.at/arsbox)*. The software framework enables the user to make any OpenGL application compatible with any configuration of the ARSBOX in active and passive stereo mode. With the help of game editors, a user can create highly complex, effective and dramatic environments with a minimum of effort.

PALMIST

The PALMIST makes available all the basic functional features to control projection screens. By means of "drag & drop", any desired media context can be imported to the schematic depiction of any particular projection screen, and displayed in it. The user has complete control over his/her presentation environment at all times. Videos can be started, paused, stopped, and played forwards and backwards, and the same applies to PowerPoint™ slideshows, sounds or 2-D images. Different segments of media content can also be linked with or made to react to one another.

A simple example of this would be a switch in a 3-D application that, when activated, starts a video on another projection screen.

Navigation, control and manipulation in virtual space highlight the strengths of an "intelligent" interface. The objectives of the PALMIST are, to make available meta-information about the virtual world and, to enable the user to apply any parameters desired to that virtual world.

The ARSBOX makes it possible to do virtual prototyping in a simple, practical way. Changing the parameters of existing objects or creating new ones are both done on the PALMIST, and the results are visualized in real time. Not only can static parameters be changed; the PALMIST also allows the user to control the dynamics of the VR world—for instance, the speed of a conveyor belt, simulation parameters, etc.

By way of illustration, consider the process of landscape gardening whereby trees can be "planted" and scaled on the grounds surrounding a newly constructed building. With the ARSBOX, the architect and the landscape gardener can get together in a totally new type of design conference. Each sees exactly what the other does, so that they can collaboratively plan the arrangement of the trees in virtual space and experiment with the effects of light and shadow with trees of varying size. Another example is the mixture of colors to create a shade of auto body paint—different lighting situations can be combined on-the-fly with different paints and the results can be assessed on the spot.

Credits

Senior Executive Developer:
Horst Hörtner

Key Researcher/Virtual Environment:
Christopher Lindinger

Development. Florian Berger, Peter

Freudling, Stefan Mittlböck-Jungwirth, Robert Praxmarer, Andreas Riedler, Andreas Jalsovec

The ARSBOX was realized in cooperation with the Department of Business Computing (Chair for Software Engineering, Prof. Gustav Pomberger) of the Johannes Kepler University, Linz

The system's interaction and control medium is a PALMIST—a pocket PC or a tablet PC equipped with a wireless LAN—running the FATE software framework developed by the Futurelab.

HIDDEN WORLDS
BERLIN

MEDIA INSTALLATION AT SAP'S BERLIN REGIONAL HEADQUARTERS

The centerpiece of the medial mise en scène is *The Hidden World of Noise and Voice*, an installation by Golan Levin and Zachary Lieberman. The New York media artists have created software that depicts sounds and voices in virtual space. Everything that the installation's microphones pick up is interpreted by the system and translated into corresponding dynamic forms that subsequently populate the environment as virtual creatures. For example, a continuous tone, depending on its pitch, is represented as a thin snake or a fat worm

slithering from the position of the microphone at which it originated out into three-dimensional space. A sonorous "blob", on the other hand, generates a compact shape that sluggishly moves forth from its source.

And this is how the previously empty space is transformed into a world full of formal variety, a domain of computer graphics whose diversity and dynamics suggest the species-richness of the oceans. The windows offering glimpses into this hidden world are rear-projection display units (Mit-

Credits

Idea and Concept: Gerfried Stocker, Horst Hörtner, Martin Honzik

Interactive Visuals: Golan Levin, Zachary Lieberman

Project Management: Martin Honzik

Software Design and Development: Wolfgang Ziegler, Peter Brandl, Roland Haring, Christian Naglhofer, Stefan Feldler, Christopher Lindinger, Florian Berger

Interface Design and Development: Stefan Feldler, Stefan Mittlböck-Jung-wirth, Erwin Reitböck, Dietmar Offenhuber, Peter Freudling, Robert Abt

Virtual Designs and Sketches: Andreas Jalsovec, Peter Freudling, Reinhold Bidner, Helmut Höllerl, Stefan Schilcher, Martin Bruner, Nina Wenhart, Christine Pilsl

Coordination: Yvonne Hauser, Pascal Maresch

Special Thanks: Karsten Koch, Astrid Kasper, Hannes Fickenscher, Marc Braun, Robert Westphal, Goebl und Mattes

subishi DLPs) that are capable of providing clear images in daylight conditions. Then, when night falls, the building's architecture is saturated by a series of large-scale projections. The architecture of the lobby and the ceilings of each upper level are visually dissolved by projections. This opens up a view through the exterior shell of the hidden world and makes it possible to follow the paths of the generated objects through the building from their point of origin to their vanishing point in the heavens above Berlin.

PULSE

Sensor-equipped surfaces installed immediately adjacent to the main entrance invite visitors to engage in direct physical contact with the building. The sensors set up there register the pulse of anyone who places his/her hand on the surface; after sundown, the beat is transmitted throughout the building. For a short time thereafter, the projections in the lobby and the levels above it pulse to the rhythm of the measured heartbeat. This interaction opportunity enables everyone to make their own very personal contribution to Berlin's cityscape by night.

INTERACTIVE ADVERTISING

Interactive advertising is a new way to call attention to commercial messages by means of interaction.

At SAP's Berlin regional headquarters, rear-projection display units (Mitsubishi DLPs) arranged facing the sidewalk along the facility's Rosenthalerstraße façade show commercial messages throughout the day. Subtle graphic attention-getters prompt passers-by to take notice of the content being displayed on these DLPs that deliver a sharp image under daylight conditions. Just by walking past, pedestrians leave behind traces on the display—ripples that resemble the waves made by the bow of a ship. Whenever someone remains stationary in front of the DLPs, his/her gestures are registered by cameras, interpreted in real time, and transformed into wave action on the screens. The result in this case is a series of concentric waves flowing out from a central point across the display. This enables passers-by—depending on the intensity of their gesticulations or movements in front of the DLPs—to produce scenarios ranging from the romantic ripples produced by a pebble tossed into a pond to the wild surf of an angry sea.

The relationship between two places is mediated by the make-up

Only those who behave

CO.IN.CIDE
TRACKS AND TRACES

residence.aec.at/coincide

Credits

Concept and idea: Heimo Ranzenbacher, Horst Hörtner, Robert Praxmarer, Ars Electronica Futurelab

Software: Robert Praxmarer

Stage: Stefan Mittlböck-Jungwirth, Martin Honzik, Christoph Scholz, Christoph Hofbauer

Web: Helmut Höllerl, Florian Landerl

A Liquid Music project for Graz 2003— Cultural Capital of Europe in conjunction with STADT_LAND_KUNST. Realized at the Ars Electronica Futurelab, Linz. The programmatic context of co.in.cide is Liquid Music (www.liquid-music.org) a project that has been manifesting itself since 1998 primarily in the form of a small annual festival in the City of Judenburg.

f a system of interaction—the "third place".

ccording to the conditions of the "third place" can reach the goal.

THE INTERRELATIONSHIP OF TWO PLACES—THE THIRD PLACE

The third place is, to a certain extent, the power at work behind its concrete manifestations, a virtuality that is fed by reality/realities and that, in turn, feeds back on reality to realize itself. The place turns out to be a theoretical (topological) object. Art traditionally operates as it were from the state into which the theorization of things successively leads. The way in which images that make a strong impression on our conceptions of things come about says, as a rule, much more about their content than the pictures themselves. Art is directly addressed here: not as the producer of images (which it basically never was) but rather in its traditional role of focusing attention upon the non-visible aspects of what it shows, and from which what is visible draws its meaning. And this is the reason why the so often evoked school of seeing in art is also a school of

aesthetic. *co.in.cide* formalizes the interrelationship of two "places" by means of a system of interaction that mediates between them—the "third place." Whenever the visualizations of visitors' bodies/ movements coincide with those of their telematic counterparts, they can open up a channel of verbal communication and establish eye contact. Only those who behave according to the conditions of the "third place" can reach that goal. When congruity is attained, the full image of the particular user's counterpart appears and replaces (assumes the place of) that user's own reflection. Saving and storing the images of the protagonists along with their voices concludes the process. The automatic upload of the file sets up an additional "place" on the Internet made up of visual and acoustic evidence (tracks + traces) of the interaction. The idea of the third place—the concept of decisive importance for *co.in.cide*—posits that the relationship that two places establish between themselves (or in which they are placed) creates for these places, even independently of the actual reference, binding conditions for the respective actions and activities carried out "on site."

LivingRoom is a multimedia installation that comes alive with th

opportunity for interaction with new media ranging from playfu

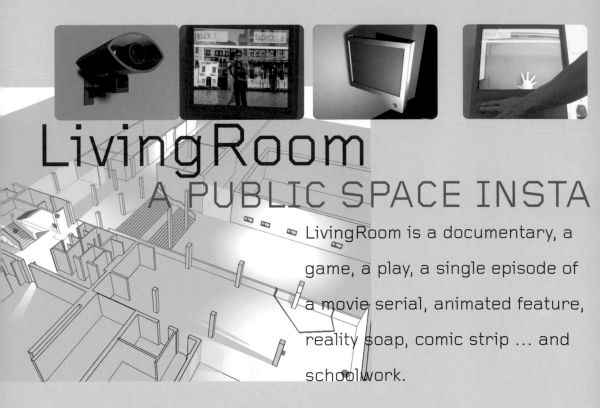

LivingRoom
A PUBLIC SPACE INSTA

LivingRoom is a documentary, a
game, a play, a single episode of
a movie serial, animated feature,
reality soap, comic strip ... and
schoolwork.

Students can play out short stories on four stages set up at different locations throughout the school. These performances are transmitted to the school auditorium, where the various episodes displayed on four different screens merge into a single story and transform the school's physical premises into a narrative space. Real footage, cut-out animation sequences, live images and processed material from the Internet blend together to form partially random, partially scripted narratives. It is not only the screens on which the short stories are displayed that make this project into a living room, the point of LivingRoom is that the school is a place that is created by the activities that go on within it and not one of passive acceptance of predetermined routines. External influences also come into play—in this application via the Web. With a custom-designed video-processing interface, a user can recompile and rework

existing episodes and, in doing so, show plot and narrative elements from a new perspective and tell alternative stories. Thus, narratives can be recorded totally spontaneously or planned in advance, and they can be realized individually or collaboratively. Virtual stage elements can be designed in different school classes or subjects and then be utilized live. Other possibilities include using LivingRoom for school theater performances and as an exhibition medium for school projects. Since LivingRoom has been conceived as a project that will accompany whole classes throughout their school years, it has intentionally been given a modular design whereby all components can be enhanced or replaced with upgraded versions. The hardware is standard equipment readily available in retail stores; the software can be expanded or replaced depending on what users want to accomplish and their respective skill levels.

ntributions of its users. The open infrastructure provides an

xperiences to educational project work.

ATION

Credits
Concept Team: Nina Wenhart, Dietmar Offenhuber, Helmut Höllerl, Christopher Lindinger, Carlos Rocha, Horst Hörtner, Stefan Mittlböck-Jungwirth, Christian Nagelhofer, Peter Brandl

Software Development: Robert Abt, Carlos Rocha, Robert Praxmarer, Christian Nagelhofer, Peter Brandl

Hardware Development: Peter Freudling, Stefan Mittlböck-Jungwirth, Walter Steinacher, Erwin Reitböck, Ewald Elmecker, Martin Honzik, Christoph Scholz

Interface Development: Martin Bruner, Florian Landerl

A project for Bundesschulzentrum Kirchdorf

INFRASTRUCTURE FOR CREATIVITY

RECORDING A SEQUENCE

• Record action
• Action sequence appears in the auditorium on the associated monitor
• Manipulate and create a sequence
• Programmed video sequence appears in the auditorium

FEEDING THE SYSTEM

• Information objects can be invoked on the stage
• Information objects can be sent from each stage to the Internet
• Recording Information objects can be used for the composition of the image

PROGRAMMING OF SEQUENCES

• A large number of video clips are stored in the data pool
• Through the web interface, video clips can be manipulated and new sequences can be arranged
• The newly programmed sequence appears in the auditorium

In the beginning, there was Humphrey—a mechatronic device that worked in conjunction with a pair of data glasses to simulate flight in a 3-D environment. This installation in the Ars Electronica Center has been a smash hit with visitors ever since the opening of the museum, which has replaced almost all of the exhibits on display there at least once over the past eight years. Humphrey, however, will continue to remain aloft in Ars Electronica's airspace, but

his new design will greatly enhance and intensify the experience of flight. Continual improvements in processing capabilities make it possible to generate simulations that get closer and closer to perfection. Virtual reality systems use stereoscopic imagery to produce the illusion of a real, three-dimensional environment. By means of force feedback devices, even physical forces can be mechanically simulated in these virtual worlds.

The contracting muscles that produce flight also give viewers a direct impression of the forces at work upon the user.

HUMPHREY II
THE ILLUSION OF FLYING

Humphrey has mutated into a prototype apparatus that uses a combination of virtual reality and force feedback technology to impart a feeling of weightlessness that is as realistic as possible.

Credits

Concept: Stefan Mittlböck-Jung-wirth, Martin Honzik, Robert Abt, Horst Hörtner, Gerfried Stocker

Project Management: Stefan Mittlböck-Jungwirth

Mechatronics: Robert Abt, Stefan Feldler, Stefan Mittlböck-Jungwirth

Virtual Environment: Andreas Jalsovec, Michael Büttner, Peter Freudling, Martin Bruner, Werner Pötzelberger, Michael Weingärtner, Christopher Lindinger

Wearable Design: Fa. Form ² – Mario Zepetzauer, Stefan Degen

Architecture: Scott Ritter, Jakob Edlbacher

Cooperations: FESTO, Wintex, Form ², Rosenbauer

Documentation: Pascal Maresch

Special Thanks: Thomas Kienzl, Wöber Anton, Flugschule „Wings", Dietmar Offenhuber, Martin Sturm, Stefan Stipek, Stefan Steiner, Gerold Hofstadler, Rudolf Hanl, Thomas Teibler, D.O.R.I.S. – Thomas Ebert, Kurt Pfleger; Gerhard Riegler, Franz Nagelreiter

By means of a system of cables, innovative air muscles transmit the physical forces at work and the feeling of movement directly to the pilot, who is able to navigate through these artificial worlds by moving his/her arms.

VIRTUAL REALITY FORCE FEEDBACK SYSTEM

Ars Electronica Futurelab engineers utilized an empirical design process to create a feeling of weightlessness and centrifugal force experienced in flight. An aspect that makes a key contribution to this is the innovative mode of navigation, which enables the user to steer through an artificial environment by means of intuitive arm movements.

The essential elements are a data helmet, specially reinforced overalls resembling a pilot's jumpsuit, and the equipment responsible for producing the force simulation. In designing the pneumatic components, engineers also took the factor of visual impact into consideration since one of their prime objectives was to enable users and observers alike to understand how the apparatus functions. The contracting muscles that produce flight also give viewers a direct impression of the forces at work upon the user. For the process of immersion—that is, for the user to completely get into a virtual world— the most important component is the data helmet that stereographically visualizes an environment consisting of computer-generated data. In keeping with the state of the art, the helmet was designed to be as light as possible and reduced to its functional elements. Leading edge technology also went into the force-feedback-generated "physics" at work in these immersive worlds, as well as the new 3-D environments.

GULLIVER'S

Gulliver's Box

Conception:
Adrian David Cheok, Hirokazu Kato, Christopher
Lindinger, Horst Hörtner, Nina Wenhart, Gerfried Stocker

Content:
Christine Pilsl, Pascal Maresch, Andreas Jalsovec

Software-Development:
Adrian David Cheok, Simon Prince, Dan Borthwick,
Hirokazu Kato, Gernot Ziegler, Roland Haring, Wolfgang
Ziegler, Stefan Feldler

Production:
Rudolf Hanl, Martin Honzik, Gerold Hofstadler

Exhibition Design:
Scott Ritter

Realized by the Mixed Reality Lab of the National
University of Singapore, Human Interface Lab of
Graduate School of Engineering Science, Osaka
University, Ars Electronica Futurelab,
Zaxel Systems, Inc.
Supported by the funding of DSTA Singapore and the
National Arts Council Singapore

Mixed Reality installation with
projected as live 3-D figures.

Credits

Concept: Hirokazu Kato, Christopher Lindinger, Horst Hörtner, Nina Wenhart, Gerfried Stocker

Content: Li Yu, Pascal Maresch, Andreas Jalsovec, Christine Pilsl

Software Development: Dan Borthwick, Simon Prince, Adrian David Cheok, Hirokazu Kato, Gernot Ziegler, Roland Haring Wolfgang Ziegler, Robert Praxmarer, Stefan Feldler

Production: Rudolf Hanl, Martin Honzik, Gerold Hofstadler, Martin Sturm, Stefan Mittelböck-Jungwirth

Exhibition Design: Scott Ritter

Supported by the funding of DSTA Singapore and the National Ars Council Singapore.

Gulliver's Box is a result of the Ars Electronica Futurelab's collaboration with Prof. Adrian Cheok (National University of Singapore) and Prof. Hirokazu Kato (Osaka University). The developments that have been brought together in this installation represent the effort to pursue new approaches to dealing with Mixed Reality content. The challenge at the core of this project was to position an innovative medium somewhere between theater, film and installation.

BOX

visitors

avatars, and enhanced with any kind of computer animation. The application on display in the Ars Electronica Center also provides visitors with the opportunity to customize recordings of their own actions and subsequently to undertake a very special process of self-reflection.

This unique aspect arises from the perspective of the viewer —just like in the world of huge Brobdignagians and tiny Lilliputians in *Gulliver's Travels*, quantum dimensional leaps and the play of scale and relation are what shatter accustomed modes of perception. Ultimately, the various approaches that go into *Gulliver's Box* seem just as fantastic and horizon-expanding as the visions in Jonathan Swift's novel. The performances rendered by this medium and the recordings of the visitors themselves are an inviting chance for viewers to fundamentally change their points of view or to reconsider them for once. The possibility of observing and manipulating the mise-en-scène from any desired position external to the action goes beyond the God-mode of computer games and seems to be unique in a media context.

The result is an infrastructure that offers artists new opportunities to convey audiovisual information, and one that ought to encourage creative people in every discipline to work with these new approaches. Seen from this perspective, the platform that has been created generates an experimental laboratory situation for a broad spectrum of forms of artistic expression. With it, performances by dancers, singers or actors can be recorded, transferred to

Interaction with characters – either those captured live or animated ones – used to be necessarily bound on monitors or projection screens, but Mixed Reality technology now gives rise to forms of artistic expression and reception in an intimate – albeit likewise projected – situation involving protagonists and viewers. In *Gulliver's Box*, the processes of creative design, display and perception are brought together in a single environment.

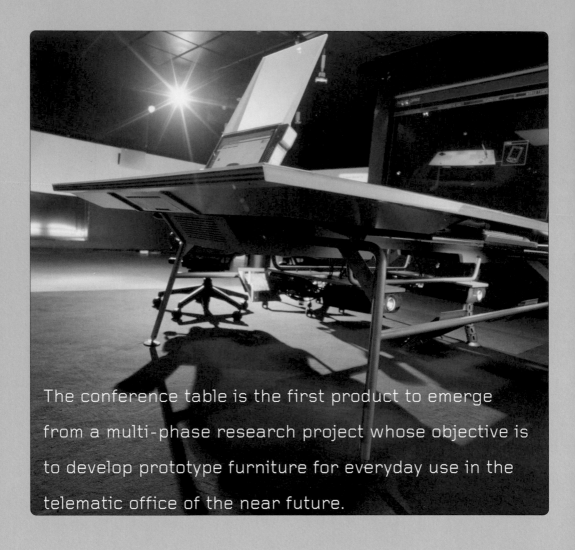

The conference table is the first product to emerge from a multi-phase research project whose objective is to develop prototype furniture for everyday use in the telematic office of the near future.

FUTURE OF

INTELLIGENT SURFACES

The "table" is an instrument of both work and communication. The prototype as an integrated means of communication and action is the basis for a "conference room" that functions simultaneously as an interface for both groups of users—those actually present and virtual participants. The aim of this project is to create an integrated, flexible, intelligent environment for the entire spectrum of available communication options.

The central element of the working environment is the "table"—a multifunctional, convertible model for a team of up to six persons on-site. Additional participants at another location can be integrated via videoconferencing. Each team member has their own personal workspace. The shared virtual working area enables participants to organize, process and share documents and other files.

This project—which is intended as a design study—attempts to construct a bridge between projection techniques and state-of-the-art digitization processes on one hand and commercially available hardware and familiar software environments on the other.

HUMAN FACTOR

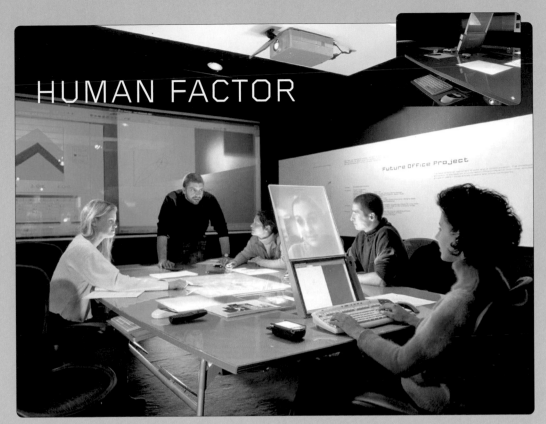

The Future Office Project pursues research on new settings for work and the integration of existing technologies into design scenarios that display both ergonomic functionality and aesthetic excellence.

FICE PROJECT

TELEPRESENCE

Lack of presence on the part of virtual participants, their inability to establish eye contact with those on-site and inadequate opportunities for them to contribute to the discussion are characteristic of conventional teleconferencing and videoconferencing technology. The aim of the *Future Office Project* is to implement a variety of acoustic and visual means to enable all those taking part in a conference to perceive and experience the virtual presence of remote participants.

COLLABORATIVE WORKING

To ensure that a team is able to work together efficiently, media that support communications are of major significance.

DIGITAL/ANALOG INTERFACE

The ability to work in a natural, intuitive way with traditional media like handwritten notes, books and other printed material will remain an important aspect of the working process. This calls for intelligent tools that enable users to convert "analog" documents into a form that can be digitally processed without tedious intermediate steps.

A MULTIFUNCTIONAL COMMUNICATIONS INSTRUMENT

CROSSPAD

The intelligent writing and drawing pad constitutes the mobile counterpart of the sensory surface integrated into the table.

C_PEN

With the C-Pen, text passages can be stored to memory without the use of a computer terminal and later be fed into the network for further processing.

IPAQ

With this handheld PC, the moderator of a conference can determine which content will be displayed on the respective projection surfaces and monitor screens.

MODERATOR DISPLAY

The conference moderator seated at the head of the table can, if need be, activate the flip-up screens integrated in the tabletop. The display consists of a flat screen for conventional computer applications and a holoscreen to enable remote participants to take part in meetings via videoconferencing. The screens can be controlled independently of one another and automatically assume a working position upon activation.

POOL

The center of the table consists of a working surface that makes it possible to use the mouse to "drag-and-drop" digital documents and objects from the user's own workplace into the large-format Pool. Objects in the Pool can be shifted by means of an eBeam marker directly onto the table's glass plate for processing. The conference moderator can also use the "Ipaq" to determine which content is displayed on the individual projection surfaces. A document camera is mounted above the Pool to allow analog documents positioned in the middle of the table to be digitized and made available to other workplaces in the network.

FUNCTIONAL DETAILS
VIDEOCONFERENCING/HOLOSCREEN

A holoscreen flips up out of the desktop. The screen's surface features a special coating that makes videoconferencing in daylight situations possible. The positioning of the image of remote conference participants within the round of those physically present creates a natural setting for interpersonal communication.

CONSOLE

Consoles for keyboards and wireless pointing devices are mounted beneath the desktop and can be pulled out when needed.

INTELLIGENT SURFACE

On a certain section of the desktop, handwritten notes and sketches made by pen on normal paper are automatically digitized. The data derived in this way can then be displayed on any screens on the desk or in the network and processed collaboratively.

MULTIPLE-PORT BANKS

Banks of ports to hook up the cables from a variety of peripheral devices are mounted at the head and foot of the table. They can be pulled out for convenient use and, afterwards, stowed out of sight under the desktop.

Credits

Concept: Gerfried Stocker, Scott Ritter
Project Management: Robert Abt
Keyresearcher Interactive Spaces: Dietmar Offenhuber
Keyresearcher Software Development: Florian Berger
Senior Executive Developer: Horst Hörtner, Christopher Lindinger
Keyresearcher Digital Surfaces: Helmut Höllerl
Content Management: Pascal Maresch

Keyresearcher Virtual Environments: Christopher Lindinger
Software Development: Robert Praxmarer, Robert Abt, Wolfgang Ziegler, Stefan Feldler
Development: Martin Brunner, Erwin Reitböck, Nikolaus Diemannsberger, Stefan Mittlböck-Jungwirth, Horst Hörtner
Screen Design: Erwin Reitböck
Furniture Development: Scott Ritter, Jakob Edlbacher

VR FLIPCHART

The VR Flip Chart can be used in conventional fashion with paper, as an electronic blackboard, and to run computer programs ranging from PowerPoint™ to stereoscopic VR applications.

The *VR Flip Chart* is the latest prototype for telematic working environments that the Ars Electronica Futurelab has designed within the framework of the *Future Office Project*. Besides a series of technical features to support conferences and seminars, the *VR Flip Chart* also incorporates a high-performance stereoscopic VR system (ARSBOX) with an integrated projection screen. This modular system can be used in conventional fashion with paper, as an electronic slate, and as hardware to run computer programs ranging from PowerPoint™ to VR applications. Control and selection of the media components are accomplished by means of a wireless handheld PC *(Palmist Project)*.

FEATURES

- Electronic paper, offering the possibility of online sharing with any computer-supported workplace
- Presentation screen for documents created with widely used applications like PowerPoint™, controlled via palmtop computer
- Online poster in public spaces with interaction support
- Window into an interactive 3-D world with polarization glasses and palmtop navigation

- Proven working methods can be retained. The user doesn't have to adapt to the medium.
- The *VR Flip Chart* is hardly any larger than a conventional flipchart. It can be custom configured to suit individual needs.

PART III

BACKSTAGE
Schnappschüsse aus 25 Jahren Festivalgeschichte
Snapshots from 25 Years of Ars Electronica

ARS ELECTRONICA 1979 – 2004
Projektregister
Project Index

1979: Erstmals präsentiert: Peter Vogels „Fairlight"-Computer.

1979: Umringt von Journalisten: Klangwolken-Erfinder Walter Haupt.

1979: Erste Pressekonferenz: Generalmanager der LIVA, Dr. Horst Stadlmayr, und Intendant des ORF-Landesstudios Oberösterreich, Dr. Hannes Leopoldseder.

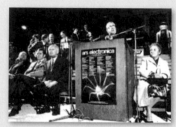

1979: Landeshauptmann Josef Ratzenböck und Bürgermeister Franz Hillinger eröffnen die erste Ars Electronica.

1979: Viele Silberballons werden als Reflektoren für Laserstrahlen zusammengebunden.

1979: Der amerikanische Roboter SPA 12 diskutiert im Club 2 im Fernsehen.

1979: Der amerikanische Roboter SPA 12 wird von Bürgermeister Hillinger persönlich vom Flughafen abgeholt.

1979: Erster Preisträger des „Großen Preises" – der Schweizer Bruno Spoerri.

1980: Frank Elstner testet die Preis-Trophäe des Linzer Designers Kristian Fenzl.

1980: Mach-Mit-Konzert mit Walter Haupt.

1980: Der damalige Kultur Stadtrat und Vizebürgermeister Prof. Hugo Schanovsky überreicht den „Großen Preis '80" an Nyle Steiner.

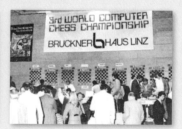

1980: „Schachmatt" – reger Andrang bei der dritten Computerschach-Weltmeisterschaft.

1980: Berühmter Gast aus Frankreich: Autor und Filmemacher Alain Robbe-Grillet.

1980: Im Gespräch – Sky-Art-Conference-Chef Otto Piene und Ars-Electronica-Mitbegründer Herbert W. Franke.

1980: Synthesizer-Erfinder Robert A. Moog in Linz.

1980: Am Beginn entschwanden manche Computerkünstler hinter und unter Drähten, um den Informationen auf die Sprünge zu helfen.

1980: Bundesminister Fred Sinowatz und Landesintendant Dr. Hannes Leopoldseder.

1980: Klaus Schulze und seine „Solisten" von der VOEST-ALPINE.

1979: Der „Chapman-Stick" – knapp am Sieg vorbei.

1980: Konzentriert – Wendy Carlos.

1980: Angeregtes Jurygespräch: Klaus Schulze und Frau Moog.

1982: Ein Machtwort wider den strömenden Regen: „Die Linzer Klangwolke findet statt", entscheidet LIVA-Chef Horst Stadlmayr. Mit ihm: Otto Piene und Hannes Leopoldseder.

1982: Ars Electronica zu Gast im Café Central.

1982: Heiße Diskussion – Café Central Gastgeber Löbl und Ars-Künstler Piene.

1982: ORF-Generalintendant Gerd Bacher, ein Tiger, der auch im Tank der Ars Electronica für Bewegung sorgte.

1982: Charlotte Moorman – es gibt sie noch, die Frau aus Fleisch und Blut, dem prognostizierten Verschwinden des Autors zum Trotz.

1982: „We have a lift off!"

1982: Prominenter Sky-Art-Eröffner – der pakistanische Wissenschafter Yash Pal.

1982: Der ungarische C.A.V.S.-Gründer Gyorgy Kepes bei der Sky-Art-Conference.

1984: Alles aufeinander abgestimmt – Leo Kupper in seiner „Klangkuppel".

1984: In Gedanken versunken – Thomas Pernes.

1984: Computerkünstler im Gespräch: Jane Veeder und Peter Weibel.

1984: Klaus Buhlert mit Heinz Josef Herbort in der Jury.

1984: Vergnügt und sinnierend: Friedrich Achleitner, Manfred Wagner, Arnulf Rainer.

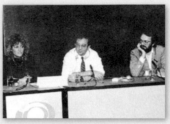

1984: Sherry McKenna, John Withney jr. und Wulf Herzogenrath zum Thema „Das digitale Bild".

1984: Isao Tomita im Gespräch mit Sponsor Yukio Casio.

1984: Isao Tomita und Ernst Dunshirn bei Playback-Aufnahmen im ORF.

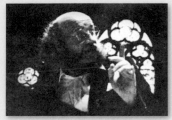

1984: Linzer Guru: der Pop-Elektronik und Ars-Electronica-Mitbegründer Hubert Bognermayr.

1984: „Bergpredigt" im Dom.

1984: Martin Hurnis „Synthophon" wurde mit dem 1. Preis (Design Altmüller/Bogner) ausgezeichnet.

1984: James Dashow referiert über Computermusik.

1984: Erschöpfung total – Glenn Branca nach seinem Konzert.

1984: Interesse am Neuen – der Linzer Altbürgermeister Koref.

1984: Generalprobe im Regen: Isao Tomita im Gespräch mit dem Wettergott?

1984: Begegnung im Donaupark: Bundespräsident Kirchschläger trifft Isao Tomita.

1984: Eingeklemmt in der Mechanik – die digitale Kunst.

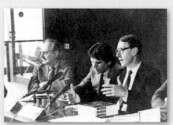

1984: „Leben im Jahr 2019" – Gerhart Bruckmann, Karl Gerbel, Friedrich Fürstenberg.

1984: Jürgen Claus in Sachen „Elektronisches Bauhaus".

1984: DDDr. Schwendter fasziniert beim Symposium.

1984: Jean-Baptiste Barrière und John Lasseter. Auch auf der Treppe des ORF-Landesstudios wurden Projekte für das kommende Jahrtausend diskutiert.

1984: Jean-Baptiste Barrière vom Pariser IRCAM.

1984: Vortrag als Performance: Mike Hentz von Minus Delta T.

1986: Video verbindet – Woody Vasulka und John Sanborn bei der Videonale 1986.

1986: Brasilien trifft Linz – Hans Donner von Globo TV.

1986: Gene Youngblood erstmals in Österreich.

1986: Richard Kriesche, Gottfried Bechtold und ORF-Kameramann Alois Sulzer.

1986: Das Künstlerpaar Inge Graf und ZYX.

1986: Stammgast in Linz: Itsuo Sakane von der weltgrößten Tageszeitung Asahi Shimbun ist noch munter.

1986: Lachen über Künstlerkollegen Günther Brus: Herman Nitsch und Gerhard Rühm im Brücknersaal.

1986: Video-Vernissage im ORF-Landesstudio Oberösterreich.

1986: Video-Vernissage im ORF. Galeriedirektor Peter Baum, Jürgen und Nora Claus, Horst Baumann bei der „Attersee-Vernissage" in der Neuen Galerie der Stadt Linz.

1986: Symposium-Stilleben mit Kenneth Boulding.

1986: „Schuwiduwa!" – Christian Ludwig Attersee als Schlagersänger im Brucknerhaus.

1986: Diskutieren bei den Computer-kulturtagen (v. li): Herbert W. Franke, Peter Weibel, Yoichiro Kawaguchi, Hervé Huitric, Larry Cuba, Woody Vasulka, Gene Youngblood.

1986: „That's it!" John Sanborn auf der Brucknerhausbühne.

1987: Nach der Verleihung des Prix Ars Electronica: Dr. Dankwart Rost, Siemens München, Gen.-Dir. Dr. Walter Wolfs-berger, Siemens Österreich, John Lasseter, Brian Reffin Smith, Jean-Claude Risset und Bundeskanzler Dr. Franz Vranitzky.

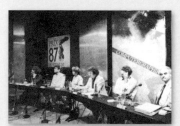

1987: Auf dem Podium (v. li.) Jean-Baptiste Barrière, Robert Pinsky, Pamela McCorduck, Jürgen Claus, Mihai Nadin, Mario Borillo.

1987: Feuerwerks-Percussionist Pierre-Alain Hubert in seinem Heimathafen Marseille.

1987: Vorbereitung des Konzertes – David Felder.

1987: Standortbestimmung – Alvin Curran installiert seine Schiffshörner.

1987: Die Veranstalter im Profil: Dr. Hannes Leopoldseder und Karl Gerbel.

1987: Internationale Kapazität: der algerisch-französische Musikwissen-schaftler Daniel Charles.

1987: „Computer und Kreativität" – Hearing mit Joseph Weizenbaum und Klaus Haefner; Gesprächsleiter Franz Kreuzer.

1987: Die nächsten Termine notiert: Herbert W. Franke, Itsuo Sakane und Hannes Leopoldseder.

1987: Ars im „Kuppelpelz" – John Lasseter und Nancy Tague haben bei der Ars Electronica die Heirat fixiert!

1987: Richard Lermans klingende Radlpartie. Mit dabei: Brucknerhaus-Chef Karl Gerbel.

1987: Brian Reffin Smith prägte den Slogan: „Spirit of Linz."

1987: Siegerfreude – Ernst Grissemann überreicht Peter Gabriel die Goldene Nica.

1988: Heiner Goebbels vor der Premiere.

1988: Konrad Zuse, der Erfinder des Computers, im Gespräch mit Gala-Moderatorin Regina Patsch.

1988: Köstliche Melange aus Ansprache-Versprechern: Eröffnungs„rede" der Urfährwändchöre.

1988: Philosophische Tafelrunde (v. li.): Peter Gente, Hannes Böhringer, Vilém Flusser, Peter Weibel, Jean Baudrillard, Friedrich Kittler, Heinz von Foerster.

1988: Geballte Prominenz: die Prix-Jury vor dem ORF-Studio.

1988: Pionier der Computerkunst – Ed
Emshwiller, multipliziert.

1988: Stammgast bei der Ars Electronica
– die Linzerin Waltraut Cooper.

1988: Gruppenbild mit Dame: Peter Kogler,
Trevor Wishart, Mario Canali, Dennis
Smalley, John Lasseter, David Sherwin,
Barbara Zawadzka, Peter Weibel, Andy
Kopra, Hannes Leopoldseder und Christine
Schöpf nach der Preisverleihung.

1988: East meets West: Douglas Kay
(USA) trifft Felix Andreev und Alexander
Shein (UdSSR) beim Ost-West-Dialog im
ORF-Studio.

1988: Bürgermeister Dr. Franz Dobusch
eröffnet Ars Electronica, festivalgemäß
via Audio-Tapes.

1988: Erster Lokalaugenschein: Erich
Wonder bei der Besichtigung des VOEST-
Geländes.

1988: Dreidimensionale Visionen –
Thomas Shannon.

1989: Die Ars Electronica im zehnten Jahr
– eine ziemlich singuläre Erscheinung.

1990: Stereokopische Betrachtung bei der
Ars Electronica.

1990: Jaron Lanier beeindruckt beim
Symposium als Navigator durch virtuelle
Welten.

1990: Lauter helle Köpfe im Publikum.

1991: Computer – was für ein Theater!
Brenda Laurel beschreibt das dramati-
sche Potenzial interaktiver Technologie.

1991: Das Team Ars Electronica/LIVA/ORF.

1992: ORF-Generalintendant Gerd Bacher als Fürsprecher der Ars Electronica.

1992: Gratulation für die Auszeichnung beim Prix für Char Davies durch Gala-Moderatorin Mercedes Echerer.

1993: Kunstminister Rudolf Scholten überreicht den Oskar der elektronischen Kunst, die Goldene Nica, an Christian Hübler von Knowbotic Research.

1993: Spatenstich Ars Electronica Center.

1993: Präsentation Ars Electronica Center 93 – ein vierfaches Prost auf das künftige Museum der Zukunft.

1993: Die Gewinner der Goldenen Nicas des Jahres 93 – Christian Hübler, Michael Tolson, Pascal Roulin und Bernard Parmegiani.

1994: Wir sind eine gemeinsame Seilschaft und durchbrechen die Lichtschranken der Zukunft. Landeshauptmann Pühringer und Bürgermeister Franz Dobusch.

1994: Winke-Winke oder „Das kreative Potenzial der aktivierten Gruppen-intelligenz". Tausende LinzerInnen zeigen dem Computer, wo es lang geht.

1994: Sie hat gut lachen. ORF-Mitarbeiterin Sigrid Steingruber immer dabei, wenn es um die Vermittlung neuer Technologien geht.

1995: Das Ars Electronica Center noch im Rohzustand.

1995: Mythos Information und seine Mythenbildner.

1995: Das Bild des Festivals hat sich über die Jahre verändert. Weniger bunte Open-Air-Ereignisse, mehr globale Vernetzung.

1995: Und schon denken wir auch an kulinarische Attraktionen und bald werden die Brötchen von Cyber-Girls serviert.

1995: Laurie Anderson trifft mit ihren multimedialen Stories den Nerv der Zeit.

1995: Kunstminister Rudolf Scholten behält trotz rapider Beschleunigung der Infos auf dem Datenhighway eine stoische Ruhe.

1996: Ein Linzer Überflieger namens Humphrey.

1996: „Glasfieber" – sportliche Interaktion mit der Hightech-Welt: Kegeln in der Stadtwerkstatt.

1996: Sehen Sie, ich bin mit den neuen Medien per du! Landeshauptmann Josef Pühringer und der Linzer Bürgermeister Franz Dobusch.

1996: So sieht die Erde aus, wenn sie leuchtet – Eröffnung 1996.

1996: „Auf dieser Bühne kann uns keiner den Revolver ansetzen", Prix Ars Electronica Gala 96, Bundeskanzler Franz Vranitzky und Gala-Moderatorin Mercedes Echerer.

1996: Richard Dawkins macht gute Meme zum Spiel, das die Informationen mit uns treiben.

1996: Viktor Klima in der Pose für die „neuen Medien".

1996: Empfängt Sandy Stone den Cyborg mit offenen Armen?

1996: „Mit dieser Brille behalten Sie im CAVE den Durchblick", berät Gerfried Stocker Bundespräsident Thomas Klestil.

1996: „Was ich Ihnen noch sagen wollte", Landeshauptmann Josef Pühringer zu Bundeskanzler Viktor Klima während der Eröffnungsreden der Ars Electronica im Neuen Rathaus.

1996: Preisträger Robert Normandeau demonstriert mit seiner Goldenen Nica für Computermusik das richtige Tragen eines Preises.

1996: Installieren, löten, Leitungen legen – durch den Tag, durch die Nacht. Das Ars Electronica Center – Museum der Zukunft musste wie eine Maschine auf seinen Betrieb vorbereitet, getestet, justiert und immer wieder rebootet werden. Probleme, die scheinbar im Traum nicht gelöst werden konnten, wurden in schlaflosen Nächten ausgeräumt. In unzähligen Arbeitsstunden haben das Team des späteren Futurelab und seine Helfer das Haus mit der Zukunft verkabelt.

1997: Skeptische Pose von Landeshauptmann Josef Pühringer und Martin Sturm, Leiter des O.K Centrums für Gegenwartskunst. Gerfried Stocker ist sich hier ganz sicher: Mit Blick in den Monitor hat das 21. Jahrhundert bereits begonnen.

1997: Vom Sky-Loft des Ars Electronica Center hat man einen Blick auf Linz und in die ganze Welt. Fernseh-Diskussion mit Bundeskanzler Viktor Klima (Mitte). Moderation: Karin Resetarits und Josef Broukal.

1997: Die schreienden Männer aus Finnland eröffnen die Ars Electronica 97.

1997: Gruppenbild mit Brillen – die Prix-Jury mit ihren Kunstsichtgläsern.

1997: Guillermo Gòmez Peña, ein Net-Warrior par excellence.

1997: Angeregte Jury-Debatte um interaktive Kunst.

1997: Das Scharfness Institute sorgt für Speis und Trank.

1997: Huge Harry verzieht keine Miene.

1997: Journalisten bei körperlicher Ertüchtigung bei Time' s up.

1997: Früh übt sich ... die wahren Cyberkids.

1997: Karin Spaink und Derrick de Kerckhove auf Jury-Tour de Net.

1997: Selbst in der Mittagspause auf der ORF-Terasse geht die Diskussion zwischen Rolf Herken, Michael Wahrman und Chris Wedge weiter.

1997: „Autodrom"-Stadtwerkstatt – interaktive Schräglage mit Fun-Funktion.

1997: Robotische Agenten mischen sich mehr oder weniger unauffällig ins öffentliche Leben.

1997: Die Vorbereitungen zur Eröffnung der Ars Electronica.

1997: Donna Haraway – „Instinktiv will ich immer das Gleiche: nämlich auf der Nahtstelle zwischen Materialität und Semiose insistieren."

1997: Sam Auinger – auf der Suche nach guten Einreichungen in der Kategorie Computermusik.

1997: Gerfried Stocker enthüllt das Cybermemorial: „Love, Peace and Radio TNC!"

1997: Heißer Tee zu heißen Rhythmen im @vent-Konzert der Ars Electronica.

1997: Ryuichi Sakamoto lässt die Bilder nach seiner Musik tanzen.

1997: Die Generation der Zukunft gibt sich im Museum der Zukunft ein Stelldichein.

1998: Das ist das reale, nicht das virtuelle Anlitz der Computerkunst– die Prix-Preisträger und ihre Statuetten.

1998: Eröffnungsempfang im Alten Rathaus.

1998: Auch dem Linzer Kunstsammler, Kunsttheoretiker und Theologen Günther Rombold bietet die Ars Electronica Gelegenheit, in die Welt des „Artificial Life" einzutreten – durch Mausklick.

1998: Die Welt der Kommunikation hat sich auch für Kinder und Jugendliche wesentlich verändert. Nicht mehr Nachzählen im 10-Fingertakt, sondern „Learning bei Doing" mit dem PC.

1998: CNN-Kriegsberichterstatter Peter Arnett stockt die Bibliothek des Ars Electronica Center auf.

1998: Derrick de Kerckhove irn Gespräch mit dem unsichtbaren Paul Virilio.

1998: Tim Druckrey erhebt die Stimme.

1998: Minensuche auf dem Linzer Hauptplatz.

1998: Anlässlich der Museumspreisverleihung verschafft Gerfried Stocker BM Gehrer den Durchblick.

1999: Michael Nyman bei der Planung des OMV-Klangparks.

1999: Die „Klangpark-Boys" um Michael Nyman bei der Studioarbeit.

1999: Jutta Schmiederer & und ihre Girls schaukeln das Festival.

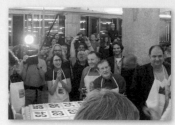

1999: Ars Electronica wird 20 – vom Teen zum Twen.

1999: Archaische Werkzeuge aus dem Gründerjahr. Leopoldseder und Dudesek schneiden sich ihr wohlverdientes Stück vom Ars-Kuchen ab.

1999: 20 Jahre Ars Electronica. Linzer Torte statt vieler Worte von Weibel und Franke.

1999: Schöpf, Leopoldseder, Weibel und Hattinger geben Anekdoten aus 20 Jahren Festivalgeschichte zum Besten.

1999: Itsuo Sakane und Dan Sandin vertieft im Erfahrungsaustausch.

1999: Sabine Wahrmann im Gespräch Tim Druckrey – etwas skeptisch beäugt von Robert Adrian X.

1999: Just Merrit just talking.

Michael Nyman haut in die Tasten Und ...

... Robin Rimbaud aka Scanner tut es ihm gleich.

1999: Jeremy Rifkin proklamiert das bio-technische Zeitalter.

1999: Äußerst charismatisch ... der Plastinator Gunther von Hagens.

1999: Sigrid Steingruber, Jean-Baptiste Barrière und Maurice Benayoun in bester Galalaune.

2000: Der Erfolg geht Hand in Hand mit Klaus Obermaier und Chris Haring.

2000: Robert Lippok und Alexander Balanescu blicken ihren Sounds im Klangpark hinterher.

2000: Akte Ars: Die Wahrheit ist für die etoy agents irgendwo da draußen.

2000: Let's talk about NEXT SEX ... Guy Ben-Ary und Ionatt Zurr beim Tischgespräch über „tissue culture".

2000: Carl Djerassi, Vater der Pille, über Sex ohne Kinderkriegen und Kinderkriegen ohne Sex.

2000: Spermracer Gerfried Stocker gibt eine schnelle Einführung in Sachen NEXT SEX.

2000: Boys and Toys ... Rafael Lozano-Hemmer und die Jungs vom Institute for Applied Autonomy.

2000: „Puppen-Mutter" Marta de Menezes umsorgt ihre durch mikrochirurgische Eingriffe veränderten Schmetterlinge.

2000: Socializing beim Social Club in der Stadtwerkstatt.

2000: An den Reglern die schiere Verzweiflung – Sergio Messina.

2000: Natacha Merrit grübelt über dem nächsten Eintrag in ihrem Digital Diary.

2000: Electrolobbyist Bruno Beusch interviewt von Net-Radioaktivist Kim Danders.

2001: Christoph Ebener und Ulli Winters: If you don't think this is art, call this number!

.... Vizebürgermeister Reinhard Dyk überzeugt den ersten Anrufer vom Gegenteil.

2001: Now you take over: electrolobby-Macher TNC Network bei der Pressekonferenz.

2001: Ohne sie geht gar nichts ... Monitore, Hubs, Kabel und Computer warten auf ihren Einsatz in der electrolobby.

2001: Relaxt chillen

... oder angeregt chatten in der electrolobby

2001: Dan Sandin im Angesicht des Ars Electronica Center.

2001: Gerfried Stocker is singing in the rain? Nein, er eröffnet die Installation „Paintball" am Hauptplatz.

2001: Als die Roboter tanzen lernten – Eröffnung der Ars Electronica im Rathaus.

2001: Gruppenbild mit Roboterarm: Symbiotica Research Group.

2001: Vladislav Delay hat im Klangpark alle Hände voll zu tun.

2001: @vent, @vent ein Lichtlein brennt Das traditionelle @vent Konzert der Ars Electronica.

2002: Hello and welcome Joshua Davis bei Ars Electronica 2002.

2002: Bürgermeister Franz Dobusch überreicht Hannes Leopoldseder den Ehrenring der Stadt Linz für besondere Verdienste um Ars Electronica.

2002: Jay Rutledge bringt die Sounds von Urban Africa nach Linz.

2002: Ein Wiedersehen bei der Ars: Erkki Huhtamo, Margaret Morse, Pertu Rastas und Lev Manovich.

2002: Gespannt lauscht Derrick de Kerckhove den Ausführungen von Annick Bureaud.

2002: Ein Mann mit Durchblick – Dietmar Offenhuber, Futurelab-Mitarbeiter der ersten Stunde.

2002: Body Movies in Aktion: Peter Higgins unterhält sich via Videokonferenz mit Rafael Lozano-Hemmer.

2002: Auch Paul Virilio ist nicht unplugged und schaltet sich live ins Symposium ein.

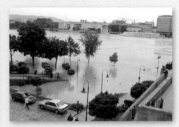

2002: Hurra, die Ars ist nicht ins Wasser gefallen. Trotz Hochwasser im August!

2002: Das Futurelab macht auf der Siggraph seinem Namen alle Ehre: Horst Hörtner präsentiert die ARSBOX, die revolutionäre und zukunftsweisende Version des CAVE – programmiert auf PC.

2002: Das Futurelab erhält den Design-preis der Stadt Linz. Bürgermeister Franz Dobusch und Vizebürgermeister Reinhard Dyk überreichen den Preis an Futurelab-Leiter Horst Hörtner.

2002: Partners of Innovation ...

2003: Keyboarder Alexei Shulgin bei seiner 386 dx Megashow.

2003: Verbeugung vor dem Publikum: Maki Namekawa und Dennis Russell Davies.

2003: Der New Yorker Sound-Großmeister DJ Spooky an den Turntables.

2003: Das Festival-Team um Katrin Emler und Iris Mayr gönnt sich eine kleine Verschnaufspause vom Produktionsstress.

2003: Großer Preis an einen großen Mann: Die Goldene Nica für Lifetime Achivement an Itsuo Sakane.

2003: Im Visier von Itsuo Sakane: Pixel und Family mit Harvey Branscomb.

2003: Strahlende Gesichter... Staatssekretär Franz Morak überreicht den Adolf-Loos-Preis an Horst Hörtner und Scott Ritter

2003: Jutta Schmiederer, assistiert von Flugbegleiter Horst Hörtner, hebt mit dem neuen Humphrey ab.

2003: Testpilot Peter Freudling vom Futurelab bei den Startvorbereitungen zu Humphrey II.

2003: Joan La Barbara, Golan Levin, Jaap Blonk und Zachary Lieberman beim Probesingen für die Performance „Messa di Voce".

2003: Nicht nur big in Japan: Das NHK-Kamerateam dokumentiert die Ars Electronica für das japanische Fernsehen.

2003: Sofa-Surfers Rainer Zendron mit Mutter Erika und Christa Schneebauer.

2004: Andreas Jalsovec, Howard Rheingold und Horst Hörtner andachtsvoll vor dem Bildschirm.

2004: Digital Communities Award Ceremony in New York: Staatssekretär Franz Morak gratuliert den Preisträgern.

2004: Digital Communities Award Ceremony in New York: Peter Kuthan freut sich mit dem Team von tonga.online.

2004: Jury-Arbeit bedeutet vor allem Überzeugungs-Arbeit – und das unter Einsatz aller Kommunikationsmittel: Sprache und Körpersprache, Mimik und Gestik. Doch wer überzeugt hier wen? Oliveriero Toscani und Gerfried Stocker.

Howard Rheingold, Jane Metcalfe und Michael Naimark.

Peter Higgins und Christopher Lindinger.

Ed Burton, Casey Reas und Hiroshi Ishii.

David Toop und Elaine Ng.

Ingrid Fischer-Schreiber, Christa Sommerer und Michael Naimark.

Christine Schöpf und Tomoe Moriyma.

Naut Humon und Horst Hörtner.

2004: Arrivederci & see ya at the next Ars Electronica!

Die Herausgeber möchten darauf hinweisen,
dass die im Register verwendeten Kategorien
(Conferences, Exhibitions, Events, Performances)
lediglich als grobe Orientierungshilfe gedacht
sind und keinesfalls eine inhaltliche, d. h.
kunstdisziplinäre Zuordnung benennen.
Sollte das eine oder andere Projekt unberück-
sichtigt geblieben sein, dann nicht, weil es
absichtlich unterschlagen wurde, sondern weil
es in der Fülle des Materials übersehen wurde.
Für solche Fälle bitten die Herausgeber und
das Redaktionsteam um Ihr Verständnis und
um Nachsicht.

The editors wish to make it clear that the
categories listed in the index (such as confer-
ences, exhibitions, events, performances) are
meant to serve only as general orientational
aids and by no means precisely specify the
contents of a certain work or the artistic cate-
gory to which it may be attributed. If a partic-
ular project has been left unmentioned, then
not with the intention of ignoring it but rather
due to the overwhelming amount of material.
The editors and the editorial staff sincerely
regret any such omission and ask for your
forbearance.

ARS ELECTRONICA 1979—2004
PROJEKTREGISTER
PROJECT INDEX

Ars Electronica 79
Festival für Kunst, Technologie und Gesellschaft

18. – 21. September 1979
Im Rahmen des Internationalen Brucknerfestes 79 Linz

Veranstalter:
Linzer Veranstaltungsgesellschaft mbH (Vorstandsdirektoren: Dr. Horst Stadlmayr und Dr. Ernst Kubin)
ORF/Studio Oberösterreich (Dr. Hannes Leopoldseder)
Programmkonzeption:
Hubert Bognermayr (Linz), Dr. Herbert W. Franke (München/Wien), Dr. Hannes Leopoldseder (Linz), Ulli A. Rützel (Hamburg)

Symposien

Der modulierte Mensch
Brucknerhaus
Herbert W. Franke (Leiter des Symposiums), Prof. Dr. Rul Gunzenhäuser (Stuttgart), Univ.-Prof. Dr. Fritz Mundinger (Freiburg/Breisgau), Barrington Nevitt (Toronto), Prof. Dr. Robert Jungk (Salzburg), Siegfried Schmidt-Joos (Hamburg), Prof. Dipl.Ing. Dr. Vladimir Bonacic (Zagreb)

Von der Computertechnik bis zum elektronischen Farbenspiel
ORF/Landesstudio Oberösterreich
Teilnehmer: Prof. Dr. Werner Kaegi (Uetrecht), Pietro Grossi (Pisa), Pierre Barbaud (Paris), Manfred Kage (Schloß Weißenstein/Stuttgart), Alexandre Vitkine (Boulogne), J. H. Löffler, Daniel W. Kühn, Caspar Henneberger (Hamburg), Tamas Ungvary (Solna, Schweden), Walter Haupt (München), Jean François Colonna (Paris)

Von der Computergrafik bis zur Videoart
ORF/Landesstudio Oberösterreich
Teilnehmer: Klaus Basset/Willi Plöchl (Stuttgart/Wien), Christian Cavadia (Centre Georges Pompidou, Paris), Helmut von Falser (München/Freising), Peter Vogel (Freiburg),

Prof. Otto Beckmann/Dipl.Ing. Oskar Beckmann (Wien), Dr. Paul Jenewein (Paris/Wien), Ludwig Rehberg (London/Stuttgart), Walter Giers (Schwäbisch-Gmünd)

Konzerte/Theater/Performances

Ekseption in Concert
Brucknerhaus
Mit Rick van der Linden, Rein van der Broek, Dick Remelink, Cor Dekker und Peter de Leeuwe
Visualisierung mit dem Videosizer (Video-Synthesizer) von Ludwig Rehberg

Magical echos
Brucknerhaus
von Eberhard Schoener
mit Peter York, Morris Peart, Andrew Powell, Jan Bloomstone, Olaf Kübler und Musikern aus Indonesien (Java und Bali)

Konzertmaschine
ORF/Landesstudio Oberösterreich
Zyklisches Konzert in vier Sätzen von Walter Giers. Demonstration im Rahmen: „Von der Computergrafik bis zur Videoart"

Träume
Sporthalle Linz
Experiment mit Licht, Wort und Bewegung in einem variablen Spiegelraum
Musik und Idee: Walter Haupt
Choreographie: Dieter Gackstetter
Ausstattung und Projektion:
Ingrid Lazarus/ Ulrich Franz
Kostümgestaltung: Günter Berger
Tonmischung: Dieter Behne
Beleuchtungstechnische Realisation:
Johann Darchinger
Beleuchtungsassistenz: Alfred Zehrer
Technische Einrichtung: Franz Keck
Solisten des Balletts der Bayrischen Staatsoper
Bereitstellung von Erzeugnissen:
Dynacord (Lautsprecher), E.M.S. (Synthesizer und Vo- coder), Institut für Schwingungsforschung (Filme), Rank Strand Electric (Lichtstellanlage SP 40/2), Sennheiser (Kopfhörer)

Astropoeticon
 ORF/Landesstudio Oberösterreich
 von Dr. Herbert W. Franke, Walter Haupt
 und Andreas Nottebohn

Preise

Großer Preis der Ars Electronica

Brucknerhaus, Stiftersaal
Moderation: Ernst Grissemann
Jury: Werner Burkhardt, Oskar Drechsler, Kai
Harster, Winfrid Trenkler, Theo Schäfer, Siegfried
Schmid-Joos, Mario Scheuermann, Henning
Vosskamp.
Teilnehmer der Endausscheidung: Emmett
H. Chapman, Joe Drobar, Walter Haupt, Daniel
W. Kühn, Ludwig Rehberg, Roboterwerke, Solton,
Bruno Spoerri, Peter Vogel, David Vorhaus.
Gewinner: Bruno Spoerri für „Lyricon"

Open-Air

Linzer Klangwolke 79:
Eröffnung der Ars Electronica 79

Anton Bruckner, Symphonie Nr. 8 c-Moll
 Donaupark
 Idee und Realisierung: Walter Haupt
 Gesamtkonzeption: Walter Haupt,
 Dr. Hannes Leopoldseder
 Elektro-akustisches Equipment:
 Fa. Dynacord, Straubing.
 Tonbandmaterial: Fa. Agfa-Gevaert,
 München, Fa. Basf, Ludwigshafen.
 Ballon: Ballonfabrik Augsburg.
 Visualisierung des Ballons mit einer Laser-
 aktion: Cinetics Performance W. Lettner
 Laser: Meditec, Heroldsberg
 Tonbandmischung: Peter Vogel, München
 Tontechnik. Ing. Walter Marterer, Ing. Bruno
 Wirlitsch ORF/Landesstudio Oberösterreich
 Organisation: Prof. Hermann Nußbaumer

Ausstellungen

Allgemeine Sparkasse
 Promenade 11 - 13: Computergrafik
Brucknerhaus, Foyer
 Präsentation elektronischer Musikinstru-
 mente und -geräte führender Firmen aus
 Japan, USA, BRD, Australien und Österreich.

Ars Electronica 80

Festival für Kunst, Technologie und
Gesellschaft

8. – 13. September 1980
25. – 29. September 1980

Im Rahmen des Internationalen
Brucknerfestes 80 Linz

Veranstalter:
Linzer Veranstaltungsgesellschaft mbH
(Vorstandsdirektoren: Dr. Horst Stadlmayr
und Dr. Ernst Kubin)
ORF/Landesstudio Oberösterreich (Dr. Hannes
Leopoldseder)
Programmkonzeption:
Hubert Bognermayr (Linz), Dr. Herbert W. Franke
(München/Wien), Dr. Hannes Leopoldseder
(Linz), Ulli A. Rützel (Hamburg)

Symposien

Elektronik in der Musik
(Symposium I)
ORF/Landesstudio Oberösterreich
Synthesizer – Musikcomputer – Digitaltechnik
Klaus Hashagen (Moderator, Bayerischer
Rundfunk, Nürnberg)
Mit: Oskar Sala (Berlin), Robert A. Moog (USA),
Wendy Carlos (USA), Claus Netzle (München),
Tomas Piggott (USA)

Literatur zum Hören und Sehen/
Literatur in Bild und Ton
(Symposium II)
ORF/Landesstudio Oberösterreich
Klaus Ramm (Spenge) Moderator
Mit: Gerhard Rühm (Köln/Wien), Heidulf
Gerngroß (Wien), Alain Robbe-Grillet (Paris),
Bazon Brock (Köln)
Radiophone Poesie:
 Hörinseln im Linzer Stadtbereich
 Konzeption: Gerhard Rühm
 Mit: Gerhard Rühm, Kriwet, Ludwig Harig,
 Paul Wühr, Ror Wolf, Hans G. Helms,
 Friedrich Achleitner, Ernst Jandl, Friederike
 Mayröcker, Franz Mon, Dieter Schnebel,
 Maurizio Kagel

Elektronische Mittel der visuellen Gestaltung:
(Symposium III)
ORF/Landesstudio Oberösterreich
Herbert W. Franke (Moderator, München)
Mit: Otto Piene (Boston), Ulrike und Dieter Trüstedt (München), Otto Frühling (Berlin), Paul Konrad Hoenich (Tel Aviv), Hans Martin Ihme (Kronshagen), Otto Beckmann (Wien), K & K Experimentalstudio (Wien)

Informatiksymposion
Johannes-Kepler-Universität Linz
Informationssysteme für die achtziger Jahre. Wechselwirkungen zwischen Informationstechnologie, Individuum, Arbeitswelt und Gesellschaft
Prof. Dr. Gernot Wersig (Freie Universität Berlin), Univ.-Prof. DDr. Adolf Nußbaumer (Wien), Prof. Dr. Carlo Mongardini (Uni Rom), Univ.-Doz. Dipl.Ing.DDr. Werner Koenne (Wien), Prof. Dr. Klaus Brunnstein (Uni Hamburg), Prof. Dr. Ing. Henry Stahl (Techn. Uni Dresden), Mag. Irmgard Herrmann (Uni Linz), Dr. Ingo Schmoranz (Inst. F. Höhere Studien, Wien), Dipl. Ing. Hanns Schwimann (Booz, Allen & Hamilton, Paris-New York) Dipl. Ing. Otto Zich, (VOEST-ALPINE, Linz), Prof.Dr. Theodor Einsele (TU München), Prof. Joseph Weizenbaum (Massachusetts), Prof. Dr. Klaus Fellbaum (TU Berlin), Dipl.Ing. Gerhard Möll (Leiter d. Inst. f. Rundfunktechnik, München), Dipl.Ing. Fritz Steiner (Innovationsforschung Kienzle Apparate GmbH, Villingen), Prof. Dr. Raul Gunzenhäuser (Uni Stuttgart), Prof. Dr. Hans Brinckmann (Gesamthochschule Kassel), Prof. DDr. Herbert Fiedler (Uni Bonn), Prof. Dr. Wilhelm Steinmüller (Uni Regensburg) Prof. Dr. Peter L. Reichertz (Med. Hochschule Hannover), Ernst Rudolf Reichl (Uni Linz)

Konzerte/Theater/ Performances

Linzer Stahlsinfonie
Brucknerhaus /VOEST
(Auftragswerk von Ars Electronica)
von Klaus Schulze, Stahlarbeitern und Maschinen der VOEST-ALPINE AG Linz
Mitwirkende:

1. Ofenmann, Hochofen IV, Adolf Gabriel; Vorwalzer, Steuerstand IV, Breitbandstraße, Ferdinand Hieslmair; Kontrollor, Scherenstraße, Kaltwalzwerk II, Walter Obermühlner; Flämmer, Flämmerei im LD-Stahlwerk III, Erich Slavik; Steuermann, Drückbank in der Schmiede, Franz Stütz; 1. Tiegelmann, Tiegel-Plattform – LD-Stahlwerk II, Helmuth Wagner and Klaus Schulze; Elektronikmusiker
Idee und Gesamtkonzeption: Klaus Schulze, Hubert Bognermayr, Dr. Hannes Leopoldseder, Ulli A. Rützel
Videorealisierung: Klaus Schulze und Klaus Cordes, sowie Alwin Sauter, Alois Sulzer, Bruno Wirlitsch (ORF-Landesstudio)
Zusammenarbeit und mit Unterstützung der VOEST-ALPINE und MOBIL OIL AUSTRIA AG.

Laser Concert
Brucknerhaus
David Tudor, Lowell Cross
Assistent: Stephen Julstrom
Co-Designer des Laser-Systems:
Carson Jeffries
Seine Partituren wurden von Lowell Cross und David Tudor ausgeführt. Das Laser-Equipment wurde von der University of Iowa, Iowa City (USA) zur Verfügung gestellt. Sowohl die elektronische Musik als auch die Laser-Bilder wurden mit Hilfe elektronischer Steuersysteme von den Künstlern „live" realisiert.

Open House
Aktionen und Vorführungen im Brucknerhaus
Performances im Mittleren Saal
Composers Inside Electronics (USA)
mit John Driscoll, Philip Edelstein, Ralph Jones und David Tudor.
Star Networks
at The Singing Point von Ralph Jones
Dry Pool Soundings
von Ralph Jones
Charmed Particies
von John Driscoll und Philip Edelstein

Non-Stop-Concerts
Claudia Robot Vacuum (Wien)
u. a. für Ars Electronica 1980 „Roboter"

Logic (Linz)

Mit: Reinhold Huemer, Werner Endtmayr,
Günther Schmölzer, Erwin Schmölzer, Otto
Pölzl, Günther Gschwentner (Technik),
Christian Öhner (Management)

Desert Harvest (Linz)

mit Arno Hemala, Franz Weger, Wolfgang
Hinger, Hans Kühnl, Franz Auinger

Cultural Noise (Wien)

mit Gerhard Lisy, Walter Heinisch,
Karl Kronfeld

Mainstreet (A)

before „Park"

Toto Blanke's Electric Circus plus

Electronic Saxes

mit: Charlie Mariano (Saxes), Bruno Spoerri
(Lyricon)

Three Motions (Wien)

mit Paul Fields, Muhammad Malli,
Fritz Novotny

Kleiner Saal

Die AKG Hörinsel

Mit 200 Kopfhörer Musikwiedergabe in
extremer Stereophonie Kunstkopf-
produktionen

Foyers

Ausstellungen und Demonstrationen
elektronischer Musikinstrumente:
Big Briar (USA)
Robert Moogs neueste elektronische
Musikinstrumente
Fairlight (Australien)
Computone (USA)
Korg (Japan)
Realton (BRD)
Musikhaus Willburger
(Linz – Publikumsorgelkurse)

Environment flötender Elektronikspiele

Helmut W. Erdmann (BRD)

Klangräume

Stationen für einen Instrumentalisten,
elektronische Klänge und Live-Elektronik

Die wandelnde Elektronik-Klangwolke
aus Berlin

Conrad Schnitzle

Return To Nature

Kai Harster (München)

Literarischer Dialog mit dem Musikcomputer.

Max Mallinger (Linz)

Warum ist etwas und nicht nichts?

Hans Otte (BRD)

Tanztheater 46 (Linz)

mit Erika Gangl, Isabella Marian und
Alfred Peschek

3. Computerschach-Weltmeisterschaft

Mychess, Duchess, Master, Parwell, Sargon 3.0,
Chess 5.0, Bibi, Belle, Schach 2.3, Kaissa, Chess
4.9, Chaos, RCP, Lexcentrique, Ostrich, Awit

Preise

Großer Preis der Ars Electronica

Moderation: Frank Elstner
Jury: Robert A. Moog (USA), Wendy Carlos (USA),
Jean-Michel Jarre (Frankreich), Klaus Schulze
(BRD), Wolfgang Sandner (BRD), Dolf Hartmann
(BRD), Hans Otte (BRD), Leopold Steinkellner (A)
Teilnehmer der Endrunde: Computer Trio „Air"
(Armin Stöwe, Ingo Werner, Reinhard Karwatky),
John Driscoll, Ralph Jones, Daniel Kühn, Jürgen
Schmitz, Nyle Steiner
Gewinner: Nyle Steiner für „The Electronic
Valve Instrument"

Open-Air

Linzer Klangwolke

Anton Bruckner, Vierte Sinfonie in Es-Dur

Donaupark, Brucknerhaus, Brucknersaal,
Foyer
Ausführende: Brucknerorchester Linz
Dirigent: Theodor Guschlbauer
Idee, Bearbeitung und Realisierung:
Walter Haupt
Gesamtkonzeption: Walter Haupt,
Hubert Bognermayr, Dr. Hannes
Leopoldseder
Elektro-Akustisches Equipment: Firma
Dynacord, Straubing
Tontechnik: ORF-Landesstudio
Oberösterreich
Erste Einspielung vom Brucknersaal in
den offenen Raum

Bruckner-Sky-Symphonie

Brucknerhaus, Foyer, Bruckner Kunstkopf
Otto Piene, Center for Advanced Visual

1980

Studies, Massachusetts Institute of Technology in Cambridge, Massachusetts, USA
Unterstützung durch die Polizeidirektion Linz und der Feuerwehr der Stadt Linz.
Visualisierung: Otto Piene, „Blue Star Linz"

Mach-Mit-Konzert
Hauptplatz
Musica Creativa auf dem Linzer Hauptplatz
Kommunikatives Musizieren der Bevölkerung
mit selbstgebastelten Klangerzeugern.
Initiiert von Walter Haupt.
Prominentenorchester mit Bundesminister
f. Unterricht und Kunst, Dr. Fred Sinowatz,
Landeshauptmann Dr. Josef Ratzenböck,
Bürgermeister der Stadt Linz, Franz Hillinger.
In vorbereiteten Aktionen wurden vor allem
auch mit Schulen Musikinstrumente selbst
gebastelt und am Linzer Hauptplatz zu Gehör
gebracht.

Linzer Klangstraße
Hauptplatz
Michael Jüllich
In Zusammenarbeit mit der VOEST-ALPINE AG.

Ausstellungen

Musica ex machina
Automatische Musikinstrumente aus
österreichischen Privatsammlungen
Zusammenstellung: Prof. Gerhard Stradner,
Österreichische Akademie der Wissenschaften, Wien
Gestaltung der Ausstellung: Prof. Friedrich
Goffitzer, Hochschule f. Gestaltung, Linz

Computer x 10
Kunst- und Spielcomputer für alle
ORF/Landesstudio Oberösterreich (Foyer)
Kunst- und Spielcomputer für alle.
Persönliche Computermusik, Computergrafiken und Computertests für alle.

Die entdämonisierten Menschen
Klemens Figlhuber (Linz)
Ausstellung skurriler Bildfiguren

1982

Ars Electronica 82
Festival für Kunst, Technologie und Gesellschaft

24.September – 1. Oktober 1982
Im Rahmen des Internationalen
Brucknerfestes 82 Linz

Veranstalter:
Linzer Veranstaltungsgesellschaft mbH
(Vorstandsdirektoren: Dr. Horst Stadlmayr und
Dr. Ernst Kubin)
ORF/Studio Oberösterreich (Dr. Hannes
Leopoldseder)
In Zusammenarbeit mit dem Center for
Advanced Visual Studies, Massachusetts
Institute of Technology
(Sky Art Conference 82 unter der Leitung
von Prof. Otto Piene)
Gesamtleitung:
Dr. Horst Stadlmayr, Dr. Hannes Leopoldseder

Symposien

Sky Art Conference
Moderation: Pierre Restany (F), Bazon
Brock (D), Edwin Taylor (USA), Otto Piene (USA)
Teilnehmer: Horst H. Baumann (D), Lowry
Burgess (USA), Jürgen Claus (D), Joe Davis (USA),
Dale Eldred (USA), Anders Holmquist (Sweden),
György Kepes (Hungary), Rockne Krebs (USA),
Heinz Mack (D), Otto Piene (USA), Steve Poleskie
(USA), Tom van Sant (USA), Tal Streeter (USA),
Howard Woody (USA), Jose Maria Yturralde
(Spain), Herbert W. Franke (D), Rus Gant (Alaska),
Bernd Kracke (D), Charlotte Moorman (USA),
Nam June Paik (USA), Vera Simons (D), Stan van
der Beek (USA).

Telecomunication Events
Charlotte Moorman/Nam June Paik:
„Concert" (u. a. mit „TV Cello")
Elizabeth Goldring/Edward Le Poulin:
„Inter-national Alarm"
Aldo Tambellini/Sarah Dickinson:
„Skygram"
Horst H. Baumann:
„Laser Video"
(in Zusammenarbeit mit Nam June Paik)

Die Welt in 24 Stunden
(Auftragswerk von Ars Electronica)
24-stündiges Telekommunikationsprojekt
Animator und Koordinator: Robert Adrian X
Frankfurt, Koordination: Thomas Bayrle
Florenz, Koordination: Maurizio Nannucci
Genf, Koordination: Gerald Minkoff
Amsterdam, Koordination: Annie Wright
und David Garcia
Wien, Koordination: Helmut Mark
Dublin, Koordination: Brian King
Toronto, Koordination: Derek Dowden
und Dieter Hastenteufel
San Francisco, Koordination:
Tom Klinkowstein;
Pittsburgh, Koordination: Bruce Breland
Vancouver, Koordination:
Henry Bull und Bill Bartlett
Hawaii, Koordination: John Southworth
Sydney, Koordination: Eric Gidney
Tokio, Koordination: Kazue Kobata
Bath (England), Koordination: Roy Ascott
Turkey: Minus Delta t.

Kommunikatiostechnologien
Johannes-Kepler-Universität Linz
Neue Medien in Bildungswesen, Wirtschaft und Verwaltung
Tagung der österreichischen Computer-
Gesellschaft gemeinsam mit der Gesellschaft
für Bildungstechnologie.Veranstaltungsort
Vorsitz: Prof. Dr. R. Gunzenhäuser (Uni
Stuttgart), Prof. Dr.M. Lánsky (Uni Paderborn),
Dr. M. Paul (TU, Wien), Doz. Dr. R. Traunmüller
(Linz)
Vortragende: Bernhard Horn (D), Guido A.
Wemans (CH), Dipl.Ing. R.C. Meiner (CH/USA),
Dipl.Ing. D. Kassing (D)

Die Industrieroboter
Fachtagung über Chancen, Perspektiven und Konsequenzen für Wirtschaft, Industrie und Gesellschaft
Programmkomitee: Christof Burckhardt
(Lausanne), Adolf Hörl (Friedrichshafen), Rolf
D. Schraft (Stuttgart), Arno Schulz (Linz), Hans-
Jürgen Warnecke (Stuttgart), Hartmut Weule
(Sindelfingen), Josef Wohinz (Graz), Burkhard
Zimmermann (Linz).

Vorträge von: Dr. Winfried Schenk (Wien), Ichiro
Kato (Tokyo), Shigeru Shinomiya (Tokyo), Taizo
Ueda (Tokyo), Alfred Dallinger (Bundesminister
f. soziale Verwaltung 1980, Wien), o. Univ. Prof.
Dipl. Ing. Dr. Franz Wojda (Wien), Dr. Mike
Cooley (UK), Prof. Dr. Eberhard Ulich (CH)

Science-fiction
*Schillerpark Hotel, ORF/Landesstudio Ober-
österreich*
General Meeting 1982 unter der Leitung von
Herbert W. Franke mit David di Francesco und
Alvy Ray Smith (Lucas-Film / Los Angeles),
Michael Weisser (Bremen), Jean-Pierre Dionnet
(Métal Hurlant/Paris), Werner Krützfeldt
(Hamburg) und Mitglieder von World-SF.

Committee 2000 – ö3
Radiotag im Programm Österreich 3 des ORF.
Round-table-Gespräch via Radio mit Künstlern,
Wissenschaftern, Politikern und Hörern über
die Vision eines Tages im Jahr 2000

Konzerte/Theater/ Performances

Das Bermuda Dreieck
(Auftragswerk von Ars Electronica)
Sound Performance mit Projektionen
Musik: Isao Tomita
Visualisierung: Ron Hays
Icarus
Laser-Oper für Multimedia und Elektronik
mit Paul Earls (Musik und Laser-System),
Otto Piene (visuelle und Raumgestaltung),
Ian Strasfogel (Regie, Produktion, Text-
revision), Richard Pittman (Dirigent), Betsy
Connors (Video), James F. Ingalls (Beleuch-
tung) und Ron Hays (Sonnenprojektionen)
Darsteller: Valerie Walters, Otto Piene,
Robert Honeysucker, Helmut Krenn, Chor
der Musik-Hauptschule Harbach unter
Hans Bachl
Musiker: The Boston Musica Viva
Sound Square
(Auftragswerk von Ars Electronica)
Aufführungen in der Ton-Raum-Installation
von Bernhard Leitner

Erdenklang

Brucknerhaus, Brucknersaal
(Auftragswerk von Ars Electronica)
Computer-akustisches Tanztheater Visuali-
sierung der Ersten Computer-Akustischen
Klangsinfonie von Hubert Bognermayr
und Harald Zuschrader
Musikalische Gesamtkonzeption:
Alfred Peschek
Computerdirigenten: Hubert Bognermayr
und Harald Zuschrader
Bühnenlandschaft: Buddy J. Podechtl,
Johann Brenner
Metallklangkonstruktion:
Betha Sarasin-Baumberger
Bildregie: Peter C. Vogel
Musiktechnik: Alois Janetschko
Beleuchtung: Heimo Angerbauer
QUANTEC-Computergesteuerte
Raumsimulatioren, entwickelt von
Wolfgang Schwarz
Spezielle Beschallungstechnik: CRAAFT
professional sound equipement
Musiksolisten: Robert Moog (USA),
Sw. Gyan Nishabda, Klaus Prünster,
Bruno Spoerri (CH), Alfred Peschek (A)

Galaxie Cygnus-a

ORF/Landesstudio Oberösterreich –
Publikumsstudio
(Auftragswerk von Ars Electronica)
Live-Demonstration einer Science-fiction-
Kurzgeschichte
Idee und Konzept: Michael Weisser (D)
Musik: Robert Schröder (D)
Visualisierung:
Michael Weisser
LP-Realisation: Robert Schröder
Video-Realisation: Michael Weisser.
Mit Unterstützung der Max-Planck-Gesell-
schaft für Radioastronomie in Bonn und
den Technikern am 100-m-Radioteleskop
in Effelsberg/Eifel. Technische Beratung
durch Mitarbeiter der ERNO-Raumfahrt
GesmbH, Bremen

Jazz und Elektronik

Alphonse Mouzon-Quartett

Brucknerhaus, Brucknersaal
Joe Albright, David Iwataki, Welton Gite,
Alphonse Mouzon.

Ars Electronica Workshop Ensemble

Brucknerhaus, Brucknersaal
Jasper van't Hof, Harry Pepl, Fransois
Jeanneau, Wolfgang Dauner, Adelhard
Roidinger, Daniel Humair
Gesamtkonzeption: Robert Urmann

Preise

Großer Preis der Ars Electronica

Brucknerhaus, Stiftersaal
Moderation: Walter Zimmermann
Jury: Robert A. Moog (USA), Gerald Dellmann
(D), Werner Krützfeld (D), Betha Sarasin-
Baumberger, Bruno Spoerri (CH), Tom Darter
Teilnehmer der Endausscheidung: Serge
Blenner, Joel Chadabe, Hans Deyssenroth,
Benjamin Heidersberger, Peter Kohlrusch, Uwe
Hüter, Ivan Tcherepnin, Martin Wichtl
Gewinner: Ivan „Cherp" Tcherepnin (USA)

Open-Air

Linzer Klangwolke

Gustav Mahler: Sinfonie Nr. 5 in cis-Moll

Brucknerhaus, Donaupark
Ausführende: Wiener Philharmoniker
Dirigent: Lorin Maazel
Idee, Bearbeitung, Realisierung als
Open-air: Walter Haupt
Gesamtkonzeption: Walter Haupt,
Dr. Hannes Leopoldseder
Elektro-Akustisches Equipment:
Firma Dynacord/Straubing
Tontechnik: ORF/Landesstudio Oberöster-
reich, Hannes Strutzenberger, Gernot Gökler
Aufnahmeleitung: Wolfgang Winkler
Mit Unterstützung der Polizeidirektion Linz
und der Feuerwehr der Stadt Linz.

Linzer Stahloper

Hauptplatz
(Auftragswerk der Ars Electronica)
von Giorgio Battistelli
mit Stahlarbeitern, Musikern und Maschinen
der VOEST
Regie: Lorenzo Vitalone
Darsteller: Oskar Czerwenka, Karl Oblasser,
Michael J. Posey, Angelo degl' Innocenti, Helmut

Krenn, Alexander Berger, Wolfgang Langeder
Kostüm: Beatrice Bordone und Studenten der
Meisterklasse für Metall an der Linzer Hoch-
schule für Gestaltung.
Musikalische Beratung: Sylvano Bussotti
Tontechnik: Gerhard Blöchl
Aufnahmeleitung: Arnold Blöchl
Linzer Stahlorchester: Arbeiter aus dem Werk
Linz der VOEST-ALPINE AG mit ihren Werk-
zeugen und Maschinen.

Sky Events
Donaupark
Charlotte Moorman/Otto Piene, „Sky Kiss"
Tal Streeter, „Linz Line"
Howard Woody, „Linz Sky Boy"
Dale Eldred, „Line of Fire"
Vera Simons, „Drift Linz"
Anders Holmquist, „Fahneninstallation"
Steve Poleskie, „Ereignisse am Himmel"
Jose Maria Yturralde, „Kite sculptures"
Tom van Sant, „Kites"
Lisa van Sant, „Kites"

Ausstellungen

Sky Art
> *Brucknerhaus, Foyer*
> Konzeption: Otto Piene
> Ausstellung mit Arbeiten von:
> Otto Piene, Vin Grabill, Rus Gant, Christopher
> Janney, Tal Streeter, Tom van Sant, Jose
> Maria Yturralde, Bernd Kracke, Stan van der
> Beek, Bernd Kracke, Marc Adrian, Jon Rubin,
> Richard Leacock, Aldo Tambellini, Peter Cam-
> pus, Miralda, Juan Downey, Nam June Paik,
> Betsy Connors, Sarah Dickinson, Ron Hays,
> Antonio Muntadas

Rost – ein deutsches Material
> *Ausstellung im ORF/Landesstudio Ober-*
> *österreich*
> von Herbert Schäfer
> und in der Zentralsparkasse Zweigstelle
> Hauptplatz.

Elektronik für alle
> *Brucknerhaus, Foyer*
> Koordination: Markus F. P. Aigner

Science-Fiction-Buchpräsentation
> *Stadtmuseum Nordico*

Ars Electronica 84
*Festival für Kunst, Technologie und
Gesellschaft*

8. – 14. September 1984
> Im Rahmen des Internationalen
> Brucknerfestes 84 Linz

Veranstalter:
Linzer Veranstaltungsgesellschaft mbH (LIVA),
ORF/Landesstudio Oberösterreich
Gesamtleitung:
Dr. Horst Stadlmayr (LIVA),
Dr. Hannes Leopoldseder (ORF)
Programmkoordination:
Gottfried Hattinger (LIVA),
Dr. Christine Schöpf (ORF)
Einzelprojekte:
Wolfgang Winkler (ORF), Mag. Alfred Pitter-
tschatscher (ORF), Dr. Volker Raus (ORF)
*Einzelprojekte in Zusammenarbeit mit
folgenden Institutionen bzw. Vereinigungen:*
Alternatives Kulturzentrum Posthof
Stadtmuseum Nordico
Kulturamt der Stadt Linz
Zeitort Wien
Stadtwerkstatt/Kulturvereinigung
Amt der oö. Landesregierung/Kulturabteilung
Forschungsinstitut für Mikroprozessortechnik
(FIM) der Johannes-Kepler-Universität
Vereinigung Österreichischer Industrieller,
Landesgruppe Oberösterreich
Linzer City Ring
ARGE Computercamp

Symposien

Die digitale Kunst
ORF/Landesstudio Oberösterreich
Zukunftsperspektiven in der Computerkunst
> Beratung: Herbert W. Franke, Peter Weibel
1. Das digitale Bild
> Moderation:
> Wulf Herzogenrath
> Teilnehmer:
> Peter Weibel(Wien), Jane Veeder(Chicago),
> Sherry McKenna (Los Angeles), Eric Gidney
> (Sidney), Walter Kroy (BRD), Mike Hentz
> (Lyon), Jürgen Claus (München)

2. Der digitale Klang
ORF/Landesstudio Oberösterreich
Moderator: Heinz Josef Herbort (Hamburg)
Mit: Isao Tomita (Tokyo), Robert A. Moog (New
York), James Dashow (Boston), Klaus Buhlert
(Berlin), Mike Beecher (London), Jean-Baptiste
Barrière (Paris), Leo Küpper (Brüssel)

Wissenschaft und Öffentlichkeit
Redoutensaal
Referent: Heinz Haber
Veranstalter: Industriellenvereinigung

Mikroelektronik für den Menschen
Kepler-Universität Linz
Fachtagung u. a. mit Vorträgen von Jörg R.
Mühlbacher, Otto G. Folberth, Johann Löhn und
Hans Leopold

Die Zukunft Österreichs – Leben im Jahr 2019
Brucknerhaus, Kleiner Saal
Interdisziplinäres Symposion unter der Leitung
von Gerhart Bruckmann (Wien)
Moderatoren: Gerhart Bruckmann (Wien), Franz
Seitelberger (Wien), Franz Kreuzer (Wien),
Manfred Wagner (Wien), Peter Kampits (Wien),
Ernst Gehmacher
Teilnehmer: Hubert Feichtlbauer (Wien),
Friedrich Fürstenberg (Bochum), Helmut
Kramer (Wien), Ewald Nowotny (Wien), Mathias
Dorcsi (Wien), Thomas Kenner (Graz), Hans
Strotzka (Wien), Georg Wick (Innsbruck),
Gertraud Czerwenka-Wenkstetten (Wien),
Anneliese Fuchs (Wien), Roland Rainer (Wien),
Helmut Detter (Wien), Robert Jungk (Salzburg),
Peter Menke-Glückert (Bonn), Roman Sexl
(Wien), Peter Weiser (Wien), Friedrich Achleitner
(Wien), Herbert W. Franke (München), Arnulf
Rainer (Wien), Rolf Schwendter (Wien), Viktor E.
Frankl (Wien), Leopold Ungar (Wien), Klaus
Zapotoczky (Linz), Heinz Zemanek (Wien)

Konzerte/Theater/ Performances

Describing planes of an expanding hypersphere
Brucknerhaus, Brucknersaal
(Uraufführung)

von Glenn Branca und Ensemble
Equipment: GBH Productions Ltd.
Der künstliche Wille
Brucknerhaus, Brucknersaal
(Uraufführung)
Elektronische Medienoper
von Peter Weibel mit Susanne Widl, Renee
Felden, Peter Weibel u. v. a.
Musik: Noa Noa, ZYX
Visueller Kommunikator und Objekte:
Werner Degenfeld
Produktionsleitung: Marcus Eiblmayr,
Marco Ostertag
Bildregie: Gregor Eichinger
Spezialtechnik: Frank Michael Habla
Bergpredigt
Aufführung im neuen Linzer Dom
Computerkonzertante Aufführung von
Hubert Bognermayr/Harald Zuschrader
Musik und Computerrealisierung: Hubert
Bognermayr, Harald Zuschrader
Worte und Parts Direction:
Walter Karlberger
Chormeister und Chortraining:
Balduin Sulzer, Kapellmeister
Computerleiter der Aufführung: Hubert
Bognermayr und Harald Zuschrader,
Klaus Prünster
Horn, Computerbläser: Anthony G. Morris
Beschallungskonzeption: Gerhard Englisch,
Pro Show
Organisatorische Leitung: Alois Janetschko
Eine Zusammenarbeit mit dem Land
Oberösterreich und der Diözese Linz.
Unterstützt von QUANTEC Raum
Simulation, DIGITAL EQUIPMENT Corp.
Wien/München und HEWLETT-PACKARD.
Kollisionen
Brucknerhaus, Foyer
(Auftragswerk von Ars Electronica)
Mythologisch-elektronisches Musiktheater
von Transcenic/Theatre d'en Face
Mit Unterstützung von Computer-Video-
Film L.E.A.S.(Laboratoire d' électronique)
IMEDIA/C.N.E.T.)
In Zusammenarbeit mit C.A.C. de Douai
und der Unterstützung des Französischen
Kulturministeriums.
Konzept und Realisation: Pierre Friloux-

Schilansky und Fransoise Gedanken
Musik: Jean-Baptiste Barrière, Pascale
Criton, Kaija Saariaho
Koordination und Klangtechnik: Gyorgy
Kurtag, assistiert von Erwin Sampermans
Dramaturgisches und technologisches
Konzept: Pierre Friloux-Schilansky
Kreation von Linie und Styling:
Sylva & Jacob Valentyne Bosman
Konzeption der Strukturen: Felix Perrotin
Bühnenausstattung: Pierre Friloux-
Schilansky und Felix Perrotin
Lichttechnik: Remi
Installation der Videoanlage: Transcenic &
A.V.P. (Antwerp Videoprojects)
Verantwortlicher für Kamera und Regie:
Jo Vandormael
Synthetische Bühnenbilder: Chiara Boeri &
Pierre Friloux-Schilansky, realisiert von der
Fa. Computer-Video-Film Paris
Elektronische Systeme und EDV:
Jean Angelidis & Fa. L.E.A.S. (Laboratoire d'
Electronique Angelidis/Sarrault), Grenoble,
Fabrice Fatoux (Plastiker)
Videogesteuerter Synthesizer: Erfinder:
Sylvain Aubin, beauftragt mit der Durch-
führung: IMEDIA, Paris (Patent bei C.N.E.T.)
Verteilung: Sjanneke Broekmeulen, Mia
Bundervoet, Luc Carels, Marc Geedts, Conny
Thomas, Carin Vandenbussche, Ludo van
Passel, Oierre Rigopoulo, Schlagzeug
Interpret des elektronisch-musikalischen
Teils: Gyorgy Kurtag
Numerische Anlage zur Aufnahme der
Bewegungen: Studio GRAME (Lyon), James
Giroudon, Pierre Alain Jaffrennou
Unterstützt von Mario Borillo, Mathemati-
ker/Forscher am C.N.R.S. (Laboratoire de
Formalisation du Raisonnement)
Jacques Droulez, Arzt/Informatik-Forscher
am Laboratorium f. sensorielle Neuro-
physiologie am C.N.R.S.
Jean-Louis Weissberg, Medienkritiker an
der Universität Paris XII

Tobias Zapfel

Brucknerhaus, Brucknersaal
(Auftragswerk von Ars Electronica)
von Thomas Pernes
Musik: Thomas Pernes

Dirigent: Thomas Pernes
Instigator: Manfred Biskup
Raumgestaltung: Adi Frühauf, Liz King
Kostümdesign: Esther Linley
Licht: Manfred Biskup
Choreographie: Liz King
(Dancecompany Vienna)
Tänzer: Harmen Tromp, Coco Auriau,
Christian Camus, Esther Linley, Katalin
Lörinc, Roderich Madl
Ausführende Musiker: Septett
Thomas Pernes: Klavier, Synthesizer,
Computer Tapes
Wolfgang Reisinger:Schlagwerk,
Perkussion, Gongs
Herbert Joos: Baßflügelhorn, Flügelhorn,
Trompete, kleine Trompete
Jürgen Wuchner: Kontrabaß
Christian Radovan: Posaune
Wolfgang Puschnig: Saxophone, Flöte, Piccolo
Karl Fian: Trompete
Erich Dorfinger: Tonregie
Wolfgang Musil: Tontechnik
Tonanlage: Electro-voice
Realisation des Tonbandes im ORF und im
Studio der Musikhochschule in Wien.

Theater der Töne

Posthof
(Auftragswerk von Ars Electronica)
Turbulente Operette in elektro-
akustischer Manier
Musik: Egger/Mechtler/Schu (Wien)
Visuelle Gestaltung: Altmüller/Bogner (Linz)
Akteure: Moidi Kretschmann, Musikkapelle
Gramastetten, Ulla Gruber, Ingrid Höller,
Helga Holzmann, Brigitte Justl, Elisabeth
Schick, Grete Szova, Peter Sommerfeld,
Arthur Singer, Ulli Altmüller, Pepi Oberauer,
St. Florianer Streichquartett, Heinz Wustinger,
Franz Fent, Ilona Bogner, Hildegard Steiger
Musiktechnik: Wolfgang Musil

Klangkuppel-Konzerte

Brucknerhaus, Stiftersaal
Variabel gesteuerte Klangkuppel-Installation
mit 104 Lautsprechern.
Mit Unterstützung des „Comissariat Géneral
aux Relations Internationales de la
Communauté Française de Belgique".

Leo Küpper (Brüssel): „Amkéa" (Uraufführung),
„Aćros", „Kouros et Korê"
Josef Anton Riedl (München): „Für Trommeln" –
„EpiphytII", „Zeichnen-Klatschen / Zeichnen-
Zeichnen", „5 Lautgedichte", „Klangsynchronie
II", „Mix fontana Mix", „Für Trommeln II";
Stephen Ferguson (Wien): „Music for 25
Synthesizers" (Uraufführung); Geraldine Ross
(Paris), „Introitus", „In Furore" für Stimme,
Synthesizer, Klavier, Schlagzeug und Tonband
(Uraufführung); Alvin Curran (Rom), „Canti
Illuminati" für Stimme, Synthesizer, Digitalelek-
tronik und Tonband (Uraufführung)

Tonband-Konzerte
Brucknerhaus, Stiftersaal
Leo Küpper (Brüssel), Mauro Graziani, François
Bayle, Bernard Parmegiani, Christian Zanesi,
James Dashow, Kazuo Uehara; Tommy Zwed-
berg, Peter Lunden/Bo Rydberg, Michael Hinton,
Pär Lindgren, Lars-Gunnar Bodin, Åke Parmerud,
Tamas Ungvary, Rolf Enström (Stiftelsen
Electronmusikstudion Stockholm, EMS), Larus
Grimsson, Robert Nasveld, Jaap M. Vink, Roland
Kayn, Tom Willems (Institut voor Sonologie-
Rijksuniversiteit Utrecht); Jean–Baptiste
Barrière (F); Josef Anton Riedl (München);
Klaus Hashagen (Nürnberg)

Stadtwerkstatt
Kulturvereinigung Friedhofstraße 6
Medienterrarium, Veranstaltungsblöcke,
Singing Pool
1. t.p.l.m.* Black Stage, Black Tracks
2. Veranstaltungsblöcke Stadtwerkstatt
 a) 8.9.1984, 22 Uhr
 Pink Industrie – Liverpool
 Alphornbläserduo – Innerschweiz
 b) 14.9.84, 21.30
 3 Trios – Düsseldorf
 Gustzav Varga, Zigeunermusik, Ungarn.
3. T.p.l.m.* Singing Pool
 Festakt im Geviert Alt-Urfahr-Ost
 12.9.84, 18.00 bis 0.30 Uhr
 a) Überfahrt – 18 bis 23.00 Uhr
 b) Musikalischer Teil + Eröffnung 18.00 bis
 2.00 Uhr
 c) Festliche Ausstattung mit Licht.
 Mit Unterstützung von Kulturamt der oö.

Landesregierung, ÖBB, Deutsche Bundes-
bahn Schiffswerft AG Linz, Landesmuseum
Linz, Feuerwehr Linz.

Preise
Großer Preis der Ars Electronica
Moderator: Walter Zimmermann
Jury: Robert A. Moog, Tom Darter, Klaus Buhlert,
Mike Beecher, Heinz Josef Herbort, Leo Küpper
Teilnehmer der Endausscheidung: Martin
Hurni, Walter Schröder-Limmer, Hans-Werner
Schwarz, Manfred Seifert, Dorothy Stone
Gewinner: Martin Hurni für „Synthophon"

Open-Air
Das Universum
Donaupark
(Uraufführung)
Die Geschichte des Universums mit Musik,
Licht, Laser und Feuer über der Donau.
Von Isao Tomita (Japan)
Wissenschaftliche Beratung: Dr. Carl Sagan,
Dr. Frederick L. Scarf, Dr. Masaki Morimoto,
Dr. Tatsuzo Ohbayashi
Mit: Goro Yamaguchi, Shakuhachi-Spieler;
Mariko Senju, Violine; Linda Roark-
Strummer, Sopran; Birgit Greiner, Alt;
William Ingle, Tenor; Riccardo Lombardi,
Bariton; der Chor des Linzer Landestheaters
Regie: Kohei Katsura

Linzer Klangwolke
Brucknerhaus, Donaupark
Ludwig van Beethoven:
Symphonie Nr. 9 d-Moll op. 125
 Ausführende: Zagreber Philharmoniker,
 Singverein der Gesellschaft der Musik-
 freunde Wien (Einstudierung: Helmuth
 Froschauer)
 Dirigent: Milan Horvat
 Solisten: Urszula Koszut, Jutta Geister,
 Wolfgang Müller-Lorenz, Kurt Rydl
 Idee, Bearbeitung und Realisierung:
 Walter Haupt, Dr. Hannes Leopoldseder
 Elektroakustisches Equipment: Firma
 Dynacord/Straubing.
 Tontechnik: ORF/Landesstudio Ober-

österreich, Gernot Göckler, Hannes
Strutzenberger, Gerhard Blöchl.
Aufnahmeleitung: Wolfgang Winkler
Performance 2019
Saxophonpower quer durch Linz zum
Brucknerhaus
mit Urban Sax
Wet Sheets – Reise in die Zukunft
Straßentheater in der Innenstadt mit
Natural Theatre Company

Ausstellungen

Klangforschungsprojekt
Brucknerhaus
Head Resonance
Gib & Nimm
Tauschinstallation im Brucknerhaus
von Waltraut Cooper
Mensch und Computer
Wechselwirkung zwischen Kunst und
Technologie
Kinder und Computer
Brucknerhaus
mit Workshop
Holographie
Präsentation des Museums für Holographie
und neue visuelle Medien (Pulheim, D)
Konzeption: Matthias Lauk

Appelle an die Menschen

Künstler und Wissenschafter aus den
verschiedenen Ländern richten im
Fernsehen FS 2 Appelle anläßlich des Orwell-
jahres an die Menschen:
Irog Wassiljewitsch Bestshew-Lada, Ernesto
Cardenal, Christo, André Cournand, Sir John
Eccels, Hazel Henderson, Robert Jungk,
Ervin Laszloi, Richard Leakey, Carl Sagan, Roald
Sagdeev, Rakesh Sharmah, Isao Tomita,
Maurice Wilkins

Ars Electronica 86
*Festival für Kunst, Technologie und
Gesellschaft*

20. – 27. Juni 1986

Veranstalter:
Linzer Veranstaltungsgesellschaft mbH (LIVA)
Vorstand:
Dr. Horst Stadlmayr
Vorstandsdirektor:
Karl Gerbel
Programmgestaltung:
Mag. Regina Patsch, Gottfried Hattinger
Beratung: Prof. Peter Weibel
Marketing, Projektkoordination:
Ing. Mag. Wolfgang Lehner
Einzelprojekte in Zusammenarbeit mit:
Alternatives Kulturzentrum Posthof
Neue Galerie der Stadt Linz
Stadtmuseum Linz (Nordico)
ORF/Landesstudio Oberösterreich
Österreichische Schiffswerften AG
Stadtwerkstatt/Kulturvereinigung
Musisches Zentrum Linz
Institut für Informatik/Johannes-Kepler-
Universität Linz

Ars Electronica Computerkulturtage Linz

Veranstalter:
ORF/Landesstudio Oberösterreich,
Intendanz: Dr. Hannes Leopoldseder
Programmgestaltung/Koordination:
Dr. Christine Schöpf
Beratung: Prof. Dr. Herbert W. Franke,
Prof. Peter Weibel

ORF-Videonale 86
ORF/Landesstudio Oberösterreich und
Kunst-Stücke-Redaktion
Konzeption:
Dr. Hannes Leopoldseder, Wolfgang Lorenz
Redaktion:
Wolfgang Ainberger, Felix Breisach, Grita Insam,
Dr. Christine Schöpf
Fachberatung:
Grita Insam, Kim Machan

Symposien

Das orbitale Zeitalter

Brucknerhaus
Diskussionsleitung: Peter Weibel
Teilnehmer:
Adolf Adam (Linz), Peter Weibel (Wien/New York), Peter Russel (Videovorführung), Kenneth E. Boulding (Uni of Colorado/ Boulder), Magda McHale Cordell (Uni of New York/Buffalo), Dr. Manfred Schmutzer (Forschungsinstitut f. Technik u. Gesellschaft/ Wien), Jürgen Claus (Künstler, Schriftsteller, D), Gene Youngblood (Lehrer am Kalifornischen Insitut f. Kunst/Los Angeles), Jean Hubert Martin (Organisator einer Weltkunstschau i. Paris), Gerhard. J. Lischka (Künstler, Theoretiker, CH)

Computerkulturtage

ORF/Landesstudio Oberösterreich
Beratung:
Herbert W. Franke, Peter Weibel
Moderatoren:
Bazon Brock (D, A) , Herbert W. Franke (BRD), Markus Peichl (A, D)
Teilnehmer: Akira Asada (Japan), Gene Youngblood (USA), Larry Cuba (USA), Edmond Couchot (F), Adelhard Roidinger (A), Woody Vasulka (USA), John Sanborn (USA), Mary Perillo (USA), Peter Weibel (A/USA), Yoichiro Kawaguchi (Japan), Hervé Huitric (F), Kathy Rae Huffman (USA), Randy Roberts (USA), Hans Donner (Brasilien)

Die Zukunft der Informationssysteme / Lehren der 80er Jahre

Johannes-Kepler-Universität Linz
Veranstalter: Österreichische Gesellschaft f. Informatik (ÖGI), Gesellschaft für Informatik (GI), Schweizer Informatiker-Gesellschaft (SI) gemeinsam mit Institut für Informatik der Universität Linz, Linzer Veranstaltungsgesellschaft mbH (LIVA), ORF/Landesstudio Oberösterreich
Hauptvorträge von: Wolfgang Händler (D), Friedrich Ohmann (D), Albrecht Blaser (D), Peter Mertens (D), Heinrich Reinermann (D), Norbert Roszenich (A), Leo A. Nefiodow (D), Herbert Wilhelmi (D)

Konzerte/Theater/ Performances

Masque Of The Red Death
Linzer Schiffswerft, Halle 1
(Auftragswerk von Ars Electronica)
Elektroakustische Heimsuchungsmesse von und mit Diamanda Galas
Sängerin: Diamanda Galas
Tontechnik: Dave Hunt
Lichtregie: Ian Gugen
Kostüme & Design: Sandy Powell
Bühnenrealisierung: Egon Andritz und Mufti („Einstürzende Neubauten"), Nina Köck, Irene Judmayer, Eva Blaickner

A Contemplation Of Dangerous Games
Brucknerhaus, Brucknersaal
(Auftragswerk von Ars Electronica)
Konzert mit Videoperformance
Cabaret Voltaire, mit Chris Watson, Stephen Mallinder, Richard Kirk

Attersee und seine Freunde
Brucknerhaus, Brucknersaal
(Auftragswerk von Ars Electronica)
Multimedia-Abend und Künstlerfest
Mit: Christian Ludwig Attersee, Günter Brus, Ludwig Gosewitz, Markus Lüpertz, Hermann Nitsch, A R. Penck, Arnulf Rainer, Dieter Roth, Gerhard Rühm, Brigitte Schwaiger, Dominik Steiger, Ingrid Wiener, Oswald Wiener, Emmett Williams, Elisabeth Seiler, Wolfram Berger, Goiserer Viergesang, Leopold Köppl, Geduldig/Thiemann und Wiener Männergesangsverein,
Regie: Edek Bartz
Licht-Design: Chris Lasker
Ton: Erwin Reithmeier

2³ (2 X 2 X 2)
Brucknerhaus, Brucknersaal
(Auftragswerk von Ars Electronica)
in Zusammenarbeit mit dem ORF/Landesstudio Oberösterreich
von John Sanborn/Mary Perillo
Video: John Sanborn, Mary Perillo
Musik: Mark Helias, Pierce Turner
Mitwirkende und Tänzer: Cyndi Lee, Mary Ellen Strom, Hillary Easton
Szene, Grafiken: Candy Yernigan
Licht- und Technikregie: Dave Feldman

Video-Assistenz: Peter Caesar,
Tontechnik: Connie Kieltyka

Angeli di Luce

Posthof

Idee: Giancarlo Cauteruccio/Pina Izzi
Literarische und theoretische Bezüge zu:
Offenbarung des Johannes, Edmond Jabes,
Peter Handke, Henry Michaux
Originalmusik: Andrea Venturoli
Textadaptierung, Kostume: Pina Izzi
Bilder und szenische Objekte: Alfredo Pirri
Inszenierung: Biancarlo Cauteruccio
Bildhauerarbeiten für Kostüme:
Antonio Di Palma
Mit: Gianni Leo, Daniele Nuccetelli,
Pierre Pelletier
Regie: Giancarlo Cauteruccio
Produktionsleitung: Pina Izzi
Fotografie und Multivisionsprogramme:
Claudio Focardi
Bühnentechnische Konsulenz:
Manola Casale
Administrative Verwaltung und Sekretariat:
Sonia Mattessich
Laser-Programmierung:
Marcello Amore
Multivision:
Natalie C.N.A. Studios, Florenz.

Minus Delta T

Donaupark

Konzert und Containercity mit Karel
Dudesek, Wolfgang Hoemann, Mike Hentz,
Gerard Couty, Ben Heidersberger, Dieter
Sellin, Stefan Witwer
Containercity: Diana Mavroleon, Petra Ilyez,
Nene del Paso, Malika Inshallah, Michael
Jansen, Christan van der Burgh

Die Straße der Sehnsucht

Posthof

(Auftragswerk von Ars Electronica)
Assoziierte Produzenten:
Gustav Dornetshuber, Wolfgang Lehner,
Istvan Nagy, Kurt Holzinger, Peter Donke
Mit: Anne Tismer, Donald Donke, Just Merit,
Sabine Schwenk, Nancy Tuffy, „Loopzilla
Kaminsky" Sophie Rois, D. Wolfman u. a.
Musik von: Dynamo Urfahr, Real People
Band, Graf Hardek, Die Feuerlöscher u. a.
Konzept und Skript: Peter Donke, Wolfgang

Lehner, Sophie Roiss, Istvan Nagy, Gustav
Dornetshuber, Kurt Holzinger
Kulisse & Bauten: Istvan Nagy, Peter
Hauenschild
Video Network: Wolfgang Lehner
Ton & Licht: Dick Wolfman, Istvan Nagy
Aufnahmeleitung, Ton: Paul Fischnaller,
Kurt Holzinger, P. C. Donke
Visuelle Betreuung: Rainer Zendron

Prima Vista

Stadtwerkstatt

Superweisende Installation
Transworld
Telefone Concert
Von Stadtwerkstatt
Konzeptausarbeitung:
Astrid Esslinger, Wolfgang Hofmann,
Thomas Lehner, Georg Ritter, Gotthard
Wagner

Musik in 1000 Informationen

Musisches Zentrum – Hauptplatz Linz

Idee/Konzept/Musik/Realisation:
SWAP (Sam Auinger/Werner Pfeffer)
Visuelle Gestaltung: REM Rudolf Mitter
Mitwirkende:
Martina Kornfehl, Raumgestaltung
Irene Faehndrich, Tänzerin
Gerald Schalek, Technischer Direktor
Richard Höllerbauer, Hausherr, musisches
Zentrum
Peter Quehenberger, Physiker
Hannes Proschko, Fotos
Gebhard Parzer, Akupunktur-Masseur
Erwin Gerstorfer, Informatiker
Horst Gady, Freund
Ausstellung:
Doris Boris Berman – Informatiker
(San Francisco), Ilona Mack-Pachler
(A/New York), Waldemar Radtke (San
Francisco), REM Rudolf Mitter (Linz)

Downtown New York 1986

Brucknerhaus, Restaurantfoyer

(Auftragswerk von Ars Electronica)
von Willoughby Sharps
Videopart (Welturaufführung)
60minütiges Videospektakel gestaltet
in Zusammenarbeit mit Susan Britton.
Ein Bericht über die Ereignisse
„downtown" New York.

Musikraum

Brucknerhaus, Stiftersaal

Konzerte mit Werken von: Richard Teitelbaum
(New York), Christina Kubisch (Mailand),
Roberto Laneri (Rom), Riccardo Sinigaglia
(Mailand), GMEM (Marseille), Peter A. Egger
(Wien), Inge Graf & ZYX (Wien), Roland Kayn
(Hilversum), Theatraction (Den Haag), James
Dashow (Rom), Felix Hess (Haren/Holland),
Michael Morris/Vincent Trasov (Vancouver)
Studio GRAME (Lyon).

Computerkulturtage

ORF-Videonale 86 (FS 1/FS 2)

Eine Fernsehwoche mit anderen Bildern
Konzept: Hannes Leopoldseder, Wolfgang
Lorenz
Redaktion: Wolfgang Ainberger, Felix Breisach,
Grita Insam, Christine Schöpf
Beratung: Grita Insam, Kim Machan
Programm u. a. mit Videos von: Peter Greena-
way, Robert Ashley, Nam June Paik, Peter Weibel,
Valie Export

Programm

Neue Bilder – Neue Zeiten

Werkaufträge:
Max Almy: Die drake'sche Gleichung „Fc"
Klaus vom Bruch (D): „Kobolds Gesänge"
Valie Export (A): „Die Zweiheit der Natur"
Monique Nahas/Hervé Huitric (F), „Les
Petites Histoires de Mamy Computer"
Yoichiro Kawaguchi (Japan): „Ocean"
Bernd Kracke (D): „Still live"
Ulrike Rosenbach (A): „Eleven, Verstehen ist
wie Hitze"
John Sanborn/Mary Perillo (USA): „Dance ex
machina"
Woody Vasulka (USA): „Eine Syntax binärer
Bilder"
Jane Veeder (USA): „4 K Tape"
Peter Weibel (A), „Gesänge des Pluriversums"
Inge Graf + ZYX (A): „Achtung! Raumkontrolle"

FS-Show Video-Mania
Präsentation Wibke von Bonin

Bilder am laufenden Band von Zbigniew
Rybzinski, Ko Nakajima, William Wegman,
Karl Kowanz/Renate Kocer, John

Sanborn/Dean Winkler, Max Almy, Dan
Reeves, Marina Abramovic/Ulay, Joan Logue,
Robert Wilson, Daizaburo Harada/Haruhiko
Shono, Dara Birnbaum, Marcel Odenbach,
Klaus vom Bruch, Joan Jonas, Helmut Rainer,
Douglas Hall, Rupert Putz, Jacques Louis/
Daniele Nyst, Woody Vasulka/Ernst Gusella,
Ed Emshwiller

Stille elektronische Post

Videoproduktion von Gottfried Bechtold
und Richard Kriesche, ORF/OÖ

„Still Life-Queen Zero"

Aufführung anläßlich Videonale im ORF-
Publikumsstudio
Videoproduktion von Bernd Kracke mit
Romy Haag und Wolfgang Scheid

Open-Air

Aurora Elettronica

Linzer Hauptplatz

(internationale Koproduktion Österreich/
Italien)
Ein Theater/Architektur-Projekt von Krypton
Leitung: Giancarlo Cauteruccio und Pina
Izzi, Multimedia-Forschungsgruppe Krypton
Szenisches Projekt, Text und Regie:
Giancarlo Cauteruccio.
Mit: Gabriella Venturi, Damiano Foa,
Laura Biagi, Morgan Nardi, Nuccio Zeni
Musik: Paolo Modugno
Produktion, Kostüme: Pina Izzi
Fotografie und Multivisionsprogramme:
Claudio Focardi
Künstlerische Beratung: Manola Casale
Technische Leitung: Vicenzo Benato
Sekretariat: Sonia Mattessich
Technischer Stab: Marcello Amore,
Massimio Bocchi, Simone Cappelli, Roberto
Ceccatelli, Carlo Chimenti
Laser: Peter Klopfer
Gerüste: Klick-Bühnen, Wien
Multivision: Natali C.N.A. Sistemi
audiovisioni, Florenz.

A. E. BLA BLA BLA

Donaupark

(Auftragswerk von Ars Electronica)
Live-Performance-Oper von Sonnaufgang
bis Sonnenuntergang

Teil 1
Good Morning Linz/Letterland
Teil 2
As The World Turns/Letterland
Teil 3
Z2A In Laser, Opera staccato
Idee/Regie/Text: Arleen Schloss
Musik: Lawrence Douglas,
Butch Morris & Orchestra
Wassernebelskulptur-Design: Ray Kelly
Feuerskulptur: Paolo Buggiani
Choreographie:
Christa Gamper, Holly J. Weiss
Buchstaben/Kostüme:
Rolando Vega
Chor: Karen Gorst
Licht: Thomas Glaube
Fotografie: Winnie Berios
Tontechnik: Connie Kieltyka
Laser: Peter Klopfer and Visual
Communications
A.E. BLA BLA BLA – Film mit Laser-Kamera:
Dan Ochiva.

Audio- Uniform-Konzerte
Idee und Konzept:
Benoit Maubrey/Hans Peter Kuhn
(USA/Frankreich)
Bänder: Hans Peter Kuhn (D)
Kostüme: Anne Leva (USA)
Choreografie: Susken Rosenthal (D),
Gregory Wolczyn (PL)
Elektronik: Wulf Köthe (D)
VOEST-ALPINE Linz, „Linz-Uniformen"

Ausstellungen

Terminal Art
Brucknerhaus Foyer
Konzeption/Organisation: Jürgen Claus
Ausstellungsassistenz: Nora Koch
1 Der elektronische Schirm
2 Sechs Labors zur Gestalttechnologie
Mitwirkende: Jürgen Claus (D), Horst H.
Baumann (D), Rudi Berkhout (NL), Gruppe „Blix"
(A), Waltraut Cooper (A), Otto Dressler (D),
Manfred Eisenbeis (D), Giovanotti Mondani
Meccanici (I), Dieter Jung (D), Manfred Kage (D),
Othmar Karschulin (D), Walter Kroy (D), Adolf
Luther (D), Franz Xaver Mittermair (A), Otto

Piene (D), Red Error (Martin Drexler - Michael
Nader, A), Ruth Schnell (A), Gudrun Bielz (A),
Dan Schweizer (USA), Peter Vogel (D), Peter
Weibel(A/USA)

Christian Ludwig Attersee
Neue Galerie der Stadt Linz

Imagining Antarctica Antarktis – Vorstellung und Wirklichkeit
Stadtmuseum Nordico
Konzept: Rachel Weiss (USA)
Künstler: Francesco Abad (USA), Marjorie Agosin
(Chile), Mel Alexenberg, (ART)n (Incorporated,
Ellen Sandor, Randy Johnson, Daniel John
Sandin-USA), Jose Bedia Valdes (Kuba), Matt
Belge (USA), Herrmann Josef Berk (D), Lowry
Burgess (USA), Donald Burgy (USA), Luis
Camnitzer (USA), Ben Davis (USA), Agnes Denes
(USA),Jose M. de Prada (Spanien), Wolfgang
Hahn (D), Richard Harrington (USA), Nigel
Helyer (Australien), Nancy Holt (USA), Nicole
Jolicoeur (Kanada), Dotte Larsen (USA),
Thorbjörn Lausten (Dänemark), Franz Lazi (D),
Mit Mitropoulos (USA), Herbert Ponting
(England), Elliot Porter, Ricardo Rodriguez-Brey
(Kuba), Gernot Schwaiger (D), Todd Siler (USA),
Robert Smithson (USA), Michelle Stuart (USA),
Charles Swithinbank (England), Natalie Talec
(Frankreich), Vladimir Tamari , Lutz Weidler und
Claudia Kölgen (D), Rachel Weiss (USA), Joseph
Yoakum (USA).

Shadow Dream
Donaupark
Lichtinstallationen von Matthew Belge und
Richard Harrington

Ars Electronica 87
Festival für Kunst, Technologie und Gesellschaft

Der freie Klang

16. – 19. September 1987

Veranstalter:
Linzer Veranstaltungsgesellschaft (LIVA)
Vorstandsdirektor:
Karl Gerbel
Programmgestaltung:
Gottfried Hattinger
Künstlerischer Beirat:
Prof. Peter Weibel

Prix Ars Electronica
Veranstalter: ORF/Landesstudio Oberösterreich
Idee: Dr. Hannes Leopoldseder
Konzept: Dr. Christine Schöpf,
Dkfm. Heinz Augner, Wolfgang Winkler
Beratung: Prof. Dr. Herbert W. Franke
Ehrenkomitee:
Pierre Boulez, John Cage, Max Headroom,
Jean-François Lyotard, Benoît Mandelbrot,
Nam June Paik, Günther Schneider-Siemssen,
Joseph Weizenbaum, John Whitney sen.

Dank für Kooperation:
Intendant Dr. Hannes Leopoldseder,
Dr. Christine Schöpf, Wolfgang Winkler,
Mag. Regina Patsch, Ing. Walter Marterer
(ORF/Landesstudio Oberösterreich),
Peter Gente und Adelheid Paris
(Merve-Verlag, Berlin), John G. Hanhardt
(Withney Museum of American Art, New York),
Reinhard Oehlschlägel (Mitherausgeber
der Zeitschrift Musik Texte, Köln), Maria
Rankov (Bureau d' Organisation Artistique,
Paris), Nicola Sani (SIM, Rom), Prof. Dr. Klaus
Hinrich Stahmer (Präsident der
Gesellschaft für Neue Musik, Sektion
der BRD der IGNM, Höchberg), Peter Ultée
(TheaterWork Holland, Amsterdam)

Symposien

Der freie Klang
Brucknerhaus, Keplersaal
Leitung: Peter Weibel (New York)

Referate: Daniel Charles (Antibes), „Ein Ohr
allein ist kein Wesen" (John Cage)
Mit zwei Videobeiträgen von Soun-gui Kim
(Marseille): „Etang de Vaccareés", „Piano
préparé" (Hommage für John Cage),
Douglas Kahn (San Francisco):
„The Sound of Music"
Kaja Silverman (New York):
„Körpersprache"
Weitere Teilnehmer – Katalogbeiträge:
Peter Weibel, Daniel Charles (Antibes) Reinhard
Oehlschlägel (Köln), Douglas Kahn (San
Francisco) , Kevin Concannon (New York),
Hugh Davis (London)

Prix Ars Electronica-Symposion
Künste im Zeitalter der künstlichen Intelligenz
ORF/Landesstudio Oberösterreich
Moderator: Jürgen Claus
Teilnehmer: Pamela McCorduck, Mihai Nadin,
Jean-Baptiste Barrière, Mario Borillo, Robert
Pinsky

Prix Ars Electronica-Künstlerforum
Computerkunst heute – Computeranimation,
Computergrafik, Computermusik
ORF/Landesstudio Oberösterreich
Moderatoren: Herbert W. Franke (München),
Jean-Baptiste Barrière (Paris)
Teilnehmer: John Lasseter (USA), Mario Canali
(I), Rolf Herken (D), Brian Reffin Smith (GB),
Jürgen Lit Fischer (CH), Melissa White (USA),
Jean-Claude Risset (F), Richard Teitelbaum(GB),
Marc Andre Dalbavie

Prix Ars Electronica-Hearing
Computerkunst – Ende der Kreativität oder
Neubeginn der Künste
ORF/Landesstudio Oberösterreich
Moderator: Franz Kreuzer
Teilnehmer:
Klaus Haefner, Joseph Weizenbaum

Konzerte/Theater/ Performances

Klangszenen
Klangereignisse, Konzerte und Inszenierungen
im Donaupark

„Differance"
von Earl Howard (New York)
Live-Konzert mit Langsaiteninstallation
von Paul Panhuysen/Johan Goedhart
(Eindhoven)
„Travelon Gamelon"
Klangfahrt für 20 präparierte Fahrräder
von Richard Lerman (Boston)

Klang-Stärken
„In Light Of Sound"
Brucknerhaus, Brucknersaal
(Weltpremiere)
David Hykes & The Harmonic Choir
(New York)
Opening Section: „Beginners Word"
Komponist/Direktor/Designer: David Hykes
The Harmonic Choir: Michelle Hykes, Marjorie
Johnson, Richard Franko, Carter Burwell, Erik
Goldmann, Alan Zeserson, David Hykes
Lichtinszenierung: Beverly Emmons
Audiodesign:
Denis Fortier/Espaces Nouveaux
„Die Donnergötter"
Posthof Linz
Rhys Chatham (New York)
Europäische Erstaufführung für sechs
elektrische Gitarren, Baß und Schlagzeug.
Gemeinschaftsproduktion von Ars
Electronica und Posthof.
Weitere Werke:
„Drastic Classicism"
„The Out of Tune Guitar No. 2"
„Guitar Trio"
„Merci Chopin"
„Untitled No. 2"
Mitwirkende:
Elektrogitarren: Karen Haglof, Robert Poss,
Mitch Salmen, Evans Wolforth, Susan
Stenger, George Arevalo
Elektro-Baß: Ernie Brooks
Schlagzeug: Jonathan Kane
Dirigent: Rhys Chatham
Tontechnik: Pierre Goirand

Klang-Körper
Aorta
Brucknerhaus, Stiftersaal
von Jeanette Yanikian (Amsterdam)

Toningenieur: Kees Koeman
Beleuchtung: Johan Vonk
Kostüme: Sarah Moreland
Stethoskope: Piet Nieuwint
Herzpulsdetektor: Willem Hienekamp
Baßreflexboxen: Peter van Velsen
Entwurf Scheibe: Kees Koenman
Konstruktion: Heka en De Mol
Choreographische Mitarbeit: Anne
Walsemann
Fotografie: Tony Thijs
Counter Tenor: Walter van Hauwe
Purcells „Music for a While", gesungen
von Alfred Deller
Technische Forschung:
1.Phase: STEIM,
2. Phase: Kees Koeman
Koordination: Walther Tjon Pian Gi
Uraufführung:
Mickery Theater Amsterdam
Kostrument
von Harry De Wit (Amsterdam)
Tontechnik: Henny Sweethal
Touch Monkeys
von Micel Waisvisz (Amsterdam)
Tontechnik: Karin de Boeft
Digitalcomputerklänge: Michel Waisvisz,
David Bristow
Computerprogramme: Wim Rijnsburger,
Frank Baldé,
Technische Entwicklung: STEIM
Komponiert für IRCAM/Paris mit Unter-
stützung des Niederländischen Kulturmini-
steriums.

Raumklänge
„Waterworks"
Donaupark
Ein Concerto grosso für Schiffshörner und
Feuerwerk, Himmelstrommeln, Synthesizer
und Tubbläser
Konzept, Komposition und Live-Electronic:
Alvin Curran (Rom)
Feuerwerk:
Pierre-Alain Hubert (Marseille)
Pyrotechnik: Ing. Alfred Pokorny (Sollenau)
Schiffshörner: Fa. Zöllner (Kiel)
Schiffshornspieler: Studenten der Komposi-
tionsklasse von Prof. Anton Voigt am

Brucknerkonservatorium (Linz)
Baßtubaspieler: Mitglieder der Militärmusik
Oberösterreich unter der Leitung von
Hauptmann Eduard Stallinger (Linz)
Computerprogramm: Gerd Eiden (Berlin)
Tontechnik: Nicola Bernardini (Rom)
Technische Koordination: Dipl.Ing. Kay
Rebensburg (Berlin)
Unterstützt von der Ersten Donaudampf-
schifffahrtsgesellschaft (Linz)
Gemeinsame Veranstaltung von Linzer
Veranstaltungsgesellschaft mbH (LIVA)
und ORF/Landesstudio Oberösterreich.

Klang-Bilder

Brucknerhaus, Stiftersaal
(Auftragswerke von Ars Electronica)

Zwei Zimmer
von Pas Paravent (Wien) mit Gästen:
Romana Scheffknecht, Rupert Putz.
Konzept: Karl Kowanz
Musik. Karl Kowanz, Sopranlk- und Alt-
saxophon, Renate Kowanz-Kocer, Schlag-
zeug, Wolfgang Poor, Baritonsaxophon.
Video: Romana Scheffknecht, Rupert Putz
Unterstützt von SONY/Wien

Boxman
von David Felder/Peter Weibel/Henry
Jesionka (Wien/Buffalo)
Komposition: David Felder
Video: Peter Weibel und Henry Jesionka
Technik: Bob O' Kane
Posaune: Miles Anderson
Choreografie: Mary Eisenberg
Eine gemeinsame Produktion von LIVA,State
University of New York at Buffalo und
National Endowment for the Arts

Programm 5
mit „Monochrome Bleu"
Konzept/Komposition/Musiker: Wolfgang
Dorninger, Thomas Resch (Linz)
Konzept/Video: Leo Schatzl, Kurt Hennrich
Gastmusiker: Peter Androsch
Technischer Mitarbeiter: Pepi Maier

Prix Ars Electronica

Veranstalter: ORF/Landesstudio Oberösterreich
Idee: Dr. Hannes Leopoldseder

Konzept: Dr. Christine Schöpf,
Dkfm. Heinz Augner, Wolfgang Winkler
Beratung: Prof. Dr. Herbert W. Franke
Ehrenkomitee: Pierre Boulez, John Cage,
Max Headroom, Jean-François Lyotard, Benoit
Mandelbrot, Nam June Paik, Günther
Schneider-Siemssen, Joseph Weizenbaum,
John Whitney sen.

Jury
Vorsitzender der Gesamtjury:
Dr. Hannes Leopoldseder
Computergrafik/Animation: Oswald
Oberhuber, Loren Carpenter, Herbert W.
Franke, Alex Graham, Richard Kriesche,
Alfred Nemeczek, Toni Verita
Computermusik: Jean-Baptiste Barrière,
Hubert Bognermayr, Gerard Grisey, Helga
de la Motte-Haber, Curtis Roads

Preisträger
Computergrafik
Goldene Nica: Brian Reffin Smith
Anerkennung:
Jürgen Lit Fischer, Melissa White
Computeranimation:
Goldene Nica: John Lasseter
Anerkennung: Mario Canali, Rolf Herken
Computermusik:
Ehrenpreis: Peter Gabriel, Jean-Claude
Risset
Anerkennung: Marc Andre Dalbavie,
Richard Teitelbaum
Stipendien: Institut Arts et Technologies
de l'Image (Universite VIII, Paris), Institut
für interaktive Systeme (Universität
Karlsruhe), Lehrkanzel für Kommunikations-
theorie (Hochschule für angewandte
Kunst, Wien)

Prix Ars Electronica Gala
ORF/Landesstudio Oberösterreich – 3sat
Verleihung der goldenen Nica 87
Moderation:
Karin Müller, Robert Hochner

Open-Air

Baustellenkonzert –
Linzer Hauptplatz
Stadtwerkstatt

Ausstellungen

Systemische Malerei
Brucknerhaus, Foyer
Peter Kotauczek
Messaggio
Piero Bordin

Klang-Park
Donaupark
mit Klang-Installationen von: Gerlinde Beck
(Mühlacker), Bill und Mary Buchen (New York),
Waltraut Cooper (Linz), Julius (Berlin), Edmund
Kieselbach (Bochum), Christina Kubisch
(Mailand), Ron Kuivila Middletown), Richard
Lerman (Boston), Bruce Odland (Boulder), Paul
Panhuysen/Johan Goedhart (Endhoven),
Liz Phillips (New York), Thomas Rother (Essen),
Peter Weibel (Wien/USA), Franz Xaver (Wien)

Videobühne Europa
ORF
Veruschka Bódy: Infermental
Österreich: Ilse Gassinger/Gudrun Bielz
Deutschland: Dieter Daniels (Bonn)
Schweiz: Rinaldo Bianda (Locarno)
Holland: Tom van Vliet (Den Haag)
Spanien: Karin Ohlenschläger (Madrid)
Italien: Lola Bonora (Ferrara)
Jugoslawien: Biljana Tomi'c (Zagreb)
England: Jeremy Welsh (London)

Ars Electronica 88
Festival für Kunst, Technologie und
Gesellschaft

Kunst der Szene

Brucknerhaus Linz
13. – 17. September 1988

Mit Audio Art Symposium
11. – 14. September 1988

Veranstalter:
Linzer Veranstaltungsgesellschaft mbH (LIVA)
Vorstandsdirektor:
Karl Gerbel
Programmgestaltung:
Gottfried Hattinger, Prof. Peter Weibel

Prix Ars Electronica
Veranstalter:
ORF/Landesstudio Oberösterreich
Idee: Dr. Hannes Leopoldseder
Konzept: Dr. Christine Schöpf, Dkfm. Heinz
Augner, Wolfgang Winkler
Beratung: Dr. Herbert W. Franke
Ehrenkomitee:
Pierre Boulez, John Cage, Max Headroom,
Jean-François Lyotard, Benoît Mandelbrot,
Nam June Paik, Itsuo Sakane, Günther
Schneider-Siemssen, Joseph Weizenbaum,
John Withney sen.
Dank für Kooperation:
Intendant Dr. Hannes Leopoldseder,
Dr. Christine Schöpf, Wolfgang Winkler
(ORF/Landesstudio Oberösterreich)
René Block (Deutsche Akademie der Künste,
Berlin)
Prof. Dr. Ing. Dr. Ing. e.h. Ludwig von Bogdandy
(Generaldirektor VOEST-ALPINE Stahl AG, Linz)
Peter Gente, Adelheid Paris (Merve Verlag, Berlin)
Vittorio Fagone, Nicola Sani (Festival Arte
Elettronica, Camerino)
Hans Peter Grillitsch (Erste Donau-Dampf-
schifffahrts-Gesellschaft, Linz)
Seppo Gründler, Josef Klammer (Steirische
Kulturinitiative, Graz)
Prof. Helmut Gsöllpointner (Hochschule für
künstlerische und industrielle Gestaltung)
John G. Hanhardt (Withney Museum of

American Art, New York)
Prof. Dipl.-Ing. Dr. Heribert Kreulitsch
(Vorstandsvorsitzender VOEST-ALPINE Stahl
AG, Linz)
Dr. Ernst Kubin (Generaldirektor ESG Verkehrs-
betriebe, Linz)
Roger Lafosse (SIGMA Festival, Bordeaux)
Reinhard Oehlschlägl (MusikTexte, Köln)
Matthias Osterwold (Freunde Guter Musik,
Berlin)
Ing. Werner Ponesch (Posthof, Linz)
Maria Rankov (BOA, Paris)
Dr. Elisabeth Schweeger (Akademie der
Bildenden Künste, Wien)
Prof. Anton Voigt (Brucknerkonservatorium Linz)

Symposien

Philosophie der neuen Technologien
Brucknerhaus
Gestaltung: Peter Gente/Adelheid Paris
(Merve Verlag, Berlin)
Teilnehmer: Jean Baudrillard (Paris), Hannes
Böhringer (Berlin), Heinz von Foerster
(Pescadero), Vilém Flusser (Sao Paulo/Robicon),
Friedrich A. Kittler (Bochum), Peter Weibel
(Wien/Buffalo, USA)

Audio-art-Symposium
Audio Art: Kunstformen der Entgrenzung
Brucknerhaus, Stadtwerkstatt, Galerien
Programmkoordination: Matthias Osterwold,
Freunde Guter Musik Berlin e. V.
Mitwirkende: Rolf Langebartels, Frans Evers,
Nicolas Collins, Llorenç Barber, Frieder Butzmann,
Thomas Kapielski, Arnold Dreyblatt, Giardini
Pensili, Hans Peter Kuhn, Logos-Duo, Gordon
Monahan, Paul Panhuysen, Horst Rickels, Tibor
Szemzö, Peter Forgacs, Vivenza Vorträge im
Rahmen des Audio-Art-Symposiums von: Paul
Panhuysen, Rolf Langebartels, Frans Evers und
Nicolas Collins

Prix Ars Electronica-Symposion
ORF/Landesstudio Oberösterreich
Das elektronische Kino
Moderation: Jürgen Claus
Teilnehmer: Toni Verita, Douglas Kay, Jean Fraço-
is Colonna, Alexander Shein, Felix Andreev

Prix Ars Electronica-Künstlerforum
ORF/Landesstudio Oberösterreich
Moderation: Jürgen Claus
Teilnehmer: David Sherwin, Peter Kogler, Andy
Kopra, John Lasseter, Peter Weibel, Mario Canali,
Denis Smalley, Trevor Wishart, Barbara Zawadzka

Prix Ars Electronica-Dialog
ORF/Landesstudio Oberösterreich
Die elektronische Ost-West-Freundschaft
Internationale Diskussionsrunde unter der
Leitung von Jürgen Claus

Konzerte/Theater/ Performances

„ ... horrend honorige Hommage ...“
　　Brucknerhaus
　　(Auftragswerk von Ars Electronica)
　　Eröffnungsperformance der Urfahr-
　　wändchöre
Die mechanische Bauhausbühne
　　Brucknerhaus, Brucknersaal
　　„Das mechanische Ballett“ (Kurt
　　Schmidt, 1923)
　　„Die mechanische Exzentrik“ (L. Moholy-
　　Nagy, 1924)
　　Aufgeführt vom Theater der Klänge
　　Inszenierung: Jörg U. Lensing
　　Assistenz: Gudula Schröder
　　Musik: Hanno Spelsberg, (M. Ballett)
　　Musiker: Hanno Spelsberg (Klavier), Axel
　　Heinrich (Schlagzeug)
　　Kostüme: Ernst Merheim und Udo Lensing
　　Licht: Sascha Hardt
　　Filmerstellung: Version 1: Interpretation des
　　Typofoto „Dynamik der Großstadt“ v. L.
　　Moholy-Nagy: Josef Schiefer,
　　Version 2: Umsetzung des Typofoto
　　„Dynamik der Großstadt“
　　Buch: Jörg U. Lensing Sascha Hardt
　　Regie: Sascha Hardt
Die mechanische Exzentrik:
　　Ablaufpartitur, Inszenierung: Jörg U. Lensing
　　Assistenz: Gudula Schröder
　　Bühnenkonstruktion, Mechanische
　　Aggregate: Jürgen Steger
　　Klangregie: Thomas Neuhaus
　　Choreographie: Malou Airaudo

(Menschmechanik)
Kamera:Herbert Twardy
Mitarbeit von: Claudia Auerbach, Sascha
Hardt, Jacqueline Fischer, Jörg Lensing,
Ernst Merheim, Thomas Neuhaus, Tanja Nie,
Gudula Schröder, Hanno Spelsberg
Choreographische Beratung: Malou Airaudo
und Heide Tegeder

XEN 3-D Movie Concert
Brucknerhaus, Brucknersaal
(Auftragswerk von Ars Electronica in
Koproduktion mit SIGMA Festival Bordaux)
Ein Stereoskopfilm
von Jon Hassell/Thomas Shannon
Buch und Regie: Thomas Shannon
Für die Aufführung mit einem Musikpro-
gramm, Komposition: Jon Hassell
Live-Konzert: The Jon Hassell Ensemble
Trompete, Keyboard: Jon Hassell
Akustik/Electronic Percussion: J.A. Deane
Synthesizer: Jean-Philippe Rykiel
Filmproduktion: Degraf-Wahrman Inc.,
Hollywood
Produktion: BOA, Paris
Unterstützt von Wiener Städtischen
Versicherung

Looking upon the Wide Waste of Liquid Ebony
Brucknerhaus, Brucknersaal
(Beim Blick auf die weite Wüste aus
flüssigem Ebenholz)
Szenisches Konzert nach einem Text von
E. A. Poe
(Auftragswerk von Ars Electronica in Kopro-
duktion mit Steirische Kulturinitiative)
Konzept/Komposition: Heiner Goebbels
(Frankfurt)
Szene/Bild/Licht: Thomas Dreißigacker (Köln)
Dramaturgische Beratung: Reinhold Grether
Filmische Realisierung: Sabine Dechent
Stimme, Akkordeon: Sven-Ake Johansson
(Berlin)
Gitarre: Rene Lussier (Montreal)
Stimme: Phil Minton (London)
Musiker der Steirischen Kulturinitiative:
Schlagzeug, Midi-Drums: Josef Klammer
Gitarre, Midi-Gitarre
 Computerprogramming: Seppo Gründler
Saxophone, Klarinette: Heinrich von Kalnein
Cello: Michael Moser

Saxophone, Baßklarinette: Otmar Kramis
Stimme, Posaune: Franz Schmuck, Bertl Mütter
Violine: Tscho Theissing

Hungers
Posthof Linz
Ein Interart-Projekt
von Ed Emshwiller/Morton Subotnick
(Los Angeles)
Stimme, Air-drums: Joan la Barbara,
Elektro-Cello: Erica Duce,
Elektronisches Schlagzeug: Amy Knoles,
Keyboard: Gaylord Mowrey,
Tanz: Nanik Wenten,
Videotechnik: Robert Campbell
Videosoftware: Dale McBeath
Videokameras: Fern Seiden, Donna Matorin
Videoequipment: Vogel Audiovision Linz
Assistent Musik: Greg Fish
Musikcomputer: Todd Winkler
Musikcomputer Software: Mark Coniglio
Assistent Musik am M.I.T.: John Nelson
Licht- und Bühnengestaltung: Aubrey Wilson
Theater-Beratung: Bob Israel
Auftragswerk von Los Angeles Festival 1987,
produziert vom California Insitute for the
Arts. Unterstützt von National Endowment
for the Arts und Rockefeller Foundation.
Produktion in Linz: Ars Electronica (Bruck-
nerhaus, LIVA) gemeinsam mit Posthof Linz
In Zusammenarbeit mit dem ORF/Landes-
studio Oberösterreich.

Stimmen aus dem Innenraum
Brucknerhaus, Stiftersaal
(Auftragswerk von Ars Electronica)
von Susanne Widl/Valie Export/Patricia
Jünger
Eine intermediale Persona-Performance
mit Susanne Widl.
Mediale Gestaltung:
Valie Export & Peter Weibel
Musik: Patricia Jünger
Bühne: Perdita Chan
Maske: Karin Schön
Text und Dramaturgie: Peter Weibel
Regie: Karl Welunschek
Elektronik und Licht: Franz Xaver
Videotechnik: Muki Pakesch
Kamera und Fotos: Gerhard Riml
Dia-Animation: H.W.Pangratz

bewegt – erstarrt, klang- und körperfiguren
Brucknerhaus, Brucknersaal
(Auftragswerk von Ars Electronica)
von Mia Zabelka/Peter A. Egger
Konzept/Komposition/Violine: Mia Zabelka
Video: Peter A. Egger
Klangobjekte: Hans Kupelwieser
Saiteninstallation: Paul Panhuysen, Johan Goedhart
Stimme: Greetje Bijma, Susanne Lohmiller
Saxophone: Michael Riessler
Percussion: Gerhard Laber
Schlagwerk: Sepp Danner, Robyn Schulovsky
Synthesitzer, Samples, Klavier: Yuki Morimoto
Klangregie: Martin Sierek
Texte: Meta Merz/Grohs
Lichtgestaltung: Norbert Chmel
Tontechnik: Adi „tucherl" Tögel
Tontechnische Assistenz: Markus Brandt
Videoassistenz: Stephan Lorenzoni
Unterstützt von BM f. Unterricht, Kunst und Sport, Niederösterreichische Kulturabteilung, VOEST-ALPINE Stahl AG, MKS Film- und TV-Produktion Ivo Strakl, Tontechnik Studer Revox

SCIAME (Schwärme)
Brucknerhaus
Von Enzo Cosimi (Rom), Fabrizio Plessi (Venedig), Luca Spagnoletti (Rom)
Choreographie/Regie: Enzo Cosimi
Bühnenbild/visuelle Gestaltung: Fabrizio Plessi
Music: Luca Spagnoletti
Darsteller: Paola Autore, Rachele Caputo, Rita Cioffi, Enzo Cosimi, Karin Elmore, Franco Senica
Lichtdesign: Stefano Pirandello,
Ton- und Videotechnik: Riccardo Silvi
Organisation: Francesco Canatlupo/Teorema
Administration: Maurizio Silvio,
Bühnengestaltung und Bühnenobjekte: Caro Ansaloni, Giovanni Gandi, Bruno Marchesin vom Centro video Arte Palazzo die Diamanti, unter der Leitung von Lola Bonora
Produktion: Occhesc, Interconti Internazionali Rovereto, Assoiazione Sarda Musica e Danza Cagliari, Cooperativa Teatro dell´Elfo di Milano, Centro Servizi e Spettacoli, Udine.

Das Hohe Lied der Liebe
(Hommage à Anton Bruckner)
Stift St. Florian
von Blue Chip Orchestra
Orchesterleitung: Hubert Bognermayr
Mitwirkende: Harald Zuschrader, Josef Sabaini, Josef Resl, Joe Drobar, Fitzcarraldo (Fritz Riedlberger), John Turner, Kristian Schultze, Peter Guschlbauer, Christian Enzenhofer, Gerhard Englisch

Ear News
Posthof
Preisträgerkonzert – Prix Ars Electronica
Mitwirkende: Barbara Zawadzka, Trevor Wishart, Jean-Claude Risset, Mia Zabelka, Javier Alvarez, Denis Smalley

Prix Ars Electronica

Veranstalter: ORF/Landesstudio Oberösterreich
Idee: Dr. Hannes Leopoldseder
Konzept: Dr. Christine Schöpf, Dkfm. Heinz Augner, Wolfgang Winkler
Beratung: Dr. Herbert W. Franke
Ehrenkomitee: Pierre Boulez, John Cage, Max Headroom, Jean-François Lyotard, Benoît Mandelbrot, Nam June Paik, Itsuo Sakane, Günther Schneider-Siemssen, Joseph Weizenbaum, John Withney sen.

Jury
Gesamtvorsitz Jury: Dr. Hannes Leopoldseder
Computergrafik/Animation: Oswald Oberhuber, Loren Carpenter, Herbert W. Franke, Alex Graham, Alfred Nemeczek, Toni Verita, Zelko Wiener
Computermusik: Jean-Baptiste Barrière, Hubert Bognermayr, William Buxton, Dieter Kaufmann, Thomas Kessler

Preisträger
Computergrafik:
Goldene Nica: David Sherwin
Auszeichnung: Peter Kogler, Andy Kopra
Computeranimation:
Goldene Nica: John Lasseter
Auszeichnung: Peter Weibel, Mario Canali
Computermusik:
Goldene Nica: Denis Smalley
Auszeichnung: Barbara Zawadzka, Trevor Wishart

Anerkennungen erhielten: Paul Codsi, John Fekner, Enrique Fontanilles, Rainer Ganahl, Franz W. Kluge, Jerzy Kular/Isabelle Foucher, Larry Malone, Achim Stößer, Tamas Walicky, Hiromi Watanabe, Heff Brice, Jeremy Gardiner, Irene Hohenbüchler, Stefan Holtel, Johann Jascha, Laszlo Kiss, George Legrady, Massimo Ontani, Norbert Speicher, Roman Tomaschitz, Mark Wilson, Thomas Wittmer, Javier Alvarez, Martin Fischer, Mathias Fischer-Diskau, Udo Hanten, Adelhard Roidinger, Alejandro Vinao, Mia Zabelka

Prix Ars Electronica Gala
ORF/Landesstudio Oberösterreich – 3sat
Verleihung der goldenen Nica 88
Moderation: Regina Patsch, Robert Hochner

Open-Air

MAeLSTROMSUDPOL
Donaupark, Donau, VOEST Gelände
(Auftragswerk von Ars Electronica)
Idee/Inszenierung: Erich Wonder
Musik/akustische Produktion: Heiner Goebbels
Text: Heiner Müller
Stimme: David Bennent
Gitarre: Rene Lussier
Saxophone, Tarogato: Peter Brötzmann
Schlagzeug, Darbouka: Peter Hollinger
Synthesizer, Programming: Heiner Goebbels
Projektleitung: Elisabeth Schweeger
Künstlerischer Mitarbeiter: Bernhard Kleber
Inspizienz: Heidi Rasche
VOEST ALPINE Stahl AG
Gesamtkoordination: Fritz Orasch
Projektleitung: Wilhelm Danninger
Koordination Verkehrsbetriebe:
Alfred Rubitzki
Koordination Hochofenbetriebe: Werner Teubl
Schiff: DDSG Linz
Licht- und Tontechnik: Gerhard Englisch Pro Show, Linz
Pyrotechnik: Ing. Alfred Polorny, Sollenau.
Musikaufnahmen: Peter Frey, im F.T.F. – Studio, Frankfurt
Sprachaufnahmen: Heiner Goebbels und tonstudio Bauer, Ludwigsburg
Montage, Abmischung: Heiner Goebbels

und Jürgen Hiller, unicorn-Studio, Frankfurt. Zusammenarbeit mit der VOEST-ALPINE Stahl und ORF/Landesstudio Oberösterreich.

Wettergebäude Stadtwerkstatt
Stadtwerkstatt
Architektur aus Wind und Wetter – ein städtebaulicher Eingriff in Alt-Urfahr Ost. Für das Projekt verantwortlich: Thomas Lehner, Georg Ritter, Rainer Zendron, Markus Binder, Werner Katzmaier, Gotthard Wagner, Wilfried Hinterreiter, Franz Moharitsch, Sabine Gruber, Kurt Holzinger, Edith Stauber, Wolfgang Hofmann, Erich Klinger, Silvia Zendron, Bernd Richard, Johannes Knipp, Peter Hauenschild, Attila Kosa, Helmut Weber, Ernst Matscheko, Dieter Lasser, Heinz Reisinger, Ingrid Scheurecker, Alexander Dessl, Herbert Schager, Ruth Scala, Margit Knipp, Otto Mittmannsgruber, Peter Utz, Brigitte Schober, Brigitte Vasicek, Almud Wagner, Kurt Hennrich, Leo Schatzl, Wolfgang Lehner, Wolfgang Dorninger, Gustav Dornetshuber, Simon Ritter, Georg Pichler

Ausstellungen

Klang-Park
Installationen im Donaupark
Gestaltung: René Block (Berlin)
Schaf-Musik-Konzert-Schloß
Von Henning Christiansen (Kopenhagen)
Solar-Musik-Gewächshaus
Von Joe Jones (Düsseldorf)
The Apponited Cloud III
Von Yoshi Wada (New York)
Schafe von Wolfgang Stengl, Gewächshauszentrum Wiesinger & Hofer, Kronstorf.

Szenen/Räume
Kunsthochschule, Meisterklasse Metall an der HS für Gestaltung, Linz
(Auftragswerk von Ars Electronica)
Koordination: Stefan Brandtmayr
Norbert Artner, Rainer Atzlinger, Sabine Bitter/Pepi Maier, Stefan Brandtmayr, Christiane Friedrich, Harald Hinterreithner, Hannes Karl, Andreas Sagmeister.

Unterstützung durch das Kulturamt der oö.
Landesregierung, OÖ. Landes-Hypo-
thekenbank, Hofmann Ofenbau Krenmayr
Baugesellschaft mbH.

Radial Arcs
Brucknerhaus, Foyer
(Auftragswerk von Ars Electronica)
Von Ron Kuivila (Middletown/USA)

Scherzophren
von Waltraut Cooper (Linz)
Installation mit Klavier, Neon und Elektronik
(Auftragswerk von Ars Electronica und Festival
ARTE ELETTRONICA, Camerino. In Zusammen-
arbeit mit dem Brucknerkonservatorium Linz
und SIÄM srl. Informatica musicale, Rom).
Musik: Anestis Logothetis (Wien), Nicola Sani,
Luca Spagnoletti (SIM, Rom)
Improvisationen: Anton Voigt und seine
Studenten des Brucknerkonservatoriums Linz,
Klavierklasse
Computer-Flügel: Bösendorfer, Wien
Technik: Walter Behr
Computer-Programm für Anestis
Logothetis: Gerhard Moser, Wolkersdorf
bei Wien
Computer-Aufnahmen: Erwin Gattermann,
Reinhard Brunner (Musikhaus Gattermann,
Bad Hall)

Video Szenen
Video Szene Amerika – Neue amerikanische
Videokunst
(Auftragsarbeit von Ars Electronica,
dem Festival ARTE ELETTRONICA, Camerino
(Italien), in Zusammenarbeit mit dem
Whitney Museum of American Art,
New York.
Teil 1 ein historischer Überblick 1967 - 1987
Teil 2 Die Biennale 1985
Teil 3 Die Biennale 1987
Teil 4 Erweiterte Formen
Videoinstallationen von Nam June Paik,
Bruce Naumann, Buky Schwartz
Programmerstellung, Organisation:
John G. Hanhardt, Kurator für Film und
Video, Whitney Museum of American Art
Koordination: Leanne Mella

Infermental Nr. 7
Buffalo, New York Edition
400 Videobeiträge von 58 Künstlern aus 30
Ländern
Editoren: Rotraut Pape, Chris Hill, Tony Con-
rad, Peter Weibel
Gesamtleitung: Rotraut Pape
Internationale Koordination: Vera Bódy
Präsentation und Musikprogramm für Linz:
Tony Conrad
Herausgeber: Hallwalls Contemprary
Arts Center, Buffalo, New York und Ars
Electronica, Brucknerhaus
Unterstützung durch die Ars Electronica,
dem New York State Council of the Arts,
dem Goethe House New York, Tops Friendly
Markets of Western New York, Delaware
Camera Mart, Parkside Press und dem Hall-
walls Contemporary Arts Center

Ars Electronica 89
Festival für Kunst, Technologie und Gesellschaft

Im Netz der Systeme

13. – 16. September 1989

Veranstalter:
Brucknerhaus Linz,
Linzer Veranstaltungsgesellschaft mbH (LIVA)
Vorstandsdirektor:
Karl Gerbel
Programmgestaltung:
Gottfried Hattinger, Peter Weibel
Katalog:
Gerhard J. Lischka, Peter Weibel

Prix Ars Electronica 89
Veranstalter: ORF/Landesstudio Oberösterreich
Idee: Dr. Hannes Leopoldseder
Konzeption: Dr. Christine Schöpf, Dkfm. Heinz
Augner, Wolfgang Winkler
Beratung: Dr. Herbert W. Franke
Organisation: Dr. Christine Schöpf

Symposien

Im Netz der Systeme
Brucknerhaus
Referenten: Dirk Becker, Laszlo Beke, Shuhei
Hosokawa, Anneta Pedretti, Mario Perniola

Die Befreiung der Medien
ORF/Landesstudio Oberösterreich
Referenten:
Maryanne Amacher, Robert C. F. Mulder,
Kristi Allik, William Buxton, Moving Picture
Company

Prix Ars Electronica – Ost-West-Dialog
Im Netz der Systeme
ORF/Landesstudio Oberösterreich
Moderation: Gerhard Johann Lischka

Konzerte/Theater/ Performances

Mediendorf
Brucknerhaus, Mediendorf im Donaupark

Aspects of Gaia
Digitaler Pfad quer durch die ganze Welt
von Roy Ascott (GB)
Mit: Peter Appleton, Matthias Fuchs, Robert
Pepperell, Miles Visman.
Unterstützung von The British Council,
Rechenzentrum Linz, Raumgestaltung
Schönegger, Kurt Hennrich, Erwin Grünber-
ger, Franz Kamper, Verein zur Förderung von
Klein- und Lokalbahnen Wien/Schwechat.

Ponton Medias
Van Gogh TV Europe live in FS 3 SAT
Mobile Art Project. Eine Vernetzung
kultureller Parallelitäten in Europa
Rene Sanglard, Anita, Malika Ziouech, Radio-
TV Rabotnik, Radio Subcom, Frigo-Gerard
Couty, Florian Reckert, Ottmar V. Poschinger,
Dieter Sellin, Input-Output-Christoph
Dreher, Rolf Wolkenstein, Gustav Hamos,
Bettina Gruber, Nina v. Kreisler, Bräunungs-
studio Malaria – Undulis Bilsen, Leopold
Gföllner, Thomas Kling, Hochschule für Bil-
dende Künste, Prof. E. Mitzka, Tillman Künt-
zel, Kai Engelhardt, Heike Nikolaus, Salvatore
Vnasco, Adajatulla Hübsch, Swiss Delega-
tion - Marianne Bösch, Anton Bruhin, Clau-
de Hentz, Minus Delta T – Mike Hentz, Karel
Dudesek, Benjamin Heidersberger, Kai Guse,
Jens Rötzsch, Erika Pasztor, Susanne Leib-
gierres, Elvira Äbolz, Art D Ameublement-
Padeluun, Rena Tangens, Axel Wirths, Fritz
Grosz, Walter Hauser, Bernd von den
Brinken, Michael Weber
Unterstützt von Gföllner Jodag,
Commodore Deutschland, Sony Deutsch-
land, Schaulandt, Hamburg, Fuba, Wien,
Bundesministerium für Unterricht, Kunst
und Sport, Wien.

Media Landscape Europa
Brucknerhaus, Foyer
(Auftragsarbeit von Ars Electronica)
Radio Subcom (CH/A/D)
Eine orbitale Inszenierung nach Motiven
des EUROPA REPORTS.
Mit der Performance Gruppe „Dead
Chickens" (Berlin), frei nach Motiven von
George Lucas, Thomas Pynchon, William
Gibson, Bruce Sterling u.a.
Kapitän: Der letzte Jedi-Ritter

Steuermann: Oil Blo
Navigator: Armin Medosch
Erter Offizier: Henryk Weiffenbach
Besatzung: Kai Fuhrmann, Brenda Chen-
Chen, Hannes Heiner, Antonia Neubacher,
Martin Scott, Werner Stahr, Ernst Walter
Sernar
Radio Performances mit 30 Transistorradios

Bild/Text-Archiv zur Medienkunst
Brucknerhaus, Foyer
von Pool Processing (D)
Pool für lebendigen Datenfluß
Pool Agenten: Heiko Idensen, Matthias
Krohn, Heiko Daxl, Kai Hoffmann, Henrich
Deppenmeier
Agenten mit besonderen Aktionen: Bruno
Hoffmann präsentiert in einer Seance die
gesamte literarische Analogie zum „Großen
Glas" von Marcel Duchamp: „Extra-Schnelle
Ausstellung der Ausrüstung für die Absto-
ßung ins Unendliche". Detlef Gerlach: „Der
Generalist, der ein und alles".

The Sublime
Brucknerhaus, Foyer
von Rabotnik TV (NL)
Mit F.F. Beckmans, Menno Grootveld,
Mathias Ijlstra, Yntse Vugts: „Akte Tessitura",
interaktive Installation.

Art Com Television
Brucknerhaus, Galeriefoyer
Von Carl Loeffler (USA)
Austausch, Ausstellung und Präsentation v.
Software für PC von Künstlern. Elektroni-
sches Netzwerk mit Online-Kunstprojekten
und Interaktivitäten.

Automaten TV
Brucknerhaus, Foyer
von Stadtwerkstatt-TV (A)
Franz Xaver, Thomas Lehner, Georg Ritter,
Markus Binder
Automaten TV mit Van Gogh TV Europe live
in 3 Sat: Stadtwerkstatt TV.

Radio Freies Utopia
Brucknerhaus, Foyer
(Auftragswerk von Ars Electronica)
von Friederike Petzold (A)
Urviech-Sendung
„Der Pfiff am letzten Loch"
„Die moderne Familie" (Installation)

Weltmodell 2
Brucknerhaus, Foyer
(Auftragswerk von Ars Electronica)
von Richard Kriesche (A)
Installation mit 25 Fernsehgeräten und
einer Sattelitenantenne

GUNAFA – Hypermedia Cocktail
Brucknerhaus, Foyer
von Station Rose(A)
mit: Gunafa Pavillon: Office der STR
Digitales Museum der STR
Station Rose Show:
„Gunafa-STR goes body touch"
Visual arts: Martin Ebner, Albert Winkler,
Elisa Rose
Moving message: Fe Rakuschan
Music: Andreas Kunzmann,
Bicycle Thieves, Gary Danner
Choreografie: Tamer Azzis, STR
Dance: Nana, Doris A. & unidentified
Mailbox: Phoenix Presseagentur
Mitarbeit: Anna Maria S., General
Guglhupf, Petra Klaus
Konzept: Elisa Rose, Gary Danner
Unterstützt von Rank Xerox, Linz

Linien
Brucknerhaus, Foyer
von Stephan Barron / Sylvia Hansmann (F)
Unterstützt von Rank Xerox, Linz

BAR No. Unendlich
Brucknerhaus, Restaurant
Von Raoul Marek (CH)
Inszenierte Gastlichkeit
Konzept: Raoul Marek
Assistenz: Margit Knipp
Unterstützt von Wienerwald GmbH

Medienfluss
2021 The Life People
Brucknerhaus, Foyer
(Auftragswerk von Ars Electronica)
Klang-Bild-Aufführung von Maryanne Amacher

Der Geist von Ibn Sabbah
Posthof Linz
von Sussan Deihim/Richard Horowitz
Sussan Deihim (Stimme, Tanz), Richard
Horowitz (Synthesizer, Nay-Flöte) Pierre G.
(Tontechnik)
In Zusammenarbeit mit dem Posthof Linz

Sonic Mirror: Simulations
Brucknerhaus, Brucknersaal
von David Dunn
Präsentation interaktiver Arbeiten
Zukunft ist Livekunst
Brucknerhaus, Foyer
von Radio Subcom mit Auftritten von Oil
Blo, Armin Medosch u. a. in ihrer Installation
(Foyer Brucknerhaus): „Media Landscape"
Cairo Rising
von Station Rose – Gary Danner/Elisa Rose
Skullbase Fracture (Schädelbasisfraktur)
Brucknerhaus, Ganzes Haus und
Restaurantfoyer
Tibor Szemzö mit „Futterbasis"
László Gööz, Posaune, King Székely, Klavier,
Gellért Tihanyi, Baßklarinette, Tamás Tóth,
Baßgitarre, János Sándor und eine Zigeuner-
kapelle, Pavel G Havlicek (Sprecher – mit
freundlicher Genehmigung von „Spartans",
Takoma Park, MD, USA), László Hortobágyi
und Tibor Szemzö (Klangregie), András Mész
(Video – Videovilág, Budapest)
Weltempfänger
Brucknerhaus, Brucknersaal
von Konrad Becker
Echtzeitkomposition für einen tropfenden
Wasserhahn und 12 Radioweltempfänger
Zusammenarbeit mit ORF/Kunstradio.
LiveRadio Ö1
Australienserie
Brucknerhaus, Foyer
von Warren Burt/Chris Mann/Allan Lamb/
Amanda Stewart/Rick Rue/David Chesworth
Whirled Music
Brucknerhaus, Brucknersaal
von Max Eastley
mit: Max Eastley, Steve Beresford, David Holmes
Tontechnik: Dave Hunt
Mit Unterstützung von The British Council
Die Stunde der Künstler
von Radio Subcom
Die Stunde des Jedi-Ritters
von Radio Subcom / Audio-Performance
Space Violins – Line of Sight
Brucknerhaus, Brucknersaal
von Jon Rose („Space Violins", ein Auftrags-
werk von Ars Electronica in Zusammenar-
beit mit dem ORF/Kunstradio)

Kunstradio
Radiokunst zur Ars Electronica
Gestaltung: Heidi Grundmann
Assistenz: Ruth Matzinger
Radiokunstnacht, Live-Radio Ö 1 und Radio
Oberösterreich.
Moderation: Giselher Smekal
Regie: Reinhard F. Handl
Leitung: Heidi Grundmann und Alfred
Pittertschatscher
mit: Konrad Becker, Wolfgang Tremmel, Bill
Fontana, Hank Bull, Christ Mann, Robert
Adrian X, Mathias Fuchs, Lucas Cejpek, Nigel
Helyer, Hildegard Westerkamp
Kommerz und Experiment
Brucknerhaus Foyer
Minderheitenprogramme in einer sich
wandelnden Radiolandschaft.
Mit Diskussion (Andrew Mc Lennan, ABC,
Sydney, Vortrag (Julean A. Simon, Wien)
In Zusammenarbeit mit ORF/Kunstradio.
Diagonal – Radio für Zeitgenossen
Redaktion: Wolfgang Kos, Michael Schrott,
Helmut Waldert, Doris Glaser, Rüdiger
Wischenbart, Peter Klein
Live-Radio Ö 1

Prix Ars Electronica

Idee: Dr. Hannes Leopoldseder
Konzept: Dr. Christine Schöpf, Dkfm. Heinz
Augner, Wolfgang Winkler
Jury
Computergrafik/Animation: Herbert W. Franke,
Paolo Calgagno, Loren Carpenter, John Halas,
Peter Kogler, Roger Malina, Alfred Nemeczek
Computermusik: Jean-Baptiste Barrière,
Hubert Bognermayr, William Buxton, Dieter
Kaufmann, Thomas Kessler
Preisträger
Computergrafik
Goldene Nica: Tamas Waliczky
Auszeichnung: Charles Csuri, Kenneth
Snelson
Computeranimation
Goldene Nica: Joan Staveley
Auszeichnung: Susan Amkraut/Michael
Girard, Simon Wachsmuth

Computermusik
Goldene Nica: Kaija Saariaho
Auszeichnung: François Bayle, Alejandro Vinão

Prix Ars Electronica-Ausstellungen
Videothek, Audiothek und Galerie

Prix Ars Electronica-Künstlerforum
Teilnehmer: Joan Staveley, Susan Amkraut,
Michael Girard, Simon Wachsmuth, Tamas
Waliczky, Charles Csuri, Kenneth Snelson,
Kaija Saariaho, François Bayle, Alejandro Vinão

Open-Air

Klang-Park
Donaupark
Colourspace
von Maurice Agis (GB)
Begehbare, labyrinthische Skulptur
Musik: Stephen Montague, Kakadu Sounds-
cape, Les Gilbert (AUS)
Klanglandschaft aus einem tropischen Na-
tionalpark im Norden Australiens.
Technische Assistenz. David Chesworth
(In Zusammenarbeit mit ORF/Kunstradio,
unterstützt von Australia Council)
Lampyrus noctiluca
von Günter Wirmsberger/Andreas John (A)
(Großer Leuchtkäfer)

Ausstellungen

Permanente Installationen
ORF/Landesstudio Oberösterreich
von: Joan Brassil, Warren Burt, Chris Mann,
Peter Callas, Lucas Cejpek, Lynn Hershmann,
John Manning, Friederike Pezold, Alan Rath,
Rick Rue, Jim Denley, Ruth Schnell, Jeffrey
Shaw/Dirk Groeneveld, Silicon Graphics,
George K. Shortess, Telcom, Udo Wid, Ste-
phen Wilson
Video-Bühne Australien
ORF/Landesstudio Oberösterreich
Programmauswahl: Sally Couacaud
Computerkunst aus Ungarn, Polen, Jugoslawien
*Konzept: Tibor Szentgyörgyi, Zdzislaw
Pokutycki, Predrag Sidjanin*
Koordination: Erich Pröll/Nordico

Ars Electronica 90
*Festival für Kunst, Technologie und
Gesellschaft*

Digitale Träume – Virtuelle Welten

8. – 14. September 1990

Mit Audio Art Symposium
11. – 14. September 1988

Veranstalter:
Veranstalter: Brucknerhaus Linz (LIVA) und
ORF/Landesstudio Oberösterreich
Vorstandsdirektor:
Karl Gerbel
Programmgestaltung:
Gottfried Hattinger, Peter Weibel

Prix Ars Electronica
Veranstalter: ORF/Landesstudio Oberösterreich
Idee: Dr. Hannes Leopoldseder
Konzept:
Dr. Christine Schöpf, Dkfm. Heinz Augner,
Wolfgang Winkler

Symposien

Gestaltung: Gottfried Hattinger, Morgan Russel,
Dr. Christine Schöpf, Peter Weibel

Von den Maschinen des Geistes und vom Geist der Maschinen
*Gehirnforschung und Computer:
Neuralnetze und Expertensysteme
Brucknerhaus Foyer*
Referenten: Dr. Erich Wessner (A) Oracle (USA),
Digital Equipment (USA), Neuron Data (USA),
J.M. Chauvet (Paris), University of California,
Siemens AG, Institut für medizinische Kybernetik

Virtuelle Welten – künstliche Wirklichkeiten
Brucknerhaus, Foyer
Referenten: Marvin Minsky (Autor M.I.T.),
Warren Robinett (Uni. of North Carolina, Dptm.
of Computer Science), Tom Furness
(Washington Technologie Center), Ron Reisman
(NASA, Ames Research Center, USA), Derrick de
Kerckhove (Uni. of Toronto, CDN)

Hypermaten – Cyberpunks

Brucknerhaus Foyer
Referenten: Eric Gullichsen (Sense B. Sausalito, Cal. USA), Patrice Gelband (Sense B. Sausalito, Cal. USA), Randy Walser (Autodesk Inc., Sausalito, Cal. USA) , William Gibson (Cyberpunk- Autor, USA), Bruce Sterling (Cyberpunk-Autor, USA), Morgan Russel (Unofficial Reality Incorporated, Budapest/Berlin/Amsterdam/Moskau), Pengo (Unofficial Reality Icorporated, Budapest/Berlin/Amsterdam/Moskau) , Steina Vasulka (Computerkünstlerin, Santa Fe, New Mexico), Woody Vasulka (Computerkünstler, Santa Fe, New Mexio), David Dunn(Computerkünstler, Santa Fe, New Mexio), Terence Mc Kenna (Computerkünstler, Santa Fe, New Mexio), Mark Pauline (Survival Research Labs/ReSearch Magazine, San Francisco), Andrea Juno.(Survival Research Labs/ReSearch Magazine, San Francisco), Jaron Lanier (VPL Inc., Red Wood City, Cal. USA), Chuck Blanchard (VPL Inc., Data Suit Designer)

Cyberspace – Virtuelle Visionen

ORF/Landesstudio Oberösterreich –
Publikumsstudio
Referenten: Timothy Leary (Futique Inc., Los Angeles, USA), Brenda Laurel (Ingteractivist, Los Gatos, Cal., USA), Arthur Kroker (Concordia College), Scott Fischer (USA)

East meets West: Der Ost-West-Round Table der Ars Electronica

ORF/Landesstudio Oberösterreich –
Publikumsstudio
Moderation: Georg Dox
Teilnehmer: Monika Fleischmann (D), Rosen Petkov (RUM), Milan Knizak (CS), Jan Jirasek (CS), Silke Gutze (DDR), Joel de Boutteville (F), Roy Ascott (UK), Lothar Winkelbauer (D), Sergei Golovanov (URS), László Dubrovay (H), Woody Vasulka (USA)

Prix Ars Electronica –Künstlerforum

ORF/Landesstudio Oberösterreich –
Publikumsstudio
Teilnehmer: Manfred Mohr (BRD USA), Charles Csuri (USA), Karl-Heinz Stockhausen (D), Myron Krueger (USA), Mario Sasso (I), Bill Davison (USA),

Jeffrey Shaw (Australien/NL) , Norman White (Can), Philippe Andrevon (F), Robert Lurye (USA)

Konzerte/Theater/Performances

Kepler's Traum – Phantastische Oper mit Musik und lunarer Astronomie

Brucknerhaus, Brucknersaal
Koproduktion mit Comune di Milano („Milano Aperta"), Alte Oper Frankfurt / „Frankfurt Feste", Comune di Novara, L´ Officina musicale italiana dell' Aquila
Musik und Texte: Giorgio Battistelli
Dirigent: Orazio Tuccella
Inszenierung: Studio Azzurro, Mailand
Regie: Paolo Rosa
Ausstattung, Video: Fabio Cirifino, Paolo Rosa
Lichtgestaltung: Fabio Cirifino
Solisten: Elisabeth Lang, Timothy Breese, Salomone Ovadia, Giovanni Trovalusci.
Ensemble: Orchestra Officina Musicale Italiana
Leitung: Orazio Tuccella
Koordination: Mauro Castellano
Verlag: G. Ricordi s.p.a.
Fiolxhilde im Video: Rossana Farinati
Duracotes im Video: Augusto Masiello
Video Operator: Mario Coccimiglio
Video-Assistenz: Elmar Bartlmae
Inszenierungskonsulenz: Lara Fremder
Repertoire-Recherchen: Simonetta Aicardi
Synchronschnitt: Cinzia Rizzo
Literarische Konsulenz: Alessandra Briganti
Regieassistenz: Katia Noppes, Luca Scarzella
Bühnenbauten: Diade coop.
Kostüme: Stefania Sordillo, Nicoletta Ceccolini
Organisation: Roberta Carraro
Mit Unterstützung des Instituts für digitale Bildverarbeitung der Forschungsgesellschaft Joanneum, Graz, TELESPAZIO s.p.a. Rom, RAI Radiotelevisione Italiana, Studio Mailand; ORF, Wien.

Kepler's last dream

Brucknerhaus, Stiftersaal
(Auftragswerk von Ars Electronica)
Allegorische Oper von Frances-Marie Uitti (USA)
Solokonzert mit einem Cello

„Concret PH", „La Legende D'eer", „Mycenes A",
„Voyage absolu des unari vers andromede"

 Brucknerhaus, Brucknersaal
 von Iannis Xenakis (F)
 Klangregie: Iannis Xenakis
 Mit freundlicher Unterstützung von Radu
 Stan, Edition Salabert

Le Système du Monde
 Brucknerhaus, Stiftersaal
 Koproduktion von: Les Ateliers du spectacle,
 un théatre pour la musique, train de nuit,
 Auftragswerk von Ars Electronica, mit
 Unterstützung von I´Espace Prévert/Aulnay
 Sous Bois/Théatre Messalia/Marseille,
 ADAMI/Fondation 93
 Musik: Serge Dutrieux (F)
 Szenenfotografie: Jean-Pierre Larroche
 Regie: Michel Rostain
 Mitarbeiter: Radek Beran, Vincent Guillot,
 Danie Lecoyer, Olivier Place, Milena Yelinkova
 Licht- und Tonregie: Frédéric Pin, Motorik-
 Eletronic: Gérard Pistillo, Bühnenbild-
 Ausführung: Les Atelies du Spectacle,
 Production-Manager: Sylvie Papandréou
 Produziert von Un Theatre pour la Musique/
 Train de Nuit/Les Ateliers du Spectacle.

Selektion – SLP
 Brucknerhaus, Stiftersaal
 Joachim Pense, Stephan Schmidt, Roger
 Schönauer, Charly Steiger, Ralf Wehowsky,
 Achim Wollscheid

Golem
 Brucknerhaus, Brucknersaal
 Eine interaktive Oper
 von Richard Teitelbaum (USA)
 Komponist: Richard Teitelbaum
 Stage Director/Set: Roy Faudree
 Video Produktion/Performance, Bühne:
 Joan Jonas
 Technischer Leiter/Video-Bearbeitung:
 Ben Rubin
 Computerprogrammierung: Joe Chung
 Kamera (Prager Aufnahmen) Jire Pechar,
 Joan Jonas, Richard Teitelbaum
 Stimme: Shelley Hirsch
 Blasinstrumente: Ned Rothenberg
 Violine und Elektronik: Carlos Zingaro
 Violine, Viola: Mary Oliver
 Percussion: Samm Bennet

 Synthesizer, Computer, Robot Pianos:
 Richard Teitelbaum
 Alvin Curran: Shofar
 Original Filmaufnahmen aus: „Der Golem:
 Wie er in die Welt kam", von Paul Wegener
 (1920), Production Assistant: Jana
 Cernikova, Producer: Barbara Mayfield
 Dank an die Teilnehmer der New Yorker
 Premiere im Jewish Museum: Kit Fitzgerald,
 Nik Williams, Joe Chung, Gerorge Lewis,
 Shelley Hirsch und Sam Bennet

Ab jetzt
 von Alan Ayckbourn
 Linzer Landestheater
 Deutsch von Corinna Borcher und
 Peter Zadek
 Inszenierung: Klaus-Dieter Wilke
 Ausstattung: Kurt Pint
 Produktion des Landestheaters Linz

Die lange Nacht der Ars Electronica
 Kunst-Stücke live (FS-ORF) von der
 Ars Electronica
 Programm. Monty Python´s flying Circus,
 Digitale Träume – Virtuelle Welten, Kepler's
 Traum, Hotel Pompino, Kathinka's Gesang,
 Treffpunkt Linz – Prix Ars Electronica 1990,
 Der Traum vom Kosmos, Hypermaten und
 Cyberpunks, East meets west (der Ost-West-
 Round Table from Ars Electronica.
 Moderation: Georg Dox
 Teilnehmer: Monika Fleischmann, Rosen
 Petkov, Milan Knizak (CS), Jan Jirasek, Silke
 Gutzer, Joel de Boutteville, Roy Ascott,
 Lothar Winkel-bauer, Sergei Golovanov,
 László Dubrovay, Woody Vasulka),
 Golems

Satelliten TV Projekt (Multimedia-Performance)
3sat
 Van Gogh TV – Live and real time television
 Pompino Research Team: Benjamin Heiders-
 berger, Mike Hentz, Salvatore Vanasco, Karel
 Dudesek, Christina Leber
 Van Gogh TV Team – Projekt Pompino: Bram
 X, Kai Engelhard, Ulrike Gabriel, Vladimir
 Grafov, Jo Kappl, Roey Müller, padeluun,
 Angela Primbs, Florian Reckert, Rucks Rick,
 Michael Saup, Rocco Schamoni, Dieter Sellin,
 Daniela Sommer, Sergej Talsdorf,
 Universal Q Prod

Van Gogh TV Team – Hotel Pompino
Offenes Kulturhaus
Anita, Mark Abbate, Anna Abrahams, Dave
Rowdy Batten, Katharina Baumann, Indulis
Bilsenz, Annelise Boodt, Juliane Brinket,
Annika Bruhns, Annet Bult, Eva Diegritz, Axel
Dill, Christof Dreher, Ulrike Dumjahn, John
Duncan, Beathe Ehlers, Mag. Martina
Engljähringer, Paul Enkelaar, Prof. Johannes
Erhardt, Franz Feigl, Eschi Fiege, Silvia Fiocco,
Freibank Musikverlag, Elisa Gelewski, Peter
Glaser, Jan Frederik Groot, Menno Grootveld,
Fritz Grosz, Thomas Henning, Hadajatulla
Hübsch, Gina am Hülse, Claudia Hirtl, Kathy
Huffmann, Eduard de Illeus, Michael Jansen,
Barbara Jürgens, Peter Kabel, Marie Kawazu,
Christiane Klappert, Bernhard Knierim,
Rainier Kurpershoek, Prof. Dr. Matthias
Lehnhard, Susanne Leibgirries, Morgan
Levine, Bob Linders, Frank Lohstöter, Irene
Lorenz, Salvatore Mannana, Bastian Maris,
Heike Nikolaus, Ole Lütjens, Anemarie
Paanaker, Lisa Paur, Martin Potthof, Kirill
Preobraghinski, Ester Sasson, Walter
Schönauer, Shigel, Frank Stukowsky, Antya
Umstädter, Gitti Vasiczek, Juriaan Vriesen,
Christian Wolf, Paul Wolf, Rolf Wolkenstein
Mitarbeit von Gruppen aus Hamburg, Wien,
Rom, Wrozlaw, Dresden, Basel, Prag, Zürich,
San Francisco und Boston.

Feu Sur Feu
Brucknerhaus, Donaupark
(Auftragswerk von Ars Electronica)
Komposition, Elektronik, Klangregie: Patricia
Feuer/Licht-Inszenierung: Pierre-Alain Hubert
Koordination: Elisabeth Schweeger

**Video-Memoiren, gefunden in einer Badewanne
zwischen Trümmerresten der Station Solaris
anno 70 der Neogen**
Brucknerhaus Stiftersaal (Präsentation)
Brucknerhaus, Foyer (Installation,
Dokumentation)
5 min Videokomposition.
Komposition, Klangregie: Mesias Maiguashca
Technik: Bernard Geyer

A Mandelbox
Eine Computer-Synthesizer-Installation
(Erinnerungsinstallation an das Konzert –
Video-Memoiren)

Prix Ars Electronica

Veranstalter: ORF/Landesstudio Oberösterreich
Idee: Dr. Hannes Leopoldseder
Konzept: Dr. Christine Schöpf, Dkfm. Heinz
Augner, Wolfgang Winkler

Jury
Computergrafik/Computeranimation:
 Paolo Calcagno (I), Loren Carpenter (USA),
 Herbert W. Franke (D), Grita Insam (A), John
 Lansdown (GB), Gerhard Johann Lischka
 (CH), Alfred Nemeczek (D)
Computermusik:
 Jean-Baptiste Barrière (F), Dieter Kaufmann
 (A), Thomas Kessler (CH), Alejandro Vinao
 (Bras./F), David Wessel (USA)
Interaktive Kunst:
 Roy Ascott (GB), William Buxton (Can), Don-
 na Cox (USA), Robert F. Malina (F),
 Brian Reffin Smith (GB)

Preisträger
Computergrafik
 Goldene Nica: Manfred Mohr
 Auszeichnung: Charles A. Csuri, Bill Davison,
 Anerkennung: Achim Stösser, Char Davies,
 Daniel Pirofsky, Andreas Henrich, Don P.
 Miller, A. Scott Howe, Yoshiyuki Abe, Mike
 North, Joseph Nechvatal, Sandra Filippucci,
 Stanislaw Sasak, Arjen van der Meulen
Computeranimation
 Goldene Nica: Mario Sasso / Nicola Sani
 Auszeichnung: Robert Lurye, Philippe Andrevon
 Anerkennung: Flavia Alman / Angelica
 Nascimento, Gerhard Pakesch, Paul Coudsi,
 William Latham, Alan Norton, Karl Sims,
 Christiane Geoffroy, Rebecca Allen, Denis
 Muren, John Lasseter, Jeff Kleiser / Diana
 Walczak, Eihachiro Nakamae, Steve
 Goldberg
Computermusik
 Auszeichnung: Karlheinz Stockhausen
 Anerkennung: Jonathan Harvey, Åke
 Parmerud, Zorah Mari Bauer
Interaktive Kunst:
 Goldene Nica: Myron W. Krueger
 Auszeichnung: Norman T. White, Jeffrey Shaw
 Anerkennung: Jill Scott, Benjamin Jay

Britton, Chico Macmurtrie, Waltraud Cooper, Richard Greene, Peter D' Agostino, Kristi Allik / Robert Mulder, Tamás Wliczky, Kyoko Abe, Ruth Schnell, Michael Rodemer, Stuart Bender / Angelo Funicelli.

Prix Ars Electronica Videothek – Audiothek

ORF/Landesstudio Oberösterreich
Alle diesjährigen Einreichungen aus Computer-animation, Computergrafik, Computermusik und Interaktiver Kunst.

Prix Ars Electronica Gala

ORF/Landesstudio Oberösterreich – 3sat
Verleihung der Goldenen Nica 90
Moderation: Regina Patsch, Dieter Moor

Ausstellungen

Unter dem Sternenhimmelkleid der Göttin
Unsichtbar bekommt die Fantasie Flügel
> *Brucknerhaus Foyer*
> (Auftragswerk von Ars Electronica)
> von Friederike Pezold (A)

Mind Cinema – das innere Kino
> *Brucknerhaus Foyer*
> (Auftragswerk von Ars Electronica)
> Konzept Visualisierung: Zelko Wiener (A)
> Psychoaktive Electroakustik: Konrad Becker

Ptolemäeus
> von Steina Vasulka (USA)

Digital Space
> von David Dunn, Woody Vasulky (USA)

Mind Machines
> von Rudolf Kapellner

Computer GO Tournament
> Organisation: Anton Steininger

Hypertext-Installationen

„Poe"
> von Franz Josef Czernin (A), Ferdinand Schmatz (A)

„The Imaginary Library"
> Pool Processing:
> Heiko Idensen, Matthias Krohn (A)
> DauerReden – LeseReisen

The Calibration of Being
> von Andrew McKenzie

Cybernetic research towards the melding of spirit and machine: an audio-visual prothesis
> „The Anti Group"

Homage to Kepler
> von Shunsuke Mitamura

Open-Air

Linzer Klangwolke

Garten der Zeiträume

Gärten des Linzer Schosses
von Bruce Odland (USA), Sam Auinger (A)
Auftragswerk der Oberösterreichischen Landes-ausstellung „Mensch und Kosmos" in Zusam-menarbeit mit Ars Electronica
Idee und Verwirklichung: Bruce Odland
Idee, Verwirklichung, Gartenmeister:
Sam Auinger
Analog-System-Design, Aufsicht, technische Betreuung: Heinz Waldes
Schaltkreis-Designer, Hardware: Roland Bahl
Software-Design, Gartenmeister:
Gerald Schalek
Audio-System-Installation, Design: Proshow
Visuelle Beraterin, Würfel-Design, Kepler-Raum-Realisation und Design: Martina Kornfehl
Würfel-Herstellung: Wolfgang Penkner
Planeten-Lautsprecher-Kreation: John Hansen und Nara Raisler
Grafisches Design, Katalogbetreuer:
Rudolf Mitter
Video: Markus Fischer
Produktionsassistentin: Karin Friedl
Fotos, Kepler-Room-Realisation:
Franz (Flieger) Stogner

Ars Electronica 91
Festival für Kunst, Technologie und Gesellschaft

Out of Control

10. – 13. September 1991

Brucknerhaus Linz (LIVA) und
ORF/Landesstudio Oberösterreich

Brucknerhaus Linz
Vorstandsdirektor:
Karl Gerbel
Programmgestaltung:
Gottfried Hattinger, Peter Weibel

ORF/Landesstudio Oberösterreich
Intendant:
Dr. Hannes Leopoldseder
Programmgestaltung:
Dr. Christine Schöpf

Prix Ars Electronica:
Veranstalter: ORF/Landesstudio Oberösterreich
Idee: Dr. Hannes Leopoldseder
Konzept: Dr. Christine Schöpf, Dkfm. Heinz
Augner, Wolfgang Winkler

Symposien

Out of Control
Brucknerhaus, Brucknersaal
Referenten: Hans P. Moravec (USA): „The
Universal Robot"
Kristine Stiles (USA):
„Thresholds of Control: Destruction Art and
Terminal Culture"

Out of Control II – Die Nanowelt
ORF/Landesstudio Oberösterreich

Prix Ars Electronica Künstlerforum
ORF/Landesstudio Oberösterreich –
Publikumsstudio
Internationale Computerkünstler präsentieren
ihre Arbeit.
Vorträger der Gewinner des Prix Ars Electronica
91 in den Kategorien Computergrafik (2D),
Computeranimation und Interaktive Kunst.

Konzerte/Theater/ Performances

Kumulus
Hauptplatz Linz
Von Barthélémy Bompard (F)
Urbanes Theater
Die Squames (F): Frank Baruk, Armelle
Berengier, Tanguy Blachere, Régius Bourquin,
Bernadette Coqueret, Didier Ismard,
Marielle Haurant, Khagan, Michael Loudes,
Philippe Pillon, Marie-Pascale Grenier.
Wächter: Barthélémy Bompard, Jean-Marie
Maddeddu, Claude Meister, Olivier Franquet.
Inszenierung: Barthélémy Bopard, Claude
Meister
Kostüme: Claire Salmon Legagneur
Licht: David Angtore.
Regie: Frédéric Barry, Christian Grisinger
Ausstattung: Frédéric Barry, Barthélémy
Bompard.

Mechanization takes command
Brucknerhaus, Brucknersaal
von Paul DeMarinis/Laetitia Sonami (USA)
Performance

Unruhiges Wohnen
Posthof Linz, Grosser Saal
Auftragswerk von Ars Electronica und
Opernhaus Zürich
von Bernd-Roger Bienert, Roman Hauben-
stock-Ramati, Elfriede Jelinek (A)
Tanztheater
Idee, Konzept, Choreografie: Bernd-Roger
Bienert
Musik: Roman Haubenstock-Ramati
Text, Stimme: Elfriede Jelinek
Mitwirkende: Ballettensemble des
Opernhauses Zürich

For me and for my gods
Brucknerhaus, Brucknersaal
von Zbigniew Karkowski (S)
Computertechnik: Ulf Bilting

Chapel Perilous
(Auftragswerk von Ars Electronica)
Von John Duncan/Zbigniew Karkowsky

Konzert mit Kurzwellen
Live-Elektronik

Kick
von John Duncan (NL)

Demontage XI
Brucknerhaus, Brucknersaal
(Auftragswerk von Ars Electronica)
von Flatz (A), Mitwirkende: Ina Brox, Sopran

Der kranke Raum
Theater Phönix, Wienerstrasse
(Auftragswerk von Ars Electronica)
von Theater Phönix (A)
Von und mit: Sam Auinger, Harald Gebhartl,
Rainer Jessl, Martina Kornfehl, Ferdinand
Öhlinger, Franz „Flieger" Stögner, Gerhard
Thaler, Fernando Toma.

Ausstellungen

„10 Becken" – Eine Zeitskulptur
Donaupark beim Brucknerhaus
(Auftragswerk von Ars Electronica)
von Roman Signer (CH)
Sprechntechnik: Erich Reichel, Hartberg/Stmk.

Unnatural Bodies
Limoni-Keller, Linz
von Jim Whiting (GB)

Earthstation
Brucknerhaus, Stiftersaal
(Auftragswerk von Ars Electronica)
von Computer-Laboratorium
Teilnehmer:
Gottfried Mayer-Kress (UC Santa Cruz,
Santa Fe Institute, Center for Nonlinear
Studies): Koordination, Design, mathemati-
sche Modelle, chaotische Attraktoren
Gideon May: Computergrafik, PhaseSpace-
Ship, fraktale Boxen, Drogenstatistik
Brad Degraf: Multimedia für SGI, Erdbeob-
achtungsdaten
Gregory Kramer, Clarity: Akustische
Gestaltung, Klangsynthese
Jenifer Bacon, grafisches Design, Darstel-
lung des Netzwerkes
Joe Takai, Computergrafik, fraktale Boxen
Tom Affinito (UC Stanta Cruz):
NeXT Multimedia Anwendung
John Chachere (US Santa Cruz):
Visualisierung der Datenbasen
J. Kalin, Simulation Laboratories:
Simulation Software
D. Goldman, Simulation Laboratories:
Simulation Software

Mer Sonic Illuminations
Brucknerhaus, Foyer
von Liz Phillips (USA)
Interaktive Klanginstallation

Delphi Digital
Brucknerhaus, Foyer
(Auftragswerk von Ars Electronica)
Sculptural Oracle
von Margot Pilz/Roland Scheidl (A)
Konzept und Realisation: Margot Pilz/GOTO MP
Kommunikationstechnik: Roland Scheidl
Video, Ton/Sound mix: Margot Pilz
Video-Gestaltung unter Verwendung von
Bildmaterial der ESA
Editing: Margot Pilz, Anna Steininger
Via Umweltberater Bremen vernetzt mit:
GreenNet, Zerbeerus, EcoNet, PeaceNet,
Compost, WWF

An unsettling matter
Brucknerhaus, Foyer
(Auftragswerk von Ars Electronica)
von Paul De Marinis (USA)
Intcraktive Klanginstallation)

West Wind Welt
Brucknerhaus, Foyer
von Ingo Günther (D)
Installation

Bubble-Plastic Destroyer
Brucknerhaus, Foyer
von Peter Zegveld (NL)
Installation

Akzidenz
Donauufer Jahrmarktgelände
von Leo Schatzl (A)
Ritual, Fossil, Videoinstallation
Projektleitung Katharina Gsöllpointner

Blätter
Brucknerhaus Foyer
von Arthur Elsenaar (NL)
Installation

QUASI
Linz-Innenstadt
Roboter-Hunder von Nick Baginsky (D)
Installation

Grund Riss
Donaupark, Brucknerhaus
(Auftragswerk von Ars Electronica)
Von Adler zu Zylber
Eine konzeptuelle Installation von Melissa

Gould (USA) & Noten aus dem Untergrund
Eine Musik- und Klanginstallation von
Alvin Curran (I)

Fliegender Teppich
Brucknerhaus Foyer
von Werner Vollert (D)
Installation, Automaten

Die Logik der Schlange
Zivilschutz-Tunnel Schloßberg
von Erik Samakh (F)
Klanginstallation

**Tortur eines schweren Kreisels mit
überlagerter Mutation**
von Krüppelschlag (A)
Installation
Gustav Dornetshuber (Linz), Randy Tremain
(Memphis TN), Bram X (Amsterdam)
Krüppelschlag: Doris Ebner, Martina Ebner,
Kurt Holzinger Just Merit, Bram Renstrom,
Gunther Sackl, André Schober, Dr. Gottfried
Wimmer, Dorothe X. Berthold Zettelmeier

Beeinflussungsapparat nach Jedermann
Galerie Fa. Paradigma
Ausstellung mit Werken von Psychiatrie-
patienten aus der Prinzhorn-Sammlung,
Heidelberg, und Reuter-Collection, Pécs Kon-
zept und Design: Inge und Ferenc Jádi (Berlin)

Prix Ars Electronica-Ausstellungen
ORF/Landesstudio Oberösterreich
Videothek, Audiothek und Galerie

TV-DINER
Personal: Käthe Be, (Berlin):
Käthering/Bedienung
Service: Art d´Ameublement, Bielefeld:
Interaktives Beschwerdesystem
Karin Karawahn (Berlin):
Fernsehlotterie/Video
Paul Lincoln, New York: Automationen
X99, Köln: Herstellung/Möblierung
Management:
Oliver Schneider (Köln): Koordination
Stiletto Studios, Berlin: Gesamtkonzept

Prix Ars Electronica

Veranstalter: ORF/Landesstudio Oberösterreich
Idee: Dr. Hannes Leopoldseder
Konzept: Dr. Christine Schöpf, Dkfm. Heinz
Augner, Wolfgang Winkler

Jury
Gesamtvorsitz: Hannes Leopoldseder
Computergrafik/Computeranimation: Gerhard
Johann Lischka, Rebecca Allen, Mark A. Z.
Dippé, Milan Knizak, Bernhard Leitner, Alfred
Nemeczek, A. J. Mitchell,
Interaktive Kunst: Roy Ascott, William Buxton,
Donna Cox, Brian Reffin Smith

Preisträger
Computergrafik
Goldene Nica: Bill Woodard
Auszeichung: Yoshiyuki Abe, Arthur
Schmidt Anerkennung: Victor Acevedo,
John Adamczyk, Cornelia Halle, John Hersey,
Rüdiger Hirt, Dick Ibach, Sui Morita, Patrizia
Pio, Robert Martin, Tiziana Stanzani, Brian
T. Sullan, Mike Zender

Computeranimation
Goldene Nica: Karl Sims
Auszeichnung: James Duesing, Yoichiro
Kawaguchi
Anerkennung: Rashel B de F, Jean Luc
Faubert, Maurice Benayoun, Peter Claridge,
Boris S. Dolgovesor, Hervec Huitric, Monique
Nahas, Nancy Kato, Mike McKenna,
Bob Sabiston, Simi Nallaseth, Eduard Ole-
schak, Michel Tolson, Pascal Vuong, Jason
White, Richard Wright

Interaktive Kunst
Goldene Nica: Paul Sermon
Auszeichnung: Chico MacMurtrie, Rick
Sayre, David Rokevon
Anerkennung: David Eagle, Nola Farman,
Alex Guzzetti, Peter Krieg, Mark Madel,
Benoit Maubrey, Christine Meierhofer,
Stephen Wilson, Jim Pallas, Don Ritter,
Mona Sarkis, Robert Mulder, Kristi Allik

Prix Ars Electronica Gala 91
ORF/Landesstudio Oberösterreich – 3sat
Verleihung der Goldenen Nica 91
Moderation: Regina Patsch, Dieter Moor

Cinema: Violence

Programmkino Moviemento
Gestaltung:
Wolfgang Steininger

Erotic Violence

The Cinema of Transgression
Richard Kern
The right side of my brain (1984)
Manhattan Love Suicides (1985)
The Evil Cameraman (1986, 1990)
Fingered (1986)
Pierce (1987)
Submit to me now (1987)
X IS Y (1990)
Money Love (1990)
Tumble (1990)

Video

Gewalt

Brucknerhaus, Keplersaal
Kurator: Kathy Rae Huffman, ICA Boston

1. **Politische Gewalt**
2. **persönliche Gewalt**

Video gegen AIDS

Video-Retrospektive John Duncan

Brucknerhaus, Keplersaal

Open-Air

Out of Control „Niemand ist sich seiner sicher"
VOEST-Brücke – Urfahr + TV-Projekt im FS
Von Stadtwerkstatt TV (A)
Konzept und Regie: Stadtwerkstatt TV –
Thomas Lehner, Georg Ritter, Wolfgang Lehner,
Reinhard Jud
Realisation: Houchang Allahyari, Reinhard
Anderle, Petra Anlanger, Norbert Artner,
Baronesse Lana Maria von Dimwald, Seebach
Andreas Baumgartner, Dominque Bejvl,
Gerhard Blöchl, Heinz Brandner, Peter Donke,
Gustav Dornetshuber, Wolfgang Dorninger,
Selam Ebead, Martina Ebner, Joachim Eckl, Fina
Eßlinger, Andreas Feichtner, Markus Fischer,
Bernhard Frankfurter, Karl Freilinger, Willibald
Fuchshuber, Charles Fürth, Stefan Gassner, Han-
nah Gehart, Caro Geier, Erwin Graf, Petra Jeup,
Dr. Karl Hafner, Peter Hauenschild, Kurt Henn-
rich, Laurenz Hofstadler, Gabi Kepplinger, Ger-
hard Kohlmayr Silvia Lappi, Dominik Lepuschitz,
Inge Maria Limbach, Georg Lindorfer, Erwin
Loidl, Christian Meisner, Didi Neidhart, Gerhard
Neulinger, Bob O'Kane, Gertrude Plöchl, Günt-
her Rainer, Peter u. Paul Reinthaler, Paul Riedl,

Elke Rittenschober, Ruth Ritter, Simon Ritter,
Helmut Rozmann, Robert Rudelstorfer, Herbert
Schager, Valerie Schager, Brigitte
Schober, Alf Schwarzlmüller, Peter Sommerfeld,
Wolfgang Amadeus Steinmetz, Markus Tremel,
Nancy Tuffy, Martin Vlk, Mark Vojca, Gotthard
Wagner, Max Zellinger, Rainer Zendron, Monika
Zoufal

Dank an:
ORF/Landesstudio Oberösterreich, 3sat, Ars
Electronica, Bundesministerium f. Landesvertei-
digung, Bundesministerium für Unterricht und
Kunst, Landesregierung Oberösterreich, Stadt
Linz, Bundespolizei Linz, Sony, Communication
Systems, Schweizer und Pilger, Kapsch, Berg-
bahnen Hinterstoder, Amiga, Commodore,
Offenes Kulturhaus Linz, Elektro Ransmayr,
Fischer Film.
Sowie an Markus Binder, Ing. Gernot Göckler,
Gottfried Hattinger, Mag. Jürgen Meindl,
Dr. Christine Schöpf, Günter Stockinger,
Dr. Ernst Strouhal, Mag. Martin Sturm,
Dr. Herbert Timmermann, Mag. Gitti Vasicek

Ars Electronica 92
Festival für Kunst, Technologie und Gesellschaft

Die Welt von Innen – Endo und Nano

23. – 27. Juni 1992

Veranstalter:
Brucknerhaus Linz und
ORF/Landesstudio Oberösterreich

Direktorium:
Vorstandsdirektor Karl Gerbel (LIVA),
Intendant Dr. Hannes Leopoldseder (ORF),
o. Prof. Peter Weibel (Vorsitzender des künstlerischen Beirates)
Ständiger künstlerischer Beirat:
o. Prof. Peter Weibel (Vorsitzender),
Dr. Katharina Gsöllpointner (LIVA),
Mag. Brigitte Vasicek (LIVA), Dr. Christine Schöpf (ORF)
Kuratoren:
Benjamin Heidersberger, Georg Kampis,
Woddy & Steina Vasulka, Dietmar Wiesner

Prix Ars Electronica
Idee:
Dr. Hannes Leopoldseder
Konzept:
Dr. Christine Schöpf, Dkfm. Heinz Augner,
Wolfgang Winkler

Symposien

Endophysik
Brucknerhaus, Stiftersaal
Kuratoren: George Kampis Tübingen D),
Peter Weibel (Städelschule Frankfurt, D)
Vorsitzender: Otto E. Rössler (D)
Referenten: Ralph Abraham (Mathematics Department, University of Santa Cruz, CA, USA),
Harald Atmanspacher (MPI für extraterrestische Physik, Garching, D), John L. Casti (Institute for Econometrics, ORÄ & System Gtheory; TU Wien; Santa Fe Insitute, Santa Fe, NM, USA), Michael Conrad (Department of Computer Science, Wayne State University, Detroit, USA), David Finkelstein (Georgia Institute of Technology, School of Physics, Atlanta, GA, USA), Donald

D.Hoffman (Department of Cognitive Science, School of Social Sciences, Irvine, USA), Lars Löfgren (Department of Information Theorie, University of Lund, Schweden), Humberto Maturana (Department de biologia, Facultad Ciencias Universidad de Chile, Santiago de Chile), Jürgen Parisi (Insitut für Physik, Uni Zürich, CH), Gordon Pask (OOC/CICT/ Universität Amsterdam Architectural Association, Londen; Brunnel University, GB), Robert Rosen (Department of Physiology and Biophysics, Dalhousie University Halifax, Nova Scotia, Can), Rob Shaw, Karl Svozil (Institut für theoretische Physik, TU Wien, A), Ichiro Tsuda (Department of Artificial Intelligence, Kyushu Insitute of Technology, Lizuka, Japan)

Nanotechnologie
Brucknerhaus, Stiftersaal
Referenten: Armin Wieder (Siemens AG, München, D), Jane Frommer (Universität Basel, CH), Stelarc (CITRÄI-Collaborative Information Technoloigy Research Insitut, Victoria, AUS)

Konzerte/Theater/Performances

Electronic Purgatory
Brucknerhaus, Brucknersaal
von Kristi Allik, Robert Mulder (Can)
The Man who Invented the 20th Century
Posthof, Grosser Saal
Von Henry Jesionka (Can/USA)
Medienperformance über Nikola Tesla
ImmediaCY
Brucknerhaus, Brucknersaal
PoMo CoMo (Can)
von Andreas Kitzmann (Schriftsteller, Schauspieler und Literaturwissenschafter und Rafael Lozano-Hemmer (Konzeptkünstler, Chemiker)
Storyboard: Andreas Kitzmann und Rafael Lozano-Hemmer
Musik: Steve Gibson und Marc Bell
Choreographie: Kelly Hargraves
Computertechnik: Will Bauer und Bruce Foss
Sprachadaptionen: Marc Boucher
Bühnenbild: Rafael Lozano-Hemmer und Geoffrey Bendz

Darsteller: Marc Boucher, Kelly Hargraves,
Will Bauer, Rafael Lozano Hemmer und
Geoffrey Bendz
Steckanschlüsse: Robert Lepage, Marcel
Achard, Nel Tenhaaf, Kim Sawchuk, Agustin
Luviano-Cordero, Elizabeth Littlejohn und
Chris Migone
Regie und Produktion: Rafael Lozano-Hemmer

Third Hand
Posthof Linz
von Stelarc (Australien)
Performance Animation

Konzertabend visuelle Musik

Immateriaux II
Brucknerhaus, Brucknersaal
Von Klaus Obermaier (A), Robert Spour (A)
Laser: Friedrich Förster

Hyena Days
Brucknerhaus, Brucknersaal
von Michael Saup, Gitarre (D), Steina
Vasulka, Violine (USA)
Media Codesigners: Woody Vasulka (USA),
David Mueller, Bob O'Kane

Konzertabend elektronische Musik

Kurator: Dietmar Wiesner

For Ann(rising)
Bandkonzert 1969
von James Tenney (Toronto /Kan)

Violektra
von Johannes Fritsch (D)

Quantized Quant
Für Soloflöte und Elektronik
von Benedict Mason

Ikrek
(für zwei 5-saitige Elektrobässe und
Electronic) von Duncan Youngerman

Stria
(Auftragswerk für IRCAM Paris 1977)
von John Chowning
Bandkonzert

In sich – außer sich
Pöstlingbergkirche, Linz
von Simon Stockhausen (D)
Ausführende: Johannes Fritsch, Dietmar
Wiesner, Kasper Töplitz, Zoltan Farkas,
Michael Svoboda, Andreas Böttger.
Konzertabend Prix Ars Electronica Preisträger

Chiaroscuro
von Francis Dhomont (Can)

Reluctant Games
von Wolfgang Mitterer (A)

Chant D´Ailleurs, Borges
von Alejandro Vinão (Arg/GB)
Solistin: Francis Lynch

Im Teilchendschungel der Wahrscheinlichkeit
Live-Sendung und Übertragung im
Brucknerhaus
Konzipiert und realisiert von Stadtwerkstatt
TV in Zusammenarbeit mit Künstlern,
Technikern und Akteuren aus Österreich,
Deutschland und Amerika
Lehner, Jud, Donke, Hennrich, Ritter,
Hauenschild, Schager, Auinger, Fischer

Resonanzen
Radiolabor ORF- Radio Ö 1, UKW 88,8 Mhz

Ausstellungen

Ausstellung Landesmuseum

Handsight
von Agnes Hegedus (H/NL)
Installation

The Virtual Museum
von Jeffrey Shaw (NL)
Dreidimenstionale computergesteuertes
Museum

Cartesian Chaos
von Peter Weibel, Bob O´Kane (D)
Unterstützt von: Interlux Hirsch GesmbH,
Silicon Graphics, Comesa GesmbH, EBG
Computer Corner, Kulturamt der Stadt
Salzburg, Schweizer&Pilger, Böhler Ybbstal-
werke, Electro City, Voest-Alpine Stahl AG,
Siemens Kulturprogramm, Siemens AG
Österreich, EMCO - Hallein, Silhouette - Linz,
Australian Council, The Canada Council -
Explorations Programme, The Canda
Council - Computer Integrated Media, The
Ontario Arts Council – Multidisciplinary
Arts, Commodor Canada – Toronto/Ontario,
Very Vivid - Toronto, Intelligent Music -
Albany/ N.Y., 3M.Canada – London/Ontario-
Canada, Zentrum für Kunst und Medien-
technologie - Karlsruhe, Bergische Univer-
sität - Gesamthochschule Wuppertal –
Fachbereich V – Design, Video- und

Computerdesign (A-6074 Rinn), Galerie
KNOLL – Wien/Budapest, Städelschule –
Institut für neue Medien – Frankfurt/M.,
Fonds voor Beeldene Kunsten – Vormgeving
& Bouwkunst – Amsterdam, Akademie
Schloß Solitude – Stuttgard, Centre d' Art
Contemporain – Ministre de la Culture –
Paris, F.N.A.C. – Paris, Galerie Isy Brachot –
Brüssel, Galérie du Tugny Lamarre – Paris,
Gidion May, Marine Bour – Delegation aux
Arts Plastiques – Ministère de Culture –
Paris
Gefördert von: Bundesministerium
für Unterricht und Kunst, Kulturabteilung
der Oberösterreichischen Landesregierung

**Die Eigenwelt der Apparate-Welt, Pioniere der
elektronischen Kunst**
Kuratoren: Woody & Steina Vasulka (USA)
Mitarbeiter: Malin Wilson, David Dunn,
David Mueller
Ausstellungsarchitektur:
Eichinger oder Knechtl

Prix Ars Electronica 92
Interaktive Kunst
Installationen der Preisträger im Landesmuseum
Home of the Brain – Haus des Seins
von Monika Fleischmann, Wolfgang Strauß
(ART+Com, D)
Zerseher
von Joachim Sauter, Dirk Lüsebrink
(ART+Com, D)
The Exquisite Mechanism of Shivers
von William Seaman
Vidodisk-Installation

Installationen im Brucknerhaus
Der innere Beobachter
von Michael Bielicky (EU)
Watch Yourself
von Timothy Binkley (USA)
Globus Oculi
von Jean-Louis Boissier (F)
Interaktive Videoinstallation
Three Linked Cubes
von Dan Graham (USA)
Zeitgenössische Videokunst in Dan
Grahams Pavillon:
Shelly Silver „We" (USA), Jason White/

Richard Wright, „Superanimism" (GB),
Irit Batsry, „A simple case of vision (Yu),
Kathleen Rogers, „The art of losing
memory" (GB) Dan Graham/Dara
Birnbaum „Rock my religion" (USA)
Tesla-Maschinen
von Günther Held (D),
Manfred Hausler (A)
Brille
von Huemer, Jelinek (A)
Flight Case
von Rudolf Macher (A)
Space Balance
Donaupark
von Christian Möller (D)
virtuelle Architektur
Hauptklammer
von Claire Roudenko-Bertin (F)
2teilig: le(UM) und Sacrifice Infinitesimal
du Motif
Vorspiel
von Christoph Steffner (A/E)
Bull's Head or Revision of the Video Buddha
von Peter Szelezcki (H)
7 Objects Meet
von Akke Wagenaar (NL)

Menschen und Meilensteine
Kreative Software
Kurator: Benjamin Heidersberger
Mitarbeiter: Eva Weber, Bernd v. den Brincken
Eine Auswahl der vorgestellten Programme
und ihre Künstler:
VisicCalc
von Dan Bricklin und Bob Frankston
Pascal
von Niklaus Wirth
PacMan
von Toru Iwatani
Xerox Star
von PARC-Gruppe
Collosal Cave
von Donald Woods
Eliza
von Joseph Weizenbaum (USA)
Deluxe Paint
von Daniel Silva
Virus 1701
von unbekanntem Urheber

Prix Ars Electronica Künstlerforum

ORF/Landesstudio Oberösterreich –
Publikumsstudio

Teilnehmer:

Computergrafik: Andrew Witkin, Carnegie Mel-
lon University, Michael Kass, Apple Computer,
Steward McSherry, Mark Wilson

Computeranimation: Karl Sims, Thinking Machi-
nes Corporation, Denis Muren, ILM, Bériou, Aga-
ve S.A., Charlie Gunn, The Geometry Center,
Cécile Babiole, Pandora

Computermusik: Alejandro Vinao, Francis Dho-
mont, Wolfgang Mitterer

Interaktive Kunst: Monika Fleischermann, Joa-
chim Sauter, Bill Seaman

Prix Ars Electronica

Idee: Dr. Hannes Leopoldseder
Konzept: Dr. Christine Schöpf, Dkfm. Heinz
Augner, Wolfgang Winkler

Jury
Vorsitzender der Gesamtjury
Hannes Leopoldseder
Computeranimation
Gerhard Johann Lischka, Rebecca Allen, Pe-
ter Weibel, Milan Knizak, Rolf Herken, A.J.
Mitchell, Stefan M. Fangmeier
Interaktive Kunst
Roger F. Malina, Roy Ascott, Florian Rötzer,
Ilka Lauchstädt, David Rokeby
Computermusik
Thomas Kessler, Christian Amirkhanian,
Márta Grabócz, Dieter Kaufmann, Trevor
Wishart

Preisträger
Computergrafik
Goldene Nica: Andrew Witkin/Michael Kass
Auszeichnung: Steward McSherry,
Mark Wilson
Anerkennung: Yoshiyuki Abe, Jószef Bullás /
Zsolt Krajcsik, Valie Export, William Latham,
David Sherwin
Computeranimation
Goldene Nica: Karl Sims
Ehren Nica: Dennis Muren/Mark A. Z. Dippé
/Steve Williams

Auszeichnung: Charlie Gunn/Delle
Maxwell, Dana S. Scott, Cécil Babiole, Bériou
Anerkennung: Cécile Babiole, Matthew
Brunner, Mario Martin Buendia, Jérôme
Estienne / Xavier Duval, Fantôme, Keith
Hunter, Xavier Nicolas / Jerzy Kular, Alan
Norton, Marc Raibert / Leg Laboratory
Interaktive Kunst
Goldene Nica: Monika Fleischmann/
Wolfgang Strauss
Auszeichnung: Joachim Sauter/Dirk
Lüsebrink, William Seaman,
Anerkennung: Kristi Allik / Robert Mulder,
Rajinder Chand, Luc Courchesne, Robert
McFadden, Rebecca Fuson, Troy Innocent,
Beverly Reiser / Hans Reiser, Henry W. See,
Simone Simons / Peter Bosch, Martin
Spanjaard
Computermusik
Goldene Nica: Alejandro Vinao
Auszeichnung: Francis Dhomont, Wolfgang
Mitterer
Anerkennung: Kristi Allik, Phillip K. Bimstein,
László Dubrovay, David E. Jones, Elsa Justel,
Catalina Peralta-Caceres, Michael Rosas
Cobian, Stéphane Roy, Wayne Siegel, Denis
Smalley, Peter M. Vaughan

Prix Ars Electronica Gala 92
ORF/Landesstudio Oberösterreich – 3sat
Verleihung der goldenen Nica 92
Moderation: Mercedes Echerer, Dieter Moor

Ars Electronica 93

Festival für Kunst, Technologie und Gesellschaft

Genetische Kunst – Künstliches Leben

14. – 18. Juni 1993

Veranstalter:
Brucknerhaus Linz und
ORF/Landesstudio Oberösterreich

Brucknerhaus Linz:
Vorstandsdirektor Karl Gerbel

ORF/Landesstudio Oberösterreich:
Intendant Dr. Hannes Leopoldseder

Direktorium:
Vorstandsdirektor Karl Gerbel (LIVA)
Intendant Dr. Hannes Leopoldseder (ORF)
o. Prof. Peter Weibel (künstlerischer Leiter)

Ständiger künstlerischer Beirat:
o. Prof. Peter Weibel
Dr. Katharina Gsöllpointner (LIVA)
Dr. Christine Schöpf (ORF)

Kuratoren:
Edek Bartz, John L. Casti, Christopher Langton,
Dietmar Wieser

Prix Ars Electronica:
Veranstaltet von ORF-Landesstudio
Oberösterreich
Idee, Konzept: Dr. Hannes Leopoldseder
Konzept: Dr. Christine Schöpf, Dkfm.
Heinz Augner, Wolfgang Winkler

Symposien

Artificial Life

Brucknerhaus Stiftersaal
Kuratoren: John L. Casti, Christopher Langton
Moderator: Kevin Kelly, Complex System Annex,
(USA)
Teilnehmer: John L. Casti, Institut für
Ökonometrie, Operations Research und System-
theorie, TU Wien; Santa Fe Institute, NM (USA)
Christopher Langton, Santa Fe Institute, NM
(USA); Los Alamos National Institute, NM (USA)
Ken Karakotsios, San Jose, CA (USA)
Przemyslaw Prusinkiewicz, Department of
Computer Science, University of Calgary (CAN)
Steen Rasmussen, Los Alamos National
Laboratory, NM (USA)
Tom Ray, University of Delaware (USA)
Karl Sims, Thinking Machines Corporation,
Boston MA (USA)
Peter Weibel, Institut für Neue Medien,
Städelschule, Frankfurt/Main (D)
Larry Yeager, Apple Computer Inc., Cupertino,
Ca (USA)

Gentechnologie

Brucknerhaus, Stiftersaal
Moderator: Florian Rötzer (D)
Teilnehmer: Michael Ausserwinkler, Bundesmi-
nister für Gesundheit, Sport und Umweltschutz
Christian Brünner, Universität Graz, (ÖVP, A)
Reinhard Löw, Forschungsinstitut für Philoso-
phie, Hannover (D)
Lothar Müller, SPÖ, Wien (A)
Helmut Ruis, Institut für Biochemie und
Molekulare Zellbiologie, Wien (A)
Horst Seidler, Institut für Humanbiologie, Wien
Johannes Voggenhuber, Grüner Klub, Wien (A)
Ernst Wagner, Institut für Molekulare Patholo-
gie, Univ. Wien (A)

Lust auf Unsterblichkeit
Kloning, Kryonik Und Kosmetik

Brucknerhaus, Stiftersaal
Moderator: Klaus Madzia, Hamburg (D)
Teilnehmer: Gerhard J. Lischka (CH)
Pattie Maes, Medialab MIT, Cambridge MA (USA)
Reimara Rössler, Universitätspoliklinik
Tübingen (D)
Mathias Wabl, Department for Microbiology &
Immunology, University of San Francisco, CA (USA)
Larry Yeager, Apple Computer Inc.,
Cupertino, CA (USA)

Roboter, Animaten und künstliche
Lebewesen

Brucknerhaus, Stiftersaal
Moderator: Peter Weibel
Teilnehmer:
Colin Angle, IS Robotics, Boston MA (USA)

Joseph Bates, Carnegie Mellon University (USA)
Louis Bec, Institute Scientifique de Recherche
Paranaturaliste, Sorgues (F) Rodney A. Brooks,
Artificial Intelligence Laboratory, MIT,
Cambridge MA (USA) Pattie Maes, Medialab
MIT, Boston MA (USA), Tamiko Thiel, Designerin
der Connection Machine München (D), Mark
Tilden, Hardware Design Laboratory, University
of Waterloo, Ontario (CAN)

Konzerte/Theater/
Performances

Der Geklonte Klang
Brucknerhaus, Brucknersaal
Komposition, Gesamtkonzept, Live-Electro-
nic: Klaus Obermaier/Robert Spour (A)
Kronos Quartet (USA): David Harrington
(Violine), John Sherba (Violine), Hank Dutt
(Viola), Joan Jeanrenaud (Cello),
Interaktive Lasersteuerung: Friedrich Förster
(D), Computerprogrammierung: Kurt Walz
(D), Video, Lichtregie: Rainer Jessl (A),
Lichtassistenz: Larry Neff, Max Audio Pro-
grammierung: Peter Böhm (A), Tontechnik:
Jay Cloidt, Raumklang-Software: Peter Böhm
Laserimages, Projektionen: Obermaier,
Spour, Förster.

Scores
Brucknerhaus
Partitur
Achim Wollscheid, Dietmar Wiesner,
Joachim Pense (D)
Komposition, Konzept: Achim Wollscheid
Komposition, Interpretation: Dietmar Wieser
Komposition, Programmierung: Joachim Pense

Brocken Light
Brucknerhaus, Brucknersaal
For Stringquartett an modiefied
CD player
Nicolas Collins und das Soldier String
Quartet (USA)
mit: Regina Carter, Violine
Dave Soldier, Violine
Ron Lawrence, Viola
Margret Parkins, Cello

What Happend II
Laetitia Sonami and the Ladies Glove
Text: Melody Sumner (USA)

Kraftwerk (D)
Brucknerhaus, Brucknersaal
Kurator: Edek Bartz
Balanescu Quartet (GB)
Brucknerhaus, Brucknersaal
spielt Musik von Kraftwerk
Alexander Balanescu, Violine/Clare Connors,
Violine/Bill Hawles, Viola/Caroline Dale, Cello

Ausstellungen

Brucknerhaus
Automatic Radio:
R.A.M.S. Attack
Konzept: Alf Altendorf und Margarete
Jahrmann (A)
Chef vom Dienst: Thomas Madersbacher (A)
Technische Beratung und Programmierung:
Bernhard Loibner (A – „All Quiet on the We-
stern Front")
Akustikkonzept: Peter Szely, Christof Cargne
Barcode
Installation von Konrad Becker/Wolfgang
Zinggl (A)
Ton-Feld III
Bernhard Leitner
Installation
Knowbotic Research
Brucknerhaus, Garage
(Goldene Nica 93 für Interaktive Kunst)
Simulationsraum – Mosaik Mobiler Daten-
klänge – Eine begehbare Datenbank
Mitarbeiter: Christian Hübler (Konzept,
Ralisierung), Alexander Tuchacek (Echtzeit-
komposition) Yvone Wilhelm (Visualisie-
rung), Georg Fleischmann (Selbstorganisa-
tion, komplexe Systeme), Detlev Schwabe
(Datenbank und Systemmanagement),
Michael Hoch (Klanganalyse, private eye),
Will Bauer (Space-tracking), Tobias Pfeil
(data-broking), Rajele Jain und Udo Zyber
(technische Installation)
Augen
Leopold Larcher/Rich. Art (A)
Das Sehende Ohr
Vortrag und Präsentation
Installation von Bernhard Leitner (A)
Project Ton-Räume P7130-TEC
Projektleiter: Bernhard Leitner,

Dr. Heinrich Pichler, D.I. Geza Beszedics, D.I.
Franz Pavuza, Ing. Manfred Wawra,
Technische Universität Wien

Trans/Form
Skulptur von Peter Sandbichler (A)
Computermodell: Constanze Ruhm, ausge-
führt an der Städelschule, Institut f. Neue
Medien, Frankfurt/M.

Videos & Software
Brucknerhaus, Foyer
Zusätzlich zum Symposium Artificial Life
wurde eine Auswahl der aktuellen Compu-
terspiele, Animationen, Videos und wissen-
schaftlichen Filme zum Thema „Künstliches
Leben – Genetische Kunst" gezeigt.

Virtuelle Emotionen
von Stefan Schemat (D)

Gen Manipulations Set (Part I)
Installation von Katrin Stockhammer/
Alexander Popper (A)

Eine Kleine Genealogie Des Künstlichen Lebens
von Arye Wachsmuth (A)

Genetische Kunst
1. Biogenetische Kunst
OÖ. Landesgalerie

Zeitpflanzen – Eine elektrochemische Prozessinstallation
Tassilo Blittersdorf (A)

Spurenapparat
von Thomas Feuerstein/Klaus Strickner (A)

Gegenwartsarchäologie
von Sabine Hiebler/Gerhard Ertl (A)

3 Bilder nach Mendel
von Stanislav Divis (CFR), Damien Hirst (GB)

Biogenetic Paintings
„The Delbruck paradox"
von David Kremers (USA)
Liz Larner (USA)

Genetix
von Niki Nickl

Legal Cheese
von Dan Peterman (USA)

Small Landscape
(im Meer, Schimmelhaufen)
von Dieter Roth (CH)

Die Ezechiel Serien
Notizen zur epigenetischen Kunst:
von Roman Verostko (USA)

Algenbilder
Molektronische Netzwerke
von Franz Xaver (A)

2. Virtuelle Kreaturen
Protegomena
von Louis Bec (F)

Creatures
von Daizaburo Harada (J)

Ants
Ants; Computer:Brain
von Peter Kogler (A)

3. Roboter
Terrain 01
Ulrike Gabriel (D)

Neuro Baby
von Naoko Tosa (J)

4. Genetische Manipulation
Void Space I, II, III
von Valie Export (A)

Msfits
von Thomas Grünfeld (D)

Andrew Head/Julie Head/Rinde Head
von Bruce Nauman (USA)

The Reign Of Rain
von Alexis Rockman (USA)

Untitled Turkey XXIII
von Meyer Vaisman (Venezuela)

Language Is A Virus From Outer Space
Alexis Rockman (USA)
von W.S. Burroughs

7 Viren
von Jochem Hendricks,
Marko Lehanka (D)

Satzbauplan
von Thomas Locher (D)

Weiter
von Susanna Morgenstern (A)

Fibonacci – Reihen
Quando
von Mario Merz (I)

tv poetry
von Gebhard Sengmüller (A)
Collaboration: Günter Ehrhart, Clemens
Zauner (Systemdesign), Bruno Klomfar
(Fotografie)
produziert von Pyramedia Wien

A. künstliches leben

Rosa Binaria
von Alba D´Urbano

Der digitale Garten III
von Ross Harley (AUS)

Kulturmeter – Die Kunst des multikulturellen Mischens
von Wolfgang Hilbert (A)

The Table Of Spirits
von Gideon May (NL)

Genetic Images
von Karl Sims (USA)

Interactive Plant Growing
von Christa Sommerer (A)/Laurent Mignon-neau (F)

Anthroposkop – Erforschung von künstlichem Leben
von Christa Sommerer (A)/Laurent Mignon-neau (F)

Animatrix
von Akke Wagenaar (NL)

Weltwürfel
von Peter Weibel (A/D)

B. Prix Ars Electronica Installationen

Das verlorene/zerrüttete Paradies?
von Jill Scott

Ist dort jemand?
von Stephen Wilson (USA)

Prix Ars Electronica Künstlerforum

Künstlichkeit: Imagination und Kreation
ORF

Computeranimation: Die Grenze heißt Imagination
Pascal Roulin, Pascavision (F); Darrin Butts, Texas A & M University (USA); Mark Malmberg, XAOS, (USA); Bèriou, Agave (F); Hannes Leopold-seder, ORF, und Eduard Bannwart, ART+COM: Präsentation des Ars Electronica Center

Computergraphik: Bilder jenseits des Sichtbaren
Char Davies, Softimage, (CDN), Michael Tolson, XAOS (USA)

Diskussion: Künstlichkeit und die Grenzen der Imagination
Mit Pascal Roulin, Darrin Butts, Mark Malmberg, Bèriou, Char Davies, Michael Tolson und Karl Sims
Diskussionleitung: Peter Weibel

Computermusik: Die Lust auf Klänge
Bernard Parmegiani (F); Javier Alvarcz (MEX); Jonty Harrison (GB)

Interaktive Kunst: Feminismus, Telekommunikation und virtuelle Räume
Jill Scott (AUS); Stephen Wilson (USA); Christian Hübler (A)

Diskussion: Realität und Virtualität
Mit: Bernard Parmegiani, Javier Alvarez, Jonty Harrison, Jill Scott, Stephen Wilson, Christian Hübler

Prix Ars Electronica

Veranstaltet vom ORF/Landesstudio Oberösterreich
Idee, Konzept: Dr. Hannes Leopoldseder
Konzept: Dr. Christine Schöpf, Dkfm. Heinz Augner, Wolfgang Winkler

Computergrafik/Animation:
Jury: Gerhard Johann Lischka (A) Vladimir Galaktionov (Rußland), Rolf Herken (D), A. J. Mitchell (GB), Philippe Quéau (F), Peter Weibel (A), Michael Kass (USA)
Goldene Nica: Michael Tolson (USA)
Auszeichnung: Char Davies (CDN)
Anerkennung: Thomas Bayrle (D); Jean-François Colonna (F); Scott Draves (USA); David, Haxton (USA); Mogens Jacobsen (DK); Laurens Lapré (NL); Jolanta Makowska (PL); Constanze Ruhm (A); Miroslav Stuchlík/Radim Vrska (CR); Roman Verostko (USA)

Computeranimation
Goldene Nica: Pascal Roulin (F)
Auszeichnung: Mark Malmberg / XAOS, (USA); Darrin Butts (USA); Bériou (F)
Anerkennung: George Barber (GB); Jules Bister (D); Jos Claesen/Anton Roebben (B); Philippe Gassie/Bruno Simon (F); Industrial Light & Magic (USA); Eku Wand (D)

Computermusik
Jury: Charles Amirkhanian (USA); Lars-Gunnar Bodin (S); Werner Jauk (A); Ivanka Stoianova (BG); Trevor Wishart (GB)
Golden Nica: Bernard Parmegiani (F)
Auszeichnung: Javier Aalvarez / MEX; Jonty Harrison (GB)
Anerkennung: David Chesworth (AUS);

Francis Dhomont (F); Roberto Doati (I); Pascal
Gaigne (F); Jens Hedman/Erik Mikael
Karlsson (S); Jacques Lejeune (F); Andrew
Lewis (GB); Cort Lippe (USA); Adrian Moore
(GB); Robert Normandeau (CDN); Michael
Rosas-Cobian (RA); Laka Saariaho (SF)

Interaktive Kunst

Jury: Roger F. Malina (USA); Roy Ascott (GB);
Florian Brody (A); Scott S. Fisher (USA);
Florian Rötzer (D)

Golden Nica: Christian Hübler, Knowbotic
Research (A)

Auszeichnung: Jill Scott (AUS); Stephen
Wilson (USA)

Anerkennung: Joseph Bates (USA); Werner
Cee/Horst Prehn (D); Agnes Hegedüs (H);
Lynn Hershman (USA); Catherine Ikam (F);
David Rokeby (CDN); Kevin Ruston (GB); Paul
S. Sermon (GB); Gerfried Stocker/Horst
Hörtner (A); Van Gogh TV (A); Akke Wage-
naar (NL); Peter Weibel (A); Mia Zabelka/
Gerfried Stocker/Andres Bosshard

Prix Ars Electronica Gala 93

ORF/Landesstudio Oberösterreich – 3sat
Verleihung der goldenen Nica 93
Moderation: Mercedes Echerer

Video

Alba D'Urbano (I): Rosa Binaria
Henning Genz (D): Symmetrie
Ken Karakotsios (USA): SimLife (1992)
John Koza (USA): Genetic Programming:
The Movie
Christopher Langton (USA): Studying Artificial
Life with Cellular Automata
Tom Ray (USA): Tierra
Brian Silverman (USA): Phantom Fish Tank
Will Wright, Justin McCormick (USA): Sim Ants
John Wyver (GB): Signs of Life
Larry Yeager (USA): Poly World
Ausstellungsgestaltung: Peter Sandbichler (A)

Film/Kino

Filmprogramm „Künstliches Leben"

Konzeption: Frank Marksteiner, Vrääth
Öhner, Holger Reichert

Brucknerhaus:

„Der Golem, wie er in die Welt kam";
Deutschland 1920, R: Paul Wegener,
Carl Boese
„Blade Runner" (Director's Cut); Originalver-
sion des Regisseurs, USA 1982, R: Ridley Scott
„The Bride of Frankenstein" – Frankensteins
Braut; USA 1935, R: James Whale
„The Bride of Re-Animator"
„Frankenstein – The man who made a
monster", USA 1931, R: James Whale
„Tetsuo II/The Body Hammer", Japan 1991,
R. Shinja Tsukmoto

Moviemento:

„Alraune", Deutschland 1927, R: Henrik
Galeen
„Frankenstein must be destroyed", England
1969, R: Terence Fisher
„Edward Sissorshands", USA 1991,
R: Tim Burton
„Die Nackte und der Satan"
„Frankensteins daugther", USA 1958
„Revenche of Frankenstein"

Sonstige Veranstaltungen

Gewalt Und Computerspiel
Brucknerhaus, Keplersaal
Eine Rauminstalltion
Galerie im Stifterhaus
Gerhard Knogler (A)
Objekt-Raum Bildbeziehung
Galerie MAERZ
Johannes Deutsch (A)
Info – Eine Geschichte Des Computers
Museum Industrielle Arbeitswelt, Steyr

Ars Electronica 94
Festival für Kunst, Technologie und
Gesellschaft

Intelligente Ambiente / Intelligent Environments

21. – 25. Juni 1994

Veranstalter:
Brucknerhaus Linz und ORF/Landesstudio
Oberösterreich

Brucknerhaus Linz:
Vorstandsdirektor Karl Gerbel
ORF/Landesstudio Oberösterreich:
Intendant Dr. Hannes Leopoldseder
Direktorium:
Vorstandsdirektor Karl Gerbel (LIVA)
Intendant Dr. Hannes Leopoldseder (ORF)
o. Prof. Peter Weibel (Künstlerischer Leiter)
Ständiger künstlerischer Beirat:
o. Prof. Peter Weibel
Dr. Katharina Gsöllpointner (LIVA)
Dr. Christine Schöpf (ORF)

Prix Ars Electronica
Veranstalter: ORF/Landesstudio Oberösterreich
Idee/Konzept: Dr. Hannes Leopoldseder
Konzept: Dr. Christine Schöpf, Dkfm. Heinz
Augner, Wolfgang Winkler

Symposien

Leben im Netz
Teilnehmer: Kay Friedrichs (Universität
Karls-ruhe); Hans Hübner (Art + Com);
Toshio Iwai (Tokyo); Howard Rheingold
(San Francisco); Jeet Singh (Art Technology
Group); Keigo Yamamoto (K-bit Institute)

Architektur und Elektronische Medien
Teilnehmer: Edouard Bannwart (Art + Com);
Toyo Ito (Tokyo); Carole Ann Klonarides
 (Long Beach Museum of Art); Selim Koder
(Eisenman Architects); Wolf D. Prix (Coop Him-
melblau); Ken Sakamura (Tokyo);
Michael Sorkin (New York), Rüdiger Lainer,
Dögl/Cherkoori (SGI Demo)

Intelligente Produkte
Teilnehmer: Manuel DeLanda (Doros Motion,
New York, USA), Kay Friedrichs (Universität Karls-
ruhe, D), Rich Gold (Xerox Parc, Palo Alto Research
Center, San Francisco, USA), Dave Warner (Loma
Linda University Medical Center, CA, USA)

Konzerte/Theater/ Performances

Elektronisches Fest – elecTRONic pARTy
von Stadtwerkstatt
Konzeption: Thomas Lehner, Georg Ritter,
Gotthard Wagner
Realisation: Dominique Bejvil, Peter Donke,
Andi Ehrenberger, Andreas Feichtner, Marti-
na Hufnagl, Andreas Kozmann, Georg Lindor-
fer, Gitti Vasicek, Mark Vojka, Christine Zigon,
in Zusammenarbeit mit dem Ars Team LIVA
und ORF/Österreichischer Rundfunk

Cyber Music
Cyper-Instruments
Brucknerhaus, Brucknersaal
von Jaron Lanier (USA)
Wort und Musik: Jaron Lanier
System und Unterstützung bei der
Aufführung: Dale McGrew
Synthezizer und Tontechnik:
Alfred „Shabda" Owens
Body Electric (Weltdesign und Steuerung):
Chuck Blanchard, David Levitt Isaac Echtzeit
Graphik Software: Ethan Joffe, Chris Paulicka
World Test Intern (Gimbal Kreisel): Rolf Rando
Datenhelm, Datenhandschuh,
Entwicklungssoftware: VPL Research, Inc.
Graphik Engine (440VGXT):
Silicon Graphics, Inc.

Electronische Musik
X-topia
Brucknerhaus, Stiftersaal
von Elliott Sharp (USA) und Soldier
String Quartet
Oil
Brucknerhaus, Stiftersaal
von Ken Valitsky und Soldier String Quartet
Katharsis
Brucknerhaus, Stiftersaal

von Günther Rabl (A)
Computer music concert of symphonic
magnitude

Electro-Clips

Brucknerhaus, Brucknersaal
Interaktive Tanzperformance, von Christian
Möller (D) und Stephen Galloway (USA)
Musik: Peter Kuhlmann (D)
Licht: Louis Philippe Demers (Canada)
Programmierung: Louis Phillippe Demers
(Canada), Daniel Schmitt (D), Sven Thöne (D)
Produktion: Theater Am Turm, Frankfurt/
Ars Electronica, Linz
Mit freundlicher Unterstützung des Forums
für Informationstechnik GmbH, Paderborn

GATES – seven and haunted

Brucknerhaus, Brucknersaal
von Mark Trayle (USA)
Cyber Musik, Performance: Mark Trayle

Intelligent Techno/Ambient Techno

Brucknerhaus, Brucknersaal
Ambient Performance live, von
Underground Resistance (Detroit, USA), Orb
(GB), Autechre (GB), Station Rose (D)

Fiesta Electra

Sporthalle Linz
Mega-Techno-Rave-into-Paradise-Party, von
Friedrich Gulda and his Paradise Band (A)
mit: Friedrich Gulda and his Paradise Band:
Friedrich Gulda (pianco, clavinova), Harry
Sokal (saxes), Mitch Watkins (guit.), Stefan
Mitterbacher (keyboard), Wayne Darlking
(bass), Michael Honzak (drums), Laurinho
Bandeira (percussion), Kathy Sampson,
Gina Charito, Doretta Carter (vocals), Phil
Edwards (vocals), Koffi Koko (dance) Fumi-
layo Weber-Hohnson (dance) Ibiza
Amnesia Dancers.
DJ`s: Dominique Animator + Jaime Silva
SDP Techno Paradise Sound und Light

CD-ROM: 15 JAHRE ARS ELECTRONICA

von Station Rose

Ausstellungen

Intelligente Environment
TV Projekt – 3 sat

Piazza Virtuale: Service Area a.i.
Ponton European Media Art Lab

Internet, 3sat und Brucknerhaus.
Installationen – TV von:
Installation: Brucknerhaus, Einstiegspunkt
zur telematischen Kommunikation.
Akustisches und visuelles Ambiente mit
Hilfe von Sensor-Matten.

Van Gogh TV – TV Projekt-3sat

von Ponton European Media Art Lab
Piazza virtuale: Service Area a. i. eine Kopro-
duktion von ORF UND ZDF.
Mit Hubert Winkels (D), Blixa Bargeld
(EINSTÜRZENDE NEUBAUTEN),
DJ WestBAm, Boris Goys, Indulis Bilzens,
Nanni Balestrini, Steve Blame.
Moderation: Thomas Königsdorfer

Sevice Area a.i. Team-Hannover

von Katharina Baumann, Norbert Bittner,
Karel Dudesek, Daniel Haude, Benamin
Heidersberger, Katharina Heinze, Roey
Horns, Till Jünas Ole Lütjens, Frank Matthäi,
Olaf Pempel, Jörn Rennecke, Axel Roselius,
Manuel Tessloff, Salvatore Vanasco,
Christian Wolff

Intelligente Ambiente – Cyber Art

Design Center Linz

Plan

von Fareed Armaly

Bar code Hotel

von Perry Hoberman
Graphics Programming & System Design:
John Harrison, Glen Fraser, Graham Lindgren
Sound Design: Dorota Blaszczak, Glen Fraser
Graphics Design: Cathy McGinnis
Project Director: Douglas MacLeod.

Spatial Locations, Version III

von Hermen Maat, Ron Miltrenburg

Architexture

computer-generated pneumatic biogrids
von Supreme Partices
Anna Bickler (Video, Institut für Neue
Medien Frankfurt)
Stefan Karp, (Architektur, Frankfurt), Gideon
May (Software, Amsterdam), Paul Modler
(DSP-Programming, Sounds, Berlin)
Michael Saup (Software, Audio, Institut für
Neue Medien, Frankfurt)
Rolf vaan Widenfekt (Software, Consultant,
Mountainview).

E-H
von Monique Mulder(D), Dirk Lüsebrink (D), Gideon May (NL)

Electronic Mirror
von Christian Möller (D)

Flow
von Charly Steiger, Videoinstallation

As far as in-between
Interaktive Videoinstallation
von Martin Kusch (A)

The intelligent mailman
von Michael Bielicky

Golden Calf
von Jefferey Shaw

Brotherhood – table III
von Woody Vasulka

network skin
Netzhaut – ein Fassadenkonzept für das Ars Electronica Center
von Christian Möller/Joachim Sauter

Cyber City Flight
a virtual stroll through Berlin, von ART+COM

Cinema Spike
Inversion of the Perspective
von Karin Hazelwander (A)
Raum-Projektion-Installation
Cinema Spike von Karin Hazelwander und Wolfgang Werner in wissenschaftlicher Zusammenarbeit.

Sabotage XIII
Im öffentlichen Raum
von Robert Jelinek (A)

Atlantis Construct
von Fürst Thaler (A)
happy nautis monitor objects, 1994
material foam, silicone, high-grade steel, size 2,3 meters
Team: Christoph Fürst v. Freystadt, Harwald v. Hatschenberg, Werner Kramer, Michael Pointner, Gerold Andreas, G. Thaler-Hohenfels
Cover: Johannes Domsich

Trigger your text
von Elfriede Jelinek, Gotttfried Hüngsberg, Hannes Franz.

Secret of Life
von Constanze Rum/Peter Sandbichler
Produktion & Support: Kay Fricke
Fotos: Kay Fricke, Christian Schoppe

Der negierte Raum
von Alba D´Urbano

Video
Intelligent Ambience
Kuratorinnen: Kathy Rae Huffman (USA/A), Carole Ann Klonarides (USA)

15 Jahre Ars Electronica
Landesmuseum Francisco Carolinum
Gezeigt wurde in einem Rückblick auf die 15-jährige Geschichte von Ars Electronica eine Retrospektive, die speziell auf die von Ars Electronica formulierten Zukunftsvisionen Bezug genommen hat.
Ein Verweis auf die Klangwolkenentwicklung und die Einbindung von Van Gogh TV als Möglichkeit des interaktiven Fernsehens ergänzten die Schau.
Koordinationsverantwortung: Peter Assmann
Ausstellungsrealisation: OÖ. Landesgalerie, ORF/Landesstudio Oberösterreich, Brucknerhaus
Ausstellungsgestaltung: Sepp Auer und Robin Hood Inc.

Computer und Spiele – Interaktive Ausstellung von Schülerarbeiten
Brucknerhaus, Foyer
Kuratiert von Waltraud Barton (ÖKS)

Public Intervention
Galerie Maerz
Harry, Ilse und Viktor stellen in der Galerie MAERZ aus.

Prix Ars Electronica Installationen
ORF/Landesstudio Oberösterreich
Videothek – Audiothek - Ausstellung

Prix Ars Electronica Künstlerforum
Computeranimation/Computergrafik: Maurice Benayoun, (Z.A Productions, Frankreich, Eric Coignoux, (Mikros Image, F), Georges Bermann/Arnault Lamorlett (Midi Minuit, F), Jim Mitchell (L& M, USA), John Kahrs (Sky Productions, USA), Keith Cottingham (USA), Michael Joaquin Grey (USA)
Computermusik/Interaktive Kunst: Ake

Parmerud (S), Jonathan Impett (GB), Ludger Brümmer (Folkwang Hochschule, D), Transit, e.V. A), Loren und Rachel Carpenter (Cinematrix, USA), Christa Sommerer (A) und Laurent Mignonneau (F)

Die Goldene Nica
Prix Ars Electronica Gala 94

ORF/Landesstudio Oberösterreich – 3sat
Verleihung der goldenen Nica 94
22. Juni 1994, Moderation: Mercedes Echerer

Prix Ars Electronica

Veranstaltet vom ORF/Landesstudio Oberösterreich
Idee / Konzept: Dr. Hannes Leopoldseder
Konzept: Dr. Christine Schöpf, Dkfm. Heinz Augner, Wolfgang Winkler

Computergrafik
Jury: Michael Tolson, Michael Bielicky, Rolf Herken, Matt Mullican, Lucy Petrovich
Goldene Nica: Michael Joaquin Grey
Auszeichnung: Keith Cottingham, John Kahrs
Anerkennung: Linda Dement, Pascal Dombis, Mogens Jacobsen, Ronaldo Kiel, Don MacKay, Stewart McSherry, Gavin Miller/ Ned Greene, Anna Gabriele Wagner, Adelhard Roidinger

Computeranimation
Goldene Nica: Dennis Muren/Mark Dippé/ILM; Marc Caro
Auszeichnung: Maurice Benayoun, Eric Co-ignoux
Anerkennung: Bériou, Peter Callas, Cassidy J. Curtis, Eric Darnell/Michael Collery, Yoichiro Kawaguchi, Sabine Mai/Frank Pröscholdt, John Tonkin, Hideo Yamashita/Eihachiro Nakamae, Thomas Zancker, Tamás Waliczky

Computermusik
Jury: Charles Amirkhanian, Lars-Gunnar Bodin, Werner Jauk, Ivanka Stoianova, Trevor Wishart
Goldene Nica: Ludger Brümmer
Auszeichnung: Ake Parmerud, Jonathan Impett
Anerkennung: Patrick Ascione, Jean-François Cavro, Akemi Ishijima, Paul Koonce,

Mesias Maiguashca, Juliet Kiri Palmer, Michel Redolfi, Michael Vaughan, Alejandro Vinão, Frances White

Interaktive Kunst:
Jury: Roger Frank Malina, Roy Ascott, Johnie Hugh Horn, Michael Naimark, Florian Rötzer,
Goldene Nica: Christa Sommerer/Laurent Mignonneau
Auszeichnung: Loren Carpenter, Transit
Anerkennung: Max Almy/Teri Yarbrow, Edward Elliott, Friedrich Förster, Michael Girard/Susan Amkraut, Richard Kriesche, Wolfgang Krüger, Brenda Laurel/Rachel Strickland, George Legrady, Patti Maes, Christian Möller, Christan Möller/Rüdiger Kramm, Catherine Richards

Open-Air

Alles Spiel
Hauptplatz
Audience participation, interaktives Spiel von Loren & Rachel Carpenter (USA)
Cinematrix ™

Sonstige Veranstaltungen

Après ARS – Erlebnishaus K4
Stadtwerkstatt
Mit den Augen der Architektur
Offenes Kulturhaus
Teilnehmer: Adolph-Herbert Kelz, Brigitte Löcker, PRINZGAU/ Podgorschek, Wolfgang Tschapeller, Hans Peter Wörndl, Heidulf Gerngross, Walter Pamminger
Info: „Eine Geschichte des Computers" Museum Arbeitswelt, Steyr

Ars Electronica 95
Festival für Kunst, Technologie und Gesellschaft

Mythos Information
Welcome to the Wired World

20. – 23. Juni 1995

Veranstalter
Brucknerhaus Linz und ORF/Landesstudio Oberösterreich

Brucknerhaus Linz:
Vorstandsdirektor Karl Gerbel
ORF/Landesstudio Oberösterreich:
Intendant Dr. Hannes Leopoldseder

Direktorium:
Vorstandsdirektor: Karl Gerbel (LIVA)
Intendant Dr. Hannes Leopoldseder (ORF)
Künstlerischer Leiter: o. Prof. Peter Weibel

Ständiger künstlerischer Beirat
o. Prof. Peter Weibel
Dr. Katharina Gsöllpointner (LIVA)
Dr. Christine Schöpf (ORF)

Prix Ars Electronica
Veranstalter: ORF/Landesstudio Oberösterreich
Idee, Konzept: Dr. Hannes Leopoldseder
Konzept: Dkfm. Heinz Augner, Dr. Christine Schöpf, Wolfgang Winkler

Symposien

Mythos Information
Brucknerhaus, Stiftersaal
Moderation: Helga Novotny
Referenten: Friedrich Kittler (D), Les Levidov (GB), Pierre Lévy (F), Frank Ogden (USA), Lucien Sfez (F), McKenzie Wark (USA), Slavoi Zizek (SL)

Wired World
Brucknerhaus, Stiftersaal
Moderation: Peter Weibel(A/D)
Referenten: John Perry Barlow (USA), Amy S. Bruckman (USA), Critical Art Ensemble (USA), Timothy Druckrey (USA), Fred Forest , Eduardo Kac (USA), Geert Lovink (NL), Saskia Sassen (USA, Richard M. Satava (USA), Nick West (USA)

Konzerte/Theater/Performances

Checkpoint 95
Nibelungenbrücke
Von Stadtwerkstatt TV (A)
Live-TV mit Telepräsenz
(In Zusammenarbeit mit ORF/Landesstudio Oberösterreich, Studio RTR/Moskau, BMCC Media Center/New/York).
Konzept: Donke, Hauenschild, Lehner, Ritter
Internationale Initiative: Kathy Rae Huffman
Technische Leitung und Parallel Raum Display: Thomas Lehner
Produktionsleitung: Stadtwerkstatt-TV
Produktion Linz: Stadtwerkstatt-TV, Peter Donke, Brigitte Vasicek.
Redaktion: Georg Ritter, Gabrielle Kepplinger
Produktion Moskau: ANST, Tatjana Didenko
Redaktion: Anatoly Prokhorov
Produktion New York: Paper Tiger TV, Karin Helmerson, Martin Luas
Redaktion: Joseph Di Mattia
Team Linz:
Bildregie: Thomas Lehner, Bildmischung: Elke Rittenschober, Schauspielleitung: Caspar v. Erffa, Kameraregie: Wolfgang Lehner, Computer, Grafik: Peter Hauenschild, Herbert Schager, Sound& Music Dee Dee Neidhard. Mark Vojka, Peter Postl, Technical Design: Thomas Lehner. Meßtechnich: Gerhard Blöchl, Techn. Betreuung PRD: Franz Xaver, Video & Computer: Margarete Jahrmann, Max Moswitzer, Set Design: Georg Lindorfer, Licht Design: Wolfgang Lehner, Still Photography: Norbert Artner, Nigel Dickinson, Produktionsbegleitung: Joachim Eckl, PR Koordination: Peter Donke, Gerald Harringer, WWW Koordinator: Paul Fischnaller, Produktionsteam: Judth Vorbach, Andreas Ehrenberger, Andreas Konzmann, Horst Mayerhofer, Alfred Wögerbauer, Host Spannlang, Dominique Bejvl, Juha Balou, und many other.....

HORIZONTAL RADIO
24 Stunden Live
Gerfried Stocker/Heidi Grundmann (A)
Teilnehmende Radiostationen

ABC Radio / The Listening Room, Andrew McLennan – BBC Radio 3, Nightwave, Matt Thompson – BBC Radio 4, Short Story, Pam Fraser Solomon, CBC, SRC, Mario Gauthier, Magyar Radio, Expeerimental Studio, Janos Decsenyi, New Radio & Performing Arts New York, Helen Thorington, ORF/Österreich 1 Kunstradio, Heidi Grundmann – ORF/Österreich 1 Zeitton, Christian Scheib, ORF/Landesstudio Tirol, Wolfgang Praxmarer, Radio 1 Ostankino, Radio Theatre, Dimitry Nicolaev, Radio Città 103, Radio B92, Belgrade, Veran Matic, Radio Città del Capo, Radio DRS II, Studio Basel, Stefan Heilmann, Radio Kappa Centrale, Radio KOL Israel, Ilana Zuckermann, Radio Popolare Network (Milano, Bologna, Firenze, Roma), Radio Sarajevo RAI Radio Uno, Audiobox, Pinotto Fava und Pino Sanlo, RNE Radio 2, Ars Sonora, Jose Iges, RTV San Marino, Pino Cesetti, SFB, Sender Freies Berlin, Manfred Mixner, Sveriges Radio (SR), P2 Musik – Studio Torsdag, Berndt R. Berndtson, YLE, Experimental Studios, Pekka Siren, YLE 1, Documentary Group, Jouko Blomberg.
Teilnehmende Künstler:
Robert Adrian X, Dimothenes Agrafiotis, Jackie Apple, Art Pool, Sam Auinger, Stefan Beck José Manuel Berengner, Bensch, Cassani, bisca 99 Posse, Luther Blisset, Jouko Blomberg, Anders Blomqvist, Blues Mobile, Isabella Bordoni, Andras Borgo, Harvey Branscomb, Rex Brough, Sheila Concari, Contained, Stefano Contanibbi, Stefan Daske, Janos Decsenyl, Barbara Doser, Patrizio Esposito, Spiros Faros, Makis Faros, Gabriele Frasca, Takumi Fukushima, Mario Gauthier, Paolo Grandi, Alberto Grifi, Gerhard Gruber, Angelika Hensler, Kurt Hofstetter, Rupert Huber, Jose Iges, Arsenije Iovanovic, Concha Jerez, Dimitri Kamarotis, Christine Köck, Mikko Laakso, Claudio Lanteri, Juan Antonio Lle, Machine for making sense, Leila Maglietta, Marco Manchisi, Hannes Mariacher, Alberto Massala, Norbert Math, Sergio Messina, Metaphysis of sound group, Chjristof Migone, Amal Mocus, Elisabeth Nicolussi, Jaakko Nousiainen, Adolfo Nunez, Bruce Odland, Roberto Paci Dalo, Maria

Pambouki, PAPA String Quartet, Vasilis Papavisiliou, Harld Pröckl, Proton Group, Jocelyn Robert, Banda Roncati, Wimme Sari, Mato Santek, Manthos Santorineos, Andi Schiffer, Martin Schitter, J.F. Sebastian, Massimo Simonini, Pekka Siren, Sodomka/Breindl, Fabrizio Spora, Ivana Stefanovic, Gerfried Stocker, Matt Thompson, Helen Thorington, Ilkka Toiviainen, Juha Valkeap, Agnieszka Waligorska, Gregory Whitehead, Hanno Winder, Günter Zechberger, Elisabeth Zeller, Stefano Zorzanello, Ilana Zuckerman.
Realisation des Radionetzes: Gerhard Blöchl, Harry Domittner, Christiane Veigl, Enrico Giardino, Gernot Göckler, Edith Kiesling, Hans Soukup, Gerhard Wiesner, Elisabeth Zimmermann
Realisation der Internet-Events: Oliver Frommel, Enrico Giardino, Arno Heimgarten, Andi Kleen, Peter Riedelsperger, Martin Schitter, Hermann Schmidt, Gerfried Stocker, Contained Co-Producers, Sponsors, Credits:
Cineca Bologna, Commune di Bologna, Galleria Toledo, GewiLAB (Uni-Graz), Giardini Pensili, Rimini (Italy), il manifesto, Kapsch AG(Austria), link Bologna, Medien Labor München, Kulturreferat der Stadt München, Ministerio de Cultura. CDMD (Spain), Telefonica (Spain), Theatre Fournos Athen (Greece), Tumultimedia (Austria), X-ART (Austria), x-space Graz (Austria), SGAE, Telefonica, La muse en Circuit

Aural Screenshots
von Wolfgang Dorninger (A)
Technische Entwicklung, Konzeptionierung und musikalische Realisation: Wolfgang Dorninger
Konzeptionierung und musikalische Realisation: Josef Linschiner
Produktion: Sonic Sound
Performer: Dietmar Bruckmayr
Lichtdesign: Peter Thalhammer
Tontechnik: Alex Jöchtl
Kompostition: Wolfgang Dorninger, Josef Linschinger, Biosphere, Peter Androsch.
Wagners Wahn oder Das heilige Land des Kapitals
Brucknerhaus, Brucknersaal
von Peter Weibel (A)

Konzeption: Peter Weibel
Software-CD-ROM-Entwicklung: Orhan
Kipcak
Mitarbeit Software: Helmut Kaplan, Kaya
Kipcak, Michael Pölzl, Katharina Copony,
Kai Pongratz
Video Recordings: Gerd Heide
Text- und Bildrecherche: Gerhard Nierhaus,
Florian Gessler, Singer: Susan Dumas,
Redaktion Text: Peter Weibel, Curd Duca.
Struktur/Software: Projekt Wagner

Synthesis – Modell 5
Brucknerhaus, Brucknersaal
Präsentiert von Granular Synthesis
Von Kurt Hentschläger/Ulf Langheinrich (A)
Kurt Hentschläger: Videosamples &
Sequence Editing
Ulf Langheinrich, Videosample & Sequence
Editing /Editorial Sound Editing
Grand Prix of ARTEC 95, Fourth Internatio-
nal Biennale in Nagoya, Japan
Featuring: Akemi Takeya
In Koproduktion mit HULL TIME BASED ARTS
/Mike Stubbs, England, PYRAMEDIA/Vienna,
Austria
Mangagement Model 5, Ursula Hentschläger

Stories from the Nerve Bible
Brucknerhaus, Brucknersaal
von Laurie Anderson (USA)
Hyper- und multimediale Performance

Here to Here
Brucknerhaus, Brucknersaal
von Saburo Teshigawara
Tanz-Performance
Choreographie, Bühne, Licht: Saburo
Teshigawara
Beleuchtung: Hiroki Shimizu
Ton: Kunukunu
Saxophone: Kazutoki Umezu
Technische Koordination: Friedrich Firmach.
Mit: Saburo Teshigawara, Kei Miyata, Shun
Ito, Koichi Ienaga, Takashi Kazeana, Maya
Kishikawa, Minako Shinohara.
Produktion: Japan Foundation und Saison
Foundation.

Tronic Artcore Event
Tabakwerke, Donaulände
Konrad Becker/Jimmy Hennrich/Martin
Reschitzegger/Leo Schatzl

Netzprojekte
Public Voice
Roland Alton-Scheidl
www. public.co.at/public/
Villa
Steffen Wernery
AUDIOREALITY, Audioland International
MAX RES O + A 95
Sam Auinger/Bruce Odland
Exodus
Michael Bielicky
Internet Programm: Ariel Sindermann
Internet Design/Projekt-Koordinator:
Amy Dolin
Waxweb 2.0
David Blair
http://bug. Village.virginia, edu
transImagine, die medialde Pumpstation
Ingrid Burgbacher-Krupka
Installation mit Bühnencharakter (Kapital
Raum)
The Blind's World I
Gerd Döben-Henisch
C@C Computer Aided Curating
http://www.is.in-berlin.de/CAC/CAC_hall.html
Eva Grubinger
Between the Words
Agnes Hegedüs
Letzte Meldung
Markus Huemer
Die ideale Stadt im Internet
Internationale Stadt
www.is.in-berlin.de/Culture/Art.html
Tai Tendo
Stichting Rainstick
Klanginstallation
ARSDOOM – art adventure
Orhan Kipcak
Moblmachung>co-realities‹
Territories, incorporations and the matrix
Knowbotic Research
Die elektronische Galerie
Kunstlabor
www.atnet.co.at
Urban Squad
Medienguerilla
Nur Schreck und die Kiste hat einen Namen
The File Room
Antonio Muntadas

LogIN: – speed

Ars Electronica, Brucknerhaus, Stiftersaal,
Zentrale Newsroom
Österreichischer Kultur-Service ÖKS (A)
Teilnehmer: Schulen in Österreich und Bayern
Zentralstelle „Computer im Kunstunter-
richt", München
Jugendgästehaus Graz.

**Die Kunst im Zeitalter der biokybernetischen
Selbst-Reproduktion,**

PUBLIC NETBASE to
Institut für neue Kulturtechnologien.
www.tO.or.at/e~scape

This is …

Reuters Österreich
Reithers Television

WAPO

World Artistic Property Organization
Norbert Nowotsch, Mark Olson, Lisa
Schmitz

Crossings

Stacey Spiegel

**Die Ursprünge von Intelligenz bei Artificial-
Intelligence-Systemen**

Luc Steels

The Thing International

www.thing.or.at/thing

The Hiroshima Project

Akke Wagenaar
In Zusammenarbeit mit Masahiro Miwa,
Michael Hoch, Matthias Melchior und
Barbara Geschwinde

Ausstellungen

Max Res

Sam Auinger/Bruce Odland

Elektronische Galerie

Kunstlabor

Alchemie der Netze

Hochschule für Gestaltung

Tronic Artcore Event

Hochschule für Gestaltung

Prix Ars Electronica Preisträger-
konzert

Brucknerhaus, Stiftersaal
Trevor Wishart (GB), Gilles Gobeil (Can),
Flo Menezes (BR)

Prix Ars Electronica Künstlerforum

WorldWideWeb:
Tim Berners Lee (USA), Robin Hanson (USA),
Pattie Maes (USA), Konrad Becker (A)
Computeranimation:
Bob Sabiston (USA), Thomas Bayrle (D)
Interaktive Kunst:
Michael Saup (D), Bill Seaman (Aus), Michael
Tolson (USA), Computermusik und Multimedia:
Trevor Wishart (USA) u.a.

Die Goldene Nica 95
Prix Ars Electronica Gala

ORF/Landesstudio Oberösterreich – 3sat
Verleihung der Goldenen Nica 95
Moderation: Mercedes Echerer

Prix Ars Electronica

Veranstaltet vom ORF/Landesstudio
Oberösterreich
Idee/Konzept: Dr. Hannes Leopoldseder
Konzept: Dr. Christine Schöpf, Dkfm. Heinz
Augner, Wolfgang Winkler

World Wide Web

Jury: Derrick de Kerckhove, Joichi Ito, Franz
Manola, Morgan Russell, Mitsuhiro Takemura
Goldene Nica: Robin Hanson
Auszeichnung: Konrad Becker, P. Maes/M.
Metral
Anerkennung: Station Rose, Antonio
Muntadas, Ed Stastny, Stephanie
Cunningham, HotWired, Scott. B. Gregory,
Charles Henrich, Klaus Johannes Rusch,
Bonnie Mitchell, David Chaum, Catherine
de Courten, Christoph J. Mutter

Interactive Kunst

Jury: Roy Ascott, Vittorio Giacci, Roger F.
Malina, Monique Mulder, Michael Naimark
Goldene Nica: Tim Berners-Lee
Auszeichung: Michael Saup, William
Seaman, Michael Tolson
Anerkennung: Maurice Benayoun, Peter
d'Agostino, Franz Fischnaller, Peter Grucza,
Lynn Hershman, Mogens Jacobsen, M.
Kosugi/Y. Ando, Webster Lewin, Lozano-
Hemmer/Bauer, Jon McCormack,
Christian Möller, Kirk A. Woolford

Computeranimation

> **Jury:** Mark A. Z. Dippé, Johnny Hugh Horn,
> Peter Kogler, Sally N. Rosenthal
> Goldene Nica: B. Sabiston/D. Atherton
> **Auszeichnung:** Thomas Bayrle, Industrial
> Light & Magic
> **Anerkennung:** Lamb & Company, Chuck
> Gamble, Industrial Light & Magic, Violet
> Suk/Martin Koch, Francois Launet, S. Levy/
> T. Munzner, Franck Magnant, Jon Mc-
> Cormack, Medialab, Ben Stassen, Demetri
> Terzopoulos, Alexei Tylevich

Computermusik

> **Jury:** Steve Arnold, Lars Gunnar Bodin,
> Ludger Brümmer, Werner Jauk, Ivanka
> Stoianova
> **Goldene Nica:** Trevor Wishart
> **Auszeichnung:** Flo Menezes, Gilles Gobeil
> Anerkennung: Javier Alvarez, Patrick Ascio-
> ne, Ron Averill, Christian Calon, Agostino Di
> Scipio, Stephan Dunkelman, Rolf Enström,
> Elizabeth Hoffmann, Erik Mikael Karlsson,
> Cort Lippe, Jack Tamul

PLANUNG, BAU, ERRICHTUNG UND AUSSTATTUNG DES ARS ELECTRONICA CENTER

ERARBEITUNG DER GRUNDLAGEN FÜR DIE BAU-ENTSCHEIDUNG DER STADT LINZ

ARCHITEKTURWETTBEWERB „ALT-URFAHR-OST" (1986/87)

Gewinner des Architektenwettbewerbs ist das Architekten-team Arch. Dipl.-Ing. Klaus Leitner/Arch. Dipl.-Ing. Walter Hans Michl mit dem Projekt „Donautor".

PROJEKTIDEE ARS ELECTRONICA CENTER (1991)

Dr. Hannes Leopoldseder, ORF

DETAILLIERUNG DER PROJEKTIDEE (1991/92)

Prof. Edouard Bannwart, ART+COM, Prof. Roy Ascott, Dr. Titus Leber, Dr. Hannes Leopoldseder, Edouard Oleschack, Kathy Huffmann, Dr. Udo Wid, Dr. Christine Schöpf

GRÜNDUNG AEC-VEREIN

Mag. Dr. Reinhard Dyk, Mag. Siegbert Janko, Prof. Dr. Herbert Lachmayer, Dr. Hannes Leopoldseder (Obmann), Mag. Karl Pilstl, Univ.-Prof. Dipl.Ing. Dr. Gustav Pomberger, Dr. Christine Schöpf, Ernst Schulz, Mag. Ronald Wodler

PROJEKTSTUDIE (1992/93)

ART+COM, Berlin, Prof. Edouard Bannwart (Geschäftsführer), Susanne Kannenberg, Ralph Lücke, Rolf Maurer. WEITERE MITWIRKENDE: Prof. Roy Ascott, Bristol, Dr. Werner Beutelmeyer, Linz, Dr. Scott Fisher, Portola, USA, Mag. Anton Knierzinger, Mag. Dr. Thomas Königstorfer, ORF, Dr. Myron Krueger, USA, Dr. Titus Leber, Paris/Linz, Architekt Klaus Leitner, Wilfried Maschtera, Universität Linz, Prof. Dr. Hermann Maurer, Graz, Mag. Karl Pilstl, TMG, Linz, Prof. Dr. Gustav Pomberger, Linz, Mag. Ekkehard Redlhammer, Ramsauer/Stürmer Consulting, Linz, Mag. Markus Riebe, Linz, Peter Schöber, Linz, Dr. Christine Schöpf, ORF, Hans Schorn, Arthouse, Linz, Mag. Jakob Steuerer, Wien/Klagenfurt, Dr. Gerhard Stürmer, Ramsauer/Stürmer Consulting, Linz. Projektleitung: Mag. Siegbert Janko/Dr. Hannes Leopoldseder

BAUPHASE I – ERRICHTUNG DES GEBÄUDES

BAUHERR

Stadt Linz, Baudirektor Arch. Dipl.-Ing. Franz Xaver Goldner

PROJEKTLEITUNG

Hochbauamt der Stadt Linz, Dipl.-Ing. Gerhart Holzleitner

GENERALPLANER

Suter + Suter, ab 1995 Hochbauamt der Stadt Linz, Projektleiter Helmut Pröll

BAUPHASE II – EINRICHTUNG UND AUSSTATTUNG DES ARS ELECTRONICA CENTER

AUSFÜHRUNG

Bau- und Errichtungsgesellschaft der Stadt Linz (BEG), Mitglieder des Aufsichtsrates: Mag. Dr. Reinhard Dyk, Univ.-Doz. Mag. Dipl.-Ing. Erhard Glötzl, Dipl.-Ing. Erich Haider, Mag. Siegbert Janko, Dr. Hannes Leopoldseder, Hans Nöstlinger (Vorsitzender), Komm.-Rat Horst Six, Dr. Peter Sonnberger, Dkfm. Max Stockinger. Geschäftsführer: Dipl.-Ing. Friedrich Angerhofer, Prokuristin: Karin Weilguny

INHALTLICHE PROJEKTLEITUNG

Siegbert Janko, Hannes Leopoldseder, ab 1. 7. 1995 in Zusammenarbeit mit Gerfried Stocker, Geschäftsführer der Ars Electronica Center Linz Betriebsgesellschaft m.b.H.

INNENARCHITEKTUR/ AUSSTELLUNGSDESIGN

Atelier Rainer Verbizh, Architekt, Paris, Büro Linz: ARGE Verbizh/ Schilcher

BAULEITUNG/KOORDINATION

Franz Starzengruber

FIRMEN UND EINZELPERSONEN BAUPHASE II

ABB Installationen Ges. m. b. H., Linz, Adept Technology Inc., Dortmund, Aerotech World Trade Ltd., Berks, UK, Monika Aigner, Pregarten, Aigner Ges.m.b.H & Co KG, Linz, Alias-Wavefront, Genf, Archimedia Institute for Arts and Technology, Linz, Arthouse, Linz, Ascension Technology Corporation, Burlington, USA, Autodesk, Wels, AVS Phoenix Mecano Ges.m.b.H., Wien, ATC, Wien, Createam – Linz, Bauelemente & Montagetechnik Ges.m.b.H., Breitenaich, Christian Bauer & Freunde, Innsbruck, BEV Bundesamt für Eich- und Vermessungswesen, Wien, Don Bryant, Querenhorst, Burisch Elektronik Bauteile Ges.m.b.H., Wien, Centrovox Kabelvertriebs Ges.m.b.H., Asten, Computer Associates, Wien, Contact GmbH, Linz, Crystal Design – Bozen, I, Danzas AG, Wels, DBI Inc., Milwaukee, USA, Digital Equipment Österreich AG, Wien, DORIS – Linz, Echtzeit Ges.m.b.H., Berlin, Eisenberger GmbH, Linz, Ericsson Schrack AG, Leonding, E-Tech Elektronikinstallations Ges.m.b.H., Linz, Euro Shop GmbH, Pasching, Evans & Sutherland Computer Ges.m.b.H., München, Externa Ges.m. b.H., Linz, Fantoni Oberösterreich Handelsges.m.b.H., Linz, GCA Gesellschaft für Computeranwendungen, Linz, Geospace Beckel-Satellitenbilddaten GmbH & Co, Salzburg, Gretter Electronic-Versand/Electronic-Shop, Kufstein, Hainbuchner Ges.m.b.H., Enns, Haslinger & Keck – Linz, Hewlett-Packard GmbH, Wien, Hi-tech, Linz, Hochbauamt der Stadt Linz, Linz, Johnie Hugh Horn, Savannah, USA, Höller Grofl- und Fachhandelsges.m. b.H., Gmunden, Karl Hölzlberger, Linz, Hörmedinger Ges.m.b.H & Co. KG, Linz, Hross & Partner Ges.m.b.H., Traun, Hudrin/Theodor Fink, Wien, IdealWien, ISS Ges.m.b.H., Mainz, IKP – Salzburg/Wien, Image, Hallein, Institut f. grafische und parallele Datenverarbeitung, Uni Linz, Institut f. Gestaltungs- und Wirkungsforschung, Uni Wien, Institut f. Telekooperation, Uni Linz, Institut f. Zeitgeschichte, Uni Linz, Jannach & Picker GmbH, Schaz, Dipl.-Ing. Thomas Kienzl, Graz, Tom Knienieder, Natters, Kodak Ges.m.b.H., Wien, Komerz – Graz, Köck Ges.m.b.H., Linz, Landesverlag Linz, Lego Dacta Lernmittel GmbH, Meckesheim, Rudolf Leiner Ges.m. b.H., Linz, Lift Technik Ges.m.b.H., Linz, Iris Mayr, Linz, Max-Planck Institut for Biological Cybernetics – Tübingen, D, Micro Automation Ges.m.b.H., Wien, Missing Link Media Research Group, Wien, Prof. Dr. M. Mühlhäuser, Linz, Murray Consulting Chicago, USA, Muschitz Ges.m.b.H., Schwertberg, Oy Netsurfer Ltd. c/o Oy Instead Ltd., Kuopio, Finnland, Neudörfler Möbelfabrik Ges.m.b.H., Neudörfel, NCSA – Urbana, USA, Österr. Akademie der Wissenschaften/Realienkunde, Roland Otahal, St. Florian, Dipl.-Ing. Dr. Gottfried Otepka, Imst, Panatronic Ges.m.b.H., Salzburg, Pyreder Metallbau GmbH & Co KG, Perg, Pedus Service/P., Dussmann Ges.m.b.H., Linz, Penta Plan, Graz, Perspektiva – Linz, Pixelpop, Linz, Post- und Telekom Austria, Quinette Gallay, Montreuil, Frankreich, Rank Xerox Austria Ges.m.b.H., Wien, Franz Ransmayr

Ges.m.b.H. & Co KG, Linz, Reality 2 Ges.m.b.H., Innsbruck, Walter Rekirsch Ges.m.b.H. & Co KG, Wien, Möbeltischlerci Resch, Aigen-Schlägl, RS Components Ges.m.b.H., Gmünd, Saro Multimedia, Untergaisbach, SBL – Linz, Schäfer Shop Ges.m. b.H., Wels, Schubert & Franzke Ges.m.b.H., St. Pölten, SensAble Technologies, Cambridge, USA, Sense 8, Nyon, CH, Dr. Seufert Computer Ges.m.b.H., Karlsruhe, Deutschland, Siemens AG Österreich, Linz, Silicon Graphics Ges.m.b.H., Wien, Softpoint Electronic Ges.m.b.H., & Co KG, Linz, Christa Sommerer & Laurent Mignonneau, Wien, Prof. Dipl.-Ing. Alexander Sommerfeld, Linz, SOS Ges.m.b.H. & Co KG, Linz S plus S, Linz, Ing. Walter Sumetzberger Ges.m.b.H., Linz, Superscape, München, D, Svoboda Büromöbel, Linz, SVV Video Vertrieb Ges.m.b.H., Nürnberg, Events/Franz Starzengruber, Katsdorf, Susanne Steinacher, Graz, Josef Steiner, Purgstall, Stereographics Corporation, San Rafael, USA, Steurer Ges.m.b.H., Hard, Star-Pak, Air Chicago, Sysis – Wien, Techcom Datenverarbeitungsges.m.b.H., Linz, Technautik, Linz, Tectrix Fitness Equipment Ges.m.b.H.i.Gr., Planegg, Tontechnischer Service Robert Schulz, Graz, Towitoko Electronics GmbH, Ottobrunn, D, Unisys, Wien, University of Illinois at Chicago (EVL), Chicago, USA, University of Southern California, L.A., USA, Atelier R. Verbizh, Paris, F, Glasstudio Leo Wenna, Linz, Wiener Städtische Allgem. Versicherung AG, Linz, Wiesner-Hager Möbel Ges.m.b.H., Altheim, X-Art, Pinkafeld, Tischlerei Georg Zehetmayr Kefermarkt.

BETRIEB DES ARS ELECTRONICA CENTER
Ars Electronica Center Linz Betriebsgesellschaft m.b.H. – Mitglieder des Aufsichtsrates: Dr. Franz Dobusch (Vorsitzender), Mag. Dr. Reinhard Dyk, Ing. Herbert Ecker, Univ.-Doz. Mag. Dipl. Ing. Erhard Glötzl, Mag. Siegbert Janko, Ing. Mag. Wolfgang Lehner, Dr. Hannes Leopoldseder, Univ.-Prof. Dipl.-Ing. Dr. Gustav Pomberger.

GESCHÄFTSFÜHRER und KÜNSTLERISCHER LEITER
Gerfried Stocker

AEC-TEAM WÄHREND DER AUFBAUZEIT
Erich Berger/Hardware Engineering, Sandra Brandstetter/Administration, Vaclav Cizkovsky/Computer Graphics, Dieter Dobesberger/Hardware Engineering, Leonhard Dobusch/Assembling Installation, Maria Falkinger/Press & Information, Oliver Frommel/Network and Coding, Doris Haider/Assistant Manager, Werner Hartmann/Assembling Installation, Horst Hörtner/Technical Director, Elisabeth Kapeller/Administration, Jürgen Kern/Cave Engineering, Wolfgang Modera/Consultant, Chris Mutter/Web Master, Dietmar Offenhuber/Computeranimation, Michael Pointner/3D Graphics, Christa Schneebauer/Web Editor, Peter Schöber/Marketing, Sponsoring, Matthew Smith/Media Design, Romana Staufer/Marketing Assistant, Gerfried Stocker/ Managing Director, Christian Strasser/Administration, Tom Teibler/House Supervisor, Tom Weber/Networkadministrator

AEC-TEAM FESTIVAL ARS ELECTRONICA
Birgit Brandner/Festival PR, Barbara Berger/Festival Assistance, Patricia Futterer/Festival Assistance, Patricia Maier/Festival Assistance, Karin Rumpfhuber/Festival Assistance, Jutta Schmiederer/Festival Producer, Doris Weichselbaumer/Festival Assistance.

WEITERS HABEN MITGEWIRKT
ARCHITEKTUR/DESIGN
Andreas Behmel, Arnold Fuchs, Wolfgang Giegler, Gerri Greiter, Andreas Hirsch, Marcus Hohenbichler, Thomas Kienzl, Armin Lixl, Scott Ritter, Sabine Schulz, Denise Schulz, Cynthia Schwertsik

AUDIO- UND VIDEOPRODUKTION
Herwig Burghard, Wolfgang Marecek, Ewald Onzek, Regina Patsch, Thomas Schneider, Christine Schöpf, Sigrid Steingruber, Alois Sulzer

AUDIO- UND VIDEOTECHNIK
Andy Pongratz, Roland Salzer, Max Tremel

BERATUNG UND DATENRECHERCHE
Gunter Amesberger, Rudolf G. Ardelt, Alfred Autischer, Christian Bauer, Andreas Berger, Gerhard Blöchl, Walther Cerny, Hartwig Diestler, Heidi Dummreicher, Antonia Hajdu, Günther Hupfer, Claudia Hutterer, Ina Jung, Anton Knierzinger, Richard Levine, Wolfgang Modera, Peter Rebernik, Markus Riebe, Christian Rohr

CAVE-CREW
Robin Bargar, Marek Czernuszenko, Greg Dawn, Tom DeFanti, Johnnie Hugh Horn, Garry Lindahl, Dave Pape, Magie Rawlings, Wolfgang Reinisch, Daniel Sandin, Thomas Schneider, Markus Thiebaux, Margret Watson

COMPUTERGRAFIK, -ANIMATION UND -DESIGN
Peter Aichner, Tamara Baldemaier, CAFM Productions, Dieter Denoth, Gerhard Empl, Thomas Empl, gregerpauschitz, Balint Hegedüs, Theresia Holocher-Ertl, Andreas Hopfner, Peter Knobloch, Michael Kozak, Erik Lamphalzer, Katja Markl, Peter Melchart, Marc Miletich, Robert Neumayr, Tobias Peer, Michael Pichler, Erik Pojar, Harald Salaun, Erwin Schmölzer, Roland Senn, Jochen Süß, Daniel Wagner, Sabine Wolfram, Christian Zehetner, Johannes Zeitelberger, Peter Zirbs

GEOGRAFISCHE INFORMATIONSSYSTEME
Thomas Ebert, Manfred Kurzwernhardt, Manfred Maier, Kurt Pfleger

HARD- & SOFTWARE ENGINEERING
George Bekey, Wolfgang Bidner, Mark Böhler, Jan Borchers, Sigi Eckmaier, Christian Falkovski, Gerald Futschek, Steven Genter, Ken Goldberg, Niki Heger, Christoph Hofinger, Oliver Holle, Tom Knienieder, Theoderich Kopetzky, Dominik Kronberger, Andreas Leibetseder, Norbert Maier, Knut Manske, Rosemary Morris, Gideon May, Christian Möller, Max Mühlhäuser, Peter Purgathofer, Nestor Pridun, Joseph Santarromana, Gernot Schaufler, Priska Steger, Wolfgang Stürzlinger-Protoy, Carl Sutter, Albert Topitz, Arnold Trost, Jens Volkert, Hermann Wakobinger, Jeff Wiegely, Helmut Wölfl

WEB-DESIGN
Heidi Jungwirth, Gudrun Köck-Litke, Silvia Müller, Gerda Palmetshofer, Martin Rutgerson, Elisabeth Schedlberger, Manuel Schilcher

Ars Electronica 96
Festival für Kunst, Technologie und Gesellschaft

Memesis – Die Zukunft der Evolution
2. – 6. September 1996

Veranstalter:
Ars Electronica Center Linz GmbH
Geschäftsführung: Gerfried Stocker
ORF Landesstudio Oberösterreich
Intendant: Dr. Hannes Leopoldseder

Direktorium, künstlerische Leitung:
Gerfried Stocker, Ars Electronica Center
Dr. Christine Schöpf, ORF Landesstudio
Oberösterreich

Produktion: Mag. Jutta Schmiederer

Prix Ars Electronica 96
Internationaler Wettbewerb für
Computerkünste
Veranstalter: ORF Landesstudio Oberösterreich
Idee: Dr. Hannes Leopoldseder
Konzept: Dr. Christine Schöpf, Dkfm. Heinz
Augner, Wolfgang Winkler
Prix Ars Electronica Koordination:
Dr. Christine Schöpf, Gabriele Strutzenberger

CONFERENCES
Netzwerk-Symposium
Netzwerk-Moderation: Geert Lovink/NL

Themensymposium
MEMESIS
Design Center Linz
3. und 4. September
Robert Adrian X/A
Roy Ascott/GB
Richard Barbrook/GB
Konrad Becker/A
Tim Boyket/AUS
John L. Casti/USA
Richard Dawkins/GB
Mark Dery/USA
Joe Engelberger/USA
Matt Heckert/USA
Francis Heylighen/B
Perry Hoberman/USA
Herbert Hrachovec/A
Albert Lichtblau/A
Geert Lovink/NL
Tod Machover/USA
Marvin Minsky/USA
Sadie Plant/GB
Douglas Rushkoff/USA
Tom Sherman/USA

Christa Sommerer/A, J
Karin Spaink/NL
Gerfried Stocker/A
Allucquère Rosanne Stone/USA
Tjebbe van Tijen/NL
VNS Matrix/Aus
Jon Rose/AUS/NL
PERKS: Simon Biggs, Rainer Linz, Stevie
Wishart, Konstanze Binder

Ars Electronica Workshops
**walking in cyberspace – neue Arbeitsmethoden
in Virtual Reality und Computersimulation**
CAVE, eine Entwicklung des Electronic
Visualisation Lab der University of Illinois
Dan Sandin/USA
textbased VR – Scenarios for virtual communities
Internetanwendungen
Oliver Frommel, Thomas Weber/A

PRIX ARS ELECTRONICA 96
*Internationaler Wettbewerb für
Computerkünste*
Veranstalter: ORF Landesudio Oberösterreich
Idee: Dr. Hannes Leopoldseder
Konzept: Dr. Christine Schöpf, Dkfm. Heinz
Augner, Wolfgang Winkler

WWW
Jury: David Blair, Oliver Frommel, Joichi Ito, Karin
Spaink, David Traub
Goldene Nica 96: etoy
Auszeichnungen: Ed Stastny, Manuel Schilcher,
Anerkennungen: Trevor Blackwell, Mark Pesce,
Masaki Fujihata, Mc Spotlight, Ron Newman,
Kevin McCurley, Andruid Kerne, Joey Anuff,
Maria Winslow, Lisa Hutton, Stuart Moulthrop,
Timothy Leary

Interaktive Kunst
Jury: Alex Adriaansens, Harvie Branscomb, Coco
Conn, Perry Hoberman, Gerfried Stocker
Goldene Nica 96: Masaki Fujihata
Auszeichnungen: Louis-Philippe Demers/Bill
Vorn, Scott Sona Snibbe,
Anerkennungen: Ken Feingold, Elisabeth
Goldring, Kazuhiko Hachiya, Harwood, Hiroo
Iwata, Knowbotic Research,
Mintz/Ditmars/Duggan, Mork/Pendry/Stenslie,
Nobuya Suzuki, Erwin Redl, Michel Redolfi/Luc
Martinez, Silver

Computeranimation
Jury: Valie Export, Lisa Fisher, Rolf Herken, A.J.
Mitchell, Michael Wahrman
Goldene Nica 96: John Lasseter
Auszeichnungen: Marc Caro/Jean-Pierre Jeunet,
Michel Gondry/Pierre Buffin

Anerkennungen: Philippe Billion, Christian Bou-
stani, John Clyne, James Duesing, Industrial
Light & Magic, Pierre Lachapelle, Arnauld
Lamorlette, Denise Minter/Tim Johnson

Computermusik

Jury: Stephen Arnold, Ludger Brümmer, Werner
Jauk, Bob Ostertag, Andrea Sodomka
Goldene Nica 96: Robert Normandeau
Auszeichnungen: James Dashow, Régis Renou-
ard Larivière
Anerkennungen: Francesco Boschetto, Chris
Brown, Kui Dong, Jonty Harrison, Matt Heckert,
Gordon Monahan, Gordon Monro, Stephen
Montague, Michel Redolfi, Jacob Ter Veldhuis,
Alejandro Vinao

Prix Ars Electronica Preisträgerkonzert
Stadtpfarrkirche Urfahr St.Josef
Le Renard et la Rose
Robert Normandeau/CDN
Media Survival Kit
James Dashow/USA, I
**Futaie – Hochwald-Musik eines aus-
gedehnten Augenblicks**
Régis Renouard Larivière/F

Die Goldene Nica
Prix Ars Electronica Gala
ORF Landesstudio Oberösterreich – 3sat
Verleihung der Goldenen Nica 96
Präsentation: Mercedes Echerer

Prix Ars Electronica Forum

ORF Landesstudio Oberösterreich
Vorträge, Diskussionen und Gespräche mit den
Preisträgern und Juroren der vier Wettbewerbs-
sparten des Prix Ars Electronica 96.
Computermusik
Robert Normandeau/Can, James
Dashow/USA, I, Régis Renouard Larivière/F
Moderation: Ludger Brümmer
(Folkwangschule Essen)
Computeranimation
John Lasseter/USA, Arnauld Lamorette/Buf/F,
Pete Docter/Pixar Studios/USA, Arnauld
Lamorette/BUF/F
Moderation: Lisa Fisher/Mass Illusions/USA
Special Lecture: Tod Machover/MIT Media-
lab/USA
Interaktive Kunst
Masaki Fujihata/J, Scott Sona Snibbe/USA,
Louis-Philippe Demers, Bill Vorn/Can
Moderation: Perry Hoberman
World Wide Web
etoy, Manuel Schilcher/A, Ed Stastny/USA
Moderation: Joichi Ito

Electronic Theatre

Rathausplatz, Ars Electronica Quarter
Best-Of-Programm aller Computeranimationen,
die seit 1987 zum Prix Ars Electronica einge-
reicht wurden. Konzept: Christine Schöpf, Johnie
Hugh Horn.
1987
 Luxo jr.: John Lasseter
 Mental Images: Rolf Herken
 Sloat: Yoichiro Kawaguchi
1988
 Red's Dream: John Lasseter
 Breaking the Ice: Larry Malone
1989
 Broken Heart: Joan Stavely
 Eurhythmy: Armkraut/Girard
1990
 Dirty Power: Robert Luyre
 Star Life: Philippe Andrevon
 Knickknack: John Lasseter
 Locomotion: Steve Goldberg
1991
 Panspermia: Karl Sims
 Maxwell's Demon: James Duesing
 Grinning evil death: McKenna/Bob Sabiston
1992
 Liquid Selves/Promordial Dance: Karl Sims
 Terminator 2: ILM
1993
 Lakmé: Pascal Roulin
 Death becomes her: ILM
 Gedicht von Ernst Jandl: Eku Wand
1994
 Jurassic Park: ILM
 KO Kid: Marc Caro/BUF
 The Quarks: Maurice Benayoun
 No Sex: Eric Coignoux
 Gas Planet: Eric Darnell
 Displaced Dice: Thomas Zanker
1995
 Gold's Little Monkey: Bob Sabiston
 Superstars: Thomas Bayrle
 Shadow Puppets: Chuck Gamble
 Forrest Gump: ILM
 Angélique Kito: Agelo Medialab
1996
 The Toy Story: John Lasseter
 Like a Rolling Stone: BUF
 City of Lost Children: BUF
 Amnesty International (if we get it): BUF

Interaktiv – Prix Ars Electronica Ausstellung

Landesgalerie des OÖ Landesmuseums
Francisco Carolinum

Voice Boxes
Natalie Jeremijenko/USA

Salon des Ombres – Hall of Shadows
Luc Courchesne/CDN

Global Interior Project
Masaki Fujihata/J

Three Men, Three Legs
Nobuya Suzuki/J

Parallel Mesmerization of Eleven Blondes and Eleven Brunettes by Two Computers
Erwin Redl/USA

Rehearsal of Memory
Harwood/GB

Motion Phone
Scott Sona Snibbe/USA

Ruhe – RAUM – Bewegung
Gerhard Funk/A

Bodymaps: artifacts of touch
Thecla Schiphorst/CDN

Sympathetic Sentience
S. Penny, J. Schulte/USA

The Machine in the Garden
Nancy Paterson/CDN

EXHIBITIONS

Themenausstellung MEMESIS

Design Center Linz

Digital Hijack
Design Center Linz
etoy

Inter Dis-communication Machine
Design Center Linz
Kazuhiko Hachiya/J

Cross-active System
Design Center Linz
Hiroo Iwata/J

Brain Opera
Design Center Linz
Tod Machover/MIT Media Lab/USA
(In Kooperation mit dem Ars Electronica Center)

No Man's Land
Ars Electronica Quarter
Robotic-Installation
Louis-Philippe Demers, Bill Vorn/Can
Ein Auftragswerk des Ars Electronica Center, in Zusammenarbeit mit Conseil des arts des lettres du Quebec, mit Unterstützung des Department of Foreign Affairs and International Trade of Canada

Napoli
Ars Electronica Quarter
Soundinstallation
Giardini Pensili, Roberto Paci Dalò, Isabella Bordoni/I

Intersection
Ars Electronica Quarter
Soundinstallation
Don Ritter/CDN

Interaktiv – Prix Ars Electronica Ausstellung

Landesgalerie des OÖ Landesmuseums
Francisco Carolinum
Siehe linke Spalte

Ars Electronica Center Exhibition 1996/1997

Ars Electronica Center
Untergeschoss

Text Editor
Hochschule für Gestaltung Linz/Archimedia, Christian Möller, Gideon May, Hermann Gruber, Christian Gusenbauer, Edith Spiegel

Virtual Touch
Hochschule für Gestaltung Linz/Archimedia, Christian Möller, Hermann Gruber, Christian Gusenbauer, Edith Spiegel

Virtual Audio
Hochschule für Gestaltung Linz/Archimedia, Christian Möller, Hermann Gruber, Christian Gusenbauer, Daniel Schmitt, Robert Wacha

Keyframes
Jens Volkert, Gerald Kotzian, Gerhard Kramler, Wolfgang Stürzlinger-Protoy, Gernot Schaufler, Abteilung für Grafische und Parallele Datenverarbeitung (GUP), JKU Linz, Institut für Informatik

Extruder – open GL Model Editor
Mit Unterstützung von SGI

Genma
Christa Sommerer,Laurent Mignonneau/A/F/J
Realisiert am Advanced Telecommunications Research Lab, Kyoto

Die Höhle von Lascaux
Benjamin Britton

Ars Electronica On Demand I
Manuel Schilcher, Christa Schneebauer, Chris Mutter, Regina Patsch, Christine Schöpf, Wolfgang Maracek, Claus Uehler, Andy Pongratz–X-Art

Erdgeschoss/Zwischengeschoss

TeleGarden
Tele-Robotic Installation
Konzept: Ken Goldberg, Joseph Santarromana/USA. Mit Unterstützung der University of Southern California USC. Projektteam: Erich Berger, George A. Bekey, Steven Gentner, Rosemary Morris, Carl Sutter,

Jeff Wiegley, Thomas Steindl. Unterstützt von: Quelle AG

Humphrey I – Flugsimulator

Ars Electronica Futurelab, Dietmar Offenhuber, Thomas Kienzl, Andreas Behmel, Tom Knienieder/WX WORX system, Horst Hörtner, Andreas Jalsovec, Joachim Schnaitter, Werner Pötzelberger, Christopher Lindinger, Jürgen Kern, Robert Praxmarer. Digitales Höhenmodell: DORIS Projektgruppe. Unterstützt von: Brau AG

Apollo 13

Museumslift
Idee: Roy Ascott
Ars Electronica Futurelab, Dietmar Offenhuber, Gerda Palmetshofer, Hermann Wakolbinger, Gerfried Stocker, Horst Hörtner, Volker Christian. Datenmaterial: Landsat™, Spot PAN (Geospace), Metosat 5 (Universität Nottingham), NOAA 4&5 (Universität Dundee)

Scheibenschreiber – der Ankündigungsroboter

Konzept: Ars Electronica Center, Gerfried Stocker, Erich Berger. Robot, Innotech Corp. Interlux Corp.

Infomaten

Konzept: Ars Electronica Center, Peter Purgathofer, Inst. Für Gestaltungs- und Wirkungsforschung in Zusammenarbeit mit gregerpauschitz graphic- und industrial design. Stationsdesign: Armin Lixl, Thomas Kienzl, Scott Ritter, Garry Graiter, Rainer Verbizh, Implementierung: Erich Berger, Helmut Höllerl, Didi Lassingleitner, Horst Köpfelsberger. In Zusammenarbeit mit: Oracle, Gericom

Future Banking

Bankomat mit Gesichtserkennung und Schließfach mit Fingerprint Scanner. In Zusammenarbeit mit Bank Austria und Keba.

1. Obergeschoss

Cyber City

GIS – Geografisches Informationssystem

Projektleitung: Thomas Ebert, Kurt Pfleger Datenquellen: Digitale Datenbestände des Bundesamtes für Eich- und Vermessungswesen (Landesaufnahme) und DORIS-Basisdaten.

SimLinz I

Konzept: Ars Electronica Center, Projektleitung: Gerhard Empl, Programmierung: Balint Hegedüs, Andreas Hopfner, Daniel Wagner, Grafik: Tamara Baldemaier GIS Daten: Manfred Mayer, SBL

Infinite Reality/Matterhorn

Mit Unterstützung von SGI

ge*Sample*te Stadt

Animation: Michael Suppan; Schnitt: Ewald

Onzek, Andreas Pösch; Architektur: Andreas Behmel, Thomas Kienzl, Rudolf Ziegler; Idee und Realisierung: KOMMERZ – Thomas Kienzl, Andreas Behmel. In Kooperation mit Quelle AG.

ArchitekTouren/Virtual City – VR-Bike

Konzept: Ars Electronica Center Projektleitung: Gerhard Empl; 3D-Modelling/Animation: Andreas Hopfner, Sabine Nedl, Tobias Peer; Programmierung: Peter Melchart, Erika Pojar; Daten: Heidi Dummreicher, Richard Levine.

Time-Explorer – Linz im Rück-*Click*

Projektleitung: Albert Topitz; Wissenschaftliche Leitung: Prof. Dr. Rudolf Ardelt JKU Linz; Realisierung: Image Kommunikationsdesign. In Kooperation mit Kulturamt der Stadt Linz.

2. Obergeschoss

Electronic Classroom

Konzept und Realisierung: Prof. Max Mühlhäuser/JKU Linz, Institut für Informatik, Abteilung Telekooperation. Unterstützt von: Gericom, SNI, HP, Pbs. In Kooperation mit: Landesschultrat für OÖ.

Smartboard

Unterstützt von: Smart Technologies Inc.

Multimedia Learnstation

Modulwand

Extended Livingroom

Coinmachine – Lego Logo

Konzept und Projektleitung: Christian Falkowski, Max Mühlhäuser/JKU Linz, Institut für Informatik, Abteilung Telekooperation; Software: Gerald Futschek/Universität Wien; Lego Roboter: Leopold Berger; Erklärungskomponente: Brigitte Bauer, Christoph Meisinger/JKU Linz.

Worldbeat

Konzept und Projektleitung: Max Mühlhäuser, Jan Borchers/JKU Institut für Informatik, Abteilung Telekooperation; Kontrollapplikation, Musical Memory: Günter Obiltschnig/JKU Institut für Informatik, Abteilung Telekooperation; Design Patterns, Joy-Sticks: Harald Hattinger/JKU Institut für Informatik, Abteilung Telekooperation; Query By Humming: Asif Ghias/Cornell Univ. New York, Elisabeth Rembold/JKU Linz, Institut für Informatik, Abteilung Telekooperation; Virtual Baton: Guy Garnett/CNMAT, University of Berkely, California; Net Music: Wolfgang Aichhorn, Armin Bachinger/JKU Institut für Informatik, Abteilung Telekooperation; David Reider/BBN Corporation, Massachusetts; Orff Instrumente: Markus Herzig, Michael Höller/ JKU Institut für Informatik, Abteilung Telekooperation;

Seitengestaltung: Andreas Lennert/ JKU
Institut für Informatik, Abteilung Telekoope-
ration; Grafikdesign: Jutta Lang/Hochschule
für künstlerische und industrielle Gestal-
tung Linz.

Gestures – Gestenerkennung

Konzept und Projektleitung: Knut Manske,
Max Mühlhäuser/JKU Linz, Institut für
Informatik, Abteilung Telekooperation; Soft-
ware: JKU Linz, Institut für Informatik, Abtei-
lung Telekooperation, Ulrich Bröckl-Fox/
Universität Karlsruhe; Gestenerkennungs-
algorithmus: Ulrich Bröckl-Fox/Universität
Karlsruhe; Applikationsimplementierung:
Oliver Hable, Simon Vogl/JKU Linz, Institut
für Informatik, Abteilung Telekooperation.

ITV/Videoaktoren

Konzept, Projektleitung und Implementie-
rung: Max Mühlhäuser, Arnold Trost/JKU
Linz, Institut für Informatik, Abteilung
Telekooperation; Teletext-Indexing-System:
Herbert Redtenbacher/JKU Linz, Institut für
Informatik, Abteilung Telekooperation; Gra-
fikdesign: Jutta Lang/Hochschule für künst-
lerische und industrielle Gestaltung Linz.

3. Obergeschoss

Sky Medialoft

Gestaltung: Wolfgang Giegler, Andreas
Hirsch, Scott Ritter, Denise Schulz – IDEAL
cultural affairs, Wien.

CAVE

Ars Electronica Center

Konzept: Dan Sandin/USA, EVL- University of
Illinois at Chicago
Implementierung AEC in Zusammenarbeit mit
Johnie Hugh Horn/USA.

Kunst- und Museumsprojekte:

Crayoland

EVL – University of Illinois at Chicago,
Dave Pape

OORT-continuum

EVL – University of Illinois at Chicago
Marcus Thiebaux, Margaret Watson, Marga-
ret Dolinsky, Grit Sehmisch, Dan Sandin,
Milana Huang, Tom Coffin, Gary Minnix,
Alan Cruz, Bor Tyng Lin, Ka-Leung Jark

Virtual Reality Museum Vandalism

EVL – University of Illinois at Chicago,
Dave Pape

Vomit Mountain

EVL – University of Illinois at Chicago,
Tom Coffin

Industrie- und Architekturprojekte:

MCE – Turbine

Strömungsvisualisierung in Turbinen
Ars Electronica Futurelab, Dietmar Offenhu-
ber, Cahya Wirawan, Horst Hörtner, Joachim

Smetschka. Auftragsarbeit für MCE VOEST
Alpine.

Greek Temple

Ars Electronica Futurelab, Dietmar Offenhu-
ber. In Zusammenarbeit mit Foundation of
the Hellenic World

Ars Electronica Center – Events 1996

@vent

Ars Electronica Quarter
21. Dezember 1996
John Duncan/USA/NL/Touch rec., DJ's:
HansK, PLAK
Konzept: Fadi Dorninger

EVENTS & PERFORMANCES

SKY – Ein Fest für Linz

*Ars Electronica Quarter, Nibelungenbrücke,
Ars Electronica Center, Rathausplatz,
Hauptstraße*
Eröffnungevent des Ars Electronica Center
Els Comediants
Konzeption: Els Comediants/
La Fura dels Baus/E

Brain Opera - Liveperformance

Design Center Linz
Tod Machover/MIT Media Lab/USA
(In Kooperation mit dem Ars Electronica
Center)

Liquid Cities

Parkbad
Konzeption und Musik: Michel Redolfi/F
Projekt-Team: Luc Martinez, Gilles Grand,
Pascal Josse, Dan Harris, Eric Wenger,
Vincent Filiali, Richard Dudas
Mit Unterstützung vom Conseil Régional
Provence-Alpes-Côte d'Azur (CRECS)

Glasfieber

Stadtwerkstatt
Stadtwerkstatt / Peter Donke, Peter Hauen-
schild, Thomas Lehner, Georg Ritter/A

Rückspiegel zur Realität

CONTAINED, *CONTAINED Gelände VOEST*
Konzeption: Just Meritt/A
Ausstellungskuratorin: Claudia Hutterer/A
Programmdirektor: Todd Blair/USA

Part I

Quality of home technology in a liquid
quiet village

Part II

Roque mechanics facilitating the beauty of
high fidelity

Part III

Traditional ceremony on the day of the
first bolt

Videoreihe

Rearview mirror on Technology

Leslie A. Gladsjo, Tatiana Didenko, Kathrin

Wilkes
Diskussion
**Small fry on a corporate silver platter –
appetiser or digestive?**
Denise Caruso, Tatiana Didenko, Kathy Rae
Huffman, Suzanne Stephanac
Aff Electronica Symposium
Funesis – Die Pest des Spassismus
Referenten
AntiFunFaction, Thomas Edlinger, Alois
Huber, Oliver Marchart, Fritz Ostermayer,
Markus Wailand, Doris Weichselbaumer u. a.
Installationen und Performances von
Hermann Atzlinger, Tina Auer, Sam Auinger,
Nick Baginsky, Franz Best, Todd Blair Tim
Boykett, Die Romantiker, John Duncan, Chip
Flynn, Brett Goldstone, Matt Heckert, Rudi
Heidebrecht, Eric Hobijn, Kammerensemble
Harmonices Mundi, Laura Kikauka, Josephi-
ne M., Chico MacMurtrie/Amorphic Robot
Works, David Moises, Gordon Monahan,
Marc 9, Linda Nilsson, Martin Reiter, Josef
Sabaini, Herbert Schager, Leo Schatzl,
Scheißleiten Musi, Manuel Schilcher, VOEST
Werkskapelle, Gordon W., Jim Whiting, Liz
Young, Erwin Zeppezauer, Berthold Zettel-
meier, Alex Zuljevic.
Contained TV
Tina Auer, Tatiana Didenko, Mathias Moser,
Kathrin Wilkes
Contained Radio
Thomas Edlinger, Fritz Ostermayer
**Sub'tronic – Das musikalische Nachtprogramm
der Ars Electronica 96**
Ars Electronica Quarter/Stadtwerkstatt
Konzeption: Fadi Dorninger/A
Mit: Kern/Wöginger/A, Dorfmeister/A,
Fennesz/A, Jim Plotkin/USA
Sabotage/Laton Records Showcas, feat. A.
Huber/A, Burger & F. Pomassl/A
Cheap Records Allnighter, feat. Pulsinger,
Tunakan, Elin und .../A
:Zoviet:France/GB
Locust/GB
Aural Screenshots, feat. Jim Plotkin/A, USA
Lull - Mick Harris/GB
Fuckhead/A
Ridin' a Train
Eine musikalische Nachtfahrt mit dem Zug
durch das Werksgelände der VOEST
Aural Screenshots feat. James Plotkin
Idee: Fadi Dorninger
Telecommunication Breakdown
Posthof
EBN – Emergency Broadcast Network/USA
In Kooperation mit stay tuned

NETZWERKPROJEKTE

Rivers & Bridges
Design Center Linz
Kunstradio
Internationales Radio- und Internetprojekt
mit Performances, Installationen, Konzer-
ten, Events an über 25 Orten in Europa und
Übersee
Konzeption: Jocelyn Robert/Can, János
Sugár/H
Bridgework – The Kunstradio All Stars
ORF Landesstudio Oberösterreich
Sam Auinger, Roberto Paci Dalò, Dorfmei-
ster, Rupert Huber, G. X. Jupitter Larsen,
Sergio Messina, Bob Ostertag, Robin
Rimbaud aka present SCANNER, Jon Rose,
Andrea Sodomka, Akemi Takeya
Kunst & Politik
Offenes Kulturhaus, Linz
Robert Adrian X/A
(In Kooperation mit dem Offenen
Kulturhaus, Linz)
SOS RADIO TNC
Design Center Linz
Beusch/Cassani/F
Radio-Netzwerk-Projekt
The Egg of the Internet
Design Center Linz
Netband – Franz F. Feigl, Erik Hobijn, Dick
Verdult, Debra Solomon/NL
Soundlives – The House of Sounds
Design Center Linz
Winfried Ritsch/A
Worlds Within
Design Center Linz
Van Gogh TV - Karel Dudesek/A, D
WWW Online Report
Design Center Linz
NL.DESIGN
Hotwired
Design Center Linz
Online Publishing

PARTIZIPATIONEN

Deep Blue
Offenes Kulturhaus
Light-and-Sound-Installation
Sam Auinger, Robert Adrian X/A
in Kooperation mit dem Offenen
Kulturhaus, Linz
RAYS (work in progress)
Stiftergalerie des OÖ Landesmuseums
Video-Licht-Objekt-Installation
Gudrun Bielz/A
Francisco Carolinum

1996

Variable Objekte
Helmuth Gsöllpointner, Christian Möller/A, D
Realisation: Sabine Reschitzegger, Daniel
Schmidt
(In Kooperation mit ARCHIMEDIA Institute
for Arts and Technologies, Hochschule für
Gestaltung, Linz)
ARCHIMEDIA

1997

Ars Electronica 97
*Festival für Kunst, Technologie und
Gesellschaft*

FleshFactor
Informationsmaschine Mensch
8. – 13. September 1997

Veranstalter:
Ars Electronica Center Linz
Betriebsgesellschaft mbH
Geschäftsführer:
Gerfried Stocker, Mag. Wolfgang Modera

ORF Landesstudio Oberösterreich
Intendant: Dr. Hannes Leopoldseder

Direktorium, künstlerische Leitung:
Gerfried Stocker, Ars Electronica Center
Dr. Christine Schöpf, ORF Landesstudio
Oberösterreich
Produktion: Mag. Jutta Schmiederer

Prix Ars Electronica
Internationaler Wettbewerb für
Computerkünste
Veranstalter: ORF Landesstudio Oberösterreich
Idee: Dr. Hannes Leopoldseder
Konzept: Dr. Christine Schöpf
Finanzen: Dkfm. Heinz Augner

CONFERENCES

Netzwerk-Symposium
Netzwerk-Moderation: Tom Sherman/USA

Themensymposium FleshFactor
Informationsmaschine Mensch
Design Center Linz
9. – 10. September
Bilwet Agency – Geert Lovink, Arjen Mulder/NL
Robert R. Birge/USA
Daniel Dennett/USA
Peter Fleissner/A
Peter Fromherz/GER
Paul Garrin/USA
Guillermo Gòmez-Peña/Mexico/USA
Roberto Sifuentes/USA
Donna Haraway/USA
Huge Harry/NL
Hiroshi Ishii/USA
Pattie Maes/USA
Steve Mann/USA
Max More/USA
Tom Sherman/USA
Patricia Smith Churchland/USA
Stelarc/AUS
Neal Stephenson/USA
Victoria Vesna/USA
Mark Weiser/USA

Museums of the Future – Fachtagung

Hannes Leopoldseder – ORF Landesstudio
Oberösterreich
Gerfried Stocker – Ars Electronica Center, Linz
Wolfgang Modera – Ars Electronica Center, Linz
Hans Peter Schwarz – ZKM Zentrum für Kunst
und Medientechnologie, Karlsruhe
sowie Vertretern des ICC Intercommunication
Center, Tokyo und zahlreichen Experten österrei-
chischer und europäischer Museen

Ars Electronica Workshops

Ars Electronica Center
on line communities & multi user environments
 John Coate/USA, Station Rose/D
 Georg Mnich (Lunatic Interactive)/D
Oudeis – a world wide odyssey
 Peter Fleissner, Andrew Garton, L.H. Grant,
 Gernot Lechner, Georg Leyrer, Ulli Noe,
 Santiago Pereson, Fellippe Rosenburg,
 Francesco Verdinelli, Monika Wunderer,
 Dan Zeller

PRIX ARS ELECTRONICA

Internationaler Weltbewerb für Computerkünste
Veranstalter: ORF Landesstudio Oberösterreich
Idee: Dr. Hannes Leopoldseder
Konzept: Dr. Christine Schöpf
Finanzen: Dkfm. Heinz Augner

.net

Jury: Derrick de Kerckhove/CDN, Oliver
Frommel/D, Joichi Ito/J/USA, Demetria
Royals/USA, Karin Spaink/NL
Goldene Nica 97: Project Taos/J
Auszeichnung: Gordon Selley/Ryarde
Hawkes/Jane Prophet, Rolf Schmidt/GB
Anerkennung: Amy Alexander, Bruce Damer,
Ryoichiro Debuchi, Hermann-Josef Hack, Omar
Khan, Zervos Komninos-Kostant, Steve Martin,
Joan Heemskerk/Dirk Paesmans, Markus
Schulthess, Alexei Shulgin, Mark von Rahden

Interaktive Kunst

Jury: Alex Adriaansens/NL, Perry Hoberman/
USA, Machiko Kusahara/J, Michael Naimark/
USA, Gerfried Stocker/A
Goldene Nica 97: Toshio Iwai/Ryuichi Sakamoto/J
Auszeichnung: Dirk Lüsebrink/Joachim Sauter/
D, Paul Garrin/David Rokeby/USA/CDN
Anerkennung: Hachiya Kazuhiko, Toshihiro
Anzai/Tamio Kihara, Knowbotic Research,
Arthur Elsenaar/Huge Harry/Remko Scha, Mark
Madel, Jon Berge, Stefan Zeyen, Barminski/
Lewin/Hesketh, KP Ludwig John/Bertram
Quosdorf, Jutta Kirchgeorg, Marita Liulia,
Die Veteranen

Computeranimation

Jury: Rolf Herken/D, Mickey McGovern/USA,
A.I. Mitchell/GB, Michael Wahrman/USA, Chris
Wedge/USA
Goldene Nica 97: Scott Squires/ILM/USA
Auszeichnung: Chris Wedge/USA
Anerkennung: Jon Mitchell/ILM, Stefan
Fangmeier/ILM, Larry Lamb, Anna Henckel-
Donnersmarck, Michèle Cournoyer, Taku
Kimura, Raquel Coelho, Carlos Saldanha,
Michel Gondry/BUF, Michel Gondry/BUF,
Stephen Weston, François Vogel, Marine
Poirson/Lionel Richerand

Computermusik

Jury: Stephen Arnold/GB, Sam Auinger/A,
Naut Humon/USA, Ben Neill/USA, Robert
Normandeau/CDN
Goldene Nica 97: Matt Heckert/USA
Auszeichnung: Maryanne Amacher/USA, Jonty
Harrison/GB
Anerkennung: Patrick Ascione, Christian Calon,
Luigi Ceccarelli, Ambrose Field, Annie Gosfield,
Joseph Hyde, Charles Kriel, Ake Parmerud,
Laetitia Sonami, Mario Verandi, Mark Wingate,
John Young

Die Goldene Nica
Prix Ars Electronica Gala 97

ORF Landesstudio Oberösterreich – 3sat
Verleihung der Goldenen Nica 97
Moderation: Sigrid Steingruber, Josef Broukal

Prix Ars Electronica Forum

ORF Landesstudio Oberösterreich
Vorträge, Diskussionen und Gespräche mit den
Preisträgern und Juroren der vier Wettbewerbs-
sparten des Prix Ars Electronica 97
Computermusik
 Jonty Harrison/GB, Maryanne Amacher/USA,
 Matt Heckert/USA
 Moderation: Naut Humon/USA
Interaktive Kunst
 Joachim Sauter/D, Dirk Lüsebrink/D,
 ART+COM/D, Paul Garrin/USA, Toshio
 Iwai/Ryuichi Sakamoto/J
 Moderation: Alex Adriaansens/NL
.net
 Ryarde Hawkes/GB, Jane Prophet/GB,
 Gordon Selley/GB, Rolf Schmidt/USA,
 sensorium Team/J
 Moderation: Joichi Ito/J
Computeranimation
 Scott Squires, ILM/USA, Chris Wedge/USA
 Moderation: A.J. Mitchell/GB

Electronic Theater

Ars Electronica Quarter, Rathausplatz
Open-Air-Präsentation der besten
Computeranimationen des Prix Ars
Electronica 97
Dragonheart: Scott Squires/ILM
Joe's Apartment: Chris Wedge/Blue Sky
Levi's: BUF
Coca Cola: BUF
Big Deal: Carlos Saldanha/Blue Sky
Fisherman's Friend: Stephen Weston/Bermuda
Shorts
Mars Attacks!: Jim Mitchell/ILM
Adrenalin: Marine Poirson, Lionel Richerand/
ENSAD
Cheerful Country: Francois Vogel/ENSAD
The Tapir: Raquel Coelho/Blue Sky
Huzzah (Bobaloo the beast boy): Larry Lamb/
Lamb & Company
Twister: Stefen Fangmeier/ILM
Sakuratei: Taku Kimura/Links Corp.
Busby: Anna Henckel-Donnersmarck/Filmakad.
Baden-Württemberg
An Artist: Michele Cournoyer/National Film
Board of Canada

EXHIBITIONS

Themenausstellung FleshFactor

Design Center Linz
Seeing is Believing
 Kazuhiko Hachiya/J
 Prix Ars Electronica 97 – Anerkennung
 Interaktive Kunst
Timesharing
 Mark Madel/NL
Garnet Vision
 Hiroo Iwata/J
**Blimp – A tool for ubiquitous tele-embodiment
„Space Browsers"**
 Eric Paulos, John Canny/USA
**Las transpiraciones del desgaste o la
devaluacion aspirada**
 César Martínez Silva/MEX
Tangible Bits
 Hiroshi Ishii, Maggie Orth, Matt Gorbet,
 Andrew Dahley, Scott Brave/USA
GenderBender
 Gregory Patrick Garvey/CAN
Kage
 Motoshi Chikamori/J
Teddyautomat
 Christoph Ebener, Uli Winters/D
Kybermax und Moritz
 Markus Brandt/A
Cyborg Detector
 Erich Berger, Pat Futterer/A, Sandy Stone/USA

Moppet
 Arkade am Taubenmarkt
 Tamio Kihara, Toshihiro Anzai/J
 Prix Ars Electronica 97 – Anerkennung
 Interaktive Kunst
Solve et Coagula
 Ars Electronica Quarter
 Stahl Stenslie, Knut Mork, Karl Anders,
 Øygard/N
IPzentrum
 Ars Electronica Quarter
 TXTD.sign/A. In Zusammenarbeit mit dem
 Ars Electronica Center und Steweag Graz.

Ars Electronica Center Exhibition 1997/1998

*Ars Electronica Center
Untergeschoss*
Pinocchio: Die virtuelle Marionette
 Wolfgang Hilbert/A
Work in Progress
 Peter Maloney/UK
Corps et graphie
 Marie-Hélène Tramus/F
Hyperscratch ver. 1
 Haruo Ishii/J
Creatures—a Life Game
 Creature Labs, a division of Gameware
 Development
Urban Feedback
 Sophie Greenfield and Giles Rollestone/UK
Erdgeschoss/Zwischengeschoss
What will remain of these
 Chris Dodge/USA
Bodyscan
 Eva Wohlgemuth/A
Rouen Revisited
 Golan Levin, Paul Debevec/USA
1. Obergeschoss
The invisible shape of things past
 Joachim Sauter, Dirk Lüsebrink, Art+Com/D
 Prix Ars Electronica 97 – Auszeichnung
 Interaktive Kunst
Urban Island
 Heidi Dumreicher, Richard Levine, Ars
 Electronica Futurelab, Gerda Palmetshofer,
 Manuel Schilcher
Virtuelles Berlin – 3-D Stadtmodell
 Art+Com/D Joachim Sauter/D, Dirk
 Lüsebrink/D
Video Distort
 In Zusammenarbeit mit SGI
Immersa Desk
 Electronic Visualization Lab (EVL),
 University of Illinois at Chicago/USA
Skin Temperature
 Sensorium Team/J
 Prix Ars Electronica 97 – Goldene Nica .net

Digital Fiction
Andreas Jalsovec/Philipp Reichart/Gerald Rossbacher/A
Linzer Luft
Luftbilder von Linz
Ars Electronica Futurelab, Dietmar Offenhuber
2. Obergeschoss
Web Hopper
Sensorium Team/J
Prix Ars Electronica 97 – Goldene Nica .net
Internet TV
Upgrade zum Extended Livingroom
Learning Robots – Seven Dwarfs
Konzept, Realisierung & Programmierung
Ian Kelly, University of Reading/UK
Zeile für Zeile – Braille-Laptop
Klaus Peter Wegge, C-Lab Paderborn, mit Unterstützung von Siemens Nixdorf
The Tables Turned
Konzept, Realisierung & Programmierung: Paul Sermon. Implementierung Ars Electronica Center: Erich Berger, In Kooperation mit ZKM, Karlsruhe
Cyberanatomy
Anatomisches VRML- Modell. Mit Unterstützung von SGI
Visible Human
Mit Unterstützung der U.S. National Library of Medicine (National Institute of Health, Bethesda, Maryland
City of News
Flavia Sparacino/USA
Ars Electronica Mediathek
Ars Electronica Center
Ottos Mops trotzt: KP Ludwig John/Bertram Quosdorf/D. Anerkennung Interaktive Kunst
Venetian Deer: Die Veteranen/D Anerkennung Interaktive Kunst
Ambitious Bitch: Marita Liulia/F Anerkennung Interaktive Kunst
The Information Age: Jutta Kirchgeorg/USA Anerkennung Interaktive Kunst
The Encyclopedia of Clamps: Bill Barminski, Webster Lewin, Jerry Heskth (De-Lux'O, Inc.)/USA Anerkennung Interaktive Kunst
Slippery Traces: The Postcard Trail: George Legrady/USA
Beyond: Zoe Beloff/USA
Scrutiny in den Great Round: Jim Gasperini, Gennessee Rice Dixon/USA

CAVE
Ars Electronica Center
Kunst und Museumsprojekte:
Multi-Mega-Book in the CAVE
Franz Fischnaller, Yesenia Maharaj Singh/I. Teilweise realisiert im Rahmen des Ars Electronica Research & Residence Program 1997.

Ars Electronica Futurelab: Dietmar Offenhuber, Horst Hörtner in Kooperation mit Dave Pape, Josephine Anstey, EVL, Electronic Visualization Laboratory, University of Illinois at Chicago.
World Skin
Maurice Benayoun/Jean-Baptiste Barrière/F Software-Entwicklung: Patrick Bouchaud, Kimi Bishop, David Nahon
Graphische Bearbeitung: Raphaël Melki Produktion: Ars Electronica FutureLab, Z.A. Production/Silicon Graphics, Europe Credits: Daniela Basics, Zorha Balesic, Laurent Simonini, Pierre Beloin, Guergana Novkirichka. Realisiert innerhalb des Ars Electronica Research & Residence Program 97
Liquid Meditation
Margaret Watson/USA, Eric Butkus/USA
Industrie – und Architekturprojekte:
Bindermichl
Ars Electronica Futurelab
Margaret H. Watson, Andreas Jalsovec, Fritz Rücker, Horst Hörtner
Fronius Virtual Welding
Ars Electronica Futurelab
Manuel Schilcher, Dietmar Offenhuber, Cahya Wirawan, Vaclav Cizkovsky, Horst Hörtner, Josephine Anstey, Hermann Wakolbinger
Siemens Collaborative Working Environment
Ars Electronica Futurelab
Oliver Frommel, Manuel Schilcher, Cahya Wirawan, Vaclav Cizkovsky, Dave Pape, Matt Smith, Horst Hörtner, Joachim Smetschka, Andi Kleen

Ars Electronica Center – Events 1997
In Concert: Noise of 3
19. Jänner 1997
Ars Electronica Center – Sky Medialoft
Seppo Gründler, Josef Klammer, Peter Herbert
Cloud Chamber
12. – 15. März 1997
Ars Electronica Center Linz, The Kitchen New York, Ö1 Kunstradio, Internet
Installation/Performance/Netzwerk/Radioprojekt
Konzept: Sam Auinger/A, Bruce Odland/USA In Zusammenarbeit mit Offenem Kulturhaus Linz.
Mitarbeit: Gerald Schalek, Gerd Thaller, Daniela Swarowsky, Thomas Stelzer, Martin Sturm, Rachel de Boer, Bill Ballou, Chris Kondek, Horst Hörtner, Manuel Schilcher, Mary-Ann Greanier, Chris Salter, Heidi Grundmann, Rupert Huber, Ben Neill, Gerfried Stocker, Jutta Schmiederer, Herbert Schager, Gottfried Hattinger, Daniel Oppenheim, Just Merrit, Martina Kornfehl,

Robert Adrian X, Attwenger, u.v.a.
Exploding Video Event
Rachel de Boer, Boris van der Meijden/NL,
Linz, Sam Auinger/A, Bruce Odland/USA,
DJ Spooky/USA, New York.
Live Event Linz: DJ Matta Hurry (Linz)
Exploding Cinema: Videokunst von Studen-
ten der Meisterklasse
Exploding Cinema: Österreichische Künstler
zeigen ihre Videoarbeiten
Groove against the Machine:VJ Boris Le
Bouffe/NL, DJ Matta Hurry/A
Floating Video: Telematische Video- und
Soundperformance über ISDN Verbindung;
Video Performance: Rachel De Boer/NL im
AEC, Linz; Sound Performance: Sam Auinger
und Bruce Odland in the Kitchen, NY
Closing-down mit DJ Matta Hurry/A
Eine Zusammenarbeit von Ars Electronica
Center, Kitchen New York, Offenes Kultur-
haus, Ö1 Kunstradio.
Workshop on Robotics & Teleoperation
Applications in Science and Arts
Ars Electronica Center
6. Juni 1997
Ken Goldberg, Andreas Wintersteiger, Udo
Kernecker, Stefan Dreiseitl, Kurt Husler,
Johann Prenninger, Erich Prem, Bianco, Cas-
sinis, Rizzi John Canny/Eric Paulos, Toshio
Fukuda, Kevin Warwick. In Zusammenarbeit
mit: Deparament of Systems Engineering &
Automation. Konzept: Erich Berger, Gerfried
Stocker; Organisation: Erich Berger
The Tables Turned
Ars Electronica Center, ZKM Karlsruhe
18. Oktober – 9. November 1997
Telematische Installation
Paul Sermon/UK
Whatever Will Be
Ars Electronica Center, Moviemento
21.– 23. November 1997
Science-Fiction Vortrags- und Filmreihe
Idee und Organisation: Karin Rumpfhuber,
Oliver Frommel, Ars Electronica Center
Konzept und Programm: Michael Palm und
Drehli Robnik. In Zusammenarbeit mit
Moviemento, Wolfgang Steiniger.
Laborantensteiniger.
Laboranten/Mutanten
The Andromedia Strain: Robert Wise
Meerschweine im Weltall: Vortrag Michael
Palm
Die Delegation, eine utopische Reportage:
Rainer Erler
Künstliches Leben – Bessere Körper
Crash: David Cronenberg
Stereo: David Cronenberg
Anticipation, ou l'amour en l'an 2000:
Jean-Luc Godard

Machine Sex: Vortrag Marie-Luise Angerer
Das Neue Gehirn
Brainstorm, Projekt Brainstorm: Douglas
Trumbull
Erfindungen ohne Zukunft: Vortrag Vrääth
Öhner
Strange Days: Kathryn Bigelow
Geschlossene Gesellschaft:
Liquid Sky: Slava Tsukerman
**Liquid Sky oder Wenn der Himmel sich ver-
flüssigt, wird es heiß:** Vortrag Isabella Reicher
Schöner Wohnen: Die Stadt
Alphaville, Lemmy Caution gegen Alpha 60:
Jean-Luc Godard
**Dissuasive Topographien, Zukunft und
Architektur im Film am Beispiel von Alpha-
ville:** Vortrag Marc Ries
Das Fremde
S.O.S. Extraterrestria: Mara Matuschka
**Invasion of the Body Snatchers, Die Körper-
fresser kommen:** Philip Kaufman
**Aliens und Ähnliches. Das Außergewöhnli-
che im Zustand der Unentscheidbarkeit:**
Vortrag Drehli Robnik

Intertwinedness I
Reflecting the structure of the net
Ars Electronica Center
4. November 1997 – 20. Januar 1998
Vorlesungs- und Eventreihe von Ars Electro-
nica Center, Archimedia Institut for Arts and
Technology, Hochschule für Gestaltung Linz
in Zusammenarbeit mit der Universität
Linz, Institut für Neuere Geschichte und
Zeitgeschichte, Institut für Philosophie und
Wissenschaftstheorie, Kulturinstitut an der
Johannes Kepler Universität Linz.
Programm: Christa Schneebauer und
Margarete Jahrmann
Mit: Melita Zajc, Erik Davis, Autonome
a.f.r.i.k.a. – Gruppe, Timothey Druckrey,
Thomas Macho, Barbara Becker, Frank
Hartmann
@vent
Ars Electronica Quarter
20. Dezember 1997
Live: Alois Huber, The Smiling Buddhas,
Pomassl, F.O.N., DJ's: Martha Hurry, DJ Riot,
DJ Hasch. Konzept: Fadi Dorninger

EVENTS & PERFORMANCES

BodyBilder – Ein Fest für Linz
*Ars Electronica Center, Rathausplatz,
Nibelungenbrücke*
Opening Event
Konzept: Fadi Dorninger, Gerfried Stocker
Organisation: Anita Platzer

Technik: Thomas Hinterberger
Lichtdesign: Rainer Jessl
Sound: Fadi Dorninger/A, Rachel de Boer/NL,
Isabella Bordoni/I Markus Brandt/A, Gordon
W. (Scharfness Institute) /CDN, Huge Harry/
NL, Rafael Lozano-Hemmer/CDN, Mieskuoro
Huutajat/SF, Pepi Öttl/A, César Martìnez
Silva/MEX, Adrianne Wortzel/USA
DJ Evva, DJ Riot, DJ Willi,Airlock, FON,
Melinda Janssen, Daniel Kousbroek, Boris
van der Meijden, Thomas Schneider, The
K. & Swamp Swallow, Ubique, u.v.a.

Parasite
Ars Electronica Center
Stelarc/AUS

Music Plays Images x Images Play Music
Posthof
Toshio Iwai, Ryuichi Sakamoto/J
Prix Ars Electronica 97 - Goldene Nica
Interaktive Kunst

Scanning Bacchae
Hafen/SBL – Sonderguthalle
Performance
Isabella Bordoni, Roberto Paci Dalò/Giardini
Pensili/I

„OR"
Design Center Linz
Dumb Type/J

The Great Clone Party
Design Center Linz
TNC Network: Beusch/Cassani/F

Radionight
ORF Landesstudio Oberösterreich, Internet
Die lange Nacht der Radiokunst – In
memoriam William S. Burroughs
Mit Projekten von: José Iges, Concha Jerez/E,
Berliner Theorie, Beusch/Cassani/F, First
Floor Electronix/Radio FRO, Familie Auer,
Radio Lada, Peter Rehberg, Sodomka/Math/
Christian/Breindl, Rasa Smite & Raitis Smits,
The Virtual Theremin Ensemble, Lucie Zeman
Mix: Sergio Messina & Gordan Paunovic

Machine Sound
Konsumhalle, Köglstraße/Im Hühnersteig
Matt Heckert/USA
Prix Ars Electronica 97 – Goldene Nica
Computermusik

**An evening spent in a hypercompetitive
state of mind**
Konsumhalle, Köglstraße/Im Hühnersteig
Time's Up/A
Auftragsarbeit der Ars Electronica
Koproduzent/Co-producer: Marstall Theater,
München, Spiel.art München
mit Time's Up: Tina Auer/A, Tim Boykett/
AUS, Mark 9, Just Merrit/A, David Moises/A,
Christian Staudinger/A, Andreas Strauss/A,
Bert Zettelmeier/A. Mit Unterstützung von:

Baltic Engineering, Catasonic Records, Opco-
de, Philips, Voest-Alpine Stahl

Interface Autodrom
Ars Electronica Quarter
Stadtwerkstatt: Tommy Lehner, Peter
Hauenschild, Georg Ritter/A

**Sub'tronic – Das musikalische Nachtprogramm
der Ars Electronica 97**
*Stadtwerkstadt, Ars Electronica Quarter,
MS Ostarichi, VOEST*
Konzeption: Fadi Dorninger/A
Beschallt von Mego Records feat. Pita,
General Magic, Farmers Manual, Fennesz/A,
Hecker/D, Haswell/UK & Bruce Gilbert/UK,
Ikue Mori & Tenko/USA, J, Airlock/D, Plotkin/
USA, Linschinger/A, Leo Anibaldi/UK, Pan-
asonic/SF, Squarepusher/UK, flesh factor
bar at Stadtwerkstatt: DJ Evva/A, Agent K
/GB, Leo Anibaldi/I, Lichtinstallation: Pepi
Öttl, Martha Hurry/A, BMG III/USA, Kratzig ,
Gü.Mix/A, HansK/A, Charlie Cabranes/USA,
Ikue Mori & Tenko/USA/J, Ubique/USA/A,
Lilith/USA, Umberto Gollini/A, Christian Wö-
ginger/A, Mego Records Showcase feat. Live
PA: General Magic/A, Farmers Manual/A,
Bruce Gilbert/GB, Fennesz/A
Sound System: Hecker/D, Pita/GB,
Potuznik/A; Visuals: SKOT

Sub'tronic health bar
Stadtwerkstatt, Lichthof

Ridin' a Train
Eine musikalische Nachtfahrt mit dem Zug
durch das Werksgelände der VOEST
Death Praxis – Ikue Mori und Tenko
Idee: Fadi Dorninger

Artists Open Badminton Challenge
Harbachschule/Urfahr
Fritz Grohs/A

**Remote Sensations – Installationen und Prozesse
im öffentlichen Stadtraum**
in Kooperation mit dem O.K Centrum für
Gegenwartskunst Linz
Kuratoren: Andrea Sodomka, Gerfried Stocker

Le Triangle d'Incertitude
*Ars Electronica Quarter, Nibelungenbrück,
Donauradweg*
Sound Installation, Cécile le Prado/F

**The Personal Safety Device – Personal Imaging
and Telepresence for Protection Against Crime**
*Landstraße, Übertragung in das Design
Center Linz*
Ambulante Performance im öffentlichen Raum
Steve Mann/USA

**Globe Theater – A Robotic Pageant- Act II,
Scene 2: Nomad Is An Island**
*Rathausplatz, Hauptplatz, Landhauspassage,
Design Center Linz*
Nomadische Installation im öffentlichen

Raum
Adrianne Wortzel/USA
Architettura della Separazione
Hafen/SBL – Sonderguthalle
Interaktive Sound-und Lichtinstallation
Isabella Bordoni, Roberto Paci Dalò/Giardini
Pensili/I
Performance Scanning Bacchae
hotSpot
*Partyschiff zwischen Ars Electronica Center
und Hafen/SBL – Sonderguthalle*
Remote Sensations für Nachtschwärmer
3D-Audio-Düker
Hauptplatz, Design Center Linz
Horst Zachmann/A
Polyphemus' Eye
Hauptplatz
Concha Jerez, José Iges/E
Displaced Emperors
Schloss-Ostfassade
Interaktive Großprojektion
Rafael Lozano-Hemmer, Will Bauer/CAN

openX

Netzwerkprojekte
Design Center Linz – Empore
The Great Clone Party
TNC Network – Beusch/Cassani/F
In Kooperation mit Ars Electronica Center,
IMI Osaka, Beta Lounge San Francisco,
Couleur 3 Genf, Radio Fritz Berlin, DJ Radio
FG Paris, Sub'tronic u.a.
Conversation with Angels
Ampcom – Andy Best & Merja Puustinen/SF
Producer: Outi Rouso, Co-production: The
Banff Centre for the Arts
Recycling the Future
On Air – On Line – On Site
10 Jahre ORF Kunstradio
Mit Robert Adrian X, Marieluise Angerer,
AVATAR (Christof Migone, Jocelyn
Robert/Quebec City/Montreal), BERLINER
THEORIE (Sam Auinger/Rupert Huber/
Berlin), Bernard Bernatzik, August Black,
Martin Breindl, Gwek Bure-Soh, FIRSTFLOOR
ELEKTRONIX (Chris Mutter, Matt Smith,
Markus Seidl/Linz), Andrew Garton, Tom
Haberfellner, Stephan Hametner, Reinhard F.
Handl, Reni Hofmüller, Bernhard Loibner,
Norbert Math, Sergio Messina, Gordan
Paunovic (B92, Belgrad), Thomas Pernes, Karl
Petermichl, RADIO FRO (Alexander Berasitz,
Nikolaus Duerk, Raimund Leeb/Linz), RADIO
LADA (Isabella Bordoni/Roberto Paci Daló/
Rimini), Peter Rehberg, Peter Riedelsperger,
Elisabeth Schimana, Martin Schitter, Tom
Sherman, Andrea Sodomka, Eva Wohlge-

mut, Günter Zechberger, Ludwig Zeininger,
Elisabeth Zimmermann u.a.
Familie Auer
ORF Kunstradio
Remote Viewing
Konrad Becker/A
Face Settings
a communication project for Women Online
Kathy Rae Huffmann/USA, Eva
Wohlgemut/A
Last Entry: Bombay, 1st of July ...
Andrea Zapp/D
Remote C
Rachel Baker/UK, Vuk Cosic/YU/SLO, Luka
Frelih/SLO, Jaanis Garancs/LV/SD,
Jodi.Org/ES/NL, Olia Lialina/R, Pit Schultz/D,
Alexei Shulgin/R, Rasa Smite + Raitis/LV
Syndicate Net.Shop
Koordinator: Eric Kluitenberg
Projektmanagement: Diana McCarty
In Kooperation mit dem Ars Electronica
Center
Grammatron
MarkAmerika/USA
Turbulence
Helen Thorington/USA
Net Sauna
MUU: John Hopkins, Tapio Mäkelä, Terhi
Penttilä, Liisa Vähäkylä/SF
Ausländer und Staatenlose
Andrew Garton/USA
Ars Electronica 97 – On Line Report
Terminal Bar – Bradley Kirkpatrick/CR
Kowloon's Gate
Sony Music Entertainment

PARTIZIPATIONEN

Reading Room
Stiftergalerie
Betty Spackman/Can, Anja Westerfrölke/A

Ars Electronica 98
Festival für Kunst, Technologie und Gesellschaft

INFOWAR – information.macht.krieg
7. – 12. September 1998

Veranstalter
Ars Electronica Center Linz
Betriebsgesellschaft mbH
Geschäftsführer:
Gerfried Stocker, Mag. Wolfgang Modera
ORF Landesstudio Oberösterreich
Intendant: Dr. Hannes Leopoldseder

Direktorium, künstlerische Leitung
Gerfried Stocker, Ars Electronica Center
Dr. Christine Schöpf, ORF Landesstudio
Oberösterreich
Produktion: Mag. Jutta Schmiederer

Mitveranstalter Ars Electronica 98
Brucknerhaus Linz/LIVA
O.K Centrum für Gegenwartskunst
Posthof Linz

Prix Ars Electronica
Internationaler Wettbewerb für Cyberarts
Veranstalter: ORF Landestudio Oberösterreich
Idee: Dr. Hannes Leopoldseder
Konzept: Dr. Christine Schöpf
Finanzen: Dkfm. Heinz Augner

Conferences

Netzwerk-Symposium
Netzwerk-Moderation: Friedrich A. Kittler/D,
Geert Lovink/NL, Georg Schöfbänker/A

Themensymposium INFOWAR
Information.macht.krieg
Brucknerhaus Linz
8. – 9. September
Peter Arnett/USA
Ute Bernhardt/D
Kunda Dixit/Nepal
Tim Druckrey/USA
J. Doyne Farmer/USA
Michael Geyer/USA/D
Lucky Green/USA
Ingo Günther/D
Joichi Ito/J
Friedrich Kittler/D
Birgit Richard/D
RTMark/USA
Douglas Rushkoff/USA
Georg Schöfbänker/A
George J. Stein/USA
Gerfried Stocker/A
Paul Virilio/F
Derrick de Kerckhove/CDN

Shen Weiguang/RCH
Michael Wilson/IRL
Moderation: Manuel DeLanda/USA

Prix Ars Electronica

Internationaler Wettbewerb für Cyberarts
Veranstalter: ORF Landestudio Oberösterreich
Idee: Dr. Hannes Leopoldseder
Konzept: Dr. Christine Schöpf
Finanzen: Dkfm. Heinz Augner

.net
Jury: Andreas Broeckmann/D , Derrick de
Kerckhove/CDN , Robert Gehorsam/USA ,
Joichi Ito/J/USA , John F. Simon Jr./USA
Goldene Nica 98: Knowbotic Research /D/A
Auszeichnung: Kazuhiko Hachiya/J, E-Lab/LV
Anerkennung: Bruce Damer & Collaborators,
Andy C. Deck , Paul Garrin/Andreas Troeger,
I/O/D, Koji Ito, Thomax Kaulmann, Susan
Meiselas/Alison Cornyn/Sue Johnson, Moove -
Lothar Bongartz/Burak Kozan, James Stevens,
Andreas Trottmann, Wendy Vissar, Michael G.
Wagner/Shane Carroll

Interaktive Kunst
Jury: Machiko Kusahara/J , John Markoff/USA,
Michael Naimark/USA , Hans Peter Schwarz/D,
Jon Snoddy/USA ,
Goldene Nica 98: Maurice Benayoun/
Jean-Baptiste Barrière/F
Auszeichnungen: Christian Möller/D ,
Peter Broadwell/Rob Myers/USA
Anerkennungen: Jim Campbell, Christoph
Ebener/ Uli Winters, Rafael Lozano-Hemmer/Will
Bauer, Akitsugu Maebayashi, Joseph Michael,
Iain Mott/Marc Raszewski/Jim Sosnin, Lisa Prah,
David Small/Tom White, Scott Sona Snibbe,
Rachel Strickland, Tamás Walicky, Stephen Wilson

Computeranimation/Visual Effects
Jury: Maurice Benayoun/F, Larry Cuba/USA,
Mark Dippé/USA, Rudolf John/A, Peter Kogler/A,
Barbara Robertson/USA, Michael Wahrman/USA

Goldene Nica 98: Liang-Yuan Wang/ROC,
Robert Legato/USA
Auszeichnungen: Tamás Waliczky/H, Kazuma
Morino/J, Christophe Hery/Habib Zargarpour/
F/USA, Rob Coleman/CDN
Anerkennungen: Joey Lessard, Thierry Prieur/
Pascal Roulin, Nobuo Takahashi, Yan Breuleux/
Alain Thibault, Laurence Leydier /IMIT, Steven
Stahlberg, Nobuto Ochiai, Constantin Chamski,
Julien Dajez, Stefan Smith/Windmill Lane Pro-
ductions, Violet Suk/Martin Koch, Yves Le Peillet,
Nelson Max, Diana Walczak/Jeff Kleiser/Kleiser-
Walczak Construction Company, Sébastien

Larrue, Mark Stetson/Digital Domain, Jan
Pinkava/PIXAR, Kaori Saito, Tom Bertino, Charles
Gibson, Dennis Muren, Phil Tippett/Craig
Hayes, Movida/Ben Stassen, Wayne Gilbert

Computermusik

Jury: Jean Baptiste Barrière/F, Jonty Harrison/GB,
Naut Humon/USA , Laetitia Sonami/F, Werner
Vollert/D
Goldene Nica 98: Peter Bosch/
Simone Simons/NL/E
Auszeichnungen: Aquiles Pantaleão/BR, Hans
Tuschku/D
Anerkennungen: Natasha Barrett, Bret Battey,
David Behrman, Luigi Ceccarelli, Ambrose Field,
Joshua Fineberg, Joseph Hyde, Gordon
Monahan, Adrian J. Moore, Maggi Payne,
Joran Rudi, Hildegard Westerkamp, G. H.
Hovagimayan/Peter Sinclair

Cybergeneration – u19 freestyle computing

Jury: Sirikit M. Amann/A, etoy.AGENT eo4,
Günter Hupfer/A , Norman Filz/A, Stefan
Sagmeister/A
Goldene Nica: Florian Nehonsky/Michael
Mossburger/Valerian Wurzer/A
Auszeichnungen: Stephan Mittendorfer/A,
Leonhard Huber/A
Anerkennungen: Martin Ankerl, Futureware
2001, Gottfried Haider, Verena Holzknecht, In-
formatikgruppe der Hauptschule Mittersill,
Helmut Klinger, Alexander Kvasnicka, Doris
Mätzler/Jürgen Bereuter, Kathrin Meralla/Paul
Swoboda, Thomas Oberhofer, Paul Pak, Thomas
Pintaric/ Christoph Sprenger/Alexander
Koschier, Peter Plessas, Markus Strahlhofer, 3A-
Klasse Volksschule Vereinsgasse, Wien

Die Goldene Nica
Prix Ars Electronica Gala 98

ORF Landesstudio Oberösterreich – 3sat
Verleihung der Goldenen Nica 98
Moderation:
Sigrid Steingruber, Josef Broukal

Prix Ars Electronica Forum

ORF Landesstudio Oberösterreich
Vorträge, Diskussionen und Gespräche mit den
Preisträgern und Juroren der vier Wettbewerbs-
sparten des Prix Ars Electronica 98
Computeranimation/Visual Effects
 mit: Kazuma Morino/J, Tamás Waliczky/H,
 Liang-Yuan Wang/Taiwan, Jean Bolte /USA,
 Christophe Hery/USA, Robert Legato/USA
 Moderation: Mark Dippé/USA
Computermusik
 mit: Hans Tutschku/D, Aquiles Pantaleao/
 BRA/GB, Peter Bosch/Simone Simons/NL/D

Moderation: Naut Humon/USA
.net
 mit: Rasa Smite/LV, Kazuhiko Hachiya/J,
 Knowbotic Research – Christian Hübler/D/A
 Moderation: Joichi Ito/J
Interaktive Kunst
 mit: Peter Broadwell/Rob Myers/USA ,
 Christian Möller/D, Maurice Benayoun/
 Jean-Baptiste Barrière/F
 Moderation: Machiko Kusahara/J

Cyberarts 98
Prix Ars Electronica Ausstellung

O.K Centrum für Gegenwartskunst

Anerkennungen Interaktive Kunst:
Audible Distance
 Akitsugu Maebayashi/J
Holodeck
 Joseph Michael/GB
Sound Mapping
 Iain Mott, Jim Sosnin, Mark Razewski/AUS
 Ambulante Performance im öffentlichen
 Raum.
Focus
 Tamás Waliczky/H
Boundary Functions
 Scott-Sona Snibbe/USA
Byte
 Christoph Ebener, Uli Winters/D
Bernadette
 Lisa Prah/USA
Case Study 309
 Tammy Knipp/USA
Project Paradise
 Centre for Metahuman Exploration/USA
Krachtgever
 Peter Bosch, Simone Simons NL/E
 *Prix Ars Electronica 98 – Goldene Nica
 Computermusik*
Border Patrol
 Paul Garrin, David Rokeby USA/CDN
 *Prix Ars Electronica 97 – Auszeichnung
 Interaktive Kunst*
Cybergeneration – u19 freestyle computing
 Präsentation der ausgewählten Arbeiten
 der Jugendkategorie.
 Titanic – der Film: Die anonymen Titaniker
 *Goldene Nica Cybergeneration–u19 freestyle
 computing*
 Midi Paint: Leonhard Huber. *Auszeichnung
 Cybergeneration–u19 freestyle computing*
 Referate-Fundus: Stephan Mittendorfer.
 *Auszeichnung Cybergeneration–u19 freestyle
 computing*
*Anerkennungen Cybergeneration–u19 freestyle
computing:*
 New Mouse: Martin Ankerl
 Würstelstand: Futureware 2001

Der Traum des Computers: Gottfried Haider
Blauer Nachthimmel: Verena Holzknecht
100 Jahre Pinzgaubahn: Informatikgruppe
der Hauptschule Mittersill
Legodogs: Helmut Klinger
Evolution: Alexander Kvasnicka
Lost Poem: Doris Mätzler/Jürgen Bereuter
38911 Basic Bytes Free: Kathrin Meralla
Life in the 90ies: Thomas Oberhofer
Der virtuelle Blindenstock: Paul Pak
Nightmare on Rainberg: Thomas Pintaric/
Christoph Sprenger/ Alexander Koschier
Well: Peter Plessas
Generation 1.x: Markus Strahlhofer
3A im Internet: 3A Klasse, Volksschule Ver-
einsgasse, Wien
**Cybergeneration – u19 freestyle computing
Preisverleihung**
Preisverleihung an die GewinnerInnen der
Jugendkategorie des Prix Ars Electronica 1998.

Prix Ars Electronica Videothek
O.K Centrum für Gegenwartskunst, Mediendeck
Die besten Computeranimationen und Visual
Effects des Prix Ars Electronica 98
Programm:
The Sitter: Liang-Yuan Wang
Landscape: Tamás Waliczky
Runners: Kazuma Morino
Replica: Violet Suk/Martin Koch
Geri's Game: Jan Pinkava
La Tour de Vesone: Sebastien Larrue
CPU: Gilbert Wayne
A-Light: Alain Thibault/Yan Breuleux
Titanic: Robert Legato/Digital Domain
Spawn: Christophe Hery/ILM
Men in Black: Robert Coleman
Fifth Element: Mark Stetson/Digital Domain
Zaijian: Nobuto Ochiai
Virtual Museum of History: Ben Stassen
U-Man: Julien Dajez
Trade Secrets from Violin Masters: Laurence
Leydier

Prix Ars Electronica Audiothek
O.K Centrum für Gegenwartskunst
Programm:
Three Inconspicuous Settings: Aquiles
Pantaleao/BR
extremités lointaines: Hans Tutschku/D
Foil-Counterfoil: Adrian-J. Moore/GB
Little Animals: Natasha Barrett/GB
Empty Spaces: Ambrose Field/GB
Gently Penetrating: Hildegard Westerkamp/CDN

EXHIBITIONS

Themenausstellung INFOWAR
Brucknerhaus

Happy Doomsday!
 Cãlin Dan NL/RO
Ultima Ratio
 Daniela Alina Plewe/D
®™arK trade show booth
 RTMark/USA
(Two-Line) Orbital Elements
 Dietmar Offenhuber/A, Christian H. Bock/A
Noto Foto-O-Ton
 Christian Helbock/A
Hommage à Hedy Lamarr & George Antheil
 Richard Brem/A
Plasm: not a crime
 Peter Broadwell/USA, ROB Myers/USA
 Prix Ars Electronica 98: Auszeichnung
 Interaktive Kunst
Artists Rifles
 Paul M. Smith/GB
Radiation
 Robert Adrian/CDN/A , Norbert Math/A
Raylab I.
 Donaupark
 von Projekt Atol/SLO/USA
 vorgestellt von Project Atol und Pact Systems
Elegy for a Dream City
 Fähre/Ars Electronica Ship Shuttle
 Ilana Zuckerman/Israel
Clickscape 98
 Stadtwerkstatt, Nibelungenbrücke,
 EA Generali-Gebäude
 Ansichten von Linz. Clickable Public Space
 Stadtwerkstatt/A
Minenfeld
 Hauptplatz
 Konzept: Gerfried Stocker
 In Kooperation mit Nachbar in Not und
 MAG (Mines Advisory Group). Begleitende
 Informationsveranstaltungen im Alten Rat-
 haus. Organisation: Birgit Rabl.

Cyberarts 1998
Prix Ars Electronica Ausstellung
O.K Centrum für Gegenwartskunst
Siehe Seite 298

Ars Electronica Center Exhibition
1998/1999
Ars Electronica Center

Untergeschoss
Processing Image
 Ofelia da Silva Zaragoza Malheiros/P
tx-transform
 Martin Reinhart,Virgil Widrich/A

Iamascope
Sydney Fels/CDN, Kenji Mase/J
Revolving Black Holes
Hadeyuki Hashimoto /J
Erdgeschoss/Zwischengeschoss
The Visible Human
Museumslift
Ars Electronica Futurelab, Dietmar Offenhu-
ber, Gerda Palmentshofer, Herman Wakol-
binger, Volker Christian. Mit Unterstützung
der U.S. National Library of Medicine (Natio-
nal Institute of Health, Bethesda, Maryland.
Netsound II
Sensorium Team/J
1. Obergeschoss
Ground Truth
Machine Child/USA
Machine Child-Performance-Kollektiv: Robin
Bargar, Insook Choi, Alex Betts,Vijendra
Jaswal, Ed Peters, Rahul Singhal, Juhan Sonin
Nomads
Dietmar Offenhuber, Markus Decker, Gerda
Palmetshofer/A
Realisiert im Ars Electronica FutureLab
Digital Fukuwarai – Telepuzzle
Hiroshi Matoba/J
2. Obergeschoss
Post Pet
Kazuhiko Hachiya/J
10_Dencies
Knowbotic Research/D/A
Prix Ars Electronica 98 – Goldene Nica .net
Ars Electronica Mediathek
Ars Electronica Center
Dawn: Anthony Rowe,Vassilios Alexiou,
James Lane, Nick Searle/GB
Wunderwelt Interaktiver Computergraphik:
Kurt Endl, Robert Endl/D
Crooner: Mogens Jacobsen/DK
Trance Machine: Anja Wiese/D
Avila Virtual: Pedro Morales/VEN
Lotus Spring: Lifeng Wang/CDN

CAVE
Ars Electronica Center
Kunst und Museumsprojekte:
World Skin
Maurice Benayoun/Jean-Baptiste Barrière/F
Prix Ars Electronica 98 – Goldene Nica
Interaktive Kunst
Software-Entwicklung: Patrick Bouchaud,
Kimi Bishop, David Nahon
Graphische Bearbeitung: Raphaël Melki
Produktion: Ars Electronica FutureLab,
Z.A. Production/Silicon Graphics, Europe
Credits: Daniela Basics, Zorha Balesic,
Laurent Simonini, Pierre Beloin, Guergana
Novkirichka

Realisiert innerhalb des Ars Electronica
Research & Residence Program 97
Mitologies
Hisham Bizri/Lebanon, Maria Roussos/USA
Ein gemeinsames Projekt von Joe Alexander,
Hisham Bizri, Alan Cruz,Tomoko Imai, Alan
Millan, Dave Pape, Maria Roussos,
Electronic Visualization Laboratory
The Thing Growing
Josephine Anstey, Dave Pape/USA, EVL
Historiae Naturalis
Dave Pape, EVL
Industrie – und Architekturprojekte:
Projekt Wittmann
Interfacesimulation für Linearsysteme
Ars Electronica Futurelab/A
Horst Hörtner, Andreas Jalsovec, Cahya Wi-
rawan, Joachim Smetschka, Klaus Taschler,
in Zusammenarbeit mit Wittmann Kunst-
stoff Geräte GmbH
PSA – Picasso Designstudie
Automobil Design Studie. Ars Electronica
Futurelab in Zusammenarbeit mit PSA

Ars Electronica Center – Events 1998
Disparate Multisensory Texture
Ars Electronica Center, Siemens Forum Wien
6. März 1998
Isabella Bordoni/I, Margarete Jahrmann/A,
Andrea Sodomka/A . Simultan-Performance
über Bild-, Ton- und Datennetze. Frauen und
neue Technologien: Videokonferenzschal-
tung zwischen Ars Electronica Center und
Siemens Forum Wien. Mit Unterstützung
von: BM Barbara Prammer, Linzer Frauenbü-
ro. Projektorganisation: Jutta Schmiederer
Intertwinedness II
Reflecting the structure of the net
Ars Electronica Center
19. Mai – 22.Juni 1998
Vorlesungs- und Eventreihe von Ars Electro-
nica Center, Archimedia Institut for Arts and
Technology, Hochschule für Gestaltung Linz
in Zusammenarbeit mit der Universität
Linz, Institut für Neuere Geschichte und
Zeitgeschichte, Institut für Philosophie und
Wissenschaftstheorie, Kulturinstitut an der
Johannes Kepler Universität Linz. Programm:
Christa Schneebauer und Margarete Jahr-
mann. Paul Miller a.k.a. DJ Spooky, Faith
Wilding, Sally Jane Norman, Christina von
Braun, F.E. Rakuschan, John Hopkins, Ravi
Sundaram, Hartmut Winkler
@vent
Ars Electronica Quarter/Donautor
18. Dezember 1998
Live: EPY (Sabotage)
DJ's: DJ Evva (FÖN), DJ'Ingle Bells (Heaven)

Visuals: SKOT
Konzept und Programm: Fadi Dorninger

EVENTS & PERFORMANCES

Censoratorium
O.K Centrum für Gegenwartskunst
Rupert Huber/A, Gisburg/USA, Anna
Clementi/I, Bettina Wackernagel/D, Mike
Daliot/A, Isabella Bordoni/I, Richard
Dorfmeister/A, Daniel Scheffler/D

Nerve Theory: Shades of Catatonia
O.K Centrum für Gegenwartskunst
Tom Sherman/CDN/USA, Thomas Loibner/A

Global Hockets
Brucknerhaus
Supreme Particles + From Scratch/D/NZ
[From Scratch: Philip Dadson, Shane Currey,
Adrian Croucher, Darryn Harkness, Supreme
Particles: Michael Saup, Anna Saup,
Anna Niemetz, DJ Tricky Chris, Robert
O'Kane, Tech: Michael Hodgson, Chris Gee,
Grant Collie]

Solar – A Wardenclyffe Project
Hafen, Modellflughafen ASKÖ
Projekt Atol, Makro, Noto, Byetone, Komet,
Ahrich and colleagues/SLO/USA/D
In Kooperation mit Ars Electronica, Raster-
music/Noton Archiv für Ton und Nichtton

Pol
Posthof Linz
Granular Synthesis: Kurt Hentschläger &
Ulf Langheinrich/A
Eine Produktion von Ars Electronica 98,
Hull Time Based Arts, ZKM Karlsruhe

Staalplaat Sound of Music
Posthof Linz
mit Negativland/USA , People like Us/GB ,
Barbed/GB , Muzictoerist/NL
Konzeption/conception: Time's Up /A

Super Collider
Stadtwerkstatt, Ars Electronica Quarter/
Donautor, Ars Electronica Center/Sky
A sound accelerator von Fa.Huber/A
Peter Kruder/A, Richard Dorfmeister/A ,
Shantel/D, Daniel Haaksman/D, Sam
Auinger/A, Tosca/A, Lukas Ligeti/USA, Sofa
Surfers/A, Kurt Dahlke/D, Paloma/D, Jim
O'Rourke/USA, Rachel de Boer/NL, Julia
Zdarsky/A, Kurt Mayer/A, Scanner/GB,
Johannes Strobl/A, Hanno Leichtmann/D
In Zusammenarbeit mit Stadtwerkstatt,
G-Stone, Lowres

Ridin' a Train
Eine musikalische Nachtfahrt mit dem Zug
durch das Werksgelände der VOEST
Pan Sonic
Idee: Fadi Dorninger

Hacker-Meeting
HEART: Hackers Electronic Art
Donaupark
InfoWar aus der Sicht der Hacker und
Cypherpunks. Organisation: Patrice
Riemens, Hinde Ten Berge

openX
eine Versuchsanordnung
Brucknerhaus, Foyer

The Acoustic Space
Xchange Net.Audio & Radio Network
Initiiert von: E-Lab/LV
Mitarbeiter:
Rasa Smite/LV/E-Lab/Xchange, Raitis
Smits/LV/E-Lab/Ozone, Janis Garancs/LV/
SD/E-Lab/X-I.net, Borut Savski/SLO/Ministry
of Experiments, Rachel Baker/UK/PPP/Back-
space Radio, Heath Bunting/UK/radio@ira-
tional.org, Peteris Kimelis/LV/Aura/Ozone,
Martins Ratniks/LV, Arvids Alksnis/LV/Ozone,
Monika Glahn/D, Martin Schitter/A/XLR,
Jinx/H, Molnar Daniel-B2men/H/Pararadio,
Katarina Pejovic/SLO, Peter Kisin – DJ
Phill/SLO, Luka Princic – DJ Nova/SLO /MZX,
Zina Kaye/AUS/Hydrogen Jukebox, Pit
Schultz/D/Mikro, Thomas Kaulmann/D/RIS ,
Adam Hyde/AUS, Honor Harger/AUS/Radio-
qualia, Gio D'Angelo/UK/Backspace Radio
Remote Participants:
CONVEX TV /Berlin, XLR /Ljubljana-Graz-
Berlin, MINISTRY OF EXPERIMENT/Ljubljana,
PARARADIO/Budapest, BACKSPACE RADIO/
London, RIS/Berlin, WORKSPACE RADIO/
Kassel, AURA/International Radioring,
RADIOQUALIA/Adelaide, LJUDMILA/
Ljubljana, OZONE /Riga

Static – Between the Stations
on air – on line – on site
ORF Kunstradio

Kunstradio @ openX
eine Kooperation mit Radio FRO, MEGO,
U.R.L., First Floor Electronics Linz/First Floor
Electronics Vancouver: Random Radio Show
In Zusammenarbeit mit Hank Bull, Peter
Courtemanche, f.O.N., Tina Frank, Norbert
Math, Sergio Messina, Roberto Paci Dalò,
Gordan Paunovic, Peter Rehberg, Elisabeh
Schimana, Maria Schubert, Markus Seidl,
Matt Smith/Sandra Winter, Hildegard
Westerkamp, Eva Wohlgemut u.a.
Organisation: Elisabeth Zimmermann

Ars Radio
in Kooperation mit: Radio FRO
Beteiligte: August Black/Markus Seidl,
Disinformation, Akin Fernandez, Tina Frank,
F.O.N, Bruce Gilbert, Adam Hyde/Honor

Harger, Sergio Messina, Christof Migone/
Jocelyn Robert, Gordan Paunovic, Gert Jan
Prins, Peter Rehberg, Maria Schubert, Matt
Smith/Sandra Wintner, Eva Wohlgemut u. a.

The Long Night of Radio Art
produziert im ORF Landesstudio
Oberösterreich
gesendet auf ORF Ö 1 und FM4
In Kooperation mit Time's Up (Staalplaat
Sound of Music)

Swarm
Ricardo Dominguez /MEX/USA

Hacking Millennium Park
TNC Network – Beusch/Cassani/F

National Heritage
Graham Harwood/GB

An Art History
Wolfgang Temmel/A

Fernleihe
Karl Heinz Maier, Hans Kropshofer/A

Columbia
RelaX/A

Neo-Scenes Occupation
John Hopkins/USA

The Joy Ride Park
Sanjin Jukic/BIH

Nettime Bible
Diana McCarthy/USA/H u. a.

Rhizome
Alex Galloway/USA

Noisia/Vision
Virtuelle Klangkörper
Sabine Seymour/A, Tom Blue/A

closedX
Projektpräsentationen durch die Netzwerk-
künstler und Teilnehmer des
Hacker-Meetings HEART.

Info Weapon Contest
Präsentation der schlagkräftigsten zivilen
Info-Weapons aus dem Contest
Konzeption: Geert Lovink/NL
Organisation: Vuk Cosic/SLO

Ars Electronica 98 Festival Report – Online
Geert Lovink/NL, Josephine Bosma/GB,
Eric Kluitenberg/NL, Manuel
Schilcher/A

News Room
Ars Electronica FutureLab
Festivaldocumentation – Videoediting –
Videoencoding – Broadbandconnectivity –
System- und Usersupport
August Black, Oliver Frommel, Michael
Harbauer, Helmut Höllerl, Horst Hörtner,
Klemens Kitzberger, Didi Lassingleitner,
Pascal Maresch, Walter Palmetshofer, Ursula
Reiter, Marie Ruprecht, Andreas Scheiber,
Joachim Schnaitter, Karl Seiringer, Joachim
Smetschka, Johannes Stelzer, Klaus

Taschler, Daniel Wetscher, Claus Zweythurm
ENCART
Breitbandvernetzung zwischen Ars
Electronica Center, C3-Center for Culture &
Communication Budapest, V2_Organisatie
Rotterdam, ZKM Karlsruhe und GDM
St. Augustin

EUROPÄISCHER KULTURMONAT

Linz September 1998
Job Opera
Donaupark
Visualisierte Linzer Klangwolke
Klaus Obermaier, Robert Spour/A

Nexus
Ars Electronica Quarter
Installationen, Videos und Skulpturen
Bernard Bernatzik/A, Hannes Franz/A,
Werner Feiersinger/A, Sabina Hörtner/A,
Ivan Kafka/CZ, Katarina Matiasek/A, Flora
Neuwirth/A, Isa Rosenberger A, Keiko
Sato/J, Imogen Stidworthy/GB, Andrea
van der Straaten/D, Martin Walde/A
Kuratorin: Johanna Schwanberg
Projektleitung: Monika Leisch-Kiesel
Veranstalter: Institut für Kunst,
Katholisch-Theologische Hochschule

Kunst & Politik
KunstRaum Goethestraße
Robert Adrian X/CDN/A

Safe Harbours/Closing the Loop
Posthof

Clickscape 98: Ansichten von Linz.

Clickable Public Space
Stadtwerkstatt, Nibelungenbrücke,
EA Generali-Gebäude

Work&Culture
OÖ Landesmuseum

Hephaistos Goes East
Donaupark

Hybrid Factory
Alte Lederfabrik, Haselgraben

Poseidons Auge
Hafen

Orpheus//Donau//Euridike
Hafen

EMARE
European Media Artists in Residence
Exchange Program
Ars Electronica Center

EU-Förderprogramme für Kultur,
Forschung und Neue Medien
Ars Electronica Center
Informationsveranstaltung der SP-
Europaabgeordneten Maria Berger,
Ilona Graenitz und Hilde Hawlicek

Ars Electronica 99
Festival für Kunst, Technologie und Gesellschaft

LifeScience
4. – 9. September 1999

Veranstalter:
Ars Electronica Center Linz
Betriebsgesellschaft mbH
Geschäftsführer: Gerfried Stocker,
Mag. Wolfgang Modera
ORF Landesstudio Oberösterreich
Intendant: Mag. Kurt Rammerstorfer

Direktorium, künstlerische Leitung
Gerfried Stocker, Ars Electronica Center
Dr. Christine Schöpf, ORF Landesstudio
Oberösterreich
Produktion: Mag. Jutta Schmiederer

Mitveranstalter Ars Electronica 99:
Brucknerhaus
O.K Centrum für Gegenwartskunst
LifeScience-Symposium in Kooperation mit
Novartis – New Skills in the Science of Life

Prix Ars Electronica 99
Internationaler Wettbewerb für Cyberarts
Veranstalter: ORF Landesstudio Oberösterreich
Idee: Dr. Hannes Leopoldseder
Konzeption: Dr. Christine Schöpf
Finanzen: Dkfm. Heinz Augner
Organisation: Gabi Strutzenberger, Judith Raab

CONFERENCES

Netzwerk-Symposium
Moderation: Birgit Richard/D

Ars Electronica 79 – 99
Brucknerhaus
4. September
Roy Ascott/GB, Edouard Bannwart/D, Karel
Dudesek/A, Herbert W. Franke/D, Walter
Haupt/D, Hannes Leopoldseder/A, Otto
Piene/USA, Itsuo Sakane/J, Christine Schöpf/A,
Gerfried Stocker/A, Peter Weibel/A, Wolfgang
Winkler, Wolfgang Lehner/A, Ulli A. Rützel/D,
Gottfried Hattinger/A, Chris Wedge/A, Christa
Sommerer/A, Joichi Ito/J, Siegbert Janko/A,
Raimund Schumacher/A, Martin Sturm/A,
Wolfgang Modera/A, Machiko Kusahara/J
Moderation:
Hannes Leopoldseder/A, Christine Schöpf/A

Themensymposium
LifeScience
Brucknerhaus
5. – 6. September
Klaus Ammann/CH

Lori B. Andrews/USA
R.V. Anuradha/India
Zhangliang Chen/PRCH
George Gessert/USA
Herbert Gottweis/A
Gunther von Hagens/D
Dean H. Hamer/USA
Eduardo Kac/USA
Daniel J. Kevles/USA
Robert P. Lanza/USA
Bruno Latour/F
Dorothy Nelkin/USA
Birgit Richard/D
Jeremy Rifkin/USA
Kari Stefansson/ISL
Moderation: Manuel deLanda/USA

„Und was ist daran Kunst?"
... und andere Partykiller aus
20 Jahren Ars Electronica
Brucknerhaus
9. September
Alex Adriaansens/NL, Bob Adrian/CAN/A,
Roy Ascott/UK, association.creation/A/H, Sam
Auinger/A, Rachel Baker/UK, Beusch/Cassani/
F/CH, Heath Bunting/UK, Douglas Davies/USA,
Tim Druckrey/USA, Christoph Ebener/D, Karl
Heinz Essl/A, etoy.ZAI/CH, Franz Fischnaller/I,
Heidi Grundmann/A, Helmut Gsöllpointner/A,
Daniel Haaksman/D, Eduardo Kac/USA, Myron
Krueger/USA, Machiko Kusahara/J, Just Merrit/
A, Olia Lialina/RUS, Heimo Ranzenbacher/A,
Birgit Richard/D, Robin Rimbaud aka Scanner/
UK, Rasa Smitis/LV, Peter Weibel/A
Veranstaltungsdesign/Design:
Bruno Beusch/Tina Cassani/F (TNC Network)
mit: Sabine Wahrmann/D, Marco Repetto/I/CH,
Stefan Biabiany/CH, Diego Bontognali/CH,
Simon Piniel/CH

PRIX ARS ELECTRONICA

Internationaler Wettbewerb für Cyberarts

Veranstalter: ORF Landestudio Oberösterreich
Idee: Dr. Hannes Leopoldseder
Konzeption: Dr. Christine Schöpf
Finanzen: Dkfm. Heinz Augner

.net
Jury: Derrick deKerckhove, Lisa Goldman,
Joichi Ito, Declan McCullagh, Marleen Sticker
Goldene Nica: Linus Torvalds/SF
Auszeichnungen: Willi Henshall (GB) /Matt
Moller (USA), Jean-Marc Philippe/F
Anerkennungen: David P. Anderson, Joanna
Berzowska, CAAD/Eidgenössische Technische
Hochschule Zürich, Free B92, Eric Loyer, Daniel

Julià Lundgren, Fumio Matsumoto/Shoei Matsukawa, Mark Napier, Nick Philip, Ramana Rao, Christa Sommerer/Laurent Mignonneau, Martin Wattenberg/Joon Yu

Interaktive Kunst
Jury: Brian Blau, Machiko Kusahara, Hans-Peter Schwarz, Paul Sermon, Jon Snoddy
Goldene Nica: Lynn Hershman/Construct Internet Design/USA
Auszeichnungen: Perry Hoberman/USA, Luc Courchesne/CDN
Anerkennungen: Joachim Blank/Karl Heinz Jeron, Christoph Ebener/Frank Fietzek/Uli Winters, Kouichirou Eto/Canon ARTLAB, F.A.B.R.I.CATORS/K-Team, Beate Garmer, Bill Keays/Ron MacNeil, Russet Lederman, Eric Paulos, Simon Penny, Daniel Rozin, Stefan Schemat/Michael Joyce/Hiroki Maekawa/Dominica Freyer/Burki Carstens/Mike Felsmann/Isabella Bordoni/Roberto Paci Dalò, Christa Sommerer/Laurent Mignonneau

Computeranimation/Visual Effects
Jury: Maurice Benayoun, Ines Hardtke, Robert Legato, Barbara Robertson
Goldene Nica: Chris Wedge/USA,Visual Effects-Team von „What Dreams May Come"/USA
Auszeichnungen: Bob Sabiston/Tommy Pallotta/USA, John Lasseter/Andrew Stanton/USA, CFC – Computer Film Company/UK, Alain Escalle/F
Anerkennungen: Jun Asakawa/Toshifumi Kawahara, Erwin Charrier, Paul Kaiser/Shelley Eshkar/Bill T. Jones, Christopher Landreth, William Le Henanff, Patrice Mugnier, Didi Offenhuber, Bruce Pukema, Daniel Robichaud, Christian Sawade-Meyer, Seiji Shiota/Tohru Patrick Awa, Lev Yilmaz/Emre Yilmaz, Manuel Horrillo Fernandez, Fuel - Peter Miles/Damon Murray/Stephen Sorrell, Ray Giarratana, Geoffrey Guiot/Bruno Lardé/Jerôme Maillot, Juan Tomicic Muller, Phil Tippett/Craig Hayes

Digital Musics
Jury: Kodwo Eshun, Naut Humon, Jim O'Rourke, Robin Rimbaud, Laetitia Sonami
Goldene Nica: Chris Cunningham und Aphex Twin/UK
Auszeichnungen: Ikue Mori/J, Mego/A
Anerkennungen: Stefan Betke, Paul DeMarinis, Rose Dodd/Stephen Connolly, John Duncan/Francisco López, Bernhard Günter, Richard Hawtin aka Plastikman, MAZK/Zbigniew Karkowski/Masami Akita, Mouse on Mars, Terre Thaemlitz, [The User], Tone Rec/Gaëtan Collet/Noëlle Collet/Claude Pailliot/Vincent Thierion, Ralf L. Wehowsky

Cybergeneration – u19 freestyle computing
Jury: Sirikit Amann, etoy.ZAI, Norman Filz, Marcus Riebe, Stefan Sagmeister
Goldene Nica: (conspirat)./A
Auszeichnungen: Phil E. Haindl/A, Alexander Fischl/Gregor Koschicek/A
Anerkennungen: Franz Berger, Sebastian Endt, Simon Gaßner, Alexander Kvasnicka, Stefanie Mitter, Takuya Nimmerrichter, Simon Oberhammer, Benedikt Schalk, Markus Strahlhofer, Patrick Toifl, Stefan Trischler, Armin Weihbold

Die Goldene Nica
Prix Ars Electronica Gala 99
ORF Landesstudio Oberösterreich – 3sat
Verleihung der Goldenen Nica 99
Moderation: Sigrid Steingruber, Josef Broukal

Prix Ars Electronica Forum
ORF Landesstudio Oberösterreich
Vorträge, Präsentationen, Diskussionen von und mit den Preisträgern des Prix Ars Electronica:
Computeranimation, Visual Effects
Bob Sabiston/Tommy Pallotta, Flat Black Films/USA, Rick Sayre, PIXAR/USA, Chris Wedge, Blue Sky Studios/USA, Alain Escalle, TRIX/F, Paddy Eason/Dan Glass, Computer Film Company/UK, Bernd Angerer, Digital Domain/USA/A
Moderation: Horst Hörtner, Ars Electronica Center/A
Digital Musics
Ikue Mori/J, Richard James (Aphex Twin)/Chris Cunningham/UK, Peter Rehberg/Christian Fennesz/UK/A
Moderation: Naut Humon/USA
Interaktive Kunst
Luc Courchesne/CDN, Perry Hoberman/USA, Lynn Hershman, Construct Internet Design/USA
Moderation: Machiko Kusahara/J
.net
Karin Jestin/Jean-Marc Philippe, KEO/F, Willy Henshall, Res Rocket/USA, Linus Torvalds
*Moderation:*Joichi Ito/J

Electronic Theatre
O.K Centrum für Gegenwartskunst
Die besten Computeranimationen und Visual Effects des Prix Ars Electronica 99.
Programm
Bunny: Chris Wegde
A Bug's Life: John Lasseter/Andrew Stanton/Pixar
Snack and Drink: Bob Sabiston/Tommy Pallotta/Flat Black Films
The Polygon Family: Toshifumi Kawahara/Jun

Asakawa
Bingo: Christopher Landreth/Alias|Wavefront
Stationen: Christian Sawade-Meyer
Bike – A Roadmovie: Dietmar Offenhuber/Ars
Electronica FutureLab
Ghostcatching: Paul Kaiser/Shelley Eshkar/
Bill T. Jones
Tightrope: Daniel Robichaud/Digital Domain
William Le Henanff: **Ultima Forsan**
Un Temps Pour Elle: Erwin Charrier/Heure
Exquise
En Dérive: Patrice Mugnier/Heure Exquise
Bad Night: Lev Yilmaz/Emre Yilmaz
The FLY BanD!: Seiji Shiota/Tohru Patrick Awa
Ronin Romance Classics: Bruce Pukema
No Way: Geoffrey Guiot/Bruno Lardé/Jerôme
Maillot
Alaris „Aliens": Juan Tomicic Muller/Daiquiri/
Spainbox
Lottery „Fantasy": Manuel Horrillo
Fernandez/Daiquiri/Spainbox:

Cyberarts 99
Prix Ars Electronica Ausstellung
O.K Centrum für Gegenwartskunst

Difference Engine # 3
Lynn Hershman/USA
In Zusammenarbeit mit Construct Internet
Design. *Goldene Nica Interaktive Kunst*
Landscape One
Luc Courchesne/CDN
Auszeichnung Interaktive Kunst
Systems Maintenance
Perry Hoberman/USA
Auszeichnung Interaktive Kunst
Anerkennungen Interaktive Kunst:
Dispersion
Eric Paulos/USA
Hamster – symbiotic exchange of hoarded energy
Christoph Ebener, Frank Fietzek, Uli Winters/D
Easel
Daniel Rozin/USA
Memories of Place: NYC Thought Pictures
Russet Lederman/USA
metaField Maze
Bill Keays, Ron MacNeil/CDN
Scanner++
Joachim Blank & Karl Heinz Jeron/D
SoundCreatures
Canon ARTLAB: Kouichirou Eto/J
In Zusammenarbeit mit IMRF (International
Media Research Foundation)
Sound Composition: Suguru Yamaguchi
Robots Production: Akihito Tagawa
(University of Tsukuba)
Visual Direction: Ichiro Higashiizumi

HAZE Express
Christa Sommerer/A/F/J, Laurent
Mignonneau/J
**Descartes oder die Einsamkeit der
interaktiven Skulptur**
Beate Garmer/D
Traces
Ars Electronica Center
Simon Penny/USA
Augmented Reality Fiction
Ars Electronica Center
Stefan Schemat, Hiroki Maekawa, Dominica
Freier, Burki Carstens, Mike Felsmann/D
Cybergeneration – u19 freestyle computing
*O.K Centrum für Gegenwartskunst/Global
Village – Arena*
(conspirat.): Raimund Schumacher/Jürgen
Oman. *Goldene Nica Cybergeneration – u19
freestyle computing*
**Von Ignoranten, Betriebssystemen und Atomra-
keten:** Alexander Fischl/Gregor Kochicek.
*Auszeichnung Cybergeneration – u19 free-
style computing*
Safer Reality – Screwing up Reality's Interface:
Phil E. Haindl. *Auszeichnung Cybergeneration
– u19 freestyle computing.*
*Anerkennungen Cybergeneration – u19 freestyle
computing:*
Webpage der HTL BRAUNAU: Franz Berger
Schweineherde: Sebastian Endt
Matura-CD der 8a und c: Simon Gassner
Good Morning: Alexander Kvasnicka
Unser Tag: Takuya Nimmerrichter
Projekt Leben: Simon Oberhammer
Mia Topo: Benedikt Schalk
AREA 51 – Back to the Surface: Markus Strahl-
hofer
The Tortoise and the Rabbit: Partik Toifl
Scream: Stefan Trischler
Simple online Security SOS: Armin Weihbold
**Cybergeneration – u19 freestyle computing
Preisverleihung**
Preisverleihung an die GewinnerInnen der
Jugendkategorie des Prix Ars Electronica

Exhibitions
Themenausstellung LifeScience
Brucknerhaus
The Creative Gene Harvest Archive
Gene Genies Worldwide/USA
Stage Elements Humans
Gina Czarnecki/UK
Human time anatomy
Anita Gratzer/A
Anatomy Art
Gunther von Hagens/D

Micro Friendship
Yasushi Matoba/J
Littoral Zone
Tiffany Holmes/USA
Science Education Team/A
Vermittlungsprogramm
LifeScience Projektpräsentationen
Piero Gilardi, Federika Russo/I, Dreamtech/
USA, Gene Genies Worldwide/USA, Fakeshop/
USA, C. Ebner, F. Fietzek, U. Winters/D
Moderation· Birgit Richard/D
The Dynamic Cell
CD-ROM
Kenneth Dawson/IR, Thomas Devlin/USA,
Michael Klymkowsky/USA, Yuri Rochev/RU,
Martin Steer/IR, Michael Snyder/USA,
Jonathan Widom/USA
Genesis
O.K Centrum für Gegenwartskunst
Eduardo Kac/USA
Spike
O.K Centrum für Gegenwartskunst
Gail Wight/USA
National Heritage
Hauptplatz
Harwood/Mongrel/UK

Cyberarts 99
Prix Ars Electronica Ausstellung
O.K Centrum für Gegenwartskunst
Siehe Seite 305

Ars Electronica Center Exhibition
1999/2000
Ars Electronica Center
Untergeschoss
Touchscreen
Anna Anders/D, Programming: Klaus Gasteier
Anomalocaris
Hiroo Iwata/J
Tracking the Net
Franz Fischnaller, Marco Monzani/I
Erdgeschoss/Zwischengeschoss
TeleZone
An architecture for net architecture
Ars Electronica FutureLab/A
Ein Projekt von Ars Electronica Center und
Telekom Austria AG. Mit Unterstützung von
Wittmann Roboterbaureihen und Automa-
tisierungsanlagen.
Realisierung: Ars Electronica FutureLab;
Projektleitung: Erich Berger/ Ars Electronica
FutureLab; Concept Consultant: Ken Gold-
berg/UC Berkeley USA; Programmierer:
Wolfgang Beer, Volker Christian, Oliver
Frommel, René Pachernegg, Jörg Piringer,
Nestor Pridun, Christian Retscher, Markus
Seidl, Martin Wiesmair, Gunther Schmidl;
Web-Design: igw gemeinsam mit greger-

pauschitz. f.o.p; PR: Ursula Kürmayr, Pascal
Maresch, Florian Sedmak, Martin Lengauer.
Wissenschaftliche Begleitung:
DI Dr. Wilhelm Burger, Lehrgang für Medien-
technik und Design an der Fachhochschule
Hagenberg. Univ. Prof. DI Dr. Jacak Witold,
Lehrgang für Software Engineering an der
Fachhochschule Hagenberg. Univ. Ass. DI Dr.
Peter Purgathofer, Institut für Gestaltungs
und Wirkungsforschung der TU Wien. Univ.
Ass. Mag Gerhild Götzenbrucker, Institut für
Publizistik und Kommunikations-wissen-
schaften der Universität Wien, Fachbereich
Elektronische und Neue Medien. Mag.
Bernd Löger, Zentrum für Alterswissen-
schaften und Sozialpolitikforschung an der
Niederösterreichischen Landesakademie
St. Pölten, Bereich Soziales und Gesundheit.
Ars Electronica Quarter
bump
association.creation/A/H
In Zusammenarbeit mit C3 Budapest, TU
Wien. Unterstützt von Stasto, Rockwell
Automation, Bosch, Bundeskanzleramt
Kunstsektion, Wissenschaftsministerium,
Österr. Kulturinstitut, Land Oberösterreich
Liquid Space
Werner Jauk, Heimo Ranzenbacher/A
In Zusammenarbeit mit ESC, Graz
1. Obergeschoss
Videoplace
Myron Krueger/USA, Technik: Katrin
Hinrichsen/USA
I Met-a-Morph
Myron Krueger/USA, Technik: Katrin
Hinrichsen/USA
Promenade
C3 – Márton Fernezelyi, Zoltan, Szegedy-
Maszak/H
ArchitecTours- VR-Bike/Millennium Dome
Ars Electronica Futurelab, Dietmar Offenhu-
ber, Andreas Jalsovec, Werner Pötzelberger,
Michaela Ortner, Markus Decker, Peter
Hössl, Jürgen Hagler, Christopher Lindinger,
Walter Frisch, Robert Praxmarer, Werner
Stadler, Land Design, Peter Higgins, Steve
Custard, Millennium Dome, London
The Bush Soul
Rebecca Allen/USA
Programmierung: Loren McQuade, Eitan
Mendelowitz, John Ying
Design virtuelle Welt: Daniel Shiplacoff, Jino
Ok, Peter Conolly, Damon Seeley, Karen Yoo,
Vanessa Zuloaga. Sound Design: Mark
Mothersbaugh, MutatoMusika. Zusätzlicher
Sound: Franz Keller, Jay Flood. Technische
Unterstützung: Maroun Harb. Mit Unter-
stützung von: Intel Corporation.

in/outSite
Ursula Damm, Michael Hoch/D
Motion picture
Emely Weil/USA
2. Obergeschoss
Nuzzle Afar
Masaki Fujihata/J
Small Fish – Screen Version
Kiyoshi Furukawa/J, Masaki Fujihata/J
Wolfgang Münch/D
Ars Electronica Mediathek
Präsentation ausgewählter CD-Roms aus den
Einreichungen zum Prix Ars Electronica 99.
Vjamm: Matt Black/UK
Stretching it wider: Zaki Omar/D
Tokyocity.ee: Raivo Kelomees/Estland
Sob: Marita Liulia/FIN
Syntagma – Bilder der Berührung: Valie
Export/A
Micros Universe: Catherine Nyeki/F
Muto: Kathryn Mew/AUS
Mut der Ahnungslosen: Lotio F./Rigoletti
M./D
The Five Reactive Books: John Maeda/USA
The Greatest Hits: Zoran Pantelic/FRY
Blix: Eric Zimmerman/USA
Web-Katalogarchiv – Ars Electronica 1979 – 1999
Ingrid Fischer-Schreiber, Jutta Schmiederer,
Helmut Einfalt, Stefan Adamski, Gerfried
Stocker, Horst Hörtner, Joris Gruber, Erich
Semlak, Astrid Benzer, Gabriele Hofer, Pascal
Maresch, Helmut Höllerl, Joachim Schnaitter,
Martin Oberhammer, Gunter Schmidl, Ars
Electronica Futurelab

CAVE
Kunst und Museumsprojekte:
CAVE
Peter Kogler, Franz Pomassl/A
Auftragsarbeit der Ars Electronica. Realisiert
im Ars Electronica FutureLab. Sound: Franz
Pomassl. Technisches Konzept: Dietmar
Offenhuber. 3D-Animation: Jürgen Hagler.
Video: Klaus Taschler. Programmierung:
Markus Greunz, Gerald Schröcker. Sound &
Trigger Programmierung: Markus Decker.
Koordination: Horst Hörtner, Pascal Maresch
Traces
Simon Penny/USA
Anerkennung interaktive Kunst. Vision sy-
stem: Andre Bernhardt. Sound code and
hardware engineer: Jamie Schulte. Graphics
code: Jeffrey Smith. Particle/Agent/Avatar
behaviors: Phoebe Senger. Siegerprojekt:
Cyberstar 98. Produziert am GMD-German
National Research Center for Information
Technology, Institute for Media Communi-
cation, Sankt Augustin, Germany (Produc-

tion: Monika Fleischmann, Koordination:
Jeremy Eccles) und an der Carnegie Mellon
University, Pittsburgh.
Special CAVE Presentations
Dan Sandin – EVL/USA
Industrie – und Architekturprojekte:
Sinus Objektbau
Ars Electronica Futurelab, Markus Greunz,
Horst Hörtner, Andreas Jalsovec, Pascal
Maresch, Alexander Wolf, Michaela Ortner,
Virtual Heavy Plate Mill
VAI Walzwerk Prozesssimulation
Ars Electronica Futurelab Dave Pape, Volker
Christian, Horst Hörtner, Andreas Jalsovec,
Gerald Kogler, Robert Praxmarer, Robert Abt,
Horst Köpfelsberger. In Zusammenarbeit
mit Institut für Wirtschaftsinformatik,
Softwareengeneering Prof. Gustav Pomber-
ger, Johannes Kepler Universität Linz
SolarCity 1
Ars Electronica Futurelab, Volker Christian,
Markus Greunz, Andreas Jalsovec, Werner
Pötzelberger, Alexander Wolf, Michaela Ort-
ner, Jürgen Hagler, Christopher Lindinger,
Nikolaus Diemannsberger
Visualisierung Lentos – Kunstmuseum Linz
Ars Electronica Futurelab, Horst Hörtner,
Andreas Jalsovec, Werner Pötzelberger,
Alexander Wolf, Michaela Ortner

Ars Electronica Center – Events 1999
Nuzzle Afar
Distance Affairs and Greetings
Ars Electronica Center, ZKM Karlsruhe, ICC Tokyo
Masaki Fujihata/J
Vortrag, Live-Schaltung, Projektpräsentation
und Videoshow. Live-Schaltung via Breit-
band zum ZKM Karlsruhe, Deutschland und
ICC, Tokio, Japan.
jomasounds
16. Juli 1999
Ars Electronica Quarter
image manipulation soundtrack
jomasounds.firstfloor.org/A
mindsweeper
Public online GAME-SOUND-VIDEO Party.
24. Oktober 1999
Ars Electronica Center, V2 Rotterdam, C3
Budapest
Christopher Lindinger, Andreas Jalsovec,
Dietmar Offenhuber, Horst Hörtner, Volker
Christian, Markus Decker, Stefan Eibelwim-
mer, Helmut Höllerl, Pascal Maresch. In Ko-
operation mit: V2 Rotterdam, C3 Budapest
@vent
17. Dezember 1999
Ars Electronica Quarter
Live: Familie Seelig (base records)

DJ: Electric Indigo (Wien)
Visuals/VJ: Sabine Stuller
Programm: Fadi Dorninger

Events & Performances

Progression
Brucknerhaus , Donaupark
Linzer Klangwolke 99
Peter Wolf, Michelle Wolf/A/USA
veranstaltet von Brucknerhaus Linz & ORF
Landesstudio Oberösterreich

OMV Klangpark
Brucknerhaus , Donaupark
Michael Nyman/UK, Robert Worby/UK, Fadi
Dorninger/A, Robin Rimbaud aka
Scanner/UK, Sam Auinger/A, Rupert Huber/
A, Gordan Paunovic/FRY, Joachim Schnaitter/
A, Markus Decker/A, Hubert Hawel/A

The Michael Nyman Band Concert
Brucknerhaus
The Michael Nyman Band/UK

Recombinant 9.9.99
Posthof, FM 4
Curation: Naut Humon/USA
Sound Traffic Control/USA, Mix Master
Mike/USA, Otomo Yoshihide/J, Barry
Schwartz/USA, Scratch Perverts/UK, DJ
Craze/USA, Ikue Mori/USA, Richie
Hawtin/CDN, Pole/D, The User/CDN, Scot
Jenerick/UK, Granular Synthesis/A, Thomas
Brinkmann/D, Sam Auinger/A, Rachel De
Boer/NL, Mazk/J, Powerbook Orchestra
(Mego)/A
featuring: Pita, Fennesz, Farmers Manual,
Rehberg & Bauer, General Magic, Haswell,
Hecker, Pop, cd_slopper, Skot
Virtual appearance modules from:
Christian Marclay/USA, Terre
Thaemlitz/USA, DJ Olive/USA, Carl
Stone/USA, Kit Clayton/USA
Plus special guests ...
Eine Veranstaltung von Ars Electronica
(In Kooperation mit Posthof Linz)

Ars Electronica Geburtstagsparty
Peter Behrens Haus
Stargäste aus 20 Jahren Ars Electronica
Moderation: Fritz Ostermayer
DJ's: DJ Evva, DJ DSL
Veranstaltungsdesign: Fadi Dorninger/A
Environment & Vj'ing: Marc Andre (MK
Visuelle Mediengestaltung), Hannes
Langeder, Monique Berger, Andrea Strasser,
Katharina Buschek, Marlene Haderer, Sabine
Stuller, Renée Stieger (MK Experimentelle
Visuelle Gestaltung)
(In Zusammenarbeit mit Universität für
künstlerische u. industrielle Gestaltung Linz)

bugrace99 – the world's fastest bug
Stadtwerkstatt
Stadtwerkstatt/A
In Kooperation mit ART & TEK (vorm.
Archimedia) Institut der Universität für
Gestaltung Linz
Im Auftrag von Ars Electronica 99

[Multiple_Dwelling]
Brucknerhaus
Fakeshop/USA

***prints* vier aminosäuren in folge**
Brucknerhaus
Robert Spour, Mario Veitl/A

Why Sync?
Ars Electronica Quarter
Rupert Huber/A
Sound-Installation
In Zusammenarbeit mit Musikprotokoll 99
Interface design: August Black
Programming und network design: Daniel
Scheffler

jomasounds
Ars Electronica Quarter
image manipulation soundtrack
jomasound.firstfloor.org/A

Radionight
Ö1, live vom O.K Mediendeck und im Internet.
Sound Drifting
ORF Kunstradio/A

Ridin' A Train
Eine musikalische Nachtfahrt mit dem Zug
durch das Werksgelände der VOEST
featuring: Radian/A
Idee: Fadi Dorninger/A

Grillabend im Global Village/BBQ
O.K Centrum für Gegenwartskunst/
Global Village – Arena

Oedipus
Theater Phönix
von Sophokles
Ein Spiel um Schicksal & Verblendung
Eine Produktion von Theater Phönix
Regie: Kaspar Erffa
Musik: Spour/Obermaier
Raum: Lindorfer
In Kooperation mit Ars Electronica FutureLab

Sound Drifting: I Silenzi Parlano Tra Loro
O.K Centrum für Gegenwartskunst –
Mediendeck
ORF Kunstradio/A
Robert Adrian/CAN/A, Roland Bastien/CDN,
Dusan Bauk/FRY, Spencer Cathey/USA,
Shawn Chappelle/CDN, Joelle Ciona/CDN,
Tim Cole/UK, Peter Courtemanche/CDN,
Justina Curtis/AUS, Tim Didymus/UK, Colin
Fallows/UK, Anna Friz/CDN, FON/A, Andrew
Garton/AUS, Grant Gregson/CDN, Josef
Gründler/A, Honor Harger/Adam Hyde/NZ,

Eileen Kage/CDN, Robert Klajn/FRY, Andreas Krach/Johannes Sienknecht/D, Norbert Math/A, Bill Mullan/CDN, Gordan Paunovic/FRY, Winfried Ritsch/A, Maria Schubert/A, Will Sergeant/UK, Markus Seidl/A, Matt Smith/SandraWintner/CDN/A, Sodomka/Breindl/A, Emilia Telese/I, Aleksandar Vasiljevic/ FRY, Eva Wohlgemuth/A
Curators: Colin Fallows/UK, Heidi Grundmann/A
Eine Koproduktion von Ö1- KUNSTRADIO, Liverpool Art School – John Moores University und Institut für elektronische Musik (IEM) an der Musikuniversität, Graz
In Zusammenarbeit mit:
Algorythmics, Alien Productions, Centre for Animation and Interactive Media, RMIT University, Melbourne, ESC, Graz, First Floor Eastside, Bauhausuniversität, Fakultät Medien, Weimar, Liverpool Institute for Performing Arts (LIPA), netzklang, radioqualia, SEAM, Studio für elektroakustische Musik an der Hochschule für Musik Franz Liszt, Weimar, SSEYO Ltd, Toy Satellite, Western Front Society

openX
eine Versuchsanordnung

Brucknerhaus
Kuratiert von August Black/USA/A
Gestaltung der openX-Zone: Scott Ritter/USA/A
Telezone
Ars Electronica FutureLab/A
Eine Architektur für Netz-Architektur
ftp_formless_anatomy
Eugene Thacker/USA
RTmark/USA
Simulation – heuristics – complexity – identity - ubiquity
C5/USA
Konsum Art_Server
Margarete Jahrmann, Max Mooswitzer/A
Starrynight
Rhizome/USA
The Soundtrack of Millennium Park
TNC Network/F
Free B92 net. Radio
B92/FRY
DreamTech International
DreamTech/USA
ACOUSTIC.SPACE 1999
net.radio OZOne/E-LAB/Xchange
arsradio 99
Radio FRO/A
Art of Work
Irational/UK

Work in Progress
Laura Bellof/SF
[robautech]
Rossi [Gerald] Rossbacher/A
Location=„Yes"
Olia Lialina/RUS
LinX3D
MaJa, Max Moswitzer/A
ENCART, European Network for CyberArt
Remote Presentations der ENCART-Kerngruppe Ars Electronica Center – Linz/A, C3 – Budapest/H, V2 – Rotterdam/NL und ZKM – Karlsruhe/D
closedX
Projektpräsentationen durch die Netzwerkkünstler: RTmark, TNC Network, C5, etoy, ENCART

PARTIZIPATIONEN

Creativity and Digital Media Expert Group
Ars Electronica Center
In Kooperation mit der Europäischen Kommission.
IST – Information Society Technologies
Ars Electronica Center
Content, Multimedia Tools and Markets
In Kooperation mit der Europäischen Kommission.
IRCAM
Ars Electronica Center
Vorträge und Diskussionen von und mit Künstlern und Forschern aus dem Bereich der elektronischen Musik.
V. Puig/M. Wanderley (Ircam, Paris), I. Zannos (SIM, Berlin), Sergi Jorda (IUA-UPF, Barcelona), Carola Boehm (Glasgow Univ.), François Pachet (Sony CSL Labs, Paris), Ronald Kuivila, Garth Paine
Art & Tec Institute Linz
Ars Electronica Quarter
Universität für Gestaltung, Linz
Up & Down – Die Aufzugsvertikale
Dr. Jeannot Simmen/D
Telematik – NetzModerneNavigatoren
Dr. Jeannot Simmen/D, Harald Krause
Präsentation Art & Tec Institute Linz
Prof. Dr. Herbert Lachmayer
Who is afraid of blue, red and green?
Galerie im Stifterhaus
Günther Selichar, Interaktive Installation
Don't Say Maybe
KunstRaum Goethestraße
Heimo Lattner/A

Ars Electronica 2000
Festival für Kunst, Technologie und Gesellschaft

NEXT SEX
Sex im Zeitalter seiner reproduktionstechni-
schen Überflüssigkeit
Sex in the Age of its Procreative Superfluousness

Linz, 2. — 7. September 2000

Veranstalter:
Ars Electronica Center Linz
Betriebsgesellschaft mbH
Geschäftsführer: Gerfried Stocker,
Mag. Wolfgang Modera
ORF Landesstudio Oberösterreich
Intendant: Kurt Rammerstorfer

Direktorium, künstlerische Leitung:
Gerfried Stocker, Ars Electronica Center
Dr. Christine Schöpf, ORF Landesstudio
Oberösterreich

Produktion: Mag. Jutta Schmiederer

Mitveranstalter Ars Electronica 2000:
Brucknerhaus
O.K Centrum für Gegenwartskunst

Prix Ars Electronica 2000
Internationaler Wettbewerb für
Cyberarts
Veranstalter: ORF Landesstudio Oberösterreich
Idee: Dr. Hannes Leopoldseder
Konzeption: Dr. Christine Schöpf
Finanzen: Dkfm. Heinz Augner
Organisation: Gabi Strutzenberger, Judith Raab

www.aec.at/nextsex
On-line Editor: Karin Rumpfhuber
Web-Design: Joachim Schnaitter, Ars Electronica
Futurelab
Programming: Erich Semlak, Joris Gruber,
Michael J. Wimmer, Ars Electronica Futurelab

CONFERENCES

Themensymposium
NEXT SEX – Sex im Zeitalter seiner reproduktions-
technischen Überflüssigkeit/Sex in the Age of its
Procreative Superfluousness
Brucknerhaus – Mittlerer Saal
3. – 4. September
Marie Luise Angerer/A
Bruce Bagemihl/USA
Kurt Behrends/D
Oron Catts, Ionat Zurr/AUS, Guy Ben-Ary/Israel
Carl Djerassi/USA
Joe Davis, Katie Egan/USA
Joanne Finkelstein/AU

Veena Gowda/India
Xin Mao/PRCH/UK
Marta de Menezes/P
Natacha Merritt/USA
Sergio Messina/I
Jens Reich/D
Stahl Stenslie/N
Allucquère Rosanne Stone/USA
Randy Thornhill/USA
Monika Treut/D/USA
Nobuya Unno/J
Moderation: Marie Luise Angerer/A,
Stahl Stenslie/N

Prix Ars Electronica Forum
ORF Landesstudio Oberösterreich
Vorträge, Präsentationen, Diskussionen von und
mit den Preisträgern und Juroren des Prix Ars
Electronica 2000: siehe Seite 311

PRIX ARS ELECTRONICA
Internationaler Wettbewerb für Cyberarts
Veranstalter: ORF Landesstudio Oberösterreich
Idee: Hannes Leopoldseder
Konzeption: Dr. Christine Schöpf
Finanzen: Dkfm. Heinz Augner

.net
Jury: Brian Blau/USA, Claudia Gianetti/E, Lisa
Goldman/USA, John Markoff/USA, Joichi Ito/J
Goldene Nica: Neal Stephenson/USA
Auszeichnungen: Sharon Danning/USA, TeleZone
Team: Erich Berger/Volker Christian/Ken Gold-
berg/Peter Purgathofer/A
Anerkennungen: Ichiro Aikawa, Natalie Book-
chin, Tom Corby/Gavin Bailey, exonemo
[Kensuke Sembo, Yae Aikawa], agent.NASDAQ
aka Reinhold Grether, Jie Geng, Ursula Hent-
schläger/Zelko Wiener, Stefan Huber/Ralph
Ammer/Birte Steffan, Patrick Lichty, Peter Mühl-
friedel/Gundula Markeffsky/Leonard Schaumann,
Kazushi Mukaiyama, 010010110101101.ORG

Interaktive Kunst
Jury: Masaki Fujihata/J, Peter Higgins/UK, Joa-
chim Sauter/D, Yukiko Shikata/J, Jon Snoddy/USA
Goldene Nica: Rafael Lozano Hemmer/CDN/Mex
Auszeichnungen: The Institute for Applied
Autonomy/USA, Golan Levin/USA
Anerkennungen: Julien Alma/Laurent Hart,
Michael Bielicky/Bernd Lintermann, Jim Cam-
pell, Rania Ho, Istvan Kantor (Monty Cantsin),
Orit Kruglanski, Jason E.Lewis/Alex Weyers,
Douglas Edric Stanley, Naoko Tosa/Sony-Kihara
Research Center, Tomoko Ueyama, Andrea
Zapp/Paul Sermon, Hiroaki Kitano (President,
The RoboCup Federation)

Computer Animation/Visual Effects
Jury: Mark Dippé/USA, James Duesing/USA, Ines Hardtke/CDN, Barbara Robertson/USA
Goldene Nica Computeranimation: Jakub Pistecky/CDN
Goldene Nica Visual Effects: Christian Volckman/F
Auszeichnungen Computeranimation: John Lasseter/Lee Unkrich/Ash Brannon/Pixar, Yasuo Ohba/USA
Auszeichnungen Visual Effects: Pierre Buffin/BUF/F, Markus Degen/A
Anerkennungen Computeranimation: Denis Bivour, Jean-François Bourrel/Jerôme Calvet, Paul Debevec, David Gainey, Cécile Gonard, Jean Hemez/Sébastien Rey, Dariuz Krzeczek, Guy Lampron, Charlotte Manning, Juliette Marchand, Timm Osterhold/Max Zimmermann, Makoto Sugawara
Anerkennungen Visual Effects: Zach Bell/Chris Gallagher/Steven Schweickart/Scott Smith, Pierre Buffin/BUF, N+N Corsino, Ray Giarratana/Digital Domain, Steve Katz/Josselin Mahot, Manfred Laumer, Fred Raimondi/Digital Domain, Lisa Slates/Chitra Shriram, Mark Stetson/Digital Domain, Alexander Szadeczky/Marcus Salzmann, Cornelia Unger, François Vogel

Digital Musics
Jury: Kodwo Eshun/UK, Naut Humon/USA, Zeena Parkins/USA, Robin Rimbaud/UK, Peter Rehberg aka Pita/A
Goldene Nica: raster-noton/Carsten Nicolai/D
Auszeichnungen: GESCOM, Chris Watson/UK
Anerkennungen: Maryanne Amacher, Dat Politics, Kevin Drumm, Mark Fell/Mat Steel, Ryoji Ikeda, Matmos (Andrew Daniel/M.C. Schmidt), Kaffe Mathews, Radian (Martin Brandlmayer/Stefan Nemeth/John Norman), Marcus Schmickler, Yasunao Tone, Uli Troyer, Erik Wiegand aka errorsmith

Cybergeneration – u19 freestyle computing
Jury: Sirikit M. Amann/A, Norman Filz/A, Florian Hecker/A, Horst Hörtner/A, Hans Wu/A
Goldene Nica: Verena Riedl/Michaela Hermann
Auszeichnungen: Gerhard Schwoiger, Erich Hanschitz/7B BRG Völkermarkt
Anerkennungen: Marlene Maier, Lisa Hofstadler, Markus Zwickl, Lisa Ratzenböck, Sebastian Endt, Kevin Ku, Mario Meir-Huber, David Feiler/Projektgruppe Brandfall, Gottfried Haider, Lukas Fichtinger/Thomas Köckerbauer, Alexander Fischl, Lukas Pilat

Die Goldene Nica
Prix Ars Electronica Gala 2000
ORF Landesstudio Oberösterreich – 3sat
Verleihung der Goldenen Nica 2000
Moderation: Ingrid Thurnher, Josef Broukal

Prix Ars Electronica Forum
ORF Landesstudio Oberösterreich
Präsentationen und Diskussionen von und mit den Preisträgern und Juroren des Prix Ars Electronica 2000:
Computer Animation, Visual Effects
Yasuo Ohba, Hiroshi Ohkubo/J, Brad West, PIXAR/USA, Jakub Pistecky/CDN, Yan Blondel, BUF Compagnie/F, Markus Degen/A, Christian Volckman/F
Moderation: Mark Dippé/USA
Digital Musics
Chris Watson, Jon Wozencroft, Touch/UK, Sean Booth, Rob Brown, Russell Haswell, GESCOM/UK, Carsten Nicolai, Olaf Bender, raster-noton/D
Moderation: Naut Humon/USA
Interaktive Kunst
Masaki Fujihata/J, Golan Levin/USA, The Institute for Applied Autonomy/USA, Rafael Lozano-Hemmer, Will Bauer/MEX/CDN
Moderation: Joachim Sauter/D
.net
Neal Stephenson/USA, Sharon Denning, Ken Ficara/USA, Erich Berger, Peter Purgathofer, Volker Christian – Ars Electronica FutureLab/A
Moderation: Joichi Ito/J

Electronic Theatre
O.K Centrum für Gegenwartskunst – Arena
Die besten Computeranimationen und Visual Effects des Prix Ars Electronica 2000
Programm:
Maly Milos: Jakub Pistecky/CDN
Chicken Supper: Zach Bell, Chris Gallagher, Steven Schweickart, Scott Smith/USA
PAF Le Moustique: Jean-Francois Bourrel, Jérôme Calvet; PAF Production/F
Musica Domestica: Denis Bivour/D
LowRider Crab: Charlotte Manning; Mental Images/USA
Potest: Steve Katz, Josselin Mahot; Pitch/USA
Use a Doodle on the Noodle: Timm Osterhold, **Max Zimmermann:** FIFTYEIGTH3D
Wege zur Qualität: Lisa Slates, Chitra Shriram; XAOS/USA
Fishing: David Gainey; PDI/Dream Works/USA
Vienna 1402: Alexander Szadeczky, Marcus Salzmann; Nofrontiere Design/A
Fiat Lux: Paul Debevec/USA
Captives: N+N Corsino; Heure Exquise!/F
Zen: Yasuo Ohba; Namco/J
Plume: Céline Gonard; CNBDI-LIN/F
Au loup: Jean Hemez, Sébastien Rey ; Heure Exquise !/F
Toy Story 2: John Lasseter, Lee Unkrich, Ash Brannon; Pixar Studio/USA
Supernova: Mark Stetson; Digital Domain/USA

Autotrader Woosh: Ray Giarratana; Digital Domain/USA
Levis Invisible Man: Fred Raimondi; Digital Domain/USA
Chemical Brothers: Pierre Buffin; BUF/F
Faux Plafond: François Vogel; Heure Exquise!/F
Sentinelles: Guy Lampron; Pygmee Productions/CDN
Loop: Makoto Sugawara. Production I. G/J
Unterwerk: Dariusz Krzeczek; Sixpack Film/A
Les Dépossédés: Iuliette Marchand; Heure Exquise!/F
Audi Telematic: Cornelia Unger; Velvet Mediendesign/D
Audi Feuerfilm: Manfred Laumer; Velvet Mediendesign/D
Disembodies: Markus Degen/A
Fight Club: Pierre Buffin; BUF/F
Maaz: Christian Volckman; Onyx Films/F

Cyberarts 2000
Prix Ars Electronica Ausstellung
O.K Centrum für Gegenwartskunst

Vectorial Elevation, Relational Architecture #4
 Rafael Lozano-Hemmer/MEX/CDN
 Goldene Nica Interaktive Kunst
GraffitiWriter
 O.K Centrum für Gegenwartskunst und öffentlicher Stadtraum
 The Institute for Applied Autonomy/USA
 Auszeichnung Interaktive Kunst
Audiovisual Environment Suite
 Golan Levin/USA
 Auszeichnung Interaktive Kunst
Anerkennungen Interaktive Kunst:
Unconscious Flow
 Naoko Tosa/J
As Much As You Love Me
 Orit Kruglanski/Israel
Watashi-chan
 Tomoko Ueyama/J
Asymptote
 Douglas Edric Stanley/USA
Free Range Appliances in a Light Dill Sauce
 Rania Ho/USA
Borderland
 Laurent Hart, Julien Alma/F
Experiments in Touching Color
 Jim Campbell/USA
The Active Text Project
 Jason E. Lewis, Alex Weyers/USA
A Body of Water
 Ars Electronica Quarter und O.K Centrum für Gegenwartskunst
 Andrea Zapp & Paul Sermon/D/UK

Outside the Circle of Fire
 Chris Watson/UK
 Auszeichnung Digital Musics
Medienlounge
 Video- und Audiodokumentation aller Einreichungen der Kategorien Computer Animation, Visual Effects und Digital Musics.
Prix Ars Electronica 2000 .net category
 Ars Electronica Center
 Präsentation der prämierten Projekte aus der .net Kategorie des Prix Ars Electronica 2000.
Cybergeneration – u19 freestyle computing
 Präsentation der ausgewählten Arbeiten der Jugendkategorie.
 Harvey: Verena Riedl/Michaela Hermann/Projektgruppe Harvey des BRG/BG Waidhofen a.d. Thaya, GarbageTM. *Goldene Nica Cybergeneration – u19 freestyle computing*
 Netdump: Gerhard Schwoiger/A
 Auszeichnung – u19 freestyle computing
 Cybervoting: Erich Hanschitz/7B BRG Völkermarkt/A: Alexander Blaschitz/Daniel Kummer/Roland Rabitsch/Martin Schliefnig/Michael Gissing/Joachim Doppelreiter
 Auszeichnung – u19 freestyle computing
Anerkennungen Cybergeneration – u19 freestyle computing:
 Unendliche Kunst: Marlene Maier
 Die Nixe meidet verschmutztes Wasser: Lisa Hofstadler
 Die Toteninsel: Markus Zwickl
 Dancing: Lisa Ratzenböck
 Zirkus/Affenbaum: Sebastian Endt
 Spooky: Kevin Ku
 MMH-Browser: Mario Meir-Huber
 Zeit.los: David Feiler/Projektgruppe Brandfall
 Chat: Gottfried Haider
 HTL-Adventure/Teilchenbeschleuniger des Grauens: Lukas Fichtinger/Thomas Köckerbauer
 TNSP-The Newtron Sound Project: Alexander Fischl
 Cybertec: Lukas Pilat
Ausstellungsgestaltung: Sabine Funk
Cybergeneration – u19 freestyle computing Preisverleihung
 Preisverleihung an die GewinnerInnen der Jugendkategorie des Prix Ars Electronica 2001.

EXHIBITIONS
Themenausstellung NEXT SEX
Brucknerhaus

Artistic Molecules & Audio Microscope
 Joe Davis, Katie Egan/USA
Tissue Culture & Art(ificial) Wombs
 Oron Catts, Ionat Zurr/AUS, Guy Ben-Ary/Israel

Nature?
Marta de Menezes/P
Digital Diary
Natacha Merritt/USA
Brave New Porn
Sergio Messina/I
KLONES
Dieter Huber/A
The I.K.U. Experience
Shu-Lea Cheang/USA
Tit for Twat
O.K Centrum für Gegenwartskunst – Mediendeck
Kaucyila Brooke/USA
sex i(n) motion
Hauptplatz
science education team/A
Spermrace
Hauptplatz und
www.aec.at/nextsex/spermrace/
medizinische Beratung: Dr. Gunter Schultes,
Zentrum f. Reproduktionsmedizin der Donau
Universität Krems, Dr. Andreas Jungwirth
Urologe, Androloge – Landeskliniken Salzburg
Laborteam: Mag. Gernot Bergthaler;
Dr. Edith Bogengruber; Dr. Edwin Engel;
Dr. Alexander Just, MTA Angela Straberger
Idee und Konzept: Gerfried Stocker und
Reinhard Nestlbacher
Organisation: Barbara Mülleder
Design & Inszenierung: Barbara Pitschmann
Webprogrammierung: Joris Gruber, Erich
Semlak, Gunther Schmidl, Gerd Eberhardt
Webdesign: Helmut Höllerl, Sebastian Polin
Digital Economy:Thomas Martetschläger

Cyberarts 2000
Prix Ars Electronica Ausstellung
O.K Centrum für Gegenwartskunst
Siehe Seite 312

Ars Electronica Center Exhibition 2000/2001
Ars Electronica Center
Untergeschoss
Talmud Project
David Small,Tom White/USA
Motion Picture
Emily Weil/USA
Ahead of Time – 3D-Modell Landesausstellung Wels
Ars Electronica Futurelab, Andreas Jalsovec,
Hans Hoffer
Tug of War
Peter Higgins, Gerfried Stocker, Joachim
Smetschka,Volker Christian, Ars Electronica
Futurelab, Gerald Schröcker, Werner Pötzel-
berger, Christopher Lindinger, Werner Stadler
Small Fish – The Installation
Kiyoshi Furukawa/J, Masaki Fujihata/J,

Wolfgang Münch/D, Programmier NTT
Video Screenings
Man As Species – Sputnik Mindtrends
Volume 8: Sputnik MindtrendsTM/USA
RoboCup: The RoboCup Federation
Sonderpreis der Jury für Interaktive Kunst
Video Dokumentation: Mika Taanila
1. Obergeschoss
Print on Screen
Eine Ausstellung, über Typografie,
Schriftbild und Text als Medium der Interak-
tion.
Text Organ
Jason E. Lewis, Alex Weyers/USA
Text Rain
Camille Utterback, Romy Achituv/USA
Alphabet Zoo & Type Me, Type Me Not
Peter Cho/USA
An Interactive Poetic Garden
David Small,Tom White/USA
Dakadaka
Casey Raes, Golan Levin/USA
Life Spacies II
Christa Sommerer, Laurent
Mignonneau/A/F/J
The Five Reactive Books
John Maeda/USA
Zeitgenossen—binary art site
Ursula Hentschläger, Zelko Wiener/A
Letters of BIT
Kenji Komoto/J
dominoa
dominoa-Projektgruppe: Petra Harml-Prinz,
Angelika Mittelmann, Renate Plöchl, Ilse
Wagner, Anja Westerfrölke/A/D
2. Obergeschoss
Discoder
exonemo: Kensuke Sembo, Yae Akaiwa/J
BeNowHere Interactive
Romy Achituv/USA
Mars Rover
Planetary Society
Ars Electronica Mediathek
Präsentation ausgewählter CD-Roms aus
Einreichungen zum Prix Ars Electronica
2000 und weitere Projekte.
Alles nur Fassade: Henrike Kreck/D
Notes01: Norbert Pfaffenbichler/A
Virtual Babyz: Andrew Stern/USA
#FFFFFF: Art Jones/USA
**All Power to the People – A Black Panther
Jazz Suite:** Paul Chan/USA
SKEYE: Tony Patrickson/USA
AVES – Audio Visual Environment Suite
Golan Levin/USA

CAVE
Ars Electronica Center

Kunst und Museumsprojekte:
Face à Face
Cathérine Ikam, Louis Fléri/F. Realisiert im Rahmen des Ars Electronica Research&Residence Programm 2000 mit Unterstützung von: Institut Image ENSAM, Cluny.
Ars Electronica Futurelab, Hörst Hörtner, Volker Christian, Andreas Jalsovec, Christopher Lindinger, Pascal Maresch, Iris Mayr, Robert Praxmarer, Joachim Schnaitter, Consulting: Sam Auinger.

Industrie – und Architekturprojekte:
VAI Continuous Casting Trainingssimulator
Ars Electronica Futurelab Dave Pape, Volker Christian, Horst Hörtner, Andreas Jalsovec, Gerald Kogler, Robert Praxmarer, Robert Abt, Horst Köpfelsberger

Solar City 2
Ars Electronica Futurelab, Andreas Jalsovec, Christopher Lindinger, Werner Pötzelberger, Jürgen Hagler, Volker Christian, Nikolaus Diemannsberger, Markus Greunz, Alexander Wolf, Michaela Ortner, Stadt Linz, Solar City Pichling, Gunter Amersberger

Hybrex Siemens ATD
Ars Electronica Futurelab, Horst Hörtner, Norman Lin, Andreas Jalsovec, Dietmar Offenhuber, Volker Christian, Gerald Kogler, Institut für Wirtschaftsinformatik, Software Engeneering Prof. Gustav Pomberger, JKU

Ars Electronica Center – Events 2000
hame [ha'me]
16. März 2000
Ars Electronica Quarter, Sky Media Loft
Laura Beloff/FIN, Markus Decker/A
Christopher Lindinger, Robert Abt
Realisiert im Rahmen des Ars Electronica Futurelab Artist in Residence Programme; ermöglicht durch Pépinières Européennes pour Jeunes Artist

Time Explorer – Geschichten aus der Zukunft
OÖ Landesausstellung 2000,
Minoritenkloster Wels
27. April – 2. November 2000
Time Explorer
Raum-Zeit-Spiegel
While you were here
Ars Electronica Futurlab

Gott ist ein DJ
5. – 17. Mai 2000
Sky Media Loft
Regie: Alexander Leiffheidt
Bühne: Andreas Thaler
Videokunst, Sujetdesign: Rachel de Boer
Musik: Fadi Dorninger

mit Kristina Brons, Sebastian Hölz
Koproduktion mit dem Landestheater Linz
jomasounds
14. Juli 2000
Ars Electronica Quarter
An evening with gymnastics, music and 3D
Feat.: snd: eleven, fadi, maex, yoschi, gfx: didi
global string
14.November 2000
Ars Electronica Center Linz, V2, Rotterdam
Atau Tanaka, Kasper Toeplitz
Telematische Installation und Performance.
@vent
21. Dezember 2000
Ars Electronica Quarter
Soundsgood Soundsystem presents Dancehallfieber feat. Mono, Thai Stylee, Natty Flo
VJ: Monika Jaksch. Programm: Joachim Schnaitter, Karin Rumpfhuber

EVENTS & PERFORMANCES

NEXT SEX on Ice
Ars Electronica Eröffnungsparty
Eishalle
Audio: Aziz (trife.life), DJ Ravissa, MC.Santana (hard: edged, Berlin)
VJ's: tba
Revue: Die Linzer Philharmonie, Eistänzerinnen & Eishockeycracks
Visuals: Renée Stieger, Sigfried Fruhauf, Paul Schneggenburger
Environment: Nicole Foelsterl, Tanja Lattner, Patrizia Schenk, Christoph Huemer, Hannes Langeder. Lichtdesign: Peter Thalhammer
Organisation: Martina Berger, Fadi Dorninger
Konzept: Fadi Dorninger
Visualisierte Linzer Klangwolke
Donaupark
actOpera – ein interaktives Spiel
Klaus Obermaier, Robert Spour/A
Veranstaltet von Brucknerhaus Linz und ORF Landesstudio Oberösterreich
Body Spin
Ars Electronica Quarter – Parkbucht
Time's Up/A
Eine Koproduktion von Time's Up und Ars Electronica Center
OMV Klangpark 2000
Brucknerhaus – Donaupark
Alexander Balanescu/UK, Isabella Bordoni/I, Rupert Huber/A, Sergio Messina/I, Siegfried Ganhör/A, To Rococo Rot/D
Eine Kooperation von Ars Electronica Center, Brucknerhaus, ORF
Movieline in der Hopfenlaube
Moviemento
Accion Mutante: Pedro Almodovar

Gendernauts: Monika Treut
Matador: Pedro Almodovar
La Flor de mi Secreto: Pedro Almodovar
Life Flesh: Pedro Almodovar
Todo Sobre mi Madre: Pedro Almodovar
**Oculation: Rogue Emissions In The Dark,
Films and Videos for a Synthetic Society**
Internationale Sammlung experimenteller
Film- u. Videoarbeiten zum Thema Sexua-
lität. Kuratiert von: Rajenda Roy und Anie
S8 Stanley. In Zusammenarbeit mit MIX
Festival New York. Organisation: Karin
Rumpfhuber
Lift by Off: Martha Colburn
Corporeal Self: Virgil Wong
3DME: Colleen Cruise
Grace: Lorelei Pepi
For Abramovic, Love Cocteau: Patty Chang
Hardhead Flair: Erika Yeomans/Doorika
Lady Fingers: Rita Gonzalez, Rachel Mayeri
El Diablo en la Piel: Ximena Cuevas
Jesse Helms is Cleaning Up America: Ro-
bert Judd
Split: Erik Deutschman
Razed by Wolves: Kathryn Ramey
The Fancy Ladies: Deborah Edmeades
The Subtler Matter: Emile Devereaux
Synthetic Pulse: Jangho Choi
Land of the Lay: Larry Shea
SLAP Drag-ons: Steve Grandell
Unternehmen Arschmaschine: Mara
Mattuschka, Gabriele Szekatsch
The Little Big: Pierre Yves Clouin
G*I*J*O: Christopher Westfall
Clamp: Maia Cybele Carpenter
Pansexual Public Porn: Del La Grace Volcano
IKU (VJ MIX): Shu Lea Cheang
In Zusammenarbeit mit Moviemento
Social Club
Ars Electronica Quarter – Stadtwerkstatt
Stadtwerkstatt/A
oi docura!
Beauty Contest 90-60-90/17-24/172
Peep Show & LatinParty
wo man
In Zusammenarbeit mit MAIZ
Intercourse – The File Cabinet Project
Brucknerhaus – Großer Saal
Istvan Kantor/CDN
*Anerkennung Interaktive Kunst, Prix Ars Elec-
tronica 2000*
Hearing Monkeys
Posthof
Lawine Torrèn, Hubert Lepka/A
In Zusammenarbeit mit Posthof Linz
Active Score Music
Brucknerhaus – Großer Saal
Scribble: Golan Levin/USA

Performers/Composers: Scott Gibbons/USA,
Golan Levin/USA, Gregory Shakar/USA
Small Fish Tale – The Performance: Masaki
Fujihata/J, Kiyoshi Furukawa/J, Wolfgang
Münch/D. Performer/Composer: Kiyoshi
Furukawa/J
D.A.V.E.
digital amplified video engine
Brucknerhaus – Mittlerer Saal
Klaus Obermaier, Chris Haring/A
Ridin' A Train
Eine musikalische Nachtfahrt mit dem Zug
durch das Werksgelände der VOEST.
Feat.: Marina Rosenfeld/USA
Idee: Fadi Dorninger/A
audio visual quicksand
Ars Electronica Center, Sky, Quarter
Audio: To Rococo Rot/D, GRAMM/D,
Bernhard Fleischmann/A
Realtime 3D Visuals: Basicray (Vladimir
Muzhesky, Chun-Chi Wang, Raichi
Hung)/USA, Crashsite (Jürgen Hagler,
Andreas Jalsovec, Werner Pötzelberger)/A,
Martin Bruner/A, Klaus Taschler/A, Nappi/A
Audio concept: jomasounds.firstfloor.org/A
Visual concept: Dietmar Offenhuber/A
20' to 2000
Goldene Nica Digital Musics
Posthof
Konzept: Carsten Nicolai/D
Mit: Komet/D, Ilpo Vaisanen/SF, Ryoji
Ikeda/J, coH/RUS, Beytone/D, Senking/D,
Thomas Brinkmann/D, Scanner/UK, Noto/D,
Mika Vainio/SF, Wolfgang Voigt/D, Elph/UK
After Show: Russell Haswell & others
In Zusammenarbeit mit Posthof Linz
Free Speech
Free Speech Camp
Ars Electronica Quarter
Konzept: Radio FRO/A 105.0 MHZ, www.fro.at
Public Campaigning
enough is enough: gettoattack, volkstanz,
gegenschwarzblau, widerst@nd MUND,
autonome a.f.r.i.k.a.gruppe. *Moderation:*
Gerhard Ruiss. **the consumer's power:**
südwind, frauensolidarität, FIAN.
**international protest against WTO, OECD
and EU:** euromarschaustria, ig kultur, in-
peg S 26/Prag 2000. **Permanent:** resistan-
cewear-Außenstudio, Protestvideos
Free Media Solidarity Networking:
Radio TV Pancevo/FRY, ANEM-Yugoslavia
solidarity and alert campaigns: reporter
ohne grenzen, internationale medienhilfe,
AIM-Yugoslavia. **Media and war:** Frank
Wichert, Institut für Sprach- und Sozialfor-
schung, Duisburg. **Buchpräsentation „Der
Kosovokonflikt. Wege in einen vermeidba-**

ren Krieg.": D. Heinz Loquai. **No media – no war in Yugoslavia?:** Heinz Pflüger, Hannes Hofbauer, Frank Wichert, Petar Janjatovic. In Kooperation mit Friedenswerkstatt Linz.

Free Speech Needs Free Media
East-west cooperation–free media projects in Europe: agora/A, bluelink/BG, contour.net/D/H, free waves/I, gym radio hollabrunn/A, isoc.bg/BG, mikro.org/D, pararadio/H, public netbase/A, radio rabe/CH, radio student/SLO, radio unerhört/D, xs4all/NL. **Radio networking:** FEM FM connected/A, Zip FM/D, voices without frontiers/Int. **Media policy by the state – comparison of Germany, Switzerland, Austria:** Verband Freier Radios Österreich

Workshops:
automatic program exchange: Verband Freier Radios Österreich/A
streaming media 1: Radio Helsinki/A
streaming media 2: Radio Helsinki/A
Permanent: Linux Demo Day

Free Speech Community Day
International free media networks demand: AMARC, Peoples Communication Charta, GILC.
convergence in europe: public voice lab/A, de balie/NL. **Free speech or free market?**
Media policy in the EU: Harald Trettenbrein, Brian Carty, Eric Kluitenberg, Erich Möchel, Alexander Baratsits.
Radio-Kantine: Live-Sendungen auf Radio FRO 105.0 MHz; **Presentation-Tent:** Internationale Protest- und Freie Medien Organisationen; **Exhibition:** Reporter ohne Grenzen; **Monochrom:** Ars in der Manege

openX – electrolobby

Showroom für netzinspirierte Digital Culture
Brucknerhaus – Foyer
Konzept und Programmgestaltung: TNC Network/F (Tina Cassani, Bruno Beusch) Raumgestaltung: Scott Ritter/USA/A. Mit Unterstützung von: Pro Helvetia, British Council.

electrolobby Residents:
Monotonik/UK
http://www.mono211.com
The Free Software Project/USA
http://www.salon.com/tech/fsp
etoy/EU/USA
http://www.etoy.com
http://www.toywar.com
Pixelporno/CH/USA
http://www.pixelporno.com
Memepool/USA
http://www.memepool.com

Next Sex Web Jam/F/A/J
http://www.chman.com
Boombox/CH
http://www.boombox.net
Sissy Fight 2000/USA
http://www.sissyfight.com
Icontown/D
http://www.icontown.de
Leonardo/F/USA
http://mitpress.mit.edu/e-journals/Leonardo/
Distributed Annotation System/USA
http://stein.cshl.org/das
http://www.wormbase.org
Lo-ser.org/A
http://lo-ser.org
Giant Connection Machine/UK
Mit: Kodwo Eshun

OpenX-electrolobby I.P.O.
Initial Public Opening
Brucknerhaus
Konzept und Programmgestaltung: TNC Network/F (Tina Cassani, Bruno Beusch) In Zusammenarbeit mit: FM4, Boombox & partners IPOmeisters: Kim Danders/USA und Hans Wu/A

Ars Electronica Media Channel
Konzept und Programmgestaltung: TNC Network in Zusammenarbeit mit Boombox & partners
Live-Feed vom Symposium und Prix Ars Electronica Forum: flavored by Mouthwatering & büro destruct.
Intercity Streams: Boombox stocktown.com (Stockholm) piratetv.net (London) micromusic.net (Zurich/Vienna) dublab.com (Los Angeles)
electrolobby Specials: mit TNC's Kim Danders Highlights:
Micro-DJ-Lectures: Kodwo Eshun Open-Source-Lifestyle: Andrew Leonard Neues Set kultureller Viren courtesy of etoy Internet Sherpas: Memepool Gameboy-Hacks: Flexecutive lo-ser Pulp Fiction: Pixelporno Sissy Fight Contest IDM-Techno: Monotonik Next-Sex-Webportal: cHmAn Human Genome-Daten via Napster-Technologie groovige Businessmodelle von Boombox

electrolobby workshop
From MOD to MP3: Stefan Trischler, Hans Wu, Sam Brown, Esa Ruoha u. a. in Zusammenarbeit mit FM4 und Monotonik

Memepool Special Edition
electrolobby.memepool.com

PARTIZIPATIONEN
Gegenverkehr
Kunst Raum Goethestraße
Mona Hahn, Oliver Fabel u.a.

2001

Ars Electronica 2001

Festival für Kunst, Technologie und Gesellschaft

TAKEOVER
wer macht die Kunst von morgen
who's doing the art of tomorrow
Linz, 1. – 6. September

Veranstalter:
Ars Electronica Center Linz
Museumsgesellschaft mbH
Geschäftsführer: Gerfried Stocker,
Mag. Wolfgang Modera
ORF Landesstudio Oberösterreich
Intendant: Kurt Rammerstorfer

Direktorium, künstlerische Leitung:
Gerfried Stocker, Ars Electronica Center
Dr. Christine Schöpf, ORF Landesstudio
Oberösterreich
Produktion: Mag. Jutta Schmiederer

Mitveranstalter Ars Electronica 2001:
Brucknerhaus
O.K Centrum für Gegenwartskunst
Universität für künstlerische und industrielle
Gestaltung Linz

Prix Ars Electronica 2001
Internationaler Wettbewerb für Cyberarts
Veranstalter: ORF Landesstudio Oberösterreich
Idee: Dr. Hannes Leopoldseder
Konzeption: Dr. Christine Schöpf
Finanzen: Dkfm. Heinz Augner
Organisation: Gabi Strutzenberger, Judith Raab

www.aec.at/takeover
Web Editorial Team: Ingrid Fischer-Schreiber,
Andreas Hirsch, Timothy Druckrey, Gabriele Hofer
Web-Design: Joachim Schnaitter, Ars Electronica
Futurelab

CONFERENCES

Themensymposium
**TAKEOVER – wer macht die Kunst von morgen/
who's doing the art of tomorrow**
Brucknerhaus – Mittlerer Saal
2. – 6. September
TAKEOVER Symposium part I
 Gerfried Stocker/A
 Jon Ippolito/USA
 Dietmar Bruckmayr/A
 Ahmad Rafi Mohamed
 Eshaq/MAL
 Wolfgang Maass/A
 Tobias O. Meissner/D
 Moderation: Gerfried Stocker/A

TAKEOVER Symposium part II
electrolobby Session
Feat.: Kerb, Moccu, Sulake Labs, Team
cHmAn, Everything, and all the other elec-
trolobby 2001 residents
Konzept/Lineup: Tina Cassani, Bruno
Beusch/F (TNC Network)
Hosted by: TNC's Network Sabine
Wahrmann/D, *Sound:* DJ Swo

TAKEOVER Symposium part III
Ruedi Baur/F/CH
Tanja Diezmann/D
Tatsuya Matsui/J
Ole Lütjens aka 370, Nico Palermo D/USA
Nora Barry/USA
Jérôme Rota aka Gej/F/ USA
Stuart Maschwitz/USA
Moderation: Ole Lütjens/D

TAKEOVER Symposium part IV
Eduardo Kac/BR/USA
SymbioticA Research Group/AUS, (Guy Ben-
Ary, Philip Gamblen, Dr. Stuart Bunt, Ionat
Zurr, Oron Catts, Gil Weinberg, Matt
Richards, Iain Sweetman)
Stuart Bunt/AUS, Natalie Jeremijenko/USA
Hiroaki Kitano/J, Joe Davies/USA
Moderation: Gerfried Stocker

TAKEOVER Special Symposium lecture
Oliviero Toscani/I

Engineers of Experience – Who's got it right?
Michael Shamiyeh/A
Peter Higgins/UK
Hiroshi Ishii/USA
Rafael Lozano-Hemmer/MEX/CDN
Gustav Pomberger/A
Horst Hörtner/A
Joachim Sauter/D
Joe Paradiso/USA
Moderation: Michael Shamiyeh/A

From Document to Event – What will remain?
Benjamin Weil/USA
Masaki Fujihata/J
Johannes Deutsch/A
Elmar Schmidinger/A
Alain Dépocas/CDN
Char Davies/CDN
Moderation: Benjamin Weil/USA

The Undertakings of Art – Who will survive?
Andreas Hirsch/A
Birgit Richard/D
Peter Noever/A
Rüdiger Wischenbart/A
Karel Dudesek/A
Moderation: Andreas Hirsch/A

Prix Ars Electronica Forum
4. – 6. September
ORF Landesstudio Oberösterreich
Vorträge, Präsentationen, Diskussionen von und
mit den Preisträgern und Juroren des Prix Ars
Electronica 2001.
Siehe Seite 319

Pixelspaces
2. – 5. September
Ars Electronica Center – Seminarraum, FutureLab
Kooperationsprojekt zwischen Ars Electronica
FutureLab und Universität für künstlerische und
industrielle Gestaltung, Linz.
Project Managers: Michael Shamiyeh/A, Dietmar
Offenhuber/A

Science from the Garage
David Nahon/F, Paul Rajlich/USA, Dietmar
Offenhuber/A, Dan Sandin/USA

Behind the Scenes
Dan Sandin & EVL Electronic Visualization
Laboratory/USA, Maurice Benayoun/F , Ars
Electronica FutureLab/A, Michael Shamiyeh/A

Open Lab – FutureLab Production Space
Ars Electronica FutureLab
Das FutureLab öffnet seinen Produktions-
raum:
Tug Of War: Christopher Lindinger/A
Architectours: Robert Praxmarer/A
Virtual Exhibition Design and Games:
Andreas Jalsovec/A
PC-CAVE: Christopher Lindinger/A

Big CAVE Shootout Night
QUAKE II im CAVE des Ars Electronica Center
Ars Electronica Futurelab/A

Prix Ars Electronica

Internationaler Wettbewerb für Cyberarts

Veranstalter: ORF Landesstudio Oberösterreich
Idee: Hannes Leopoldseder
Konzeption: Dr. Christine Schöpf
Finanzen: Dkfm. Heinz Augner

Net Vision/Net Excellence
Jury: Pete Barr-Watson/UK, Tanja Diezmann/D,
Solveig Godeluck/F, Machiko Kusahara/J, TNC
Network/F
Goldene Nica Net Vision: Team cHmAn/F
Goldene Nica Net Excellence: Joshua Davies/USA
Auszeichnung Net Vision: Yuji Naka/Sonic
Team/Sega/J, Neeraj Jhanji/J/RI
Auszeichnung Net Excellence: Chris McGrail/
Dorian Moore/Dan Sayers/Kleber/UK, Brian
McGrath/Mark Watkins/USA
Anerkennungen Net Vision: Gino Esposto/
Michael Burkhardt/Paco Manzanares/CH,

GameLab/Ranjit Bhatnagar/Frank Lantz/Peter Lee/Eric Zimmermann/USA
Anerkennungen Net Excellence: Alison Cornyn/Sue Johnson, Laurence Desarzens/ Raoul Cannemeijer, Bradley Grosh, Philip Kaplan, Netbay World, Barbara Neumayr, Frederick Noronha/Partha Pratim Sarkar, Toke Nygaard/ Michael Schmidt/Per Jørgen Jørgensen, Tarun Tejpal, Mark Tribe/Alex Galloway, ultrashock. com, Voltaire, Walker Art Center/New Media Initiatives, Steve Whitehouse

Interaktive Kunst
Jury: Masaki Fujihata/J, Ulrike Gabriel/D, Peter Higgins/UK, Hiroshi Ishii/J/USA, Joachim Sauter/D
Goldene Nica: Carsten Nicolai/D/Marko Peljhan/SLO
Auszeichnungen: Haruki Nishijima/J, association.creation/A
Anerkennungen: Paul DeMarinis, Magali Desbazeille/Siegfried Canto, Gerhard Eckel, Frank Fietzek, Hiroo Iwata, Kenneth Rinaldo, Smart Studio, Keiko Takahashi/Shinji Sasada/Koichi Nishi, Edwin van der Heide/Marnix de Nijs, Adrian Ward, Herwig Weiser/Albert Bleckmann

Computer Animation/Visual Effects
Jury: Christian Volckman/F, Paddy Eason/UK, Christophe Héry/F, Barbara Robertson/USA, Rick Sayre/USA
Goldene Nica: Xavier de l'Hermuzière/Philippe Grammaticopoulos/F
Auszeichnungen: Ralph Eggleston/USA, Laetitia Gabrielli/Max Tourret/Mathieu Renoux/Pierre Martee/F
Anerkennungen: Julien Charles/Lionel Catry/ Nicolas Launay/Olivier Pautot, Candice Clémencet/Jean-Dominique Fievet, Mike Daly, Sébastien Ebzant/Aurélien Delpoux/Loïc Bail/Benjamin Lauwick, Alain Escalle, Stefan M. Fangmeier, One Infinity, Bob Sabiston/Tommy Pallotta, Robert Seidel/Michael Engelhardt, Jeremy Solterbeck, Hans Uhlig/Tony Hurd, Jason Wen/ Howard Wen/Andrew Jones/Casey Hess/Don Relyea

Digital Musics
Jury: Ned Bouhalassa/CDN, Reinhold Friedl/D, Tony Herrington/UK, Naut Humon/USA, Kaffe Matthew/UK
Goldene Nica: Ryoji Ikeda/J
Auszeichnungen: bLectum from bLechdom/USA, Markus Popp/oval/D
Anerkennungen: Ted Apel, Aeron Bergman/Alejandra Salinas/Lucky Kitchen, Richard Chartier, Louis Dufort, Orm Finnendahl, John Hudak, kid606, J Lesser, Mille Plateaux, Pan sonic, Janek Schaefer, Tigerbeat6

Cybergeneration – u19 freestyle computing
Jury: Sirikit M. Amann/A, etoy.TAKI, Florian Hecker/ A, Horst Hörtner/A, Robert Pöcksteiner/A
Goldene Nica: Markus Triska/A
Auszeichnungen: Martin Leonhartsberger/A, Johannes Schiehsl/Peter Strobl/Conrad Tambour
Anerkennungen: Andrea Maria Gintner/Michaela Maria Plöchl, Jürgen Hoog, Marvin Jagadits/ Michael Payer, Nicole Karner/Tanja Payerl, Marian Kogler, Thomas Lettner, Fabian Schlager, Martin Spazierer/Daniel Spreitzer, Philipp Strahl, Sonja Rosa Vrisk, René Weirather, Thomas Winkler

Die Goldene Nica
Prix Ars Electronica Gala 2001
ORF Landesstudio Oberösterreich – 3sat
Verleihung der Goldenen Nica 2001
Moderation: Ingrid Thurnher, Josef Broukal

Prix Ars Electronica Forum 2001
ORF Landesstudio Oberösterreich
Präsentationen und Diskussionen von und mit den Preisträgern und Juroren des Prix Ars Electronica 2001.

Computer Animation/Visual Effects
Running Pixels
> Überblick über die Entwicklungen im Bereich der Computeranimation: 15 Jahre Prix Ars Electronica mit Screenings und Vortrag. Die Geschichte der Computergraphik: Video Screening. Dieter Daniels/D. James Murphy/ Pixar/USA, Mathieu Renoux/F, Xavier de l'Hermuzière, Philippe Grammaticopoulos/F
> *Moderation:* Rick Sayre/USA

Digital Musics
> Markus Popp, oval/D, Ryoji Ikeda/J, Jon Wozencroft/UK, bLectum from bLechdom/USA
> *Moderation:* Naut Humon/USA

Interaktive Kunst
> association.creation/A, Carsten Nicolai/D, Marko Peljhan/SLO, Haruki Nishijima/J
> *Moderation:* Joachim Sauter/D

Net Vision/Net Excellence
electrolobby Wrap-up
> Künstlergespräche mit den Preisträgern und Präsentation der Ergebnisse des electrolobby Game-Jams. Sébastien Kochman, Olivier Janin, team cHmAn/F, Takao Miyoshi, Sega/J, Neeraj Jhanj, Kyoko Watanabe, ImaHima/J, Chris McGrail, Abby McGregor, Kleber/UK, Joshua Davis/USA, Brian McGrath, Mark Watkins/USA
> electrolobby Fadeout: Enthüllung der Online Gamehall. *Moderation:* Tina Cassani, Bruno Beusch/F (TNC Network)

Electronic Theatre

O.K Centrum für Gegenwartskunst – Arena
Die besten Computeranimationen und Visual
Effects des Prix Ars Electronica 2001.
Programm:
F 8: Jason Wen, Howard Wen, Andrew Jones,
Casey Hess, Don Relyea/USA
For The Birds: Ralph Eggleston/USA
Synchronicity: Hans Uhlig, Tony Hurd/USA
Le Processus: Xavier de l'Hermuzière, Philippe
Grammaticopoulos/F
Lightmare: Robert Seidel, Michael Engelhardt/D
L'Enfant de la Haute Mer: Laetitia Gabrielli, Max
Tourret, Mathieu Renoux, Pierre Marteel/F
Intransit: Mike Daly/AUS
Waking Life: Bob Sabiston, Tommy Pallotta/USA
Dice Raw: Thin Line between Raw and Jiggy –
One Infinity/USA
The Perfect Storm: Stefen M. Fangmeier/USA
AP 2000: Sébastien Ebzant, Aurélien Delpoux,
Loic Bail, Benjamin Lauwick/F
KAMI: Lionel Catry, Julien Charles, Nicolas
Launay, Olivier Pautat/F
Trick or Treats: Candice Clémencet, Jean-
Dominique Fievet/F
Moving Illustrations of Machines: Jeremy
Solterbeck/USA
Le conte du monde flottant: Alain Escalle/F

Cyberarts 2001
Prix Ars Electronica Ausstellung
O.K Centrum für Gegenwartskunst
polar
 Carsten Nicolai/D, Marko Peljhan/SLO
 Goldene Nica Interaktive Kunst
Remain In Light
 Haruki Nishijima/J
 Auszeichnung Interaktive Kunst
bump
 association.creation/A
 Auszeichnung Interaktive Kunst
Anerkennungen Interaktive Kunst:
Signwave Auto-Illustrator
 Adrian Ward/UK
Floating Eye
 Hiroo Iwata/J
Rakugaki
 Keiko Takahash, Shinji Sasada, Koichi Nishi/J
brainball – winning by relaxing
 Smart Studio/S
you think therefore I am
 Magali Desbazeille, Siegfried Canto/F
Autopoiesis
 Ken Rinaldo/USA
Spatial Sounds
 Marnix de Nijs, Edwin van der Heide/NL

Schmarotzer – Parasites
 Frank Fietzek/D
zgodlocator
 Herwig Weiser/D
RainDance
 O. K Centrum für Gegenwartskunst, Arena,
 Hauptplatz
 Paul de Marinis/USA
ovalprocess/-commers
 Markus Popp/D
 Auszeichnung Digital Musics
Highway
 John Hudak/USA
 Anerkennung Digital Musics
Potential Difference
 Ted Apel/USA
 Anerkennung Digital Musics
Net Vision, Net Excellence
Präsentation der ausgezeichneten Net-Projekte
des Prix Ars Electronica.
 Banja, the online game
 team cHmAn/F
 http://www.banja.com
 Goldene Nica Net Vision
 Phantasy Star Online
 Yuji Naka; Sonic Team/USA/J
 http://www.sega.com/sega/game/pso_lau
 nch.jhtml
 Auszeichnung Net Vision
 ImaHima
 Neeraj Jhanji; ImaHima Inc./Japan
 http://shiva.imahima.com
 Auszeichnung Net Vision
 |P|R|A|Y|S|T|A|T|I|O|N|
 Joshua Davis/USA
 http://www.praystation.com
 Goldene Nica Net Excellence
 Warp Records
 Chris McGrail; Kleber/UK
 http://www.warprecords.com
 Auszeichnung Net Excellence
 Manhattan Timeformations
 Brian McGrath/Mark Watkins/USA
 http://www.skyscraper.org/timeformations
 Auszeichnung Net Excellence
Cybergeneration – u19 freestyle computing
 Powersphere: Martin Leonhartsberger/A
 Goldene Nica Cybergeneration – u19 freestyle
 computing
 Professor Brösl: Johannes Schiehsl/Peter
 Strobl/Conrad Tambour/A. *Auszeichnung*
 Cybergeneration – u19 freestyle computing
 JIND: Markus Triska/A. *Auszeichnung – u19*
 freestyle computing
Anerkennungen Cybergeneration – u19 freestyle
computing:
 Return To Sender: Andrea Maria Gintner/
 Michaela Maria Plöchl

Omega::Shield: Jürgen Hoog/A
Digital 2001: Marvin Jagadits/Michael Payer/A
Gesichter-Logos: Nicole Karner/Tanja Payerl/A
HTML-Editor: Marian Kogler/A
Stay Alive: Thomas Lettner/A
House-Designer: Fabian Schlager/A
Toonplanet 3D: Martin Spazierer/Daniel
Spreitzer/A
http://: Philipp Strahl/A
Bilder für Sam und Spice: Sonja Rosa Vrisk/A
Flash Experiment: René Weirather/A
SMS-Notifier: Thomas Winkler/A

Cybergeneration – u19 freestyle computing
Preisverleihung
Preisverleihung an die GewinnerInnen der
Jugendkategorie des Prix Ars Electronica 2001.
Mediendeck
Video- und Audiodokumentationen sämt-
licher Einreichungen der Kategorien Com-
puter Animation, Visual Effects und Digital
Musics.
Brain Bar: Smart Studio/S

EXHIBITIONS

Themenausstellung TAKEOVER
Brucknerhaus

Fish&Chips
SymbioticA Research Group/AUS
SymbioticA – The Art & Science Collaborati-
ve Laboratory, Department of Anatomy &
Human Biology, University of Western
Australia.
Green – oder wie ein Licht die Welt verdreht
Reinhard Nestelbacher, DNA-Consult/A
Chromosome Studies
Ben Fry/USA
**Rückprojektion – der Gummibär mit Sonnen-
brand im Internet**
ESCAPE*spHERE/A
Streaming Cinema
Part One – Examination of the Medium:
A Perfect Artistic Website: Young-hae
Chang Heavy Industries/South Korea
Nightshift: Pierre Wayser/F
Part Two – Life Stories:
Life At Night: John O'Brien/USA
A Weird Tale of Christmas: Analogik-
Indians/F
Brain Girl: Marina Zurkow/USA
D'où viens-tu?: Jeannette Lambert/CDN
Belgrade Frozen: Aleksander Gubas/YU
Badcop: Martin Dahlhauser, Mike Tucker,
Tim Freccia/D
Crack the CIA: Guerrilla News
Network/USA
Part Three: Art and Poetry

Winterlight: Peter Eudenbach/USA
Music Hat: Peter Eudenbach/USA
Golden Boy: Bill Cahalan/USA
Dream: Al Sacui/USA
Tango: Mirek Nisenbaum/USA
Under The Happiest Dawn: George Aguilar/USA
Part Four: Whimsy
Sandbox: Can I Play?: Jib Jab Media/USA
The Heist: Dave Jones/AUS
The Garden: Steve Whitehouse/CDN
Orlando: iFace/I
Kuratiert von: Nora Barry/USA
Streaming Cinema wurde unterstützt
durch Media Arts Fund of the Philadelphia
Foundation, Pennsylvania Council on the
Arts, Pennsylvania Film Office.
Singlecell
Singlecell.org
Beteiligte Künstler: Golan Levin/USA, Danny
Brown/UK, Peter Cho/USA, James Tindall/UK,
Marius Watz/NO, Joshua Davis/ USA, Martin
Wattenberg/USA, Arola & Salminen/FIN,
Steve Cannon/USA, Casey Reas/USA, Lia/A,
Ed Burton/UK
What Will Remain
Johannes Deutsch, Elmar Schmidinger/A
unitM
WIFI Oberösterreich
Ars Electronica FutureLab/A
Auftragsarbeit von WIFI Oberösterreich in
Zusammenarbeit mit: Architekturbüro
Kneidinger
keks®
Hauptplatz
Peter Fattinger/Studenten der TU Wien
Paintball
Hauptplatz
Christoph Ebener, Uli Winters/D

Cyberarts 2001
Prix Ars Electronica Ausstellung
O.K Centrum für Gegenwartskunst
Siehe Seite 320

T.O.C. Takeover Campus
Kunstuniversität Linz, Hauptplatz
Ausstellungs- und Diskursebene für medien-
künstlerische Ausbildungsfelder. Arbeiten
von Studierenden der Visuellen Medienge-
staltung an der Universität für angewandte
Kunst Wien sowie works in progress. In Ko-
operation mit der Kunstuniversität Linz
lab-ac.at/ars
Studierende der Visuellen Mediengestaltung
an der Universität für angewandte Kunst
Wien. Mit: Nico Alm, Elke Auer, Zvonimir
Bakotin, Ille Cvetkoski, Konstantin Demblin,
Markus Hafner, Philipp Haupt, Christoph
Hoeschele, Eva Jantschitsch, Iris Kern,

Matthias Klien, Michael Loizenbauer, Miralf,
Susha Niederberger, Nikolaus Passath, Ro-
bert Pinzolits, Rainer Prohaska, Markus No-
wak, Gerhard Schwoiger, Esther Straganz,
Matthias Tarasiewicz, Christian Töpfner
Gäste: Thomas Schweigen & Vera von Gun-
ten, Iris Thalhammer, Cornelia Schwaighofer
Konzept: Rosa von Suess, Bernhard Loibner

meatspace
Stadtwerkstatt/A

Field-Work
Masaki Fujihata/J

TGarden™
sponge/foam/B/USA
Cynthia Bohner-Vloet, Maja Kuzmanovic,
Ozan Cakmakci, Steven Pickles, Cocky Eek,
Joel Ryan, Laura Farabough, Christopher
Salter, Nik Gaffney, Sha Xin Wei, Evelina
Kusaite, Yifan Shi, Peggy Jacobs, Dave Tones-
sen, Marchel van Doorn.
Forschung, Entwicklung und Produktion von
TGarden™ unterstützt von: Banff Center for
the Arts, Media and Visual Arts, Ars Electro-
nica 2001, V2-Institute for the Unstable
Media, Georgia Institute of Technology,
STEIM, Daniel Langlois Foundation for Art,
Science and Technology, Starlab, NV

onScreen_2
Ars Electronica Gallery for Digital Video,
Art & Videodesign.
Timestop: Thomas Maier/A
Inside: m-box/A/D
Besenbahn: Dietmar Offenhuber/A
Digital Playground: Klaus Taschler/A
limo01, limo02, Sono_01: Joachim Smetschka/A
Kuratiert von: Joachim Smetschka/A

s.EXE interactives
Christina Goestl/A

The Finalists
Bob Squad: Miles Chalcraft/UK, Anette
Schäfer/D

xxero
Transpublic
faces@ars
Mit: Rachel Baker/UK, Aileen Derieg/USA/A,
Kathy Rae Huffman/USA/UK, Diana McCarty/
USA/DE, Marlena Corcoran/USA/DE, NOVA/
D, Florence Ormezzo/F, Ushi Reiter/A, Kerstin
Weiberg/DE, Anja Westerfroelke/A, Elfi
Sonnberger/A, Doris Weichselbaumer/A
xxero extensions
real life visual realization by flora-fauna.de/
D/UK
translation procexx: Ushi Reiter/A
xxero MOO workshop: hosted and suppor-
ted by servus.at
Slam-Session und xxero leisure
Transpublic

Präsentationen von Medienkünstlerinnen
und Drinks, bytes & bits.
Female Takeover – ff
Kunst Raum Goethestraße/A
Mit: Nine Budde/D, Cornelia Sollfrank/D,
Rachel Baker/UK, Snergurutschka/A, Faith
Wilding/USA, Cue P. Doll/USA
Eine Kooperation von Kunst Raum Goethe-
straße und FAKULTAET

take over systems, connect systems
Radio FRO/A, radioqualia/AUS
Testreihe für einen internationalen Kunst-
und Kulturkanal unter Anwendung von
Streaming-Technologien und der Verknüp-
fung verschiedener Audio-Datenbanken.
Hörfestival – Indymedia & Kanak Attack
take over systems, connect systems Work-
shops
Independent Media Networking – panel
Host: Alexander Baratsits/A (Radio FRO)
Host: Helmut Peissl/A

T.O.C. Takeover Campus – work in progress
Präsentationen
Mit: ESCAPE*spHERE/A, sponge/foam/B/
USA, Masaki Fujihata/J, Christoph Ebener,
Uli Winters/D, Christina Goestl/A, Joachim
Smetschka/A, The Finalists/D

Ars Electronica Center Exhibition 2001/2002
Ars Electronica Center
Untergeschoss
Oskar
Gerald Steinbauer, Roland Koholka,
Wolfgang Maass/A
Phantom
Peter Freudling
Westcam Datentechnik GmbH
The Responsive Window I
Joseph Paradiso/USA,
Benjamin Fry, Che King Leo, Kaijen Hsiao,
Nisha Checka, Josh Lifton, Gerold Hofstadler
Apartment
Marek Walczak, Martin Wattenberg,
Jonathan Feinberg/USA
Erdgeschoss/Zwischengeschoss
onScreen_1
Ars Electronica Gallery for Digital Video,
Art & Videodesign.
Joachim Smetschka/A
Design: Scott Ritter/A
While you were here
Sensorium Group/J
n-lab u19 database
Design: Scott Ritter. Graphics: Gottfried
Baumgartner

1. Obergeschoss
Print on Screen
Eine Ausstellung, über Typografie, Schriftbild und Text als Medium der Interaktion. Siehe Ars Electronica Exhibition 2000.
Valence
Ben Fry/USA
2. Obergeschoss
Get in Touch
Eine Ausstellung an der Schnittstelle von Mensch und Maschine. Mit Projekten von: Hiroshi Ishii, Tangible Media Group, Will Arora, James K. Alt, Jason Alonso, Joanna Berzowska, Scott Brave, Colin Bulthaup, Charlie Cano, Daniel Chak, Angela Chang, Seungho Choo, Emily Cooper, Ben Chun, Andrew Dahley, Blair Dunn, Benjamin Fielding-Piper, Rich Fletcher, Phil Frei, Matt Gorbet, Andres Hernandez, Rujira Hongladaromp, James Hsiao, Zahra Kanji, Matthew Karau, Minoru Kobayashi (NTT), Jay Lee, Tim Lu, Matthew Malcolm, Ali Mazalek, Seye Ojumu, Julian Orbanes, Maggie Orth, Dan Overholt, Gian Pangaro, Joseph Panganiban, Joe Paradiso, James Patten, Beto Peliks, Ben Piper, Sandia Ren, Gustavo Santos, Victor Su, John Underkoffler, Craig Wisneski/USA
ClearBoard
Curlybot
inTouch
MusicBottles
Peg Blocks
PingPongPlus
Pinwheels
Triangles
I/o bulb/Urp
Ausstellungsdesign: Scott Ritter/USA/A, Jakob Edlbacher/A
Running Text
Ars Electronica Futurelab, Gerfried Stocker, Volker Christian, Wolfgang Beer, Gerald Kogler, Robert Abt
Future Office Project
Ars Electronica FutureLab/A
Gerfried Stocker, Dietmar Offenhuber, Helmut Höllerl, Christopher Lindinger, Robert Praxmarer, Martin Bruner, Robert Abt, Wolfgang Ziegler, Erwin Reitböck, Nikolaus Diemannsberger, Stefan Mittlböck-Jungwirth, Stefan Feldler
Design: Scott Ritter, Jakob Edlbacher
Ars Electronica Mediathek
Yellowtale, Golan Levin/USA

CAVE
Ars Electronica Center
Kunst und Museumsprojekte:

Touring the CAVE
EVL: Alive on the Grid
Dan Sandin, EVL/USA
Eine Kooperation von: Ars Electronica Center Linz/Electronic Visualization Laboratory, University of Illinois at Chicago/Interactive Institute – Tools for Creativity Studio, Uema, Sweden/State University of New York (SUNY), Buffalo – Center for Computational Research and the Department of Media Study/Indiana University, H.R. Hope School of Fine Arts, University Information Technology Services, Advanced Visualization Laboratory/C3 Center for Culture & Communication Foundation, V2 Lab at the Institute for the Unstable Media, Rotterdam collaborating with the University of Eindhoven, The Netherlands.
Industrie – und Architekturprojekte:
I.L.V.O. – Santo Stino
Ars Electronica Futurelab, Andreas Jalsovec, Werner Pötzelberger, Christopher Lindinger, Peter Freudling, Florian Berger, Nikolaus Diemannsberger
Via Donau
Ars Electronica Futurelab, Andreas Jalsovec, Pascal Maresch, Joachim Smetschka, Werner Pötzelberger, Christopher Lindinger, Robert Praxmarer
Gericom – Laptop
Design-Studie
Ars Electronica Futurelab

Ars Electronica Center – Events 2001
Summer Evenings Synergies
22. Juni 2001
Ars Electronica Center, Foyer
Eröffnung der Ars Electronica Gallery for Digital Video, Art & Design
Joachim Smetschka/A
Quarter III
Ars Electronica Quarter
Live Performance: Monomorph/I
DJ's: Marco Passarani/I, Airlocktronics/D, Christian Wöginger/A
@vent
13. Dezember 2001
Ars Electronica Center, Foyer
Live Performance: The Memory Foundation vs. Hi-Lo, DJ Tin
DJ's: p.k. One/A, Martin P./A
Digital Video: Thomas Mayer/A, m-box/A,D, Dietmar Offenhuber/A, Klaus Taschler/A
Das Lächeln der Sphinx
Ingeborg Bachmann
Memory und andere Spiele. Eine Performance.
15. November 2001
Sky Media Loft

Performance und Konzept: Jovita Dermota
Klangkünstler: Ulrich Müller. Video: Melanie
Stiehl und Alexander Stern. Dramaturgische
Mitarbeit: Eva-Maria Schachenhofer. Regie-
assistenz: Michael Doppelhofer. Diskussion:
Monika Treut/D, Univ. Prof. Rainer Born/A

EVENTS & PERFORMANCES

Paintball – Opening
Hauptplatz
Christoph Ebener, Uli Winters, Raumschiff
Interactive/D
Moderation: Ferry Öllinger

LO_TEK_SUPASONIC_CAMPUS_BASHMENT
Kunstuniversität Linz
T.O.C. Takeover Campus – Opening Party
Mit: Stehtrommler Hirsch/A, Soundsgood/
A/D, Betalounge/D, Nico Palermo/D/USA,
s.EXE/A, kitchen club catering/A, MC Didi/A,
/.maia and nja (Vidok)/A, Earcondition/A,
Female Artistics (breakerinnen)/A
Design: Dietmar Bruckmayr/A
Organisation: Martina Berger/A
In Kooperation mit der Kunstuniversität Linz

OMV Klangpark 2001
Brucknerhaus – Donaupark
Vladislav Delay, Luomo/FIN
Real Space Streaming und Live Performan-
ces: Vladislav Delay, Luomo/FIN

Dialtones: A Telesymphony
Brucknerhaus – Großer Saal
Golan Levin/USA
Mit Scott Gibbons, Greg Shakar, Yasmin
Sohrawardy/USA
Technische Unterstützung: Ars Electronica
Futurelab: Joris Gruber, Erich Semlak, Gunter
Schmidl, Jörg Lehner. Auftragsarbeit der Ars
Electronica, realisiert im Rahmen des Ars
Electronica Research and Residence Pro-
gramm 2001. Mit Unterstützung von: The
Greenwall Foundation, The Daniel Langlois
Foundation, Cellphoneart.com, Design Ma-
chine NYC, Thundergulch, jet2web Telekom
Austria, jet2web Mobilkom, Aculab, Nokia,
Siemens, Hartlauer.

A sophisticated soirée
*O.K Centrum für Gegenwartskunst –
Mediendeck*
91v2.0/A/D: Erich Berger, Eva Dranaz/3007,
Jochen Fill/3007, jaromil aka denis roio,
ranta_a, zeitblom, Frank Kaster, Michael Kuhn

Ryoji Ikeda in Concert
Brucknerhaus – Großer Saal
Ryoji Ikeda/J
Goldene Nica Digital Musics

Superstrings
Brucknerhaus – Großer Saal

Marina Koraiman/A
Container Park
Container Terminal Linz AG
Feat.: Thilges3/A, XDV.org/A, Señor Coconut
y su conjunto/Chile
Concept: Fadi Dorninger/A

Down with the Messy Gearhound Fiesta
Posthof
fLeetwood Macintosh: bLectum from bLech-
dom, kid606, Lesser/USA
Special Guests: Cyclo, Carsten Nikolai/D,
Ryoji Ikeda/J
Ars Electronica in Kooperation mit Posthof

Movieline
Moviemento
In Kooperation mit Moviemento
Solaris: Andrei Tarkovsky/RUS
The Story of Computer Graphics
Filmdokumentation über die Entstehung
der Computergraphik. Produziert für das
25-Jahr-Jubiläum der Siggraph.

electrolobby

Showroom for Digital Culture & Lifestyle
Brucknerhaus – Foyer
Konzept, Programmdesign und Koordination:
Tina Cassani, Bruno Beusch (TNC Network/F)
Raumdesign: Scott Ritter/USA/A

electrolobby Residents:
Game Jam/F/FI/UK/D/A/DK/USA
Die electrolobby als internationales Game-
labor. Feat.:Team cHmAn, Sulake Labs, Kerb,
Moccu, Lippe, Kaliber10000, mach5design,
Praystation. Eine Koproduktion von TNC
Network und Vectorlounge.
E-Sport: Gaming Goes Pro/D/KR
Feat.: Kambiz Hashemian, Ana Vranes, Domi-
nik Kofert. In Kooperation mit Progaming. de
Kerb/UK
www.kerb.co.uk
Feat.:Jim McNiven, Pete Barr-Watson,
Sermad Buni, Dylan Van Loggerenberg.
Team cHmAn/F
www.teamcHmAn.com
Programmierung des Game-Jam-Interface
der electrolobby. Feat.: Sébastien Kochman,
Olivier Janin, Damien Giard, Sébastien Ja-
cob, Stéphane Logier, Alexandre Guesnerot,
Gaël Cecchin, Denis Bonnetier, Rodolphe
Bonvoisin, Gauthier Havet, Gunther Welker.
Moccu/D
www.moccu.com
Games als effektives Kommunikationsinter-
face. Feat.: Jens Schmidt, Björn Zaske.
Lens Flare Screenings 98 – 01/UK
Begleitprogramm zum electrolobby-Game-

Schwerpunkt. Kompiliert von: Onedotzero,
London. Mit Beispielen von: Wipe Out (feat.:
graphics by Designers Republic), Tekken, Final
Fantasy, Tomb Raider and many more.

Keitai Zone/J
Einblicke in die Wireless-Kultur rund um den
i-mode-Standard in Japan.
Feat.: Andrea Hoffmann

Everything/USA
www.everything2.org
Eine kollaborative Real-Time-Enzyklopädie
für die Digital Generation. Feat: Nathan
Oostendorp & the Everything-Noders.

Habbo Hotel/FI/UK
www.habbo.com
Ein virtuelles Fünf-Sterne-Hotel als Social
Entertainment Environment. Feat: Sampo
Karjalainen, Aapo Kyrölä & the Habbo-Guests

From Bedroom Programmers To Media Gods/USA
Mono211.com/ars-electronica-2k1/*
Feat.: Simon Carless, aka Hollywood

micromusic.net/CH
www.micromusic.net
Digital-Lifestyle-Plattform, auf der sich alles
um Computergame-Sounds dreht. Feat: Paco
Manzanares (aka wanga), Mike Burkhardt
(aka superB), Gino Esposto (aka carl). Suppor-
ted by: Schweizer Kulturstiftung Pro Helvetia

Openlaw Project/USA
www.openlaw.org
Feat.: Wendy Seltzer

Kaliber10000/DK/USA/UK
www.k10k.net
Funkiges E-zine für die internationale
Design-Community. Feat.: Michael Schmidt,
Toke Nygaard, Per Jørgensen

404Zone/A
Feat.: Simon Scheiber, Teilnehmer des u19-Cyber-
arts-Wettbewerb

Lens Flare Screenings & electrolobby Panels
Brucknerhaus – electrolobby
Panels Hosted by: TNC Network's Sabine Wahr-
mann/D
**Screening: Lens Flare – Game animations/
Part 1.** Feat.: Final Fantasy IX, Eutechnyx, Jet
Set Radio, Startopia, Shen Mue, Spawn, and
many more. Micromusic Live-Set und Start
des Game Jam
**Screening: Lens Flare – Game animations/
Part 2.** Feat.: Warcraft III, Wip3out, Gran Turis-
mo 2, Tekken Tag Tournament, Prince of Per-
sia 3D, The Last Revelation, and many more.
Panel: Games Unlimited
Profi-Gamer berichten über E-Sport.
**Screening: Lens Flare – Game animations/
Part 3.** Feat.: Abe's Exoddus, Final Fantasy VIII,
G-Police 2, and Parasite Eve.
Panel: Digital Instinct

Creatives internationaler Game-Design-
und Web-Entertainment-Agenturen präsen-
tieren ihre aktuellsten Produktionen.
**Screening: Lens Flare – Game animations/
Part 4.** Feat.: Tomb Raider 1 + 2, Duke Nukem,
Wipeout 2097, Parappa the Rapper, Ghost in
the Shell, Bladerunner, and many more.
Panel: Kännykkä Quick Lunch
Exklusive M-Toy-Show

**Prix Ars Electronica Forum Net Vision/Net
Excellence. electrolobby Wrap-Up**
ORF Landesstudio Oberösterreich
Hosted by: Tina Cassani, Bruno Beusch/F
(TNC Network)

electrolobby Web-TV
Produziert und moderiert von TNC Network.
Video: TNC Network's Christina Clar

K10k's Design-Newsfeed
Live Newsfeed produziert von Kaliber10000

FM4 @ electrolobby
Live Berichte aus der electrolobby auf FM4
Feat.: Martin Pieper, Veronika Weidinger,
Stefan Trischler, Gerlinde Lang

PARTIZIPATIONEN

ISEA Meeting @ Ars Electronica
Ars Electronica Center, Seminarraum
Jahresmeeting der ISEA Mitglieder

Digi-Sta-Lab/J
Brucknerhaus
Digital Stadium von NHK stellt die aufre-
gendsten Kunstprojekte des neuen digita-
len Zeitalters vor.

A1-Ticketing mit ekey
Hauptplatz
Ein Projekt von: ekey biometric systems,
jet2web Mobilkom Austria.

Ars Electronica 2002
Festival für Kunst, Technologie und Gesellschaft

UNPLUGGED
Kunst als Schauplatz globaler Konflikte
Art as the Scene of Global Conflicts
Linz, 7. – 12. September

Veranstalter:
Ars Electronica Center Linz
Museumsgesellschaft mbH
Geschäftsführer: Gerfried Stocker,
Mag. Wolfgang Modera
ORF Landesstudio Oberösterreich
Landesdirektor: Dr. Helmut Obermayr

Direktorium, künstlerische Leitung:
Gerfried Stocker, Ars Electronica Center
Dr. Christine Schöpf, ORF Landesstudio
Oberösterreich
Koordination & Produktion:
Katrin Emler

Mitveranstalter Ars Electronica 2002:
Brucknerhaus
O.K Centrum für Gegenwartskunst
Universität für künstlerische und industrielle
Gestaltung Linz

Prix Ars Electronica 2002
Internationaler Wettbewerb für Cyberarts
Veranstalter: ORF Landesstudio Oberösterreich
Idee: Dr. Hannes Leopoldseder
Konzeption: Dr. Christine Schöpf
Finanzen: Dkfm. Heinz Augner
Organisation: Gabi Strutzenberger, Judith Raab

www.aec.at/unplugged
Editorial Team: Ingrid Fischer-Schreiber, Andreas
Hirsch, Gabriele Hofer, Rüdiger Wischenbart
Web-Design: Joachim Schnaitter [L.A.M.E.]

CONFERENCES

Themensymposium
UNPLUGGED – Kunst als Schauplatz globaler
Konflikte/Art as the Scene of Global Conflicts
Brucknerhaus – Mittlerer Saal
8. – 12. September
Plug-In I: Who is unplugged?
 Gerfried Stocker/A
 Aminata Traoré/Mali
 Saskia Sassen/USA
 Jeremy Rifkin/USA
 Moderation: Gerfried Stocker/A
Plug-In II: Artistic Aggression
 Iba Ndiaye Djadji/Senegal
 Oumou Sy/Senegal
 Jay Rutledge/D
 Davis O. Nejo/Nigeria/A

 Marcus Neustetter, The Trinity Session/ZA
 Moderation: Andreas Hirsch/A
Plug-In III: Wiring Africa
 Michael Jensen/South Africa
 Michel Mavros/Senegal
 Birama Diallo/Mali
 Keith Goddard/Zimbabwe
 Dominic Muntanga/Zimbabwe
 Lisa Goldman-Carney/USA
 Moderation: Michael Jensen/South Africa
Plug-In IV: Local Conflicts – Global Media
 Danny Schechter/USA
 Jennifer Sibanda/Zimbabwe
 Winters Negbenebor/Nigeria
 Philippe Quéau/F
 Moderation: Derrick de Kerckhove/CDN
Plug-In V: Coaching the Arts
 Hans-Peter Schwarz/D
 Gunalan Nadarajan/Singapore
 Anthony Moore/UK
 Marie Luise Angerer/A
 Gerhard Funk/A
 Moderation: Reinhard Kannonier/A
Video Conference
 Paul Virilio/F
 Derrick de Kerckhove/CDN
Plug-In VI: Operated by Art
 Hou Hanru/China
 Peter Fend/USA
 Mark Napier/USA
 Azza El'Hassan/Palestina
 Moderation: Tom Sherman/CDN
Plug-In VII: Global Conflicts – Local Networks
 Ignacio Ramonet/F
 Lori Wallach/USA
 Joichi Ito/J
 Alex Galloway/USA
 Derrick de Kerckhove/CDN
 Moderation: Rüdiger Wischenbart/A/D

Prix Ars Electronica Forum
10. – 12. September
ORF Landesstudio Oberösterreich
Präsentationen und Diskussionen von und mit
den Preisträgern und Juroren des Prix Ars Elec-
tronica 2002
Siehe Seite 328

Pixelspaces
Der Raum als Spiel – Das Spiel als Raum
8. – 9. September
Ars Electronica Center
Pixelspaces I + II
 Robin Clark/UK, Ernest W. Adams/UK, Adri-
 an David Cheok/Singapore, Armin Mohsen
 Daneshgar/A, Bruce Thomas/AUS, Friedrich
 Borries/D, Masuyama/J
 Koordination: Ars Electronica FutureLab
 Projektmanagement: Dietmar Offenhuber

Creating Interfaces
Polyethnical Media and Cultural Diversity
Ars Electronica Center
10. September
Ein Projekt von Radio FRO/A in Kooperation mit
Ars Electronica.

Conditions and Prerequisites for a Multi-ethnic Media Landscape
Gunther Kress/UK, Brigitta Busch/A,
Otto Tremetzberger/A
Moderation: Cornelia Kogoj/A
**Closed Borders in an Age of Migration –
Perspectives and Political Practices**
Karin König/A, Herbert Langthaler/A,
Julian Circo/A, Rubia Salgado/A
Moderation: Boris Buden/Rep. of Croatia/A

Prix Ars Electronica

Internationaler Wettbewerb für Cyberarts
Veranstalter: ORF Landesstudio Oberösterreich
Idee: Dr. Hannes Leopoldseder
Konzeption: Dr. Christine Schöpf
Finanzen: Dkfm. Heinz Augner

Net Vision/Net Excellence
Jury: Joichi Ito/J, TNC Network (Tina Cassani,
Bruno Beusch)/F, Pete Barr-Watson/UK, Tanja
Dietzmann/D, Joshua Davies/USA
Goldene Nica Net Vision: Radical Software
Group (RSG)
Goldene Nica Net Excellence: Josh On/Future-farmers/NZ/USA
Auszeichnungen Net Vision: Michael Aschauer/
Josef Deinhofer/Maia Gusberti/Nik Thönen, It's
Alive Mobile Games/S
Auszeichnungen Net Excellence: Alexandra
Jugovic/Florian Schmitt/Hi-Res!/D/UK,
schoenerwissen/D
Anerkennungen Net Vision: Jonathan Gay/USA,
Alexandra Jugovic/Florian Schmitt/Hi-Res!/D/UK,
Harper Reed/USA
Anerkennungen Net Excellence: Peter
Kuthan/Sabine Bitter/Thomas Schneider/
Helmut Weber/A, Kenneth Tin-Kin Hung/Hong
Kong/USA, Francis Lam/China, Elan Lee/USA

Interaktive Kunst
Jury: Alex Adriaansens/NL, Peter Higgins/UK,
Hiroshi Ishii/J, Masuyama/J, Christa Sommerer/A
Goldene Nica: David Rokeby/CDN
Auszeichnungen: Rafael Lozano-Hemmer/CDN/
MEX, Ranjit Makkuni/IND
Anerkennungen: Autorenwerkstatt MEET,
Luc Courchesne/CDN, Crispin Jones/UK, Ryota
Kuwakubo/J, Golan Levin/USA with Scott
Gibbons/Greg Shakar/Yasmin Sohrawardy/Joris
Gruber/Erich Semlak/Gunther Schmidl/Jörg

Lehner, Tetsuya Mizuguchi/J/United Game
Artists, Volker Morawe/Tilman Reiff/D, Michael
Saup+supreme particles/D,Yasuhiro Suzuki/NHK
Digital Stadium/J, Atau Tanaka/Kaspar Toeplitz/J/D,
The Synthetic Character Group/USA, Young
Hay/HK/Horace Ip/Alex Tang Chi-Chung

Computer Animation/Visual Effects
Jury: Bill Buxton/USA/CDN, Stuart
Maschwitz/USA, Barbara Robertson/USA, Rick
Sayre/USA, Rita Street/USA
Goldene Nica: Pete Docter/David Silverman/Lee
Unkrich/Andrew Stanton/USA
Auszeichnungen: BUF/F, Peter McDonald/AUS
Anerkennungen: Hiroshi Chida/J, Erik Nash/
Digital Domain/Dreamworks/USA, Lars Magnus
Holmgren (aka Dr. Frankenskippy/AUS), Wojtek
Wawszczyk/PL, Jason Watts/The Mill/UK,
Yasuhiro Yoshiura/J

Digital Musics
Jury: Bevin bLectum (Bevin Kelley/USA), Florian
Hecker/CH, Tony Herrington/UK, Naut Humon/
USA, Chris Watson/UK
Goldene Nica: Yasunao Tone/J
Auszeichnungen: Aeron Bergman/Alejandra
Salinas/Lucky Kitchen/USA/E, Curtis Roads/USA
Anerkennungen: Anticon, Iancu Dumitrescu/
Ana-Maria Avram/RO, PXP, Goodiepal/Mainpal
Inv./DK, Russell Haswell/UK, Francisco López/USA,
Raz Mesinai/USA, Phoenecia, Marina Rosenfeld/
USA, Mika Taanila/Ø (Mika Vainio)/SF, Carl
Michael von Hausswolff/S, Stephan Wittwer/CH

Cybergeneration – u19 freestyle computing
Jury: Sirikit Amann/A, Horst Hörtner/A, Barbara
Lippe/A, miss monorom/CH, Hans Wu/A
Goldene Nica: Karola Hummer/A
Auszeichnungen: Philipp Luftensteiner, sofa 23
Anerkennungen: Projekt „Dezentrale Medien"/
Semen Aklan/Gülcan Ates/Nerdjivane Brahimi/
Flamur Kryezi/Franz Fiser/Asif Mohamed Naseri/
Jean Paul Nduwayezu/Ferda Özel/Ruwani Rosa/
Reza Soltani/Sezer Üzum, BG XIX, Manuel
Fallmann, Georg Gruber, Stephan Hamberger,
Dominik Jais, Marian Kogler, Martin Kucera, Ra-
phael Murr, Lucas Reeh, Iris und Silvia
Schweinöster, René Weirather

Die Goldene Nica
Prix Ars Electronica Gala 2002
ORF Landesstudio Oberösterreich – 3sat
Verleihung der Goldenen Nica 2002
Moderation: Karin Resetarits

Prix Ars Electronica Forum
ORF Landesstudio Oberösterreich
Präsentationen und Diskussionen von und mit
den PreisträgerInnen und JurorInnen des Prix
Ars Electronica 2002
Computer Animation/Visual Effects
 Peter McDonald/AUS, Olivier Cauwet; BUF/F
 Guido Quaroni; Pixar/USA
 Moderation: Rita Street/USA
 Monsters, Inc.: Disney/Pixar/USA
Digital Musics
 Alejandra Salinas, Aeron Bergman;
 Lucky Kitchen/ES/USA, Curtis Roads/USA,
 Yasunao Tone/USA
 Moderation: Naut Humon/USA
Interaktive Kunst
 Video Konferenz Linz-Liverpool: Rafael
 Lozano-Hemmer/MEX/CDN
 Ranjit Makkuni; Xerox Parc & DMO/Indien
 David Rokeby/CDN
 Moderation: Peter Higgins/UK
Net Vision/Net Excellence
 It's Alive!/S, Maia Gusberti, Michael Aschauer,
 Nik Thönen, Sepp Deinhofer/A, Alex
 Galloway; RSG/USA, schoenerwissen/D
 Amy Franceschini; Futurefarmers/USA
 Alexandra Jugovic, Florian Schmitt; Hi-Res!/UK
 Moderation: Joshua Davis/USA

Electronic Theatre
O.K Centrum für Gegenwartskunst – Arena
Die besten Computeranimationen und Visual
Effects sowie Dokumentationen der drei besten
Werke der Kategorie Interaktive Kunst.
Programm:
Monsters, Inc.: Disney/Pixar Studios/USA
Mouse: Wojtek Wawszczyk/D
AnnLee you proposes: Lars Magnus Holmgren
aka Dr. Frankenskippy/UK
The Time Machine: Erik Nash; Digital Domain/
Dreamworks/USA
Molly, Star-Racer: Savin Yeatman-Eiffel, Thomas
Romain; Sav! The World Productions/F
Tinnov: Jonathan Turner, Maya Kurasawa;
Cosgrove Hall Digital/UK
Polygon Family: Episode 2: Hiroshi Chida/J
Panic Room: BUF/F
Kikumana: Yasuhiro Yoshiura/J
E3: Robert Seidel, Michael Engelhardt/D
Man Garden: Yuriko Amemiya/J
BMW Pool: Jason Watts/UK
Necklace of Flowers: Kazuma Morino, Stripe
Factory/J
Harvey: Peter McDonald/AUS
L'âme et la pierre: Alain Escalle; Z-A Production/F
Bodymovies: Rafael Lozano-Hemmer/MEX/CDN
The Crossing-Project: Ranjit Makkuni/India
n-cha(n)t: David Rokeby/CDN

Cyberarts 2002
Prix Ars Electronica Ausstellung
O.K Centrum für Gegenwartskunst
Eine Auswahl der besten Projekte des Prix Ars
Electronica 2002.
n-cha(n)t
 David Rokeby/CDN
 Goldene Nica Interaktive Kunst
**The Crossing-Project: Living, Dying and Transfor-
mation in Banaras**
 Ranjit Makkuni/India
 Auszeichnung Interaktive Kunst
Body Movies – Relational Architecture # 6
 Hauptplatz Linz
 Rafael Lozano-Hemmer/MEX/CDN
 Auszeichnung Interaktive Kunst
Anerkennungen Interaktive Kunst:
PLX – parallax of the game
 Ryota Kuwakubo/J
Global String
 Atau Tanaka, Kasper Toeplitz/F
The Visitor: Living by Number
 Luc Courchesne/CDN
R111
 Michael Saup & supreme particles/D
Globe-Jungle-Project
 Yasuhiro Suzuki, Nae Morita/J, NHK, Digital
 Stadium
FX Factory
 MEET Autorenwerkstatt/D
AlphaWolf
 The Synthetic Character Group/USA
Dialtones
 Golan Levin/USA
An Invisible Force
 Crispin Jones/UK
Pain Station
 Volker Morawe, Tilman Reiff/D
Body Brush
 Hay Young/Hong Kong
Rez
 Tetsuya Mizugushi/J
A Lecture on Disturbances in Architecture
 C.M. von Hausswolff/S
 Anerkennung Digital Musics
Revision Land – The Tale of Pip
 Lucky Kitchen/E/USA
 Auszeichnung Digital Musics
Fysikaalinen regas – A Physical Ring
 Mika Taanila, Ø (Mika Vainio)/FIN
 Anerkennung Digital Musics
Cybergeneration – u19 freestyle computing
 Präsentation ausgewählter Arbeiten aus der
 u19-Kategorie des Prix Ars Electronica.
 TI-92: Karola Hummer/A, *Goldene Nica
 Cybergeneration – u19 freestyle computing*
 Arena: Phillipp Luftensteiner/A, *Auszeich-*

nung Cybergeneration – u19 freestyle computing
minials: sofa23/A, *Auszeichnung Cybergeneration – u19 freestyle computing*
Anerkennungen Cybergeneration – u19 freestyle computing:
www.herein.at: Projekt Dezentrale Medien/A
Flash Animation: Schüler des BG XIX/A
o fortuna: Manuel Fallmann/A
interactive_flash_experiments: Georg Gruber/A
Meine Homepage: Stephan Hamberger/A
Berufsbekleidungsprogramm: Dominik Jais/A
Topix: Marian Kogler/A
www.filmemacher.at: Martin Kucera/A
Overcast: Rahael Murr/A, Alex Schomacker/A
DJ_Sky feat.HP – Deskjet 695c: Lucas Reeh/A
Digitale Malereien: Silvia und Iris Schweinöster/A
$%§§§$%$YYYY: René Weirather/A
Cybergeneration – u19 freestyle computing Preisverleihung
O.K Centrum für Gegenwartskunst
Preisverleihung an die GewinnerInnen der Jugendkategorie des Prix Ars Electronica 2002.

EXHIBITIONS

Themenausstellung UNPLUGGED
Brucknerhaus
Weltkarten – Change the Map
Brucknerhaus
Cybergrafien einer Welt der Daten- und Informationssysteme.
space&designstrategies: Elsa Prochazka/A
Energy Solution/Water Resources
Peter Fend/USA
Energy Solution/Water Resources beinhaltet:
From Austria to the East – Eurasian Scenario II
From Austria to the South – Austria Flyway (Startbahn Österreich) II
Restoration of Savanna
Water-Based Energy Technologies
Circulatory System
Carnivore
RSG/USA (Radical Software Group)
http://rhizome.org/carnivore
Goldene Nica Net Vision
They Rule
Josh On, Futurefarmers/USA
http://www.theyrule.net
Goldene Nica Net Excellence
./logicaland
Maia Gusberti, Michael Aschauer, Nik Thoenen, Sepp Deinhofer/A

http://www.logicaland.net
Auszeichnung Net Vision
net.flag – flag for the Internet
Mark Napier/USA
http://www.potatoland.org/pl.htm
Internet-Metrik:: Biophily*Warp Map
Thomas Feuerstein/A
http://www.myzel.net/geomorph
Programming: Peter Chiocetti, Marcus Linder, Harald Milchrahm
Minitasking
schoenerwissen/D
http://www.minitasking.com
Auszeichnung Net Excellence
border rescue
social impact/A
Video: Natalia Mueller
Webdesign: Stefan Amerstorfer
Technical support: X-Net
Klimakonverter
Ars Electronica Quarter
Werner Jauk, Heimo Ranzenbacher/A
Unterstützt von Stadl Graz/Kultur; Land Steiermark/Kultur; BKA Sektion Kunst.
Kunst gegen Gewalt
Brucknerhaus
Unterstützt von Initiative Kunst gegen Gewalt
We Fall: Uri Dotan/Israel
Iconic Panopticum: Sharif Waked/Israel
African Art Screen
Brucknerhaus
L'Atelier du grand jeu: Baba Diawara et Frères/Senegal
La Valise: Souyabou Kandji/Senegal
The Water: Moataz Nasr/Egypt
Horror – Sitcom – Comedy Videos: HSC – Highly Social Cinema
World White Walls: Emeka Udemba/Nigeria
@rtscreen – Between the Large Tree and the Small One: Davis O. Nejo/Nigeria/A/Cross Cultural Communication, *Ars Electronica Quarter.*
Projektauswahl: Davis O. Nejo/Nigeria/A

Cyberarts 2002
Prix Ars Electronica Ausstellung
O.K Centrum für Gegenwartskunst
Siehe Seite 328

CAMPUS
Kunstuniversität Linz, Hauptplatz
Ausstellungs- und Diskursebene für medienkünstlerische Ausbildungsfelder. Arbeiten von Studierenden des Studiengangs „Audiovisuelle Medien" der Kunsthochschule für Medien Köln.
Eine Kooperation von: Ars Electronica, Kunstuniversität Linz, Kunsthochschule für

Medien Köln. Koordination: Marie-Luise
Angerer/A/D, Ursula Damm/A, André
Zogholy/A, Rainer Zendron/A
sound performance: Alberto de Campo/A,
Jörg Lindenmaier/D
Monospace: Maximilian Erbacher/D
**MultiCultureMolecular Humans. Society as
MultiCultureMolecular Virus Epidemy:**
Jaanis Garancs/Estonia
Say hello to peace and tranquility: Dagmar
Keller/D, Martin Wittwer/CH
Politische Unordnung: Anja Kempe/D
Loser Raum: Anja Kempe/D
diagnose%prognose: Yun-Chul Kim/Korea
www.ilovesteilacoom.com: Viola Klein/D
deterritoriale Schlingen: Thom Kubli/CH,
Sven Mann/D
Ein schwingender Raum: Ko Kubota/J
Ohne Titel: Ko Kubota/J
Ohne Handy und viel Archiv: Anke
Limprecht/D
Das Korallenriff: Agnes Meyer-Brandis/D
Power Game: Aurelia Mihai/Romania
Wenn der Hase mit dem Igel: Heike Mutter/D
Name einfügen: Naujokaite Neringa/Latvia
Verdacht auf: Tilman Peschel/D
Ki: Susanna Schönberg/I, Pascal Fendrich/D,
Ruben Malchow/D, Matthias Neuenhofer/D,
Charlotte Desaga/D
Nogame: Susanna Schönberg/I
Speisung: Martin Seck/D
Gegen alle illegalen Inhalte: Till Steinmetz/D
Pausenplattform: Cathrin Vahl/D
Verstärker: Olaf Vahl/D
swingUp Games: Olaf Vahl/D
paintOn Games: Olaf Vahl/D
Hemispherios: Sandra Vasquez de la Horra/
Chile
Boxsack: Jochen Viehoff/D
Campus Workshop
Mediale Ein-/Aus-Bildung.
Andreas Altenhoff/A, Marie-Luise Angerer/
A, Alberto de Campo/A, Ursula Damm/D,
Jochen Viehoff/D, Christoph Nebel/CH,
Sabine Funk/A, Michael Shamiyeh/A
Konzept: Stefan Römer/D
Boxsack: Lecture, Jochen Viehoff/D
Sound Performance
Yun-Chul Kim/Korea, Alberto de Campo/A,
Jörg Lindenmaier/D
Video Show focusing on Africa
zusammengestellt von Marcel Odenbach.
Identification: Mawuli Afatsiawo/Ghana
Journey: Mawuli Afatsiawo/Ghana
de la vie des enfants au XXIéme siècle:
Papisthione/F, Senegal

Ars Electronica Center Exhibition 2002/2003
Ars Electronica Center

Untergeschoss
Cyclops – an observing giant
Leading Edge Design Corp./J
Shunji Yamanaka, Kinya Tagawa, Jun Hom-
ma, Nicholas Oxley, Yuji Mitani
Jam-O-Drum: Circle Maze
Tina Blaine, Clifton Forlines/UK
Erdgeschoss/Zwischengeschoss
OnScreen_3
Ars Electronica Gallery for Digital Video Art
& Design
Timestop 02: Thomas Maier/A
**The Everyday Strangeness – Animation in
the Refrigerator:** Ernst Spiessberger/A/D
Programm: Joachim Smetschka/A
Design: Scott Ritter/A
Ars Electronica Center - Vorplatz
Box 30/70
Sam Auinger/A, Bruce Odland/USA
Box 30/70 wurde initiiert und produziert
von: singuhr-hörgalerie in parochial, Berlin,
Siemens Arts Program, München.
1. Obergeschoss
Hidden Worlds
Hidden Worlds of Noise and Voice
Golan Levin/USA, Zachary Lieberman/USA,
Gerfried Stocker/A. Ars Electronica Future-
lab: Peter Freudling, Christopher Lindinger,
Michael Breidenbrücker, Dietmar Offenhu-
ber, Horst Hörtner, Robert Abt, Stefan Mittl-
böck, Robert Praxmarer, Wolfgang Ziegler,
Stefan Mittlböck-Jungwirth. Design: Scott
Ritter. Mit Unterstützung von SAP.
Tool's Life
Motoshi Chikamori, Kyoko Kunoh, inim++/J
Aussichtsposten
Ars Electronica Futurelab, Dietmar Offenhu-
ber, Christopher Lindinger, Peter Brandl,
Christian Naglhofer, Erwin Reitböck, Robert
Praxmarer, Wolfgang Ziegler. Golan Levin,
Zachary Lieberman/USA.
Design: Jakob Edlbacher/A
Carnivore
Scott Sona Snibbe/USA, Mark Napier/USA,
Alexander R. Galloway/USA, RSG (Radical
Software Group)/USA
Joshua Davis/USA
Info-Benches
Ars Electronica Futurelab, Helmut Höllerl,
Stefan Schilcher, Florian Landerl, Nina
Wenhart, Pascal Maresch, Stefan Mittlböck-
Jungwirth. Design: Scott Ritter/USA/A
INSTAR
Ars Electronica Futurelab, Horst Hörtner,

Christopher Lindinger, Robert Abt, Reinhold Bidner, Andreas Jalsovec, Helmut Höllerl, Dietmar Offenhuber, Robert Praxmarer, Wolfgang Ziegler. In Zusammenarbeit mit: Institut für Wirtschaftsinformatik, Software Engineering Prof. Gustav Pomberger, Institut für Pervasive Computing Prof. Alois Ferscha, Wolfgang Narzt, Volker Christian/ Johannes Kepler Universität Linz sowie Siemens CT SE1 Dieter Kolb, Reiner Müller, Christian Clément, Jan Wieghardt.

RE:MARK
Golan Levin/USA, Zachary Lieberman/USA, Christopher Lindinger. Realisiert im Rahmen des Siemens Artist in Residence Programm.

2. Obergeschoss

Get in Touch
Eine Ausstellung an der Schnittstelle von Mensch und Maschine. Siehe Ars Electronica Exhibition 2001.

SandScape
Hiroshi Ishii/J/USA, Tangible Media Group/USA, Ben Piper/UK, Carlo Ratti/UK Yao Wang/USA, Assaf Biderman/USA

Digital Cubes
Simon Schiessl/D

Future Office Project – VR-Flip Chart
Ars Electronica Futurelab, Gerfried Stocker, Horst Hörtner, Dietmar Offenhuber, Christopher Lindinger, Robert Abt, Wolfgang Ziegler, Florian Berger, Erwin Reitböck, Stefan Feldler. Design: Scott Ritter/A/USA, Jakob Edlbacher/A

Ars Electronica Mediathek
Anthology of Art: Jochen Gerz

CAVE/ARSBOX
Ars Electronica Center
Kunst und Museumsprojekte:
Gesichtsraum
Johannes Deutsch/A
Ars Electronica Futurelab: Andreas Jalsovec , Pascal Maresch, Joachim Schnaitter, Christopher Lindinger, Peter Freudling, Florian Berger, Christopher Galbraith.
Realisiert im Rahmen des Ars Electronica Research & Residence Program 2002.
Industrie – und Architekturprojekte:
WFL-Digital Mockup
Ars Electronica Futurelab
FACC Airplane Interieur
Design Studie, Ars Electronica Futurelab

Ars Electronica Center – Events 2002
bip-hop
21. Mai 2002
Ars Electronica Quarter
Live: tennis/UK, si-cut.db/UK, tonne/UK
Visuals: Phase4, Twinde & Obtik

Live Electronic Music Nights
Linz Fest 2002. X-Change Festival der kulturellen Ost-West-Begegnung.
31. Mai 2002, Sky Media Loft und O.K Centrum für Gegenwartskunst
Electric Indigo/A, DJ Lucca/CZ, DJ Dork/H, DJ Slavka/Ex-Yu
07. Juni 2002
E-Jam mit Pavel Fajt/CZ, Virgin Helena/ Kroatien, Rico Gubla und DJ Ohrgasmus
14. Juni 2002
Electronic Music Night mit Roland von der Aist/A, Aka Tell/A, Dima Savin und Ilya Furmanov/Russland

headscapes 1.0
Konzert für 96 Kopfhörer
27. Juni 2002, Sky Media Loft
Extended-Guitar, Elektronik, Gadgets: Seppo Gründler. EDV-Schlagzeug, Sensoren: Josef Klammer

Radiotopia in Concert
Live Performance & CD Präsentation
20. Dezember 2002, Ars Electronica Center
Renée Gadsen, Rupert Huber, Norbert Math, Joachim Schnaitter

EVENTS & PERFORMANCES

Body Movies
Relational Architecture # 6
Hauptplatz Linz
Rafael Lozano-Hemmer/MEX/CDN
Auszeichnung Interaktive Kunst
Konzept und künstlerische Leitung: Rafael Lozano-Hemmer. Programmierung: Conroy Badger, Crystal Jorundson. Portraits: Rafael Lonzano-Hemmer, Julia García, Ana Parga, Donato Lemmo, Elizabeth Anka.
Entwicklung: V2_Organisatie, The Canada Council for the Arts.
Die aufwändige technische Präsentation wurde ermöglicht durch die großzügige Unterstützung von SAP AG.

Visualisierte Linzer Klangwolke
Donaupark
Harmonices Mundi – Von der Harmonie der Welt
Christian Muthspiel, Hans Hoffer/A
Veranstaltet von: Brucknerhaus Linz, ORF Oberösterreich

Faust II Hybrid Version
Peter Behrens Haus (Alte Tabakfabrik)
66 b/cell/J
DJing & VJing: con.trust music & a.s.a.p.
In Kooperation mit: Kunstuniversität Linz, Institut Bildende Kunst und Kulturwissenschaften, Bildhauerei, Experimentelle Visuelle Gestaltung

Open Air – A Radiotopia
on line – on site – on air
www.aec.at/radiotopia
Künstlerische Leitung: Rupert Huber
Projektorganisation: Silvia Keller
Die Idee für dieses Projekt entstand in vielen Diskussionen zwischen: Rupert Huber, Gerfried Stocker, Andres Bosshard, Elisabeth Zimmermann. Projektname entwickelt von: Renée Gadsden „Radiotopia", August Black „Open Air".
Remote Station Linz mit: Ashwell Adriaan, Alexander Balanescu, August Black, Isabella Bordoni, Andres Bosshard, Lorenzo Brusci – Timet, Anna Friz, Rupert Huber – Tosca, Hubert Hawel, Silvia Keller, Steffen Kopany, Lukas Ligeti, Norbert Math, Thomas Mulcaire, Michael Nyman (Telefon), radioqualia, Dennis Russell Davies, Joachim Schnaitter, Thomas Schneider, Andreas Strauss, Sandra Wintner, Elisabeth Zimmermann, Pamela Z, u.v.a.
Weitere Teilnehmer:
/sms ;-), 8gg, alien.producions + many others, ABC, The Listening Room, Ashwell Adriaan, Alessandro Aiello, José Alberto, Guido Arbonelli, Sam Auinger, C. Banasik, Ros Bandt, Alfred Banze, Chris Becker, Scott Becker, Dinah Bird, Wende K. Blass, Tiziano Bonini, Brad, Steve Bradley, Brave New Waves, CBC 1 (Canada), Martin Breindl, Dimitry Bulatov, Warren Burt, John Byleveld, Jeffrey Byrd, Chris Byrne, Arinda Caballero, Christof Cargnelli, Rosas Carlos, Thanos Chrysakis, Annabelle Chvostek, CKUT Montreal, Code-Tripper, CONSUM, Viv Corringham, David Crawford, Gary Danner, Robert Dansby, Víctor Manuel Rivas Dávalos, Paul Devens, Die Siraenen (Barbara Gabriel, Susanna Gruber, Gabriele Stöger), DJ.hackmac@magnet.at, ei, Emap.FM – Internet R@adio (Musikwissenschaften Uni Wien und online), farmersmanual, Irving Flores, Alessandro Fogar, Angela B. Forster, Arthur Fournier, Jens Gantzel, Marc Garrett, Andrew Garton, Geerken, Peter Geerts, Gulan Genco, Alison Gerber, GintasK, Hans Groiss, Christian Gruber, gullibloon, Chris Haderer, Markus Hammer, Janko Hanushevsky, Volker Hennes, Lin Hsin Hsin, Alois Hummer, Jose Iges, Oscar Rodrigo Alonso Inclán, Indymedia Argentina, Ina Ivanceanu, Jaromil, Jeremy, Concha Jerez, Jerome Joy, Ceyda Karamursel, Kathy Kennedy, Kid Koma's, Klammer, Knutopia, Tetsuo Kogawa, Jeroen Kumeling, Laboratorio de Experimentación Artística Sonora (LEAS)/ Fondo Nacional para la Cultura y las Artes (Fonca), Laboratorio de Poética Experimental: Emilio Farrera, Marold Langer-Philippsen,

Forbes Latimer, Ingo Leindecker, Sophea Lerner, Lifeloop, Sean Linezo, Maï Lingani, Ángel Marín, Massimo Mascheroni, Jonathan Matis, Sergio Messina, Kostya Mitenev, Enrico Mitrovich, Frank Moore, Lisa Moren, Mario Mota, Thomas Mulcaire, Narcotic Syntax, Inês Neuparth, Dimitry Nikolaev, Tore Nilsson, Domenico Olivero, OneWorld Radio, Hugo Palacios, Luca Palladino, Giovanni Papini, Gordan Paunovic, Phonurgia Nova, Public Voice Lab, radioqualia, Radio 1476, Radio Africa, Radio Educación Mexiko, Radio FRO, Radio Mocambique, Radio New Zealand, Radio Orange, Indu Ramesh, Guiseppe Rapisarda, Emiliano López Rascón, Rendezvous c-lab, Daiya-Gerda Resl, Jorge Reyes, rhino.dorsalis, RNE Ars Sonora, Ángel Rodríguez, Adalberto Romero, Carlos Rosas, Ulises Salanueva, Markus Seidl, Manfred Seifert, Michaël Sellam, Mary Simoni, Eva Sjuve, SMS-Intervention, Andrea Sodomka, Anabella Solano, Hugo Solís, Refugio Solís, Spent, ssb, Stazione di Topolo, Dr. Gabriele Stöger, Giampiero Strafaccia, Tina Strauss, The Church of Harvey Christ, The Cultural Revolution, The Trinity Session (_sanman, The | Premises), Henning Timcke, 2tonga.online, Jo van der Spek, Gareth Vanderhope, Ángel Viveros, Meri von KleinSmid, Fujui Wang, Hildegard Westerkamp, Richard Williams, Max Würden, Ilana Zuckerman

OMV Klangpark 2002
Donaupark
Opening & Live Performance & Real Space Streaming

Open Air – A Radiotopia – Soirée
Brucknerhaus, Donaupark
Alexander Balanescu, Dennis Russell Davies, Andres Bosshard, Lorenzo Brusci – Timet, Rupert Huber, Isabella Bordoni, Michael Nyman (Telefon), Pamela Z u.a.

Lange Nacht der Radiokunst
on air: ORF Ö1 Kunstradio, Radio Österreich International (Kurzwelle – kHz 5945), Radio 1476 (Mittelwelle)
on line: www.kunstradio.at/radiotopia
Mit: CBC1/CDN, Radio Afrika/A, Radio Educacion/MEX, RNE/E, Radio New Zealand/NZ, Radio FRO/A, Radio Mocambique, ABC/AUS, CKUT Montreal/CDN
Producers – on air/Linz: Anna Friz/CDN, Ashwell Adriaan/ZA, Thomas Mulcaire/ZA
Producers – Webcast/from Linz: Honor Harger/Adam Hyde, radioqualia/NZ
Project website: Sandra Wintner, FirstFloor/A/CAN, Matthias Simkovics/A
Technik: Hubert Hawel, Alois Hummer

Projektmanagement: Elisabeth Zimmer-
mann, Ö1 Kunstradio
Ein Projekt von Ars Electronica in
Zusammenarbeit mit ORF Ö1 Kunstradio

Urban Africa Club
Stadtwerkstatt
Mit: Magic System/Côte d'Ivoire, Pee Froiss/
Senegal, BMG 44/Senegal, Techno Issa/Mali,
Djigui/Mali, Zola/South Africa
Kuratiert von: Jay Rutledge/USA/D

Sintflut
Brucknerhaus – Großer Saal
Detlef Heusinger/A
Slowakisches Philharmonisches Orchester
Dirigent: Manfred Mayrhofer. Musik: SWR
Symphony Orchestra Baden-Baden.
Elektronische Realisation: Experimental-
studio der Heinrich-Strobel-Stiftung des
Südwestrundfunks e.V., Freiburg (Breisgau)
Klangregie: André Richard, Joachim Haas
Ars Electronica in Kooperation mit Bruckner-
haus

Test Patches
Brucknerhaus – Großer Saal
66b/cell/J

O.K Nights
*O.K Centrum für Gegenwartskunst –
Mediendeck*
O.K Night 1, Concert performance: Atau
Tanaka/F
O.K Night 2, Live Act: Soundsilo/A, DJing:
Bitz/A (Hausverbot, Graz), nika_nosh/A
(femalepressure, Wien), Live visuals-video-
mixing by SOFA23/A
O.K Night 3, Concerts: C.M. von
Hausswolff/S, Russel Haswell/USA

Digital Musics in Concert
Brucknerhaus – Großer Saal
Yasunao Tone/USA, Goldene Nica Digital
Musics, Curtis Roads/USA, Auszeichnung
Digital Musics

Artists 9-11
Part I + Part II (Welt Premiere)
Brucknerhaus – Mittlerer Saal
Ein Film von Deborah Shaffer/USA
New Yorker Künstler nach dem 11. September
Regie: Deborah Shaffer; Produzent: Martin
Kraml, MMKmedia; Redakteur: Karl Khely,
ORF Kunst-Stücke; Kamera & Schnitt:
Michael Berz; Ton: Harald Wilde; Musik:
Patricia Lee Stotter. In Kooperation mit: ORF
Kunststücke.

Vivisector
Brucknerhaus – Großer Saal
Klaus Obermaier, Chris Haring/A
Choreographie, Tanz: Chris Haring
Visual Concept, Video Art, Composition:
Klaus Obermaier

Tänzer: Tom Hanslmaier, Chris Haring,
Konstantin Mishin, Olaf Reinecke

Gameboyzz Orchestra Project
Ars Electronica Center – Sky Medialoft
kunstbande SLA/PL
In Kooperation mit: Polnisches Jahr in
Österreich 2002.

HipHop Worldwide
Posthof
BMG 44, Pee Froiss/Senegal, Lucky
Kitchen/E/USA, Anticon/USA, Texta/A
Ars Electronica in Kooperation mit Posthof.

Movieline
Moviemento
Begleitprogramm aus Dokumentationen
und Kurzfilmen zur Thematik UNPLUGGED
und zum Thema 9-11 sowie Videoarbeiten
von StudentInnen der Kunsthochschule für
Medien Köln.
In Kooperation mit Moviemento.
UNPLUGGED
ID Swiss: Fulvio Bernarsconi, Christian Davi,
Nadia Fares, Wageh George, Kamal Musale,
Thomas Thümena, Stina Werenfels, CH 1999
Trouble in Paradise: Darcus Howe, United
Kingdom 2000
Aftershocks: Rakesh Sharma, India 2001
News Time: Azza El-Hassan, Palestine 2001
Cuando lo pequeño se hace grande: Mariem
Perez Riera, Puerto Rico 2001
Little Senegal: Rachid Bouchareb, F 2001
Vacances au Pays: Jean-Marie Téno, Kamerun/
F/D 2000
Bread and Roses: Ken Loach, UK 2000
Ausländer Raus: Schlingensiefs Container –
Paul Poet, A 2000
Under the skin of the city: Rakshan Bani
Etemad, Iran 2001
9-11
Artists 9-11 From the Ashes I: Deborah
Shaffer, USA 2001
Artists 9-11 From the Ashes II: Deborah
Shaffer, USA 2002
Für Ihre Sicherheit: Bernd Oppl, A 2001
The Voice of a Prophet: Robert Edwards,
USA 2001
Film Show Kunsthochschule für Medien Köln
Fenster mit Aussicht: Vera Lalyko, D 2001
Freunde/The Whiz Kids: Jan Krüger, D 2001
Die Suche nach dem Almsana-Massiv: Nik
Kern, D 2002
Mountain Mover: Nik Kern, D 2002
**Lehrfilm über die Rekonstruktion von Stasi-
Akten:** Anke Limprecht, D 2001
Visuelle Musik: Jochen Peters, D 2002
Fremdkörper: Katja Pratschke, D 2001
Du und ich, wir könnten einander gehören:
Sven Hargut, D 2001

Le coeur volé: Stephanie Thiersch, D 2001
Ich muß gehen: Florian Mischa Böder, D 2001
Out of EDEKA: Konstantin Faigle, D 2001
Filmauswahl: Andreas Gruber

electrolobby – TransIT Room

Brucknerhaus – Foyer
Versuchsreihe, in der exemplarisch Vermittlungs-
modelle für die (künstlerische) Ausübung neuer
Kulturtechniken erprobt werden.
Space&designstrategies: Elsa Prochazka/A

SEARCH
The Trinity Session, Johannesburg (Stephen
Hobbs, Kathryn Smith, Marcus Neustetter)
in Zusammenarbeit mit _sanman (Southern
African New Media Art Network) und The |
PREMISES.
Kingdom of Piracy <KOP>
www.aec.at/kop
http://211.73.224.150/
Co-Kuratoren: Shu Lea Cheang, Armin
Medosch, Yukiko Shikata. Produktion: Ray
Wang; Koordination: Mia Chen
Mulonga – The Loop
tonga.online
www.mulonga.net, initiiert von der Austria
Zimbabwe Friendship Association(AZFA),
Linz, und der Arbeitsgruppe TONGA.ONLINE.
Webteam: Sabine Bitter & Helmut Weber
gemeinsam mit: Calvin Dondo, Dumisani
Dube, Bert Estl, Keith Goddard, Stefan Hecke,
Hedi and Peter Kuthan, Ingo Lantschner,
Dominique Mair, Elizabeth Markham,
Stanford Muchineripi Dominic Muntanga,
Sengamo Ndlovu, Theophorah Sianyuka,
Werner Puntigam, Thomas Schneider,
Elisabeth Thomsen, Carsten Wagner, Kevin
Wakley, Penny Yon, Simba Zwangobani u. a.
Web administration: Stefan Kuthan.
FM4
*täglich live aus dem electrolobby – TransIT
Room.* Feat.: Veronika Weidinger, Stefan
Trischler, Gerlinde Lang
electrolobby Kitchen
Präsentationen der electrolobby – TransIT
Room TeilnehmerInnen, Umschlagplatz für
Ideen, Standpunkte und Beiträge sowie
Diskussionsforum von und mit Künstler-
Innen der Ars Electronica 2002.
**Buchpräsentation „Before and After the
I-Bomb. An Artist in the Information
Environment":** Edited by Peggy Gale, Tom
Sherman/CDN. Mit Unterstützung der
Botschaft von Kanada in Österreich.
Sintflut: Detlef Heusinger/A

Soundarchitecture and Acoustic Accidents:
Andres Bosshard/CH
Kingdom of Piracy: Armin Medosch/D
SEARCH: Marcus Neustetter/South Africa
Mulonga – The Loop: tonga.online
Moderation – Post Processings UNPLUGGED
Symposium: Andreas Hirsch/A, Rüdiger
Wischenbart/A/D

PARTIZIPATIONEN

**Embrace The Swarm – Exploring Collaborative
Authorship**
Art & Tek Institute
Arbeiten aus der Zusammenarbeit des Ars
Electronica Center mit der Kunstuniversität
Linz und dem Ravensbourne College of
Design and Communication Kent/UK.
Project management:
Michael Shamiyeh/A, Gerhard Funk/A,
Dietmar Offenhuber/A, Helmut Höllerl/A,
Michael Breidenbrücker/UK, Karel Dudesek/UK
Studenten: Linz: Nikolaus Diemannsberger,
Peter Freudling, Joachim Koll, Margit Nobis,
Tina Reisinger, Regina Raml, Bettina Stein-
maurer, Heike Nösslböck, Vinzenz Naderer,
Clemens Mock, Simon Wilhelm. London:
Julieta Leveratto, Zoe Papadopoulou, Chan
Ming Yee Amy, Martine Hermsen, Jon Cam-
beul, Steven Cullen, Wai-Sang Damon Yau,
Nadia Kahn
Digi-Sta-Lab/J
Brucknerhaus
Projektpräsentationen aus dem Digital
Stadium Lab von NHK/J.
Public Information Day: EC-Funding Programmes
Ars Electronica Center
Informationsveranstaltung über Förderpro-
gramme der EU. In Zusammenarbeit mit der
Europäischen Kommission, Bundeskanzler-
amt und CSC-Cultural Service Centre
Austria
Sixth Framework Programme 2002 – 2006
Bernard Smith, European Commission
Culture 2000 Programme
Sigrid Olbrich-Hiebler, Bundeskanzleramt
Kunstsektion
EC funding Programmes
Walter Koch, CSC Cultural Service Centre
Austria
Best Practice
Klaus Nicolai, Medienkulturreferent Dresden
Vera Kockot, Trans-Media-Akademie Hellerau
**Best Practice – Realtime & Presence – Composi-
tion of Virtual Environments**
Initiiert von Kulturbüro Dresden in Koopera-
tion mit Trans-Media-Akademie Hellerau.
Mitveranstalter: Ars Electronica Center Linz,

V2_Organisation Rotterdam. Unterstützt durch das Culture 2000 program der EU. Patronat: Staatsministerium für Wissenschaft und Kunst, Sachsen, Kulturstiftung Sachsen.

Komposition virtueller Bild-Klang-Räume
Bertrand Merlier/F, Jean-Marc Duchenne/F, Frieder Weiß/D, Dominik Rinnhofer/D, blueLAB/D, *Moderation:* Vera Kockot, Klaus Nicolai

Interaktives Bild-Klang-Environment
Klanginstallation: Frieder Weiß/D, Simultan Presence 02: Dominik Rinnhofer/D, Position: Jo Siamon Salich/D, Hartmut Dorschner/D (blueLAB)
PLUGGED: Udo Zickwolf/D, blueLAB/D
4Hands: Bertrand Merlier/F, Jean-Marc Duchenne/F

Ars Electronica 2003
Festival für Kunst, Technologie und Gesellschaft

CODE – The Language of Our Time
CODE=LAW CODE=ART CODE=LIFE
Linz, 6. – 11. September

Veranstalter:
Ars Electronica Center Linz
Museumsgesellschaft mbH
Geschäftsführer: Gerfried Stocker,
Mag. Romana Staufer
ORF Landesstudio Oberösterreich
Landesdirektor: Helmut Obermayr

Direktorium, künstlerische Leitung:
Gerfried Stocker, Ars Electronica Center
Dr. Christine Schöpf, ORF Landesstudio Oberösterreich
Koordination & Produktion:
Katrin Emler, Manu Pfaffenbichler

Kuratorische Berater:
Tim Didymus, Dennis Russell Davies, Ingrid Fischer-Schreiber, Cecilia Hausherr, Naut Humon, Iris Mayr, Christiane Paul, Casey Reas, Giaco Schiesser

Mitveranstalter Ars Electronica 2003:
Brucknerhaus
O.K Centrum für Gegenwartskunst
Universität für künstlerische und industrielle Gestaltung Linz

Prix Ars Electronica 2003
Internationaler Wettbewerb für Cyberarts
Veranstalter: ORF Landesstudio Oberösterreich
Idee: Dr. Hannes Leopoldseder
Konzeption: Dr. Christine Schöpf
Finanzen: Dkfm. Heinz Augner
Organisation: Gabi Strutzenberger, Judith Raab

www.aec.at/code
Web Editor: Ingrid Fischer-Schreiber, Web Design: Joachim Schnaitter, Web Team: Daniela Ortner, Barbara Höller, Andreas Wrabo, Gunther Schmidl, Günther Kolar, Wolfgang Mayrhofer, Volker Haider

CONFERENCES

Themensymposium

CODE – The Language of Our Time
CODE=LAW CODE=ART CODE=LIFE
Brucknerhaus – Mittlerer Saal
7. – 11. September
The Meaning of Code
Gerfried Stocker/A
Friedrich Kittler/D

Cindy Cohn/USA
Erkki Huhtamo/SF/USA
Peter J. Bentley/UK
Moderation: Gerfried Stocker/A
The Art of Code
Giaco Schiesser/CH
Richard Kriesche/A
Roman Verostko/USA
Casey Reas/USA
Moderation: Roy Ascott/UK
Social Code
Howard Rheingold/USA
Leo Findeisen D/A
Florian Cramer/D
Fiona Raby/UK
Hans Peter Schwarz/CH
Moderation: Mark Federman/CDN
Collective Creativity
Pierre Lévy/F/CDN
John Warnock/USA
Marc Canter/USA
James McCartney/USA
Moderation: Mark Federman/CDN
Tangible Code
Hiroshi Ishii/USA
Oliver Fritz/CH
Joachim Sauter/D
Scott deLahunta/UK/NL
Jonathan Norton/USA
Moderation: Hiroshi Ishii/USA
Software & Art I
Golan Levin, Zachary Lieberman/USA
Sebastian Oschatz/D
Alex Galloway/USA
Ben Fry/USA
James McCartney/USA
Lia/A
Christa Sommerer/A, Laurent Mignonneau/F
Moderation: Casey Reas/USA
Software & Art II
Christiane Paul/USA
Alexei Shulgin, Olga Goriunova/RUS
Alex McLean/UK, Amy Alexander/USA
Christian Hübler/A/CH
Andreas Broeckmann/D
Moderation: Christiane Paul/USA

Prix Ars Electronica Forum
ORF Landesstudio Oberösterreich
9. – 11. September
Vorträge, Präsentationen, Diskussionen von und
mit den Preisträgern und Juroren des Prix Ars
Electronica 2003. Siehe Seite 337

Pixelspaces
Ars Electronica Center
8. – 9. September
Pixelspaces – DAMPF
Sensory Environments – Immaterial Interfaces

Scott deLahunta/UK/NL, Justin Manor/USA,
Joreg Dießl/D, Sebastian Oschatz/D, Adrian
Cheok/SGP, Hirokazu Kato/J, Horst Hörtner/A,
Angelika Oei/NL, Klaus Obermaier/A, Paolo
Coletta/I, Joachim Sauter/D
Moderation: Christopher Lindinger/A
DAMPF (Dance and Media Performance
Fusions) ist eine Kollaboration von: tanz
performance köln, Animax Multimedia-
Theater Bonn, V2_Lab Rotterdam, Ars Elec-
tronica Center Linz. Unterstützt durch das
Culture 2000 program der EU.

Towards a Society of Control?
Ars Electronica Center/Sky Medialoft
9. September
Ein Projekt von Radio FRO/A in Kooperation mit
Ars Electronica.
**Panel A: Containing Information: Digital
Standards, New Copyright Standards and their
Impact on Freedom of Information**
Cindy Cohn/USA, Juliane Alton/A, Mark
Terkessidis/D, *Moderation:* Erich Möchel/A
**Panel B: Digital Standards and the Public
Domain: Consequences and Current Strategies
for an Independent Public Sphere**
Konrad Becker/A, Alan Toner/IRL, Milos Vojte-
chovsky/CZ, Zeljko Blace/HU, Babau-Iladi/CZ
Moderation: Honor Harger/NZL
Practice Zone
Stadtwerkstatt
Stream on the Fly – Personalized Streaming
Radio Technology, Host: Thomas Thurner,
Team Teichenberg/A
The Frequency Clock – The Streaming Suit-
case, Host: Adam Hyde/NZL
The Cultural Broadcasting Archive
Host: Ingo Leindecker/A

Prix Ars Electronica

Internationaler Wettbewerb für Cyberarts
Veranstalter: ORF Landesstudio Oberösterreich
Idee: Dr. Hannes Leopoldseder
Konzeption: Dr. Christine Schöpf
Finanzen: Dkfm. Heinz Augner

Net Vision/Net Excellence
Jury: Ed Burton/UK, Joshua Davis/USA, Casey
Reas/USA, Steve Rogers/GB, Yukiko Shikata/J
Goldene Nica Net Vision: Yury Gitman/Carlos J.
Gomez de Llarena/USA/VEN
Auszeichnungen Net Vision: David Crawford/
USA/S, Golan Levin/USA
Goldene Nica Net Excellence: Sulake Labs Oy/SF
Auszeichnungen Net Excellence: Lia/A, James
Tindall/USA

Anerkennungen: Net Vision/Net Excellence: Antoni Abad/E, Christophe Bruno/F, Amit Pitaru/ James Paterson/IL/GB, Agathe Jacquillat/Tomi Vollauscheck/FL@33/F/A, Jared Tarbell/Lola Brine/USA, Axel Heide/onesandzeros/Philip Pocock/Gregor Stehle/D, Wiggle/Han Hooger-brugge/J/NL, LAN/CH, Last.Team (Michael Breidenbrücker/Felix Miller/Martin Stiksel/D/A), LeCielEstBleu/F, ubermorgen (E. Maria Haas/ Luzius A. Bernhard/A/CH), Shinya Yamamoto/J, www.sourgeforge.net

Interaktive Kunst

Jury: Scott S. Fisher/USA, Tomoe Moriyama/J, Joseph Paradiso/USA, Christiane Paul/USA, Stahl Stenslie/N
Goldene Nica: Blast Theory in collaboration with Mixed Reality Lab, University of Nottingham/UK
Auszeichnungen: Margarete Jahrmann/Max Moswitzer/A, Maywa Denki/J
Anerkennungen: Ross Cooper/UK & Jussi Ängeslevä/SF, dECOi, Sibylle Hauert/Daniel Reichmuth/Volker Böhm/CH/D, Haruo Ishii/J, George Legrady/USA, Justin Manor/USA, Agnes Meyer-Brandis/D, Iori Nakai/J, Henry Newton-Dunn/Hiroaki Nakano/James Gibson/Ryota Kuwakubo/GB/J, Marcel.lí Antúnez Roca/E, Marie Sester/F/USA, Scott Snibbe/USA

Computeranimation/Visual Effects

Jury: Loren Carpenter/USA, Olivier Cauwet/F, Hiroshi Chida/J, Bob Sabiston/USA, Rita Street/USA
Goldene Nica: Romain Segaud/Christel Pougeoise/F
Auszeichnungen: Carlos Saldanha/Blue Sky Studios, 20th Century Fox/USA, Koji Yamamura/J
Anerkennungen: Christoph Ammann/CH, Erich Armstrong/Sony Pictures Imageworks/CDN, Jérôme Decock/Olivier Lanerès/Mélina Milcent/ Cécile Detez de la Dreve/F, Roger Gould/Pete Docter/Pixar/USA, Thorsten Fleisch/D, Luc Froehlicher/La Maison/F, H5/Ludovic Houplain/ Hervé de Crécy/F, Wayne Lytle/ANIMUSIC/USA, Siri Melchior/DK, Jordi Moragues/E, Tippett Studio/USA, Sathoshi Tomioka/J,

Digital Musics

Jury: AGF aka Antye Greie/D, Naut Humon/USA, Alain Mongeau/CDN, Marcus Schmickler/D, David Toop/UK
Goldene Nica: Ami Yoshida/SachikoM/Utah Kawasaki/J
Auszeichnungen: Florian Hecker/A, Maja Solveig Kjelstrup Ratkje/N
Anerkennungen: Oren Ambarchi/AUS, Whitehouse/UK, Kevin Drumm/USA, Rudolf Eb.er/CH, Phil Niblock/USA, Yuko Nexus 6/J, Gert-Jan Prins/NL, Rechenzentrum/D, Tujiko NorikoJ/F,

Toshiya Tsunoda/J, Aaron Funk/CDN, Venetian Snares & Rachel Kozak/CH, Mark Wastell/ Toshimaru Nakamura/Taku Sugimoto/ Tetuzi Akiyama/UK/J

Cybergeneration – u19 freestyle computing

Jury: Sirikit Amann/A, Tina Auer/A, Horst Hörtner/A, Manfred Nürnberger/A, Martin Pieper/A
Goldene Nica: Georg Sochurek/A
Auszeichnungen: Martin Leonhartsberger/Sigrun Fugger/A, Armin Ronacher/Nikolaus Mikschofsky/A
Anerkennungen: Dominik Dorn, Georg Gruber, Manuel Fallmann, David Hackl, Thomas Hainscho, Hauptschule Steinerkirchen/Traun, Alexandra Voglreiter/Katharina Krummel/Anna Obermeier, Projektgruppe der HBLA für künstlerische Gestaltung Garnisonstraße Linz, Franz Wengler/Christof Haidinger, 7a des BORG 3 Wien, Tobias Schererbauer/Matthäus König/ Sebastian Schreiner

Die Goldene Nica
Prix Ars Electronica Gala 2003

ORF Landesstudio Oberösterreich – 3sat
Verleihung der Goldenen Nica 2003
Moderation: Ingrid Thurnher

Prix Ars Electronica Forum

ORF Landesstudio Oberösterreich
9. – 11. September
Präsentationen und Diskussionen von und mit den Preisträgern und Juroren des Prix Ars Electronica 2003.

Computer Animation/Visual Effects
 William H. Frake/Blue Sky Studios/20th Century Fox/USA, Koji Yamamura/Yamamura Animation, Inc./J, Romain Segaud, Christel Pougeoise/ Supinfocom/One plus One/F
 Moderation: Shuzo John Shiota/J
Changes in Media Art – Special Lecture
 Itsuo Sakane/J
 Preisträger des Golden Nica Award for Life Achievement des Prix Ars Electronica 2003
Digital Musics
 Florian Hecker, Mego/D/A, Maja Solveig Kjelstrup Ratkje, John Hegre, Lasse Marhaug/N, Ami Yoshida, Sachiko M, Utah Kawasaki/ F.M.N. Sound Factory/J
 Moderation: Naut Humon/USA
Interactive Art
 Maywa Denki/J, Margarete Jahrmann, Max Moswitzer/A, Blast Theory/Mixed Reality Lab/UK
 Moderation: Stahl Stenslie/N/D
Net Vision/Net Excellence
 David Crawford/USA/S, Golan Levin/USA Carlos J. Gomez de Llarena, Yury Gitman/ VEN/USA, Sulake Labs Oy/SF, Lia/A, James

Tindall/UK
Moderation: Steve Rogers/UK

Electronic Theatre

O.K Centrum für Gegenwartskunst – Arena
Präsentation der prämierten Computerani-
mationen und Visual Effects des Prix Ars
Electronica 2003.
Programm:
Tim Tom: Romain Segaud, Christel Pougeoise/F
Atama Yama: Koji Yamamura/J
Gone Nutty: Ice Age DVD – Carlos Saldanha/
Blue Sky Studios/20th Century Fox/USA
The Dog who was a Cat: Siri Melchior/DK
Gestalt: Thorsten Fleisch/D
Mantis: Jordi Moragues/E
**3D Character Animation for Blockbuster Enter-
tainment:** Tippett Studio/USA
Au bout du fil: Jérôme Decock, Cécile Detez de
la Dreve, Olivier Lanerès, Mélina Milcent/F
Untitled: Christoph Ammann/CDN
Dolce Vita: Luc Froehlicher/F
Justice Runners: Satoshi Tomioka/J
Remind Me: Ludovic Houplain/Hervé de Crécy/F

Cyberarts 2003

Prix Ars Electronica Ausstellung

O.K Centrum für Gegenwartskunst
Can you see me now?
Blast Theory/Mixed Reality Lab/UK
Goldene Nica Interaktive Kunst
Tsukuba Series
Maywa Denki/J
Auszeichnung Interaktive Kunst
nybble-engine-toolZ
Margarete Jahrmann, Max Moswitzer/A
Auszeichnung Interaktive Kunst
Anerkennungen Interaktive Kunst:
Deep Walls
Scott Snibbe/USA
Pockets full of Memories
George Legrady/USA
Supported by the Daniel Langlois Founda-
tion for the Arts, Science and Technology,
Montreal, The College of Letters and Science
at the University of California, Santa Barbara
Block Jam
Henry Newton-Dunn, Hiroaki Nikano, James
Gibson, Ryota Kuwakubo/J
Streetscape
Iori Nakai/J
ACCESS
Marie Sester/F/USA
Last
Ross Cooper/UK, Jussi Ängeslevä/SF
Instant City
Sybille Hauert, Daniel Reichmuth/CH
Aegis Hyposurface

dECOi/F
Hyperscratch ver.12
Haruo Ishii/J
Earth core laboratory and elf-scan
Agnes Meyer-Brandis/D
Cinéma Fabriqué
Justin Manor/USA
Requiem
Marcel.lí Antúnez Roca/E
Cybergeneration – u19 freestyle computing
Ausstellung der prämierten Arbeiten der
u19-Kategorie des Prix Ars Electronica 2003.
Rubberduck: Georg Sochurek, *Goldene Nica
Cybergeneration – u19 freestyle computing*
**Gerät zur Messung und Analyse von Spon-
dylolisthese:** Martin Leonhartsberger,
Sigrun Astrid Fugger, *Auszeichnung Cyberge-
neration – u19 freestyle computing*
:.be A bee.: Armin Ronacher, Nikolaus
Mikschofsky, *Auszeichnung Cybergeneration
– u19 freestyle computing*
*Anerkennungen Cybergeneration – u19 freestyle
computing:*
lyrix.at: Dominik Dorn
individual interface inflex.org: Georg Gruber
system interrupted: Manuel Fallmann
Die Fliege: David Hackl
schools out for Rosh Hodesh Adar II:
Thomas Hainscho
Der Sprung ins Ungewisse: Hauptschule
Steinerkirchen/Traun
i2 was ist eine tolle Seite?: Alexandra Vogl-
reiter, Katharina Krummel, Anna Obermeier
Bewegung: Projektgruppe der HBLA für
künstlerische Gestaltung Garnisonstr. Linz
Akustische Lesehilfe für Sehbehinderte:
Franz Wengler, Christof Haidinger
Klangbilder: Class 7a at the BORG3, Vienna
Das Studio und die Greenbox: Tobias Scherer-
bauer, Matthus König, Sebastian Schreiner
**Cybergeneration – u19 freestyle computing
Preisverleihung**
Die Preisverleihung an die Gewinner der
Jugendkategorie cybergeneration – u19 free-
style computing des Prix Ars Electronica 2003.
Produktion Cyberarts 2003: Florian Prix
Design: Peter Sommerauer

Exhibitions

Themenausstellung CODE

Brucknerhaus – Foyer
Das universelle Datenwerk – datenwerk: mensch
Richard Kriesche/A
MicroImage
Casey Reas/USA
FooD (F-zero-zero-D), Reactive Graphics History

John Maeda/USA
Visually Deconstructing Code
Ben Fry/USA
Epigenetic Painting
Roman Verostko/USA
CODeDOC II
Kuratiert von: Christiane Paul/USA
Mit: Ed Burton/UK, epidemiC/I, Graham
Harwood/UK, Jaromil/I/A, Annja Krautgasser
& Rainer Mandl/A, Joan Leandre/E, Antoine
Schmitt/F und John F. Simon, Jr./UK
bitforms gallery
Steve Sacks/USA
Trash Mirror
Daniel Rozin/USA
Crossing & The Nomadic Lines of Flight
Shirley Shor/USA
Dictionary of Primal Behaviour
Urtica/FRY
Ars Electronica Quarter – Art&Tek
Matarisama Dolls
Masahiro Miwa, Noriaki Ogasawara/J
Music Creatures
Marc Downie/UK with the Synthetic
Characters Group at the MIT Media Lab
24!
Michael Aschauer, Norbert Pfaffenbichler,
Lotte Schreiber. In Kooperation mit
O.K Centrum für Gegenwartskunst
co.in.cide
Hauptplatz/Ars Electronica Quarter – Art&Tek
Heimo Ranzenbacher, x-space & Ars Electro-
nica Futurelab/A. Produktion: Ars Electronica
Futurelab.
Mobile Feelings
Hauptplatz
Christa Sommerer/A, Laurent Mignonneau/F
Ein Projekt von IAMAS Institute for Advan-
ced Media Arts and Sciences, Gifu/J in Zu-
sammenarbeit mit France Telecom Studio
Créatif, Paris. Ars Electronica in Kooperation
mit voestalpine AG
Not to Scale
Kunstraum Goethestraße
Isabelle Cornaro/F, Heman Chong/SGP,
Daniel Kluge/D

Cyberarts 2003
Prix Ars Electronica Ausstellung
O.K Centrum für Gegenwartskunst
Siehe Seite 338

CAMPUS
Kunstuniversität Linz, Hauptplatz
Media I Art I Education
Arbeiten von Studierenden des Departe-
ment Medien & Kunst, Hochschule für
Gestaltung und Kunst Zürich.

Eine Kooperation von: Ars Electronica, Uni-
versität für künstlerische und industrielle
Gestaltung Linz und Hochschule für Gestal-
tung und Kunst Zürich. Unterstützt von:
Pro Helvetia Schweizer Kulturstiftung und
Schweizer Botschaft, Wien. Koordination:
Cecilia Hausheer/Giaco Schiesser/CH,
Rainer Zendron/Wolfgang Almer/A.
BEATWEEN: Impuls im Puls – Michael Hampel
FAX.BOOT.FORCE: Become an Engine of One:
Felix Eggmann, Max Rheiner
Heimatwerk: Georg Huber, Ivan Sterzinger
Loogie.net tv: Marc Lee
ImageWriter: Silvan Leuthold
Jusqu'ici tout va bien: Anne-Lea Werlen,
Carmen Weisskopf
Luxus4all 1/2 open office: Mario Purkat-
hofer, Doma Smoljo
Mommy, i want superalgorithms too...!:
Niki Schawalder
Desktop Hardware Orchestra: Roger Wigger,
Mascha Leummens
Recombinant_Hardware Hacker Project:
Project Directors: Prof. Margarete Jahr-
mann, Prof. Giaco Schiesser, Max Moswitzer
SuPerVillainizer: Conspiracy Client – LAN,
Annina Rüst
Swiss Dotcoms in Retrospect: Thomas
Comiotto, Niki Schawalder
track-the-trackers---: Annina Rüst
16elemente: Christine Szabo, Valentina Vuksic
Compiler: Magazine for Contemporary Art
Research Director: Susann Wintsch,
Concept: Milica Tomic, Susann Wintsch,
Project Director: Hildegard Spielhofer
Forum: Gabriela Gerber, Lukas Bardill
Schatten-tv: Jörg Köppl, Philipp Schaufel-
berger
public plaiv: An interdisciplinary research
project by the Department of Fine Arts of
the University of Art and Design Zurich in
cooperation with the Chair in Modern and
Contemporary Art of the University of
Zurich
Edit: MountainView: Felix S. Huber, Florian
Wüst in Zusammenarbeit mit Daniel Burk-
hardt
Sitzungszimmer: Cornelia Heusser
VonZeit zuZeit: Tom Karrer
Jubilee: Zehn Jahre Studienbereich Film/
Video
forschungsgruppe_f

Ars Electronica Center Exhibition 2003/2004

Ars Electronica Center

Untergeschoss

Autostereoscopic/SeeReal
Ars Electronica Futurelab/A
Unterstützt von: SeeReal Technologies,

Tissue
Casey Reas/USA
Installiert am Responsive Window, einem
Projekt von Joe Paradiso, MIT Media Lab.

Social Sound Fetish
Werner Jauk, Jörg Dieber, Doris Jauk-Hinz,
Herwig Stieber, Fränk Zimmer, GEWI Lab. In
Zusammenarbeit mit Graz 2003.

Erdgeschoss/Zwischengeschoss

OnScreen_4
echo sparks
Double: Kerry Tribe
Three Trucks: Euan Macdonald
The Exchange Programm: Michael Mandi-
berg, Amy Satterthwaite
Paradise Road: Karina Nimmerfall
Mom and Me Watching Zoolander: Anne
Walsh
SLA/screed #16, Patricia Hearst's 2nd tape:
Sharon Hayes
Ohne Titel (Diner): Judith Amman
und es gibt diese tage am meer, johnny:
Siggi Hofer
Wren's Room: Jeannie Simms
Eat My Goal: Susanne Jirkuff
Konzept und Programm: Susanne Jirkuff. Ein
Projekt im Rahmen des Stadtstipendiums
Linz 2002.

Humphrey II
Flugsimulator
Ars Electronica Futurelab/A
Stefan Mittlböck-Jungwirth, Gerfried Stok-
ker, Horst Hörtner, Andreas Jalsovec, Robert
Abt, Michael Büttner, Peter Brandl, Martin
Bruner, Stefan Feldler, Peter Freudling,
Martin Honzik, Christopher Lindinger,
Werner Pötzelberger, Erwin Reitböck, Wolf-
gang Ziegler, Thomas Kienzl, Wöber Anton,
Flugschule „Wings", Dietmar Offenhuber,
Martin Sturm, Stefan Stipek, Stefan Steiner,
Gerold Hofstadler, Rudolf Hanl, Thomas
Teibler. D.O.R.I.S. – Thomas Ebert, Kurt
Pfleger; Gerhard Riegler, Franz Nagelreiter.
Ausstellungsarchitektur: Scott Ritter, Jakob
Edlbacher. In Kooperation mit: Festo, Wintex,
Form², Rosenbauer.

Elevated Space
Museumslift
EXIT: Margit Thieme
Fußgänger: Minka Ludwig, Emilie Hagen

Uzumaki: Volker Gebhard
Der Mond und die Suppe: Karin Reisinger
**Um-Chi-Im e Je-Sul – Die Kunst der Bewe-
gung:** Andreas Mäule
Implementierung: Ars Electronica Futurelab,
Dietmar Offenhuber, Volker Christian,
Christopher Lindinger, Robert Abt, Andreas
Riedler, Erwin Reitböck, Thomas Lorenz

Flow in a Lift
Außenlift
Gil K (Wiggle)/USA/J, Han Hoogerbrugge/
NL, Jeroen Beltman, Tatsuya Yoshida

Little Red MR – Rotkäppchen im Cyberspace
MR Ground Zero/J, Kenji Iguchi, Tomoki Saso,
Aska Morinobu, Yasuko Saito, Mizuho Hana-
zawa, Ayako Takagi, Kasumi Shigiyama, Yoko
Muta, Eriko Matsumoto, Satoshi Umase,
Mana Son, Mariko Takeuchi, Tomohiro
Nishita, Masa Inakage, imgl, Keio University
Inakage Lab

1. Obergeschoss

Hidden Worlds
Gulliver's Box
Konzept: Hirokazu Kato, Christopher Lindin-
ger, Horst Hörtner, Nina Wenhart, Gerfried
Stocker. Content: Li Yu, Pascal Maresch, An-
dreas Jalsovec, Christine Pilsl. Software-
development: Dan Borthwick, Simon Prince,
Adrian David Cheok, Hirokazu Kato, Gernot
Ziegler, Roland Haring Wolfgang Ziegler,
Robert Praxmarer, Stefan Feldler. Produk-
tion: Rudolf Hanl, Martin Honzik, Gerold
Hofstadler, Martin Sturm, Stefan Mittel-
böck-Jungwirth. Ausstellungs Design: Scott
Ritter. Mit Unterstützung von: DSTA Singa-
pore und National Arts Council Singapore.

Key Grip
Justin Manor/USA
Realisiert im Rahmen des Siemens Artist in
Residence Programm.

2. Obergeschoss

Smart Objects
LabSpace
Sam Auinger, Dietmar Offenhuber, Helmut
Höllerl, Pascal Maresch, Erwin Reitböck,
Peter Brandl. Ausstellungsdesign: Scott Ritter
Networked Portrait
John Gerrard/IRL
Ars Electronica Futurelab: Andreas Jalsovec ,
Martin Bruner, Erwin Reitböck, Christopher
Lindinger, Pascal Maresch. Realisiert im Rah-
men des Ars Electronica Futurelab Artist in
Residence Programme; ermöglicht durch
Pépinières Européennes pour Jeunes Arti-
stes 2003.
Protrude, Flow
Sachiko Kodama, Minako Takeno/J
Supported by Denshijiki Industry Co., Ltd.

Social Mobiles
Crispin Jones/UK with IDEO
Graham Pullin, Mat Hunter, Anton Schubert
Streetscape
Iori Nakai
Audiopad
James Patten, Ben Recht/USA
Developed at the MIT Media Lab
PuppetTools
Frédéric Durieu/B, Kristine Malden/USA,
Jean-Jacques Birgé/F
Block Jam
Ryota Kuwakubo, Henry Newton-Dunn,
Hiroaki Nakano, James Gibson,
bitforms gallery
Steve Sacks/USA
 Floccus: Golan Levin
 RPM: Casey Reas
 re:move: lia

CAVE/ARSBOX
Ars Electronica Center
Kunst und Museumsprojekte:
 Citycluster From the Renaissance to the
 Gigabits Networking Age
 Franz Fischnaller/I
 Produziert von F.A.B.R.I.CATORS, Milan/I in
 Zusammenarbeit mit: Electronic Visualiza-
 tion Lab, University of Illinois at Chicago
 raum.art ein elektronisches Museum
 A. Benjamin Spaeth/D, Erwin Herzberger,
 Uwe Wössner
 Uzume
 Petra Gemeinböck/A, Roland Blach/D,
 Nicolaj Kirisits/A. Implementiert am CCVE
 IAO Fraunhofer Stuttgart.
Industrie – und Architekturprojekte:
 NAVEG Drehscheibe Linz
 Ars Electronica Futurelab, Horst Hörtner,
 Andreas Jalsovec, Pascal Maresch, Werner
 Pötzelberger, Peter Freudling, Andreas
 Riedler, Florian Berger
 Foo Billard
 Florian Berger, Ars Electronica Futurelab

Open Lab
Ars Electronica Futurelab
 Arsbox/UnCave: Florian Berger/Michael
 Büttner/Wolfgang Ziegler/A (Ars Electro-
 nica Futurelab)
 Lumas: Carlos Andreas Rocha/USA (MIT
 Media Lab), Robert Praxmarer/A (Ars Elec-
 tronica Futurelab)
 Beyond the Desktop: Orhan Kipcak/A (FHS
 Joanneum), Helmut Höllerl/A (Ars Electronica
 Futurelab)
 Liquid Sound: Marko Malle/Mathias Piket/
 Chiara Pucher/Eva Schindling/A (FHS Joanneum)

Zeitraumgreifer LS82T: Daniel Fabry/Virgil
Guggenberger/Anika Kronberger/Erwin
Wagner/Christian Zagler/A (FHS Joanneum)
Augmented Sound Reality: Daniel Dobler/
Philipp Stampfl/A (FHS Hagenberg)
Educational Projects: Games and Architec-
ture Workshop: TU Wien & Ars Electronica
Futurelab. Elevated Space Workshop: TU
Wien & Ars Electronica Futurelab. Beyond
the Desktop Workshop: FHS Joanneum &
Ars Electronica Futurelab. Leonding Work-
shop: Kunstuniversität Linz & Ars Electronica
Futurelab
Research from the Garage: Peter Brandl,
Stefan Feldler, Christian Naglhofer, Erwin
Reitböck

Ars Electronica Center – Events 2003
Johannes Deutsch – Computerbilder
 24. Jänner – 02. März 2003
 Stadtmuseum Nordico, Galerie Maerz und
 Ars Electronica Center Linz
opening night – Sky Media Loft Cafe & Bar
 19. September 2003
 Sky Media Loft
 DJ Makossa (swound sound system, FM4)
 in Kooperation mit FM4
1st International DOM-Conference
 21. März – 22. März 2003
 Kunstuniversität Linz, Ars Electronica Center Linz
 Referenten: Michael Shamiyeh, Reinhard
 Kannonier, Gerfried Stocker, Oliver Fritz/CH,
 Wilfried Posch/A, Bruce Fisher, Mathias
 Hollwich, Marc Rosa/USA, Makoto Sei
 Watanabe/JAP, Oliver Schürrer/A, Markus
 Braach/CH, Winy Maas/NL, Makus Neppl/
 NL, Bernhard Franken/D, Urs Hirschberg/A,
 Kas Oosterhuis/NL, Pau Sola-Morales/USA,
 Florian Böhm/D, Dennis R. Sheden/USA,
 Hiro Ishii/USA, Bill Buxton/CDN
love is free
 10. Jänner 2003
 Sky Media Loft
 Feat.: Patrik Huber, Georgie Gold and the
 Disco Killers

EVENTS & PERFORMANCES

Teleklettergarten – Opening
 Hauptplatz
 Gruppe FOK/CH. Ein Projekt des Studienbe-
 reiches Neue Medien der Hochschule für
 Gestaltung und Kunst Zürich.
Opening Reception Ars Electronica 2003 und
Linzer Klangwolke
 Brucknerhaus
 Eröffnung der Ars Electronica 2003 und der
 Linzer Klangwolke. Ausblicke auf Highlights

des Festivals und Live-Performances: mit Dennis Russell Davies/USA, Maki Namekawa/D, Maywa Denki/J. Eine gemeinsame Veranstaltung von Ars Electronica, Brucknerhaus und ORF Oberösterreich.

Visualisierte Linzer Klangwolke

Europa – eine symphonische Vision
Donaupark
Christian Kolonovits, Chris Laska/A
Kuratiert und veranstaltet von: Brucknerhaus Linz, ORF Landesstudio Oberösterreich

Animation!

Computeranimationen am Linzer Hauptplatz. Best-of der spannendsten Computeranimationen aus den Einreichungen zum Prix Ars Electronica.

login: Ars Electronica

Peter Behrens Haus (Alte Tabakwerke)
386 dx megashow: Alexei Shulgin/RUS
Colophony Circuit: Electric Indigo & Mia Zabelka/A
Visuals: Glam Fatal/A
Djing: DJ Mao/A
Design & Furnishing: Tanja Lattner, Betty Wimmer. Ars Electronica in Zusammenarbeit mit Kunstuniversität Linz, Institut Bildende Kunst und Kulturwissenschaften, Bildhauerei und Experimentelle Visuelle Gestaltung.

Messa di Voce

Brucknerhaus
Tmema/USA/Jaap Blonk/NL/Joan La Barbara/USA
Eine Auftragsarbeit von Ars Electronica unterstützt von: SAP, la Fondation Daniel Langlois pour l'art, la science et la technologie, Eyebeam Atelier, The Rockefeller MAP Fund, Arts Council England.
Tmema: Golan Levin & Zachary Lieberman
Composers/Performers: Jaap Blonk, Joan La Barbara

Floating Points in the OMV Klangpark

Donaupark
kuratiert von: Tim Didymus/UK
Live-Performances
AGF und Koan Master
Dark Symphony – Retrospektive internationaler Arbeiten mit der Koan-Software
Mixed and edited: Al Jolley, Tim Didymus
Arbeiten von: Paul Cohen, Tim Cole, Tim Didymus, Brian Eno, Andrew Garton, Richard Garrett, Steve Grainger, Michael Hagleitner, Mark Harrop, Al Jolley, Yoshio Machida, Kelvin L. Smith, Emilia Telese, Mashashi Genzan Yano

Japanese Animation!

Hauptplatz
ACA Media Arts Festival/J
Justice Runners: Tomioka Satoshi

Mustafrog and NINJA bunny: Usagi Tanaka
Fisher Man: Saku Sakamoto
The Evening Traveling: Akino Kondoh
The Snow Woman's Castle: Iwai Akiko
Affordance: Hiroyuki Okui
Tribe #1, #2, #3: Hiroyuki Nakao
Sirop de Namaquemono: Tominaga Mai
Scarlett Road: Tomoyasu Murata

O.K Night

O.K Centrum für Gegenwartskunst Arena
Transcription of Sound
Justin Manor/USA, Eric Gunter/USA, Timon Botez/N

Principles of Indeterminism

An Evening from Score to Code

Brucknerhaus, Donaupark
Live-Musik und Realtime Graphics.
Die Idee für dieses Projekt entstand in vielen Diskussionen zwischen: Dennis Russell Davies, Gerfried Stocker, Naut Humon und Rupert Huber. Mit Unterstützung von: Bruckner Orchester Linz, Dennis Russell Davies, Dr. Heribert Schröder, ORF Oberösterreich, Österreich 1, Claude Mussou/INA (Groupe de Recherches Musicales), Steven Joyce/Boosey & Hawkes, Andreas P. Leitner/Universal Edition AG, Rudolf Andrich/Sacem, Madame Françoise Xenakis, Dianna Santillno/Bill Viola Office, Arcotel Nike, PANI Projection & Lighting. Audio/technical concept: Naut Humon, Hubert Hawel. Eine gemeinsame Produktion von Ars Electronica Festival und Brucknerhaus Linz mit Unterstützung von ORF, PANI Projection & Lighting.

metamorph #1

Brucknerhaus – Großer Saal 19:30
Bruckner Orchester Linz, Dirigent: Dennis Russell Davies
 Musik: Edgar Varèse: „Déserts"
 Video: Bill Viola
 Sound Director: Johannes Kretz
 Musik: Morton Subotnick: „Before the Butterfly"
 Visuals: Sue Costabile
 Sound Director: Peter Otto
Maki Namekawa (piano/computer)
 Musik: Marco Stroppa: „Traiettoria ... deviata"
 Visuals: Marius Watz
 Sound Director: Johannes Kretz
Bruckner Orchester Linz, Dirigent: Dennis Russell Davies
 Musik: Iannis Xenakis: „Analogique A"
 Visuals: Lia
 Sound Direktor: Johannes Kretz

metamorph #2

Brucknerhaus – Foyer zum Mittleren Saal 21:00
Dennis Russell Davies (Piano), Maki Namekawa (Piano)

Musik: Steve Reich: „Piano Phase"
Visuals: Martin Wattenberg
Brucknerhaus – Mittlerer Saal
Rupert Huber/Tosca: „I could be you"
Visuals: Justin Manor
Studio Percussion Graz
Musik: Steve Reich: „Drumming"
Visuals: Justin Manor
Rupert Huber/Tosca: „I could be you"
Visuals: Justin Manor

metamorph #3
Donaupark 22:00
Musik:
Iannis Xenakis:„Analogique B"–2 Channel Tape
Iannis Xenakis: „Gendy3" – 2 Channel Tape
Iannis Xenakis: „Persépolis" –4 Channel Tape
Visuals: Gerda Palmetshofer, Stefan Mittlböck

metamorph #4
Brucknerhaus – Großer Saal 22:30
Persépolis: Remixing Xenakis
Remix:
Otomo Yoshihide – Visuals: Lia
Ryoji Ikeda – Visuals: Ryoji Ikeda/Naut Human
Remix of the Remixers: Naut Humon
Visuals: Sue Costabile

metamorph #5
Brucknerhaus – Großer Saal 23:00
„Data Spectra"
Musik und Visuals: Ryoji Ikeda
„Multiple Otomo"
Musik und Visuals: Otomo Yoshihide
„# dominant"
Musik: Rupert Huber, Visuals: Marius Watz

Digital Musics in Concert
Brucknerhaus
Livekonzert der Preisträger der Kategorie
Digital Musics des Prix Ars Electronica 2003.
astro twin/cosmos: Ami Yoshida, Sachiko M,
Utah Kawasaki (F.M.N. Sound Factory)/J
Sun Pandämonium: Florian Hecker (Mego)/A
voice: Maja Solveig Kjelstrup Ratkje, Jazz-
kammer: John Hegre, Lasse Marhaug

MARX
Industriehalle Rubblemaster/Südpark Pichling
Performance: Oliver Augst, Marcel Daemgen,
Christoph Korn/D, Thomas Desy/A
Installationen: Robert Spour/A, Claus
Prokop/A, Josef Linschinger/A und Frequenz-
Pop by Egotrip/Andre Zogholy/A
Eine Produktion von Rubblemaster Linz

POL – Mechatronic Performance
Posthof
Marcel.lí Antúnez Roca/E
POL ist eine Produktion von PANSPERMIA S.L.
Ko-produziert von: Festival d'Estiu de Barce-
lona Grec 2002, Mercat de les Flors,
MEDIA-EUROPA¡ Fira de Teatre de Tàrrega
Unterstützt von: Institut Català de les Indú-

stries Culturals – Generalitat de Catalunya,
INAEM-Ministerio de Educación, Deporte y
Cultura, ICUB-Ajuntament de Barcelona.
In Zusammenarbeit mit: COPEC, Lufthansa.
Mitarbeit: FESTO, Josep Abril, Sanyo, Native
Instruments, Vegap, New Balance,
Fundición Ubach, Macanitzats EBLAN
Ars Electronica in Kooperation mit Posthof.

In Concert – Errata Erratum
Posthof
DJ Spooky That Subliminal Kid/USA
Ars Electronica in Kooperation mit Posthof.

Movieline
Moviemento
Aktuelle Film- und Videoproduktionen der
Hochschule für Gestaltung und Kunst Zürich:
Wald.exe: Thomas Gerber, 2002
Faster Movie, kill, kill, kill: Thomas Isler, 1995
Der Komplex: Fabienne Bosch, 2002
Timing: Chris Niemeyer, 1999
Amnesie: Anne-Catherine Kunz, 1999
Wunderland: Michael Hertig, 2000
Filmprogramm zum Festivalthema:
Jenseits der Stille: Caroline Link, D 1996
Kira: Ole Christian Madsen, DK 2001
(Österreich-Premiere)
Pi: Darren Aronofsky, USA 1997
The Pillow Book: Peter Greenaway,
GB/NL/F 1996
Fast Film & Im Anfang war der Blick: Bady
Minck, A/LUX 2002
Code inconnu: Michael Haneke, F/D 2000
Film ist 1-6: Gustav Deutsch, A 1998
Film ist 7-12: Gustav Deutsch, A 2002
Die Schönste 1: Ernesto Romani, DDR 1957
Die Schönste 2: Ernesto Romani, DDR 1957
In Kooperation mit Moviemento.

electrolobby

electrolobby: emerging arts
Brucknerhaus

Processing
Casey Reas, Ben Fry/USA
www.proce55ing.net
Processing: Programmiersprache, grafische
Programmierumgebung, Lernoberfläche
und Designer-Community. Ein offenes
Projekt, initiiert von: Ben Fry, Casey Reas,
weiterentwickelt von: Aesthetics and Com-
putation Group im MIT Media Lab, Interac-
tion Design Institute Ivrea/I und einer im
Internet verstreuten Gruppe von Entwick-
lern. Teilnehmer: Casey Reas/USA, Ben
Fry/USA, Amit Pitaru/ USA, Hernando Barra-
gan/COL/I, Golan Levin/ USA, Lia/A, Marius
Watz/N/D, Schoenerwissen/D, Juha Huus-
konen/SF

LeCielEstBleu
www.lecielestbleu.com
Feat.: Frédéric Durieu/B, Kristine
Malden/USA

demo scene
www.scene.org
Feat.: Ekkehard „sTEELER" Brüggemann/D,
Matti „Melvyn" Palosuo/SF, Markus „Droid"
Pasula/SF, Dierk „Chaos" Ohlerich/D

kuda.org
www.kuda.org
Feat: Kristian Lukic, Zoran Pantelic, Branka
Curcic/FRY

Pure Data Connections
http://algo.mur.at/pd/ars03
Feat: REMI (Michael Pinter & Renate Oblak),
Algorithmics (Winfried Ritsch), Pi (Martin
Pichlmaier)/A

electrolobby Kitchen
KünstlerInnen der electrolobby stellen ihre
Positionen und Arbeiten zur Diskussion.

Communication Grill Chang-Tei
www.iik.jp/~cgc/contents/concepten.html
Feat.:Kou Sueda, Koji Ishii/J

Telematic Embrace
Roy Ascott
Buchpräsentation: „Telematic Embrace.
Visionary Theories of Art, Technologies, and
Consciousness", Hrsg.: Edward A. Shranken,
The University of California Press 2003.

CodePlay @ UMe
http://newmedia.umaine.edu/codeplay/
Softwareprojekte von Studenten der Univer-
sity of Maine: Alice, The Pool, Breakdown
und Internet2@UMe. Leitung: Joline Blais,
John Ippolito, Mike Scott/USA

bitforms gallery
www.bitforms.com
Steve Sacks/USA.

Creative Commons/USA
Präsentation Creative Commons Moving
Image Contest: Joshua Davis/USA

MagNet
Feat.: Slavo Krekovic/SK(3.4 Review), Ales-
sandro Ludovico/I (Neural), Georg Schöll-
hammer/A (springerin), Simon Worthington
& Pauline van Mourik Broekman/ UK (mute)

DIVE
http://kop.fact.co.uk/DIVE
Dokumentation zum Projekt Kingdom of
Piracy <KOP>.
DIVE was created by Kingdom of Piracy and
edited by Armin Medosch, commissioned by
the VirtualCentre-Media.net, supported by
Culture2000, and co-produced by FACT.

Radio FM4
Live Berichte von der Ars Electronica aus
dem mobilen Studio von FM4. Feat.: Veronika
Weidinger, Stefan Trischler, Gerlinde Lang

CODE Arena
STWST/A
Stadtwerkstatt
Kurz-Präsentationen von Projekten einzelner
electrolobby-Teilnehmer in der Green Box.

Visual Codes
Moderation: Joshua Davis/USA

demo-scene/scene.org Awards 2002
Moderation: Matti „Melvyn" Palasou/SF,
Ekkehard „sTEELER" Brüggemann/D

Encoded Music
Moderation: Alex McLean, Adrian Ward/UK

The Aesthetics of Code
Moderation: Ed Burton/UK

Green Box
STWST/A
Stadtwerkstatt

Nightline in the Green Box – DJs and acts
Special feat.: I-WOLF/A (klein rec.), DJ Spooky
That Subliminal Kid/USA

PARTIZIPATIONEN

Preisverleihung des >digital sparks< 2003
Sky Medialoft
MARS/D – Media Arts Research Studies Fraun-
hofer Institut für Medienkommunikation
Monika Fleischmann, Wolfgang Strauss,
Diane Müller und das Team von netzspan-
nung.org.
　Machines will eat itself: Franz Alken
　Loser Raum: Anja Kempe
　how-to-bow.com: Nora Krug

Thema Musik Live: Donaupositionen
Sky Medialoft/Bayern 4 Klassik
Lydia Hartl/D, Walter Kroy/D, Gerfried
Stocker/A. *Moderation:* Christine Lemke
Matwey/D, Christian Scheib/A
Music: AGF, Jonathan Norton
In Kooperation mit BMW Group

Digi-Sta-Lab/J
Brucknerhaus
Projektpräsentationen aus dem Digital
Stadium Lab von NHK/J.

Ars Electronica 2004
25 Jahre Festival für Kunst, Technologie und Gesellschaft

TIMESHIFT – Die Welt in 25 Jahren
Linz, 2. – 7. September

Veranstalter:
Ars Electronica Center Linz
Museumsgesellschaft mbH
Geschäftsführer: Gerfried Stocker
Prokurist: Dr. Rainer Stadler

Direktorium, künstlerische Leitung:
Gerfried Stocker, Ars Electronica Center
Dr. Christine Schöpf, ORF Oberösterreich

Koordination & Produktion:
Katrin Emler – Ars Electronica Festival

Kuratorische Berater:
Sonja Bettel, Dennis Russell Davies, Karel Dudesek, Fadi Dorninger, Heidi Grundmann, Andreas Hirsch, Naut Humon, Monika Leisch-Kiesl, Michael Naimark, Christa Sommerer, Tadashi Yokoyama, Benjamin Weil, Elisabeth Zimmermann, Ina Zwerger

Mitveranstalter Ars Electronica 2004:
ORF Oberösterreich
Landesdirektor: Helmut Obermayr
LIVA Veranstaltungsgesellschaft mbH
Vorstandsdirektoren:
Wolfgang Winkler, Wolfgang Lehner
O.K Centrum für Gegenwartskunst
Direktor: Martin Sturm

Kooperationspartner: Universität für künstlerische und industrielle Gestaltung Linz, Lentos Kunstmuseum, Posthof Linz

Prix Ars Electronica 2004
Internationaler Wettbewerb für Cyberarts
Veranstalter: Ars Electronica Center Linz
Museumsgesellschaft mbH
Idee: Dr. Hannes Leopoldseder
Konzeption und Koordination: Dr. Christine Schöpf (ORF), Gerfried Stocker (AEC)
Organisation: Iris Mayr

www.aec.at/timeshift
Web Editor: Ulrike Ritter, Cornelia Sulzbacher
Web Design: Volker Haider, Günther Kolar, Stefan Eiblwimmer

CONFERENCES

Themensymposium
TIMESHIFT – Die Welt in 25 Jahren
The World in Twenty-Five Years
Brucknerhaus – Mittlerer Saal
3. – 4. September
TIMESHIFT Symposium I – Progress
 José-Carlos Mariátegui/PE
 Roger F. Malina/F
 Peter Weibel/A
 Esther Dyson/USA
 Ismail Serageldin/ET
 Moderation: José-Carlos Mariátegui
TIMESHIFT Syposium II – Disruption
 Jonah Brucker-Cohen/USA
 Joichi Ito/J
 Krzysztof Wodicko/USA
 Bruce Sterling/USA
 David Turnbull/AUS
 Moderation: Jonah Brucker-Cohen/USA
TIMESHIFT Syposium III – Spirit
 Alena Williams/USA
 Geetha Narayanan/IND
 Roy Ascott/UK
 Sherry Turkle/USA
 Marvin Minsky/USA
 Moderation: Alena Williams/USA
TIMESHIFT Syposium IV – Topia
 Nadja Maurer/D
 Gerhard Dirmoser/A
 Joan Shikegawa/USA
 Derrick de Kerckhove/CDN
 Stewart Brand/USA
 Moderation: Nadja Maurer/D

Prix Ars Electronica Forum
Brucknerhaus – Mittlerer Saal
5. – 7. September
Ein neues Format für das Prix Ars Electronica Forum. Präsentationen und Diskussionen, Audio- und Videobeiträge zu prämierten Projekten und Beiträge von Experten.
Siehe Seite 348

Pixelspaces
Ars Electronica Center
4. und 6. September
Transfer
 Nicoletta Blacher/A, Steve Clark/UK, Masaki Fujihata/J, John Gerrard/IRL, Horst Hörtner/ A, Myron Krueger/USA, Ramia Mazé/S, Jon McCormack/AUS, Michael Naimark/USA, Michael Rakowitz/USA

Media Art Forum – Digital Avant Garde
Lentos
2. September
 Benjamin Weil/USA, Lynn Hershman/USA,
 Christa Sommerer/A & Laurent Mignonneau/
 F, Lev Manovich/USA, Roy Ascott/UK

Special Lecture
On the History of Interaction between Art and Technology – Towards the Cultural Evolution of Human Beings
Brucknerhaus – Mittlerer Saal
6. September
 Itsuo Sakane/J
 Preisträger des Golden Nica Award for Life
 Achievement des Prix Ars Electronica 2003

Ars Electronica – Network of Media Art
transpublic
3., 4. und 7. September
 Gerhard Dirmoser/A, Projektpräsentation

Collaborative Broadcasting – Models of technological innovation for tactical media
Ars Electronica Center /Sky Medialoft
5. September
Ein Projekt von Radio FRO/A in Kooperation mit
Ars Electronica.
Panel A: Models & Stories: Usage of technological tools for community media initiatives
 Manu Luksch/UK, Agnese Trocchi/I, Georg
 Wimmer/A, Ingo Leindecker/A, Michael
 Hüners/D, Wolfgang Temmel/A
 Moderation: Gerhard Fröhlich/A, Simone
 Griesmayr/&A
Panel B: Strategies & Perspectives: Scenarios of alternative platforms and possibilities of media convergence
 Steve Buckley/UK, Robert Horvitz/CZ, Eric
 Kluitenberg/NL
 Moderation: Armin Medosch/D

Launch of Creative Commons Austria
Brucknerhaus, Mittlerer Saal
7. September
Eine Veranstaltung von Österreichische Compu-
tergesellschaft (OCG) in Zusammenarbeit mit
Ars Electronica
 Christiane Asschenfeldt/D, Joichi Ito/J, Ga-
 briele Kotsis/A, Julia Küng/A, Georg Pleger/A,
 Jimmy Wales/USA
 Moderation: Armin Medosch

Re-inventing Radio Symposium
Brucknerhaus
6. September
 Heidi Grundmann/A, Bob Adrian/A/CDN, radio-
 qualia, Inke Arns/D, Gene Youngblood/USA
 Moderation: Sabine Breitsameter
 In Kooperation mit Ö1 Kunstradio

Prix Ars Electronica

Internationaler Wettbewerb für Cyberarts
Veranstalter: Ars Electronica Center Linz
Museumsgesellschaft mbH
Idee: Dr. Hannes Leopoldseder
Konzeption und Koordination: Dr. Christine
Schöpf (ORF), Gerfried Stocker (AEC)
Vorsitzende der Gesamtjury (ohne Stimmrecht):
Hannes Leopoldseder, Christine Schöpf

Net Vision
Jury: Ed Burton/UK, Casey Reas/USA, Steve Rogers/
UK, Cornelia Sollfrank/D, Yumi Yamaguchi/J
Goldene Nica: Creative Commons
Auszeichnungen: MarcosWeskamp/USA/J,
MoveOn.org/USA
Anerkennungen: Nicolas Clauss/ Jean Jaques
Birgé/Didier Silhol/F; Peter Cho/ USA; Jonah
Brucker-Cohen/Mike Bennett/IRL/ USA; Francis
Lam/HK; Miranda Zuñiga Ricardo/ USA; Marcus
Hauer/Anne Pascual/Schoenerwissen/OfCD/D;
Alessandro Ludovico/I; Robert Hodgin/USA,
Jonah Peretti/Chelsea Peretti/ Michael
Frumin/USA; Runme.org

Interaktive Kunst
Jury: Scott deLahunta/NL, Peter Higgins/UK,
Tomoe Moriyama/J, Elaine Ng/HK/USA, Hiroshi
Ishii/J/USA
Goldene Nica: Mark Hansen/Ben Rubin/USA
Auszeichnungen: Feng Mengbo/China; Ken
Rinaldo/USA
Anerkennungen: Julien Maire/F; Barbara
Musil/A; Golan Levin/Zachary Lieberman/Jaap
Blonk/Joan La Barbara/USA/NL; Marc Downie/
Paul Kaiser/Shelley Eshkar/USA; Daniel Sauter/
Osman Khan/USA; Electronic Shadow (Naziha
Mestaoui/Yacine Aït Kaci)/F/B; Amanda Parkes/
Hayes Raffle/USA; James Auger/Jimmy Loizeau/
Stefan Agamanolis/IRL; Severin Hofmann/David
Moises/A; Mark Coniglio/Dawn Stoppiello/ USA;
Miyajima Tatsuo/Tachibana Hajime/J; ESG Ex-
tended Stage Group/D

Computeranimation/Visual Effects
Jury: Ellen Poon/USA, Barbara Robertson/USA,
Shuzo Shiota/J, Virgil Widrich/A, Lance Williams/
USA
Goldene Nica: Chris Landreth/CDN
Auszeichnungen: Park Sejong/AUS, François
Blondeau/Thibault Deloof/Jérémie Droulers/
Christophe Stampe/F
Anerkennungen: Markus Bledowski/D; Leigh
Hodgkinson/UK; Andrew Stanton/USA
Luc Froehlicher/F; Richard James/UK; Joe
Takayama/J; Morio Kishida/Yoshihiko Dai/
Hiroshi Chida/J; Heidi Wittlinger/Anja Perl,

Max Stolzenberg/D; Paul Debevec/USA
Liam Kemp/UK; Mikitaka Kurasawa/Takashi
Yamazaki/J; Guillaume Herent/Xavier André/F

Digital Musics

Jury: Naut Humon/USA, Masahiro Miwa/J,
Gordon Monahan/CDN/D, Tujiko Noriko/J, David
Toop/UK
Goldene Nica: Thomas Köner/D
Auszeichnungen: AGF aka Antye Greie/D, Janek
Schaefer/USA
Anerkennungen: Paul Panhuysen/NL; Alvin
Curran/Domenico Sciajno/I; Chlorgeschlecht/
UK; Leafcutter John/UK; Anne Laplantine/D;
John Duncan/USA; Christian Fennesz/A; Horacio
Vaggione/F, Tom Hamilton/USA; Felix Kubin/D;
Furudate Ken/Ishida Daisuke/Jo Kazuhiro/No-
guchi Mizuki/J; Zeena Parkins/Ikue Mori/USA/J

Digital Communities

Internationale Berater: Carlos Afonso/BR,
Shahidul Alam/BGL, Marko Athisaari/SF,
Hisham Bizri/USA/LEB, David Brake/UK, Nathalie
Caclard/F, Marc Canter/USA, Pier Luigi Capucci/I,
Birama Diallo/Mali, Derrick de Kerckhove/CDN,
Kunda Dixit/NEP, Jim Downing/AUS, Weigui
Fang/China, Anna Fernandez-Maldonado/Peru,
Alex Galloway/USA, Solveig Godeluck/F, Lisa
Goldman/USA, Carlos Gomez de Llarena/VEN,
Helmut Höllerl/A, Mizuko Ito/J, Neeraj Jhanji/IN,
Matt Jones/UK, Peter Kuthan/A, André
Lemos/BR, Matt Locke/UK, Geert Lovink/NL,
Pattie Maes/USA, José-Carlos Mariátegui/Peru,
Lars Midboe/S, Winters Negbenebor/NIG,
Marcus Neustetter/ZA, Margit Niederhuber/A,
Alexander Nieminen/SF, Frederick Noronha/IN,
Dietmar Offenhuber/A, Sebastian Oschatz/D,
Jonah Peretti/USA, Rosen Petkov/BG, Per
Platou/S, Jean-Luc Raymond/F, Chris Rettstatt/
USA, Scott Robinson/MEX, Danny Schechter/
USA, Christa Schneebauer/A, Christa Sommerer/
A, Russel Southwood/UK, Sergei Stafeev/RU,
Sulake Oy/SF, Anthony Townsend/USA, Linnar
Viik/EST.
Nominating Jury: Denise Carter/UK, Cory
Doctorow/CDN, Ama Dadson/Ghana, Andreas
Hirsch/A, Mike Jensen/ZA
Awarding Jury: Andreas Hirsch/A, Joichi Ito/J,
Shanthi Kalathil/USA, Jane Metcalfe/USA,
Dorothy Okello/Uganda, Howard
Rheingold/USA, Oliviero Toscani/I

In Zusammenarbeit mit Electronic Frontier
Foundation, UNESCO Digi-Arts, SAP

Goldene Nicas
 The World Starts With Me/NL/Uganda
 www.theworldstarts.org
 Wikipedia
 www.wikipedia.org

Auszeichnungen
 dol2day – democracy online/D,
 http://www.dol2day.de
 Krebs-Kompass/D, www.krebs-kompass.de
 Open-Clothes
 www.open-clothes.com/
 smart X tension/A/Zimbabwe
 www.mulonga.net
Anerkennungen
 Cabinas Públicas de Internet/PE
 http://cabinas.rcp.net.pe
 Children with Diabetes/USA
 www.childrenwithdiabetes.com/
 DakNet: Store and Forward/USA/IND,
 www.firstmilesolutions.com
 Del.icio.us, http://del.icio.us/
 DjurslandS.net/DK, www.djurslands.net
 iCan/UK, www.bbc.co.uk/ican
 kuro5hin, www.kuro5hin.org/
 Kythera-Family.net, www.kythera-family.net
 The Lomographic Society
 www.lomography.com
 Nabanna/IND
 http://ictpr.nic.in/baduria/welcome.html
 NYCwireless/USA, www.nycwireless.net
 **Télécentre Communautaire Polyvalent Tom-
 bouctou**/RMM
 Wikitravel, www.wikitravel.org
 Daily Prophet/USA; www.dprophet.com

u19 – freestyle computing

Jury: Sirikit Amann/A, Tina Auer/A, Manfred
Nürnberger/A, Martin Pieper/A, Joachim Schnait-
ter/A
Goldene Nica: Thomas Winkler/A
Auszeichnungen: Gottfried Haider/A, Manuel
Fallmann/A
Sachpreise: Multimedia-Team/Europahaupt-
schule Hall in Tirol/A, David Haslinger/A
Anerkennungen: Manuel Eder; Projektgruppe
2A, 3A, 3B HBLA für künstlerische Gestaltung
Linz; Onan (Sebastian Schreiner, Franz Gruber,
Tobias Schererbauer); Patrick Derieg-Hüt-
mannsberger; Gerald Gradwohl; Michaela
Meindl, Michael Mayrhofer-Reinhartshuber;
BG/BRG Waidhofen/Thaya; Mathias Kunter;
Franz Haider; Christoph Wiesner

[the next idea]
Kunst- und Technologiestipendium

Jury: Wilhelm Burger/A, Horst Hörtner/A,
Michael Kräftner/A, Gustav Pomberger/A,
Christa Sommerer/A/J
Gewinnerprojekt: Moony – Sensitive Smoke Pro-
ject: Akio Kamisato, Satoshi Shibata, Takehisa Mashi-
mo
Nominierungen: Ctrl-Shift www.ctrl-shift.net
web: Jason Corace Quinn
Centralia Community: Brett Jackson

Sinktop: Yuji Nakada, Tomofumi Yoshida
Touchy Chattels: Martin Zeplichal
Visual Resonator: Junji Watanabe, Maki Sugimoto

Ars Electronica Gala
Prix Ars Electronica Award Ceremony
Brucknerhaus Linz – 3sat
3. September
Verleihung der Goldenen Nicas 2004
Moderation: Inge Maria Limbach

Prix Ars Electronica Forum
Brucknerhaus
5. – 7. September
Vorträge, Präsentationen, Diskussionen von und
mit den Preisträgern und Juroren des Prix Ars
Electronica 2004.
Forum I: Interactive Art
> Mark Hansen/Ben Rubin/USA; Feng Mengbo/
> CN; Ken Rinaldo/USA
> *Moderation:* Scott deLahunta/NL

Pioneer Lecture: Myron Krueger/USA
Forum II: Digital Musics
> Thomas Köner/D; AGF/D; Janek Schaefer/UK
> *Moderation:*Naut Humon/USA

Forum III: Computer Animation/Visual Effects
> Chris Landreth/CDN; Park Sejong/AUS;
> François Blondeau/Thibault Deloof/Jérémie
> Droulers/Christophe Stampe/F
> *Moderation:*Shuzo John Shiota/J

**Commons & Communities – Social Life in the
Digital Age**
> *Moderation:* Ina Zwerger/Sonja Bettel/A,
> in Zusammenarbeit mit Ö1 Matrix
> **Forum IV: Net Vision**
> **Realität und Vision der Digital Commons**
> Lawrence Lessig/USA, Marco Weskamp/USA,
> MoveOn.org/USA
> *Juryvertreter:* Ed Burton
> *Diskussion mit:* Georg Greve/D, Paula
> LeDieu/UK, Peter Rantasa/A, 4youreye/A
> **Forum V: Digital Communities**
> **Communities mit Zukunft**
> Jimmy Wales/USA, Nicole Öhlrich/D, Dorothy
> Okello/UG, Alex Okwaput/UG
> *Juryvertreter:* Howard Rheingold/USA
> *Diskussion mit:* Michael Eisenriegler, Joichi
> Ito/J, Armin Medosch/UK

Electronic Theatre
O.K Centrum für Gegenwartskunst – Arena
Präsentation der prämierten Computeranimatio-
nen und Visual Effects des Prix Ars Electronica 2004.
Programm:
Ryan: Chris Landreth/CDN
Birthday Boy: Park Sejong/AUS
Parenthèse: François Blondeau, Thibault Deloof,
Jérémie Droulers,Christophe Stampe/F
Mother – Excerpt from Lines Of Unity – Eleven

Aboriginal Poems: Markus Bledowski/D
moo(n): Leigh Hodgkinson/UK
Finding Nemo: Andrew Stanton/USA
Toyota RAV4 Deflate: Luc Froehlicher/F
New Balls Please: Richard James/UK
MICROCOSM: Joe Takayama/J
Winning Eleven Tactics: Morio Kishida, Yoshihiko
Dai, Hiroshi Chida/J
no limits: Heidi Wittlinger; Anja Perl, Max
Stolzenberg/D
The Parthenon: Paul Debevec/USA
This Wonderful Life: Liam Kcmp/UK
Onimusha 3: Mikitaka Kurasawa, Takashi
Yamazaki/J
Pfffirate: Guillaume Herent, Xavier André/F

Cyberarts 2004
Prix Ars Electronica Exhibition
O.K Centrum für Gegenwartskunst
Die Ausstellung prämierter Projekte des Prix Ars
Electronica 2004.
Listening Post
> Mark Hansen/Ben Rubin/USA
> *Goldene Nica Interaktive Kunst*

Banlieue du Vide
> Thomas Köner/D
> *Goldene Nica Digital Musics*

Augmented Fish Reality
> Ken Rinaldo/USA
> *Auszeichnung Interaktive Kunst*

Ah_Q
> Feng Mengbo/CN
> *Auszeichnung Interaktive Kunst*
Anerkennungen Interaktive Kunst:
Topobo
> Amanda Parkes/Hayes Raffle/USA

Demi-Pas
> Julien Maire F/D

Alert
> Barbara Musil/A

Messa di Voce
> Golan Levin/Zachary Lieberman/Joan la
> Barbara/USA/Jaap Blonk/NL

Loops
> Marc Downie, Paul Kaiser, Shelley Eshkar/USA

We interrupt your regularly schedule program
> Daniel Sauter/Osman Khan/USA

Iso-phone
> James Auger, Jimmy Loizeau, Stefan Agam-
> anolis/UK/USA

3 minutes²
> Electronic Shadow (Naziha Mestaoui/Yacine
> Aït Kaci)F

Turing Train Terminal
> Severin Hofman/David Moises/A

1000 Deathclock in Paris
> Tatsuo Miyajima/Hajime Tachibana/J

Interactive generative stage and dynamic

costume for André Werners „Marlowe, the Jew
of Malta" (Videodokumentationen)
ESG Extended Stage Group/D
Isadora-Future of Memory Improvisation
Marc Coniglio/Dawn Stopiello/USA

u19 – Preisverleihung
Die Preisverleihung an die Gewinner der
Jugendkategorie u19 – freestyle computing
des Prix Ars Electronica 2004
u19 – freestyle computing
Ausstellung der prämierten Arbeiten der u19-
Kategorie des Prix Ars Electronica 2004
GPS::Tron: Thomas Winkler, *Goldene Nica –
u19 –freestyle computing*
radio2stream: Gottfried Haider, *Auszeich-
nung –u19 – freestyle computing*
MINDistortion.tk: Manuel Fallmann,
Auszeichnung – u19 – freestyle computing
Hos Geldiniz Avusturya: Multimedia-Team/
Europahauptschule Hall in Tirol, *Auszeich-
nung/ Sachpreis – u19 – freestyle computing*
Es war einmal ein Mann ...: David Haslinger,
*Auszeichnung/Sachpreis – u19 – freestyle
computing*
Anerkennungen – u19 – freestyle computing:
Fantasy X – dark dreams: Manuel Eder
[phonetcard] - Vom Wort zum Bild: Projekt-
gruppe 2A, 3A, 3B HBLA für künstlerische
Gestaltung Linz
Onan Casting + Onan TV: Sebastian Schrei-
ner/Franz Gruber/Tobias Schererbauer
Junky Hugs: Patrick Derieg-Hütmannsberger
Sulaa: Gradwohl Gerald
Eyeboard: Michaela Meindl/Michael Mayr-
hofer-Reinhartshuber
Kisum – Kitam-Rofni: BG/BRG Waidhofen/Th.
Revo Race: Mathias Kunter
complement: Franz Haider
Dual Mouse: Christoph Wiesner

Exhibitions
Themenausstellung TIMESHIFT
Brucknerhaus
Timeline +- 25
Eine zweiteilige Zeitachse für die Lobby des
Brucknerhauses: „t-25" über die Geschichte
der Ars Electronica von ihren Anfängen 1979
bis heute; "t+25" als frei zugängliche Websei-
te, auf der die Teilnehmer Vorhersagen für
die nächsten 25 Jahre treffen und abstim-
men können. *Konzept:* Michael Naimark,
Gloria Sutton. *Ausstellungsarchitektur:* Scott
Ritter
Ars Electronica – Network of Media Art
Gerhard Dirmoser/A
Modular Synthesizer
Joe Paradiso/USA

Gedanken bewegen
Institut für Human-Computer Interface, TU
Graz/A; Institut für Elektronische Musik und
Akustik, Universität für Musik und darstel-
lende Kunst, Graz/A
TraceEncounters
W. Bradford Paley, Jefferson Y. Han, unter
Mitarbeit von Peter K. Kennard/USA

Digital Avant-Garde/Prix Selection
Lentos Kunstmuseum
2. – 7. September (Verlängerung der Ausstellung:
8. September – 4. Oktober)
Ausgestellte Projekte
The Legible City (1988–1991): Jeffrey Shaw/
AUS (Sammlung des ZKM, Karlsruhe, D)
Think about the people now (1991): Paul
Sermon/UK
Interactive Plant Growing (1992): Christa
Sommerer/A, Laurent Mignonneau/F
(Sammlung des ZKM, Karlsruhe, D)
America's Finest (1989–1993): Lynn Hersh-
man/USA (Sammlung des ZKM, Karlsruhe, D)
Inter Dis-Communication Machine (1993):
Kazuhiko Hachiya/J
Landscape One (1997): Luc Courchesne/CDN
(Auftragsarbeit des NTT InterCommunica-
tion Center, Tokio 1997)
In Zusammenarbeit mit Eyebeam, American
Museum of the Moving Image, Österreichisches
Kulturforum. Kuratiert von Benjamin Weil und
Gerfried Stocker.
Die Ausstellung Digital Avant-Garde wurde
gemeinsam mit SAP entwickelt.

Cyberarts 2004
Prix Ars Electronica Ausstellung
O.K Centrum für Gegenwartskunst
Siehe Seite 348

CAMPUS
Kunstuniversität Linz
Arbeiten von Studierenden des IAMAS/J
Eine Kooperation von: Ars Electronica, Uni-
versität für künstlerische und industrielle
Gestaltung Linz und IAMAS, Gifu/J
Koordination: Christa Sommerer
NOW!
KARAKURI BLOCK: Natsu Kawakita + No-
buya Suzuki + Takahiro Hayakawa
bounce street: Mika Miyabara + Tatsuo Sugimoto
An Experiment for New Hiragana: Masaki
Yamabe
TEXTRON: Yosuke Kawamura
8 viewpoints: Tomohiko Saito + Tomoyuki
Shigeta
Ototenji (Sound-Braille): Mika Fukumori
Heaven's Eye: Nobuhisa Ishizuka

Bug???: Etsuko Maesaki
Jubilation: Tsutomu Yamamoto
ikisyon 11 (11th RU society-ikisyon): ressenti-
ment
Irodori (Capturing Color): Tomoyuki Shigeta +
Takanori Endo + Takuya Sakuragi
Kemuri-mai: Jean-Marc Pelletier
Yoi-no Mujina Goushi: Hiroko Tochigi
FloatingMemories: Tomohiro Sato
I Agree.: Koichiro Shibao
Nagashiima Book (The other Nagashima).:
Yasuyuki Nagashima
Letter Picture Book: Shiroi hon (White Book):
Mika Fukumori
colors: Aiko Utsumi
low: Hiroaki Goto
Diary: Chiharu Nishiyama + Kouki Yamada
aggregation: Kohei Kawasaki
domino: Jun Watanabe
polyphony@ver1.0: Toshiyuki Nagashima
Micro-Plantation: Akinori Oishi
Time, Space: Hisato Ogata
Tasting Music: Michihito Mizutani
far beside: Kayo Kurita + Takahiro Kobayashi
michikake (phases of the moon): Rina Okazawa
Life in Norway — Web Documentary: Web
Director: Atsuko UDA, Web Designer: Aya
Fukuda; Producer: Aske Dam (Telenor),
Cooperation: IAMAS, Gifu/J
IAMAS Screening program
 selected by Hideyuki Oda + Shinjiro Maeda
STUDIO!
 Info.Scape Project: Info.Scape Research Team
 Archive of „Manner Arts" Project: Archive of
 „Manner Arts" Project Team
 Interactive Chaos: Atsuhito Sekiguchi + Isato
 Kataoka
 Time Machine!: Masayuki Akamatsu
IMPACT!
 Sonic Interface: Akitsugu Maebayashi
 Former Artist-in-Residence works: Video
 Presentation, 1996–2004
 OPNIYAMA: Akinori Oishi (TEAMchman)
 Asian Roll: Atsuko Uda
 visible! link cafe: Hisako K. Yamakawa + Yuko
 Abe
PLAY!
 Opening Event: Celebration March: Taro
 Yasuno
 DSP Night I: Sound performance
 DSP Night II: Sound performance
 IAMAS Unofficial Public Internet Radio Station

Ars Electronica Center Exhibition 2004/2005
Ars Electronica Center

Untergeschoss
Gulliver's World
 Ars Electronica Futurelab/A
 Konzept: Christopher Lindinger, Roland
 Haring, Peter Freudling, Andreas Jalsovec,
 Horst Hörtner, Dietmar Offenhuber,
 Hirokazu Kato/J
 Projektleitung: Christopher Lindinger
 Technischer Leiter: Roland Haring
 Realisierung: Christopher Lindinger, Peter
 Freudling, Andreas Jalsovec, Christian Nagl-
 hofer, Stefan Feldler, Christine Pilsl, Christine
 Gruber, Thomas Grabner, Daniel Leithinger,
 Robert Priewasser, Rudolf Hanl, Martin
 Sturm, Theodore Watson (UK/USA),
 Hirokazu Kato (J)
Erdgeschoss /Zwischengeschoss
Innovision Wall
 Ars Electronica Futurelab/A
 Konzept: Horst Hörtner/A
 Realisierung: Christian Naglhofer, Roland
 Haring, Erwin Reitböck, Christopher Lindin-
 ger/A
Cheese
 Christian Möller/D
 Programmierung: Sean Crowe/USA
 Models: Melissa Berger/USA, Laura Clum-
 eck/ USA, Natasha Desai/USA, Kyra Locke/
 USA, Susan Marshall/USA, Cameo Cara
 Martine/USA. Unter Mitarbeit von Pierre
 Moreels/F, Pietro Perona/I, Javier Movellan/
 E, Marni Bartlett/USA, CALTECH, California
 Institute of Technology, Center for Neuro-
 morphic Systems Engineering, Pasadena
 and the Machine Perception Laboratory at
 the University of California San Diego's
 Institute for Neural Computation
Commotion
 Bram Dauw, Alexandre Armand/CH
 Produced at the ecal MID (ecal-
 mid.kaywa.com/c4.html)
 Programing help from FUR
 (www.fursr.com/) and Jerôme Rigaud
 (www.anti-chambre.net/)
 developed on Director MX
1. Obergeschoss / Robolab
Messa di Voce
 Golan Levin (USA), Zachary Lieberman
 (USA), Jaap Blonk (NL), Joan La Barbara (USA)
Watchful Portrait (Caroline)
 John Gerrard/IRL
 Konzept: John Gerrard; Interaction-Design:
 Erwin Reitböck (A), 3D Portrait-Entwicklung:
 Werner Pötzelberger (A), John Gerrard. Reali-

siert mit Unterstützung des Siemens Artist-in-Residence-Programms bei Ars Electronica.

Networked Portrait
John Gerrard/IRL

LibroVision – Gesture Controlled Virtual Book
Ars Electronica Futurelab/A - Christian Nagl-hofer, Robert Praxmarer, Horst Hörtner

INSTAR
Ars Electronica Futurelab/A - Dietmar Of-fenhuber, Horst Hörtner, Andreas Jalsovec, Christopher Lindinger, Robert Praxmarer, Robert Abt, Wolfgang Ziegler, Reinhold Bidner

Moony
Takehisha Mashimo, Satoshi Shibata, Akio Kamisato/J
Das [the next idea] Kunst- und Technologie-Stipendium wurde von voestalpine ermöglicht. Realisiert im Ars Electronica Futurelab

Topobo
Amanda Parkes/Hayes Raffle/USA

Dog[Lab]01
France Cadet/F

2. Obergeschoss

Archiquarium
Ars Electronica Futurelab/A
Basierend auf der Studie „25 Jahre Ars Elec-tronica" von Gerhard Dirmoser/A
Ausstellungsarchitektur: Scott Ritter/Jakob Edelbacher/A. Konzept: Hemut Höllerl.
Konzept, Software: Dietmar Offenhuber
Technisches Consulting: Gerold Hofstadler, Stefan Hackl. Hardware-Entwicklung: Stefan Feldler. Grafikdesign, Software: Philipp Sei-fried, Birgit Beireder. Content-Recherche: Nina Wenhart. Datenbank/ Web-Develop-ment: Günther Kolar. Datenbankentwick-klung: Gunter Schmidl. Datadesk / Daten-pult: Philipp Seifried, Helmut Höllerl, Nina Wenhart. Datawall/Datenwand: Gerhard Dirmoser, Stefan Feldler, Philipp Seifried, Helmut Höllerl, Nina Wenhart, Günther Kolar. Timeslider / Zeitschiene: Dietmar Offenhuber, basierend auf „Ars Topics" von Gerhard Dirmoser. Datapool/Datenpool: Birgit Beireder, Nina Wenhart, Helmut Höllerl. Navigator: Günther Kolar, Gunther Schmidl. Produktion: Ellen Fethke

Screenart

Eine Welt der Wahrheiten
Stephan Huber/D
Dank an S. Lieb, C. Strobl, T. Huber

Somnambules
Nicolas Clauss/F: künstlerisches Konzept, Libretto, Kamera, Programmierung; Jean-Jacques Birgé/F: Musik, Libretto, Kamera, Produktion; Didier Silhol/F: Tanz
Mit: Anne-Catherine Nicoladzé (Tanz), Elsa Birgé (Hände), Didier Petit (Cello), Bernard

Vitet (Trompete). Eine Koproduktion von A.P.R.E. / Thécif – Région Ile de France/Atelier de Paris – Carolyn Carlson. Mit Unterstüt-zung des Kultur- und Kommunikationsmini-steriums. © A.P.R.E. 2003

Bitforms Gallery
Steve Sacks/USA

I/O Brush
Kimiko Ryokai, Stefan Marti, Hiroshi Ishii/USA

La Pâte à Son
Frédéric Durieu /B/F, Kristine Malden/USA/F, Jean-Jacques Birgé/F, Thierry Laval/F

Sur la Table
Osman Khan/USA

Protrude
Sachiko Kodama, Minako Takeno/J

Nudemessenger
Konzept, Programmierung, Multimedia-Produktion, Sounddesign: Francis Lam/HK

Futureme.org
Matt Sly, Jay Patrikios/USA

3. Obergeschoss – Sky Medialoft

Remote Furniture
Noriyuki Fujimura/J
Mitarbeit bei den Ausstellungen „Public Communication Sculpture" 1999–2000: Nodoka UI. Sammlung Deutsche Bank Art

Außenlift – Incredible Elevator –FH St. Pölten
Gerald Schöllhammer (Head of Visuals), Mario Reitbauer, Markus Prinz, Richard Hastik (Visuals), Christoph Schöfer (Head of Programming)
Projektbetreuer: Thomas Zöchbauer, Thomas Bredenfeld

Generatives Teilchen-Continuum: FH Düsseldorf
Konzept und Umsetzung: Christian Glauerdt, Ina-Marie Kapitola, Marion Woerle; Spiritus rector: Tanja Kullack; Musikalische Konzept-entwicklung und Umsetzung unter Mitwir-kung von Maciej Sledziecki
Realisiert in Zusammenarbeit mit Thoeodore Watson

Ars Electronica Center – Medienfassade

Seek
Lia/A, Miguel Carvalhais/P

Interactive Playground
FH St. Pölten
Betreuer: Thomas Zöchbauer (Projektmana-ger), Thomas Bredenfeld

Beam me up!
Studenten: Lukas Litzinger (Head of Pro-gramming), Adam Kogler, Ingrid Kail, Bern-hard Nekham (Programming), Andreas Stocker (Programming, Visuals), Michael Leitner (Head of Background Visuals), Rita Mantler, Gabriele Kugler (Background Visu-als), Christian Lakatos (Background Visuals,

Head of Coordination), Kerstin Kopsche,
Alexander Kastner (Coordination)

Diffusion
Institut für Künstlerische Gestaltung der
Techischen Universität Wien; Institut für
Mediengestaltung/Digitale Kunst der
Universität für Angewandte Kunst Wien
Projektleitung: Thomas Lorenz, Petra
Gemeinböck, Christine Hohenbüchler,
Nicolaj Kirisits
sphinx: Julia Schmölzer, Klaus Picher, Irene
Bittner
hauskleid: Elisabeth Steinegger, Matthias
Würfel
bønk: Florian Gruber, Clemens Hausch
tic.txt: Asli Serbest
r-slides: Ruth Brozek
Growing City: Winni & Klaus Ransmayr
Di ANA LOG: Barbara Larndorfer/Björn
Wilflinger/A
Die Ars Electronica Medienfassade realisiert mit
Unterstützung von SAP und Mitsubishi.

CAVE
Ars Electronica Center
Karma
Kurt Hentschlager/A/USA
Mersea Circles
Masaki Fujihata, Takeshi Kawashima/J
Coast Digital ist die erstePhase des Coast
Project. Beauftragt und produziert von
Future Physical/shinkansen und firstsite für
COAST, eine Initiative des Essex County
Council. Basierend auf VRizer: F. Berger/Ars
Electronica Futurelab/A

Ars Electronica Center – Events 2004
2nd International DOM-Conference
Topographies of Populism: Everyday Life, Media,
and the City
Kunstuniversität Linz, Auditorium/Aula,
25. –27. März 2004
**PANEL 1: Populism – An Attempt to Comprehend
the Term Populism**
Robert Pfaller (A), Helmut Dubiel/D, Rein-
hard Kannonier/A, Walter Ötsch/A, Thomas
Frank/USA, Sanford Kwinter/USA, Stefano
Boeri/I
**PANEL 2: Populism and Media – Strategies of
Mobilization**
Michael Shamiyeh/A, Thomas Held/A, Hélè-
ne Lipstadt/USA, Manfred Fassler/D, Georg
Franck/A, Måns Wrange/SE
**PANEL 3: Populism and Media – Strategies of
Anticipation**
Thomas Duschlbauer/A, Gerfried Stocker/A,
Jeffrey Inaba/USA, Greg Van Alstyne/CDN,
Bill Moggridge/USA

**PANEL 4: Strategies of Anticipation – Architecture
for People**
Christian Kühn/A, José Miguel Iribas/ES,
Ellen Dunham-Jones/USA, Liane Lefaivre/NL/
A, Jonathan Sergison/UK, Carel Weeber/NL
**PANEL 5: Strategies of Anticipation – Architecture
with People**
Michael Shamiyeh/A, Dennis Kaspori/NL,
Juan Palop-Casado/ES, Marcos Lutyens/USA,
Ramon Prat/ES, Ricardo Scofidio/USA

Digital Avant-Garde
Prix Selection at Eyebeam/New York
Ausstellung 21. Mai – 18. Juli 2004
The Legible City: Jeffrey Shaw/USA
America's Finest: Lynn Hershman/USA
Think about the people now: Paul
Sermon/UK
Landscape One: Luc Courchesne/CDN
Interactive Plant Growing: Christa Sommerer,
Laurent Mignonneau/A/F
n-cha(n)t: David Rokeby/CDN
Videoplace: Myron W. Krueger/USA
Inter Dis-Communication Machine: Hachiya
Kazuhiko/J
Opening Reception mit Live Performance
von Rupert Huber/A und Justin Manor/USA
Interactions/Art and Technology
American Museum of the Moving Image New York
20. Mai – 18. Juli 2004
Networked Portrait: John Gerrard/IRL
RE:MARK: Golan Levin, Zachary
Lieberman/USA, Christopher Lindinger/A
ARSBOX
VRizer: Game Engines on the ARSBOX
World Skin: Maurice Benayoun, Jean-
Baptiste Barrière/F
CAVE: Peter Kogler, Franz Pomassl/A
An Interactive Poetic Garden: Tom White,
David Small/USA
Key Grip: Justin Manor/USA
See Banff!: Michael Naimark/USA
Interactive Bars: Ars Electronica Futurelab
Animation Theater
*Screenings at American Museum of the Moving
Image and Eyebeam*

Positions and Perspectives
Symposium at the Austrian Cultural Forum
21. –22. Mai 2004
Interaction, Immersion and the Illusion of Control
Mit Christoph Thun-Hohenstein, Hannes
Leopoldseder, Christine Schöpf, Gerfried
Stocker, Benjamin Weil, Jeffrey Shaw, Lynn
Hershman, Paul Sermon, Maurice Benayoun,
John Gerrard, Luc Courchesne, Perry
Hoberman, Jim Campbell
Moderation: Benjamin Weil

Broader Contexts: Art, Technology and Society
Mit: Carl Goodman, Michael Naimark, Christa Sommerer, Laurent Mignonneau, Kazuhiko Hachiya, Zachary Lieberman, David Rokeby, Institute for Applied Autonomy, Justin Manor, Golan Levin, Myron Krueger
Moderation: Michael Naimark
Supported by: SAP, Eyebeam, American Museum of the Moving Image, ORF, Wired, Electronic Frontier Foudation, ZKM, Goethe Institut New York, UNESCO, TEKSERVE, The Gershwin Hotel

Digital Communities – Preisverleihung
23. Juni 2004
Verleihung der Preise der Kategorie Digital Communities des Prix Ars Electronica 2004 im Rahmen des United Nations Global Compact Summit in New York
Vertreter der Gewinnerprojekte:
Wikipedia: Danny Wool
The World Starts With Me: Alex Okwaput/ UG, Emer Beamer Croni/NL, Meddie Mayanja/ UG, Hester Ezra Kluit/NL, Ineke Aquarius/NL
Krebs-Kompass: Nicole Öhlrich/D, Marcus Öhlrich/D
dol2day: Andreas Hauser/D, Bartosz Plodowski/ D, Oliver Specht/D, Jens Matheusik/D
Open-Clothes: Masaki Ari/J, Manami Iwasaki/ J, Mizue Ayashi/J, Kayoko Yanagihara/J, Yusuke Tamura/J
smart X tension: Penny Yon/ZIM, Peter Kuthan/ A, Dominic Mutanga/ZIM
Künstler und Sprecher: Dennis Russell Davis/A, Maki Namekawa/D, Martin Wattenberg/USA, Philip Glass/USA, Howard Rheingold/USA, Les Hayman, SAP/USA, Denise O'Brien UN Global Compact, Moderator: Peter Goldmark/USA

Digital Communities – Ausstellung
im UN-Hauptquartier New York
24. Juni – 18. Juli 2004
Dokumentation der Gewinnerprojekte.

EVENTS & PERFORMANCES

An Evening in the Gardens
Franz-Joseph-Warte
Mit Sam Auinger/A, Bruce Odland/USA, Rupert Huber/A, AGF/D, Fuzzy Love/CDN, DJ Record Player Laura Kikauka/CDN
Ars Electronica Gala – Prix Ars Electronica Award Ceremony
Brucknerhaus Linz – 3sat
Verleihung der Goldenen Nicas 2004
Visualisierte Linzer Klangwolke: Sens-Ation
Donaupark
Peter Wolf/A
Kuratiert und veranstaltet von: Bruckner-

haus Linz, ORF Oberösterreich
Vita Pulsante
Ars Electronica Quarter
Shuttle-Schiff: Live on Board: centrozoon/D with Tim Bowness/UK
Fourier-Tanzformation I+II: Miko Mikona/D
The Manual Input Session: Tmema/USA
Demi-Pas: Julien Maire/F/D
ROOM TO MOVE.version02: Pepi Öttl/A
Re-inventing Radio
Die lange Nacht der Radiokunst
Live: on air – on line – on site
Ars Electronica Center/Sky Media Loft, Radiokulturhaus Wien, ORF Österreich 1
Mit: Sam Auinger, Seppo Gründler, radioqualia, FirstFlooRadio, Felix Kubin, Bruce Odland, pandorabox.org, Matt Smith, Aleksandar Vasiljevic
Live-Streams von Wien, Linz, Baltimore, Berlin, Hamburg, London, Mexico City, Montréal, New York City, Santa Barbara, Vancouver, Weimar auf http://kunstradio.at
Kuratiert von Elisabeth Schimana/A
Die große Partitur – The Great Score
Ars Electronica Center/Sky Media Loft
Seppo Gründler, Elisabeth Schimana/A
Quarter Nightline
Stadtwerkstatt
Nightline mit japanischen und lokalen Djs und Vjs
Kunstuniversität Linz: Stefan Siebenschlaf, Katharina Blei, Washer, Cherry Sunkist, Aka Tell, DJ Joko13, DJ Elwood, DJ Marcin Gajewski, Karo Szmit & Doris Prlic, Graben 12, a.s.a.p.
IAMAS: Takako Akamatsu, Yoshihisa Suzuki, Satoshi Fukushima, Apple Smoothie, Yuichi Matsumoto, Jean-Marc Pelletier, Masayuki Akamatsu
Kunstuniversität Linz: Horace, Revolver Dogz, Joko13, Beans, Jiwon, Parov Stelar, The Bitles, DJ Aka Tell feat. MC Wan, DJ Parov Stelar, Marcin Gajewski, Graben 12, Karo Szmit, a.s.a.p.
IAMAS: mimiZ, Resonic.kir.kit, Jon Cambeul, WacomMusic, anagma+KLOMA, Carl Stone, Eric Lyon, Meor, Monjyu, Masayuki Akamatsu, DSPBox Solo
Kunstuniversität Linz und *IAMAS*—Big DJ Jam! In Zusammenarbeit mit Stadtwerkstatt, FM4
FORE – Interaktives Golfen
Ars Electronica Quarter
Stadtwerkstatt/A
Konzept und künstlerische Leitung: Peter Hauenschild, Georg Ritter
Projektmanagement: Gabriele Kepplinger
Interface-Design: Brainsalt.org
Grafik/Soundprogrammierung: Mario Stangl
Dank an Golfclub.Stärk.Linz.Ansfelden; Gavin Crockett; Golfschule Arno-Golf, Sterngartl;

Erich Wassermair, Europlan; Tassilo Pelligrini

Sensory Circus

Ars Electronica Quarter

Time's Up/A

Unterstützt von: Stadt Linz, Land Oberösterreich, BKA .Kunst, Festo, Baumann/Glas/1886 GmbH, Silverserver, Cycling74, Viertbauer-Zauner GmbH, servus.at, Kunstuniversität Linz, Sommertheater Schwanenstadt, Kultur2000 Programm der Europäischen Union

Push/Pull

Lentos

Edwin van der Heide/Marnix de Nijs/NL

Apparition

Posthof

Tanz- und Medienperformance

Idee, Konzept, Leitung, Visuals, Musik: Klaus Obermaier/A; Konzept, interaktives Design, technische Entwicklung:Peter Brandl, Christopher Lindinger, Jing He (Ars Electronica Futurelab, A), Hirokazu Kato (Osaka University, J); Choreograph und Performer: Desirée Kongerod, Robert Tannion; Dramaturgie: Scott deLahunta/NL

Eine Koproduktion von Ars Electronica Center Linz, South Bank Centre London and Singapore Arts Festival. Realisiert im Rahmen von DAMPF_lab, ein Projekt von tanz performance köln, Animax Multimedia Theater Bonn, V2_Lab Rotterdam, Ars Electronica Futurelab Linz. http://dampf.v2.nl/

Mit Unterstützung des Kultur2000 Programms der Europäischen Union, Posthof Linz, CCL – Choreographic Centre Linz und Landestheater Linz.

O.K Night

O.K Centrum für Gegenwartskunst

Eine Nacht mit Electronic Theatre, preisgekrönten Installationen aus dem Prix Ars Electronica 2004

Matki Wandalki

O.K Centrum für Gegenwartskunst

Live-Konzert von Felix Kubin

Anerkennung in der Kategorie „Digital Musics"

Japanese Animation!

Hauptplatz

Winter Days: Kawamoto Kihachiro

GA-RA-KU-TA Mr.Stain on Junk Alley: Masuda Ryuji

KOMANEKO: Goda Tsuneo

FRANK: Fuyama Taruto

HOSHI NO KO: Osanail Kumiko

Fushigisekai ATAGOURU: Hashimoto Katsuyo

Mizue Mirai: FANTASTIC CELL

RealoTime: Suzuki Yuuki

GARA: Yokohara Hirokazu

Magic Shadows Light and Shadow of Edo: Tokyo Exhibition

title movie: Ito Yuichi

TOKYO SCANNER: Oshii Mamoru, Mori Building Co., Ltd.

Ski Jumping Pairs, Official DVD: Mashima Riichiro

Digital Musics in Concert

Brucknerhaus, Großer Saal

Live-Performances der Digital Musics-Preisträger des Prix Ars Electronica 2004:

„Skate" von Janek Schaefer/UK

AGF/D, featuring Craig Armstrong und Sue Costabile

„Banlieue du Vide" von Thomas Köner/D

Freiluft-Musik – Music Alfresco

Donaupark

Ausgewählte Digital Musics aus dem Prix Ars Electronica

Musik von: Aphex Twin, Ryoji Ikeda, Maryanne Amacher, Pan sonic, Kid606, Christian Fennesz , Ami Yoshida, Sachiko M, Antye Greie, Thomas Köner, Utah Kawasaki, Maja Solveig Kjelstrup Ratkje, Mouse On Mars, Oren Ambarchi, Zeena Parkins, Ikue Mori, Trevor Wishart, Kevin Blechdom, Blevin Blectum, Tujiko Noriko, Matmos, Raz Mesinai, Marina Rosenfeld, Francis Dhomont, Carl Michael von Hausswolff, Janek Schaefer, Markus Popp – OVAL, John Duncan, Annie Gosfield, Rechenzentrum, Gert-Jan Prins, Florian Hecker, Phill Niblock, Maggi Payne, Masami Akita, Yasunao Tone, Anne Laplantine, Aeron Bergman, Alejandra Salinas – Lucky Kitchen, Natasha Barrett, Curtis Roads, Zbigniew Karkowski, Peter Rehberg, Russell Haswell, Phoenecia, Whitehouse, Francisco López, J.Lesser, Louis Dufort, Rudolf Eb.er, Kevin Drumm, Carsten Nicolai, Komet, Ilpo Vaisanen, Coh, Beytone, Senking, Thomas Brinkman, Scanner, Leafcutter John, Marcus Schmickler, Pxp, The User, Chris Watson, Chlorgeschlecht, Aaron Funk – Venetian Snares, Rachael Kozak, Alvin Curran, Richard Hawtin, Terre Thaemlitz, Stefan Betke, Horacio Vaggione, Felix Kubin, Adrian Moore, Peter Bosch, Simone Simons, Hans Tutschku, Ambrose Field, Hildegard Westerkamp, Tom Hamilton, Gordon Monahan, Jonty Harrison, Christian Calon, Åke Parmerud, Laetitia Sonami, John Young, Robert Normandeau, Gilles Gobeil, Bernard Parmigiani, Denis Smalley. *Auswahl:* Naut Humon

Mulonga.net

Donaupark

Klangbrücke zwischen Linz und Zimbabwe. Idee und Realisierung: Peter Kuthan/ARGE Zimbabwe/Linz in Kooperation mit Keith Goddard und Penny Yon, Kunzwana Trust/ Harare, Binga/Zimbabwe und den Künstlern

von Tonga.Online, Simonga and Windhund
L' Espace Temporel
Passages Between Analog and Digital
　Passage I
　Lentos, Skulpturenhalle/Auditorium
　　Live-Electronics von Rupert Huber
　　Les Enfants Terribles: Philip Glass
　　Aufgeführt von Maki Namekawa, Dennis
　　Russell Davies
　　Visuals von Martin Wattenberg
　　Different Trains, America before the War:
　　Steve Reich. Aufgeführt vom Bruckner
　　Quartett. Visuals von Safy Etiel (unter-
　　stützt von Edirol)
　　Temps du Miroir: Ludger Brümmer. Aufge-
　　führt von Ludger Brümmer, Maki Namekawa
　Passage II
　Brucknerhaus, Großer Saal
　　Triangel: Péter Eötvös. Aufgeführt von
　　Lazlo Hudacsek, Bruckner Orchester
　　Taxi drive in the city: Edward Artemiev
　　Solaris: Visuals von Andrei Tarkovski
　　Lux Aeterna: György Ligeti
　　A Space Odyssey: Visuals von Stanley
　　Kubrick
　　Atmosphères: György Ligeti. Aufgeführt
　　vom Bruckner Orchester.
　　A Space Odyssey: Visuals von Stanley
　　Kubrick
　Passage III
　Brucknerhaus, Mittlerer Saal
　　Venice: Christian Fennesz
　　Visuals von Jon Wozencroft
　Passage IV
　Brucknerhaus, Großer Saal
　　Music for 18 Musicians: Steve Reich
　　Aufgeführt von Bruckner Orchester,
　　Synergy Vocals
　　Visuals von Lotte Schreiber, Dietmar Offen-
　　huber, Norbert Pfaffenbichler, Casey Reas
　Passage V
　Donaupark
　　**Threnody for the Victims of Hiroshima
　　(Tren ofiarom Hiroszimy):** Krzysztof
　　Penderecki. Aufgeführt von String Quartet,
　　Polymorphia
　Passage VI
　Brucknerhaus, Großer Saal
　　Flüux:/Terminal: Skoltz_Kolgen
　　**Extol/Salvo – Salutations to Ligeterecki
　　(a composite).** Tributes, Turbulations and
　　remix. Featuring Audiointerpretationen
　　von Naut Humon und Christian Fennesz.
　　Visuals von Sue Costabile und Lillevan.
　　Noisegate Remix by Naut Humon/Tim
　　Digulla (Audiovisuals). Adaptiert von der
　　Installation NoiseGate by Granular
　　Synthesis.

Kuratiert von: Dennis Russell Davies, Gerfried
Stocker und Naut Humon

Vox Vocis 1.0: Hiddens Gardens
Ars Electronica Sky Media Loft
　　Concha Jerez, José Iges, Pedro López/E
　　Rosario Cruz: Sopran; Concha Jerez: Video,
　　Live-Video-Processing und Stimme; Pedro
　　López: Programmierung und Live-Audio-
　　Electronics; José Iges: aufgenommenes
　　Material, Live-Audio-Electronics und Stimme
The Big Showdown
Brucknerhaus, Großer Saal
　　Game-Engines als Werkzeug von Künstlerinnen.
　　Ecstasis: human presence in digital environ-
　　ments, Metraform/AUS (produziert mit der
　　Unterstützung von RMIT university, I-Cubed
　　und Film Victoria)
　　**Visualisierung von statistischen Sachverhal-
　　ten in Computerspielen:** Modulo5 (Michael
　　Zoellner, Daniel Kupczyk)/D
　　**Ah_Q (Mirror of Death, the dancing pad
　　version of Q4U)**: interactive performance,
　　Feng Mengbo/CN
　　Showdown – Shootdown: Ars Electronica
　　Futurelab, Rune Dittmer, Friedrich Kirschner
Linz schreibt Zukunft – Linz Writes its Future
Hauptplatz
　　Das Zukunftsboard – Linz +25 – Future Me
　　In Kooperation mit Radio Oberösterreich,
　　cyberjuz.at, Mobile Medienwerkstatt der
　　Kinderfreunde, Radio Fro, Stadtteilarbeit
　　„Leben im Franckviertel", Medea Linz
　　Konzept: Michael Naimark, Ausführung:
　　Dieter Mackinger, Gesamtkommunikations-
　　konzept: Nicoletta Blacher
Iso-phone
Hauptplatz
　　James Auger, Jimmy Loizeau, Stefan
　　Agamanolis/UK/USA
Movieline
Moviemento
　　Filmprojekte der japanischen Hochschule
　　IAMAS
　　goldentime: Hirotomo Yamashita
　　in-: Satoshi Uemine
　　SLIMDOWN: Ken Morita
　　CUBE: Hirofumi Ohashi
　　Karaena: Katsumi Iwata, Yasunori Ikeda
　　inertia: Tadasu Takamine
　　The ATMAN: Kanako Imao
　　R: Masakazu Saito, Rintaro Teshima
　　KO-KOTSU #2: Yoshiyuki Sakuragi
　　MY OLD HOME, 2001: Ma Chao
　　KITSUNE-MAI – sacred dance: Taishi Yamamoto
　　frame: Tadashi Okabe
　　Life Line: Keiko Matsunaga
　　Section chief and Mr. Tanaka: Tateki Futagami

AnaGuRaHaJiMaRi: Naoki Nishiwakl
kashikokimono: Takahiro Hayakawa
air: Arisa Wakami
The Story of Floating Dogs: Mayumi Tsuboi
reflraection: Keiko Hino
The boy understood well: Aiko Inada
An example 01: Ai Hasegawa
tapir: Chisato Satou
no title: Aya Fukuda
shi-ra: Kayoko Kuwayama
A Piece of Sunsession #02: Masakazu Saito
Snarl-Up!!!: Akio Okamoto
V: Noriyuki Kimura
On02: Shinjiro Maeda:
On03: Shinjiro Maeda
Yasunori Ikeda: 7x7

electrolobby

Brucknerhaus, Foyer
electrolobby – media ad hoc
Installations – Discussions – Workshops
Live-Berichterstattung von FM4
Audiomobile
 Matt Smith, Sandra Wintner, Christina
 Hofer, Ushi Reiter, Claus Harringer, Peter
 Kulev, Martin Grenz, Markus Decker/A
 Unterstützt von Mercedes Benz
Radio Astronomy
 radioqualia/AUS
 A cooperation between radioqualia, the
 Windward Community College Radio
 Observatory in Hawaii, USA, NASA's Radio
 Jove network, the Ventspils International
 Radio Astronomy Centre in Latvia and the
 cultural center RIXC from Riga, Latvia. The
 research phase of Radio Astronomy is sup-
 ported by the Daniel Langlois Foundation.
Seven Mile Boots
 Laura Beloff/N, Erich Berger/A, Martin Pichl-
 mair/A
VSSTV – Very Slow Scan Television
 Gebhard Sengmüller in Zusammenarbeit
 mit Jakob Edlbacher, Johannes Obermayr,
 Ludwig Ertl, Andreas Konecky/A. Unterstützt
 von Ulmer GmbH Profil- und Fördertechnik,
 BKA Kunstsektion, Kulturabteilung Land
 Salzburg, Kulturamt Stadt Wien
Creative Commons Austria
 Georg Pleger, Roland Alton-Scheidl, Michael
 Breidenbrücker/A
DIGISTA
 Digital Stadium des japanischen Fernseh-
 senders NHK präsentiert digitale Kunstpro-
 jekte
The Time Machine
 Aleksandar Vasiljevic/FRY
 Unterstützt von KulturKontakt Austria

electrolobby – artists do it first
 History Lounge für die Archive der Ars Elec-
 tronica
Minimundus – Milestones of 20th Century Media Art
 Seppo Gründler/A

Partizipationen

Language of Networks
Conference
Ars Electronica Center, Art&Tek
1. – 2. September
Panel I – Information Visualization
 Ulrik Brandes, Lothar Krempel, Anne Nigten,
 Bradford Paley, René Weiskircher
Panel II – Mapping of Research & Innovation
 Jürgen Güdler, Nikolas Kastrinos, Wolfgang
 Neurath, Stefan Thurner
Panel III – Networks and Art
 Gerhard Dirmoser, Lydia Haustein, Urs
 Hirschberg, Astrit Schmidt-Burkhardt
Panel IV – Networks and Power
 Wouter de Nooy, Brain Holmes, Harald
 Katzmair, Josh On
Panel V – Sociometry
 Rupert Laireiter, Brigitte Marschall, Michael
 Schenk
Panel VI – Networks and Business
 Harald Katzmair, Michael Stampfer, Don
 Steiny, Gerhard Wührer
Introduction Lecture – „Networks: Science-Art":
 Lothar Krempel
Evening Lecture – „Group Dynamics at the Amundsen-Scott South Pole Station":
 Jeff Johnson
 Presentation: Digital Media for Artists:
 Gerhard Funk, Joachim Smetschka
Workshop I – Science Communication:
 Harald Katzmair, Elke Ziegler
Workshop II – Software for SNA: Pajek:
 Vladimir Batagelj, Andrej Mrvar
Eine Kooperation von Ars Electronica und
FAS.research. Mit wissenschaftlicher Unterstüt-
zung von: Max Planck Institut für Gesellschafts-
forschung, Gerhard Dirmoser, Johannes Kepler
Universität Linz. Unterstützt durch: Bundesmi-
nisterium für Bildung, Wissenschaft und Kultur,
Bundesministerium für Verkehr, Innovation und
Technologie, Bundesministerium für Wirtschaft
und Arbeit, Rat für Forschung und Technologie-
entwicklung

Language of Networks – Mapping Science, Art, and Technology
Exhibition
Art & Tek
 Mit Projekten von: Lothar Krempel, Harald
 Katzmair, Vladimir Batagelj, Ulrik Brandes,

Alden Klovdahl, touchgraph, TU Wien, Lada Adamic, McFarland, Ning Yu, Paul Mutton, Doug McCune, Josh On, Valdis Krebs, Wouter de Noy, www.caida.org, Sergei Maslov, Kim Sneppen, Uri Alon, Ronnie Ramlogan and Gindo Tampubolon, Jason Owen-Smith, Neo D. Martinez, Jim Moody, David Krackhardt, Linton Freeman, Peter Bearman, Volker Schneider, Patrik Kenis, Volker Raab, Dorothea Wagner, Jane & David Richardson, Miguel Centeno, Chaomei Chen, Skye Bender-deMoll, Ka-Ping Yee, Jeff Johnson, Martin Wattenberg, Marcos Wescamp, Ismael Celis, Schoenerwissen, Katherine Moriwaki/ Jonah Brucker-Cohen, Dennis Paul, Bradford Paley, Gerhard Dirmoser, Martin Höpner, Jürgen Pfeffer, K. Claffy, Doris Spielthemer, Thomas Pluemper, Max Ruhri, Andrej Mrvar, Brian Holmes, Christian Gulas, Jürgen Lorner, Gerhard Funk, Wolfgang Neurath, Urs Hirschberg, René Weiskircher, Joachim Smetschka, Jacob L. Moreno

Creation of Art, Design and Technology – Master Class in the Arab States
Brucknerhaus
4. und 5. September
Ein Workshop von Digi-Arts, dem Wissensportal der UNESCO

Mit Omar Karim Kamel (Cairo), Samirah Al-Kasim (Cairo), Mohammed Aziz Chafchaouni (Rabat), Khalil Chamcham (Rabat), Derrick de Kerckhove (Toronto), Ahmad Nasri (Beirut), Eissa Salih Al Hor (Doha), Mosa Bin Abdalla Al Kindy(Oman), Muhammad Ayish (UAE), Ahmad Mustafa (London), Dimitrios Charitos (Athens), Roger Malina (Marseille), Teemu Leionen (Helsinki), George Awad (Beirut), Jaco du Toit (Paris)

Mulonga.net Station
HMH Galerie Kunstereignisse
3. – 7. September; Verlängerung der Ausstellung: 8. – 14. September

Installationen und Videodokumentationen rumd um das bei Prix Ars Electronica 2004, Kategorie Digital Communities, prämierte Projekt „smart X tension"

Australian Media Art
Architekturforum Oberösterreich

Fish-Bird
Mari Velonaki, David Rye, Steve Scheding, Stefan Williams, Australian Centre for Field Robotics, The University of Sydney/AUS Produziert mit Unterstützung des Australian Research Council, Linkage Grant. Industriepartner: Australian Council for the Arts; Artspace; Australian Network for Art and Technology; Museum of Contemporary Art; Patrick Systems and Technology; Australian

Centre for Field Robotics, the University of Sydney. Präsentiert bei Ars Ars Electronic durch Novamedia

Life Signs
Troy Innocent/AUS
Produziert mit Unterstützung von Film Victoria. Präsentiert bei Ars Ars Electronic durch Novamedia

R-MA/IDM_NME~XR+CP= e'MAZINEst
Kunstraum Goethestraße
Ravensbourne College of Design and Communication/UK
Kuratiert von Karel Dudesek und Jim Wood

Johannes Deutsch
Katholisch-Theologische Privatuniversität Linz
3. –7. September, 9.00 – 13.00. Verlängerung der Ausstellung: 8. September 2004 – 31. Jänner 2005

	1996/1997	1997/1998	1998/1999	1999/2000
1. UG	Texteditor Virtual Touch Virtual Audio Keyframes Extruder	Pinnochio Virtual Touch Virtual Audio Work in Progress Corps et Graphie	Processing Image Virtual Touch Virtual Audio tx-transform Corps et Graphie	Processing Image Virtual Touch Virtual Audio Touchscreen Nomads
	Genma Die Höhle von Lascaux AE Ôn Demand I CAVE Crayoland OORT-contiuum Vandalism MCE-Turbine Greek Temple Vomit Mountain	Hyperscratch Creatures – A Life-Game Urban Feedback AL On Demand I CAVE Mulitmega Book World Skin Bindermichl Fronius Virtual Welding Liquid Meditation Siemens Collaborative Working Environment	Iamascope Revolving Black Hole AE On Demand I CAVE Mitologies Projekt Wittmann The Thing Growing Historiae Naturalis PSA – Picasso Designstudie	Anomalocaris Tracking the Net AE On Demand II CAVE CAVE Sinus Objektbau Solar City 1 Traces Lentos VAI Walzwerk Prozess- simulation
EG/ZG	Telegarden Humphrey Apollo 13/Lift Scheibenschreiber Infomaten Futurebanking Fingerprint Safe	Telegarden Humphrey Apollo 13/Lift Scheibenschreiber Infomaten Bodyscan im Humprey Rouen Revisited	Telegarden Humphrey Apollo 13/Lift The Visible Human/Lift Scheibenschreiber Infomaten What will remain of these Netsound II/Sensorium	Telegarden Humphrey Apollo 13/Lift The Visible Human/Lift Telezone Infomaten
1. OG	GIS Sim Linz I Infinite Reality/Matterhorn Ge*Sample*te Stadt ArchiTektouren VR Bike Time Explorer	GIS Sim Linz I Invisible Shape of Things Past Ge*Sample*te Stadt ArchiTektouren VR Bike Time Explorer Urban Island Virtuelles Berlin Video Distort Immersa-Desk Skin Temperature Digital Fiction Linzer Luft	Ground Truth Time Explorer Infinite Reality/Matterhorn Nomads Telepuzzle Linzer Luft	I Met a Morph/Videoplace Iamascope Immersa-Desk Promenade ArchitecTours VR Bike Millenniums Dome The Bush Soul in/outSite Motion Picture What will remain of these
2. OG	Electronic Classroom Smartboard Multimedia Learnstation Modulwand Extended Livingroom Coinmachine – Lego Logo Worldbeat Gestures – Gestenerkennung ITV/Videoaktoren	Electronic Classroom Smartboard Multimedia Learnstation Modulwand Internet TV Learning Robots – 7 Dwarfs Worldbeat Zeile für Zeile The Tables Turned Cyberanatomy/Visible Human Voxelman Atlas City of News Mediathek Ottos Mops Clamps Ventian Deer Ambitious Bitch The Information Age Slippery Traces: The Postcard Trail Beyond Scrutinity in the Great Round	Electronic Classroom Smartboard Postpet Webhopper 10_Dencies Learning Robots – 7 Dwarfs Worldbeat Zeile für Zeile The Tables Turned Mediathek Dawn Wunderwelt Interakt. Computergraphik Crooner Trance Machine Avila Virtual Lotus Spring GIS	Electronic Classroom Smartboard Webhopper Telepuzzle Learning Robots – 7 Dwarf Nuzzle Afar Small Fish Screen Version Mediathek Time Explorer Katalogarchiv Sim Linz II Vjamm Stretching it wider Tokyocity.ee Sob Syntagma Micros Universe Muto Mut der Ahnungslosen The Five Reactive Books The Dynamic Cell The Greatest Hits Blix

| --- | --- | --- | --- | --- |
| …mud Project
…tual Touch
…tion Picture
…chscreen
…ead of Time/LA Wels | Oskar | Cyclops | Cyclops | Gullivers World
 Extruder
 Modelling Table
 World Creator
 Character Editor
 Greenbox
 Virtual Expedition |
| …g of War
…all Fish | Ahead of Time/LA Wels
Touchscreen
Phantom
The Responsive Window I
Apartment
Tug of War
Small Fish | Ahead of Time/LA Wels
Touchscreen

The Responsive Window I
Jam o Drum
Tug of War
Small Fish | SeeReal
Touchscreen

Tissue/Responsive Window II
Jam o Drum
Tug of War
Small Fish | |
| …On Demand II
…/E
…ace à Face
…AI CCC Trainingssimulator
…olar City 2
…iemens Hybrex | AE On Demand III
CAVE
 EVL-Show
 ILVO San Stino
 Via Donau
 Gericom Laptop – Design-
 studie | AE On Demand III
CAVE/ARSBOX
 Gesichtsraum
 WFL – Digital Mockup
 FACC – Airplane Interior | AE On Demand III
CAVE/ARSBOX
 City Cluster
 NAVEG Drehscheibe Linz
 Foo Billard
 raum.art
 Uzume | CAVE/ARSBOX
 Karma
 Mersea Circles |
| …egarden
…umphrey
…ollo 13/Lift
…e Visible Human/Lift

…ezone
…omaten | Telegarden
Humphrey
Apollo 13/Lift
The Visible Human/Lift

onScreen
Telezone

While You Where Here
n-lab u19 database | Telegarden
Humphrey
Apollo 13/Lift
The Visible Human/Lift

onScreen
Telezone

While You Where Here
n-lab u19 database | Telegarden
Humphrey II
Apollo 13/Lift
The Visible Human/Lift
Elevated Space/Lift
Flow in a Lift/Außenlift
onScreen
Little Red MR

While You Where Here | Commotion
Humphrey II
Apollo 13/Lift
The Visible Human/Lift
Elevated Space/Lift
Generatives Teilchen/Lift
Flow in a Lift/Außenlift
Incredible Elevator/Außenlift
Innovision Wall
Cheese |
| …nt on Screen
…ext Organ
…extrain
…Alphabet Zoo /Type me Again
…An Interactive Poetic Garden
…Dakadaka
…Life Spacies II
…The 5 Reactive Books
…Binary Art Site
…Letters of Bit
…Dominoa | Print on Screen
 Text Organ
 Textrain
 Alphabet Zoo /Type me Again
 An Interactive Poetic Garden
 Dakadaka
 Life Spacies II
 The 5 reactive books
 Binary Art Site
 Valence | Hidden Worlds
 Noise and Voice
 Tools Life
 Aussichtsposten
 Carnivore
 Infobenches
 INSTAR
 Re:Mark | Hidden Worlds
 Gulliver's Box
 Key Grip
 Aussichtsposten
 Carnivore
 Infobenches
 INSTAR
 Re:Mark | Robolab
 Messa di Voce
 Watchful Portrait
 Networked Portrait
 Librovision
 INSTAR
 Moony
 Lego Mindstorms
 Topobo
 Dog[lab] 01 |
| …ectronic Classroom
…hartboard
…onemo
…ebhopper

…lepuzzle

…ars Rover
… now here Interactive | Get in Touch
 Clearboard
 curlybot
 inTouch
 musicBottles
 pegblocks
 PingPongPlus

 Pinwheels
 Triangles
 Urp
 Running Text

Future Office Project | Get in Touch
 Sandscape
 curlybot
 inTouch
 musicBottles
 pegblocks
 PingPongPlus

 Pinwheels
 Digital Cubes
 Urp
 Running Text

Future Office Project
VR-Chart | Smart Objects
 Sandscape
 Labspace
 Networked Portrait
 musicalBottles
 Tool's Life
 Protrude

 Social Mobiles
 Streetscape
 Audipad
 Puppet Tools
 Blockjam
 Bitforms Gallery
Future Office Project
VR-Chart | Archiquarium
 Archiquarium
 Datenpult
 Datenwand
 Zeitschiene
 Datenpool
 Navigator

Screenart
 Welt der Wahrheiten
 Somnambules
 Bitforms Gallery
 Pâte à son
I/O Brush
Sur la table
Protrude |
| …ediathek
Time Explorer
Katalogarchiv
AVES
ArchitecTours/Millenium
Dome
Alles nur Fassade
Notes01
Virtual Babyz
#FFFFFF
All Power to the People
Jazz Suite
SKEYE | Mediathek
 Time Explorer
 Katalogarchiv
 AVES
 Yellowtale
 architecTours/PC | Mediathek
 Time Explorer
 Katalogarchiv | Mediathek
 Time Explorer
 Katalogarchiv

Medienfassade
 i-Noodles
 Guest Book | Mediathek
 Nudemessenger
 Futureme.org

Medienfassade
 Seek
 Beam me up!
 Di Ana Log
 tic.txt
 bønk
 sphinx
 growing city
 hauskleid
 r-slides |

2004

INNOVISION BOARD
Kooperation SAP
Virtuelles Gästebuch
Horst Hörtner, Christopher Lindinger, Peter Freudling, Roland Haring, Christian Naglhofer, Erwin Reitböck

INTERACTIVE BAR
Kooperation SAP
Interaktive Bartische
Golan Levin, Zachary Lieberman
Horst Hörtner, Gerfried Stocker, Martin Honzik, Christopher Lindinger, Stefan Mittlböck-Jungwirth, Dietmar Offenhuber, Erwin Reitböck

WALK.IN.FORMATION
ICT&S Center Universität Salzburg
Arsbox VOD-System
Ursula Mayer Rabler
Andreas Jalsovec, Florian Berger, Reinhold Bidner, Peter Freudling, Horst Hörtner, Christopher Lindinger, Robert Praxmarer, Nina Wenhart, Wolfgang Ziegler

HIDDEN WORLDS BERLIN
Kooperation SAP
Kunst am Bau
Idee und Konzept: Gerfried Stocker, Horst Hörtner, Martin Honzik
Interactive Visuals: Golan Levin, Zachary Lieberman
Projektmanagement: Martin Honzik
Softwaredesign und -entwicklung: Wolfgang Ziegler, Peter Brandl, Roland Haring, Christian Nagelhofer, Stefan Feldler, Christopher Lindinger, Florian Berger
Interfacedesign und -entwicklung: Stefan Feldler, Stefan Mittlböck-Jungwirth, Erwin Reitböck, Dietmar Offenhuber, Peter Freundling, Robert Abt
Virtual Designs und Sketches: Andreas Jalsovec, Reinhold Bidner, Helmut Höllerl, Stefan Schilcher, Martin Bruner, Nina Wenhart, Christine Pilsl, Peter Freudling
Koordination: Yvonne Hauser, Pascal Maresch
In Kooperation mit: SAP, Karsten Koch, Astrid Kasper, Hannes Fickenscher, Mark Braun, Robert Westphal, Goebl und Mattes.

ARCHIQUARIUM
Ars Electronica Center
Archivinstallation
Basierend auf der Studie „25 Jahre Ars Electronica" von Gerhard Dirmoser
Ausstellungsarchitektur: Scott Ritter/Jakob Edelbacher
Konzept: Helmut Höllerl.
Konzept, Software: Dietmar Offenhuber
Technisches Consulting: Gerold Hofstadler, Stefan Hackl. Hardware-Entwicklung: Stefan Feldler. Grafikdesign, Software: Philipp Seifried, Birgit Beireder. Content-Recherche: Nina Wenhart. Datenbank/ Web-Development: Günther Kolar. Datenbankentwicklung: Gunter Schmidl. Datadesk / Datenpult: Philipp Seifried, Helmut Höllerl, Nina Wenhart. Datawall/Datenwand: Gerhard Dirmoser, Stefan Feldler, Philipp Seifried, Helmut Höllerl, Nina Wenhart, Günther Kolar. Timeslider/ Zeitschiene: Dietmar Offenhuber, basierend auf „Ars Topics" von Gerhard Dirmoser. Datapool/Datenpool: Birgit Beireder, Nina Wenhart, Helmut Höllerl
Navigator: Günther Kolar, Gunther Schmidl
Produktion: Ellen Fethke

GULLIVER'S WORLD
Ars Electronica Center
Augmented-Reality-Installation
Konzept: Christopher Lindinger, Roland Haring, Peter Freudling, Andreas Jalsovec, Horst Hörtner, Dietmar Offenhuber, Hirokazu Kato/J
Projektleitung: Christopher Lindinger
Technischer Leiter: Roland Haring
Realisierung: Christopher Lindinger, Peter Freudling, Andreas Jalsovec, Christian Naglhofer, Stefan Feldler, Christine Pilsl, Christine Gruber, Thomas Grabner, Daniel Leithinger, Robert Priewasser, Rudolf Hanl, Martin Sturm, Theodore Watson (UK/USA), Hirokazu Kato (J)

DAMPF – APPARITION
DAMPF_lab
Tanz- und Medienperformance, Ars Electronica Festival 2004
Idee, Konzept, Leitung, Visuals, Musik: Klaus Obermaier
Konzept, interaktives Design, technische Entwicklung: Peter Brandl, Christopher Lindinger, Jing He (Ars Electronica Futurelab, A), Hirokazu Kato (Osaka University, J); Choreograph und Performer: Desirée Kongerod, Robert Tannion; Dramaturgie: Scott deLahunta/NL
Eine Koproduktion von Ars Electronica Center Linz, South Bank Centre London and Singapore Arts Festival. Realisiert im Rahmen von DAMPF_lab, ein Projekt von tanz performance köln, Animax Multimedia Theater Bonn, V2_Lab Rotterdam, Ars Electronica Futurelab Linz. http://dampf.v2.nl/
Mit Unterstützung des Kultur2000 Programms der Europäischen Union, Posthof Linz, CCL – Choreographic Centre Linz und Landestheater Linz.

SCALEX – SCALABLE EXHIBITION SERVER
Virtuelle Museumsnavigation
EU-Projekt in Kooperation mit:
atelier für digitale medien (admTM)/A, Ars Electronica Center, C3 Center for Culture and Communication/H, Joanneum Research Graz/A, FWU Institut für Film und Bild in Wissenschaft und Unterricht/D, Lost Boys Business Solutions/NL, Národní Technické Muzeum/CZ, Technisches Museum Wien/A, Universität Linz/A, Universiteit van Amsterdam/NL, ZKM Zentrum für Kunst und Medientechnologie/D,
Projektkoordinator: FH Joanneum Graz/Studiengang Informations-Design

MOTION TRACES
Mobilkom Austria
Interaktive Installation
Konzept und Umsetzung: Scott Ritter, Golan Levin, Zachary Lieberman
Peter Brandl, Stefan Feldler, Horst Hörtner, Helmut Höllerl, Stefan Mittlböck, Christian Naglhofer

2003

DREHSCHEIBE LINZ
NAVEG Linz
CAVE-Visualisierung
Florian Berger, Peter Freudling, Horst Hörtner, Andreas Jalsovec, Pascal Maresch, Werner Pötzelberger, Andreas Riedler

NOVGOROD

Hochschule für Gestaltung Offenbach
ARSBOX Ausstellung
Bernd Kracke/D
Michael Büttner, Stefan Feldler, Horst Hörtner, Andreas
Jalsovec, Christopher Lindinger, Stefan Mittlböck-Jung-
wirth, Wolfgang Ziegler

NETWORKED PORTRAIT

John Gerrard/IRL
Andreas Jalsovec , Martin Bruner, Erwin Reitböck,
Christopher Lindinger, Pascal Maresch
Realisiert im Rahmen des Ars Electronica Futurelab
Artist in Residence Programme. Ermöglicht durch
Pépinières Européennes pour Jeunes Artistes 2003.

KNOTEN VÖSENDORF

ASFINAG
3D-Verkehrssimulation
Kooperation mit: Elmar Schmidinger.
Dietmar Offenhuber, Robert Praxmarer, Christian
Nagelhofer, Peter Brandl

CO.IN.CIDE

Graz 2003, Stadt Judenburg
Telematische Installation
Konzept und Idee: Heimo Ranzenbacher, x-space
Horst Hörtner, Robert Praxmarer, Helmut Höllerl,
Stefan Mittlböck Jungwirth, Martin Honzik, Florian
Landerl, Christoph Hofbauer, Christoph Scholz

GULLIVER'S BOX

Ars Electronica Center
Installation
Konzept: Hirokazu Kato, Christopher Lindinger, Horst
Hörtner, Nina Wenhart, Gerfried Stocker
Inhalt: Li Yu, Pascal Maresch, Andreas Jalsovec,
Christine Pilsl, Softwareentwicklung: Dan Borthwick,
Simon Prince, Adrian David Cheok, Hirokazu Kato,
Gernot Ziegler, Roland Haring Wolfgang Ziegler, Robert
Praxmarer, Stefan Feldler, Produktion: Rudolf Hanl,
Martin Honzik, Gerold Hofstadler, Martin Sturm, Stefan
Mittelböck-Jungwirth, Ausstellungsarchitektur: Scott
Ritter
Mit Unterstützung von: DSTA Singapore, National Arts
Council Singapore.

HUMPHREY II

Ars Electronica Center
Flugsimulator
Stefan Mittlböck-Jungwirth, Gerfried Stocker, Horst
Hörtner, Andreas Jalsovec, Robert Abt, Michael Büttner,
Peter Brandl, Martin Bruner, Stefan Feldler, Peter
Freudling, Martin Honzik, Christopher Lindinger,
Werner Pötzelberger, Erwin Reitböck, Wolfgang Ziegler,
Thomas Kienzl, Wöber Anton, Flugschule „Wings",
Dietmar Offenhuber, Martin Sturm, Stefan Stipek,
Stefan Steiner, Gerold Hofstadler, Rudolf Hanl, Thomas
Teibler, D.O.R.I.S. – Thomas Ebert, Kurt Pfleger; Gerhard
Riegler, Franz Nagelreiter
Ausstellungsarchitektur: Scott Ritter, Jakob Edlbacher
In Kooperation mit: Festo, Wintex, Form², Rosenbauer

LABSPACE

Ars Electronica Center
Installation

FUTURELAB-TEAM (STAND AUGUST 2004)

Horst Hörtner

Geb. 1965
Studium Telematik (TU Graz), Entwickler
für Realtime Control Systems. Grün-
dungsmitglied von x-space, einer unab-
hängigen Künstler- und Technikergruppe
zur Realisierung interdisziplinärer Projek-
te. Seit 1996 Leiter des Ars Electronica
Futurelab.

Mag. Helmut Höllerl

Geb. 1971
Studium Sozial und Wirtschaftswissen-
schaften, Johannes Kepler Universität
Linz. Seit 1996 im Ars Electronica Future-
lab tätig. Seit 2000 Keyresearcher der
Forschungsgruppe Digital Surfaces.

DI Christopher Lindinger MAS

Geb. 1977
Studium Informatik, Johannes Kepler
Universität Linz. Kulturmanagement
(ICCM/Salzburg). Seit 2002 Doktorand
der technischen Wissenschaften, Johan-
nes Kepler Universität Linz.

DI Dietmar Offenhuber

Geb. 1973
Studium Architektur, Technische Univer-
sität Wien. Seit 1995 im Ars Electronica
Futurelab tätig. Seit 2000 Keyresearcher
der Forschungsgruppe Interactive Space.

DI Dr. Robert Abt

Geb. 1963
Studium Festkörperphysik, TU Graz,
Theoretische Physik, Karl Franzens Uni-
versität Graz. Seit 1999 im Ars Electronica
Futurelab tätig. Mitglied der Forschungs-
gruppe Virtual Environments.

DI Florian Berger

Geb. 1972
Studium Theoretische Physik, Johannes
Kepler Universität Linz. Seit 2001 im Ars
Electronica Futurelab tätig. Mitglied der
Forschungsgruppe Virtual Environments.

DI (FH) Reinhold Bidner

Geb. 1975
Studium MultiMediaArt an der Fachhoch-
schule Salzburg. Seit 2001 im Bereich
Digital Surfaces.

DI (FH) Peter Brandl

Geb. 1976
Studium Telematik, TU Graz, Medientech-
nik und -design an der Fachhochschule
Hagenberg. Seit 2002 im Bereich Digital
Surfaces.

Sam Auinger, Helmut Höllerl, Dietmar Offenhuber,
Peter Brandl, Pascal Maresch, Erwin Reitböck

LIBRO VISION
Kooperation SAP
Gesture Controlled Virtual Book
Horst Hörtner, Christian Nagelhofer, Robert Praxmarer,
Reinhold Bidner

LIVINGROOM
Bundesschulzentrum Kirchdorf
Kunst am Bau
Dietmar Offenhuber, Nina Wenhart, Helmut Höllerl,
Horst Hörtner, Robert Abt, Carlos Andreas Rocha, Peter
Brandl, Martin Bruner, Ewald Elmecker, Peter Freudling,
Martin Honzik, Florian Landerl, Christopher Lindinger,
Stefan Mittlböck-Jungwirth, Christian Nagelhofer,
Robert Praxmarer, Erwin Reitböck, Christoph Scholz,
Walter Steinacher
In Kooperation mit: BIG/IMB DI Maannel, Ing. Heinz,
Architekturbüro Riepl & Riepl, Peter Riepl.

VRIZER
Ars Electronica Futurelab
Gameengine im CAVE
Florian Berger, Christopher Lindinger, Andreas Jalsovec,
Michael Büttner, Wolfgang Ziegler

2002

GESICHTSRAUM
Ars Electronica Center
CAVE-Applikation
Johannes Deutsch
Florian Berger, Peter Freudling, Christopher Galbraith,
Horst Hörtner, Andreas Jalsovec, Christopher Lindinger,
Pascal Maresch, Joachim Schnaitter.
Realisiert im Rahmen des Ars Electronica Research &
Residence Program 2002.

AUSSICHTSPOSTEN
Ars Electronica Center
Installation
Dietmar Offenhuber, Christian Nagelhofer, Peter
Brandl, Christopher Lindinger, Erwin Reitböck,
Robert Praxmarer, Wolfgang Ziegler
Design: Scott Ritter

INFO BENCHES
Ars Electronica Center
Installation
Helmut Höllerl, Stefan Schilcher, Florian Landerl,
Pascal Maresch
Design: Scott Ritter

I.L.V.O. SAN STINO
Logistiksimulation ÖBB
CAVE-Applikation
Andreas Jalsovec, Christopher Lindinger, Florian Berger,
Nikolaus Diemansberger, Peter Freudling, Werner
Pötzelberger

GRUNDSTEINLEGUNG
ÖBB – I.L.V.O. San Stino
Video & Animation
Reinhold Bidner, Andreas Jalsovec, Nina Wenhart,
Pascal Maresch

IMAGING URBIS
Manchester
Installation
Projektleitung: Land Design Studio, Lol Seargent
Sam Auinger
Helmut Höllerl, Dietmar Offenhuber, Erwin Reitböck

INSTAR
Siemens CT SE1
Forschungskooperation
Horst Hörtner, Christopher Lindinger, Robert Abt, Rein-
hold Bidner, Andreas Jalsovec, Helmut Höllerl, Dietmar
Offenhuber, Robert Praxmarer, Wolfgang Ziegler
Ars Electronica Futurelab in Kooperation mit: Institut
für Wirtschaftsinformatik – Softwareengineering, Prof.
Gustav Pomberger, und Institut für Pervasive Compu-
ting Prof. Alois Ferscha, Wolfgang Narzt, Volker Christian/
Johannes Kepler Universität Linz, Fachhochschule
Hagenberg sowie Siemens CT SE1 Dieter Kolb, Reiner
Müller, Christian Clément, Jan Wieghardt.

MM-FRAMEWORK
SIEMENS CT SE2
Forschungskooperation
Florian Berger, Horst Hörtner, Robert Praxmarer
Ars Electronica Futurelab in Kooperation mit: Institut
für Wirtschaftsinformatik – Softwareengineering, Prof.
Gustav Pomberger, Johannes Kepler Universität Linz

RT-LINUX
Siemens CT SE2
Forschungskooperation
Andreas Riedler, Horst Hörtner, Florian Berger
Ars Electronica Futurelab in Kooperation mit: Institut
für Wirtschaftsinformatik – Softwareengineering, Prof.
Gustav Pomberger, Johannes Kepler Universität Linz

MOSAIK
Zukunftszentrum Innsbruck
Installation
Helmut Höllerl, Gerfried Stocker, Andreas Jalsovec,
Nina Wenhart

HIDDEN WORLD OF NOISE AND VOICE
Ars Electronica Center
Installation
Golan Levin, Zachary Lieberman, Gerfried Stocker,
Christopher Lindinger, Dietmar Offenhuber, Robert Abt,
Horst Hörtner, Peter Freudling, Stefan Mittelböck-
Jungwirth, Robert Praxmarer, Wolfgang Ziegler,
Michael Breidenbrücker
Design: Scott Ritter
Mit Unterstützung von: SAP

VR-FLIP CHART
Ars Electronica Center
Installation
Gerfried Stocker, Robert Abt, Florian Berger, Stefan
Feldler, Horst Hörtner, Christopher Lindinger, Dietmar
Offenhuber, Erwin Reitböck, Wolfgang Ziegler
Design: Scott Ritter, Jakob Edlbacher

XEDIT
X-Art Gmbh
Mobile Audio Recorder
Wolfgang Ziegler, Erwin Reitböck, Carlos Andreas Rocha.
Andreas Pongratz/X-Art.

ZUKUNFTSZENTRUM INNSBRUCK
Permanent Exhibition Design
Ausstellung
Gerfried Stocker, Horst Hörtner, Christopher Lindinger,
Dietmar Offenhuber, Robert Abt, Florian Berger, Peter
Freudling, Yvonne Hauser, Andreas Jalsovec, Christopher
Lindinger, Pascal Maresch, Stefan Mittlböck-Jungwirth,
Dietmar Offenhuber, Robert Praxmarer, Erwin Reitböck,
Andreas Riedler, Wolfgang Ziegler

2001

ARSBOX I
Ars Electronica Center
PC-CAVE-Infrastruktur
Horst Hörtner, Christopher Lindinger, Florian Berger,
Peter Freudling, Andreas Jalsovec, Stefan Mittlböck-
Jungwirth, Robert Praxmarer, Andreas Roiedler.
In Kooperation mit: Institut für Wirtschaftsinformatik –
Softwareengineering, Prof. Gustav Pomberger, Johannes
Kepler Universität Linz

FACE THE FUTURE II
Ars Electronica Center
Fassadengestaltung, Plott
3D-Modelling (Roboter): Andreas Jalsovec; Konzeption,
Grafikdesign: Reinhold Bidner.
© JST ERATO Kitano Symbiotic Systems Project.

FUTURE OFFICE PROJECT
Ars Electronica Center
Installation
Gerfried Stocker, Dietmar Offenhuber, Robert Abt,
Martin Bruner, Nikolaus Diemansberger, Helmut Höllerl,
Horst Hörtner, Christopher Lindinger, Pascal Maresch,
Stefan Mittlböck-Jungwirth, Robert Praxmarer, Erwin
Reitböck, Wolfgang Ziegler
Design: Scott Ritter, Jakob Edlbacher

LANDESAUSSTELLUNG KÄRNTEN 2001 FRIESACH
Exhibition Animations
Nina Wenhart, Markus Gansberger, Jürgen Hagler,
Andreas Jalsovec, Jacob Pock, Klaus Taschler
Projektleitung: Hans Hoffer

IMAGEVIDEO QUELLE ÖSTERREICH
Videoproduktion
Nina Wenhart, Reinhold Bidner

**RÜCKPROJEKTION – DER GUMMIBÄR MIT
SONNENBRAND IM INTERNET**
Ars Electronica Festival TAKEOVER
Installation
Konzept, Idee, Installation: ESCAPE*Sphere, Barbara
Imhof, Sandrine von Klot.
Dietmar Offenhuber, Pascal Maresch, Robert Abt,
Volker Christian, Gerald Kogler, Robert Praxmarer

WIRTSCHAFTSGESCHICHTE STIFT MELK
Installation
Helmut Höllerl, Klaus Taschler, Werner Pötzelberger,
Jürgen Hagler, Nina Wenhart, Martin Bruner, Martin
Honzik. In Kooperation mit: Architekturbüro Hans Hoffer

BAUGESCHICHTE STIFT MELK
Installation
Jürgen Hagler, Horst Hörtner, Dietmar Offenhuber, Volker
Christian, Stefan Mittlböck-Jungwirth, Klaus Taschler,

Martin Bruner
Geb. 1972
Seit 1998 im Ars Electronica Futurelab
tätig. Seit 2000 im Bereich Digital Surfa-
ces, seit 2000 Keyresearcher der For-
schungsgruppe Virtual Environments.

DI (FH) Stefan Feidler
Geb. 1976
Studium Medientechnik und -design,
Fachhochschule Hagenberg. Seit 2001 im
Ars Electronica Futurelab, Mitglied der
Forschungsgruppe Interactive Space.

Peter Freudling
Geb. 1976
Studium Industrial Design, Universität
für künstlerische und industrielle Gestal-
tung Linz, Studium Wirtschaftswissen-
schaften. Seit 2001 im Ars Electronica
Futurelab. Mitglied der Forschungsgrup-
pe Virtual Environments.

Yvonne Hauser
Geb. 1979
Studium der Wirtschaftswissenschaften,
Johannes Kepler Universität Linz. Seit
2001 Team Assistance im Ars Electronica
Futurelab.

Roland Haring
Geb. 1975
Studium Medientechnik und -design,
Fachhochschule Hagenberg. Seit 2003
im Ars Electronica Futurelab tätig. Mit-
glied der Forschungsgruppe Virtual
Environments.

Mag. Martin Honzik MAS
Geb. 1970
Studium Experimentelle Visuelle Gestal-
tung, Universität für künstlerische und
industrielle Gestaltung Linz, Studium
Kulturmanagement am ICCM, Salzburg,
Johannes Kepler Universität Linz. Seit 2001
im Ars Electronica Futurelab. Mitglied der
Forschungsgruppe Interactive Space.

Andreas Jalsovec
Geb. 1974
Seit 1997 im Ars Electronica Futurelab.
Mitglied der Forschungsgruppe Virtual
Environments.

Werner Pötzelberger, Nina Wenhart, Martin Honzik
In Kooperation mit: Architekturbüro Hans Hoffer

VIA DONAU LOGISTIKSIMULATION
CAVE-Applikation
Andreas Jalsovec, Christopher Lindinger, Pascal Maresch,
Werner Pötzelberger, Robert Praxmarer, Joachim
Smetschka, Joachim Schnaitter

2000

ACTIVE SCORE MUSIC
Projektdokumentation Ars Electronica Festival 2000
DVD-Produktion
Scribble: Golan Levin; Performers: Scott Gibbons, Golan
Levin, Greg Shakar.
Small Fish Tale: Masaki Fujihata, Kiyoshi Furukawa,
Wolfgang Münch.
Joachim Schnaitter, Joachim Smetschka, Stefan Eibel-
wimmer, Horst Hörtner, Pascal Maresch, Klaus Taschler,
Nina Wenhart, Jutta Schmiederer
In Zusammenarbeit mit: Harald Domitner, Taife
Smetschka, Hubert Hawel, Andreas Pongratz, Steffen
Teuchert, Mel Greenwald, ZKM Karlsruhe, Fischer Film,
Schmidt & Viteka

ARCHITECTOURS
Millennium Dome London
Installation
Dietmar Offenhuber, Markus Decker, Walter Frisch,
Jürgen Hagler, Perter Hössl, Andreas Jalsovec,
Christopher Lindinger, Michaela Ortner, Werner
Pötzelberger, Robert Praxmarer, Werner Stadler

TUG OF WAR
Millennium Dome London
Installation
Konzept und Idee: Gerfried Stocker, Peter Higgins/Land
Design Studio.
Realisation: Joachim Smetschka, Christopher Lindinger,
Volker Christian, Horst Hörtner, Werner Pötzelberger,
Werner Stadler

SPERM RACE
Ars Electronica Festival 2000
Webdesign und Webprogrammierung
Joris Gruber, Erich Semlak, Gunther Schmidl, Gerd
Eberhardt, Helmut Höllerl, Horst Hörtner, Sebastian
Polin.

FACE À FACE
Ars Electronica Center
CAVE-Applikation
Cathérine Ikam, Luis Fléri/F
Volker Christian, Horst Hörtner, Andreas Jalsovec,
Christopher Lindinger, Pascal Maresch, Iris Mayr, Robert
Praxmarer, Joachim Schnaitter.
Consulting: Sam Auinger
Realisiert im Rahmen des Ars Electronica Research &
Residence Programm 2000 mit Unterstützung von:
Institut Image ENSAM, Cluny.

HAME [HA'ME]
Interaktive Installation
Laura Beloff/FIN
Markus Decker, Robert Abt, Christopher Lindinger.
Realisiert im Ars Electronica Futurelab im Rahmen des
Programms Pépinières Européennes 2000.

RITTER
Landesausstellung Kärnten 2001 Friesach
Exhibition Design Model
Projektleitung: Architekturbüro Hans Hoffer
Andreas Jalsovec

HYBREX SIEMENS ATD
CAVE Visualisierung
Horst Hörtner, Norman Lin, Andreas Jalsovec, Volker
Christian, Gerald Kogler, Dietmar Offenhuber.
Ars Electronica Futurelab in Kooperation mit: Institut
für Wirtschaftsinformatik – Softwareengineering, Prof.
Gustav Pomberger, Johannes Kepler Universität Linz

SOLAR CITY
Stadt Linz, Solar City Pichling
CAVE-Visualisierung
Gunter Amersberger
Andreas Jalsovec, Christopher Lindinger, Werner
Pötzelberger, Jürgen Hagler, Volker Christian, Nikolaus
Diemannsberger, Markus Greunz, Michaela Ortner,
Alexander Wolf

MATRIX
Ars Electronica Futurelab
Softwarearchitektur
Volker Christian, Robert Abt, Wolfgang Beer, Martin
Bruner, Joris Gruber, Helmut Höllerl, Horst Hörtner,
Andreas Jalsovec, Gerald Kogler, Christopher Lindinger,
Pascal Maresch, Martin Pichlmaier, Robert Praxmarer

TIME EXPLORER
Landesausstellung Wels 2000
Installation
Gerfried Stocker, Robert Abt, Martin Bruner, Volker Chri-
stian, Nikolaus Diemansberger, Jürgen Hagler, Helmut
Höllerl, Horst Hörtner, Andreas Jalsovec, Gerald Kogler,
Christopher Lindinger, Pascal Maresch, Stiliana Mitzeva,
Dietmar Offenhuber, Werner Pötzelberger, Robert
Praxmarer, Joachim Schnaitter, Johann Stelzer, Klaus
Taschler, Nina Wenhart, Daniel Wetscher, Gundi Zachl
In Kooperation mit: Archtikturbüro Hans Hoffer und
Sam Auinger.

TIME EXPLORER MEDIA
Landesausstellung Wels 2000
Webdesign
Helmut Höllerl, Pascal Maresch, Martin Bruner, Sebasti-
an Polin, Stiliana Mitzeva

RAUM-ZEIT-SPIEGEL
Landesausstellung Wels 2000
Installation
Pete Nevin, Lucy Harrison
Christopher Lindinger, Robert Abt, Volker Christian,
Robert Praxmarer
In Kooperation mit: Archtikturbüro Hans Hoffer und
Sam Auinger.

VAI CONTINOUS CASTING SIMULATOR
VA Industrianlagenbau
Trainingssimulator im CAVE
Volker Christian, Robert Abt, Horst Hörtner, Andreas
Jalsovec, Gerald Kogler, Horst Köpfelsberger, Christop-
her Lindinger, Dave Pape,, Robert Praxmarer
Ars Electronica Futurelab in Kooperation mit: Institut
für Wirtschaftsinformatik – Softwareengineering, Prof.
Gustav Pomberger, Johannes Kepler Universität Linz.

ARS ELECTRONICA FESTIVAL 2000 NEXT SEX

Webdesign
Joachim Schnaitter, Karin Rumpfhuber, Joris Gruber,
Gunther Schmidl, Erich Semlak

UNIT-M

WIFI Linz
Kunst am Bau
Konzept: Gerfried Stocker, Dietmar Offenhuber, Joachim
Smetschka.
Robert Abt, Wolfgang Beer, Martin Bruner, Volker Chri-
stian, Stefan Eibelwimmer, Joris Gruber, Jürgen Hagler,
Helmut Höllerl, Horst Hörtner, Martin Honzik, Gerald
Kogler, Philip Krammer, Roland Marschner, Pascal Ma-
resch, Martin Pichlmaier, Sebastian Polin, Robert Prax-
marer, Gunter Schmidl, Werner Stadler
In Kooperation mit: WIFI, Architekturbüro Franz Knei-
dinger, Peter Minixhofer, Karin Pressl, Martina Angerer,
Walter Burgstaller, Felix Messner u.v.a.

1999

KATALOGARCHIV ARS ELECTRONICA 1979 – 1999

Ars Electronica Festival
Webarchiv
Gerfried Stocker, Ingrid Fischer Schreiber, Jutta Schmie-
derer, Horst Hörtner, Joris Gruber, Erich Semlak, Astrid
Benzer, Gabriele Hofer, Pascal Maresch, Helmut Höllerl,
Joachim Schnaitter, Martin Oberhammer, Gunter
Schmidl. Unter Mitarbeit von: Helmut Einfalt, Stefan
Adamski, DIRECTMEDIA Publishing GmbH, Berlin

ARS-ELECTRONICA PROJEKTARCHIV

Ars Electronica Center
Webarchiv
Doris Haider, Gabriele Hofer, Joachim Schnaitter, Joris
Gruber, Erhard Wimmer

ARS ELECTRONICA SHOP

Ars Electronica Center
Webshop
Ursula Kürmayr, Gerfried Stocker, Joris Gruber,
Erich Semlak

ZEIT

Landesausstellung Oberösterreich 2000 Wels
Exhibition Design Model
Projektleitung Architekturbüro Hans Hoffer
Andreas Jalsovec

CAVE

Ars Electronica Center
CAVE-Applikation
Peter Kogler, Franz Pomassl
Dietmar Offenhuber, Jürgen Hagler, Klaus Taschler,
Markus Decker, Markus Greunz, Gerald Schröcker,
Pascal Maresch, Horst Hörtner.
Auftragsarbeit der Ars Electronica, realisiert im Ars
Electronica Futurelab.

CONFETTI KLANGTHEATER GANZOHR II

ORF Radiokulturhaus
Exhibition Design
Volker Christian, Joachim Smetschka, Dietmar
Offenhuber, Vaclav Cizkovsky

Mag. Pascal Maresch

Geb. 1969
Studium Publizistik und Kommunika-
tionswissenschaft, Kunstgeschichte,
Salzburg. Seit 1998 im Ars Electronica
Futurelab. Seit 2000 Content Manager.

Mag. Stefan Mittlböck-Jungwirth

Geb. 1977
Studium Malerei und Grafik, Universität
für künstlerische und industrielle Gestal-
tung Linz. Seit 2001 im Ars Electronica
Futurelab. Mitglied der Forschungsgruppe
Interactive Space.

DI (FH) Christian Naglhofer

Geb. 1979
Studium Medientechnik und -design,
Fachhochschule Hagenberg. Seit 2002
im Ars Electronica Futurelab.
Mitglied der Forschungsgruppe Virtual
Environments.

DI (FH) Erwin Reitböck

Geb. 1969
Studium Medientechnik und -design,
Fachhochschule Hagenberg. Seit 2001 im
Ars Electronica Futurelab. Mitglied der
Forschungsgruppe Interactive Space.

DI (FH) Stefan Schilcher

Geb. 1979
Studium Informationsdesign, Fachhoch-
schule Joanneum Graz. Seit 2002 im Ars
Electronica Futurelab. Mitglied der For-
schungsgruppe Digital Surfaces.

Nina Wenhart

Geb. 1975
Studienkombination aus Rechtswissen-
schaften, Visuelle Mediengestaltung,
Philosophie und Architektur.
Seit 1999 im Digital Media Studio des Ars
Electronica Futurelab.

Associated Members

Birgit Benetseder, Rune Dittmer, Jing He, Daniel Lei-
thinger, Christine Pilsl, Werner Pötzlberger, Milena
Rieser, Christoph Scholz, Michael Schweiger, Philipp
Seifried, Peter Senoner, Walter Steinacher, Martin
Sturm, Theodore Watson, Bernhard Weber

CYBER COUPLE

Covergestaltung für „Format"
Rendering
Andreas Jalsovec, Joachim Schnaitter

HUMPHREY 3D-WELTEN

Ars Electronica Center
Installation
Andreas Jalsovec, Christopher Lindinger, Dietmar Offenhuber, Werner Pötzelberger, Joachim Schnaitter

MILLENNIUMPARK

Ars Electronica Center, ORF
TV- ScienceFiction Story und Internet-Observatory zum Millenniumswechsel
TNC Network Bruno Beusch, Tina Cassani/F
Gerfried Stocker, August Black, Volker Christian, Markus Decker, Helmut Höllerl, Horst Hörtner, Andreas Jalsovec, Klemens Kitzberger, Christopher Lindinger, Pascal Maresch, Iris Mayr, Dietmar Offenhuber, Robert Praxmarer, Klaus Taschler, Nina Wenhart.
Moderation: Robert Wiesner

MINDSWEEPER

Encart
Lan-Game & DJ-VJ-Session
Kooperation: V2 Rotterdam / C3 Budapest
Christopher Lindinger, Andreas Jalsovec, Dietmar Offenhuber, Horst Hörtner, Volker Christian, Markus Decker, Stefan Eibelwimmer, Helmut Höllerl, Pascal Maresch

OEDIPUS

Theater Phoenix
3D-Visualisierung als Bühnenbild
Andreas Jalsovec, Christopher Lindinger, Werner Pötzelberger. In Kooperation mit: Theater Phönix, Kaspar Erffa, Obermaier/Spour, Lindorfer

KÖRNERPARK

Sinus Objektbau
CAVE-Visualisierung
Markus Greunz, Horst Hörtner, Andreas Jalsovec, Pascal Maresch, Michaela Ortner, Alexander Wolf

TELEZONE

An architecture for net architecture
Ars Electronica Center
Webcommunity & Robotics
Ein Projekt des Ars Electronica Center und der Telekom Austria mit Unterstützung von Wittmann Roboterbaureihen und Automatisierungsanlagen.
Projektleitung: Erich Berger. Concept Consultant: Ken Goldberg/UC Berkeley USA. Programmierer: Wolfgang Beer, Volker Christian, Oliver Frommel, Rene Pachernegg, Jörg Piringer, Nestor Pridun, Christian Retscher, Markus Seidl, Martin Wiesmair, Gunter Schmidl
Web Design: igw gemeinsam mit gregerpausch f.o.p.
PR: Ursula Kürmayr, Pascal Maresch, Florian Sedmak, Martin Lengauer
Wissenschaftliche Begleitung: DI Dr. Wilhelm Burger, Lehrgang für Medientechnik und Design an der Fachhochschule Hagenberg, Univ. Prof. DI Dr. Jacak Witold, Lehrgang für Software Engineering an der Fachhochschule Hagenberg, Univ. Ass. DI Dr. Peter Purgathofer, Institut für Gestaltungs und Wirkungsforschung der TU Wien, Univ.Ass. Mag Gerhild Götzenbrucker, Institut für Publizistik und Kommunikations-wissenschaften

der Universität Wien, Fachbereich Elektronische und Neue Medien, Mag. Bernd Löger, Zentrum für Alterswissenschaften und Sozialpolitikforschung an der Niederösterreichischen Landesakademie St. Pölten

VIRTUAL HEAVY PLATE MILL

VA Industrieanlagenbau
Prozesssimulation im CAVE
Horst Hörtner, Markus Greunz, Andreas Jalsovec, Joachim Smetschka, Michaela Ortner, Margaret Watson
In Kooperation mit: Institut für Wirtschaftsinformatik – Softwareengineering, Prof. Gustav Pomberger, Johannes Kepler Universität Linz

LENTOS KUNSTMUSEUM

Stadt Linz
CAVE-Visualisierung
Horst Hörtner, Andreas Jalsovec, Werner Pötzelberger, Alexander Wolf, Michaela Ortner

ARS ELECTRONICA FESTIVAL 1999 LIFESCIENCE

Webdesign
Joachim Schnaitter, Markus Decker, Joris Gruber, Gerhard Niederleuthner, Gunter Schmidl, Erhard Wimmer

1998

FACE THE FUTURE I

Ars Electronica Center/Fassadengestaltung, Plott
August Black, Dietmar Offenhuber, Joachim Smetschka, Niq

KLANGTHEATER „GANZOHR" I

ORF Radiokulturhaus
Exhibition Design
Sam Auinger, André Heller
Gerfried Stocker, Volker Christian, Vaclav Cizkovsky, Horst Hörtner, Dietmar Offenhuber, Joachim Smetschka, Joachim Schnaitter. In Kooperation mit: ORF Ö1: Alfred Treiber, Architekturbüro Hans Hoffer

NOMADS

Ars Electroinica Center
Installation
Dietmar Offenhuber, Gerda Palmetshofer, Markus Decker

BESUCHERLEITSYSTEM

ORF Oberösterreich
Infostation
August Black, Michael Harbauer, Helmut Höllerl, Horst Hörtner, Dietmar Lassignleithner
In Kooperation mit: Komerz, Thomas Kienzl

PROCESSING IMAGES

Ars Electronica Center
Research in Residence
Ofelia da Silva Zaragoza Malheiros
Helmut Höllerl

EUROPÄISCHER KULTURMONAT

Stadt Linz
Webdesign
Manuel Schilcher, Uschi Reiter, Joris Gruber, Manuela Kiesenhofer, Mario Meisenberger, Elisabeth Schedlberger

KULTURHANDBUCH

Stadt Linz
Webdesign
Joachim Schnaitter, Joris Gruber, Manuel Schilcher

VIDEO.AEC.AT
Ars Electronica Center
Webcam-Portal
Volker Christian, Horst Hörtner, Andreas Jalsovec,
Gerald Kogler, Christopher Lindinger, Robert Praxmarer,
Gerald Schröcker

ARS ELECTRONICA FESTIVAL 1998 INFOWAR
Webdesign
Manuel Schilcher, Joachim Schnaitter, Helmut Höllerl,
August Black, Joris Gruber, Manuela Kiesenhofer, Mario
Meisenberger, Uschi Reiter, Gunter Schmidl

SPEEDNET
Telekom Austria
Video On Demand
Peter Stadlmann
Manuel Schilcher, Joris Gruber, Helmut Höllerl, Horst
Hörtner, Klemens Kitzberger, Pascal Maresch, Joachim
Schnaitter

INTERFACESIMULATION FÜR LINEARSYSTEME
Wittmann Kunststoffgeräte GmbH
CAVE-Applikation
Horst Hörtner, Andreas Jalsovec, Joachim Smetschka,
Klaus Taschler, Cahya Wirawan

1997
WORLDSKIN
Ars Electronica Center
CAVE-Applikation
Maurice Benayoun/Jean-Baptiste Barrière/F
Software-Entwicklung: Patrick Bouchaud, Kimi Bishop,
David Nahon. Grafische Bearbeitung: Raphaël Melki
Produktion: Ars Electronica Futurelab, Erich Berger,
Gilbert Netzer. Z.A. Production/Silicon Graphics, Europe
Credits: Daniela Basics, Zorha Balesic, Laurent Simonini,
Pierre Beloin, Guergana Novkirichka
Realisiert innerhalb des Ars Electronica Research &
Residence Program 97

VIRTUELLE SCHWEISSWERKSTATT
Fronius
CAVE-Visualisierung
Josephine Anstey, Vaclav Cizkovsky, Horst Hörtner,
Dietmar Offenhuber, Manuel Schilcher, Herman
Wakolbinger, Cahya Wirawan
In Kooperation mit: Christian Doppler Labor für
Softwareengineering Gustav Pomberger

MOBILE WORKSHOP (150 JAHRE SIEMENS)
Siemens AG
Networked CAVE Application
Horst Hörtner, Dave Pape, Josephine Anstey, Vaclav
Cizkovsky, Dietmar Offenhuber, Oliver Frommel,
Andreas Jalsovec, Andi Kleen, Manuel Schilcher,
Joachim Smetschka, Matt Smith, Cahya Wirawan,
In Kooperation mit: Telekom Austria, Peter Stadlmann

**MÜHLKREISAUTOBAHN A7-BINDERMICHL/
STADT LINZ**
CAVE-Visualisierung
Margarete Watson, Horst Hörtner, Andreas Jalsovec,
Manuel Schilcher
In Kooperation mit: Architecturbüro Kneidinger,
Schreiner Consulting TAS, Andreas Gratt

MULTI MEGA BOOK IN THE CAVE
Ars Electronica Center
CAVE-Applikation
Franz Fischnaller, Yesenia Maharaj Singh, Dave Pape,
Josephine Anstey
Dietmar Offenhuber, Horst Hörtner.
Teilweise realisiert im Rahmen des Ars Electronica
Research & Residence Program 1997.
In Kooperation mit: Dave Pape, Josephine Anstey, EVL,
Electronic Visualization Laboratory, University of
Illinois, Chicago.

openX
Ars Electronica Festival 1997 – FleshFactor
Exhibition Design
Dietmar Offenhuber, Gerda Palmethofer
In Kooperation mit: Kommerz/Thomas Kienzel

SONNENBLUME
ORF/Animation
Vaclav Cizkovsky

VISIBLE HUMAN
Ars Electronica Center
Animation im Aufzug
Dietmar Offenhuber, Volker Christian, Herman
Wakolbinger, Gerda Palmetshofer.
Mit Unterstützung der U.S. National Library of Medi-
cine (National Institute of Health, Bethesda, Mary-
land.

1996
APOLLO 13
Ars Electronica Center
Animation im Aufzug
Dietmar Offenhuber, Hermann Wakolbinger,
Gerda Palmetshofer

HUMPHREY I
Flugsimulator
Dietmar Offenhuber, Horst Hörtner, Andreas Jalso-
vec, Joachim Schnaitter, Werner Pötzelberger, Chri-
stopher Lindinger, Jürgen Kern, Robert Praxmarer.
In Kooperation mit: Thomas Kienzl, Andreas Behmel,
Tom Knienieder/WX WORX system
Digitales Höhenmodell: DORIS Projektgruppe.
Unterstützt von: Brau AG

APOLLO 13
Museumslift
Idee: Roy Ascott
Ars Electronica Futurelab, Dietmar Offenhuber, Gerda
Palmetshofer, Hermann Wakolbinger, Gerfried Stocker,
Horst Hörtner, Volker Christian.
Datenmaterial: Landsat TM, Spot PAN (Geospace),
Metosat 5 (Universität Nottingham), NOAA 4&5
(Universität Dundee)

STRÖMUNGSVISUALISIERUNG IN TURBINEN
MCE VOEST Alpine
CAVE Visualisierung
Jürgen Kern, Horst Hörtner, Dietmar Offenhuber,
Joachim Smetschka, Cahya Wirawan

ARS ELECTRONICA ORGANISATION & TEAM

Das Ars Electronica Center ist eine Einrichtung der Stadt Linz/is an institution of the municipality of Linz. Ars Electronica Center, Festival und Prix Ars Electronica werden unterstützt von/are supported by: Stadt Linz, Land Oberösterreich, Bundeskanzleramt/Kunstsektion, BMBWK

ARS ELECTRONICA CENTER LINZ MUSEUMSGESELLSCHAFT MBH

AUFSICHTSRAT

Vorsitzender: Vbgm. KR Dr. Erich Watzl
Stv. Vorsitzende: Prof. Dr. Hannes Leopoldseder, Stadtrat MMag. Klaus Luger
Mitglieder des Aufsichtsrates: Vorstandsdirektor Univ. Doz. Mag. DI Dr. Erhard Glötzl, KD Mag. Siegbert Janko, GR Horst Lausegger, oUniv. Prof. DI Dr. Gustav Pomberger, Vorstandsdirektor Wolfgang Winkler

GESCHÄFTSFÜHRUNG

Gerfried Stocker, Künstlerischer Leiter
Dr. Rainer Stadler, Prokurist

BETRIEBSRAT

Christa Schneebauer
Gerold Hofstadler
Thomas Mauhart

VERWALTUNG

Leitung: Elisabeth Kapeller
Thomas Mauhart
Rita Thaller
Birgit Wasmeyer
Michaela Wimplinger
Redaktion & Recherche: Christa Schneebauer
EU Projekte: Eva Luise Kühn

ARS ELECTRONICA FESTIVAL UND PRIX ARS ELECTRONICA

VERANSTALTER

Ars Electronica Center Linz
Museumsgesellschaft mbH

MITVERANSTALTER

ORF Oberösterreich
Landesdirektor: Helmut Obermayr
LIVA Veranstaltungsgesellschaft mbH
Vorstandsdirektoren: Wolfgang Winkler, Wolfgang Lehner
O.K Centrum für Gegenwartskunst
Direktor: Martin Sturm

KOOPERATIONSPARTNER

Universität für künstlerische und industrielle Gestaltung Linz, Lentos Kunstmuseum Linz, Posthof Linz

DIREKTORIUM, KÜNSTLERISCHE LEITUNG

Gerfried Stocker, AEC
Christine Schöpf, ORF

PRIX ARS ELECTRONICA

Veranstalter: Ars Electronica Center Linz Museumsgesellschaft mbH
Idee: Dr. Hannes Leopoldseder
Konzept und Koordination:
Christine Schöpf, ORF
Gerfried Stocker, AEC

ORGANISATION UND PRODUKTION

Katrin Emler – Ars Electronica Festival
Iris Mayr – Prix Ars Electronica
Produktionsteam:
Nicoletta Blacher
Ellen Fethke
Ingrid Fischer-Schreiber
Magnus Hofmüller
Verena Kain
Sonja Panholzer
Manuela Pfaffenberger
Clara Picot
Gerlinde Pöschko
Susanne Posegga
Jutta Schmiederer
Klemens Schuster
Andre Zogholy

ARS ELECTRONICA FUTURELAB

Forschungs- und Entwicklungslabor
Leitung: Horst Hörtner
Futurelab Team siehe Seite 360

ARS ELECTRONICA CENTER DIGITAL ECONOMY

Presse- und Öffentlichkeitsarbeit, Marketing, Sponsoring, Webdesign
Leitung: Ursula Kürmayr
Presse & Public Relations:
Wolfgang Bednarzek, Ulrike Ritter

Robert Bauernhansl
Jasna Brenneis
Barbara Egger
Stefan Eibelwimmer

Thomas Eifried
Gerda Hinterreiter
Christoph Hofbauer
Günther Kaiblinger
Diana Kienesberger
Günther Kolar
Tamara Kub
Wolfgang Mayrhofer
Stiliana Mitzeva
Nicolas Naveau
Daniela Ortner
Daniel Peherstorfer
Doris Peinbauer
Gunther Schmidl
Karin Schürz
Cornelia Sulzbacher
Wieser Veronika
Andreas Wabro
Claudia Wall
Werner Wetzlinger

ARS ELECTRONICA CENTER
MUSEUM OF THE FUTURE

MUSEUMSBETRIEB, VERANSTALTUNGS-
UND BESUCHERSERVICE
Leitung Museumsbetrieb: Herbert Gattringer
Leitung Besucherservice: Renata Aigner
Leitung Veranstaltungsservice: Michaela Lang
Daniel Braden
Margit Hofer
Viktoria Klepp
Alois Preinstorfer
Karl Schmidinger
Michael Sperer
Günther Waldhäusl

SYSTEMBETRIEB UND HAUSTECHNIK
Leitung: Gerold Hofstadler
Florian Arthofer
Bogdan Florescu
Gerhard Grafinger
Stefan Hackl
Rudolf Heinrich Hanl
Florian Keclik
Alexander Kneidinger
Faruk Kujundzic
Günter Mayr
Werner Mayr
Walter Ruprechtsberger
Thomas Steindl

SKY MEDIALOFT – GASTRONOMIE
Leitung: Silvia Nöhbauer
Tarek Bello
Marlies Gabriel-Griessl

Inge Himmelbauer
Claudia Kosowan
Sonja Portenkirchner
Eszter Rupp
Nicole Untersberger
Kerstin Valach
Julia Wellmann
Barbara Wernick
Wurzinger Bernadette
Nikolaus Ziak

INFOTRAINER
Viktoria Aistleitner
Sandra Bachner
Andreas Bauer
Joachim Blattner
Mathias Breuer
Florian Deutsch
Karl Federspiel
Manfred Gärtner
Hannelore Gebetsberger
Ulrike Gollner
Paul Gould
Ulrike Gschwandtner
Jacqueline Gstrein
Sigrid Hannesschläger
Birgit Hartinger
Barbara Hummer
Dominik Hussak
Walter Jamnig
Uwe Karner
Johann Kirchhofer
Helga Kranewitter
Sabine Kutis
Anna Katharina Link
Leopold Mainz
Sandra Mühlböck
Otto Naderer
Heinrich Niederhuber
Michaela Obermayer
Regina Pilgerstorfer
Anna-J.Prandstätter
Nina Rastinger
Isabella Rozic
Birgitt Schäffer
Julia Schauer
Jeldrik Schmuch
Sabine Siegl
Andrea Starmayr
Maria Steinbauer
Anita Helga Stockenreiter
Danijela Tolanov
Florian Wanninger
Alexander Weber
Monika Weinberger
Jürgen Wiesner

BIBLIOGRAFIE

Linzer Veranstaltungsgesellschaft (Hrsg.): *Ars Electronica 1979 im Rahmen des Internationalen Brucknerfestes 79*, Linz 1979

Linzer Veranstaltungsgesellschaft (Hrsg.): *Ars Electronica 1980 im Rahmen des Internationalen Brucknerfestes 80*, Linz 1980

Linzer Veranstaltungsgesellschaft (Hrsg.): *Ars Electronica im Rahmen des Internationalen Brucknerfestes Linz, Festival für Kunst, Technologie und Gesellschaft 1982*, Linz 1982

Österreichische Gesellschaft für Informatik (ÖGI): *Die Industrieroboter. Chancen Perspektiven und Konsequenzen für Wirtschaft, Industrie und Gesellschaft*, Linz 1982

Linzer Veranstaltungsgesellschaft (Hrsg.): *Ars Electronica im Rahmen des Internationalen Brucknerfestes Linz, Festival für Kunst, Technologie und Gesellschaft 1984*, Linz 1984

Linzer Veranstaltungsgesellschaft/Peter Weibel, *Zur Geschichte und Ästhetik der digitalen Kunst*, Supplement zum Katalog Ars Electronica 1984, Linz 1984

Linzer Veranstaltungsgesellschaft (Hrsg.): *Ars Electronica. Festival für Kunst, Technologie und Gesellschaft 1986*, Linz 1986

Österreichischer Rundfunk ORF, Landesstudio Oberösterreich (Hrsg.): *Computerkulturtage Linz – ORF-Videonale 86*, Linz 1986

Linzer Veranstaltungsgesellschaft (Hrsg.): *Ars Electronica 1987. Festival für Kunst, Technologie und Gesellschaft*, Linz 1987

Hannes Leopoldseder (Hrsg.): *Prix Ars Electronica, Meisterwerke der Computerkunst, Edition 87*, Verlag H. S. Sauer, Worpswede

Peter Weibel; Hochschule für Angewandte Kunst; Linzer Veranstaltungsgesellschaft (Hrsg.): *Jenseits der Erde. Das orbitale Zeitalter*, Hora Verlag, Wien 1987

Hannes Leopoldseder: *Linzer Klangwolke. Kunsterlebnis zwischen Himmel und Erde. Die Geschichte eines Markenzeichens*. Edition Christian Brandstätter, Wien 1988

Hannes Leopoldseder (Hrsg.): *Prix Ars Electronica, Meisterwerke der Computerkunst, Edition 88*, TMS-Verlag, Bremen

Im Netz der Systeme, *Kunstforum International*, Bd. 103, September/Oktober 1989, Köln 1989

Karl Gerbel/Hannes Leopoldseder (Hrsg.): *Die Ars Electronica. Kunst im Zeitsprung*, Landesverlag, Linz 1989

Ars Electronica (Hrsg.): *Philosophien der neuen Technologien*, Merve Verlag Berlin 1989

Gottfried Hattinger/Peter Weibel (Hrsg.): *Ars Electronica 90, Band 1: Digitale Träume/Digital Dreams; Band 2: Virtuelle Welten/Virtual Worlds*, Veritas Verlag, Linz 1990

Hannes Leopoldseder (Hrsg.): *Der Prix Ars Electronica. Internationales Kompendium der Computerkünste*, Veritas Verlag, Linz 1990

Karl Gerbel (Hrsg.): *Ars Electronica 1991. Out of Control*, Landesverlag Linz 1991

Hannes Leopoldseder (Hrsg.): *Der Prix Ars Electronica. Internationales Kompendium der Computerkünste*, Veritas Verlag Linz, 1991

Karl Gerbel/Peter Weibel (Hrsg.): *Ars Electronica 1992, Die Welt von Innen – Endo und Nano*, PVS Verleger, Wien 1992

Hannes Leopoldseder (Hrsg.): *Der Prix Ars Electronica. Internationales Kompendium der Computerkünste*, Veritas Verlag, Linz 1992

David Dunn (Hrsg.): *Eigenwelt der Apparate-Welt. Pioneers in Electronica Art. Ars Electronica 1992*, Linz (Katalog zur Austellung „Eigenwelt der Apparatewelt. Pioniere der Elektronischen Kunst, 22. 6. – 7.7. 1992, Oberösterreichisches Landesmuseum Francisco Carolinum, Linz; Künstlerische Leitung: Peter Weibel, Kuratoren: Woody Vasulka und Steina Vasulka)

Karl Gerbel/Peter Weibel (Hrsg.): *Ars Electronica 93. Genetische Kunst – Künstliches Leben. Artificial Life – Genetic Art*, PVS Verleger, Wien 1993

Hannes Leopoldseder (Hrsg.): *Der Prix Ars Electronica. Internationales Kompendium der Computerkünste*, Veritas Verlag, Linz 1993

Karl Gerbel/Peter Weibel (Hrsg.): *Ars Electronica 94. Intelligente Ambiente – Intelligent Environments*, Band 1 und 2, PVS Verleger, Wien 1994

Hannes Leopoldseder (Hrsg.): *Der Prix Ars Electronica. Internationales Kompendium der Computerkünste*, Veritas Verlag, Linz 1994

Karl Gerbel/Peter Weibel (Hrsg.): *Ars Electronica 95. Mythos Information, Welcome to the Wired World*, Springer Wien-New York 1995

Leopoldseder, Hannes/Schöpf, Christine (Hrsg.): *Der Prix Ars Electronica. Internationales Kompendium der Computerkünste*, Österreichischer Rundfunk (ORF), Landesstudio Oberösterreich, Linz 1995

Gerfried Stocker/Christine Schöpf (Hrsg.): *Ars Electronica Festival 96. Memesis – The Future of Evolution*, Springer Wien-New York 1996

Siegbert Janko/Hannes Leopoldseder/Gerfried Stocker (Hrsg.): *Ars Electronica Center. Museum der Zukunft*, Linz 1996

Hannes Leopoldseder/Christine Schöpf (Hrsg.): *Der Prix Ars Electronica. Internationales Kompendium der Computerkünste*, Springer Wien-New York 1996

Gerfried Stocker/Christine Schöpf (Hrsg.): *FleshFactor – Informationsmaschine Mensch*. Ars Electronica Festival 97, Springer Wien-New York 1997

Hannes Leopoldseder/Christine Schöpf (Hrsg.): *Cyberarts. International Compendium. Prix Ars Electronica*. Springer Wien-New York 1997

Manfred Beneder (Hrsg.): *robots@aec.at. Proceedings on the 1st Workshop on Teleoperation an Robotics, Applications in Science and Arts*. R. Oldenburg, Wien-München 1997

Ars Electronica Center (Hrsg.): *Guide 97*, Linz 1997

Ars Electronica Center (Hrsg.): *Wegweiser 97*, Linz 1997

Gerfried Stocker/Christine Schöpf (Hrsg.): *InfoWar*, Springer Wien-New York 1998

Gerfried Stocker/Christine Schöpf (Hrsg.): *Information.Macht.Krieg*, Springer Wien-New York 1998

Gerfried Stocker/Christine Schöpf (Hrsg.): *Ars Electronica 98. InfoWar*, Springer Wien-New York 1998

Hannes Leopoldseder/Schöpf, Christine (Hrsg.): *CyberArts 98. International Compendium. Prix Ars Electronica*. Springer Wien-New York 1998

Hannes Leopoldseder/Schöpf, Christine (Hrsg.): *CyberArts 99. International Compendium. Prix Ars Electronica*. Springer Wien-New York 1999

Ars Electronica Center (Hrsg.): *Wegweiser 99*, Linz 1999

Ars Electronica Center (Hrsg.): *Guide 99*, Linz 1999

Timothy Druckrey/Ars Electronica (Hrsg.): *Ars Electronica – Facing the Future*, MIT Press, Cambridge/Mass. 1999

Hannes Leopoldseder/Christine Schöpf/Gerfried Stocker (Hrsg.): *Ars Electronica 79–99: 20 Jahre Festival für Kunst, Technologie und Gesellschaft*, Linz 1999

Gerfried Stocker/Christine Schöpf (Hrsg.): *LifeScience*. Springer Wien-New York 1999

Gerfried Stocker/Christine Schöpf (Hrsg.): *NEXT SEX – Sex in the Age of its Procreative Superfluosness/Sex im Zeitalter seiner reproduktionstechnischen Überflüssigkeit*. Springer Wien – New York, 2000

Hannes Leopoldseder/Christine Schöpf (Hrsg.): *CyberArts 2000. International Compendium. Prix Ars Electronica*. Springer Wien – New York, 2000

Gerfried Stocker/Christine Schöpf (Hrsg.): *TAKEOVER – who's doing the art of tomorrow/wer macht die kunst von morgen*. Springer Wien – New York, 2001

Hannes Leopoldseder/Christine Schöpf (Hrsg.): *CyberArts 2001. International Compendium. Prix Ars Electronica*. Springer Wien – New York, 2001

Gerfried Stocker/Christine Schöpf (Hrsg.): *UNPLUGGED – Art as the Scene of Global Conflicts/ UNPLUGGED – Kunst als Schauplatz globaler Konflikte*. Hatje Cantz – Ostfildern-Ruit, 2002

Hannes Leopoldseder/Christine Schöpf (Hrsg.): *CyberArts 2002. International Compendium. Prix Ars Electronica 2002*. Hatje Cantz – Ostfildern-Ruit, 2002

Gerfried Stocker/Christine Schöpf (Hrsg.): *CODE – The Language of our Time – Code = Law Code = Art Code = Life*. Hatje Cantz – Ostfildern-Ruit, 2003

Hannes Leopoldseder/Christine Schöpf (Hrsg.): *CyberArts 2003. International Compendium. Prix Ars Electronica 2003*. Hatje Cantz – Ostfildern-Ruit, 2003

Gerfried Stocker/Christine Schöpf (Hrsg.): *TIMESHIFT – The World in Twenty-Five Years/Die Welt in 25 Jahren*. Hatje Cantz – Ostfildern-Ruit, 2004

Hannes Leopoldseder/Christine Schöpf/Gerfried Stocker (Hrsg.): *CyberArts 2004. International Compendium. Prix Ars Electronica 2004*. Hatje Cantz – Ostfildern-Ruit, 2004

Hannes Leopoldseder/Christine Schöpf/Gerfried Stocker (Hrsg.): *Ars Electronica 1979 – 2004. 25 Jahre Netzwerk für Kunst, Technologie und Gesellschaft*. Hatje Cantz – Ostfildern-Ruit, 2004

IMPRINT

Editors
Hannes Leopoldseder, Christine Schöpf, Gerfried Stocker

Editing
Jutta Schmiederer, Heimo Ranzenbacher

Translations
From the German:
Part I: Aileen Derieg, Catherine Lewis
Part II: Mel Greenwald, Catherine Kerkhoff-Saxon
From the English:
Part I: Angela Kornberger
Part II: Michael Kaufmann

Proofreading
Ingrid Fischer-Schreiber, Giles Tilling/WordWorks

Graphic Design
Part I: Gerhard Kirchschläger
Part II: Jacqueline Ployer

Printed by
Gutenberg-Werbering Gesellschaft m.b.H., Linz

Published by
Hatje Cantz Verlag
Senefelderstraße 12
73760 Ostfildern-Ruit
Deutschland / Germany
Tel. +49 / 711 / 44050
Fax +49 / 711 / 4405220
www.hatjecantz.com

Hatje Cantz books are available internationally at selected
bookstores and from the following distribution partners:

USA/North America – D.A.P., Distributed Art Publishers,
New York, www.artbook.com

UK – Art Books International, London, sales@art-bks.com

Australia – Towerbooks, French Forest (Sydney),
towerbks@zipworld.com.au

France – Interart, Paris, commercial@interart.fr

Belgium – Exhibitions International, Leuven,
www.exhibitionsinternational.be

Switzerland – Scheidegger, Affoltern am Albis,
scheidegger@ava.ch

For Asia, Japan, South America, and Africa, as well as for
general questions, please contact Hatje Cantz directly at
sales@hatjecantz.de, or visit our homepage
www.hatjecantz.com for further information.

ISBN 3-7757-1525-8

Printed in Austria

Ars Electronica 1979 – 2004
The Network for Art, Technology and Society: The First 25 Years
25 Jahre Netzwerk für Kunst, Technologie und Gesellschaft

**AEC Ars Electronica Center Linz
Museumsgesellschaft mbH**

Managing Directors
Gerfried Stocker, Rainer Stadler

Hauptstraße 2, A – 4040 Linz, Austria
Tel. +43.732.7272-0
Fax +43.732.7272-2
info@aec.at
www.aec.at

PHOTO CREDITS

18/1: Fotostudio Krutzler + Wimmer, Kurt Aumayr, Traun; 18/2: LIVA-Archiv; 19–21: LIVA-Archiv; 22: Pascal Maresch; 25: Art Tower Mito, Mito/J; 26: Fotostudio Krutzler + Wimmer, Kurt Aumayr, Traun; 27–29: LIVA-Archiv; 30: Sepp Schaffler; 31–32: LIVA-Archiv; 33: ORF-Archiv; 34–37: LIVA-Archiv; 39: Art+Com, Berlin; 40/1: Andrea Eizinger; 42–44: Ars Electronica Archiv; 45/1: Rubra; 45/2: Ars Electronica Archiv; 46: ORF-Archiv; 47–50/1: Sabine Starmayr; 50/2: Marianne Weiss; 51–53/1: Sabine Starmayr; 55–58: Sabine Starmayr; 62–65: LIVA-Archiv; 66: 67: LIVA-Archiv; 68: Sepp Schaffler; 69: LIVA-Archiv; 70: Ars Electronica Archiv; 71: Pascal Maresch; 72: Norbert Artner; 76/1: Ars Electronica Archiv; 77/1: Sabine Starmayr; 78/2–3: Ars Electronica Archiv; 79, 84–85, 91: Rubra; 92: Fotostudio Krutzler + Wimmer, Kurt Aumayr, Traun; 93: LIVA-Archiv; 94: Sepp Schaffler; 95–96: LIVA-Archiv; 101: ORF-Archiv; 107: Norbert Artner; 110–111: ORF-Archiv; 112/113: Martín Vargas; 115: Sabine Starmayr; 116/1–3: Sabine Starmayr; 116/4: Rubra; 117/1: Norbert Artner; 121: Sabine Starmayr; 122/1–3: Sabine Starmayr; 122/4: Otto Saxinger; 124/2: Pascal Maresch; 125/1: Sabine Starmayr; 125/2: Robert Worby; 125/3–4: Sabine Starmayr; 126/1: Sabine Starmayr; 127/128: Sabine Starmayr; 129/1–2: Pascal Maresch; 129/3: Sabine Starmayr; 130–131: Sabine Starmayr; 132/1–2: Rubra; 132/3–6: Pascal Maresch; 133: Pascal Maresch; 134/1: PILO; 134/2: Paschal Maresch; 135: PILO; 136/137: PILO; 138: PILO; 139/1: PILO; 139/2–3: Ars Electronica Archiv; 140/1: PILO; 140/2: Norbert Artner; 141–144: PILO; 145: Scott Ritter; 146–151: PILO; 152/1–2: PILO; 152/3: Pascal Maresch; 153/1: PILO; 153/1–3: Pascal Maresch; 154: PILO; 154/2: Norbert Artner; 155: Ars Electronica Archiv; 156–162: PILO; 163: Ars Electronica Archiv; 164: Norbert Artner; 165: Pascal Maresch; 167: Ars Electronica Archiv; 168/1–2: Ars Electronica Futurelab; 169: Pascal Maresch; 170/1: Ars Electronica Future-lab; 170/1–3: Pascal Maresch; 172/1–2: Ars Electronica Archiv; 172/3–4: Pascal Maresch; 172/5: Sabine Starmayr; 172/6: Ars Electronica Archiv; 173/1: Ars Electronica Archiv; 173/2–13: Ars Electronica Future-lab; 174: Ars Electronica Archiv; 175/176: Ars Electronica Futurelab; 177: Ars Electronica Archiv; 178: Norbert Artner; 180–181/1: Ars Electronica Archiv; 181/2: Ars Electronica Futurelab; 182–184: Ars Electronica Future-lab; 185: Ars Electronica Archiv; 186/187: Pascal Maresch; 188/189: Ars Electronica Futurelab; 190–195: Ars Electronica Archiv; 196/1–4: Ars Electronica Archiv; 196/5: PILO; 197/1, 3–4: Ars Electronica Archiv; 196/2: PILO; 198/199: Ars Electronica Archiv; 200: PILO; 201–203: Ars Electronica Archiv; 206–225: LIVA-Archiv, ORF-Archiv, Ars Electronica Archiv; 361/1: Norbert Artner; 361, 363, 365: Pascal Maresch

The Ars Electronica Center Linz is an institution of the municipality of Linz.

Das Ars Electronica Center Linz ist eine Einrichtung der Stadt Linz.

Ars Electronica is supported by:
Stadt Linz
Land Oberösterreich
Bundeskanzleramt/Kunstsektion
BMBWK

Stadt Linz

Land Oberösterreich

Bundeskanzleramt / Kunstsektion

Wesentliche Unterstützung kommt von Kooperationspartnern aus der Wirtschaft und Sponsoren. Zum Zeitpunkt des Erscheinens dieser Publikation sind dies folgende Unternehmen:

Considerable support has been given by our sponsors and cooperation partners in industry. At the time of going to press, our thanks go to:

SAP AG

Telekom Austria

voestalpine

Gericom AG

Mitsubishi Electric

SIEMENS

Siemens Österreich

FESTO

FESTO

Ö1

Microsoft Österreich

Mercedes Benz

Sony DADC

Sony DADC

Casinos Austria

Innovatives-Österreich

BMWA

bm:bwk

BMBWK

Additional Support: 3com, Lenz Moser, Brau AG, Frank & Partner, Lexmark, Pöstlingbergschlößl, VS Fickenscher, Bundesministerium für Verkehr, Innovation und Technologie, M-AUDIO, Jindrak, KulturKontakt Austria, Spring, KLM, FAS.research